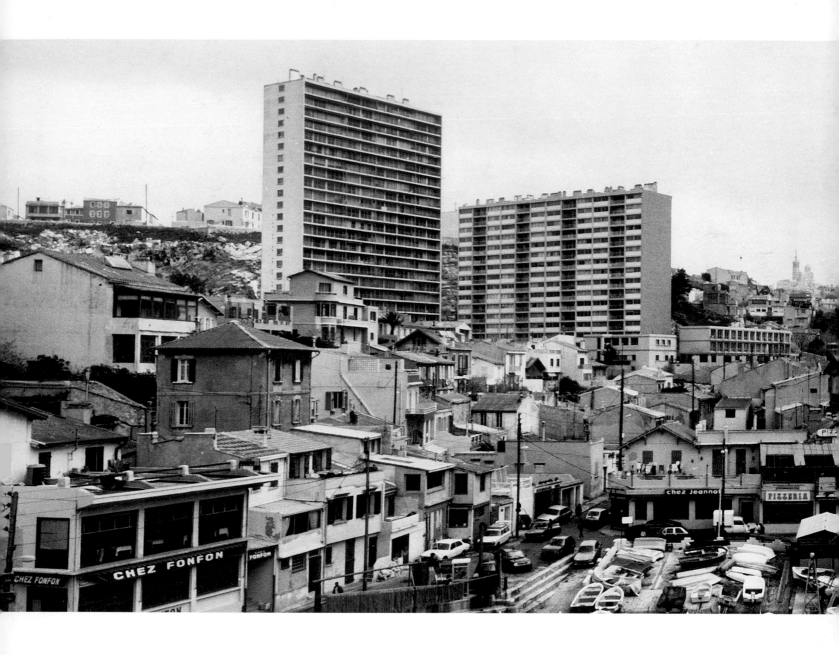

ABOVE Holger Trülzsch,
Marseille (Bouches du Rhône), 1986

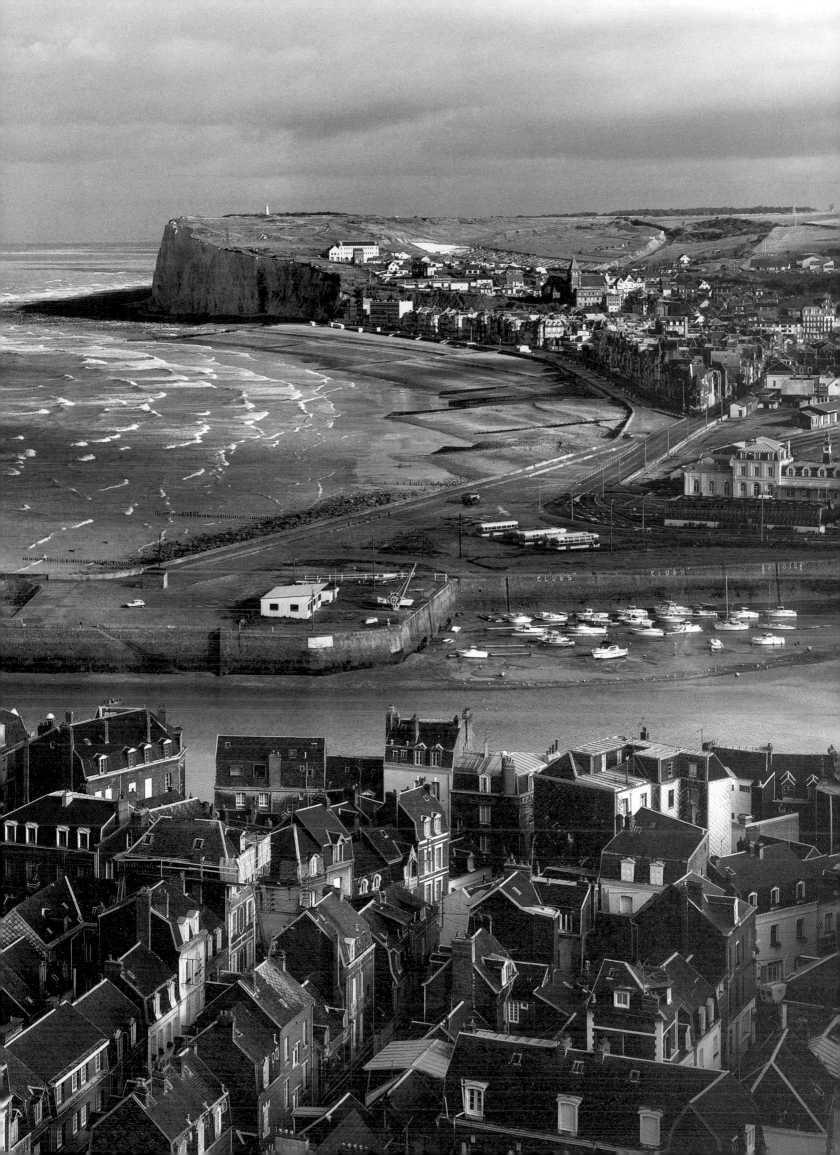

ABOVE Suzanne Lafont, *Cokerie, Drocourt (Pas de Calais)*, 1985

PREVIOUS TWO PAGES Robert Doisneau, *Villejust (Essone)*, 1984

PRE

INVESTED SPACES IN VISUAL ARTS, ARCHITECTURE

MISES

& DESIGN FROM FRANCE: 1958–1998

GUGGENHEIM MUSEUM

PREMISES
Invested Spaces in Visual Arts, Architecture, & Design from France: 1958–1998

Guggenheim Museum SoHo | October 13, 1998–January 11, 1999

HUGO BOSS

is the sponsor of this exhibition as part of its ongoing
support of the Solomon R. Guggenheim Foundation

DVD production and integration is provided by

Transportation assistance is provided by

This exhibition is supported by the French Ministry
of Foreign Affairs through the Association Française
d'Action Artistique and the Cultural Services of the
French Embassy, New York. Additional support is
provided by Etant donnés, The French-American Fund
for Contemporary Art, New York. Additional support
is provided by The Florence Gould Foundation.

PREMISES: FRENCH CINEMA, 1958-1998
is sponsored by

ISBN 0-8109-6915-7 (hardcover)
ISBN 0-89207-214-8 (softcover)

Guggenheim Museum Publications
1071 Fifth Avenue
New York, New York 10128

Hardcover edition distributed by
Harry N. Abrams, Inc.
100 Fifth Avenue
New York, New York 10011

Printed in Italy by Mariogros

Design: Design/Writing/Research, New York

CONTENTS

Premises: Invested Spaces in Visual Arts, Architecture, & Design from France: 1958–1998 covers a broad range of artistic practice, one whose hallmark is a literary and philosophical intellectualism. Since the end of the 1960s, much of the art from this rich vein has been mined internationally, becoming the model in a variety of disciplines.

Starting with Yves Klein—who opened up new dimensions in painting with his fire images, body imprints, and unmistakable blue monochromes—and with Jean Nouvel—who became the forerunner of new architecture, this multifaceted exhibition displays works by French artists, designers, and architects from the last forty years.

Premises clearly illustrates how dedicated the French arts are to contemporary reality and to an unbroken vision toward the future. Its discourse is not limited to the tangible physical space of today's material world, but has long encompassed the dimensions of the imaginary and the virtual, and even the cyberworlds of tomorrow. International culture and art history would be unthinkable without the contribution of France.

Hugo Boss is pleased to support this exhibition of the artistic force from France, one whose influence has been felt well beyond Europe, and, indeed, throughout the creative world.

JOACHIM VOGT
Chairman and CEO
HUGO BOSS

Art for art's sake is akin to pursuit of life for life's sake—innocently worthwhile. Technology for technology's sake, however, knows no such innocence. For this reason, Zuma Digital is especially proud, as we begin our association with the Solomon R. Guggenheim Foundation, to provide DVD production and integration for *Premises*—the first major fine art exhibition to make use of this technology.

As a younger, techno-aware generation makes its way into view, the exploration for technology-based artworks may become the human justification of technological evolution. Like many of the works it depicts, *Premises*, in its ambitious use of contemporary DVD technology, attempts to realize the inherent opposition between mass communication devices, such as DVD, and the artist's urge to enunciate an individual statement. With seeming paradox, DVD is used to both ends within *Premises*.

Zuma Digital's support of the Guggenheim represents Zuma's support of a universally respected cultural institution, with the courage to recognize that new technologies sometimes create productive unrest. Through our sponsorship of *Premises* and the Guggenheim, Zuma Digital is hoping to contribute to the continued exploration of the artist's vision through the lens of contemporary technology.

Premises is an extremely expansive and unprecedented survey of the universe of modern and contemporary French art and architecture. It is our great pleasure to contribute to this effort. We hope you enjoy the exhibition and the unique experience it offers.

DAVID ANTHONY
Chief Executive Officer
ZUMA Digital, New York City

Arman, New York

BDIC, Musée d'Histoire Contemporaine, Paris

Patrick Berger, Paris

Bibliothèque Nationale de France, Paris

Jean Brolly, Paris

Louise Bourgeois, New York

Daniel Buren, Paris

Jean-Marc Bustamante, Paris

Caisse des Dépôts et Consignations, Paris

Sophie Calle, Paris

Centre Georges Pompidou,
 Musée national d'art moderne, Paris

Centre d'art contemporain de Cluny

Jay Chiat Foundation, New York

Collection Paolo Curti, Milan

Brigitte Cornand, Paris

Deutsche Architektur-Museum, Frankfurt

District Grand Caen, Caen

Marie-Thérèse Etienne-Martin, Paris

Collection Feelisch, Ramscheid

Fonds National d'Art Contemporain, Paris

Fondation Le Corbusier, Paris

FRAC Bourgogne, Dijon

FRAC Languedoc-Roussillon, Montpellier

Gagosian Gallery, New York

Galerie Chantal Crousel, Paris

Galerie Denise René, Paris

Galerie Daniel Templon, Paris

Gérard Garouste, Marcilly-sur-Eure

Henri Gaudin, Paris

Finn Geipel, Nicolas Michelin, Labfac, Paris

GEMACI, Paris

Laurent Gervereau, Paris

Jochen Gerz, Paris

Dominique Gonzalez-Foerster, Paris

Marie-Ange Guilleminot, Paris

Thomas Hirschhorn, Paris

Fabrice Hybert, Paris

ISKRA, Paris

Yves Klein Archives, Paris

Bertrand Lavier, Aignay le Duc

Claude Lévêque, Paris

Duncan Lewis, Paris

Luhring Augustine Gallery, New York

Matthew Marks Gallery, New York

Annette Messager, Malakoff

Musée d'art moderne de la Ville de Paris

Musée d'art moderne et contemporain, Geneva

Museum Haus Lange, Krefeld

OPHLM, d'Ivry sur Seine

Office for Metropolitan Architecture
 Rem Koolhaas, Rotterdam

Dominique Perrault Architecte, Paris

Jean-Pierre Raynaud, Bougival

Annie Rutault, Vaucresson

Ninon Rutault, Vaucresson

Sarkis, Paris

Holly Solomon Gallery, New York

Daniel Spoerri, Seggiano

Philippe Starck, Paris

Xavier Veilhan, Paris

Jean-Luc Vilmouth, Paris

Walker Art Center, Minneapolis

One lender wishes to remain anonymous.

From its inception, the Guggenheim Museum has had a remarkably strong international orientation with a distinct focus among American museums on various facets of the European avant-garde. In the past two decades, our exhibition program has emphasized artists working in France through such important shows as *Henri Michaux* (1978), *Yves Klein: A Retrospective* (1982), *French Art Today: 1986 Exxon International Exhibition*, as well as seven separate exhibitions devoted to Jean Dubuffet's work. *Premises: Invested Spaces in Visual Arts, Architecture, & Design from France: 1958–1998* renews the Guggenheim's longstanding commitment to the European avant-garde while also providing an opportunity to introduce recent art and architecture from France to an American audience.

While the Guggenheim has explored the arts of many national groups, the curators of *Premises* chose a theoretically driven concept as a lens to explore notions of space in the work of architects, artists, and designers working in France. By disregarding the traditional hierarchies that oppose architecture and art, the catalogue and exhibition offer a provocative scenario that parallels current tendencies toward interdisciplinarity in contemporary visual culture while attempting to transcend an exhibition argument centered purely on nationalism.

Premises was coorganized by the curatorial teams of the Centre Georges Pompidou and the Guggenheim Museum under the direction of Bernard Blistène, Alison M. Gingeras, and Alain Guiheux. Their collective efforts shepherded both this catalogue and exhibition to extremely successful ends.

An exhibition of this ambition could not have been realized without the assistance of many individuals. I am particularly grateful to Joachim Vogt, Chairman and Chief Executive Officer of Hugo Boss, for his ongoing valued support of the museum; without his constant collaboration, as well as that of Isabella Heudorf, Art Sponsorship, this and many other exhibitions at the museum would not be possible. The museum owes a special debt to David Anthony, Chief Executive Officer, and Blaine Graboyes, Creative and Technical Director, at Zuma Digital for the provision of essential DVD production and integration for this exhibition. I would also like to extend special thanks to Jean-Cyril Spinetta, President Directeur-Général at Air France, for transportation assistance. We are also particularly grateful to Tom Haga, President, and Linda Toleno, Vice President, Sales and Marketing, Pioneer New Media, for providing the Guggenheim with equipment and technical expertise used in the preparation of the exhibition. For the support of the film program, I would like to thank Jérôme Brunel, Chief Executive Officer, Credit Lyonnais Americas. In addition, this exhibition could not have been mounted without the support of the French Ministry of Foreign Affairs through the Cultural Services of the French Embassy, New York. In particular, I would like to recognize Jean Digne, Director of the Association Française d'Action Artistique, and the board of Étant donnés, The French-American Fund for Contemporary Art, for their unfailing support of the work of the artists of the exhibition. The Florence Gould Foundation should also be recognized for a grant that supported research and development for this exhibition.

THOMAS KRENS
Director, The Solomon R. Guggenheim Foundation

Several images taken from an extensive commission by the government agency DATAR (Délégation à l'Aménagement du Territoire et à l'Action Régionale) serve as a visual introduction to this catalogue. DATAR photographers, whose preoccupations ranged from reportage to more aesthetic compositions, documented urban, suburban, and rural sites in France during the 1980s, a period marked by extreme topographic and sociopolitical transformation. The notions of *site*, *space*, *territory*, and *location* are the subject of these photographs, and by extension, become a synecdoche for this exhibition.

Playing upon the two meanings of its title, the first being locality or space and the second thought or argument, *Premises* explores the past forty years of aesthetic production in France in relation to the interweaving of mental and physical space—a theme that has preoccupied many international artists. *Premises* spans a range of disciplines, including installation, film, video, photography, architecture, and design since the end of the 1950s. Each work selected for the exhibition constitutes a specific site, a distinct locality, or a physical as well as psychic territory. From the hermetic, white *Cell No. 3* built by Absalon as his own habitation to the cavernous, organic space of Annette Messager's *En Balance* or the transparent glass screens that compose the skin of Jean Nouvel's Fondation Cartier building, the artists and architects in this exhibition construct a built environment. In order to further highlight each discipline's investment in the construction of space, the exhibition design has been conceived as a "superimposition" of visual-art installations with architectural rooms that are enclosed by semitranslucent rear screen walls. Without imposing a hierarchy or arguing a direct relation between art and architectural practice, this speculative design attempts to question each discipline by the specificities of the other: a "mise-en-péril" of one by the other.

This catalogue is divided into two main sections, architecture and visual arts, each of which is organized into five distinct thematic chapters. Each chapter groups together works by several generations of artists or architects dealing with similar motifs, yet each work is studied individually in order to explore its varied meanings. As an epilogue to the catalogue, the work of four prominent designers, Sylvain Dubuisson, Garouste & Bonetti, Philippe Starck, and Martin Szekely, is included. Each designer was asked to imagine an environment that corresponds to the notion of "invested space"; their propositions were realized in the form of a virtual image and are accompanied by a statement by the designer in this section. These interventions open the exhibition to a different reflection on the relationship of design practice, lived space and everyday life.

Premises is the result of a unique collaboration between the curatorial staffs of the Guggenheim Museum and the Musée national d'art moderne at the Centre Georges Pompidou in Paris. After three years of preparation, this complex project has been dependent on the tremendous effort of numerous individuals. Both teams that made up this unique, transatlantic collaboration should be recognized for the success of *Premises*. This exhibition would not have been possible without the enthusiastic support of Thomas Krens, Director of the Solomon R. Guggenheim Foundation, and Jean-Jacques Aillagon, President of the Centre Georges Pompidou, along with Werner Spies, Director of the Musée national d'art moderne—Centre de création industrielle, and Lisa Dennison, Chief Curator and Deputy Director of the Solomon R. Guggenheim Museum. We are equally indebted to François Barré, Former President of the Centre Georges Pompidou, and Germain Viatte, Former Director of the Musée national d'art moderne—Centre de création industrielle, for their crucial roles as initiators of our collaboration. We would also like to thank those individuals who have worked closely with the direction of our two institutions, especially Joël Girard, Chef de Cabinet in the President's office at the Centre Georges Pompidou, Min Kim, Max Hollein, and Greg Jordan, Executive Assistants to the Director of the Solomon R. Guggenheim Foundation, as well as Diane Dewey, Administrative Coordinator, and Jeffrey Saletnik, Administrative Assistant,

RIGHT "Premise" definition, from
*Webster's Third New International
Dictionary of the English Language,
unabridged* (Springfield, Mass:
G. & C. Merriam Company, 1976),
p. 1789

Jean-Pierre Marcie-Rivière, President of the Société des Amis du Centre Georges Pompidou, and François Trèves, President of the Société des Amis du Musée national d'art moderne.

We wish to also express our deepest gratitude to His Excellency M. François Bujon, French Ambassador in the United States, as well as Richard Duqué, the French Consul Général in New York. We are grateful to Pierre Buhler, Conseiller Culturel, and the French Cultural Services of the French Embassy in New York, for lending invaluable support to this exhibition; in particular, we thank Estelle Berruyer, Ellie During, Béatrice Ellis, and Emmanuel Morlet, as well as Emmanuelle de Montgazon, Cultural Attachée at the French Embassy in Tokyo. The assistance of the French Ministry of Foreign Affairs, in particular of Jean Digne, Director, and Marie-Paule Serre, Director of Visual Arts at the Association Française d'Action Artistique, made a substantial contribution toward the realization of the exhibition. For his assistance with the Sarkis publication and the support of the *Premises* conference, we would like to extend a special thanks to Yves Mabin, Deputy Director of the Bureau du Livre, French Ministry of Foreign Affairs.

An exhibition of this magnitude could not have been realized without the involvement of the many lenders who are listed at the beginning of this volume. We would also like to thank all of the artists and their assistants, associates, and estates for their invaluable help: Albert Amsellem for his assistance with the Absalon estate; Corice Canton Arman, Alain Bizos, and Lynne Brown; Annie Vautier; Jerry Gorovoy; Annick Boisnard, Sophie Streefkerk; Jeanne-Claude Christo; Francine Déroudille; Anne d'Harnoncourt and Ann Tempkin for their assistance with the Marcel Duchamp estate; Marie-Thérèse Etienne-Martin; Véronique de Fenoÿl; Marianne Filliou; Cyril Herniot; Mrs. Paul-Armand Gette and Paul Gette; Marion Hohlfeldt; Anne Marchand for her assistance with the Gina Pane estate; Jacques Caumont and Colette Soardi; Stéphane Bara, Alain Bonnefoux, Anne Groslafaige, and Thiphaine Treins; Rotraut Klein Moquay, Daniel Moquay, and Philippe Siauve for their assistance with the Yves Klein estate; Etienne Bossu, and Vincent Lecocq; Christine Delgado, and the staff of Storefront for Art and Architecture; Uwe Fleckner and Stefan Richter; Pavel Schmidt; Benoît d'Aubert, Claire Burrus, Elizabeth Lebovici, and Daniel Soutif for their assistance with the Philippe Thomas estate; Niki de Saint-Phalle for her assistance with the Jean Tinguely estate.

¹prem·ise *also* prem·iss \'preməs\ *n, pl* premises *also* premisses [in sense 1, fr. ME *premisse*, fr. MF, fr. ML *praemissa*, fr. L, fem. of *praemissus*, past part. of ¹*praemittere* to place ahead, send ahead, fr. *prae-* pre- + *mittere* to send; in other senses, fr. ME *premisses*, fr. ML *praemissa*, fr. L, neut. pl. of *praemissus* — more at SMITE] 1 : a proposition antecedently supposed or proved : a basis of argument: as a : a proposition in logic stated or assumed as leading to a conclusion : either of the first two propositions of a syllogism from which the conclusion is drawn b : something assumed or taken for granted : PRESUPPOSITION; *esp* : something implied as a condition precedent c *obs* : a condition stated beforehand : STIPULATION ⟨the ~s observed, thy will by my performance shall be served —Shak.⟩ 2 premises *pl* : matters previously stated or set forth: as a : the part of a deed preceding the habendum, being formerly the first of eight parts making up an old-style deed and serving to state the names and addresses of the parties and to make the recitals necessary to explain the transaction (as the consideration, the capacity of the parties to act, and the identity of the land to be conveyed) b : the part of a bill in equity that sets forth the causes of complaint, the parties against whom redress is sought, and other pertinent explanatory matter 3 premises *pl* a *archaic* : property that is conveyed by bequest or deed b : a specified piece or tract of land with the structures on it c : a building, buildings, or part of a building covered by or within the stated terms of a policy (as of fire insurance) d : the place of business of an enterprise or institution 4 *obs* : an antecedent happening or circumstance — usu. used in pl.

We would also like to thank the following individuals, institutions, and galleries for their assistance: agnès b., Pierre del Fondo and Yves Seban; Annick Leroy; Guy Tosato and Barbara Schroeder Carré d'Art, Nîmes; Pierre-François Bourcet; Wolfgang Feelisch (with an extra thank you for his assistance with the cover image); Rosie Bordet; Alain-Dominique Perrin and Lice Roy, Fondation Cartier, Paris; Louis Deledicq, Fondation Dubuffet, Paris; Gaita Leboissetier, Hélène Vassal, and Sara Chiarella, Fonds National d'Art Contemporain, Paris; Anne Dary, FRAC Franche-Comté, Besançon, Amy Barak, Director, FRAC Languedoc-Roussillon; Nathalie Abou Isaac, Philippe Bérard, and Véronique Legrand, MAC-Galeries Contemporaines des Musées de Marseille; Suzanne Pagé, Sophie Krebs, and Jacqueline Munck, Musée d'art moderne de la Ville de Paris; Bernard Ceysson, Joëlle Musso, and Patricia Pays, Musée d'art moderne, Saint-Etienne; Serge Lemoine, Musée de Grenoble; Niklas Svennung; Andrès Pardey, Musée Jean Tinguely, Basel; Galerie Nathalie et Georges-Philippe Vallois, Paris; and Ealan Wingate, Gagosian Gallery, New York.

We would like to thank the following eminent authors who contributed to the exhibition catalogue: Joseph Abram, École d'Architecture de Strasbourg; Dudley Andrew, Director of the Institute for Cinema and Culture, University of Iowa; Benjamin H. D. Buchloh, Professor of Art History, Columbia University; Denis Hollier, Professor of French Literature, New York University; Sylvère Lotringer, Professor of French Literature and Philosophy, Columbia University; D. N. Rodowick, Professor of English and Visual/Cultural Studies, University of Rochester; and Sophie Tasma-Anargyros, Design Critic, Paris. Our sincere thanks are also due to J. Abbott Miller, Creative Director; and Paul Carlos, Scott Devendorf, and Elizabeth Ellis, Design Associates, at Design/Writing/Research for their outstanding design of this catalogue.

The engagement of the entire staff of the Centre Georges Pompidou and the Guggenheim Museum has assured the successful realization of this exhibition. We wish to acknowledge the tireless efforts of our legal and administrative staffs, specifically Guillaume Cerutti, Directeur Général; Sophie Aurand, Production Director; Fabrice Merizzi, Production Director Associate; and Martine Silie, Head of Exhibitions, at the Centre Georges Pompidou, and Judith Cox, Deputy Director and General Counsel; Gail Scovell, Associate General Counsel; Julie Lowitz, Assistant General Counsel; and Elyssa Wortzman, Staff Counsel, at the Guggenheim for their involvement in the contractual negotiations between the two institutions. In addition, Marion Kahan, Exhibition Program Manager, has proven herself an invaluable resource in the course of the exhibition-planning process.

The curatorial staffs of the Musée national d'art moderne—Centre de création industrielle and the Solomon R. Guggenheim Museum worked continuously on this project over the course of several years. For the Visual Arts Section of the exhibition, we wish to thank the Pompidou team, which so generously aided in the development of this project: Hervé Derouault, Assistant du Directeur-Adjoint du MNAM; Catherine Duruel, Assistante en Chef de l'exposition; and Sophie Blasco, Secrétaire du Directeur—Adjoint du MNAM, for their dedication, as well as Françoise Bertaux, Editorial Coordinator and Head Researcher; and Juliana Montfort, Project Researcher, for their work on the catalogue. Among the Solomon R. Guggenheim Museum staff, we wish to deeply thank Sara Cochran, Project Research Assistant, and our curatorial interns: Frédérique Focher, Josette Lamoureux, Jemima Montagu, Ji-Eun Rim, and Tanya Waring.

We are deeply indebted to the members of the Pompidou architectural team for their diligence while working on this portion of the exhibition: Nathalie Crinère, Assistant Architect for the Exhibition Design; Jacqueline Stanic, Project Researcher; Nicole Toutcheff, Project Coordinator and Researcher for the Catalogue; Monique Baillon, Photographic and Documentary Researcher; and Catherine Crozier, Secretary of the Architecture Department, and all the other individuals who made the architecture section possible: Architecture Studio, Charlotte Aillaud, Joseph Belmont, Sonia Benamo, Patrick Berger, Giorgio Bianchi, Mme Georges Candilis, Stefanie

Canta, Frédéric Borel, Paul Chemetov, Henri Ciriani, Marcella Ciriani, Véronique Descharrières, Bernard-Félix Dubor, Jean Esselinck, Isabelle Faye, Hervé Ferquel, Edouard François, Yona Friedman, Massimiliano Fuksas, Henri Gaudin, Finn Geipel, Nadine Gibault, Jean-Marie Girault, Agnès de Gouvion Saint-Cyr, Lucien Hervé, Borja Huidobro, Jean-Marc Ibos, Michel Jacques, Alexis and Dusanka Josic, Alain Kahan, Rem Koolhaas and OMA, Lucien Kroll, Charlotte Kruk, Anne Lacaton, Gaëlle Lauriot-Prévost, Christine Legat, Marceau Lépinay, Duncan Lewis, Dominique Lyon, Olivier Masse, Nicolas Michelin, Annette Nêve, Jean Nouvel, David Peïcéré, Dominique Perrault, Renzo Piano, Etienne Pierrès, Christian de Portzamparc, Stijn Rademarkers, Serge Renaudie, Richard Rogers, Jacqueline Salmon, Catherine Sayen, Peter Smithson, Philippe Starck, Evelyne Tréhin, Bernard Tschumi, Yannis Tsiomis, Marja Van der Burgh, Donald Van Dansik, Jean-Philippe Vassal, Bruno Vidalie, Paul Virilio, Myrto Vitart, Wilfried Wang, and Inge Wolf.

For their contributions to the selection of objects, ephemera, and ideas that went into the exhibition sequence and catalogue pages on the Situationist International, we wish to thank Claude Dityvon, Christian Caujolles, and Gilou Le Griouec of the Agence VU, Brigitte Cornand and Les Films du Siamois, Paris, Sylvère Lotringer, Tom McDonough, Jemima Montagu, Jacqueline Stanic, and Laurent Gervereau, Director of the Musée d'Histoire Contemporaine/BDIC, Paris.

The Architectural Audiovisual Program would not have been possible without the constant help and involvement of Harouth Bezdjian, Audiovisual Manager; Murielle Dos Santos, Executive Producer and Film Researcher; Vivian Jaminet, Accountant; Vahid Hamidi, Technical Advisor; Gilles Bion, Archivist; and Patricia Ciriani, Video PreView and Assistant Film Researcher. Special thanks are also due to the following people and institutions for their precious contribution to the video-production architecture: Charlotte Aillaud, Esther Agricola, Jacques Barsac, Jacques Bocquet, Claudine Colin Communication, Richard Copans, Jacques Deschamps, Catherine Drouin Prouvé, Hélène Fentener van Vlissinger, Odile Fillion, Alain Fleischer, Philippe Gaucherand, Jean-François Grunfeld, Lyonel Guyon, Olivier Horn, Peter Kalvelage/film Produktion Mainz-Germany, Philippe Laïk, Gérard Moulinet, Stan Neumann, Fabio Rieti, Jean-François Roudot, Bernard

```
                          ESPACE
                          ESPACE LIBRE
                          ESPACE CLOS
                          ESPACE FORCLOS
               MANQUE D'ESPACE
                          ESPACE COMPTÉ
                          ESPACE VERT
                          ESPACE VITAL
                          ESPACE CRITIQUE
          POSITION DANS L'ESPACE
                          ESPACE DÉCOUVERT
     DÉCOUVERTE DE L'ESPACE
                          ESPACE OBLIQUE
                          ESPACE VIERGE
                          ESPACE EUCLIDIEN
                          ESPACE AÉRIEN
                          ESPACE GRIS
                          ESPACE TORDU
                          ESPACE DU RÊVE
                 BARRE D'ESPACE
       PROMENADES DANS L'ESPACE
          GÉOMÉTRIE DANS L'ESPACE
      REGARD BALAYANT L'ESPACE
                          ESPACE TEMPS
                          ESPACE MESURÉ
           LA CONQUÊTE DE L'ESPACE
                          ESPACE MORT
                          ESPACE D'UN INSTANT
                          ESPACE CÉLESTE
                          ESPACE IMAGINAIRE
                          ESPACE NUISIBLE
                          ESPACE BLANC
                          ESPACE DU DEDANS
             LE PIÉTON DE L'ESPACE
                          ESPACE BRISÉ
                          ESPACE ORDONNÉ
                          ESPACE VÉCU
                          ESPACE MOU
                          ESPACE DISPONIBLE
                          ESPACE PARCOURU
                          ESPACE PLAN
                          ESPACE TYPE
                          ESPACE ALENTOUR
                 TOUR DE L'ESPACE
        AUX BORDS DE L'ESPACE
                          ESPACE D'UN MATIN
      REGARD PERDU DANS L'ESPACE
             LES GRANDS ESPACES
         L'ÉVOLUTION DES ESPACES
                          ESPACE SONORE
                          ESPACE LITTÉRAIRE
         L'ODYSSÉE DE L'ESPACE
```

LEFT Georges Perec, *Espèces d'espaces* (Paris: Collection l'Espace Critique, Galilée, 1974), p. 11

Somoteys, Odile Soudant, Nicolas Stern, Richard Ugolini, and Odile Vaillant.

The following companies and institutions have provided footage and assistance in the preparation of the architecture portion of *Premises*: Académie d'Architecture, Paris; Album Productions; Byzance Films; Caisse des Dépôts et Consignations, Paris (Patrick Valentin); Ex-Nihilo, Paris (Patrick Sobelman, Bénédicte Vauban); Fondation Le Corbusier; Gesh Production, Montreuil; IBM Italy; Institut Français d'Architecture; Institut National de l'Audiovisuel (Marie-Josiane Rouchon and Marithé Cohen); Kunstverein in Hamburg, Germany; La SEPT-ARTE (Pierrette Ominetti); Les Films d'Ici, Paris (Serge Lalou and Giulietta Von Salis); Les Films du Rond-Point, Paris; Lucern Culture and Congress Centre, Switzerland; Ministère de l'Equipement, du Logement et des Transports, Service de l'Information et de la Communication (Isabelle Boisseau, Isabelle Thabart, and José Parreira); Ministère des Affaires Etrangères (Anne Coutinot and Anne-Catherine Louvet); ORF Entreprise, Wien, Austria (Marion Oberdorfer); OSB Sportstättenbauten GmBh, Berlin, A. Delacour; Polygone Films (Subtitlings) and particularly Fernand Garcia; Productios Cercle Bleu SA; RFO Malakoff (Dominique Richard, Joëlle Guillemand); Vidéothèque de Paris (Alain Esméri, Corinne Kaufmann). We are also most grateful to Guy Carrard, lab manager, and Pierre-Henri Carteron, scanning and digitalization; as well as all of the staff photographers, especially Georges Meguerditchian and Philippe Migeat. For architectural video postproduction, we must thank Bernard Clerc-Renaud, Patrick Arnold, Bernard Lévêque, Didier Coudray, Christian Bahier, Sébastien Bretagne, Alain Echardour, and Nicolas July.

It was a pleasure to work with Christine van Assche, Chief Curator of New Media at the Musée national d'art moderne, and Marie Anne Lanavère, Project Research Assistant, for their development and realization of the single-channel video program. We would also like to thank all those who helped them with this ambitious project: Elisabeth Harter, Etienne Sandrin, Alain Echardour, Jean Dufour, Muriel Colin-Barrand, Association GPS, Isabelle Danto, Vidéothèque de Paris, Anne-Catherine Louvet, Direction of the Audiovisual Service of the Ministry of Foreign Affairs, Laetitia Rouiller and Philippe Le Fresne, Association Peyotl, Alain Sartelet, CNC-Images de la Culture, and Liza Szlezynger.

We would like to thank Marie-Laure Jousset, Chief Curator of the Design Department, and Raymond Guidot, Curator and Project Manager at the Musée national d'art moderne, for the organization of the design section of the exhibition. They were assisted in this task by Nicole Chapon-Coustère and Marielle Dagault, Photographic and Documentary Researchers. We are most grateful to Images de Synthèse and Pascal Cagninacci of Société Deis for the work they performed for the video wall. For the preparation of Philippe Starck's site-specific project, we would like to thank Thierry Gaugain of Agence Starck and Ion Condiescu of Artvision. Finally, we recognize the collaboration of Jacques Bobroff, Espace Lumière, L'École Nationale Supérieure de Création Industrielle; Jacqueline Klugman, Passage de Retz, Paris; Pierre Staudenmeyer, Galerie Néotu, Paris; and Professor Yves Dumez of the Hôpital Necker-Enfants Malades, Paris.

For the *Premises* film program, we wish to thank guest curators Dudley Andrew and D. N. Rodowick as well as John G. Hanhardt, Senior Curator of Film and Media Arts, and Maria-Christina Villaseñor, Assistant Curator of Film and Media Arts, at the Solomon R. Guggenheim Museum for their immense efforts. We would also like to thank Jean-Michel Bouhours, Curator for Film at the Musée national d'art; Christophe Bichon, Cinematographic Archives; and Patrick Palaquer, Stills Photographer, and Laure Sainte-Rose, film conservator, at the Centre Georges Pompidou. Françoise Bertaux, Mark Betz, Patrice Blouin, Dominique Bluher, Pascale Furbeyre, Véronique Godard, Morad Koufane, Sylvère Lotringer, Laurent Perrault, Rajendra Roy, Sally Shafto, and Lisa Ventry also made an inestimable contribution to the selection, conceptualization, and organization of the program's contents. A special thanks is also extended to French Cultural Service in New York and the French Ministry of Foreign Affairs (Bureau du Cinéma/Bureau des Documents Audiovisuels) for facilitating the loan of numerous film prints.

For their contributions to this catalogue, we would like to extend our sincere thanks to the Publications Departments in both institutions. At the Guggenheim, we thank Anthony Calnek, Director of Publications; Elizabeth Levy, Managing Editor/Manager of Foreign Editions; Elizabeth Franzen, Manager of Editorial Services, who oversaw the complex editorial preparation of the text; Esther Yun, Assistant Production Manager, who handled difficult production issues with great skill; and Jennifer Loh, Administrative Assistant. This catalogue could not have been realized without the help of freelance editors Stephen Frankel, who edited the architecture section, Lisa Cohen, Maureen Clarke, Stephanie Fleischmann, Kristin Mariott Jones, Joy Katz, Jennifer Knox-White, and Diana C. Stoll. We would also like to thank the translators who worked on this enormous volume: Lory Frankel, John Goodman, Ellen Sowcheck, Molly Stevens, and Diana C. Stoll. A very special thanks must also be extended to Martin Béthenod, Director of the Publication Department of the Centre Georges Pompidou, for his advice; Daniel Soutif; Marie-Laure Verroust, for her outstanding photo research; Craig Houser, who assisted with editorial work and gave counsel; and Alain Bergala, for his advice as well.

We would like to thank the Guggenheim staff authors who over the last year contributed texts to this catalogue: Nancy Spector, Curator; Jennifer Blessing, Associate Curator; Fiona Ragheb, Assistant Curator; John Hanhardt, Senior Curator for Film and Media Arts; Sara Cochran, Project Research Assistant; and Jemima Montagu, Curatorial Intern. We would also like to thank Arindam Dutta, Jonathan Massey, Tom McDonough, Joanna Merwood, and Tom Weaver for their scholarship and written contributions. We must also thank the curators of the Musée national d'art moderne—Centre de création industrielle who generously contributed texts for the catalogue: Jean-Pierre Bordaz, Marc Bormand, Jean Michel Bouhours, Olivier Cinqualbre, Sophie Duplaix, Catherine Grenier, Raymond Guidot, Nadine Pouillon, Didier Semin, Jonas Storsve, and Christine Van Assche, as well as the other authors: Philippe Arbaïzar, Marc Bedarida, Jacinto Lageira, Marie Anne Lanavère, Richard Scoffier, and Daniel Soutif. We thank Laurence Camous, Curator, Head of the General Documentation, Musée national d'art moderne—Centre de création industrielle, and especially her team: Brigitte Vincens, Christine Sorin, Teresita Arraya, Dominique Bornhauser, Valérie Séguéla, Laurence Gueye, Eyelyne Blanc-Jannin, Nicole Brégégère, Maria-Irina Tepeneag, Agnès de Bretagne, and Patrick Renaud. Finally, we must thank all those who contributed toward the research of this exhibition: Gilles Baume, Clara Bertaux, Nicolas Borg-Pisani, Marie Carcuac, Estelle Dupuis, Elisabeth Herter, Jacinto Lageira, Marie Anne Lanavère, Sylvie Marcombes, Is-

abelle Merly, Grégoire Poisson, Valérie Ranson-Enguiale, Léanne Sacramone, Liza Szlezynger, and Samuelle Verley.

We would also like to express our gratitude to our respective registrarial staffs: at the Centre Georges Pompidou, particularly Annie Boucher, Head Registrar, and Bruno Veret, Associate Registrar; at the Guggenheim, Suzanne Quigley, Head Registrar for Collections and Exhibitions, and Meryl Cohen, Registrar, for their tremendous skill in organizing and coordinating the safe transport of these works from Europe and America.

In exchange for their advice, expertise, and hard work, we thank the members of the exhibition design and installation team at the Guggenheim, including Karen Meyerhoff, Director; Sean Mooney, Exhibition Design Coordinator; and Jessica Ludwig and Susan Lee, Graphic Designers. In addition, thanks go to Scott Wixon, Manager; F. Joe Adams, Assistant Manager; Mary Ann Hoag, Lighting Designer; and Richard Gombar, Construction Manager, from the Art Services and Preparations Department of the Guggenheim, as well as Peter Read, Manager of Exhibition Fabrication and Design; Anthony Villamena, Assistant Construction Manager; and Dennis Vermeulen, Senior Exhibition Technician. We would like to offer heartfelt thanks to Paul Kuranko, Multimedia Support Specialist, who was so generous with his expertise and patience. Further, we wish to express our gratitude to our talented conservation department, particularly Gillian MacMillan and Carol Stringari, Senior Conservators.

We would like to acknowledge the Public Affairs Departments of both institutions, who have helped us communicate our goal and aspirations, including Scott Gutterman, Director of Public Affairs; Julia Cadwell, Public Affairs Coordinator; and Joyce Lee, Public Affairs Assistant, all at the Guggenheim. The immense assistance of the Centre Georges Pompidou communications staff must also be recognized, in particular Jean-Pierre Biron, Director of the Communications Department; Carol Rio, Chief Press Officer; Nicole Richy, Deputy Director for Communication Department in charge of the external relations section; Anne de Nesle, Public Relations Manager, and Vitia Kirchner, Public Relations Assistant.

We thank Marilyn JS Goodman, Director of Education; David Bleecker, Education Program Assistant; Felicia Liss, Education Program Manager; and Laura Miller, Director of Marketing and the Visitor Services Department at the Guggenheim for their advice and management of programming around the exhibition, and Gina Rogak, Director of Special Events, for her management of the opening events.

Ben Hartley, Director of Corporate Communication and Sponsorship; Anne Haskel, Manager of Corporate Sponsorship; Anne Chase-Mustur, Development Coordinator; Julia C. Schieffelin, Director of Institutional Giving; and Melanie Forman, Director of Development, worked incredibly hard to secure funding for the show. Michael Wolfe, Director, and Peter Katz and Wesley Jessup, Senior Budget Analysts, of the Budgeting and Planning Department of the Guggenheim skillfully managed the exhibition budget.

Last, but certainly not least, we wish to express our gratitude to those individuals whose scholarly advice and countless hours of discussion and debate enriched various aspects of this exhibition: Pierre Adler, Marianne Alphant, Sylvie Astric, Georges Banu, Michèle Bargues, Geoffrey Batchen, Laurent Bayle, Director of the IRCAM, Yann Beauvais, Jennifer Blessing, Patrice Blouin, George Borchardt, Marc Bormand, Jennifer Bornstein, Robert Breer, Gisèle Breteau-Skira, Olivier Cadiot, Jean-François Chevrier, Thérèse Cremel, Nadia Croquet, Karen Cooper, François Cusset, Sylviane de Decker, Jean Dufour, Christophe Evans, David Galbraith, Michel Gilles, Suzette Glénadel, Jean-Luc Godard, Thierry Groensteen, Bellatrix Hubert, Rosalind Krauss, Monique Laroze, Laurence Louppe, Martine Blanc-Montmayeur, Jeff Nelson, François Niney, Hector Obalk, Jean-Loup Passek, Olivier Saillard, Teresa Seeman, Daniel Soutif, Peter Szendy, Paul Sztulman, Adrienne Mancia, Nan Rosenthal, Jim Rubin, Ruben Verdu, Catherine Verret, Eric de Visscher, Olav Westphalen, Charles Wilp, and François Wolf.

BERNARD BLISTÈNE
ALISON M. GINGERAS
ALAIN GUIHEUX

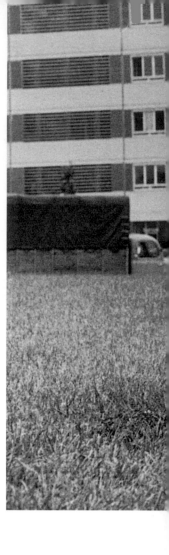

CONSUMED BY MYTHS

SYLVÈRE LOTRINGER

Everyday Myths

Henri Lefebvre began writing his *Critique of Everyday Life in August*, 1945. It was the first summer after the Liberation of Paris. Everyone was out in the street, arm in arm, men with open shirts, women in short pleated skirts and bright red lips. Life was starting up again like an old battery.

One day that August I saw people walking en masse from La Butte Ménilmontant, a quintessential working-class district, all the way down to Place Gambetta, a stone's throw from the wall against which the last Communards were executed in 1871, Cinco de Mayo style. Place Gambetta was a riot of faces, loudspeakers, children floating above the crowd, everyone cheering and singing popular tunes. They had announced the event the night before: "Tomorrow we'll be broadcasting live from the 20th arrondissement." Le Vingtième, with its cobbled passages, dead-end alleys, twisted streets, down-and-out inhabitants, hosting the National radio program. . . . And everybody was there, of course. It was a chance to be heard all over the country— even the world.

The festival on Place Gambetta was the last popular show of strength before the people of Paris were shipped away to the *banlieue*, dispersed in housing projects, hooked up in front of the magic box. By the time Lefebvre's *Critique* came out in 1947, the Marshall Plan was launched over "Free Europe," the Germans had become our best pals, and the Communists had been dropped from the French government. The next war was already on.

Maybe it had never stopped. The allied bombings had made the city fragile, a blueprint for future assaults. "New cities would be built," urbanist-philosopher Paul Virilio wrote later, but they would be just "a repetition, an urbanistic redundancy, a negation of this brute fact of space brought out by the second war . . . symbols of the pseudo-society which had pulled them back in place."[1] The modern city, with its rows of standing corpses, became a monument to its own disappearance.

The next assault didn't come from above but from out of the ground: thousands of state-sponsored building sites blighted the land. This happened all over Europe, of course. Widespread construction helped jump-start the postwar economy and provide shelter for those whose homes had been destroyed. Between 1945 and 1967, three-and-a half million apartments were built, assembly-line style. Streamlined, cost-efficient, hugely profitable, these "mass-produced commodities," conceived as "neutral containers of social relations" drew on the most advanced technology available— another by-product of the war. Production was thoroughly rationalized: straight lines, prefab panels, repetition, assemblage. "The techno-bureaucratic society," Lefebvre wrote, "was beginning to model its own décor."

Slum dwellers and workers from the capital were lured to the suburbs with the promise of "modern conveniences." Life in the huge satellite dormitory communities, like Sarcelles, built in 1956, became an exercise in total alienation. In *Deux ou trois chose que je sais d'elle* (Two or Three Things I Know About Her, 1965). Jean-Luc Godard observed this mutation in details, but chaotically, as it was happening in

1. Paul Virilio, *Essai sur l'insécurité du territoire* (Paris: Stock, 1976), p. 18.

ABOVE Jean-Luc Godard, *Deux ou trois choses que je sais d'elle*, film still, 1967

everyday life. For this he filmed one of the apartments like a cube, inside out, outside in, approached people the same way, alternatively speaking of them as things, and of things as people. The ambiguity was already present in the title: knowing about *her* (*elle*), the *banlieue*, Juliette, prostitution, the new life.

In his early writings, Marx introduced the notion of "alienation" to account for the transformation of human relations into things through the action of money, commodity, capital, these things in turn exerting their power over people. The very last shot of Godard's film ironically displayed market products on the grass, equating the "complex feelings" elicited in people by the housing complex with the commodity itself: 1+2=3. The film's overall metaphor was Marina Vlady (Juliette) prostituting herself to escape the oppressive domesticity and boredom of everyday life. The conclusion was inescapable: in a capitalist world life is a form of prostitution.

Godard's film was a kind of sociological essay. Sociology then was a new, ambitious science. It was expected to solve all the problems that had emerged after the breakup of traditional societies. The discrepancy was increasing, though, between the accumulative process at work in society at large and "human facts" tied down to natural rhythms and time cycles. These traditional symbols of everyday life were celebrated by Gaston Bachelard, a self-taught postman from the provinces turned philosopher of science and epistemologist. His *Poetics of Space* (1958) dealt with spaces of solitude indelibly inscribed in the human mind, childhood dwellings with their cellars, attics, corners, or "houses of things," drawers, wardrobes. These intimate retreats were like shells that enclosed memories, dreams, and thoughts in a slow spinning spiral.

Bachelard resurrected everyday life as a primitive refuge. But the entire Modernist tradition after Baudelaire had rejected it as an "excrement of the mind" (André Breton). The Surrealists' critique of bourgeois life was merely poetic, an evasion into the *merveilleux*. The same repudiation of the quotidian as inauthentic resurfaced in existential philosophy. Life experienced by the masses, "enormous and stupid," was nothingness; only moments of profane illumination, angst, and self-revulsion could reclaim individuals from the abjection of everyday life, and allow them to choose their grim destiny. Lefebvre, a Marxist philosopher, was convinced on the contrary that capitalism had moved to everyday life, and it was there, rather than in relations of production, that transformations would occur. This idea, in the late 1950s, became seminal for the Situationists who

offset alienation in the quotidian through "situations" of their own making. It returned as well in the early 1970s with Gilles Deleuze and Félix Guattari's global analysis of capitalism in terms of decoded flow. Rightly, Communist party officials accused Lefebvre of revisionism. He was "ignoring the class point-of-view."

In the late '50s and early '60s, France went through a major transformation—a second revolution—in just a few years turning from a mostly rural country to an advanced industrial society. Social conditions improved overall cushioning conflicts between classes with new intermediary categories: the "new working class" (white collar workers), the new service class, the new managerial class. The development of domestic appliances, promoted to "home arts," drastically changed the outlook on everyday life. French homes started looking more like showrooms—as in Jacques Tati's straight-faced take on modernity in *Play-Time* (1967). Fridges, washing machines, TVs, and cars became widespread, and so was boredom and aimlessness. Propped up from the outside (marketing, publicity), everyday life started hemorrhaging from within. Sociology lamented the erosion of family structures, urban loneliness, the lack of communication. The new society was setting in.

A sense of longing pervades George Perec's *Les Choses: Une histoire des années soixante* (Things: A story of the '60s). Published in 1965, the novel does manage to chronicle the entire decade. The protagonists are a young couple of modest means dreaming of a new *vita nuova*—not love: money, material possessions, all the "things" displayed in shop windows. Just fresh from college, they refuse the alienation of the work place but they are consumed by signs. They even make them their job, becoming "freelance product analysts," a social limbo miles away from the consumer mirage or utopia. One after another, all their friends gave up and became professionals. And they finally did the same, frustrated by the frenzy of "this world which promised so much, and gave them nothing." Brilliantly conceived and thoroughly ironic, *Les Choses* is a literary analogue to Flaubert or Godard's early films. Unlike the contemporaneous *Nouveau Roman* (New novel, Sarraute, Simon, Robbe-Grillet, Butor, Beckett), it wasn't a symptom of Modernist "decay," as the Situationists had it—the self-dissolution of literary forms—but its acute diagnosis.

Analysis of the nature of the new consumer culture was also made possible by the timely rediscovery of Ferdinand de Saussure's *Course in General Linguistics*, originally published in 1916. Like Saussurian linguistics, consumerism was separating signs from their referents, turning objects into signs, and signs into desire. (It could be argued that the problematics of desire itself was brought out by consumerism.) Saussure's major contribution, though—the one which allowed both Roland Barthes in *Mythologies* (1957) and Jean Baudrillard in *System of Objects: Consuming Signs* (1968)—to pursue their inquiry beyond mere sign analysis or myth analysis, was the linguist's early realization that the "value" of signs didn't reside in the signs themselves, but in their *difference*, in their capacity for being "decoded" and endlessly exchanged for other signs, just like stocks in the stock market. Saussure was the first to reintegrate the science of signs, or semiotics, into the general economy of capital.

Like consumerism, the sign-system Saussure called *langue* (language), was a principle of classification and an instrument of integration. This linguistic construct was to the diversity of the phenomenon of language what Emile Durkheim's "social" was to society in general: an *a priori* totalization. Using Saussure's categories as leverage, Baudrillard stigmatized the totalizing nature of consumerism whose signs don't refer to the world outside, but are apprehended as pure signs, without any presence or history.

The most remarkable thing about the consumer universe is that it actually engages consumers to look for objects that could become signs, "object signs," readymade references capable of exhibiting their difference as identity. What is being consumed therefore isn't even the signs themselves, let alone the actual material products they refer to, but "the idea of their relation." Consumerism, Baudrillard concluded, is a "total idealistic practice which has nothing to do (beyond a certain threshold) with the satisfaction of

any need or with the principle of reality. It is irresponsible because it is based on a *lack*." "Lack" happened to be intrinsic to psychoanalyst Jacques Lacan's definition of human desire, which prevailed at the time as some sort of universal truth. It was rather an accurate description of consumer subjectivity, or of the *myth* of subjectivity enacted by consumer culture.

Beyond a certain threshold, though, consumer culture, like Baudrillard's theory, started spinning away from the principle of reality into the black hole of simulation—the unchecked flows of capital. *Simulations*, one of the most influential essays in America in the '80s, diagnosed that "the transition from signs which dissimulate something to signs which dissimulate that there is nothing, marks the decisive turning point. The first implies a theology of truth and secrecy (to which the notion of ideology still belongs). The second inaugurates an age of simulacra and simulation, in which there is no longer any God to recognize the real from its artificial resurrection."[2] Is it surprising then that students in May 1968 would challenge consumer desires and utopia? Perec's novel was a detailed case study of the pernicious effect signs exert on contemporary sensibility: "They surrendered to signs of luxury; they loved luxury before loving life." A May-1968 graffiti encapsulated it: "The more you consume, the less you live."

Like semiotics, consumer society privileges form over content and synchronic relations over change. Both are "mythical" in that sense. Bringing Claude Lévi-Strauss' studies on primitive myths to bear on bourgeois culture, Barthes asserted that the function of myths is to immobilize the world, or rather turn it into a second nature: "Semiology has taught us that myth has the task of giving a historical intention a natural justification, and making contingency appear eternal. Now this process is exactly that of bourgeois ideology."[3] It is the mythological vision known as bourgeois humanism that Michel Foucault dismissed in *The Order of Things* (1966), the idea of "man" as the totalization of consciousness, the absolute subject of history and foundation of all knowledge. In spite of appearances, Structuralism

hadn't made a dent in this notion of man as an autonomous human subject, merely preserved the possibility of its return by the abstraction of its own system. Rather, the Good News that Foucault announced—freeing ourselves from the "all too human" element in man—marked Nietzsche's return in French philosophy. Lucien Goldman, a Lukácsian sociologist, could proclaim in May 1968 that "structures moved to the street."

Denouncing myths or ideologies is always fair game. Accounting for them in specific terms is another story. Was a science based on bourgeois ideology, like semiology, equipped to pull apart the inner mechanisms of its own myths? In *The Consumer Society* (1970), Baudrillard suggested that, being its own myth, consumer society couldn't maintain any critical stance in relation to itself. Any denunciation of consumption was a mirage, or an easy disclaimer, since it was just the other side of the myth. Worse still, this mirage of critique was the veritable embodiment of the mythical project. Even revolution can be consumed like a can of Campbell soup.

Barthes, though, in "Myth Today" (1970), indicated one possible alternative to bourgeois mythology. Myth being a double system whose signification derives from a sort of "constantly moving turnstile," it is possible to steal the "naturality" of the first myth in order to produce another myth which would be truly artificial. Eagerly embracing consumer society as a *conditional* utopia, Perec managed to do just that: re-mythifying consumerism, but with a loud Nietzschean laugh.

Entering Into The Void

In a spectacle what is false becomes true,
provided one enters into the game.

Daniel Spoerri

The French *Nouveaux Réalistes* (New realists) never claimed to be critical of consumer mythology. Like American "pre-Pops" (Jasper Johns, Robert Rauschenberg), they embraced mass-produced, popular artifacts as a second nature. Not every one of the artists that art critic Pierre Restany called

2. Jean Baudrillard, *Simulations*, 1981 (New York: Semiotext(e), 1983), p. 12.
3. Roland Barthes, *Mythologies*, 1957 (New York: Hill & Wang, 1972), p. 142.

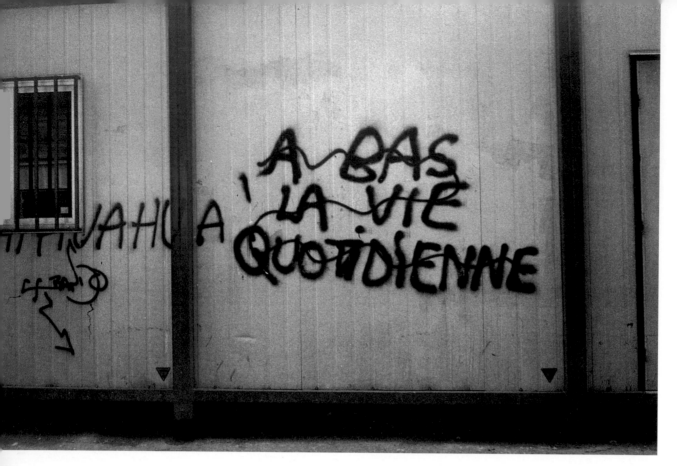

LEFT Graffiti around the construction site of the Centre Georges Pompidou, circa 1976, Photo taken by the artist Raymond Hains in preparation for his work *Palissades* (1977)

Nouveau Réaliste, though, was a bona fide "realist." This may have been alright for the original core—Arman, François Dufrêne, Raymond Hains, and Jean Tinguely—but could hardly be applied to Yves Klein, its major proponent. Restany had to do a lot of acrobatics to weld Klein's cosmic energy to their more prosaic everydayness. Yet the definition he gave his new school of art, "the new realism of pure sensibility," was obviously custom-made for Yves Klein.

Klein advocated "*pure* color" (monochrome painting), and "pictural *sensibility*" was the lyrical state he intended to communicate. When asked about his own realism, Klein would simply quote Ben Gourion: "Whoever doesn't believe in miracles isn't a realist." Klein believed in miracles. Unlike his friends, he didn't need Duchamp as a model, he had God himself—Bachelard coming in a close second with his fabulous line: "First there is nothing, next there is a deep nothing, then a blue depth."

In 1957, Klein presented a series of *Monochrome Propositions* emphasizing the complete autonomy of color. Taking his cues from Malevich's square, he saw the monochrome as a way of materializing cosmic energy through the impregnation of the spectator's sensitivity. Klein moved in a mythical universe of cosmogenesis where affects offered an integral perception of Absolute Reality. It is all the more astonishing that Benjamin H. D. Buchloh would have reproached him for not having demystified aesthetic production with his monochromes, as Rodchenko did.

Klein, he wrote, merely repeated the gesture of the avant-garde and disavowed "the historical legacy of Modernism itself." In other words, Klein lacked "historical consciousness"—because he wasn't an art historian like Buchloh. But this would amount to denying art any capacity for "energy and excess," as Sande Cohen put it, which was Klein's only rationale for going beyond the commodity form of art.[4] Klein did have a "historical consciousness," although not the kind art historians would care for. It meant disavowing what Buchloh called the especially "specialized, bourgeois elite" by going back to the *Middle Ages*. Ubu would have liked that.

Klein's close friend, Arman, also born in Nice, exhibited "accumulations" of identical objects, rubber-stamp imprints, used envelopes, heaps of nails, pliers, or guns. His use of repetition parodied the assembly line. In glass cases, he displayed sliced artifacts, like old coffee-grinders lined up in an aerial view or neatly dissected musical instruments. Amplified through multiplication, his objects were more apt to express "the collective consciousness of the object." He chose them used and discarded to emphasize their poetic everydayness. But poetry went that far. With *Poubelles* (Trashcans), Arman unloaded the contents of garbage cans collected in affluent and working-class Parisian districts in separate glass cases—a deadpan comment on the discrepant lives of social classes. The project unwittingly confirmed the Situationists' judgment on con-

4 .See Benjamin H. D. Buchloh, "The Primary Colors for the Second Time," *October 37*, Summer 1986 and Sande Cohen, *Academia and the Luster of Capital*, (Minneapolis: University of Minnesota Press, 1993), pp. 132ff.

temporary culture—they called it "garbage art." But, of course, any art for them was garbage.

There wasn't much to be dismissed in Klein's monochrome project: it had no texture, no color, no canvas, nothing but "stabilized pictural sensibility." For Klein, the physicality of painting wasn't necessary to affect the senses: the painter's mental energy could impregnate the gallery space with an invisible "pictorial climate." It was the very essence of painting. Strangely enough, what Klein himself called the "creation of an ambience"—a privileged place for communication or a mental environment capable of transmitting the state of sensitivity itself independently of any object—wasn't so far off from the Situationists' attempt at constructing "unities of ambience" by roaming through the city, one of their major strategies to counter the passivity and isolation enforced by advanced capitalist society. Doing away with any intermediary allowed both of them to directly "perceive-assimilate," in Klein's words, the "prime-state material of sensibility."

It may come as a huge surprise that two contrary, even contradictory, figures like Debord and Klein would resort to similar strategies for pretty much the same purpose, *sublating* art into life; but there may be even more surprises to come. In any case, both Klein and Debord had been impressed by Malevitch's idea that the painter's composition didn't have to be tied down to the canvas, but instead directly transferred to space. Both were fulfilling the ultimate Modernist desire to do away with representation. This, of course, carried over to politics.

Klein's epoch-making event, *Le Vide* (The void), at the Galerie Iris Clert in April 1958, couldn't have been more inappropriate in strictly political terms. France was going through a major crisis. Rebel generals in Algiers had just staged a coup, Paris was wrecked with violent popular protests. The Algerian conflict was threatening to engulf the country. General de Gaulle seized power a few weeks later and proclaimed the Fifth Republic. It was hardly a time to celebrate sensibility and nothingness. Yet Klein's opening turned out to be public as well, an unwitting parody of

the prevailing chaos outside. Klein had done his utmost to give it the largest possible audience. Initially he wanted to descend a blue, condom-like cover by helicopter on top of the Obelisk. Then he planned to flood it with blue light, but leave the base in shadow, effectively sending the prickly monument floating in its prime "mystical splendor" over the entire Place de la Concorde. The idea was to position his trademark monochrome blue in the outside space, outside the gallery, in the entryway and paint the walls inside white, to signify the passage from his "blue period" to an invisible, intangible, immaterial color. At the last minute authorization to flood the Obelisk was canceled. It may have saved the country.

Klein believed that if he concentrated his energy long enough, people would feel its presence. Everything, including thought, occupied space. "I am a painter of space," Klein said in 1962, taking his *Monochrome Propositions* out of the Galerie Colette Allendy. "You don't need them anymore," he said. "People can buy space instead." And they did. Klein sold his "zones of immaterial pictorial sensibility" for a receipt and twenty grams of gold which he solemnly threw in the river. It may have been difficult to feel any presence among the two thousand people who mobbed the small space at the Galerie Iris Clert for an entry fee of 1,500 francs, although a number claimed they did. The opening turned into a riot, with police in the street and fire trucks parked nearby. Klein regulated the flow inside with a loudspeaker. Pushing art to the limits of the gallery space, Klein managed to turn it into another street demonstration. It all ended at La Coupole with a huge dinner in which Klein delivered his "revolutionary speech." This was the first leg of his Blue Revolution.

Pierre Restany's role as critic-impresario merits more than a passing footnote. The well-publicized operation by which he propelled Klein and the *Nouveaux Réalistes*, was indicative of the changes occurring in French art and society. There was more to his efforts than mere publicity. It isn't usual, after all, that curators would become members in good standing of their own group. Yet on October 17, 1960,

Restany signed the New Realists' *Declaration*, which he himself wrote, on International Klein Blue (IKB) paper. It was equally unusual that a critic's body would be cast, also colored in IKB, as part of a series of "relief-portraits," by which Klein meant to impregnate his fellow artists with his own energy.

In retrospect, one could look at the strategy of this loose cannon, Restany, as an anticipation of the new breed of "curator-artists," who from the mid '80s and '90s started staking their claims to being conceptual artists in their own right. Between the art of curators and the art of art historians, both using artists' art as their material, there may be less need for the artists themselves. They are far too numerous anyway, and not all successful by far, now that being an artist can pass for a lucrative profession. Are we attending here to a rescue operation (of art) on the part of the institutions themselves, or are curator-artists contributing unwittingly to fulfill what Baudrillard has long proclaimed to be the disappearance of art? We may still be expecting too much of art in a world that makes too little of everything. If art has ceased to be sacred, or heroic, or original in any way, if it now spends most of its energy recycling itself in the name of *la différence*, then there's nothing especially sacrilegious about curators themselves "reappropriating" it for more ambitious operatic projects where the overall orchestration becomes far more important than each of its parts.

For better or for worse, *Premises* may be one of the purest examples of what one might call "curatorial art" inasmuch as its explicit purpose is not to showcase individual artists, but to create an installation of its own on the scale of the entire museum space. Conceptualizing the use of space astride traditional boundaries that define interior and exterior—from the mental space of artists' studios and storefronts, garrets or mobile-homes, fictional and sacred places that artists turn into their work, to the more physical space of the body, cells, shelters, floating rooms—*Premises* keeps marking space like an urban Robert Smithson jetty, shifting from objects to images, precepts to concepts, concepts to signs, and from magical communion or exorcism to the new communication technologies. Along the way, wrapping art within architecture and film, or turning architecture into an immaterial monument, it gradually raises the question of what an exhibition space actually is, or could be, as space. This implicit reflection on the museum as the ultimate art premise, or demise, ends up unfolding in its complex spirals the very space of thought.

Klein wasn't an easy artist to pigeonhole. He wasn't a minimalist *avant la lettre*, or pre-Pop, proto-Conceptualist, ante-Fluxus, or an early proponent of "happenings," all things he crossed in his short transversal trajectory. And being the son of two abstract painters, he definitely stayed away from abstraction. He never even fit in among the *Nouveaux Réalistes*. He just wasn't of this world, let alone of the art world, where he never had more than a *succès de scandale* in his lifetime. He once said, "My art won't belong to this era because what I'm mainly looking for is to create in my work this 'transparency,' this incommensurable 'void' in which the permanent and absolute spirit lives free from every dimension." What "school" would ever have condoned that?

Klein realized very early on that art had to be bigger than it had ever been or could be. It was nothing if it didn't coincide with life itself. This is something he shared with another "idea man": Guy Debord. Like Klein, Debord wasn't a Minimalist. If anything, he was a *maximalist*. He wanted everything. The only art worth pursuing was the art of life. Klein's art was a way of reaching a "state of quality" that would be equivalent to what the great painters of the past, Vermeer, Giotto, managed to achieve; something that would allow one "the next day, waking up, to find again the real *joie de vivre*." But can there be a real *joie de vivre*, a real *art de vivre*, a way of turning life into art, if you don't make it an art? What Debord increasingly forgot is that one can only get out of art—into revolution, utopia, eternal bliss, whatever—as an artist would.

Guy Debord discovered the Lettrist group in 1951. The little band had come to the Cannes festival to push Isidore Isou's film, *Traité de bave et d'éternité* (Treatise of slime and

eternity), a four-and-a-half-hour bid to demolish the art of cinema. Isou was the charismatic leader of the Lettrist movement, a somewhat wacky group of young artists and poets practicing vehement insubordination in arcane meta-graphics (collages). Isou's "mechanics of invention," a cycle of cultural inflation and decay followed by an era of re-newal, was based on the fate of Modernist poetry from Baudelaire to Mallarmé. The word being the last bastion to destroy, the Lettrists dissociated the letter.

The furor over Isou's film got young Debord thinking. He followed the Lettrists to Paris and spent two glorious years in the company of thieves and assassins, which gave him a good standing in a long line of outlaw poets going all the way back to François Villon. One year later he finished his first film, *Hurlements en faveur de Sade* (Howls for Sade). It had no image, only an alternation of white and black screens, with dialogues lifted from various sources. The last sequence consisted of 24 interminable minutes of silence over a black screen. (John Cage's silence, the same year, only lasted 4 minutes and 33 seconds.) Eventually Debord reneged his own film, judging it too aestheticized—the beginning of a dizzying cultural escalation which ended up with his suicide in 1994. The Cannes Festival played a major role in his destiny, but it assumed an even greater role in Yves Klein's. In 1962, director Jacopetti specially shot a sequence of Klein publicly using his nude models as "body brushes" for *Mondo Cane*. Expecting it would constitute the whole film, Klein arrived at the Palais du Festival for the premiere in style and in character, sporting a dashing blue Rolls Royce. He was dumbstruck with rage when he realized that his sublime ritual had been cast into a freak show. His first heart attack happened then and there.

In the *Deutsche Zeitung*, John A. Thwaites strongly ad-vised Spur, a German group affiliated with the Situationist International (SI), to study Klein's manifestos before dis-missing the question of his monochromes as unproductive polemics. "The 'government of sensibility' isn't as far as they think from their 'Situationist culture,'" Thwaites wrote. "Only it's been conceived far more accurately." The Situa-tionists made no comment, just posted his outlandish sug-gestion on their Clipboard.[5] But it was a shrewd remark. The two projects, were indeed closely related.

Klein and Debord couldn't have been more different in style. Klein loved pomp and ceremony. He was like a child, people said, he couldn't resist uniforms. He hired two Republican Guards for the opening of *Le Vide* (this created a minor scandal in official circles); got married with all the Knights of the Order of Saint-Sebastian in full regalia by his side; wore a formal evening jacket to perform his "anthropometries" (body painting) on the stage, his own version of the theater of cruelty.

By contrast Debord was like an old mole; drank all night, always hid away from the limelight. The only time he wore a formal jacket was in his writing. But then he would turn to the most rhetorical models, skeptic moralists like La Rochefoucault, icy utopists like Saint-Just, cynical strate-gists like Machiavelli or Clausewitz. Debord kept his own romanticism at bay with his deprecating irony. His favorite weapon was the maxim, a lapidary form that carves deep into the flesh. The perfect style (*stylus*, blade) for a maxi-malist. He always had an eye on the guillotine, and the other on his friends.

Klein's writings were considered naïve, even embar-rassing. Restany called what he published, untutored, in *The Theater of the Void*, "a compact and confused outpour ing of texts, dashed off on paper in a fairly uncritical spirit."[6] The artist obviously needed an art critic to edit his mind. "Project my mark outside of myself, I did that! When I was a child," is how Klein began his 1960 manifesto. Was he just a brat? (He was often called Peter Pan.) Colette Allendy said he never read a book, just scanned for quotes. He never even read Bachelard properly. "I am not literary," he himself said. And yet a closer look would bring out something else, some-thing difficult to define, compact at the core and cosmic in scope. Klein's writing evidently had no "style"; but it had a soul, and this soul radiated in every direction. It was a stun-ning exercise in levitation. Instead of developing a coherent argument, Klein would follow his thoughts wherever they

5. *Internationale Situationniste #5*, December 1960
6. Pierre Restany, *Yves Klein* (New York: Harry N. Abrams, 1982), p. 184

headed, jumping across the mental landscape as Van Gogh would dash across the dark blue sky and the yellow chair and the man's slumped body with his pale blue cap, and it was all the same powerful whirl of pure color, every single particle tightly screwed to his retina.

Instead of explaining his work, Klein kept showing his mind. And there was something very moving and beautiful about it. It made everything it touched glow. His mind was standing naked in front of us, like his models in front of the audience, or like himself as a child standing "in front of everything psychological in me," realizing that he had five senses and was capable of making himself "function." And this he could do so well because he was *out of his mind*. Projected outward from the get go. "Then I lost my childhood. Like everyone else really—let's not have any illusion—and, adolescent, keeping at this little game, I quickly met with nothingness. I didn't like nothingness, and this is the way I got acquainted with the void, deep void, the blue depth!" Like Mallarmé, Klein looked at *L'AZUR* and signed his name to the back. His first artwork was the clear blue sky he saw on the beach at Nice, his hometown, at age eighteen, a mythological event and a vision of infinity. He always hated the birds after that for punching holes in it. "Birds must disappear!"

What Klein was making us experience is the fact that his mind wasn't "separate"—a term by which the SI stigmatized living in the spectacular society—but "unitary" in the most cosmic way. His mind was moving with the world, it belonged to the earth, it embraced all its elements: earth, air, water, fire. And there was no need for images. Everything was material, just as language is material and not metaphorical. Bodies, color, space, wind, storm, it was all material, and material for his work. Matter was energy, and energy can be communicated. Klein managed to raise "the idea of the Ready-made to the cosmic dimension," as Restany superbly wrote.

As the flesh could be turned into a paintbrush, all the *états-moments* (moment-states) he experienced would directly leave their marks—rain, wind, sweat, sap, dust, fire, blood, Christ's blood. "All the events of nature's "subjects," humans, animals, vegetables, minerals, and the atmospheric circumstances, all this interests me for the naturometries. I will even work, I believe, no more with color, but with the models' sweat mixed with dust, with their own blood maybe, plants' sap, earth color, etc., and time will turn the results into blue IKB. monochrome. Fire is there too, and I want its imprint. An anthropophagic era is coming, only terrifying in appearance. It will be the practical embodiment on a universal scope of the well-known words: 'Whoever eats my flesh and drinks my blood, will remain in me and I remain in him.' Spiritual words, of course, but they will take effect for a time, before the arrival of the blue era of peace and glory, in total edenic freedom reclaimed by humans on the immaterial sensibility of the universe."[7] That was utopia materialized in the flesh. A delirium of the first order.

In the aftermath of 1968, Gilles Deleuze and Félix Guattari published the first book of philosophy that ever took delirium seriously.[8] For them delirium had nothing aberrant about it, on the contrary: it was the flows of capital experienced in their purest state, absolute exchangeability. The exaltation of space and immateriality in Klein was a celebration of the flows. They endowed color with a radiance independent of any line or figuration. "For color! Against the line and drawing!" he wrote by hand on a picture taken in 1956, the day he entered the Order of San Sebastian. "My motto: I espouse the cause of pure color, invaded by ruse, occupied and oppressed by the line and its manifestation in drawing, in order to defend it and liberate it and lead it to triumph and final glory." This radiance was something tangible, like an aura, a "pictural climate" rather than a painting. Color didn't have to be seen, Klein could feel its cosmic energy freely flowing through him, picturality in its primordial state, a truly glorious event. This had happened earlier on to Raymond Roussel, who experienced literary glory independently of any actual writing. Roussel would travel throughout the world in his custom-made limousine, a whole apartment on wheels, with all the window-

7. *1960: Les Nouveaux Réalistes* (Paris: Musée d'art moderne de la Ville de Paris, 1986), p. 264
8. Gilles Deleuze and Félix Guattari, *Anti-Oedipus*. Trans. by Brian Massumi (Minneapolis: University of Minnesota Press, 1983).

shades down. He didn't need to see the landscape, establishing a traveling climate was enough. Delirium was something of the kind: a state of uncontrolled excitement or emotion in which one becomes porous to the universe. Absolute proximity, of course, has its downsides; everything goes right through you. It's ecstasy, then terror. One moment you're totally open and the next it's an oyster, a stone, a clenched fist. The intensity is too much. The world is killing you.

It was such a relief then being able to rely on other bodies with strict boundaries, dress codes, public rituals, the Order of San Sebastian, the sect of the Rosicrucians. Klein joined both in full regalia. He was always deeply moved by the pomp and solemnity of Catholic celebrations. He paid his devotions to Nice's patron saint, Saint Rita, in Southern Umbria, eager to commune with the miraculous void of creation. Heindel advocated levitation as a way of experiencing a kind of "immaterial sensibility," and Klein flew himself from a mansard roof to the street, "into the void." And he had pictures taken for publicity.

The Suicidal Avante-Garde

It will be a cold day in hell when you see a major American museum mount a show of the cultural production of the Weather Underground or Black Panthers. The Situationists are OK, they're French.

Mike Kelley

Debord experienced immaterial moments as well. Actually, the more creative period of the SI, before Debord started shooting from the hip, was full of experiments whose explicit purpose was to loosen up the hold of "the spectacle" on everyday life. The Situationists set up a number of games based on some kind of collective excitement and visual experimentation, starting with the *dérive*—drifts that they originally practiced on their own, for days on end, and were later amplified into what they called the "construction of situations," from which they derived their name.

Situations were ephemeral creations, "moments of life concretely and deliberately lived." Relinquishing any explicit goal, the Situationists would drift through the city, walkie-talkies in hand, intensely aware of what they perceived and experienced. They would discard the monumental avenues carved by Baron Haussmann out of the ramble of popular dwellings—elegant scars built over the wounds of 19th century revolutions—and walk through bustling areas like Les Halles, or working-class districts in the northeast of town with labyrinthine streets and narrow passages more akin to the conformation of their own brains. Their "hasty passage through various ambiences," as Debord called it, was meant to shatter the city's increasing homogeneity and reconnect its fragments according to what they would recognize along the way as their own authentic desires. This process of continual reinvention involved, in Rimbaud's words, the systematic disorientation of the senses through the dissolution of every spatial coordinate. *Dérive* was something like an induced collective *delirium*—going off the track, away from the furrow, deviating from the straight line. Plugging their little decoded machines among the huge overcoded flows of the bourgeois capital, the Situationists would draw lines of escape, construct abstract situations, anticipating in the present the promised utopian life.

Like Klein's "moment-states," situations bore the mark of the immediate. They didn't have to be represented in a tangible form in order to exist, and this may explain why the Situationists' "field reports" often were so disappointing. They were dreaming of a cartography of desires drawn

out of their encounters with "social morphology," a new science capable of measuring the intensity of various flows, identifying stumbling blocks (Place de Valois, Banque de France) or resisting the pull of the vortexes that guarded more fluid "zones of ambiance"—in short everything that contributed to making certain urban areas auspicious or malevolent.

In keeping with what Lefebvre had mapped out before them, the Lettrist International recognized that everyday life had moved to the center of contemporary struggles. There were few other choices. After Krushchev's report to the 20th Congress of the Communist Party in the Soviet Union in 1956, Stalinism was officially dead. But the Soviet State still hadn't loosened its grip, and the convulsions that followed within the Communist block, in Hungary, then Poland, were ruthlessly crushed. The French CP sheepishly condoned Russian repression, and prominent intellectuals, including Lefebvre, finally left. Revolutionary movements were rising outside of organized parties. Fidel Castro successfully took over Cuba. In 1957, just before the SI was founded, a first revisionist journal, *Arguments*, was started. Debord and Raoul Vaneigem, a student of Lefebvre's who joined the hard fraction of the SI in 1961, drew most of their political ideas from *Socialisme ou Barbarie* (Socialism or barbarians). The journal, founded in 1949 by a group of ex-Trotskyites including Jean-François Lyotard, denounced Soviet bureaucratic exploitation, the perversion of party rule. They were convinced that boredom and powerlessness would drive workers to revolt and self-management. Debord briefly joined the group in 1960.

For Debord, the new society only meant one thing: the "total occupation" of social life by the commodity. Reaching its final stage, capital had also reinvented itself from scratch as a benevolent, even an exciting system. Those it used to enslave as workers now were being associated as consumers. The problem wasn't anymore to satisfy workers' needs, but to instill in them desires that would satisfy consumption.

The concept of ideology conveniently assumed that the masses were made to adhere to a deceptive order and that the consciousness of truth, like dawn, would automatically dispel the monsters. There was a huge difference, though, between what Marx considered a mere inversion of reality (ideology as *camera obscura*) and the absolute take-over of life that the SI diagnosed. Consumer utopia was a totalitarism of a new kind, the complete absorption of everyday life in a fool-proof artificial landscape. The invasion of the body-snatchers. "Not only is the relation to commodity visible," Debord wrote, "but it is all one sees. The world one sees is its world."[9] Ideological critique had to be all the more merciless.

It is not surprising that Debord failed to recognize Klein's bold experimentations with the codes for what they were. Debord blasted every contemporary artist and writer, to the point that there was hardly an exception. Besides, he abhorred anything that had to do with religion and lashed out at the "incantatory pictorial mysticism" of Klein's monochromes. That put him, he wrote, "spontaneously in the forefront of a fascist wave that is making headway in France."[10] That Debord would call Klein a fascist didn't prove much. For him, it may even have been a term of endearment. Klein wasn't any more a fascist than Debord was, actually far less so in relation to his own entourage. If anything, he was doing what Debord tried to do before he took himself for Lenin and the entire world for the Tzarist empire.

Klein even planned his own rehabilitation center, or sensitivity training, a wacky corporate version of the *dérive* meant to de-program creative individuals from ambient zombification. He called it: "The School of Sensitivity." His idea was simple: free individuals from their individualism. That was also the SI's goal, constructing situations of their own making in which desires, freed from basic needs, would find their own fulfillment. Klein's method, however, was just the opposite. Instead of an active disorientation, he advocated the return to a more grounded moral tradition, synthesizing the spirit of chivalry and medieval craftsmanship. "Duty to quality" was at the heart of what he called the Blue Revolution, whose program he directly communicated to President Eisenhower in an "ultra secret" letter dated

9. Guy Debord. *Society of the Spectacle*, 1967 (Detroit: Black & Red, 1977), p. 42
10. *Internationale Situationniste #2*, 1958

May 20, 1958, as "France is being torn by painful events." To avoid chaos or dictatorship, he suggested that a government be quickly formed with "members of our movement" under the sponsorship of an international "consulting body." The economy itself would be stabilized through a barter system capable of providing real equality, such that "the rich man will necessarily be an authentic genius in his specialty. That, in a word, will simply be justice."

Klein didn't have a problem with the spectacle. He was one all by himself, like Salvador Dali, in turn performer, shaman, showman, inventor. He kept moving breezily from the social to the atmospheric to the cosmic and the mystical. The idea of being locked up in a close fight with an elusive enemy wouldn't even have crossed his mind. And the spectacle was everywhere. It wasn't a relation between images, but "a social relation between people, mediatized by images," and this precluded any real form of dialogue or participation. "Integration" and "separation" were the major features of the absolute alienation that affected the entire society. "Integration," because it homogenized social relations; "separation," because everything that capital made available through its technological advance, and justified in the name of progress—car, television, travel, etc.—reinforced the conditions of social isolation.

Integration separates, separation integrates. The two notions at first seem mutually exclusive, but they function together in a way that Paul Virilio's work illuminates. The fable of Howard Hughes instantly comes to mind. Hughes, the man who owned aviation companies and movie studios (integration), ended up alone in the desert of Las Vegas, "the first technological monk of post-modernity." His destiny, Paul Virilio suggested, foreshadowed a *mass situation*: the sharp reversal of the intensity of speed into "polar inertia." While electronic speed—media's "real-time"—collapses near and far, making the whole world instantly available to us, its actual effects are isolation and inertia. Howard Hughes "is an extraordinary figure because he dreamed of owning the world, and ended up proving that one can become autistic precisely because one owns it all."[11] Autism,

the dictionary says, is "abnormal subjectivity; acceptance of fantasy instead of reality". The spectacle made everyone autistic.

Virilio's work could be read as a powerful rewriting of the *Society of the Spectacle* in light of the new technologies' impact on everyday life. It wasn't just the high level of their accumulation, as Debord believed, but the speed with which images are being transmitted that translates into "a concrete fabrication of alienation." The homogenization of the socio-political space—telepresence, the illusion of ubiquity—is a product of speed. Speed has persistently been disregarded in human history in favor of economy. But exchange doesn't explain everything. The speed with which it occurs is a form of violence: intensive time eradicates space, instantaneity cancels memory and history, provoking a generalized derealization of reality. These, Virilio asserted, picking up a familiar Debord tune, weren't just so many effects brought about by technology, they were the symptoms of a war deliberately waged against the population ever since wartime economy was extended in peacetime (WWII). The fusion of science and war in the present "military-communication complex" highlighted the breakdown of the distinction between military and domestic. It made it even more difficult to recognize one's enemy. Like the spectacle, technology is now everywhere, both outside and inside our bodies, and this makes the resistance to technology (and the fascination for its invasive capacity) even more inexpungable. The virtual theatricalization of the real world through the communication and imaging technologies, even more than the conquest of space, signals the "endo-colonization" of society and the virtual disappearance of the social, let alone of humanity.

Conspiracy theory is present from the start in the last film Debord made with Brigitte Cornand: *Guy Debord: His Art and Times* (1994)—the title, of course, is ironical. It opens with a heated argument about Debord's *Commentary on the Society of the Spectacle* (1988) originally broadcast on French National Television, a typical gathering of French, male, liberal intellectuals debating Debord's paranoia: "This

11. Paul Virilio/Sylvère Lotringer, *Pure War* (New York: Semiotext(e), 1983), pp. 73 ff

book says a lot about a pathology," says one. "The idea of conspiracy is the weak point of his book. . . . He explains that the secret is generalized. . . ." Shrewd and devious as usual, Debord enjoyed preempting these accusations by putting them outright. He knew, of course, that they were right.

Paranoia is always right because it *creates* reality in its own image. This is what Dali suggested in 1932 with his "paranoiac-critical" method, which Jacques Lacan put to good use. Paranoid delirium isn't elaborated after the fact, it is a sudden and total phenomenon which modifies the objective world. In that sense, the world itself is delirious, and doing everything in its power to pass for rational. This applies as well to the kind of *systematized* delirium exemplified by the SI's critique of the spectacle. Trying to make sense of what is basically insane: the decoded flows of capital.

The early experiments of *dérive* were an attempt at decoding the flows, following a nonfigurative line, which can be seen as mutant "because it is made up of as many singularities as stopping points which nevertheless do not break up the line."[12] This is the line of escape, or *unsystematized* delirium, produced both by the SI and Klein's drifts. Deterritorialized flows cannot be grasped as such, they only become identifiable when they are captured by a code. This happened when the SI extracted a binary code—them/us—out of the more seismic intensity of creative drift. This kind of critique involved matching in oppositional terms the multiple forms and significations that the spectacle took, endlessly referencing from sign to sign through a process of ever expanding critical irradiation. Debord himself interpreted everything according to a strict code of behavior, emitting orders and pronouncing exclusions. An artist in politics, excommunication became his monochrome. Until he found himself alone, the last of the just—Saint Just.

Most of the dissensions had to do with Michele Bernstein and Debord's refusal to make any accommodation with existing culture. One couldn't renew art, they maintained, without reconstructing society as a whole. They had a point, of course, and the current commodification of art abundantly confirms their analyses. But it was a bit much,

actually quite insane, asking artists or architects to wait for the revolution before doing their work. They first clashed with the Dutch section of the SI led by Asger Jorn and Constant, who advocated instead a collective, non-competitive attitude to art production. The struggle came to a head with the expulsion of the most active section of the movement, the Spur group from Munich. Jorn was spared for reasons which were less than ideological: his paintings helped finance the SI, even long after he resigned in 1961.

A real turning point came for the Situationists in 1961–62. Jorgen Nash and other members from the Scandinavian group broke off as well from the Paris nucleus over the question of "the artistic avant-garde" and founded with Spur the 2nd Situationist International. The embattled SI denounced an international plot, a "Counter-Situationist Operation." They began to assume the position of a persecuted sect surrounded by heathens—an *ultra-left* sect. A sense of anguish and despair starts pervading Vaneigem's analyses at the time. Their life wasn't living, he wrote, but surviving. "What we're subjected to is the *weight of things in the void*. This is what reification is about. . . ."[15] Paradoxically, it wasn't poverty and destitution that led to this life of agony, but the spectacle of *les choses*: "The comfort and super-abundance of the elements of survival are pushing us to suicide or revolution." Vaneigen's teaching increasingly turned into preaching, as if painting a vision of present-day apocalypse would suffice to exorcise the powerful seduction of the spectacle.[14] Like the Cathars, a thirteenth-century sect of heretic Christians who were exterminated by the Church for their dark Manicheist theogony, they were the "chosen" waiting for the unavoidable collapse of the old world. "Why did Saint Augustine fight the Manicheans so violently?" Vaneigem asked. "He seized up the danger of a myth which offers only one solution, the victory of good over evil. . . ." The antagonism that the SI is about to renew, he added, "is the most ancient that exists, it is the radical antagonism. . . ." Like the Manicheans, they were longing for a world purified from Satan's simulacra and restored to its god-like

12. Gilles Deleuze and Félix Guattari, *On the Line* (New York: Semiotext(e), 1983), pp. 46–47.

RIGHT Yona Friedman, *Paris Spatial*,
1959, photo collage and drawing

authenticity.[15] What are Klein's mystical yearnings compared to the SI's apocalyptic theology?

New Babylons

The historicization of the Situationist movement started before it even began, and by the Situationists, *même*. While ostensibly proclaiming that they wouldn't leave any traces, building on quick sand, they actually set up their own archives two years before the creation of the SI. By now they're on their way to becoming the most well-known avant-garde movement of the late '50s and '60s. "Archival retrieval, reconstruction, and historicization" are on the way.[16] A ground-breaking exhibit at the Centre Pompidou in 1989 displayed the products. Given the Situationists' stark refusal of art as pure commodity form, institutional interest quickly shifted to the only "artistic" area that could be salvaged (forget about politics): architecture and urbanism.

Created by Debord in 1952 as a breakaway group, the Lettrist International was the first cultural circle in France to consider architecture as a critical part of a revolution in living. Between 1955–58, they eagerly sought ways of experimenting with it as well as with modes of behavior. They were preceded in all this by Constant and the Cobra group—Cobra stands for Copenhagen, Brussels, Amsterdam—established right after WWII to find collective alternatives to "individualist culture." Cobra considered that the problematic stage of modern art was over and had to be replaced by an experimental attitude in which architecture would play an essential role. Cobra eventually merged with Asger Jorn and Pinot Gallizio's Imagist Bauhaus, active since 1955. Together with the LI, these groups formed the SI in 1957.

In its first proclamation, the Dutch section announced that the aesthetic and utilitarian principles of contemporary urbanism had to be overcome "in favor of a conception which envisages habitat as a décor for the totality of life." Constant discovered Lefebvre's heretical writings on everyday life very early and eagerly responded to his dream of extending Marx's inversion of Hegelian philosophy to "superior" activities like art and culture. The model that he adopted had nothing to do with the official history of Modern architecture, dominated by Le Corbusier and the Modern movement. During a visit to Italy, Constant was struck by a temporary gypsy encampment, and decided to install them permanently on the premises. This became his lifetime project for the New Babylon—the name, a symbol of decadence and revolution in mores, was apparently suggested by Debord himself—a temporary habitation, collective and fluid, constantly remodeled: "a nomad camp on the planetary scale."

New Babylon was explicitly conceived for a utopia and returned to the pure exercise of collective imagination. In this Edenic society, everyone would be free to create their own lives and give them the shape of their desires, "play, adventure, and mobility" experimented with on the widest scale. This artificial, entirely "constructed" environment, would merge elements of community life or city life into a new kind of fluid urban space extended to the entire world, "a structure no longer made of clusters, as in traditional habitat, but espousing the tracings, both individual and collective, of errancy: networks of inter-related units forming chains that could develop and extend in every direction." Entering Lefebvre's dialectic world from the bottom up, like a mole, Constant unexpectedly delivered an entirely new model for everyday life: the rhizome.

A "rhizome" isn't rooted and arborescent like a tree, but fluid, immanent and acentered, like crab-grass, "a process that ceaselessly extends itself, breaks off and starts again... It has neither beginning nor end, but always a middle, through which it pushes and overflows." The rhizome is a conceptual machine set up to dismantle dialectical thinking and any kind of dualistic and hierarchical formation. Constant's "nomad city," which only existed as an architectural blue-print, a utopian diagram, turned out to be programmatic in other ways as well: a model for nomad thought. "Many people have a tree planted in their heads, but the brain itself is much more like a grass."[17] The New Babylon space, Constant wrote, "has all the characteristics of a labyrinthine space in which movements aren't subjected to the

13. *Internationale Situationniste #8*,
January 1963
14. Cf. *The Revolution of Everyday Life*,
1972 (London: Left Bank Books, 1983).
15. Cf. Greil Marcus, *Lipstick Traces* (Cambridge, Mass.: Harvard University Press,
1989).
16. *October* 79 (Special Issue on Guy
Debord and the Internationale Situationniste), Winter 1997.

constraints of whatever spatial or temporal organization."

The idea of the labyrinth directly informed the Situationists' experiments through the bourgeois city. Constant's meeting with Debord made it possible to elaborate further the concept of unitary urbanism, which the Dutch section conceived, in 1958, as "a complex and continuous activity meant to recreate human environment." The collective construction of situations through *dérive*, "a fluctuating community without any mooring, in which contacts can only be maintained through intensive telecommunication," was based on unitary urbanism. The World Wide Web is a disembodied and corporate version of all these collective yearnings.

As early as in 1959 Debord and Constant started clashing on the question of utopia. Debord saw it in terms of immediate political action—"choosing," he declared, "between a description of the Golden Age and the austere period of its preparation." Being an architect, and not a revolutionary mystic, Constant decided instead to embark on a detailed description of New Babylon "instantly and without delays." In the following years he did just that by means of architectural drawings, collages and photomontages, to which he kept denying the status of art.

Constant's *New Babylon* was published in 1960, the year he resigned from the SI. It provided a somewhat more accurate view of what he had in mind. For one, New Babylon embraced modern technology, freedom from material contingencies being the necessary prerequisite for greater organizational complexity and social mobility. Contrary to functional cities, where collective services are integrated in the urban texture, these now were concentrated in fully automatized megacenters of production carefully kept at a distance from the space of everyday life. Social amenities, on the other hand, were regrouped inside that space in autonomous units, or sectors, themselves lumped together by clusters which appeared independent from the outside but actually communicated from the inside. This allowed for a slow and continuous flux of people within each sector and from sector to sector. As for faster circulation, it was

provided both from above, on the continuous roof-terraces of the sectors (planes, helicopters) and from under, on the ground level (cars). The sectors themselves were generally raised on widely spaced pilots above the road. The advantage of this outlay, as Constant saw it, was that each level was independent, clearing the second deck for an outdoor space, "a second artificial landscape on top of the natural one." Sectors were loosely connected to each other like large meshes in a wire network; external collective services were installed in these zones which were free from construction.

At the very same moment Yves Klein happened to conceive independently a project along similar lines. Klein hadn't paid much attention to architecture until he started decorating the Gelsenkirchen opera house in the Ruhr with a team of artists and architects, including Werner Ruhnau, with whom he designed the "roof of air" on top of the building's cafeteria. Back in France, he involved both Ruhnau and architect Claude Parent in an ambitious project which he called "Architecture of the Air." Always been fascinated by levitation, Klein became very enthusiastic about using "air heavier than the air" for his cities in space. Like Constant's Babylon, Klein's project was mythological: Architecture of the Air was Eden itself in light of new technical advances, the Golden Age returned in an artificial state.

Like New Babylon, Klein chose to keep technology apart from domestic habitat. The engineering systems were buried, architect Claude Parent said, "in immense silos which surrounded or supplemented everyday life. Everything that was necessary for life in fresh air, happy life, was present there." Technology, in other words, could be felt everywhere, but it had to be inconspicuous, leaving large tracts of unspoiled nature all around for human gatherings. Another main element of Klein's project was the highway, which served as a base for all the technical installations. Flows of pressurized air capable of covering huge amounts of land, like an immense air-roof, protected humans from rain or storm and adjusted atmospheric conditions to their desires. This air-walled enchanted garden came straight out of a chivalrous tale, Gauvain saving the sequestrated damsel

17. Gilles Deleuze and Félix Guattari, *On the Line*, op. cit.

from asocial love. Klein had social concerns as well. Each town was divided in sectors equally shared by everyone. Walls, partitions, and roofing, everything that privatized space and excluded other kinds of human relationships, were removed. Doing away with individual and family codes for a more inventive kind of sociality was the explicit goal of Klein's "School of Sensitivity." It was true for Constant's New Babylon as well.

In New Babylon, the flexibility of interior spaces similarly allowed for multiple variations in environment and ambiance within a rather small volume. Sectors could easily be dismantled and built anew. This capacity to alter shapes and atmospheres at will was explicitly meant to induce participation from the occupants, passivity being a major element of the society of the spectacle. The continuous metamorphosis of habitat—it seemed less inscribed in space than created along the way by the intensity of the experience—further discouraged long-term memory, on which habits and resentment thrive. It favored instead short-term memory, which is rhizomatic, an active process of forgetting, Nietzsche's anti-memory or anti-genealogy. In Constant's labyrinth, no one could retrace their steps or retrieve images they previously had in mind. Constant recognized later on that his project was mostly a provocation. But what is "theory" if not a provocation for reality to answer in kind?

The question of the city, first raised by the SI, was gradually moving to the center of the debate as possible alternatives were sought to offset the disaster of "social construction." But this entailed breaking open the "liberal" structures of the profession and turning the Ecole des Beaux-Arts, a glorified trade school, into a more regular academic institution. It took the turmoils of 1967–68, the increasing political activism of architecture students mobilized against American aggression in Vietnam, and their violent critique of "bourgeois architecture" sold to special interests, before major institutional changes were grudgingly made. Architecture was still considered an "art," not a field of studies. In fact, to this very day French architects consider themselves artists and remain legally irresponsible

for their own projects, which still have to be approved by accredited engineers. In the early '60s, the "human sciences," led by semiotics, were quickly spreading over a number of disciplines, and a more interdisciplinary approach to architecture (sociology being especially appropriate) helped raise architectural questions in a broader urban context.

The passage from the city to urban life was graphically present in both Constant and Yona Friedman's projects. Friedman's drafts for Spatial Urbanism, New York (1960–62) and Bridge-City overlapping the river Seine, presented a similar metabolic flow of short-term, maze-like sectors suspended over old cities in a three-dimensional megastructure. Fixed forms, though, weren't really the point for "unitary urbanists." They were primarily concerned with tapping on the unused vitalism and creativity of social life. Conceptually, they were breaking away from rationalist urbanism as well as from industrialized housing, which were ghettoizing life gathering within a single megastructure a multiplicity of functions until then kept separate.[18] Instead of isolating humanity in anonymous "garden cities," or packing them in rat cages, they were trying to project in spatial terms the chaotic image of a new society to come, more mobile and playful, transient and anarchical, acknowledging this overwhelming fact of the time: the advent of an artificial, "constructed" nature that could be tapped on for more utopian projects.

A group of young English architects gathered around a magazine started in 1961, *Archigram*, (short for "architectural telegram"), who were doing this on a much wilder scale, unbridled by any political, pedagogical, or practical considerations. Contrary to the Situationists, the English group was "short on theory, long on draughtsmanship and craftsmanship." They were designing for pleasure, knowing all too well that they would never be given a chance to put any of their iconoclastic ideas in orbit. They didn't hide their admiration for the industrial development of the last century, which they considered unfulfilled. These architects, Peter Cook, Dennis Crompton, David Greene, Michael Webb and Warren Chalk, were the heirs of English liberalism and

pragmatic philosophy; in Lefebvrian terms, they considered that present possibilities didn't match real possibilities. Being fully committed to rationality and progress, they were convinced that a technological society would offer more freedom of choice and allow people to play an active part in determining their own lives: "It is now reasonable to treat buildings as consumer products," they wrote, "and the real justification of consumer products is that they are the direct expression of a freedom to choose."[19]

There doesn't seem to have been a direct connection

ABOVE Aftermath of the student riots in the streets of Paris, May, 1968

between Archigram and the SI or Constant. But the two groups roughly moved in the same direction. In *Archigram 3*, the idea of considering cities first of all as "a collection of events, and only secondarily a collection of buildings" led as well to the notion of situation as a way of creating a truly living city: "Situation, the happenings within spaces in the city, the transient throwaway world of people, the passing presence of cars, etc., are important, possibly more important than the built environment—the built demarcation of space. Situation can be caused by a single individual, by groups or a crowd, their particular purpose, occupation, movement and direction." This emphasis on behavior and attitudes threatened to take them beyond the boundaries of conventional architecture, as happened to the Situationists. But they eventually arrived at it in an entirely different way, as architects, by exceeding the very categories of "house" or "city" through strange collective contraptions of their own design.

In a changing world, Archigram believed, buildings would have to change too. But instead of distrusting the repetition and standardization inherent to mass-production in a consumer-oriented society, they relied on them to provide parts that could be changeable or interchangeable. This aesthetic of replacement, or body parts, with buildings becoming body-bags of sorts; it certainly made economic sense as well. Archigram conceived a "Plug-in Capsule" made for the assembly-line similar to the Saturn rockets launched from the Vehicle Assembly Building in Cape Kennedy. A space rocket: the very "walking building" they had been dreaming about. They felt connected to a tradition that went all the way back to Le Corbusier's vision, in the 1920s, of a new world through images of ships and planes, silos and factories. They were making "machines for living in" and not just metaphorically. The "Plug-in City" (1964) had removable house elements placed into a megastructure of concrete, and they also had a "Walk-in City," moving around on gigantic legs. "Whatever else it was to be," Peter Cook wrote, "this city was not going to be a deadly piece of built mathematics."[20]

18. Simon Sadler, *The Situationist City* (Cambridge, Mass.: The MIT Press, 1998), chapter 3.
19. *Archigram* (Boston: Birkhauser Verlag, 1991), p. 78. Peter Cook Ed.

These objects gradually burst their seams. After all, the "Plug-in City" was just a replacement city, and "Capsule houses" replacement houses. Around 1965, they started evolving hybrids. The Living-Pod came first, since it could be hung anywhere. It took them to a new kind of nomadism in a mobile world in which "the need for a house (in the form of a permanent static container) as part of man's psychological make-up will disappear."[21] The house became a simple appliance for carrying with you, the city a machine for plugging into. The "Drive-in Home" presented some kind of clothing-skin that could get smaller or bigger depending on the size of the contained population. The Cushicle, the home-on-your-back, the transient pad, finally disintegrated the house. Yet it still was a mechanism, like a car. The Suitaloon, a space suit acting as a minimal house, "clothing for living in," broke away from that. The owner's body itself became the body of the vehicle. Each suit had a plug, like a door key, and you could plug into your friend and be in one envelope, or step out of your suit when you leave, or plug envelopes to form larger spaces.[22] From then on, Archigram moved in a state of metamorphosis, which they defined as the continually changing but always existing environment, hybrid assemblies that were both mass-produced and private worlds, "always alive but never the same. Always complete but always in metamorphic transience." Generalized nomadism tied to a world-wide locative system, generating "moment-villages" at the interface of personality and environment: "Its group-regroup-shift implication suggests that its ultimate metropolis might be an anarchy-city or that the concept of 'place' exists only in the mind."[23] Archigram meets New Babylon meets rhizome.

Nothing very exciting happened in France before the divine surprise of the Centre Georges Pompidou, except for May 1968, of course, but the two events may actually be linked. The Pompidou, or "Beaubourg," as it is often called, from the name of the plateau it was built on, has widely been credited for the new departure of French architecture in the '80s and '90s. But this may well be an afterthought. In any case, Beaubourg should never have been built.

Beaubourg Affects

In the 1960s, the French government decided to move the Les Halles food market, "Paris' Belly" (Zola), to the suburb of Rungis. A controversy erupted over the destruction of the modern pavilions in cast-iron and glass built by Baltard in 1853. It was tentatively decided that they would be turned into a National Museum of Modern Art, or a free general-purpose library. By the end of 1968, it was decided that the library would be built instead on the Plateau Beaubourg nearby, currently used as a truck parking lot. (The Baltard pavilions were dismantled and replaced by the present, rather mediocre hybrid complex.) De Gaulle resigned in December 1969 and Georges Pompidou, the new French president, personally took on Beaubourg as a presidential project involving both the library and a center for the contemporary arts. Other grand public projects were underway at the time, like the La Défense business center, and the Charles de Gaulle international airport—power displays on the part of a regime that had been badly shaken by the events of May 1968.

President Pompidou boldly launched a blind international competition and placed architect Jean Prouvé at the head of the jury. To everyone's surprise, the winners, among six-hundred participants, were Renzo Piano and Richard Rogers, two unknowns from Italy and England. Like Prouvé, the two young architects were interested in advanced technology and industrial design. Although trained in the Modernist tradition, they realized that the building's main features should be flexibility and replaceability of parts. They selected prefabrication, lightweight materials, and steel structures with adaptable fixings to allow for various arrangements of external elements, thus making sure that the building would be functional and polyvalent. They also located structure, mechanical equipment, and elevators on the exterior to facilitate public circulation, in effect giving Beaubourg the familiar look of *having its insides outside.*[24]

Georges Pompidou, a sometime scholar and would-be art connoisseur, hated the project. He demanded that Prouvé present an alternative, but the architect flatly re-

20. *Archigram #4*, op.cit.
21. *Archigram*, pp. 51–52.
22. *Archigram*, p. 80.
23. *Archigram*, p. 74.

fused. He had fulfilled his mission; now it was up to the president to take responsibility, with whatever international flack that may ensue. Feverishly, Pompidou consulted with his lawyers and advisers and realized that he simply couldn't renege his word publicly. Reluctantly he signed in the unwanted construction which now immortalizes his name.

In spite of all the controversies, the Centre Pompidou instantly became an all-time favorite of the public, topping the Eiffel Tower. In the national list for design, it ranked first—with Piano & Rogers second, after Le Corbusier, as architects. Every effort was made, of course, to conceal the presidential faux-pas and change the rules in order to prevent future embarrassment. Paradoxically, specialists heralded Beaubourg as the exemplar of French architecture's "demonstrated tendencies toward a universal, rational system of design applicable in all circumstances," in short, a model of "Cartesian clarity."[25]

Piano & Rogers explicitly credited Cedric Price as their main source of inspiration. Price happened to be Archigram's mentor, "almost the only architect in England at the time," they wrote, "to actually build pop-up domes and disposable buildings and therefore come to grips with the near future." His major project was the "Fun Palace" (1961), which wasn't "universal," but custom-made for Joan Littlewood's working-class Theatre Workshop in East London. She described the proposal as both a "university of the streets" and "a laboratory of fun." Their idea of fun wasn't passive, as in the "spectacle," but involved action and reaction, stimulation, and information. Price's strong sense of personal freedom and his fascination with technology made him critical of architecture. He remained intent on satisfying people's aspirations by evolving mass-production of standardized components. "Shouldn't we plan with people, instead of for people?" he asked.[26] Price took leisure very seriously. This crazy utopia that he shared with the Archigram group, where metal cities move with long legs, was the land of pure delight, technological ecstasy. People would drift aimlessly, getting lost, getting everything they wanted. Wasting time. Everyone was into leisure, pleasure, passing encounters, in the disappearance of all family links. Life, for them, was something free, joyous, and uninhibited. Something like happiness.

Price's architecture emphasized impermanence and planned obsolescence. His theory was that the silent majorities who don't live to change the world, who aren't communists, capitalists, anticapitalists, actually use reality, grind it to the ground. In one of his well-known projects, Price built the same house twice. He first repaired it after use, but then he let it go, let it crumble down. And Beaubourg was just that: something to let go of. In a famous essay, Baudrillard noted that "the masses rush toward Beaubourg as they rush toward disaster sites, with the same irresistible elan. Better: they are the disaster of Beaubourg. It is the masses themselves who put an end to mass culture."[27]

The masses don't go to Beaubourg to get culture: unlike the Eiffel Tower, which is empty, there are things there blocking the view, paintings, sculptures, boring stuff. But exhibits instantly fade in the memory. People go to Beaubourg just to be there—*being there* is the sight. They look at themselves going up and down in the transparent elevators, among the façade's myriad reflections. They *are* the Fun Palace, they *are* the show. Such an expensive building, so costly to maintain, it's France's *potlatch*. And they grind the place down.

"What should have been put in Beaubourg?" Baudrillard asked. "Nothing. The void. . . ." Not exactly Klein's Void, a transcendental vacuum cleaner like Jeff Koons', but the disappearance of art itself. The distinction between interior and exterior doesn't hold there anyway. It is Möbius'' truth. "Yet if you had to have something in Beaubourg," he concluded, "it should have been a labyrinth." Baudrillard had no idea who Price was, or Archigram, or Constant; he hates everything about architecture anyway. But he made a great reading of the building.

Many people dismissed his essay as an exercise in cyni-

24. Nathan Silver, *The Making of Beaubourg: a Building Biography* (Cambridge, Mass.: MIT Press, 1994), p. 46.
25. Wojciech Lesnikowski, *The New French Architecture* (New York: Rizzoli, 1990), p. 43–44.
26. *Archigram 2*, 1962.

cism. Yet, as it turned out, it was *literally* what Piano & Rogers themselves had in mind: "The image of culture is static and elitist," the two declared at the time. "Our problem is to make it live. . . . Our building is a tool, not a rigid, tailor-made architectural monument. It is fluid, flexible, easy to change, full of technical resources inside and outside, on top and underneath. You and we, however, the users and the designers, must decide what to plug into those technical resources. Why should the art books be in the library, and art solely in the museum? The Center is a public event: *thus the greater the public involvement, the greater the success.*"[28] This is what Beaubourg's biographer called: "an admirable regard for the role of architecture in a democracy. It gives a cogent argument for a populist monument."

Of course, Baudrillard had no intention, of inviting the masses to participate in an "edifying" project, rather exhort them to turn into a critical mass and implode. There is no longer a need for a "critique" of culture, the masses do that much better themselves. All they want is the spectacle, and they leave nothing behind. An arch-commodity, Beaubourg was meant to be consumed. Like Disneyland, it is there to hide the fact that the whole world has become a museum, an overloaded memory, and that there is hardly anything worth remembering anymore.

The Torrent

"I ask you to turn away from the spectacle."
President Clinton, Address to the Nation (August 18, 1998)

May 1968 was a populist event as well, and a great success on that score: it involved the entire country. It was something like the Beaubourg effect on a national scale. In a world of simulation, feedback and overdeveloped control circuits, it was like power itself imploded. The reaction was absolutely disproportionate to the occasion. The spark came from a handful of "enragés" from Nanterre, students who didn't play the game, or decided to play another game: the provocation game. It was just a form, adaptable, flexible, polyvalent, just like Beaubourg. It could fit any situation, or rather turn anything into a "situation." All it took was deliberate irreverence and irresponsibility. Playing with the codes, escalating the stakes: interrupting a class, asking a Communist leader stupid questions playing with the media. A single match can start a forest fire.

Rightist groups threaten to break-up an anti-imperialist meeting on campus. Leftist students mobilize. Classes in Nanterre are suspended. Students take over the administrative services. The leaders are disciplined. The Students' Union calls for a meeting at the Sorbonne. The Chancellor loses his nerve, summons the police to campus. Three hundred students are arrested. The whole Latin Quarter is in uproar, return to status quo is impossible. Nobel prize winners protest. Teachers go on strike nationally. On the night of May 10th, students build the first barricade.

For the most part, the French left was abandoning the idea of revolution, meaning the violent takeover of the state. Weary of any "irresponsible provocation," especially from the ultra-left, the French Communist Party now advocated a "pacific passage" to socialism. Long-term historical memory could only be found, at this point, among the revolutionary left, neo-Leninist splinter groups (various Maoists boosted by the recent "cultural revolution"), autonomists, and neo-anarchists. The Situationists and "enragés" merging into the March 22 Movement in Nanterre belonged to the ultra-fringes.

The first barricades of May 10–11 were a euphoric experience, a political carnival for the local population. Consumer boredom dissipated. Social fragmentation dissolved. Everyday life no longer was a rationalization of work and status. Everything seemed possible.[29]

The police crackdown overnight was massive and brutal, hundreds wounded, burnt cars scattered in the streets. The country woke up to a major political crisis. The workers' unions called for a general strike. The special police forces retreated. One million people took to the streets. The Sorbonne was reopened. Factories throughout the country were occupied. Everything was in flux. "It's a torrent. I can't get hold of it," de Gaulle exclaimed. Exactly ten years after

27. Jean Baudrillard, "The Beaubourg Effect: Implosion and Deterrence," 1981, in *Simulacra and Simulations*. (Ann Arbor: The Michigan University Press, 1994).
28. Quoted in Nathan Silver, op. cit., pp. 103–104.

the General took over the state, the country was paralyzed.

From May 12–22, state power evaporated, unleashing a ludic atmosphere, the kind Lefebvre had dreamed of: divisions between work, leisure, politics, and culture were abolished in a vision that was resolutely "unitary and totalizing." It was the 1871 Paris Commune all over again, replayed live. Desire, pleasure, and festive activities found an immediate outlet in speech. Lycées, universities, École des Beaux-Arts, théâtre de l'Odéon were occupied. Impromptu assemblies celebrated, non-stop, their newfound freedom. "Desalienation" was on its way, imagination was taking over. The "Student Commune," it seemed, was spilling into some kind of cultural revolution. Yet a wide discrepancy still divided students' aspirations from the political parties and trade unions which they had hoped to bypass. Besides, the response of less organized elements (young workers, *lumpen*) proved to be unsettling. After Daniel Cohn-Bendit was expelled, on May 24, a new round of barricades and violence, street warfare erupted anew involving tougher, "uncontrollable segments" of the population. The Stock Exchange was torched, streets devastated; police stations were raided.

Finally the bourgeoisie took to the streets. A massive pro-Gaullist demonstration was held on the Champs-Elysées on May 30. Sensing that the revolution was slipping away, "enragés" and Situationists called for workers to "take over the economy directly."[30] Direct democracy and self-management of the factories, the *Socialisme et Barbarie* program. But Communist-backed trade-unions decided on an orderly return to work, and the police started expelling strikers from the factories. On June 10, Gilles Tautin, a young Maoist, and several young workers were killed. Violence flared up again. During the night of June 10–11, dozens of barricades erupted citywide, fights intensified on both sides. The festival was turning into a "civil war," with Molotov cocktails, grenades, and massive police repression. More than twelve-hundred people were arrested and brutalized. The disorder and destruction began to scare the population. The next day the state banned all extreme-left organiza-tions, and the Sorbonne was evacuated.

Was a revolution underway? The Situationists believed it was. They considered the students' movement a mere rear-guard. The spontaneous general strike, the first ever, had been initiated by young workers and disenfranchised proletarians. Direct class struggles would be resuming, nothing would ever be the same. "The movement of May was the active proletariat looking for its theoretical con-science."[31] It had found it in the SI. . . .The truth is that the movement had peaked a few years earlier and its presence in May 1968 had been negligible. The SI dissolved just a few years later. Vaneigem said he had wasted all these years.

Beginning Again

How to begin again, after all the myths are consumed? Lefebvre said that there was a historical time for utopia. This time passed. Utopia wasn't a good fit anyway because, although outside of it, history remained its ultimate moti-vation. Events can't be understood in terms of development, because that would exclude the untimely, the unpre-dictable, whatever didn't exist before. There's no getting out of History if this isn't already done. One of the main legacies of May 1968 is the challenge of history as a big narrative and its reformulation in terms of *becoming*, so that, Deleuze wrote, "the event has the privilege of beginning again when time is past."[32] History and becoming don't have the same future or the same past. Although becoming is part of History, it constantly parts from it to assert its own timing. We will never know what happened, or what an event will prove capable of in times to come.

Starting again in the thick of things, without any ulti-mate goal or reward. Setting up a situation capable of making a dent, or a ripple, in everyday life. Connecting elements otherwise kept apart. Introducing a hiatus in the spectacle. A few young artists have been doing just that: not making political art, but "making art in a political way," as Thomas Hirschhorn put it.

Hirschhorn, a young Swiss artist living in Paris, uses cardboard boxes, aluminum foil, transparent plastic wrap,

29. f. Jean-Pierre Le Goff, May 68: *L'her-itage impossible* (Paris: Editions La Decouverte, 1998).
30. Rene Vienet, "Enrages and Situation-ists in the Movement of Occupations," [1968] (New York: Autonomedia, 1992).

ball-point pens, wood, and Scotch tape to raise transcendent questions about our society. You could have seen them awkwardly scrawled on signboards in the Paris metro around some press pictures or clippings: "Help me, please." It isn't money that he was asking for, but some kind of involvement. The press photo shows a South American crowd sifting through a garbage dump. "I don't understand."[33] The question went right to the heart of the "spectacle." Breaking down the pattern of passivity, making something happen, an event: thinking. Thinking is automatically shared. Putting together all these bits of separate information that prevent understanding. It is a strangely moving experience when a question is born, including this one that underlies them all: how is such a thing as collective stupidity possible? As Deleuze said, we haven't yet began to think.

Hirschhorn makes "wall-displays" with magazine images or advertisements, disconnected and perishable material that he awkwardly links with lines of crumpled aluminum paper, like a Christian Boltanski shrine, to suggest "my confusion, my desolation in relation to events, in relation to the world." Unlike political art made in the U.S., which is always a critique from someone who allegedly knows, Hirschhorn doesn't pretend to know any better than his audience. Actually he goes out of his way to assume a lowly position, what he calls his "strategy of weakness," challenging anyone's right to assume a higher position. Besides, "claiming one's weakness allows one to overcome the kind of weakness that's forced upon you." Everywhere in his work lie ready-made answers, huge crocodile tears made of cheap aluminum material.

Like his plastic wrap, with which he builds precarious edifices to house his art, shanty towns camping in the outskirts of the capital or parasitic appendages encroaching on a bank or a museum, "half-construction, half-destruction," Hirschhorn remains transparent to his audience, exhibiting much less objects than the very process by which thinking comes into being, through doubts and hesitation, dumb persistence, stuttering. Like thinking, art has to be shaky because it is alive. Everything else, smooth, smart, ostensibly laconic, "finished," belongs to the commodity form. In his *Fifty-fifty* series, Hirschhorn only covers half of the plywood or cardboard with Scotch-taped images, and leaves the other half empty, an invitation for participation, sharing, solidarity. In *Less*, the surface dwindles down to almost nothing. Proliferation, on the one hand, heaps of paper material in a corner, nothing adding up; on the other hand, disappearance, hand-outs, trash. *Arte povera*. His recent work, made for an exhibition in Switzerland, displays gold bars made of aluminum. You can never be too explicit.

Fabrice Hybert sets up his own company, Unlimited Responsibility, Inc., in 1994, to manage his own projects as well as those of other artists. Unlike Hirschhorn, Hybert has no qualms entering the business world and using modern technology. Yet his rationale is very similar: reclaim human creativity from the grip of mercantilism and the passivity of communication. Taking his cues from Deleuze, Hybert set up little desiring machines in the midst of the capitalist system, redirecting its flows, extending them in unpredictable ways. In 1995, upping the ante on Andy Warhol, he perversely turned the Musée d'art moderne de la Ville de Paris into a "Hybermarket," exhibiting a variety of commercial products which he eventually sold to the public for near-wholesale prices. That was his "Brillo-box" project. Hybert's contraptions are not meant to elicit consumer desires, but provide unrestricted pleasure, like the swing equipped with two dildos and obligingly test-marketed by his friends. In 1997 at the Venice Biennale, he created a sensation by turning the French Pavilion into a live television studio, engaging the audience to break through the little window and produce their own "spectacle" in broad daylight.

The same active engagement in the logic of the spectacle characterizes what could be called Pierre Huyghe's "dubbing" strategies, which aim to change people's relation to their everyday life. In an early project, *Posters* (1992–95), Huyghe asked actors to impersonate a group of workers clearing out a construction site at Barbès Rochechouart, a

31. SI #12, September 1969.
32. Gilles Deleuze, *Difference and Repetition*, 1968 (New York: Columbia University Press, 1994), p. 152.
33. Thomas Hirschhorn, *Les plaintiffs, les bêtes, les politiques* (Geneva).

populous district in Paris. He then posted the life-size photograph of the scene right above them on a preexisting billboard, so that passers-by would be simultaneously confronted with two versions of the ongoing action. The gap between the actual event and its representation experienced in real time introduces instant doubt and disorientation as to the nature of reality, an active moment of "becoming" in the vacillation of ordinary space-time coordinates. Were the workers on the site the actors on the poster, or were they trying to replicate at best they could the image posted on the billboard? The mental displacement experienced in situ was enough to transform everyday reality into a constructed situation, engaging the viewers in a vertiginous space where the separation between art and life, real and imaginary was temporarily suspended.

This "doubling" of reality on the very premises, and the artificial production of a universe of simulacra, opened a logic of "repetition," in the Deleuzian sense: not the return of the same, but a multiplicity of choices between constantly shifting models of interpretation. Unlike the Situationists, or Paul Virilio, Pierre Huyghe isn't trying to restore a lost authenticity behind the screen of images, but explore the complex interplay between various appearances which are never meant to reveal a deeper truth or reality. Remaking *Rear Window* with non-professional actors; mixing Godard's *Two or Three Things* with *Dr. Jekyll and Mr. Hyde*; presenting simultaneously, on a three-fold screen, multiple-language versions of the same classic Hollywood film; filming a team of actors dubbing Poltergeist in French in the absence of the original, each person separately enacting one's role and yet all communally involved (*Dubbing*, 1996); mixing live scanned conversations with a diasporamic loop of French sub-titles to *2001: A Space Odyssey* (*Daily*, 1996), these are so many ways by which Huyghe manages to vampirize the reality effect of the media, through a deliberate use of the very technologies that were assumed to preclude dialogue and participation.

What concerns Pierre Huyghe, ultimately, isn't to reveal a reality allegedly present behind the mask—we're never given access to reality in its naked state anyway, everything being interpretation, and interpretations of interpretations—but to turn each version into a "program," an open structure liable to be altered through its concrete implementation. In short, the calculated repetition of models of behavior, media icons, archetypal narratives, becomes a means of generating a moment of reality in its irreducible singularity. Amateurs awkwardly reenacting a well-known scenario become like artists experimenting with their own material, or people experimenting with their own lives. "What interests me," Pierre Huyghe declared, "is that a given know-how acquired in art could be reinterpreted outside of it, that a practice could be applied for another use—create interferences, constitute space-times, resolve economic problems—rather than directly dealing with artistic problems." One never leaves art for reality, or subsumes art into life; one turns art into the production of possible worlds outside. The less turned toward its own history, the more art creates its own singularity as an event in the world. The Situationists wanted to construct a new lifestyle enacting in the present what they expected of a realized utopia. Through a myriad of interlocked narratives, of multiple and chaotic singularities, a more playful scenario is coming to the fore, where artificiality isn't the sign of alienation but its very contrary: the advent of a liberating complexity through tentative revolutions diagrammatizing the everyday. Catelan called that "soft utopia." Félix Guattari called it *Soft Subversions*.[33]

It took a long time for French artists to start paying attention to French philosophy. Paradoxically, they often took their cues from the American art world in which "French theory," as it is called in the U.S., has played a major role over the last twenty-five years. This crisscrossing wasn't exactly new. Throughout all these years French theory, being a creation in its own right, fronted for French art and it was logical that it would be put to task as well on these "premises." On the American continent, it had been

reused for competitive purposes, prestige, exclusion, promotion, like everything else, but also, and this is more interesting, to fulfill some far deeper injunctions of the culture. Arriving in the New York harbor, Freud feared that he was bringing America the plague. But the plague had landed before he did, and it swallowed psychoanalysis alive, eventually spitting it out as ego-psychology. Why? Because ego is the American myth—the free individual—and this myth, or rather this consuming passion, and the impossibility of ever satisfying it, are constitutive of the culture, the price one has to pay in order to belong. The ego is a makeshift structure built over an abyss. It isn't surprising then that a similar détournement happened to "French theory" put to task to "deconstruct" a subjectivity that had never been constructed to start with, let alone problematized, but deliberately left fallow in order to directly expose the individual—or rather the "dividual"—to every social pressure. In an advanced capitalist society like America, where schizophrenia is built-in by the system as part of the normal circulation of its flows, subjectivity (life) isn't personal, and it is up to everyone to "personalize" it (customize it) as best they can—or reinvent it against all odds, which may be one of the most vital functions of art. It would have been more helpful then to question the mirage of subjectivity, the lack *strategically induced* in order to instill social conformity and dependency, rather than spend an inordinate amount of energy questioning its image. The same feature is present in the critical matrix in which "French theory" was cast against its will, turning Baudrillard's paradoxes into a social critique, which they certainly aren't, at least not in this crude form. Nor were Foucault, and even less Deleuze and Guattari critical (reactive) in that way, but analytical and programmatic. Critique, whether in art or commentary, is the inescapable complement to subjective fragility because what it really does is assert one's right to judge and condemn, to be the one who knows, at the expense of the object itself. It is a defense mechanism, as such entirely devoid of creative features. It constitutes as well what Gary Indiana, talking about '80s neoconceptual art, called "a form of mar-

ket criticism" because it simultaneously produces values for the art market. On both counts, its status and destination is the institution, whatever its claims to radicality. This is also true for the "neo-critical avant-garde" which gives itself the right to watch art values in the name of a purified version of history.

It is worth noting how different the young European artists' take on French thought from its current use in the American context. It is far less deconstructive and subjectivity-oriented, formal, or ideological. It is definitely more explanatory and outward-oriented, actively engaged in the transformation of social perceptions. Unfettered by any critical orthodoxy, the new generation of French artists seems freer to map out new venues for art which address crucial contemporary issues, the way French theories themselves— or some of them at least, the more experimental and pragmatic, or gamelike and provocative—have done for more than two decades. In the early '80s, French theories were reappropriated in America in a "critical" way to fend off the wave of European neo-expressionist art that was threatening the supremacy of New York–based art. What the present *Premises* may well announce is a return to French theory *as art*, freeing both art and theory from overall cynical commodification. A new department for both.

I would like to thank Sande Cohen for his shrewd remarks; Chris Kraus for her insights on Georges Perec; and Hubert Tonka, editor of *Utopie*, for his suggestive comments on the Pompidou and French Architecture; also to Maureen Clarke, Elizabeth Franzen, and Alison Gingeras for their unfailing editorial support.

33. Félix Guattari, *Soft Subversions* (New York: Semiotext(e)), 1997.
34. Cf. Sylvère Lotringer, "The Third Wave: Art and Commodification of Theory," in Richard Hertz, *Theories of Contemporary Arts*, 2nd ed. (Englewood Cliff, NJ: Prentice-Hall, 1993).

PREMISES, PREMISES

SKETCHES IN REMEMBRANCE OF A RECENT GRAPHIC TURN IN FRENCH THOUGHT

DENIS HOLLIER

The Word of the Year

We're chatting around the dinner table and someone uses the word *galerist*. All of a sudden there is a lexical pause. Is the word a neologism? I get up to look in the dictionaries, and can't find it in any of the ones I have at hand.

The next morning, I head for the library. In the French dictionaries, I search in vain for *galeriste* in the *Trésor de la langue française* (1981), the *Grand Robert* (1985) and the *Robert méthodique* (1989). Not until I come upon the five-volume *Grand Larousse usuel* (1997) do I find what I'm looking for: "Galerist: Owner or manager of an art gallery."

I am no more successful on the Anglo-American front. There's no mention of *galerist* in *The American Heritage College Dictionary* (1993), the *Oxford Encyclopedic* (1991), the *Oxford Concise* (1995), the *Oxford Advanced Learner's Dictionary* (1995), or in the *Webster's Dictionary of American English* (1996). It does indeed appear in the *Oxford-Hachette French Dictionary* (1994) as "Galeriste: Art gallery owner," but only in the French-English part of this bilingual dictionary, and not in the English-French.

Finally, on the German front, Gerhard Wahrig's *Deutsches Worterbuch* (1997) is the only monolingual dictionary to confirm the word's existence. Could it be that *galerist* is the word of the year? (The word appears first in bilingual dictionaries, as if it belonged to an international vocabulary prior to being introduced into a national language. It could be found as early as 1980 in a whole series of Collins's bilingual German dictionaries, German-English in particular.)

Out of curiosity, I open Pierre Assouline's 1988 biography of Daniel-Henry Kahnweiler that's lying on a table, to check the epigraph "Ce sont les grands artistes qui font les grands marchands." And here "marchand" translates as "dealer."

So once again the merchants, in their latest incarnation as dealers, have been chased out of the temple; but this time, there is a slight variation on the theme, with the latest in iconoclasm: the paintings have been chased out with them. It's not simply that painting doesn't sell anymore (that there are no more buyers). It's that the market itself has disappeared: there's no more selling. There are no more dealers/merchants because there is no more merchandise. Aesthetic transactions seem to be able to do without this materialist fetishism. The time when signed objects, unique or not, circulated "in person," from hand to hand, from the studio to the gallery, and from there to the collector's or museum's wall, has suddenly become slightly archaic.

1. Recalled by Picon during an interview in one of the Radio France-Culture broadcasts, reprinted in Gaetan Picon, "Entretiens," in *La Vérité et les mythes* (Paris: Mercure de France, 1979), p. 53. [Unless otherwise noted, translations of titles cited throughout this essay and in the notes are by the translator.]

alliées, composées comme dans un
andais dont elles garderaient le cerne
rmeté élastique du pinceau et le vernis
on ne sait s'il est dû à la matière des
lumière de la scène, à l'onguent dont
t le tableau ou à l'éclairage du musée),
ansportées dans la grande casserole où
sous vos yeux, y perdent leurs cou-
formes et leur discontinu, s'y amollis-
naturent, tournent à ce roux qui est la
ntielle de la sauce ; au fur et à mesure
élevez, du bout de vos baguettes, quel-
ents de ce ragoût tout neuf, d'autres
nnent les remplacer. A ce va-et-vient
assistante, qui, placée un peu en retrait
s, armée de longues baguettes, ali-
nativement la bassine et la conversa-
ute une petite odyssée de la nourriture
ez du regard : vous assistez au Crépus-
rudité.

udité, on le sait, est la divinité tutélaire
ure japonaise ; tout lui est dédié, et si
onaise se fait toujours *devant* celui qui
(marque fondamentale de cette cui-
ue peut-être il importe de consacrer
cle la mort de ce qu'on honore. Ce qui

Où commence l'écriture ?
Où commence la peinture ?

est honoré dans la crudité (terme que bizarrement
nous employons au singulier pour dénoter la
sexualité du langage, et au pluriel pour nommer la
part extérieure, anormale et quelque peu tabou de
nos menus), ce n'est pas, semble-t-il, comme chez
nous, une essence intérieure de l'aliment, la plé-
thore sanguine (le sang étant symbole de la force et
de la mort) dont nous recueillerons par transmigra-
tion l'énergie vitale (chez nous, la crudité est un
état fort de la nourriture, comme le montre méto-

31

2. Gaëtan Picon, *Malraux par lui-même* (Paris: Éditions du Seuil, 1953), p. 117. Claude-Edmonde Magny speaks of "the kind of isolation in which [the novel] automatically places the reader." Magny, *The Age of the American Novel*, trans. Eleanor Hochman (New York: Ungar, 1972), p. 17. On the tendency toward collectivization through sight/ vision/the gaze, see the lecture that Georges Bataille gave at the Collège de Sociologie, Paris on January 22, 1938, especially his comments inspired by Edith S. Bowen on the social behavior of fish: "Vision is an important factor in the integration of these aggregations. Neither blinded fishes nor normal fishes in the dark ever aggregate" (quoted in Georges Bataille, *The College of Sociology (1937–39)*, trans. Betsy Wing [Minneapolis: University of Minnesota Press, 1988], p. 411, n. 17). See also Jules Monnerot, *Les Faits sociaux ne sont pas des choses*, (Paris: Gallimard, 1995), p. 120: "The effect of the group is, according to Professor Grassé, due to precise sensorial stimulants. Grassé notes 'The stimulant seems to be of a visual nature here.' From this he deduces the following mechanism: visual stimulation, through the intermediary of the brain, produces a stimulating effect on the hypophysis, which regulates the functioning of the ovaries."

A galerist, according to the translation given in the bilingual dictionary, doesn't sell. He has a *place*. He is defined—and defines himself—by his premises.

An Interview for Radio France-Culture

In 1975, Radio France-Culture broadcast a series of programs on Gaëtan Picon, a central figure in the cultural politics of the Fifth Republic.

In 1958, Picon became one of Andre Malraux's closest associates in the Ministry of Cultural Affairs. Among his many initiatives was a plan to create a space independent from the Museum Administration—which he considered too exclusively oriented toward the acquisition and conservation of patrimonial capital—where contemporary art could be exhibited. This eventually led to the creation of the Centre Georges Pompidou.[1]

Yet Picon's relations with Malraux began in an entirely different domain: he was one of the first critics of Malraux's literary work, and he remains, to this day, one of the best. Some time after World War II, Picon no doubt began to wonder why one of the uncontested stars of world literature had abandoned—while he was still young, and to the astonishment of an entire generation of admirers—the genre in which he had been so successful—the novel—turning instead to art theory and, shortly afterward, politics. In his 1953 *Malraux*, Picon attributes this transformation to the unanimist *engagement* inherited from a Popular Front esthetic: "Paintings and statues," he writes, "are the point toward which our gazes converge, books the point from which our dreams diverge."[2]

Picon's work in the ministry would in fact soon also lead him away from literature. And when the interviewer on

France-Culture asked him to explain this evolution, he answered with a curious understatement that seems more like some sort of joke: "What fascinates me more and more in painting is that one views it quickly."[3]

Those words no doubt just slipped out. They in fact go counter to everything else Picon says about his own tastes during the broadcast. Shortly after making this statement, for example, he returns insistently to his inability to imagine an esthetic experience that is not inscribed in time: "Time, for me, is the very space of art. And space is not the space of art. Everything I think, everything I feel, everything I love is under the sign of time and not under the sign of structures juxtaposed in space."[4] "Time is, in the work of art, the beating of its invisible heart," he wrote in one of his last books on painting, borrowing his telling title from Chateaubriand: *Admirable tremblement du temps*.[5]

Yes, the words slipped out. But they are no less significant for all that. They reveal a disaffection with a kind of painting whose heart had ceased to beat to the rhythm of time and the invisible. Painting for Picon had lost its pulse. Time was no longer even missing from it. And thus it is with a certain sadness that Picon diagnosed the ills of contemporary painting, which he defined as an "optical device" devoted to the "evacuation of time."[6]

And yet, when one looks back on all this, there is something unexpected about these regrets of his. For at the time, most critics took the reverse tack. They warned of the risks painting ran if it gave in to the opposite temptation; with a strict and fearful eye, they followed the ever-increasing experiments that endeavored to give the visual arts temporal parameters. Still, there was nothing particularly new in these warnings.

Gotthold Ephraim Lessing, for one, in *Laocoön*, had already criticized Titian for representing, one next to the other, two isolated episodes in the life of the Prodigal Son. Lessing did not yet speak in terms of synchrony and diachrony; he did state, however, that paintings must not treat subjects that take (up) time. They must not treat events that occurred sequentially as if they had occurred simultaneously. While it was possible to force actions that were separate in time onto one and the same surface, to impose a juxtaposition on them, this would not *produce* time. And it was not by adding together disparate immobilities that movement could be created.[7]

When Clement Greenberg reopened the debate in 1940 with his article "Towards a Newer Laocoön," he did so in order to radicalize Lessing's positions. According to Greenberg, painting's abdication to literature begins at a much earlier point than the one Lessing chooses. Temporal temptation does not appear with montage, it is programmed in the representational project itself. It is not brought about by the simultaneous representation of two distinct moments; the representation of a single moment is sufficient. Since time is a fundamental dimension of the represented itself, there is only one way for painting to break away from literature and time, and that is to renounce representation. In this sense, abstraction is the optical device that attempts to evacuate time.[8]

The Painter's Studio

As I mentioned, the interviews with Picon were broadcast on Radio France-Culture. This detail may at first appear merely to add a hint of local color, and since New Yorkers can't listen to France-Culture, chances are that this fact won't mean much to the visitors of *Premises*. Perhaps we need to offer a crash course in French civilization ("Culture and Radio in Contemporary France," or "High Culture and France-Culture")?

It just so happens that a recent issue of the journal *Le débat* (The debate), entitled "Radio-Exception" (and subtitled "A French Specialty"), included a hefty dossier on the defense and illustration of France-Culture. The table of contents rounded up all the usual suspects, but it was the lead article that caught my eye—"The Radiophonic *Cabinet of Curios*"—because it seemed unusual, written as it was by a painter, Henri Cueco. Cueco begins his essay with a discussion of the painter's studio in the age of radio, which could and should be taken into account by anyone who wants to

3. Picon, *La Verité*, p. 20.
4. Ibid., p. 44.
5. Gaëtan Picon, *Admirable tremblement du temps* (Geneva: Skira, 1970), p. 114.
6. Picon, ibid., p. 135.
7. Gotthold Ephraim Lessing, *Laocoön: An Essay Upon the Limits of Painting and Poetry*, trans. Ellen Frothingham (New York: The Noonday Press, 1957).
8. Clement Greenberg, "Towards a Newer Laocoön," in Greenberg, *The Collected Essays and Criticism*, ed. John O'Brian, vol. 1 (Chicago: University of Chicago Press, 1986), pp. 22–28.

modernize the various appliances that Courbet had brought onto the premises of his realist allegory: "Painters listen to the radio," writes Cueco. "Since they invent spaces, they lose the notion of time. Radio restores time to them, without saying what time it is, by the presence of familiar, punctual voices in the studio."[9]

"Painters listen to the radio": this sentence is worthy of a slight digression.

Here is one of the definitions with which Jean-Paul Sartre begins his book *The Psychology of the Imagination*: "Words are not images: the function of the acoustic or optic phenomenon which we call the word has no resemblance whatsoever to this other physical phenomenon, the picture."[10] The desire to be done with this dichotomy (and Sartre's very classic opposition merely echoes Lessing's dualism, with only the slightest modification), to overcome the deep rift between words and images has certainly provided contemporary visual arts and theory with one of their most productive axes. Contacts, exchanges, the hybridization that increased with the interface of the two fields all stem from this desire. The iron curtain has been torn down; the border has become porous. And to paraphrase Michel Butor, words have entered painting en masse.[11]

But this osmosis, this fusion comes at a cost, which is that of a new division that, in its turn, has produced its own effects of exclusion. Boundaries have not disappeared, they have merely shifted. The juxtaposition of words and images occurs on the basis of their sharing a common space: that of the graphic trace. For of course, it is in written form, and only in written form, that words enter painting. (Butor's book is illustrated with images, it is not accompanied by a soundtrack.) It is the passage to writing that allowed words to emerge soundlessly on the plane. And as words enter painting, the voice is extinguished. So while Sartre could still speak of words as being indifferently either acoustical or optical, Butor could not: his words became *dephoneticized* when they entered painting. In order to be allowed to rub elbows with images, words first had to break with their noisy past, like the novice who takes his vow of silence

upon entering the monastery. The opposition word/image is replaced by that of graphic/phonetic. The common program of this new, general graphemics has been sealed by the exclusion of sound: the sound is off, precisely because it is out of print. It leaves no trace.

Painters, according to one of them, listen to the radio. But the most interesting aspect of this arrangement is that radio, only recently introduced into the painter's studio, does not touch the premises of the painting. Succession (the sequence of sound) does not encroach on simultaneity (the plane of the painting). Cueco in fact does not mention bringing sound (or time: sounds in time, says Lessing) into painting; he speaks of precisely the opposite: he wants to make painting enter into time, to paint in time while painting in sound. But this doesn't go beyond the studio. By themselves, the sounds emanating from the radio cannot introduce an audiovisual version of words into painting.

In other words, and contrary to the implications of Paul Claudel's book on Dutch painting, *L'Oeil écoute*,[12] it is not the eye that listens but the ears, and only the ears. These are words that remain without consequences because they haven't let themselves be reduced to silence. They do not infringe on the painting. Cueco, later in his essay, describes this arrangement between images and words in terms of "friendly neighbors,"[13] an expression first used by Lessing in describing the independence of their respective territories. "Painting and poetry," he wrote, "should be like two just and friendly neighbors."[14] And as long as poetry is associated with the book, no major problems are raised by this idea. Text and image are accustomed to sharing a same surface, to existing together on the same page or the same canvas. But how can one draw the topography of this relationship when one moves from letter to voice, since—when all is said and done—sound, which leaves no trace, escapes territorialization? In what space does a sound take place? Does a sound take place in the same space as a letter or a line? Michel Chion proposes the word "acousmatics" for sounds whose source is not territorializable (not even, he says, off-screen in film). Radio is the best example of this:

9. *Le débat* 95, May–August 1995, p. 16.
10. Jean-Paul Sartre, *The Psychology of the Imagination*, trans. Bernard Frechtman (New York: Citadel Press, 1966), p. 119. This is a traditional position that is shared by Saussurean linguistics and phenomenology. Jacques Derrida wrote "For the property of the sign is not to be an image," in *Of Grammatology*, trans. Gayatri Chakravorty Spivak (Baltimore: Johns Hopkins University Press, 1976), p. 119.
11. Michel Butor, *Les Mots dans la peinture* (Geneva: Skira, 1969; reprinted in *Répertoire IV* [Paris: Éditions de Minuit, 1974]). A year earlier, Michel Foucault had written "Ceci n'est pas une pipe" (in *Dits et écrits* [Paris: Gallimard, 1968], and two years later, Jean-François Lyotard (to whom Butor's book is dedicated), published *Discours, figures* (Paris: Klincksiek, 1971).
12. Paul Claudel, *L'Oeil écoute*, Paris: Gallimard, 1946.
13. Cueco, "Radiophonic *Cabinet*."
14. Lessing, *Laocoön*, chap. 18, p. 110.

the radio transmits a voice whose source cannot be seen, a voice without a face, a voice of the unknown.[15] So how can two things be neighbors, if one of them does not take place?

Of Programmatology

I spoke of a common program. But what in fact is a program?

Of Grammatology, Derrida's 1967 book in which he registers the emergence of this extended graphemics, opens precisely on this subject. The first paragraph of the first chapter is entitled "The Program," and here Derrida sets out the program—in the traditional sense of the word—of what will follow. He also announces what, in the long run (there is promise in the program), will remain in a certain sense the future of his own program, the program of his books to come.[16]

And yet these opening pages do not simply have an annunciatory function. The program (what a program is) is also, in a certain sense, the book's subject: a taking stock of an unheard revolution, of the movement from the era of the book to that of the program. *Of Grammatology* begins with a lexicographical remark: the word *program* has lost the humility it had in the past (*Littré* had only five lines to define it, divided into two acceptations, one of which was figurative). Initially "program" was used to designate a poster or brochure that informed people ahead of time of a play's contents or a ceremony's proceedings. It provided everything one needed to know before entering (and in order to enter) the premises. But once the threshold had been crossed, once the curtain had gone up, the program could be forgotten: it was the thing itself that mattered. The program effaced itself before the work. Understood in this way, the program remained exterior to what it announced or described, to what it promised. Today, it has lost this exteriority. It has become a double agent, both messenger and messiah, referring to both inside and outside. It has taken the place of what it announces. No longer content merely to read a program before entering, we now enter in the middle of a program. And if we read a program to find out what's on TV, we also turn on the TV to watch a pro-

gram. The program has overrun its borders, it has entered into the facts, into the thing itself; it has moved from promise to premise. [17]

Derrida connects this overflowing to a massive deliteralization of writing, a certain way that writing has of "getting out of hand."[18]: "Now we tend to say *writing* . . . to designate not only the physical gesture of literal pictographic or ideographic inscription, but also the totality of what makes it possible. . . . And thus we say *writing* for all that gives rise to an inscription in general." One speaks of writing in "cinematography, choreography, of course, but also [of] pictorial, musical, sculptural *writing*," as well as "military or political writing." Even in the field of biology, one speaks of "*writing* and program in relation to the most elementary processes of information within the living cell." Cybernetics is the last stage of this metastasis: "the entire field covered by the cybernetic program will be the field of writing." The program programs.[19]

This expanding programmatics removes the graph from the premises of what Derrida has called "the vulgar concept of writing."[20] It terminates the logocentric contract between word and writing that was traditionally guaranteed by the standard of the Book: the Book, the recording of the voice of its master, the product of the union between the voice of the author and the hand of the scribe, is the instrument of the voice's territorialization. The voice takes place in the book and the book gives it a place. Emancipated writing, in contrast, refers to a graphemics that is ever freer from the pattern/patronage/patronization of the Book.

Two local but symptomatic events illustrate the breaking of the logocentric contract. The first concerns its graphic side, the second its phonetic side—if we can still apply this distinction to these events, since in the long run they question the very economy of relations between the spoken word and writing (and their clear segregation) formatted according to the model of the Book.

15. After speaking about the acousmeter-radio, Michel Chion corrects himself: "Forgive me for this truism: radio is acousmatic by nature." Michel Chion, *La Voix au Cinéma* (1982) (Paris: Cahiers du Cinéma, 1993), p. 32.
16. Derrida, *Of Grammatology*.
17. Ibid.
18. This "getting out of hand" is the subject of Andre Leroi-Gourhan's *Le Geste et la parole*, 2 vols. (Paris: Albin Michel, 1964–65).
19. Derrida, *Of Grammatology*, p. 9. *Of Grammatology* appeared in 1967. Dictionaries date the appearance of the words "programmer," "programming," and "to program," to about 1960.
20. Regarding the opposition between the "vulgar concept of writing" and "arche-writing," see ibid., pp. 56–58. The "vulgar concept of writing" is that of a linear, phonocentric writing—that is, writing conceived on the model of "the vulgar concept of time" and of sounds in time "avec laquelle il fait système."

en livre de poche avec *le Degré zéro de l'écriture*, Paris, 1972.
d. du Seuil, « Tel Quel », 1973. – Traduction en allemand.

ONS, ARTICLES ★

Gide et son Journal », *Existences* (revue du Sanatorium France, Saint-Hilaire-du-Touvet).
nces.
yle de *l'Étranger* », *Existences*.
édie antique », *Théâtre populaire*, 2.
ce-Observateur, 24 juin 1954.
sur Brecht), *France-Observateur*, 8 juillet 1954.
sa critique », *Théâtre populaire*, 14.
quel théâtre ? », *Théâtre populaire*, 18.
es Coréens, de Michel Vinaver », *France-Observateur*, 5.
a signification au cinéma » et « Les unités traumatiques *ue internationale de filmologie*, X, 32-33-34.
ociologie de l'alimentation contemporaine », *Annales*, 5.
graphique », *Communications*, 1.
ouvrages de Cl. Lévi-Strauss : sociologie et socio-logique », *sciences sociales*, 1, 4.
a Tour Eiffel (images d'André Martin), Paris, Delpire, », 1964.
age », *Communications*, 4.
n Histoire des spectacles, Paris, Gallimard, « Encyclopédie 513-536.
» (sur le *Proust* de G. Painter), *la Quinzaine littéraire*,
nalyse structurale des récits », *Communications*, 8.
Antoine Gallien, Paris, Éd. du Seuil, « Écrire », 1967.
» (sur Severo Sarduy), *la Quinzaine littéraire*, 15 mai 1967.
man » (sur *Drame* de Ph. Sollers), in *Théorie d'ensemble*, l, 1968.
Communications, 11.
ar », *Mantéia*, v.
e un langage ? » (Sur J.-L. Schefer), *la Quinzaine littéraire*,
e culturelle » (sur les Hippies), *Communications*, 14.
. signifiant », préface à *Eden, Eden, Eden*, de Pierre Guyotat, 1970.
talien), Parme, Franco-Maria Ricci, 1970 (version française 1970.
sur Beethoven), *l'Arc*, 40.
Julia Kristeva), *la Quinzaine littéraire*, 1er mai 1970.
e » (sur *la Lettre et l'Image*, de Massin), *la Quinzaine litté-* o.

n peut trouver une bibliographie complète des articles, dans : Stephen Heath, *Vertige du déplacement, lecture de* e », 1974.

1971 « Le troisième sens, notes de recherche sur quelques photogrammes de S.M. Eisenstein », *Cahiers du Cinéma*, 222.
« L'ancienne Rhétorique, aide-mémoire », *Communications*, 16.
1971 « Style and its image », in *Literary Style : a symposium*, éd. S. Chatman, Londres et New York, Oxford University Press, 1971.
« Digressions », *Promesses*, 29.
1971 « De l'œuvre au texte », *Revue d'esthétique*, 3.
« Écrivains, intellectuels, professeurs », *Tel Quel*, 47.
« Réponses », *Tel Quel*, 47.
« Languages at war in a culture at peace », *Times literary Supplement*, 8 octobre 1971.
1972 « Le grain de la voix », *Musique en jeu*, 9.
1973 « Théorie du Texte » (article « Texte »), *Encyclopaedia Universalis*, tome xv.
« Les sorties du texte », in *Bataille*, Paris, Union générale d'éditions, « 10/18 », 1973.
« Diderot, Brecht, Eisenstein », in *Cinéma, Théorie, Lectures* (numéro spécial de la *Revue d'esthétique*), Paris, Klincksieck.
« Saussure, le signe, la démocratie », *le Discours social*, 3-4.
« Réquichot et son corps », in *l'Œuvre de Bernard Réquichot*, Bruxelles, Éd. de la Connaissance, 1973.
« Aujourd'hui, Michelet », *l'Arc*, 52.
« Par-dessus l'épaule » (sur *H* de Ph. Sollers), *Critique*, 318.
« Comment travaillent les écrivains » (interview), *le Monde*, 27 septembre 1973.
1974 « Premier texte » (pastiche du *Criton*), *l'Arc*, 56.
« Au séminaire », *l'Arc*, 56.
« Alors la Chine ? », *le Monde*, 24 mai 1974.

OUVRAGES ET NUMÉROS DE REVUES CONSACRÉS A ROLAND BARTHES

Mallac (Guy de) et Eberbach (Margaret), *Barthes*, Paris, Éditions universitaires, « Psychothèque », 1971.
Calvet (Louis-Jean), *Roland Barthes, un regard politique sur le signe*, Paris, Payot, 1973.
Heath (Stephen), *Vertige du déplacement, lecture de Barthes*, Paris, Fayard, « Digraphe », 1974.
Numéro spécial de la revue *Tel Quel*, 47, automne 1971.
Numéro spécial de la revue *l'Arc*, 56, 1974.

La graphie pour rien...

The first is precisely the entrance of words in painting. The book, having lost its monopoly on writing, is engulfed in a graphemics that overflows its boundaries: it is no longer the center. Simultaneously, however, on the phonetic side of this arrangement, a phonography that has also ceased to be a tributary to the myth of phonetic writing is taking shape. The sound track appears, and on it the voice (sound) is recorded by a mechanical device no longer reliant upon the human hand, no longer assignable to a living word: the end of the book and the beginning of writing ring, in Derrida's words, the death knell of speech (to use the title of the first chapter of *Of Grammatology*). This death of the word, however, must first be understood as the birth of a dead word, the birth of a word that has ceased to be live—a nonliving word. The word, no longer territorialized by a supposedly phonetic writing, is dis-located, cut off from its source, defused and diffused: the end of the book, it is also the appearance of a phonography outside of the book.[21] Words in painting and the radio in the studio—whether they are aware of one another or not—are two contemporary sides, two manifestations of the grammatological program in the visual arts.

The Invention of the Writable *[scriptible]*[22]

For the sake of innocent bibliophilia, I wish there were a meaningless set of type, whose characters would convey no message, like the whorls of shells, the patterns on butterfly wings, or effigies within stones, like all the abandoned literature enshrouded in the history of the planet and slowly accumulating in its archives.

Roger Callois, "The Ultimate Bibliophilia" (1970)

The proliferation of writing outside the book (and words in painting is but one example of this) has its counter-

21. Derrida speaks of "the extension of phonography and of all the means of conserving the spoken language, of making it function without the presence of the speaking subject." *Of Grammatology*, p. 10.
22. The word *scriptible* has customarily been translated in English as *writerly*. Its meaning, however, seems closer to *writable*, i.e., capable of being written, and we have translated it as such throughout this essay. (DH/AW)

part within the book itself, now opening its borders to all kinds foreign graphemes. The book has become ever more hospitable to traits that are hybrid and heterogeneous, vacillating indecisively between writing and drawing, like Ludwig Wittgenstein's little silhouette, both rabbit and duck. These graphemes are blurred, out of focus and coming out of nowhere; they erect obstacles in the path of readers who stumble haplessly upon them, losing the train of their reading. Jean-Francois Lyotard has called these graphemes "caviardages."[23] And even when they are made of letters that are identifiable, they float in an uncertain space, between writing and utterance, or even between two languages.[24] These graphs constitute a new type of difficulty for reading, a kind of blow below the belt; a difficulty of an order entirely different from, for example, hermeneutic resistance opposed by semantic obscurity. The difficulty is not that of a text that is, as one says, "difficult to read." It's that the text doesn't let the reader take up his position as reader. It's not simply that reading aloud is now longer allowed; it's reading to oneself that has become impossible. It's no longer merely a matter of words having taken a vow of silence upon entering the museum—they have become unpronounceable. By becoming visible, writing has lost its readability.

Derrida reminds us that Leibniz attributed the invention of Chinese writing to a deaf man.[25] As for Antonin Artaud, he invested in hieroglyphics and Eastern ideograms his dream of a theatricalization of the illegible. And the same search for an unpronounceable writing (unheard of, inaudible) can be seen in the rise of neo-Orientalism that, using Maoism as its background, took over the literary and theoretical avant-garde of the 1960s.[26]

In this context, *The Empire of Signs*, the book that came out of Barthes's journey to Japan, has something of an initiatory travel narrative about it. It presents itself as the chart of a delicate semantic seismology, the recording and analysis, on an almost mystical Richter scale, of the infinitesimal tremors that Japan so generously offered up to him, on the satori Zen model, giving him access to "this

emptiness of language which," as he writes in the first fragment, "constitutes writing."[27] This sequence must be taken literally: writing here no longer transcribes a full utterance (nor does it propose to fill an empty utterance's demand for plenitude); it responds to a void in utterance. Barthes's book offers a series of euphoric variations on this sentence—the author of the book has lost the power of speech. Writing, here, no longer functions as the mediator of an interiorization of the utterance (the generator of an interior voice), but rather, as the inscription of a silence.[28]

It was in Japan that Barthes had the blinding revelation of the "writable," during a scribbling lesson (a lesson in writing illegibly) that, all things being equal in other respects, has certain analogies with the writing lesson that Claude Lévi-Strauss relates in the middle of *Tristes tropiques*.[29] Indeed, for Barthes as for the Nambikwara Indians, the revelation sprang from a fascination with a writing that was inaccessible to them. But the parallel stops there. Barthes discovered, in Japanese, a language that had the thoughtfulness not to address him directly, not to speak to him—to leave him in peace. Free to write. Barthes experiences his epiphany of the writable at the same time that he discovers a writing not reserved for those who can read it; he discovers a calligraphic generosity that certain rare modes of writing demonstrate when—whether in Japan or in the work of French poet Stephane Mallarmé—they do not care if they are approachable by a reader or not. And with this he suddenly becomes aware of everything that writing loses in bending to the demands of the readable, in attempting to couple with the readable. Writing deserves more than freedom on parole. The empire of signs, for Barthes (unlike for Sartre), is certainly not prose.

Until this discovery, Barthes was not particularly interested in the visual arts. But his stay in Japan opened his eyes to the immensity of the field those arts would offer his new passion for the unreadable. Thus his ever-increasing references in the 1970s to the works of painters all occur under the sign of a graphemic perversion of the letter. Not a matter of words in painting here, Barthes defines his program in

23. Lyotard, *Discours, Figure*, p. 305.
24. Think of all those words in Derrida that belong to more than one language: *nous, est, legs, fort*, etc.
25. Derrida, *Of Grammatology*, p. 118.
26. Around this time, Philippe Sollers used Chinese ideograms throughout his novel *Nombres* (Paris: Éditions du Seuil, 1968), Julia Kristeva published *Des Chinoises* (Paris: Éditions des Femmes, 1974), and Ezra Pound's reflections on Chinese ideograms made him the most important American writer for the French avant-garde. (Derrida refers to Pound in *Of Grammatology*, p. 92.) In this context, one should also mention Maurice Roche's "pictographic" novels, including *Compact* (trans. Mark Polizetti [Elmwood Park, IL: Dalken Archives Press, 1988]), which were originally published as part of the *Tel Quel* book series.
27. Roland Barthes, *L'Empire des signes* (Paris: Flammarion, 1970), p. 10; published in English as *The Empire of Signs*, trans. Richard Howard (New York: Hill and Wang, 1982), p. 4. *L'Empire des signes* was published, like Butor's *Les Mots dans la peinture*, by Gaëtan Picon, in the collection he edited for Albert Skira, "Les Sentiers de la création." Another title in the same collection is Roger Caillois's *L'Écriture des pierres*.
28. On the difference between "internalized speech" and "stilled voices," see Jacques Derrida, "The Double Session," in Derrida, *Dissemination*, trans. Barbara Johnson (Chicago: University of Chicago Press, 1981), p. 184. Japan was, for Barthes, a kind of leisurely Trappist monastery, providing access to what he calls, in his preface to *La Vie de Rancé*, and quoting Chateaubriand in reference to old age, "the region of profound silence." Roland Barthes,

a preface to a catalogue of a 1973 exhibition of paintings by André Masson: "For writing to be manifest in its truth . . . it must be illegible."[30] That same year, in an article on the painter Bernard Réquichot, Barthes relates the following anecdote: A Mycenean jar is discovered by an archaeologist who deciphers, and then translates, its Greek inscription. A second archaeologist arrives and demonstrates that there is in fact no inscription, merely a graffiti-like scribbling. The text's elevation to the illegible here must have provided Barthes with food for thought: "Thus is born a special semiography (already practiced by Klee, Ernst, Michaux, and Picasso): illegible writing."[31] The anecdote figures in a paragraph called "Illegible," and Barthes gives that same title once again to the paragraph in his essay on Saul Steinberg in which he speaks of Steinberg's "simulated writings."[32] And no doubt he must have gazed upon Cy Twombly's paintings with the same sadness Moses felt when, after forty years of wandering in the desert, he contemplated, for an instant, a Promised Land. "The writer's misfortune, his difference (in relation to the painter, and especially to a painter of writing like TW), is that he is forbidden graffiti."[33]

But the mere mention of a taboo is often the best motivation for its transgression. *Roland Barthes par Roland Barthes* was published in 1975. On the final page of this self-portrait, Barthes includes the facsimile, in the guise of a signature, of two samples of his scribbling. They are accompanied by the following captions: "Doodling" followed by ". . . or the signifier without signified."[34]

The writable is, in effect—and in the most literal fashion—illegible (or rather the invention of the writable makes illegibility lose its negative connotation—it gives it a good name). But it's not that it's obscure, it's that it isn't articulated. It is illiterate, analphabetic writing.

The novelistic without the novel

Barthes introduced the concept of the writable in *S/Z*, which appeared the same year as *The Empire of Signs*. In spite of their apparently dissimilar subjects, these two contempo-

rary books are deeply connected. "Why Japan?" Barthes asks on the cover of *The Empire of Signs*. "Because it is the land of writing." A similar question could be asked regarding *S/Z*. Why the novel? Because it is the land of reading.

The novel is, in effect, of all literary genres, the one that depends most closely on the reading market, that is, on the implications—economic, ideological, etc.—of the regime of readability (and it is to this that Sartre was referring when he wrote that the empire of signs was prose). The novelistic sign must be a good conductor; it must know how to efface itself. The page of a novel must never act as a screen. Thus the novel is the genre least disposed to the attempts at "opacification" for which Barthes had invented the concept of the writable. Yet this is where the paradox begins: it just so happens that—and perhaps for this very same reason—the novel is their privileged terrain. "The writable," says Barthes in a famous definition, "is the novelistic without the novel."[35] The writable is the novel freed from the law of genre, freed from the bonds of narrative reason.

And what exactly is this narrative reason? Its precepts arise from that most classic opposition between painting and poetry around which Lessing had organized his *Laocoön*: signs that are next to each other must relate to things that are next to each other; signs that follow each other must relate to things that follow each other. The division is clear (on one side the visual arts—signs in space; on the other the epic and phonetic arts—sounds in time). And mutual interference is not advised (painting must be wary of narrative and the narrative arts must shy away from the descriptive). This system rests on one premise: the separation of the audio from the visual, of the melody from the plane.

The *nouveau roman* attacks this advice head on. Self-consciously miscast, this novel—against the grain of its medium—deliberately choose to align itself with the readability code of the pictorial medium, first by refusing narrative, and second by adopting description.

Painting has all the reasons in the world for abstaining from narrative: because painting has only one grammatical

"Chateaubriand: 'Vie de Rancé'" (1965), in *Le Degré zéro de l'écriture, suivi de Nouveaux essais critiques* (Paris: Éditions du Seuil, 1972), p. 107.

29. Claude Lévi-Strauss, "A Writing Lesson," in Lévi-Strauss *Tristes tropiques*, trans. John and Doreen Weightman (New York: Atheneum, 1974), pp. 294–304.

30. Roland Barthes, "Masson's Semiography," in Barthes's *The Responsibility of Forms*, trans. Richard Howard (New York: Hill and Wang, 1985), p. 155. Also of interest here are Barthes's essays on the typographer Robert Massin and on the designer and illustrator Erté (both collected in the same posthumous volume).

31. Roland Barthes, "Réquichot and His Body" (1973), in ibid., p. 220.

32. Roland Barthes, "All Except You," in Barthes *Oeuvres complètes*, ed. Eric Martin, vol. 3 (Paris: Éditions du Seuil, 1995), p. 400.

33. Roland Barthes, "Cy Twombly: Works on Paper" (1979), in *Responsibility of Forms*, p. 167.

34. Roland Barthes, *Roland Barthes*, trans. by Richard Howard (Berkeley: University of California Press, 1994), p. 187.

35. Roland Barthes, *S/Z*, trans. Richard Howard (New York: Hill and Wang, 1974), p. 5.

tense—the present—its possibilities of a sequence of tenses are almost nonexistent. How can one distinguish, in painting, the perfect tense from the pluperfect? Paradoxically, it is precisely this poverty—a major handicap for narrative ambition in painting—that the nouveau roman covets. Georges Perec wrote an entire novel without using the letter "e" (*La Disparition*); ten years earlier Alain Robbe-Grillet took a similar vow of poverty, reducing to a minimum his verbal tenses. Discussing Robbe-Grillet's prose, Gérard Genette has written: "One thing can be a present, another a memory, another still a lie, and another a fantasy, but all these planes are on the same level, that of the real *here and now*." The texture of Robbe-Grillet's novels, declared Genette, "in reality knows only one tense, the present."[36] To the *nouveau roman* we owe a flat, *monochrone* narrative. Its pages offer the reader the even light of a homogeneous present tense, a smooth ride (no bumps, no thrills), in allover. Everything is one level surface in a narrative without relief.

Still, it retains an essential difference from painting. For even if Titian treats the various episodes of the life of the prodigal son on a single plane, the spectator can always reestablish temporal perspective by referring to the Gospels. And this was, we recall, the central point of Greenberg's revision of Lessing's *Laocoön*. Robbe-Grillet's readers, on the other hand, have nothing of the sort at their disposal, no text to refer to. His are novels without a libretto: it is impossible to index the narratives' pseudo-time on the extratextual temporality of history. When one scene follows another in the narrative, are we to read these as two consecutive scenes? Are they even two different scenes? Or are they different versions of the same scene? Is there a real sequence or are the two scenes in fact contemporary? Succession or serialization? This is the great era of the and/or. The novelistic without the novel: a prolonged hesitation between syntagma and paradigm.

This systematic elimination of temporal points of reference is, for the reader, the most disorienting effect of the nouveau roman's antinarrative bias. Why do days necessarily follow one another? Let's recall Alain Robbe-Grillet's

skepticism regarding the following stage direction in Samuel Beckett's *Waiting for Godot*: "*The next day. Same time. Same place.*" Robbe-Grillet comments: "But is it really the next day? Or after? Or before? . . . In this universe where time does not pass, the words *before* and *after* have no meaning."[37] *The novelistic without the novel*, to take up Barthes's expression once again, is the novelistic freed from the vulgar notion of time—it is disoriented, directionless, *in the labyrinth*, evolving independently of any diegetic vectorialization. The story is suspended and has become reversible. Whether scenes follow one another or not, they float, freed from narrative syntax. They do not form a story. Since the *post hoc* is no longer trustworthy, how can one risk a *propter hoc*? And if one can say, as Lyotard does—in *Discours, figure*, a book that offers one of the most powerful critiques of narrative reason of that moment—that time represses, then the first effect, and the most visible, of an even partial lifting of this repression is a vast and brutal deficit of readability.[38]

"No one here wants to be involved in a story": this declaration that Maurice Blanchot attributes to one of the voices in *Awaiting Oblivion* could sum up the negative inspiration common to all those who were involved—in theory or in practice, as critics or as novelists—in the narrative experiments of the time.[39] How *not* to write a story? How to write a *non*-story? How to produce something *writable* that will not transform itself into script? How to produce the novelistic without falling back on story-telling?

In his technical writings, Sigmund Freud insisted on what he called the "rule of abstinence": an analyst must never give in to the demands that transference causes his patient to place on him.[40] The experiments in the novel during the 1960s evoke a transferential crisis of the same sort. And here we could speak of a psychoanalytical novel in so far as it seems that the novelist uses all his skill in order *not* to respond to the demands that are made on him, to the demands that he arouses; he uses all his skill to insure that the reader will make a demand that he in turn will not meet, a demand that he has decided to frustrate, to disap-

36. Gérard Genette, "Vertige fixé," in *Figures* (Paris: Éditions du Seuil, 1966), p. 78. The standard of narrative poverty, for Robbe-Grillet, is not painting, but cinema. This does not change the argument in any way. In the preface to his screenplay for the 1961 film *Last Year at Marienbad*, directed by Alain Resnais, Robbe-Grillet wrote "Whereas literature has a whole gamut of grammatical tenses which makes it possible to narrate events in relation to each other, one might say that on the screen verbs are always in the present tense." Robbe-Grillet, *Last Year at Marienbad*, trans. Richard Howard (New York: Grove Press, 1962), p. 12.
Regarding the "eternal present" to which the cinema is supposedly condemned, see the chapter entitled "The Aesthetic of the Movies and of the Novel: A Comparison," in Magny, *Age of the American Novel*, p. 26ff.
37. Alain Robbe-Grillet, "Samuel Beckett, or Presence on the Stage," in Robbe-Grillet, *For a New Novel*, trans. Richard Howard (Freeport: Books for Libraries Press, 1970), pp. 113, 119.
38. Lyotard, *Discours, figures*, pp. 151–55. This critique of narrative *disposition* is taken up by Lyotard once again in *The Postmodern Condition*, trans. Geoff Bennington and Brian Massumi (Minneapolis: University of Minnesota Press, 1984), p. 37 ff. Paul Ricoeur, in a critique of a critique, wrote, "Time becomes human insofar as it is articulated in a narrative manner," in *Temps et récit*, vol. 1 (Paris: Éditions du Seuil, 1983), p. 17. See also Jean-Toussaint Desanti, (*Réflexions sur le temps* (Paris: Éditions Grasset et Fasquelle, 1992), p. 63: "The word 'narrative' [récit] thus designates *the reciprocal engagement of the word [la parole] in time and time in the word.*"
39. Maurice Blanchot, *Awaiting Oblivion*, trans. John Gregg. (Lincoln: University of Nebraska Press,1997); *L'Attente l'oubli* (Paris: Gallimard, 1962), p. 22. This phrase, in which Blanchot quotes himself, is taken from one of his earlier *récits*, *When the Time Comes*, trans. Lydia Davis (Barrytown: Station Hill Press, 1985), p. 47; *Au moment voulu* (Paris: Gallimard, 1951), p. 108.
40. Sigmund Freud, "Further Recommendations in the Technique of Psychoanalysis: Observations on Transference-Love" (1919), in Philip Reiff, ed., *Therapy and Technique*, trans. Joan Riviere (New York: Collier, 1963), pp. 170ff.

41. Philippe Sollers, *Vision à New York* (Paris: Éditions Grasset et Fasquelle, 1981), p. 76. Sollers also speaks of refusing "vigorously to state what have you, but while *saying it [en le disant]*" in "Novel and the Experience of Limits," in Sollers, *Writing and the Experience of Limits*, trans. Philip Barnard (New York: Columbia University Press, 1983), p. 192. Derrida, in his critique of the "Seminar of 'The Purloined Letter,'" points out a technical error of this kind in Lacan's work: an analyst giving in to the demand for story. Lacan—the reader being the first victim of the plot—let himself get caught up in the story; the story, because it acts as a screen for the screen hid the scene from him, hid the framework and the premises of the narrative. Because he only retains from Poe's tale what "is justifiably called its history, what is recounted in the account, the internal and narrated face of the narration," Lacan misses "the scene of writing before the letter—in which the narrative is inscribed." Jacques Derrida, *The Post Card*, trans. Alan Bass (Chicago: University of Chicago Press, 1987), pp. 427, 483.
42. Sollers, "Novel," p. 107.
43. Sollers, *Drame* (Paris: Éditions du Seuil, 1965), p. 73; published in English as *Event*, trans. Bruce Benderson and Ursula Molinaro (New York: Red Dust, 1986), p. 35. In an essay on *Drame*, Barthes also emphasizes the unacceptable short-circuit of the writable (the text of *Drame*) and the readable (the reference to the novel): "It still seems provocative nowadays to use the term 'novel' to describe a book which has no (visible) anecdote and no (named) character." Roland Barthes, "Drama, Poem, Novel," in Barthes, *Writer Sollers*, trans. Philip Tody (Minneapolis: University of Minnesota Press, 1987), p. 41.
44. Sollers, "Novel," p. 205.
45. Deleuze emphasizes the importance of ekphrasis in Sacher-Masoch's novels: descriptions of paintings and sculptures, as well as the frequent use of model sittings, even literal "suspensions," of *tableaux vivants*, etc. Unlike de Sade, who, in a discussion of painting in his novel *Juliette*, wrote, "It is not easy for art, which is motionless, to depict an activity the essence of which is movement." Quoted in Gilles Deleuze, *Masochism*, trans. Jean McNeil (New York: Zone Books, 1989), p. 70.
46. Ibid.
47. Gilles Deleuze, "Klossowski or bodies-language," in *The Logic of Sense*, trans. Mark Lester (New York: Columbia University Press, 1990), pp. 280, 281. See also the way in which Althusser moves from history to the concept of history.
48. Alain Robbe-Grillet, "From Realism to Reality," in Robbe-Grillet *For a New Novel*, 161–62.

point. These formal experiments pursue the ideal of a narrative that would continue to maintain a demand that it refuses to satisfy—a novel that doesn't deliver. Philippe Sollers, in a book of interviews, phrases it best when he calls the demands of serious storytelling, of "'tell us a story,' etc." "ridiculous."[41]

This psychoanalytical efficiency, the desire—by cutting supply—to expose completely, in its chasm, the requirements of storytelling (tell me, tell me everything) that dictate the market of the novel is one of the reasons these authors insist on presenting as *novels* books that have no story to tell, books in which we can't manage to identify or isolate a single story, books that we can't summarize (what happens? what's the plot?), and from which a screenwriter would be unable to extract a script. For, as Sollers has said, it is precisely when "a book that does not seem to recognize any of the genre's rules dares to call itself a *novel*"[42] that the guardians of readability are seized with panic. It is the appropriation of the word "novel," printed arrogantly on the cover of a book that is reputed to be unreadable [writable], that is scandalous, like the mustache on the upper lip of Marcel Duchamp's Mona Lisa. The portrait of a trickster becomes a novel of a cheater: he cheats with the novel. Rather than playing the game, he exposes its rules, like Sollers did in *Event* [*Drame*]: "Suspended story in which nothing would ever seem to happen."[43] A nominal phrase, without a verb, mirror image of the novel it summarizes. "We have no infantile desire to be told stories," Sollers declares, "but we would, perhaps, like to open our eyes, even at the risk of blinding ourselves, on the sources of all stories."[44]

So what about the matricial site of this primitive scene—the mother of all stories—where nothing happens, but where everything begins?

Here we must return to the *nouveau roman's* second weapon in the critique of narrative reason: description, which, according to some, it uses abusively, even perversely. Lessing, we recall, already saw in the descriptive mode a perversion of the epic. Gilles Deleuze goes one step further. In his study on Austrian novelist Leopold Von Sacher-Masoch, he integrates description into the clinical tableau of perversion itself: description is to perversion what narration is to transgression. Whereas sadism is associated with a narrative precipitation that demands action and movement, descriptive suspense is at the heart of the masochistic erotic configuration.[45] In light of these definitions, Deleuze proposes to interpret structuralism itself as the symptom of a contemporary intellectual sensibility that he characterizes as profoundly masochistic: "In a certain respect, it is our epoch which has discovered perversion."[46] Desensitized to the narrative fury that carried off de Sade, we no longer need the accumulation of "abominable narrative" on top of "abominable narrative," but, at the most, a theory of the abominable narrative, its program, its concept: we are turning away, writes Deleuze, from narratives in favor of their grammar, their structure, "that is, the form that may be filled by these descriptions and accounts (since it makes them possible) but . . . does not need to be filled in order to be called perverse."[47]

Description, in this context, is totally freed from the documentary function that it had in the openings of realist novels. From this point on it unfolds independently of any referent, freed from the problematic of copy and resemblance. It describes what is *not* there but is "inside my head," as Robbe-Grillet wrote about the seagulls of his 1955 novel *Le Voyeur*.[48] (Describing what you have never seen.) Description no longer relates to reality, but acts to mask the paucity of the real. Its object is not the thing, but the nothing of the thing. Rather than describing what takes place, it produces, on the threshold of nothing, what we could call in French a *non-lieu*, a non-place: the *non-lieu* of the fetish, the place of what does not take place. Instead of copying a model, it liberates the power of the simulacrum.

Thus the function of description is twofold: to mark a place and insure that it remains empty; and to act in such a way that nothing happens without letting nothingness happen. Particularly efficient as a story-retardant, if not a story-repellent, the descriptive mode functions above all

PAGES 188–89 From *Roland Barthes par Roland Barthes*. Detail of the illustration "ou le signifiant sans signifié. . . ."

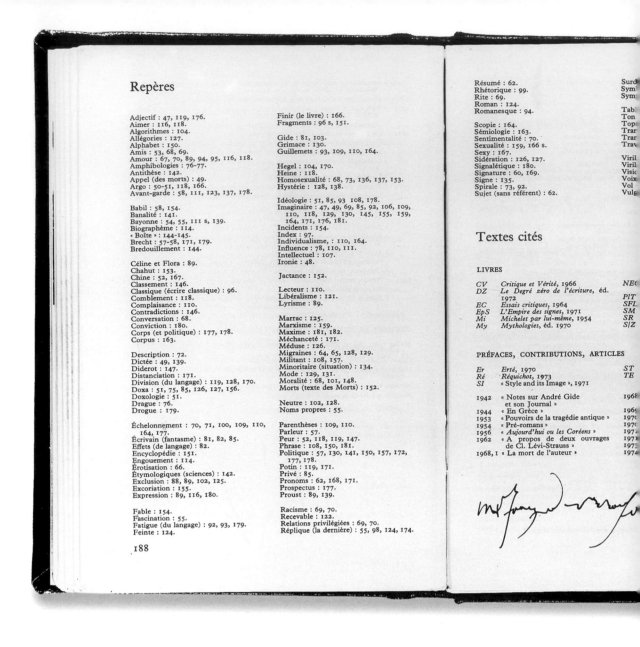

as place holder, the main thing being that, beneath the mask of description, the narrative stays on, on hold, cut off from its end, that it keeps running even in neutral: on the threshold of nonnarration, the zero degree of narration. Description (often qualified as "painstaking") is a pending, suspended, delayed narrative, for a narrative, too, can have the possibility of *not* arriving at its destination.[49] "In Masoch's novels," wrote Deleuze, "it is the moments of suspense that are the climactic moments."[50] The descriptive mode here is the perfect outlet for the erotics of the freeze-frame, of addressing someone without a verb (Tu m'), of the "fixed [or frozen] vertigo," of the *tableau vivant* that a number of contemporary novelists—from Klossowski to Robbe-Grillet—borrowed from Sacher-Masoch. Like a certain sexuality that one calls "perverse" because it is diverted from its "natural" end, the descriptive mode has as one of its chief virtues the diversion of narrative from its "natural" end.

Barthes relates Robbe-Grillet's descriptions to this same kind of narrative potentialization when he writes that they mark the "*locus* of a possible story."[51] (The novelistic without the novel would thus begin when, in place of a *story*, we find the *place* of a story.) They open out onto, halfway between a real story and a non-story, a possible story: they open out onto a story that does not take place. The affirmation of the possible is automatically associated with what one could call, reversing Barthes's formulation, the unreality effect.

Obviously there would be something absurd in trying to situate such a place too precisely. As a provisional, allegorical example, I would mention, in conjunction with that place, if not a place strictly speaking, at least the image of a place, the image of a scene without images. And I do so, perhaps tenuously but not arbitrarily, because Barthes himself mentions it, like an epigraph, at the beginning of his

49. The plot, wrote Barthes, "recedes, diminishes, dies away under the weight of objects." Roland Barthes, "Literal Literature," in Barthes, *Critical Essays*, trans. Richard Howard (Evanston: Northwestern University Press, 1972), p. 57. And Genette wrote, about Flaubert, of a "narrative crushed as it were by the sumptuous proliferation of its own setting . . . description is elaborated for its own sake, at the expense of the action, which it does not attempt to elucidate, it might be said, so much as to suspend or distance." Gérard Genette, "Flaubert's Silences," in *Figures of Literary Discourse*, trans. Alan Seridan (New York: Columbia University Press, 1982), p. 193.
50. Deleuze, *Masochism*, p. 33.
51. Barthes, "Literal Literature," p. 57.

Critical Essays, a collection in which the *nouveau roman*—and Robbe-Grillet in particular—occupies a major place. The lead article, devoted to Dutch painting, begins in fact with a brief reflection on the empty naves of the churches painted by Saenredam.[52]

We can also evoke, along the same lines, like a still life with characters, the empty volumes and spaces of *Last Year at Marienbad*, the film by Robbe-Grillet and Alain Resnais, with its empty hotel corridors, its gardens peopled with statues, the empty memories of the hotel guests: could it be more than the soundless place of a story that will never take place, never have taken place, never manage to go beyond mere possibility? The place of a ghostly story that will never be put to rest?

Theatricality without the theater
My head is as empty as a theater when the play has ended.
Søren Kierkegaard[53]

In his early writings, Barthes was mostly interested in theater. The emergence of the *nouveau roman* did not radically alter his focus; with Robbe-Grillet, he was first seduced by a certain type of empty theatricality, equivalent to what he described around that same time, in speaking of Charles Baudelaire's unrealized theatrical projects, as "theatricality protected from the theater."[54] The *nouveau roman* somehow opened up a space for a theater that wouldn't deliver.

The importance of the reference to theater for the literary avant-garde of the 1960s and 1970s may seem surprising when one recalls that it was accompanied by an almost total lack of interest in institutional sites and forms of theater. While the preceding generation—that of Samuel Beckett and Robert Pinget—continued to produce novels and plays alternately, *Tel Quel*'s generation wanted to put an end to the separation between book and stage that governed the alternating of genres. It wanted to build theatricality into the novel prior to any staging: a specific theatricality that would have nothing to do with the representation on stage of an already written text, but instead be linked to the writing of a text creating its own theatricality while avoiding representation.

Antonin Artaud is the essential reference here. But Artaud's exemplary position comes from the failure of his experiment (just as Baudelaire's unrealized projects allowed him to protect theatricality from theater). Indeed, not withstanding the fact that all theatrical practices are far from equal with regard to his program, it would be naïve to assume that, as Derrida points out, the execution of such a program could have simply depended on technical or cultural decisions (such as choice of the stage, lighting, staging, etc.) and just as naïve to imagine that Artaud could have carried it out had he been given the proper means.[55] It is not a simple question of place (of "premises," in the literal sense). And if the question of its "place" must be addressed, it must be done at a radical level. Indeed, the experience of the theater that haunted Artaud had nothing to do with seeking a stage where it could be produced; it wanted to "produce . . . its own space."[56]

In the 1960s, when the avant-garde novel borrowed the theatrical metaphors it needed to define its program from Artaud, it did so with the same demands in mind. Halfway between book and theater, between the surface of the page and the volume of the stage, these metaphors refer to what we could call a topology of fiction: flatness of the physical support, depth of the textual fabric. How does one move from the film of the printed surface to the volumetrics of the performance? Sollers's *Nombres*, "novel" published in 1968, presents itself as a protocol for generating that relief from a layer of signs. "This envelope is flatness and depth itself," wrote Sollers.[57] Through Sollers's simple device of rotating pronouns and verb tenses, something emerges that is akin to pure narrative theater for the duration of its reading, something atopic, alien to the surface of the page: "the idea that something happens in a three-dimensional space while, at the start and in the end, there are only two dimensions."[58]

At stake in fictions of this kind is the exploration of a theatricality generated by the writing of the text itself, instead of being added to the text at the moment of its stag-

52. "Saenredam painted neither faces nor objects, but chiefly vacant church interiors" (Barthes, "The World as Object" [1953], in *Critical Essays*, 3).
53. Quoted in Georges Bataille, *Haine de la Poésie* (Paris: Éditions de Minuit, 1947), p. 35.
54. Roland Barthes, "Baudelaire's Theater," (1954), in Barthes *Critical Essays*, p. 30.
55. Jacques Derrida, "The Theater of Cruelty and the Closure of Representation," in Derrida, *Writing and Difference*.
56. Ibid., p. 347. Derrida wrote that Artaud was seeking a theater that would put an end to the "classical forgetting of the stage," to the "erasure of the stage," a theater, in other words, whose energy would be used exclusively to invent and produce its staging. On the subject of the critique of theatricality (the opposition between production—use and spectacle—mention), see Gilles Deleuze and Félix Guattari, *L'anti-oedipe*, Paris, Éditions de Minuit, 1972. Jean-François Lyotard, *Économie libidinale*, Paris: Éditions de Minuit, 1974.
57. Philippe Sollers, *Nombres* (Paris: Éditions du Seuil, 1968), p. 23.
58. Ibid.

PAGES 170 – 71 From Hubert Damisch,
The Origin of Perspective, pp 170–71,
Detail of the illustration "The Città ideale"

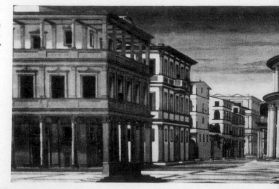

22 The *Città ideale*, known as the Urbino panel. Urbino, National Gallery of the Marches. Photo: Martino Oberto.

orders and crowned by a conical roof, occupying its center. A view of architecture that connotes "renaissance," and in which the gaze, despite the apparent simplicity of a construction organized around a unique vanishing point established on the central axis of the painting, does not really manage to anchor itself anywhere but rather proceeds, without one's being able to figure out why at first, by successive slippages and—as one would say of an equestrian mount—by ambling about: being continually sent back from the center to the periphery, its allure limited by the extremely wide angle of vision, which seems to have determined the panel's oblong format [239.5 × 67.4 cm] as well as the structure of what is presented as a scenic configuration in which the forward-most lateral structures, two buildings of cubic form, each with one facade parallel to the picture plane, challenge the importance of the central cylindrical volume, somewhat recessed and on a curved surface over which the eye tends to skid.

What is the value of such a "description"? Each of its terms invites discussion, as does the choice of characteristics held to be relevant, and the list of those that were excluded: the problem precisely will be to determine whether, and under what conditions, in accordance with what criteria of relevance and in what order of consequence, a painting such as this permits itself to be described, and demands to be.)

Suspended Representation 170

ing. For the concept of theatricality here refers to the theatrical exception (an offstage theatricality) of a text that cannot be contained by, or represented on, a given stage: it refers to an event that remains spatial even though there is no room for it, an event that, like Mallarmé's Hamlet, would be "alien to the place where it appears"[59]—a theater that, because of its nonobjective exteriority (an exteriority that never materializes into the solid, indisputable transcendence of an object), can only be named, following Artaud, under the threatening aegis of its double. This theatricality "protected" from the theater (theatricality *save* the theater, emptied from it), is that of a theater *without* the theater that, at the same time and paradoxically, would also be the ultimate version of the so-called play *within* a play, the play being brought within a play by being put out of the theater. Both in and out, within/without. It qualifies the restlessness of an unstable, dislocated space that incessantly oscillates, vascillates between the two sides of the stage, always shifting: fort/da, from within to without, onstage/offstage, from mental space to theatrical space. Derrida uses this particular theatricality to locate the spatiality of Mallarmé's (unfinished) book: "the theatrical world is a mental world"; but that is because "the mental world is already a stage."[60]

The strangeness of some dreams comes from the way the world, suddenly exhibitionist, shows off, as Jacques Lacan said. By a spectacular void, space provokes our gaze. The same oneiric theatricality dominates the *Ideal Cities* painted during the Italian Renaissance, with their deserted esplanades—as deserted as Saenredam's churches or as the corridors of Marienbad—that bring to mind, for Hubert Damisch, the sleeping (or dead) cities of de Chirico.[61] These are certainly all places of a possible story. They produce an impression of unreality that Damisch characterizes, as Barthes does, by means of a strange negative reference to narration. This impression, he asserts, "owes nothing to fable, or history, unless this be negatively."[62]

With the phrase "unless this be negatively," it's as if the scene had incurred a narrative debt that it refuses to acknowledge, let alone reimburse. These *Ideal Cities* are in

fact not "abstract" paintings—nonfigurative or nonrepresentative—that simply refused to abide by a narrative contract: they do not present themselves as places of a possible story. Yet this empty stage holds out the promise of a story, the equivalent of the dimming of the lights. But when it has barely begun, the presentation is suspended, on the threshold of representation. *Nihil privativum*, as Kant would say. The "without" (as in "the novelistic without the novel") can be seen. And there is something missing in its place. The cut is not clean. These empty esplanades set off a demand for a story, but refrain from fulfilling it. The choice of these paintings should be enough to indicate that resistance to iconography—at the heart of Damisch's argument—cannot be reduced to a suspension of the demand for stories; quite the contrary: it reinforces that demand in order to deny it more fully.[63]

The reshuffling of relations between image and text that was prompted by structuralism followed two axes, depending on whether it was as *readable* or as *writable* that language bypassed the image. In this context, Damisch's position is that of a graphemic radicalism visible, for ex-

59. Stéphane Mallarmé, "Crayonné au théâtre," in Mallarmé, *Oeuvres complètes* (Paris: Gallimard, 1942), p. 302.
60. Derrida, "The Double Session," in *Dissemination*, trans. Barbara Johnson (Chicago: University of Chicago Press, 1981), p. 235. By themselves, words have a remarkable "scenic capacity." "Words are not overtaken by the spatialization of representation," wrote Derrida in "Freud and the Scene of Writing" (*Writing and Difference*, p. 219). Derrida insists on the double demand of the Freudian topic: the affirmation of a spatiality of the psychical and the refusal of its anatomical localization.
61. Jacques Lacan, *The Four Fundamental Concepts of Psycho-Analysis*, trans. Alan Sheridan (London: Hogarth Press, 1977), quoted in Hubert Damisch, *The Origin of Perspective*, trans. John Goodman (Cambridge, Mass.: The MIT Press, 1994), p. 97. Damisch speaks of a theatricality reinforced "by the absence in this theater of any and all human presence," (p. 212) "with the emptiness of the setting paradoxically reinforcing the 'theatrical' effect" (p. 265).
62. Damisch, ibid., p. 171.
63. This painting "visibly intends to narrate something," wrote Roger Caillois regarding Piranesi's *Prisons* and de Chirico's paintings of empty esplanades. Roger Caillois, *Au coeur du fantastique* (1965), in *Coherences aventureuses* (Paris: Gallimard, 1976), p.190. The efficiency of these paintings is a result of the promise of a story joined with the fact that the promise is not kept: they are haunted by a story they never tell.

You knew it from your first inspection, which occurred some thirty years ago now: this painting (if such is the appropriate term) is clearly not a painting like others, like, also in this same museum, the *Flagellation* of Piero della Francesca and the *Pentecost* of Signorelli—to choose by design two works in strict perspective, at least one of which (the Signorelli) is not, properly speaking, at least originally, a "painting" at all because it was the banner of a confraternity intended to be carried in processions, subsequently transferred to canvas. In the circumstance the poetic effect (for that is what is in question) owes nothing to fable, or history, unless this be negatively and in a way yet to be defined. The image of this *ideal city* offers nothing to view that can be *narrated:* which provides sufficient justification, in the view of some, for its genre to be qualified as "abstract," for it to be assigned a value that is essentially "decorative." Unless one were to cast into narrative form, or at least that of a *program,* the ordered sequence of trials awaiting any analyst who lets down his guard the least bit, through which he must necessarily pass, for otherwise the title borne by the panel in the museum will be of no help to him.

For soon enough the spectator—or as we ought to say, *il riguardanto,* "the observer," a usage still employed by Poussin: this question is related to that of the "painting"—cannot help but discover that he is impli-

"Et antichn in prospettiva"

171

ample, in the way he distances himself from the *aggiornamentalists* of the readable such as Louis Marin or Jean-Louis Schefer, by turning the painting into the last line of defense of a pictoriality that refuses even the slightest compromise with the linguistic and the narrative.[64] The scenography that Damisch proposes—careful to separate the optical from the linguistic—attempts to undo the hold of what is said over what is seen, as opposed to iconography, which in front of a painting compulsively looks for the text—real or possible—that it illustrates. The visible, at least when it comes to painting, is not structured like a language. In a painting, the pictorial is what the linguistic approach cannot grasp, it is what resists readability: the pictorial is the unreadable (or even better, the writable) of the painting. *(Noli me legere.* Writing lesson number three—or yet another allegory of unreadability. The agency of the letter in painting can only be that of an unreadable letter. It appears that one must take this unreadability in the most literal way—at least this is what is implied in Damisch's treatment of the Urbino panel inscriptions. He unwittingly takes on the role of the second archaeologist (in Barthe's article on

the painter Réquichot). Art historians—more philologist than ever—had hoped to find Cyrillic writing in these inscriptions. Damisch moves in the opposite direction, maintaining that the writing is a "simulated writing" (as in Requichot, Steinberg, et al.),[65] that it does not deliver. One may recall the scene in Augustine's *Confessions* in which Augustine watches his master Ambroise's lips move without making a sound. But Ambroise was skimming a book, not gazing at a painting: and if the book can sustain an "internalized speech," the painting must generate a "stilled voice.")

The critique of narrative reason cannot here be separated from that of phonocentrism. Even if the subject of Damisch's book is not literary, but pictorial, the book is nevertheless a major contribution to the critique of narrative reason that was the theoretical platform of the structuralist and poststructuralist era. In the field of cultural practices, it places painting in the forefront of resistance to narrative. "The image of this *ideal city*," Damisch insists, "offers nothing to view that can be *narrated.*" No one, here, wants to be involved with a story. But in addition, the act of looking at a painting is first and foremost one that "doesn't necessitate our allowing ourselves to be spoken by it."[66] This rejection of the tale takes root in the assumption of a deep complicity between voice and narrative. Resistance to the narrative in painting is infallibly a resistance to the phonetic. Using the entire semantic range of the French verb *entendre,* which means both "to hear" and "to understand," Damisch thus writes that the analysis of a painting must aim "less at helping us to understand [*entendre*] than at helping us to see."[67] Contrary to what Claudel said, the eye does not listen. If there is a truth in painting (to use a title that Derrida owes to Damisch), it is a truth that would never say, like Lacan's prosopopoeia, "I, truth, am speaking." This thesis is not really new, of course. Lessing was already saying that painting did not lend itself to the diachrony of the syntagma (sound in time). But Damisch formulates it with all the activist energy of his anti-phonetism, which culminates in the last sentence of his book. Perspective, he concludes, "has

64. Damisch, *Origin of Perspective,* p. 261.
65. Ibid., p. 274.
66. Ibid., pp. 171, 263.
67. Ibid., p. 263.

its origin (or its departure) outside speech, outside the *phonic* element."[68] *Pictura poesia muta.*

It would of course be absurd to reduce grammatology simply to a mere substitution of grammacentrism for phonocentrism; grammatology implies, in a more significant way, a suspension of the classical opposition between the spoken word and the written word, the decentered spoken word being caught in its turn in the program of an archewriting. Yet it remains difficult, when one when looks back at the actions of the artistic and theoretical avant-garde of those years, not to be sensitive in retrospect to the way this deconstructive decentering led to a campaign of "phonophobia": voice and speech were the bad objects of the time.

This militant graphemics was meant, among other things, to deflect the offscreen sounds from the pictorial field, to prevent the visual from being assaulted by the phonetic. It shies away from that multimedia promiscuity that led a phenomenologist, Maurice Merleau-Ponty, to write: "the phonograph playing in the next room, and not expressly seen by me, still counts in my visual field."[69] Painting, however, remains the last stronghold against this stitching together of the audio and the visual. Painters may listen to the radio, but they remain painters: they may paint *in* sound, but their paintings remain soundproof, resistant to time as well as sound, resistant to sounds in time as well as to the sound of time, including the sound of history, the last defense against the experience of sounds in space.

Stanzas

So long as the action moves forward, the poetry is epic or dramatic; when the action stops and the poetry portrays nothing except the unique state of the soul, the pure feeling it is experiencing, the poetry in itself is lyric.　　　Abbé Batteux[70]

In *Awaiting Oblivion*, the last *récit* published by Blanchot, two voices converse: "Why are you so interested in this room?" "What is happening here? For the moment, we are speaking—Yes, we are speaking—But we did not come here to speak—All the same, we came speaking," etc.[71] What can we say about this dialogue? We could say that the splitting of the voices creates its own space. This dialogue, it seems, has no function other than to maintain, between the two voices, the stereophonic gap that constitutes its own premises, to maintain the space between them and to maintain itself in it. But can one describe a room? And from where does one describe it? From the inside? To what does "here" refer—to the book or to the room?

The development of the novelistic genre has been linked to the creation in the eighteenth century, in Western domestic space, of those private places—individual bedrooms.[72] But the room in *Awaiting Oblivion* (as in most of Blanchot's work, fictional or not) has nothing to do with a room of one's own. Nothing in it recalls the architectural setting in the shelter of which writing or reading could take place. Here, the relationship between space and language is strangely reversed: the conversation does not take place in the room; it allows the room to take place. The room becomes its own double, in the conversation that names it, in the dialogue in which it is housed. Echo chamber: the room echoes in the text that describes it, that accompanies its partition.

"Please allow me to skip this description of a room," wrote André Breton in a famous invective in the *Surrealist Manifesto*. It is in relation to Breton's condemnation that Blanchot examines, in his essay on Robbe-Grillet's *Voyeur*, the status of description in the *nouveau roman*.

André Breton at one time reproached novelists for their penchant for description, their desire to makes us interested in the yellow wallpaper in the bedroom, the black and white tile, the wardrobes, drapes, fastidious details. It is true that these descriptions are boring; all readers skip over them, happy nonetheless that they are there, precisely to be skipped over: we are in a hurry to go into the room, we want to go right to what is going to happen. But what if nothing happened? If the room remained empty? If everything that happens, all the events we come upon, all the beings of whom we catch a glimpse, only contributed to making the room visible, ever more visible, more susceptible to being, more exposed to that clarity of a total description, firmly

68. Ibid., p. 447.
69. Maurice Merleau-Ponty, *Phenomenology of Perception*, trans. Colin Smith (London: Routledge & Kegan Paul, 1962), p. 277.
70. Quoted in Gerard Genette, *The Architect: An Introduction*, trans. Jane E. Lewin (Berkeley: University of California Press, 1992), p. 32.
71. Blanchot, *Awaiting Oblivion*, p. 36.
72. Ibid., p. 40.

delimited and yet infinite? What would be more fascinating, more unusual, perhaps more cruel, and in any event closer to Surrealism?[73]

This is an odd passage. It begins in the indicative mode. Readers (which means us), Blanchot asserts, want to go forward, want to get to the story; they are impatient to go in, to get to the point, to the room and what is happening there. Even if they might come back to them later, they do not want to waste their time reading pages of description. But, at the precise moment when, their hand on the doorknob, they are about to move to the other side of the page, to what the narrative narrates, at that precise moment Blanchot's sentence changes mood and grammatical mode. The text suspends itself, freezes, on the room's threshold, in an interrogative mode, in a freeze-frame. Narration, it seems, has scattered, evaporated, like a river disappearing in sand. Did the readers pursue their gesture? Did they enter the room? Silence. Foot fixed on the doorstep. Is there still a reader? What should one make of the "empty room" hypothesis, since after all it was what triggered this stance? Can one enter an empty room? How does one know if it is empty without entering it? But how can a room remain empty after one enters it?

It is like entering a recess, as if, Blanchot writes, the room were receding into visibility, exposing its emptiness, turning it into pure visibility (as happens, according to Lacan, with the exhibitionist emptiness of the scene of the dream): visibly empty—empty and visible at the same time, and even more so one than the other, a void made even more spectacular by the absence of spectators.

Still life with and without character—within and without me. An empty room: a room without me, but within me.

I do not intend to tour Blanchot's numerous rooms here. I shall only mention one, in his novel *Death Sentence*: "Everything about that room, plunged in the most profound darkness, was familiar to me; I had penetrated it, I carried it in me."[74]

The Museum and Its Double

The bifurcation of the solitary space of reading and the solidary space of the museum was what, according to Picon, caused Malraux to give up the novel and turn instead to exploring the visual arts, which led to his writing *Le Musée imaginaire*. For Malraux, the book required the recess of a private, intimate, and intimist space, a space that tolerates absences and deep engrossment, whereas the visual arts belong to a space without reserve, a space of acts of total presence and objectivity. Absorption and theatricality: we are always alone when we read, we are never alone in front of a visual artwork or, to repeat Picon's maxim, "Paintings and statues are the point toward which our gazes converge, books the point from which our dreams diverge."[75] This interpretation, with its ideal of communal consumption—a cultural version of socialist sharing—allows traditional media to benefit from a positive prejudice. When in 1935 André Gide (at that time a recent convert to Communism and a close associate of Malraux) wrote, "If I had to be alone in order to contemplate a work of art, the more beautiful it was, the more sadness would prevail over joy," no sense of doubt weighs upon the kind of work to which this communitarian aesthetic impulse applies. The pleasures of reading are more solitary than those of contemplating the visual arts.[76]

It is not inconceivable that a minister of culture—managing a variety of actual museums (museums with walls)—would subscribe to such a point of view. But it is lacking what is newest in the idea of the imaginary museum that alone challenges the binary opposition of the imaginary and the real, of dream and perception. The segregation of the private and the public (of the bedroom and the museum) is without a doubt, whether Malraux intended it or not, its first victim, as is made even more evident by the American translation of Malraux's title: it is hard to say which side of the wall will most benefit from its disappearance. Will the museum, once its wall removed, gain in privacy or in publicness? How does one recognize the difference between being inside and being outside a museum without a wall?

73. Maurice Blanchot, "La clarte romanesque," in Blanchot *Le Livre à venir* (Paris: Gallimard, 1959), p. 196.
74. Maurice Blanchot, *Death Sentence*, trans. Lydia Davis (Barrytown: Station Hill, 1978), p. 67.
75. See Denis Hollier, *Epreuves d'artistes* (Paris: Galilée, 1996), pp. 41–42.
76. André Gide, *Les nouvelles nourritures*, in Gide, *Romans (récits et soties) et oeuvres lyriques*, ed. Yvonne Davet and Jean-Jacques Thierry (Paris: Gallimard, 1958), p. 269.

PAGES 272–73 From Hubert Damisch, *The Origin of Perspective*, pp 170–71, Detail of the illustration "The Città ideale"

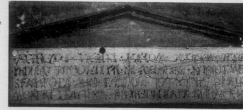

61 The *Città ideale*, inscription on the pediment of the palace to the left. Photo: Martino Oberto.

62 The *Città ideale*, inscription on the pediment of the palace on the right. Photo: Martino Oberto.

through an exercise in the genre of *ekphrasis;* or it uses the reproduction to suggest that paintings exist only to be described. In the one case as in the other, the hypothesis, with regard to paintings constructed "in perspective," that the latter has a privileged relation to description, perhaps constituting its most fundamental ground, is reinforced by the fact that the set of discrete elements included in the description are organized as a progression commencing on the ground, checkered or not, which is the foundation of the representation, thence proceeding from bottom to top and from foreground to background:[63] the synchronic configuration of which perspective

63. Cf., for example, G. Bernini's description of the *Città ideale* in the catalog published on the occasion of the cleaning of the painting, cited cat., p. 6.

Suspended Representation 272

Walter Benjamin, in "The Work of Art in the Age of Mechanical Reproduction," rebuts Picon's hypothesis. His essay begins with a reflection on the museum in the age of photography ("process reproduction can bring out those aspects of the original that are unattainable to the naked eye")[77] but rapidly leaves that subject and branches off toward film: the museum gives way to the cinema. Picasso, writes Benjamin, is a mistake, an anachronism, for which Chaplin fortunately compensates (and which he corrects).[78] The mutation brought about by photography and, more specifically, by its cinematographic developments, in what André Bazin called the ontology of the image (specifically the radical displacement of the classic alternative between perception and imagination), has made painting and the museum institution irreversibly obsolete.[79] Benjamin here is totally opposed to the popular front (Gide's, Picon's) utopia of collectivizing the pleasures of the eye. In his views, painting is, by its very essence, irrelevant to public space, and the very exposure of painting to the public eye goes against the grain of the medium. "The simultaneous contemplation of paintings by a large public, such as developed in the nineteenth century, is an early symptom of the crisis of painting.... Painting simply is in no position to present an object for simultaneous collective experience, as it was possible for architecture at all times, for the epic in the past, and for the movie today."[80]

Malraux's starting point was the same as Benjamin's. But rather than posing the question of the relation between museum and cinema, painting and film, in diachronic terms, Malraux does so in terms of synchrony, proposing the imaginary museum as a museum that is the exact contemporary of cinema, a museum conceived in terms of cin-

ema. All too often we forget that the space of the museum without walls was established based on a reflection on cinema and montage (much more than on painting itself).[81] Thus the question raised by Malraux's imaginary museum is precisely the one that Benjamin had closed: that of the possible coexistence of the canvas and the screen, of the space of the museum and the space of the cinema. While for Benjamin the cinema takes the place *of* the museum, for Malraux cinema takes its place *in* the museum. Granted this museum, having become imaginary, is no longer tied to the *hic et nunc* of real space, no longer submitted to the uncontested authority of the object. But these trespassings are reversible. They work in both directions. The museum without walls finds its double in the museum without either windows or doors, like Gottfried Wilhelm von Leibniz's monad (the absolute room—a room with no view). And here one must speak of the relatively recent but massive entrance of rooms, specifically dark rooms, obscure rooms, in the space of museums. Who has not recently had the feeling, when coming upon an installation, of entering

77. Walter Benjamin, "The Work of Art in the Age of Mechanical Reproduction," in *Illuminations*, trans. Harry Zorn (New York: Schocken Books, 1969), p. 220.
78. Ibid.
79. With his usual lucidity, André Bazin was one of the first to measure how central for Surrealist inspiration this mutation in the ontology of the image and the correlative importance of the media that embody it were. For Surrealism, he wrote, "the logical distinction between imaginary and real tends to be abolished." André Bazin, "Ontologie de l'image photographique" (1945), in Bazin, *Qu'est-ce que le cinéma?* (Paris: Éditions du Cerf, 1994), p. 16. In this sense, despite the minimal affinity that they had for one another, the imaginary museum was a project contemporary with Surrealism.
80. Benjamin, "Mechanical Reproduction," pp. 233–34.
81. Malraux referred to: "the art book playing the part of an accelerated film." André Malraux, "The Museum without Walls," in Malraux *The Voices of Silence*, trans. Stuart Gilbert (Princeton: Princeton University Press, 1973), p. 46. It should be noted that Malraux had cited Benjamin as early as his 1939 essay "Esquisse d'une psychologie du cinéma."

is an example functioning, simultaneously, as a model for the successive articulation of the components of the image in the three dimensions of projective space.

There remains a problem that you've already mentioned once or twice: that of the inscriptions on tablets within the two small pediments atop the foreground palaces in the Urbino panel (three lines in length on the right, and four lines on the left). These inscriptions, which include not only Latin letters but also characters that seem to be in Greek or Cyrillic, have long interested scholars. But the history of the attempts to decipher them is itself revealing of the interests prevailing in the history of art, and of the priority accorded questions of attribution and dating by it.

The first to describe these inscriptions, Passavant, was able to decipher only the four letter sequence M G–F G, which he thought might be the initials of a certain Maestro Giapo Cebdroli da Gubbio, of whom nothing is known save that he was a ceramist.[64] At the turn of the present century, when the idea of attributing this panel to Luciano Laurana was beginning to gain ground, scholars pointed to a passage in the *Descrizione del Palazzo Ducale in Urbino* by Bernardino Baldi, published in 1587, where it was stated that "Luciano Laurana had a perfect mastery of drawing and painted in a most accomplished way, as can be seen in certain small panels on which are delineated, in conformity with the rules of perspective, and colored some scenes which are without doubt from his hand, given that his name is inscribed on them, as are other things, in Slavic language and characters."[65] Budinich profited from a 1901 cleaning to make a close study of these inscriptions, particularly the one on the left, in which he thought he could make out two sets of characters, one indicating a date (147–), and another corresponding to the birthplace of Laurana, URANNA.[66] Dis-

64. Passavant, *Rafael . . .*, op. cit., vol. 1, p. 442; French trans. vol. 3, pp. 380–82.
65. "Che Luciano Laurana avesse buonissimo disegno e acconciamente dipingesse si vede in certe tavolette nelle quali son tirate con ragioni di prospettiva e colorite alcune scene, delle quali non si può dubitarsi che siano sue essendovi scritto il suo nome, e alcune altre cose cl' caratteri e linguaggio schiavone." Bernardo Baldi, "Descrizione del palazzo ducale in Urbino," as cited in *Vita e fatti di Federico di Montefeltro*, Bologna, 1826, pp. 264ff.
66. Kimball, "Luciano Laurana and the 'High Renaissance,'" op. cit., pp. 175–79.

a movie theater? More and more, the rooms of the museum have been transformed into projection rooms, dark rooms, grottoes without an outside, spaces for whispering video projections in which viewers or visitors, between beholders and passers by, watch time go by, in an engrossed and engrossing distraction, where it is difficult to say whether it is the convergence of gazes or the divergence of dreams that is being enacted.

Translated from the French by Alyson Waters.

A GENEALOGY OF TIME:
THE NIETZSCHEAN DIMENSION OF FRENCH CINEMA, 1958-1998

D. N. RODOWICK

Non pas passer les universaux à la râpe de l'histoire, mais faire passer l'histoire au fil d'une pensée qui refuse les universaux. Quelle histoire alors?

Michel Foucault, note written 7 January 1979[1]

If cinema does not die a violent death, it retains the power of a beginning.

Gilles Deleuze, Preface to the English edition of *Cinema 2: The Time-Image*, p. xiii

First story of 1968. In *Ce que je crois*, Maurice Clavel reports that "When I disembarked at the Gare de Lyon in Paris on the third of May, I bought the newspapers, and, reading the headlines reporting the first student riot, said calmly to my wife, 'Isn't it strange, that's it, here we are. . . .' 'Where?,' she asked me. 'In the middle of Foucault' For finally, didn't *The Order of Things* herald this great geological fracturing of our humanist culture that emerged in May 1968?"[2]

Second story of 1968. On the same day, a young critic writing for *Cahiers du cinéma*—having just seen Alain Resnais' *Je t'aime, je t'aime*—emerges from a theater in the Latin Quarter and is swept up in the force of history as students and police clash among barricades and burning cars on the Boulevard St. Germain. What rapport can there be between fiction and reality, he thinks afterwards? What is the historical significance of this film, perhaps Resnais' most disorienting meditation on time, apparently so distant from any political thought? What can cinema mean for this apocalyptic present marked by the collective belief that the passing of time is a carnivalesque Event—in fact, a break in time between past and future where the future is open to an infinite set of possibilities, anything is possible, and change is inevitable?

The filiations between these two stories are deeper than appear at first glance. Could Resnais' most abstract meditation on time and memory relate forcefully to the historical eruption of May and June 1968 in France? This idea is no less odd than the first reaction of Maurice Clavel: to isolate immediately French poststructuralism as one of the primary causes of the student and worker protests.

One way of approaching French filmmaking from 1958 to 1998 is through the problem of history. To do so, we must not only examine the relationship between film and audiovisual culture in general, but also ask with Foucault: Which history, then? What is history, or perhaps historical thought, through visual culture? The immediate impact of modern French media and art is to mark the emergence of a visual culture distinctly different from that of the prewar period, one of whose qualities is the redefinition of how time and thought are expressed through audiovisual culture. Indeed, to state my thesis directly, after 1958 there emerges in French audiovisual culture a new philosophy of history in images that is indelibly associated with Nietzsche's presence in poststructuralist thought. Here we find a strange reversal. While *Premises* is dedicated to an investigation of space in modern French visual culture, space is, in strikingly diverse ways, "invested" by time. In their new Nietzschean elaboration, space and time are refigured:

1. From the Chronology in Foucault's *Dits et écrits*, vol. I (Paris: Gallimard, 1994), p. 56; my translation.
2. *Dits et écrits*, vol. I, 32–33; my translation.

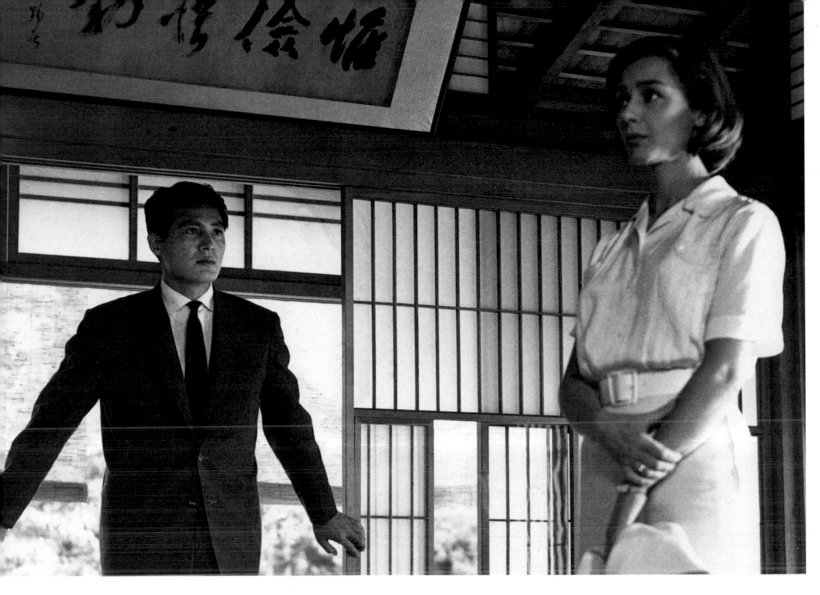

space becomes an event defined by the force of time as becoming and virtuality. Space no longer occupies a single time, but is instead crossed by multiple lines of descent (so many alternative paths and deviations in the line of time either barred, forgotten, or barely dreamed) and launches into the future as an undetermined set of possibilities.

II

Michel Foucault and Gilles Deleuze are the two figures most closely associated with the French turn to Nietzsche in the 1960s.[3] Foucault himself remarked only infrequently on the cinema, and indeed is often considered an historian of "discourse" rather than of visual culture. In his book on Foucault, Deleuze takes the opposite tack. For Deleuze, Foucault is a philosopher of the visible as well as the discursive. Indeed, Deleuze suggests, Foucault's description of epistemic shifts is marked by the emplacement of audiovisual regimes: changing articulations of the visible with respect to the expressible—modes of seeing and ways of saying—that organize knowledge, power,

and subjectivity in distinct historical eras.[4]

This philosophic consideration of history as the emplacement and displacement of audiovisual regimes also informs Deleuze's two-volume theory of film, *Cinema 1. The Movement-Image* and *Cinema 2: The Time-image*.[5] One consequence of these books is to present a case for the primacy of cinema in the emergence and organization of twentieth-century visual culture. Deleuze argues that the history of cinema as an audiovisual form is marked by a tectonic shift. The displacement of the movement-image by the time-image involves both a turn in the order of signs, requiring two different semiotics, and in the image of thought characterizing the philosophical orientation of the two regimes. The movement-image is characterized by a Hegelian logic, that is, a dialectical organization of images and signs in an organic representation marked qualitatively by a will to truth. Alternatively, the time-image presumes a Nietzschean aesthetic whose images and signs are organized by "fabulation," a falsifying narration defined not by representation but by simulacra whose qualities are "powers of the

3. The publication of Deleuze's *Nietzsche et la philosophie* in 1961 was the opening volley in this Nietzschean decade. Foucault participated in the 1964 colloquium on Nietzsche organized by Deleuze at Royaumount; together Deleuze and Foucault proposed the publication of a new edition of Nietzsche's collected writings, which appeared in 1967 with an introduction coauthored by the two philosophers. For a critical history of the influence of Nietzsche on modern French thought, see Alan D. Schrift's *Nietzsche's French Legacy: A Genealogy of Poststructuralism* (New York: Routledge, 1995).

4. See Deleuze's *Foucault*, trans. Seán Hand (Minneapolis: University of Minnesota Press, 1988). Originally published as *Foucault* (Paris: Éditions de Minuit, 1986). See also my essay "Reading the Figural" in *Camera Obscura* 24 (1991), pp. 11–44.

5. *Cinema 1: The Movement-Image*, trans. Hugh Tomlinson and Barbara Habberjam (Minneapolis: University of Minnesota P, 1986); cited hereafter as MI. Originally published as *Cinéma 1: l'image-mouvement* (Paris: Éditions de Minuit, 1983). *Cinema 2: The Time-Image*, trans. Hugh Tomlinson and Robert Galeta (Minneapolis: University of Minnesota P, 1989); cited hereafter as TI. Originally published as *Cinéma 2: l'image-temps* (Paris: Éditions de Minuit, 1985).

ABOVE Alain Resnais, *Hiroshima mon amour*, 1959, film still

false": the *indiscernability* of the real and the imaginary in the image; a temporal (dis)ordering of narration presenting differences in the present that are *inexplicable*, and alternative versions of the past whose truth or falseness are *undecidable*; and as a result, a transformation in the problem of judgment, of deciding the necessity or contingency of possible or probable interpretations where *incompossible* worlds proliferate as incongruous presents and not-necessarily-true pasts. These are two different images of thought where the Hegelian will to truth, which identifies the orderly unfolding of history with reason, is challenged by a Nietzschean critique of values, which asks not "What is true?" but rather "Who wants the truth, and what do they will in wanting it?"[6]

The movement-image and the time-image thus present two broad regimes of images and signs. Indeed the emergence of the latter from the former traces a slow but definite shift in the nature of visual culture wherein the aesthetic innovations of the French New Wave and contemporary cinema in France resonate with other experiments in French audiovisual culture and the arts. Deleuze's second volume is especially useful for defining the exemplarity of French film and audiovisual culture since 1958. However, I also want to make a larger argument concerning the nature of Deleuze's philosophical analysis. The transition described from *The Movement-Image* to *The Time-Image* also effects a more general displacement in the philosophy of history, indeed a shifting relation between history and thought marked by confrontations in the postwar *episteme* between existentialism—with its Hegelian conception of history and politics—and the poststructuralism of Deleuze and Foucault, with their Nietzschean and genealogical concepts of history and thought. This new historical sense informs equally the reconsideration of time and change in contemporary French visual culture.

It may seem odd to ask the question of history of Deleuze since he insisted that his two books do not offer a "history of cinema."[7] Certainly they are the product of philosophical activity and not historical research in any sense of the term. Deleuze has every right to emphasize that what the two books offer is a taxonomy of signs and their logics as well as an elaboration of concepts, and are thus primarily works of philosophy.

At the same time, however, the two books present many features of an historical work. They are organized across a broad temporal division: an historical break divides the time-image, which appears largely in the period following the World War II, from the movement-image that precedes it. Indeed Deleuze even presents an historical context for this break. Prewar societies were sustained by organic ideologies (democracy or socialism) that functioned as universals defined by a notion of history as progress. The movement-image is marked by the coherence of sensorimotor situations: perceptions derive from coherent and meaningful images of the world and extend into actions capable of transforming the world; events are linked in meaningful ways organized by origins and ends; opposition and conflict are resolvable through actions and are amenable to coherent solutions; individuals act as the agents of history; and finally, the individual stands, *pars pro toto*, for the collective and thus expresses the will of a people.[8] In the movement-image, then, the protagonists' actions drive a chronological narrative marked by the dialectical unfolding of effects from causes, reactions from actions, according to a logic of "rational intervals"—the beginning of an image or sequence unfolds in continuity from the ones that precede it. An image of organic unity forms as images are linked or extended according to principles of association and contiguity, and associated images are integrated into a conceptual whole and differentiated into more extensive sets. This is a chronological or empirical conception where time can only be presented indirectly as continuous segmentations of space whose parts are commensurate with the whole of the film. Deleuze calls this process "an open totality in movement" that gives rise to a model of the true as totalization, an ideal world perfectly commensurate and analogous both with its referent and the subject who comprehends it. This notion of chronologi-

6. For a more complete account of these questions, see my *Gilles Deleuze's Time-Machine* (Durham: Duke University Press, 1997), especially Chapter 5, "Critique, or Truth in Crisis."

7. The prefaces to both the English and French editions of *Cinema 1* begin with the statement, "This is not a history of the cinema." For a discussion of what it means to read Deleuze's two volume film theory as historical, see András Bálint Kovács' essay "The Film History of Thought" in Gregory Flaxmann, ed., *Thinking Images: Gilles Deleuze and the Philosophy of Cinema* (Minneapolis: Universtiy of Minnesota Press, forthcoming). Indeed I owe my inspiration for discussing the two regimes as Hegelian and Nietzschean philosophies of history in images to my discussions with Kovács, who makes the case, quite convincingly, that Deleuze's taxonomy of cinematic signs cannot be defined independently of a conception of film history, or, more deeply, historical thought.

8. It is interesting to compare Deleuze's account of organic narration with Jean Hyppolite's characterization of Hegel's philosophy of history, whose object is a dialectical and supraindividual reality—the life and destiny of a people. See his *Introduction à la philosophie de l'histoire de Hegel* [1948] (Paris: Editions du Seuil, 1983).

cal time conforms precisely with a linear and teleological conception of history.

The time-image emerges from Italian Neorealism and comes to fruition in the French New Wave. The narrative innovations of Neorealism, the New Wave, or New German Cinema all derive from the experience of physical, social, and psychological reconstruction of societies devastated during the World War II. This experience defines a set of characteristics that make possible the emergence of direct images of time. As images of emptied and wasted spaces surged in everyday life, postwar cinema discovered "a dispersive and lacunary reality" that motivated ambiguous and undeciphered images (MI 212). Especially in the French New Wave, as narration is freed from sensory-motor situations and any teleological orientation, lines of action becomes lines of flight whose points of departure and arrival are arbitrary or undetermined: journeys to and from Paris and the provinces (Claude Chabrol's *Le Beau serge* [*Bitter Reunion*, 1958] or *Les cousins* [*The Cousins*, 1959]); errant trajectories in the city whose value is more ethical or analytical than spatial (Eric Rohmer's *Six Moral Tales* [1962–72] or François Truffaut's *Antoine Doinel* trilogy); investigations whose object is obscure and whose ends are inconclusive (Jacques Rivette's *Paris nous appartient* [*Paris Belongs to Us*, 1960]). But perhaps the purest example of what Deleuze calls the *forme-balade* is found in films like Truffaut's *Tirez-sur le pianiste* (*Shoot the Piano Player*, 1960) or Jean-Luc Godard's *À bout de souffle* (*Breathless*, 1959) or *Pierrot le fou* (1965). Here, classical narration yields to unpredictable lines of flight: an accumulation of disparate urban landscapes and disjunct geographies connected only by the dual sense of the French word *évasion*, both flight from the law and play or leisure.

The protagonists of New Wave films thus define a nomadism where the characters of the time-image wander errantly and observe in emptied and disconnected spaces; linear actions dissolve into aleatory strolls that organize elliptical narratives guided predominantly by chance.[9] (There is a similar process at work in the reconfiguration of urban space in Situationist *dérives* and psychogeographies, as well as the errant and floating perspectives presented by many works in *Premises*.) In so doing they represent a kind of postmodern historical subjectivity—the faltering belief in totality, either from the point of view of the great organic ideologies or from a belief in the image as anything other than a partial and contingent description of reality. Since the linking of images is no longer motivated by actions, space changes in nature, becoming a series of disconnected "any-spaces-whatever" organized by a logic of "irrational intervals"—"interstices" which no longer form a part of any sequence either as the end of one or the beginning of another. Because it is autonomous and irreducible, the irrational interval gives rise to a transcendental or direct image of time as aberrant or false movement. It is not spatial nor does it form part of an image. Rather, as a direct image of time, the interstice presents a force that unhinges images and sounds into disconnected series and episodic sequences which can no longer form an organic image of the whole.

Consider, for example, Marguerite Duras' *India Song* (1975). The opening shot of the film frames a red sun setting into clouds over a verdant delta. This is a direct image of time in its simplest manifestation: an autonomous shot describing a single event as a simple duration. The ensuing shot of a piano in a darkened room is nowhere motivated by this image. Nor will there be any clear spatial or temporal links in the cascade of images that follow. The cut defines an unbridgeable interval; each shot becomes an autonomous segment of time. Similarly, instead of linking one to another, images divide into series—the embassy interior with its piano and its mirror that unsettles the difference between on- and offscreen space, the ruined exterior of the villa, the tennis court, the park, the river. The same may be said of the soundtrack. At the beginning we hear the beggar's cries, then the two "intemporal voices" whose mutual interrogation initiates *India Song*'s uncertain narration. The sounds themselves divide into distinct series—the beggar, "les intemporelles," the piano theme, the voices and music of the reception, the cries of the vice-

9. In a comment that echoes Deleuze, in an interview with *Cahiers du cinéma*, the French political philosopher Alain Badiou recently characterized the New Wave in a similar way: "Some films which, ideologically, seem only to figure a romantic nihilism without any political consequence (for example, *À bout de souffle*), have a real effect . . . which aims toward other things: errance and delocalization, the fact of asking fresh questions, outside of the mediation of an instituitional representation, across a character who is anything but 'settled.' In this sense, these films contributed to the delocalizations of May '68." See "Penser le surgissement de l'événement: entretien avec Alain Badiou," *Cahiers du cinéma* (numéro hors série 68, 1998), p. 14.

consul—and it is never certain whether they occupy the same time or not. Between and within the relations of image and sound, the interval divides and regroups but never in a decidable or commensurable way. This geometry of the time-image is not totalizable as an image of truth. Acts of seeing and hearing replace the linking of images by motivated actions and the exertion of will; pure description replaces referential anchoring. In this manner, new kinds of images and signs appear where "Making-false [*faire-faux*] becomes the sign of a new realism, in opposition to the making true of the old" (MI 213). The movement-image presents time indirectly as the unfolding of a causally motivated space, a truthful image that subsumes the reality it represents as a return of the same. But with the direct image of time—elliptical events marked only by chance connections; undeciphered and ambiguous images producing events in their unique duration—there also appear new values. As I will argue later, this is a Nietzschean conception of time and history marked by the logic of eternal recurrence.

Finally, Deleuze argues in the Preface to *The Movement-Image* that the cinema has a place in both the history of art and the history of philosophy. In each case this relates to conceptual innovation in cinematic practice, which Deleuze examines through his taxonomy of images and signs. While these classifications are largely philosophical—based on Henri Bergson's *Matter and Memory* and, especially in the first volume, the semiotic of Charles Sanders Peirce—the fundamental division of the time-image from the movement-image is art historical. Mapping a century-long transformation in our cultural modes of envisioning and representing, Deleuze adopts Wilhelm Worringer's distinction between organic and crystalline regimes to characterize the qualitative differences between the movement- and time-image.[10] However, when Deleuze refers to the organic movement-image as "classic" and the crystalline time-image as "modern," this means neither that the latter flows from the former as natural progression or teleology, nor that the modern form necessarily opposes the classic as

negation or critique. Instead, this transition represents a distinct, if gradual, transformation in the nature of belief and the possibilities of thought. If the modern cinema offers a *direct* presentation of time, the emergence of this time-image is not a necessary consequence of the evolution of the movement-image. For Deleuze, the history of cinema is in no way a progression toward an ever more perfect representation of time. Rather, the relation between time and thought is imagined differently in the postwar period, as represented in the signs produced by the time-image and by changes in the image of thought occurring in postwar science, art, and philosophy. And here history returns to philosophy since what is at stake is a shift in our image of thought, that is, "the image of what thought gives itself of what it means to think, to make use of thought, to find one's bearings in thought."[11]

One could map postwar filmmaking in France as the emergence of the crystalline regime of the time-image as a new perspective on the history of film style. But I want to argue instead that Deleuze presents us with two "histories" or, more precisely, two distinct and incommensurable logics for thinking historically *through* images and signs. If Deleuze demurs from characterizing the content of his books as "history," they nonetheless present a shift in the way history is thought, and indeed may suggest that we reconsider the very idea of history as a philosophical concept and as a force expressed through audiovisual culture. In French film since 1958, there appears a new orientation of the visible with respect to the expressible—of image and sound as well as movement and time—that defines a new conceptual relation with questions of history, memory, and

10. Worringer contrasts the organic and the crystalline as compositional strategies on the following basis. Each is an a priori will to form that expresses a culture's relation to the world. Organic forms express a harmonious unity where humanity feels at one with the world. Here representations are based on natural forms and are sustained by the belief that natural laws support and lend them truth. Alternatively, the crystalline represents a will to abstraction. When a culture feels that it is in conflict with the world, that events are chaotic and hostile, it tends to produce pure geometric forms as an attempt to pattern and transcend this chaos. See, for example, Worringer's important studies *Abstraction and Empathy*, trans. Michael Bullock (New York: International Universities Press, 1953) and *Form in Gothic*, ed. Herbert Read (New York: Schocken Books, 1964). Deleuze's sense of visual history is equally indebted to Heinrich Wölfflin's *Principles of Art History*, trans. M. D. Hottinger (New York: Dover Publications, 1932).

11. Gilles Deleuze and Félix Guattari, *What Is Philosophy?*, trans. Hugh Tomlinson and Graham Burchell (New York: Columbia University Press, 1994), p. 37.

LEFT Marguerite Duras, *India Song*, 1975, film still

12. "Sur les façons d'écrire l'histoire," interview with Raymond Bellour in *Les Lettres françaises* 1187 (15–21 June 1967), pp. 6–9. Cited in my translation from *Dit et écrits*, p. 585

13. The preeminence of Hegel in the immediate postwar period is amply represented in Maurice Merleau-Ponty's comment in *Sense and Non-Sense* that "All the great philosophical ideas of the past century had their beginnings in Hegel. the philosophies of Marx and Nietzsche, phenomenology, German existentialism, and psychoanalysis; it was he who started the attempt to explore the irrational and integrate it into an expanded reason which remains the task of our century." Cited in Mark Poster's *Existential Marxism in Postwar France: From Sartre to Althusser* (Princeton: Princeton Universsity Press, 1975), p. 6. Poster's book is an invaluable account of the influence of Hegel in France through the teachings of Alexandre Kojève and Jean Hyppolite and the subsequent rereadings and responses in French political and social theory of the 1960s and '70s. While my perspective here is to contrast the Hegelian approach to history with a Nietzschean genealogy, one can equally trace this history, as does Poster, as different appropriations of Hegel. Indeed it is important to mark the very different appearances of Hegel in three contexts: first in the work of Sartre, Merleau-Ponty, and the early Lacan; second, in the rereading of Hegel by Hyppolite and Althusser, perhaps the greatest mentor figures of the poststructuralist generation; and finally looking at the very different critiques of Hegelian dialectics found in Derrida and Deleuze.

politics while marking the emergence of a new form of subjectivity, one of whose consequences may have been to ignite the historical desire expressed in May '68.

The exemplarity of the time-image in contemporary French cinema, and the series of French films presented in this exhibition, thus become the occasion to examine three "premises": that reading Deleuze and Foucault together is a way of comprehending what a cinematic history of concepts means in contrast to a dialectical conception of history; that the movement-image and time-image are historical in the sense of presenting two distinct audiovisual regimes, which may be distinguished by, among other criteria, the passage from a Hegelian philosophy of history to a Nietzschean or genealogical historical thought; that French cinema since 1958 may be characterized by the concept of genealogy elaborated by Foucault in his reading of Nietzsche.

III

When Deleuze remarks that his film books are not history it is necessary to ask: What does "history" mean in this context? To understand the Nietzschean dimension of French cinema as a genealogy of time, we must examine how and under what conditions a philosophical discourse on Nietzsche emerged and circulated in French intellectual culture, and how it transformed notions of the historical subject.

In a 1967 interview with Raymond Bellour, Foucault remarked that the discipline of history was the object of a curious "sacralization" by the French left in the 1950s and '60s. Many intellectuals observed a respectful distance to history as a way of reconciling their research and writing

with their political consciences. Under the cross of history, this attitude became "a prayer to the gods of just causes."[12] To question the identity of history with reason, or to exhume the Hegelian foundations of historical knowing through a genealogical critique, was unthinkable since it would expose the historical contingency of the political rationality associated with the particular Marxism of the French Communist Party. Throughout the 1960s, history's largely Hegelian project seemed more and more *démodé*, the product of a past century, as linguistics, sociology, and ethnology abandoned dialectical concepts for the synchronic analysis of "structures."

In this interview, Foucault implicitly addresses a number of conflicts that arose as existentialism, structuralism, and poststructuralism vied for intellectual dominance in postwar France. This intellectual history underscores a number of concepts that circulated in art practice and theory, as well as film and film theory, with respect to the nature of representation, signification, and the place of the subject.

A Hegelianized Marxism was the dominant discourse for students of philosophy in Foucault and Deleuze's generation. The prevailing philosophers of the existentialist period—Jean-Paul Sartre and Maurice Merleau-Ponty—derived their philosophical positions from the phenomenology of Husserl and Heidegger as well as Marx's writings on political economy. This Marxism, however, was strongly directed by Alexandre Kojève's lectures on Hegel published in 1947.[13] Structuralism emerged as a critique of phenomenology and existentialism. For example, Claude Lévi-Strauss, Jacques Lacan, and Louis Althusser all drew upon the methodology of a Saussurean linguistics for their critical investigations of the human sciences: anthropology, psychoanalysis, and political economy. Where the existentialists privileged the concept of human action in history, structuralism emphasized the synchronic analysis of "structures"—myth, the logic of the signifier, history as "absent cause"—independent of human agency. By the same token, where existentialism privileged the philosophical analysis

of consciousness as the central fact of human existence, structuralism was characterized by its "anti-humanism," its decentering of the subject as a function of social structures.

The rereadings of Freud and Marx by Lacan and Althusser, as well as Heidegger's magisterial if particular recovery of Nietzsche, set the stage for poststructuralism to emerge as a distinctly philosophical response to the structuralist privileging of the human sciences. Moreover, in the institutional framework of, as Deleuze put it, a "generation ruined by the history of philosophy," Nietzsche's status as a marginal philosopher in France opened a line of flight for a philosophy fatigued by the rationalist tradition. In this manner, a new conceptualization of history and the subject appeared in the Nietzscheanism of Deleuze, Foucault, Jacques Derrida, Pierre Klossowski, Helène Cixous, and Sarah Kofman. The renewed interest in Nietzsche had multiple dimensions, and was less a "return" in the sense of Lacan's return to Freud or Althusser's rereading of Marx, than the opening of a new territory of concepts: a critique of the will to truth, an interpretation of the complex connections between knowledge and power, and a new attention to questions of style and rhetoric in philosophical discourse. Alan D. Schrift notes that one consequence of the turn to Nietzsche, in Foucault for example, was to reexamine how questions of agency could be addressed without returning to phenomenology's emphasis on the centrality of human consciousness.[14] Thus the turn to Nietzsche reinvented the relation between history and agency: by rearticulating the relation between language, power, and desire; by transforming the problem of meaning so as to undermine any claim to universality; in opposing binary thinking with a network of differential meaning; and by conceiving the subject not as a centered and unified perspective on the world, but as a complex intersection of discursive, libidinal, and social forces.

IV

Contrary to the usual way of representing poststructuralism, the turn to Nietzsche was a way of reasserting the force of history occluded by structuralism, and in so doing, reassessing what history means in relation to force, memory, or time. Deleuze is right to insist that his theory does not present a history of cinema. But the logic of the time-image itself can be revaluated in the Nietzschean sense as the emergence of an historical *dispositif* which presupposes not only a rearticulation of time in relation to space, but also the expression of a new "historical sense" and the anticipation of a new historical subject. I want to continue, then, with some indications of how Deleuze's Nietzschean aesthetic of the time-image resonates with Foucault's discussion of genealogy.

The 1960s and '70s in France were an extraordinary period of cinematic experimentation and cross-fertilization with literature, art, critical theory, and philosophy as represented most clearly in the films of Duras, Godard, Resnais, and Alain Robbe-Grillet. Moreover, after the phenomenal success of *The Order of Things* in 1966—and the subsequent influence of publications like *Nietzsche, Genealogy, History*—Foucault's radical reconceptualization of the historical project became increasingly influential in both film theory and practice. In the 1970s, for example, *Cahiers du cinéma* began to reassess the problem of history by publishing Jean-Louis Comolli's series of essays on technology and ideology, the collective analyses of *Young Mr. Lincoln, Hangmen Also Die*, and *La Marseillaise*, and discussions of Foucault's ideas concerning popular memory as counter-memory.[15]

At about the same time, a new kind of historical filmmaking emerged in the work of Comolli, René Allio, and others. Some of these films such as Allio's *Moi, Pierre Rivière . . .* (1976) and Hervé Guibert's project for filming *Herculine Barbin, dite Alexina B* (1979) were directly influenced by Foucault's research. Of course, a number of films of the 1960s anticipated a genealogical examination of history and a rethinking of time—above all Alain Resnais'

14. "That is to say," Schrift writes, "where the structuralists responded to existentialism's privileging of consciousness and history by eliminating them both, the poststructuralists took from structuralism insights concerning the working of linguistic and systemic forces and returned with insights to reinvoke the question of the subject in terms of a notion of constituted-constitutive-constituting agency situated and operating within a complex network of sociohistorical and intersubjective relations" (pp. 5–6).
15. For a brief account in English of Foucault's influence on contemporary film theory, see "Film and Popular Memory: *Cahiers du Cinéma*/Extracts" in *Edinburgh Magazine* 2 (1977), pp. 19–36. Also see Guiliana Bruno's essay "Towards a Theorization of Film History," *iris* 2.2 (1984), pp. 41–55.

Nuit et brouillard (*Night and Fog*, 1956), *Hiroshima mon amour* (1959), *Muriel ou le Temps d'un retour* (*Muriel*, 1963), and *La Guerre est finie* (*The War is Over*, 1966) as well as a number of films by Chris Marker, and by Jean-Marie Straub and Danièle Huillet. However, it was the release of Marcel Ophüls' *Le Chagrin et la pitié* (*The Sorrow and the Pity*) in 1971—as well as René Allio's *Les Camisards* (1971) and Michel Mardore's *Le Sauveur* (1970)—that launched a decade of films that explicitly took on problems of historical representation, knowing, and memory more or less in the context of Foucault and the new history.[16]

The question remains open, however, of why contemporary French cinema should have been, and in many respects continues to be, a privileged site for a meditation on time. Even in Deleuze's account, the time-image has avatars in many different countries and different periods of film history. Yet French filmmakers, and the history of contemporary French cinema, form a definitive crest-line throughout *The Time-Image* in the experiments with time and subjectivity expressed, each in different ways, in the work of Danièlle Huillet, Philippe Garrel, Max Ophüls, Jean Renoir, Eric Rohmer, and Jean-Marie Straub, .

A deeper exercise in intellectual and aesthetic history needs to explain the conditions that enabled this genealogical current to pass through philosophy and history to film and back again. I will leave it to the audience of *Premises* to judge to what extent these concepts either illuminate or obscure individual works or programs. My argument is that only in France was this experimentation *philosophically* possible. From *The Order of Things* to *Cinema 2: The Time-Image*, there runs a Nietzschean thread that passes between philosophy, film theory, and film practice as an extraordinary examination of time and history both in philosophy and in cinema. To understand the Nietzschean dimension of modern French cinema, then, we must ask the following question: How can time be the basis for historical knowing? Hegel's dialectical conception of the relation between reason and history and Nietzsche's genealogy as a critique of values give very different responses to this question.

In Foucault and Deleuze's accounts, only through difference can we think historically—that is, in relation to time and time's definition of subjectivity. In "Theatricum philosophicum," Foucault's appreciation of Deleuze's philosophy of time in *Difference and Repetition* and *Logic of Sense*, he explains that there have been three great attempts in philosophy to think the event, all of which have failed: neopositivism, phenomenology, and the philosophy of history. In each case difference is foreclosed by the figure of the circle, or what Foucault calls the "ill-conceived principle of return." The philosophy of history, for example, defines events as existence in time, but only on the condition that they are spatialized and submitted to a centered and hierarchical order. The philosophy of history encloses the event in a circular time where, according to Foucault, "it treats the present as a figure framed by the future and past. The present is the future in another time whose very form is already being drawn; and it is a past to come which preserves the identity of the present's content" (TP 176, *83*).[17] The philosophy of history is founded, like the movement-image, on an empirical conception of time: a chronological ordering of events in space and a volumetric expansion of the whole which are drawn together in a circular figure of dialectical commensurability. From the present to the past, and from the present to the future, time can only be represented as the return of the same in a spatial image of analogical adequation.

In *Nietzsche, Genealogy, History*, Foucault opposes the philosophy of history with what Nietzsche called "effective history."[18] *To effect* must be taken in its most literal sense—to do or to take action. Rather than being a meditation on history's monuments, *effective* history seeks to take action *in* and *for* the present through the analysis of continuing and emerging regimes of forces. Genealogy does not take refuge in the absolute, for effective history is without constants and, in this manner, requires a new form of "historical sense."[19]

Genealogy does not oppose history as an alternative, and therefore a truer or deeper, philosophy. Rather, it op-

16. René Prédal describes these films as appearing in two waves. From 1974–76 the first wave includes *Stavisky* (Alain Resnais), *Lacombe Lucien* (Louis Malle), *Souvenirs d'en France* (André Téchiné), *La Brigade* (René Gilson), *Que la fête commence* (Bertrand Tavernier), *Section spéciale* (Constantin Costa-Gavras), *Moi, Pierre Rivière* (René Allio), *Je suis Pierre Rivière* (Christine Lipinska), *Le Juge et l'assassin* (Bertrand Tavernier), *L'Affice rouge* (Frank Cassenti), *Une fille unique* (J. Nahoun), and *Lu Cecilia* (Jean-Louis Comolli). A second wave occurs in 1979 and '80 with *La Chanson de Roland* (Frank Cassenti), *Ma blonde, entends-tu dans la ville?* (René Gilson), *L'Ombre rouge* (Jean-Louis Comolli), and *Molière* (Ariane Mnouchkine). See his *50 ans de cinéma français* (Paris. Nathan, 1996), pp. 364–68. Undoubtedly, the most extraordinary and powerful film which takes on the problem of history and memory in this period is Claude Lanzmann's *Shoah* (1985). And experiments continue, a notable example being Hervé le Roux's reexamination of 1968 in *Reprise* (1997).

17. In *Language, Counter-Memory, Practice: Selected Essays and Interviews*, ed. Donald F. Bouchard (Ithaca: Cornell University Press, 1977); cited hereafter as TP. Originally published in *Critique* 282 (November 1970), pp. 885–908. Page numbers in italics indicate that I have revised the translation and invite the reader to consider the French version as published in *Dit et écrits*, vol. 2, pp. 75–99.

18. Also in *Language, Counter-Memory, Practice: Selected Essays and Interviews*; cited hereafter as NGH. Originally published in *Hommage à Jean Hyppolite* (Paris: PUF, 1971). Page numbers in italics indicate that I have revised the translation and invite the reader to consider the French version as published in *Dit et écrits*, vol. 2, pp. 136–56.

19. In "Vom Nutzen und Nachteil der Historie für das Leben," Nietzsche uses the term "historicher Sinn" which can be translated as meaning or sense. Early on, Nietzsche develops this concept with a strategic ambiguity. Foucault makes the case, however, that genealogy requires a new "sense" incorporating all the connotations of the term: meaning, logic, perception or perspective, instinct, sensibility, reason, etc. For the historical subject, it is nothing less than a new positionality within history and historical knowing.

poses "the metahistorical deployment of ideal significations and indefinite teleologies. It is opposed to the search for origins" (NGH 140). To search for origins is to try to recover "what has already been" in an image exactly adequate to itself. Nietzsche condemned the concept of origin (*Ursprung*) as a search for the ideal form behind appearances: a static and ideal meaning ordered by a time signifiable in space that freezes historical thought in "an attempt to capture the exact essence of things, their purest possibilities, and their carefully protected identities, because this search assumes the existence of immobile forms that precede the external world of accident and succession" (NGH 142). In this respect, the philosophy of history, like the indirect image of time as space, belongs to what Deleuze called the Platonic order of representation.

The search for origins is complemented by a teleological movement. By drawing a circle that passes between two points—a beginning and an end—things are given form on a territory where time and space are frozen in a dialectical image. Confined to a space ordered by teleology, historical knowing demands judgment as a transcendent and "suprahistorical" perspective, universal because it is timeless, that Nietzsche associates with both Plato and Hegel. This is "a history whose function is to compose the finally reduced diversity of time into a totality fully closed upon itself; a history that always encourages subjective recognitions and attributes a form of reconciliation to all the displacements of the past; a history whose perspective on all that precedes it implies the end of time, a completed development. The historian's history finds its support outside of time and pretends to base its judgments on an apocalyptic objectivity" (NGH 152). The search for origins is marked, like the organic narration of the movement-image, by a specific value—the will to truth. It seeks to confirm itself in an image of Truth as the selfsame, or repetition as resolution rather than differentiation.

This is why, in its critique of origins and the circular form of time, genealogy recasts history as discontinuity; the highest task of effective history is to introduce discontinuity into time. This involves a redefinition of time as a nonlinearity with neither origin nor finality—what Nietzsche called *Entstehung*, or emergence, wherein history is considered as "the very body of becoming" (NGH 144). By the same token, teleology is replaced by *Herkunft* or provenance, which uncovers, within the apparently unique aspect of a concept or character, the proliferation of events from which they descend. Without meaning accorded proactively by an origin or retroactively by an end, history ceases to be spatial and representational. Instead it concerns time and the event: what Deleuze called the *virtual* as the myriad unheard or unacted upon possibilities that reside in the interval of every passing present. Genealogy does not return in time to reestablish a continuity broken by forgetting; it does not show the past as an ideal form animating an ever-present secret that would be the ground for a concept or character. "To follow the complex web of provenance," Foucault writes, "is to hold what happened in its proper dispersion: to identify the accidents, the minute deviations—or conversely, the complete reversals—the errors, the false appraisals, and the faulty calculations that gave birth to those things that continue to have value for us; it is to discover that at the root of what we know and who we are, there is neither truth nor being, but the exteriority of an accident" (NGH 146, *141*).

Therefore, effective history liberates us from universal history because it knows the quality of becoming offers the following possibility: "The forces operating in history are not controlled by destiny or regulative mechanisms, but respond to haphazard conflicts. They do not manifest the successive forms of a primordial intention and their attraction is not that of a conclusion, for they always appear through the singular randomness of events. . . . We want historians to confirm our belief that the present rests upon profound intentions and immutable necessities. But the true historical sense confirms our existence among countless lost events, without a landmark or point of reference" (NGH 154–55). Historical sense reintroduces becoming to all that one thought immortal in humanity. Historical knowing does not mean "to find again" and certainly not "to find ourselves." Rather, history "effects" in the degree that it "introduces discontinuity into our very being . . ." (NGH 154).

In this way, historical knowing must be subjected itself to a genealogical critique. Rather than posing an image of truth in the transcendent subject who judges, genealogy looks for discontinuities in the forms of knowledge and their patterns of descent, both in the concepts of history and in the values that inform them. Rather than pretending to be objective, or that history follows natural laws, effective history diagnoses and evaluates, affirms or critiques, setting in play a will to power that challenges current values with its own. According to Foucault, the search for the ideal form behind appearances in the Platonic theory of representation, and the dialectical will to truth of the Hegelian philosophy of history, is an invention of the dominant classes (classes dirigeantes) who seek to foreclose understanding of the multiple and contingent (in)determinations that mark every event. Genealogy, alternatively, understands that the historical beginning of things is not marked by an identity frozen at the point of origin; rather it is the disparate—the discord of multiple and undetermined counter-possibilities—that claims the attention of the genealogist.

The dialectical perspective is suprahistorical; it freezes time in a spatial image as a totality and, paradoxically, forecloses time from history in an act of judgment. Thus, it will never understand or express change except by erecting monuments to the past. In this respect, the logic of the movement-image is entirely commensurate with the dialectical or Hegelian conception of history. With its empirical conception of time as a linear and chronological force, the movement-image projects an image of (historical) thought marked by dialectical opposition and conflict ending in teleology—an indirect image of time given as a spatial whole. And, in a grand dialectical gesture, the movement-image projects its own history in just the same way. In The Movement-Image, the evolution of the indirect image of time unfolds, in Deleuze's account, in an image of history as progress—the gradual and teleological perfection of a logic of signs and an image of thought that reaches its culmination and limit in the late films of Alfred Hitchcock.[20] By bringing the movement-image to its logical conclusion, and also in suggesting a "beyond" the movement-image, Hitchcock's films paradoxically signal in cinema both the "end of history" and the emergence of genealogy.

The history of the movement-image is the movement of a great dialectical synthesis wherein the indirect image of time functions as a universalizing logic that encompasses and subsumes all the forms of difference articulated within it. There are, of course, industrial and economic reasons for this universality; namely, Hollywood's aesthetic and economic domination of world cinema. But curiously, for Deleuze, even if the montage forms of Soviet cinema and the great European experimental film movements of the 1920s differ in kind from Hollywood cinema, by challenging its characterization of movement and time based on action and causality, logically they do not differ in nature. All are variations animated by the same "world spirit" as it were, or rather, in Deleuze's terms, an "image of thought" comprised by an organic representation and an indirect image of time.

Alternatively, the time-image and the movement-image are separated by fundamental discontinuities that

20. This is in fact the argument of the last chapter of The Movement-Image. Unfolding logically through Peirce's categories of Firstness (quality), Secondness (cause), and Thirdness (relation)—or perception and affection-images, to action-images, and finally to mental-images—in the first fifty years of cinema the movement-image discovers every logical permutation available to it until it achieves its final synthesis. "Inventing the mental image or the relation-image," Deleuze writes, "Hitchcock makes use of it to close the set of action-images, and also of perception and affection-images. Hence his conception of the frame. And the mental image not only frames the others, but transforms them by penetrating them. For this reason, one might say that Hitchcock accomplishes and brings to completion the whole of the cinema by pushing the movement-image to its limit. Including the spectator in the film, and the film in the mental image, Hitchcock brings the cinema to completion" (MI 204).

no dialectic can master. While the movement-image is universal, the time-image is rare, even in the postwar period. Thus discontinuity is not negativity in the Hegelian sense, nor is the time-image a critique or overcoming of the movement-image. While its logical nature is based fundamentally on discontinuity, there is no definitive break between the time-image and the movement-image that can be measured along a linear and chronological timeline. Between the two regimes there is a fundamental slippage where the presentation of time changes as the meaning of time changes with respect to historical understanding. Only the movement-image has a history, as it were; it demands that we look for its origin to understand its gradual progression in a teleology. But the time-image demands instead a genealogy. It neither displaces the movement-image nor marks its end. Rather we must look for the time-image in French cinema as multiple lines of descent that have a fluctuating appearance in time.

The two images of time, indirect and direct, have a curious relationship then in the history of cinema. The movement-image may have logically completed its evolution or accomplished its teleological unfolding in the postwar period, but it does not "end" there; in fact it retains more than ever the force of universality promoted by the economic hegemony of Hollywood and the multinational entertainment state. Looking at certain of the more adventurous contemporary directors, or the discontinuous images of music videos, we can understand how the movement-image has accommodated the time-image—while nonetheless marginalizing it and limiting it—and thus perpetuates a certain image of thought and conceptualization of the whole. In many respects, the logic of the movement-image persists as strongly as ever, although in a postmodern frame as pastiche and hybrid or schizophrenic style. The new French stylists of le cinéma du look—Luc Besson, Jean-Jacques Beneix, and Léos Carax—or even Matthieu Kassovitz, are as good examples as any.

Alternatively, there are strong intimations of the time-image in films by Jean Renoir and Max Ophüls that both follow and precede the end of World War II. The time-image does not follow upon the "end" of the movement-image; rather it appears intermittently in the classic period as an ever-possible and eternally recurring force. Time as virtuality persists as a reserve within history—the potentiality of lines of variation and unanticipated innovations within the space of history. Its genealogy threads through the movement-image in a discontinuous and "untimely" fashion "that is to say," as Nietzsche wrote, "acting counter to our time and thereby acting on our time and, let us hope, for the benefit of a time to come."[21] In fact what it is is time as force and eternal recurrence—the metaphysical foundation of a counter-memory ever renewable in creative expression. The dialectical and teleological unfolding of the movement-image in space, and the emergence of the direct image of time in the autonomous or irrational interval, thus coexist in a complex and contradictory play of forces.

Characterized by an open totality in movement, only the movement-image has a "history" in the sense of reaching that teleological point or retrospective synthesis where a final sense or logical culmination is achieved. Whereas the movement-image is marked by the logic of an organic representation and a universal dialectical unity, the time-image promotes another logic which—in its own discrete, subterranean, and cunning fashion—threads through even the first fifty years of cinema before throwing the movement-image into crisis in Italy and France. If the time-image is not "historical," this means that we should not look for its meaning in either origins or ends. Because it is fundamentally nonlinear and nonchronological, the time-image is not renderable as a history of progress or as a progression, nor is it subject to a spatial representation. It is what happens between spaces, between events, a fissuring of space by time as the eternal recurrence of chance and possibility. And this is why even if, in Deleuze's rather dire and often elitist perspective, the cinema is dying from a quantitative and qualitative mediocrity, it always preserves the power of a new becoming and a new beginning.

21. "On the uses and disadvantages of history for life" in Untimely Meditations, trans. R. J. Hollingdale (Cambridge: Cambridge University Press, 1983), p. 60.

Therefore, only the movement-image "evolves"; the time-image "recurs." Their concept of history is different because they present two different conceptions of time, two different relationships with the whole, and a qualitative difference in the expression of change. The fundamental discontinuity resides in the heart of time itself. The movement-image presents time as Cronos—repetition of the same; history as a circle. But if time is presented "directly" in modern French cinema, this is rather Aïon—not a succession of presents, but recurrence as a labyrinthine branching of time. In "Theatricum philosophicum," Foucault embraces Deleuze's concept of time for genealogy, describing it as:

> a splitting quicker than thought and narrower than any instant. It causes the same present to arise—on both sides of this indefinitely splitting arrow—as always existing, as indefinitely present, and as indefinite future. It is important to understand that this does not imply a succession of present instances that derive from a continuous flux and that, as a result of their plenitude, allow us to perceive the thickness of the past and the outline of a future in which they in turn becomes the past. Rather, it is the straight line of the future that repeatedly cuts the smallest width of the present, that indefinitely recuts its starting from itself.... What repeats itself is time; and the present—split by this arrow of the future that carries it forward by always causing it to swerve from one side to the other—this present endlessly recurs. It recurs as singular difference; what never recurs is the analogous, the similar, and the identical. (TP 193–195, 97)[22]

The time-image recurs rather than "evolves" because it is incommensurable with the empirical conception of time where past, present, and future are ordered as chronological succession. Time no longer resolves itself in the image of a circle that subsequently grows in volume and depth; this is history as teleology. But rather, the thinking of history becomes a synthesis of time where every passing present introduces chance as a line of variation—a nomadic becoming—that liberates us from the tyranny of both a fixed memory of the past and an already determined future. Defined by Nietzsche as eternal recurrence, time as Aïon is rather a virtuality "in" the present. It divides the passing present so that time is never identical to itself but rather falls back into the past as multiple lines of descent and launches into the future as an undetermined set of possibilities.

Where the movement-image is organic, following the concept of time as succession or Cronos, the montage form of the time-image presents as false or aberrant movements this fundamental discontinuity in time. Marked by recurrence rather than repetition, the irrational interval assures the incommensurability of interval and whole. Because the interval is a dissociative force, succession gives way to *series*. Images are strung together as heterogeneous spaces that are incommensurable one with the other. Seriality thus defines the montage form of the time-image. But in so doing, the value of the interval changes and unleashes new powers.

Consider *Ici et ailleurs* (Here and elsewhere, Godard-Gorin-Miéville, 1977). The opening of the film shows well the forms of discontinuity characteristic of the time-image. There are no credits. In fact, there is no real "beginning" to the film; whose origins are equally indistinct and in question. Godard's voice simply appears over black leader:

> En 1970, ce film s'appelait *Victoire*.
> En 1974, il s'appele *Ici et ailleurs*,
> et ailleurs,
> et"[23]

This narration continues over two images: First, videotext on black background:

> mon
> ton
> son image

and then a filmed image of the word "ET" apparently carved out of styrofoam. Miéville repeats the same text over four images: a fedayeen man showing a woman how to aim a rifle; a French family watching television; a group of

22. The conceptualization of time according to Deleuze's original reading of Nietzsche's concept of eternal recurrence is the great project of *Difference and Repetition*, trans. Paul Patton (New York: Columbia University Press, 1994). On the difference between Cronos and Aïon, see *The Logic of Sense*, trans. Mark Lester with Charles Stivale (New York: Columbia University Press, 1990). I discuss this redefinition of time more completely in *Gilles Deleuze's Time Machine*, especially Chapter Five.
23. "In 1970, this film was called *Victory*. In 1974, it's called *Here and elsewhere*, and elsewhere, and"

fedayeen in the desert; and then a black title on white background which states, in both French and Arabic, "the will of the people."

Subsequently, the images divide into five intercalated series. First there is documentary footage of the Palestinian fedayeen shot in February and July 1970 in Jordan and Lebanon by Godard and Gorin's Dziga Vertov Group, which was to have been part of a film entitled *Victoire*. Then there are images constructed in 1974: diegetic material involving a French family, their everyday life, their relations with the media, and the father's search for work; didactic studio performances which include the "diegetic" actors; and finally non-diegetic inserts of various types (interpolated videotext, intertitles and placards, images processed by videomixer, black leader, filmed televisions, slide viewers, and sound mixers, etc.). The film freely intermixes different materials of expression and styles of presentation (documentary, fictional, didactic) so as to maximize the difference between series. This discontinuity and heterogeneity is produced, as it were, by the "ET" that circulates between Godard's voice and the image, passing into Miéville's voice, and indeed *between* all the images as an irrational interval. In series, the interval divides rather than associates, thus attaining a new value. "[In] Godard's method," writes Deleuze, "it is not a question of association. Given one image, another image has to be chosen which will induce an interstice *between* the two. This is not an operation of association, but of differentiation . . . : given one potential, another one has to be chosen, not any whatever, but in such a way that a difference of potential is established between the two, which will be production of a third or of something new" (TI 179–180).

Throughout the film, "here and elsewhere" functions as a concept that organizes a disparate set of spaces (Jordan-France, film-video, image-sound) and times (1970, 1974), which in their strategic repetitions continually differ one from the other as incommensurable series. The series of images, and images and sounds, can neither be unified in a transcendent perspective nor reconciled into a whole

that will confer a retroactive sense on the history, indeed histories, that the film presents. 1970 *and* 1974: the film holds the two times together in their incommensurability. The documentary images can neither repeat nor adequately represent the strategies and politics of the fedayeen in 1970, nor do they sustain a coherent memory of, much less restore to life, a movement all but destroyed by the betrayal of Black September—the massacre at Amman of the fedayeen by Jordanian troops. No action unifies the images. No historical meaning can be recovered by linking 1970 Jordan to 1974 France in a chronological and continuous time. Each time Godard and Miéville return to the Palestinian images ("EN REPENSANT A CELA" states a recurrent video intertitle), the film branches into yet more complex series, each of which reflexively questions the capacity of images and sounds to master the past by incorporating it as a present image. Each repetition of the "original" documentary images yields a differentiation and complexification of sense that falsifies preceding series. The formal organization of the first film, as well as the political perspective of the Dziga Vertov group, are continually questioned along with the nature of their identification with the conflict and their methods for filming it. Images repeat in discontinuous series; sounds and voices interrogate the self-evidence of given images, gradually revealing artifices in their construction and suggesting ever more complex and subtle variations in how they should be read, reinterpreted, and juxtaposed with other images and sounds. The film unfolds as a genealogical critique not of the Middle East conflict, but of its historical representations both in the mass media and in the interval that separates the unfinished *Victoire* from the ever provisional *Ici et ailleurs* as two divergent perspectives on the problems of making a political film. Instead of a "truthful" representation, Godard and Miéville seem to suggest, we need a pedagogy of the image that critically evaluates its relations with time and history. In this way, the recurrence in series of *Victoire* within *Ici et ailleurs* implicitly takes place as a Nietzschean critique and reval-

LEFT Jean-Marie Straub and Danièle Huillet, *Chronique d'Anna Magdalena Bach* (*Chronicle of Anna Magdalena Bach*, 1969), film still

uation of the earlier film's theory of direct revolutionary action modeled on a Hegelianized existential Marxism.

One might say that this is a film about a failed project—including the 1970 film on the Palestinians, the Dziga Vertov group as a media collective, and indeed the revolutionary aspirations of May '68. Perhaps it is better to say that it is a film about the "ill-conceived principle of return," and an exercise in effective history that unleashes new powers of the image and a new form of historical sense in the then present of 1974. We live in a society where images and sounds are made to be consumed, yet whose infernal repetitions across film, television, print, and radio, rather, consume us. "Little by little," the soundtrack recounts, "we are replaced by uninterrupted chains of images enslaving one another, each image has its place, like each of us at our place in a chain of events where we have lost all power." This is a psychological automaton where the image functions as a substitute for thinking and a vehicle for the accumulation of pseudo-events in a false totality that crowds out the myriad alternatives and counter-memories a genealogical history might liberate for us.

Yet in their incommensurability, the images of *Ici et ailleurs* return in ever-more differentiated series that interrogate the mass media's crowding out of both the memory and actuality of revolutionary struggle. While no image or sound will ever be an adequate or "truthful" representation of this struggle, the irrational interval nonetheless sustains a principle of recurrence where the struggle for Palestinian self-determination enters into series with a number of other singular points distributed throughout the film—the French Revolution (1789), the Soviet Revolution (1917), the Popular Front in France (1936), the popular uprisings of 1968—which are made to circulate across the media-

saturated present of 1974 France. It does not matter that these are all "failed" revolutions that the film cannot add up in a restored totality. For what is at stake is not return but recurrence—the force of time as change—where the interstice sustains new values and a new form of historical sense. *Ici et ailleurs* becomes "effective" history by introducing discontinuity into time in the form of the interstice. Rational connections present spatial intervals—the indirect image of time as a succession of sets or segmentations of space. But irrational intervals are not spatial, nor are they images in the usual sense. They open onto what is outside of space yet immanent to it: the anteriority of time to space as virtuality, becoming, the fact of returning for that which differs. This force opens a line of variation in any image, sign, idea, or concept that attempts to express it. If time is given us here as a perception, this is not an analogical image in space, but rather time as virtuality or Event—a reserve within history of ever-renewable and unanticipated lines of variation "acting counter to our time and thereby acting on our time, let us hope, for the benefit of a time to come." In other words, when time is rendered as incommensurable with space in the interstice, a vast territory of potentialities opens in every present that passes. Through events, virtuality unfolds as an unlimited reserve of future acts, each of which is equally possible in itself, yet incompossible with all the others. Thus the event "is pure immanence of what is not actualized or of what remains indifferent to actualization, since its reality does not depend upon it. The event is immaterial, incorporeal, unlivable: pure *reserve*. . . . It is no longer time that exists between two instants; it is the event that is a meanwhile [*un entretemps*]: the meanwhile is not part of the eternal, but neither is it part of time—it belongs to becoming."[24] Events are immanent to every moment of time's passing, yet remain both outside and in between the passage of time. Between each measure of time there is an infinite movement, so many possible worlds and immanent modes of existence, that we must recover from time's passing.

24. Deleuze and Guattari, *What Is Philosophy?*, pp. 157–58. On the question of history and the event in relation to direct images of time, also see "The Memory of Resistance," the concluding chapter of *Gilles Deleuze's Time Machine*.

Jean-Luc Godard, *Pierrot Le Fou*, 1965, film still

The direct image of time, then, is a paradoxical construction. Rather than an historical image of thought, it gives us "thought without image."[25] The irrational interval offers a nonspatial perception—not space but force, the force of time as change, interrupting repetition with difference and parceling succession into series. There is movement in the image, of course, which is given as an actual perception in space. But the differential relations "between" images and sounds are furrowed by a pure virtuality: the force of time as eternal recurrence. Time is always outside the image; it recedes from the image toward an absolute horizon, since it is incommensurable with space. The "will to falsehood" of the direct time-image draws all of its powers from this quality of incommensurability: indiscernability of the real and the imaginary in the image; inexplicability of narrative events; undecidability of relative perspectives on the same event, both in the present and in the relation of present and past; and, finally, the incompossibility of narrative worlds, which proliferate as incongruous presents and not-necessarily-true pasts.

Foucault's adoption of Nietzsche's concepts (*Entstehung*) emergence and *Herkunft* (descent) are equally marked by Deleuze's analysis of time as eternal recurrence, as the citation above from "Theatricum philosophicum" makes clear. This is why the time-image requires genealogy rather than history and how the time-image projects a new concept of historical sense. In Hegel's phenomenology and philosophy of history, the dialectic does not liberate the different; on the contrary, it guarantees that difference will always be recaptured by unity and totality. The dialectical sovereignty of the same lets the different be only under the law of the negative as a moment of nonbeing. In dialectical contradiction we find not the subversiveness of the other, but a secret work for the benefit of the identical and return of the same.

But the time-image reveals in cinema a new thinking of difference, indeed a new thought of time, as event and series, that liberates difference from the logical system where it is mastered by opposition, negation, and contradiction. In other words, one quality of the direct image of time is to free difference from the dialectic, which informs all philosophies of representation and indeed the philosophy of history. In this way, modern French cinema answers the call made by the turn to Nietzsche in French philosophy of the 1960s. From the image of thought to a thought without image, the time-image liberates historical sense from the historical image of thought as the body of becoming. Here Foucault's genealogy and Deleuze's time-image coincide in a common project: to reject resemblance in representation; to free difference from the dialectic; and to free the subject from judgment and the will to truth.

V

In *Nietzsche, Genealogy, History*, Foucault outlines three dimensions of historical sense that confront the concepts of universal history: oppose an idea of history as reminiscence or recognition with a parodic use of history; oppose history as continuity or tradition by showing the dissociative quality of identity; and finally, oppose the will to truth in history with the powers of the false. In each case, Foucault asks that another form of time be deployed in history: a counter-

25. See *Difference and Repetition*, trans. Paul Patton (New York: Columbia University Press, 1994), pp. 276 et passim.

memory that detours the will to truth promoted by the metaphysical and anthropological models of history. In conclusion, I would like to outline three lines of descent wherein modern French cinema engages this genealogical project as an art of the event, parallel to the reconfigurations of space by time expressed elsewhere in *Premises*.

The parodic use of history does not recognize or represent the reality of the past in the present; rather, it shows how our present reality is constantly being destroyed and remade. This is a carnivalesque deployment of history—an inversion of values and multiplication of masks—where all the monuments representing our values and identity are derealized. Let us call this a cinema of the simulacrum. Godard is the best, though not only example, as our programs on film's self-interrogations, "Cinema within Cinema," demonstrate. Here there is a confrontation with the history of the movement image where difference returns to problematize identity in two ways: as a critique of cinematic representation and as a remaking of film history. The simulacrum expresses a power of the false as the indiscernability of imaginary and real. A discontinuity divides representation within itself and the image no longer anchors meaning in the past as origin by an analogical reduction. The analogical repetition of the real in the image is subverted—"it's not a just image, it's just an image" in Godard's formula—as well as the logic of signs deployed by Hollywood cinema. In the cinema of the simulacrum, the image is not the site of truth; instead there is the multiplication of images in discontinuous series as a logic of sense that is continually being destroyed and remade through a process of experimentation and invention.

This is a confrontation not only with the history of cinema as continuity or tradition, but also with how an idea of history is projected in the logic of the movement-image itself. From *Á bout de souffle* to *Forever Mozart* (1996), Godard has never stopped writing his *Histoire du cinéma* as a carnivalesque remapping of the history of cinema—its genres, styles, and monuments—in a process of citation and reconfiguration. This remapping of history also includes cinema's confrontation with the history of art and how history is presented in art, whether it be writing (*Pierrot le fou*), music (*Prénom: Carmen* [First name carmen], 1983), painting (*Passion*, 1982), or other media such as television (*Ici et ailleurs*; *Comment ça va* [How is it going?], 1976; *Numéro Deux*, 1975). Our programs dedicated to "Intermediation" provide many other examples.

A second line of descent in modern French cinema, which might be called a "cinematic genealogy of morals," threads through our programs dedicated to "Zones of Exchange," "Public/Private Spheres," and "Utopia/Dystopia." Here the dissociative quality of identity undermines the presumed continuity of a French mentality or the universality of bourgeois morality. Rohmer's series of "Six Moral Tales" and "comédies et proverbs"—a Pascalian cinema where choice means always having to say you're sorry—is the obvious example. But the purest examples of Rohmer's genealogy of morals are found in his examination of the confluence of morals and the history of representation in *La Marquise d'O* (*The Marquise of O...*, 1976) and *Perceval le gallois* (*Perceval*, 1978). Equally important are Chabrol's dissections of the French bourgeoisie and Jean Rouch's continuing confrontations with how French identity is scarred by the violence of its colonial past. In each case, but with different stylistic emphases, these filmmakers show the contradictoriness of a moral sensibility that insists on its foundation in a culture or a history. Wherever the very Cartesian French self insists on its historical continuity and unity, there returns within the subject a repressed will or desire, sometimes ludic but often violent, that is a dispossession of the subject by the "other." Where difference divides identity we are all "maîtres fous," as if to say with Foucault that, "If genealogy in its own right gives rise to questions concerning the land that surveys our birth, the language that we speak, or the laws that govern us, it is to illuminate the heterogeneous systems which, masked by the self, inhibit in us any form of self-identity" (NGH 162, 154).

The purest and most complicated line of descent of the time-image follows what Deleuze calls "fabulation" and "falsifying narration." Here the true may be understood to be "historical." Yet what is known is no longer anchored in a sure link between present and past, perception and memory. Instead there is a desire to understand the past across mutually contradicting positions that seem nonetheless to be true. However, these positions are only contradictory if they are assumed to be necessary rather than contingent. For if the relation between past and present was continuous and determined, we could not imagine having acted differently in the past, or preventing a repetition of past violence in the future. The powers of the false insist that truth is historical, but in saying so, our relation to the past must be clarified. Falsifying narration does not mean that history is no longer true or cannot be known. Rather, it asks how the will to truth is transformed by a historical sense marked by the undecidability of relative perspectives on the same event, both in the present and in the relation of present and past, and in the incompossibility of narrative worlds which proliferate as incongruous presents and not-necessarily-true pasts.

Take for example the opening of *Hiroshima mon amour* (1959). There are two voices-off (He: "You saw nothing at Hiroshima. Nothing." She: "I saw *everything. Everything*"), and two "times" of the image, the abstracted images of the lover's bodies, intertwined but never able to merge, and the "documentary" images of Hiroshima, linked without distinct chronology. While the woman's voice seems to cue the documentary images, there is no concrete evidence that these images represent her point of view or memory. Without a chronology or "rational" links to situate them, the voices, bodies, and images of Hiroshima are part of an uncertain present. Whether the voices belong to the bodies, or the documentary images belong to a memory, or all three exist together in a distinct diegetic present is undecidable. These are three series of events presenting distinct "points" of present that may not be reconcilable in the same world. Sure criteria for judging what is subjective and objective, present or

past, perception or memory are strategically absent. The French actress may well have seen nothing in Hiroshima; the Japanese architect may really know nothing about what happened during the German Occupation in Nevers.

Resnais and Duras give no reason for doubting either the historical veracity of the nuclear violence visited on Hiroshima, or the narrative veracity of the actress' account of the death of her German lover at Nevers. There are nothing but "true" stories in this film and indeed the true is understood to be "historical." But if history cannot ground itself in a will to truth as either the return to an originary memory or a suprahistorical perspective that masters the past in a single glance, then the nature of historical sense must change. The spectator is no longer in the position of juror, adjudicating the veracity or probability of one character's narration with respect to another. There is no "truth" to uncover. Instead there is a set of transformations where narrations continually falsify one another in series that may just as easily contradict as corroborate one another. There is no point—fixed, intemporal, or suprahistorical—outside these series that enables us to make a subsumptive judgment that transcends and unifies them in a position of truth.

Our program on "Fabulation" represents well this line of descent. But it may also be found in screenings dedicated to "Voices of Interiority" and "Traces, Documents, Ethnographies" as well as "Zones of Exchange." This is a confrontation in the present—a conflict between memory and history, expressed in the essay-films of Chris Marker and Godard as well as the interrogations of everyday life and history in the films of Raymond Depardon, Claude Lanzmann, Marcel Ophüls, or Jean Rouch—where "the historical analysis of this rancorous will to knowledge reveals that all knowledge rests upon injustice (that there is no right, not even in the act of knowing, to truth or a foundation for truth) and that the instinct for knowledge is malicious (something murderous, opposed to the happiness of mankind). . . . [The] will to knowledge does not achieve a universal truth On the contrary, it ceaselessly multiplies the risks, creates dangers in every area; it breaks down illu-

sory defenses; it dissolves the unity of the subject; it releases those elements of itself that are devoted to its subversion and destruction" (NGH 163).

In all three lines of descent, modern French cinema presents neither the "death of the subject" nor the "end of history." Rather, as in the philosophy of Foucault and Deleuze, there is a reconceptualization of the historical subject and the event as a "critical ontology of the present." As Alan Schrift notes, "insofar as the subject position delivered to us by modernity is not an ontological necessity, other subject positions and possibilities of knowledge will be historically possible in terms of the contingencies of the present moment Foucault's genealogy of the subject provides a theoretical articulation of this account of multiple subject positioning insofar as it frames the subject not as a substance but as a form, a form, moreover, that is not always identical to itself" (57). This is not only a discontinuity in time which disrupts understanding the event in terms of origin, unity, and finality, but also a discontinuity that divides the subject internally, who thus becomes open to change, multiplicity, and is marked as much by chance or contingency as by necessity and determination. For

Deleuze, philosophy and art become experimentation—an opening and exploration of new territories and lines of variation in our current modes of existence and our spaces of desire and sociality. In Foucault, this is the overcoming of a will to truth where the "purpose of history, guided by genealogy, is not to discover the roots of our identity, but to commit itself to its dissipation" (NGH 162). Here being finds no shelter from the force of time as change. Time forever divides the subject from itself, introducing an interstice or "irrational interval" in the subject who is now crossed by difference and nonidentity. Divided by time as eternal recurrence, the historical subject expresses an affirmation: that "new thought is possible; thought is again possible" (TP 196). Expressed equally in the Nietzchean dimension of French cinema and historical thought, one can easily imagine this phrase as a graffiti from May '68.

I would like to thank Steve Ungar, András Bálint Kovács, Dudley Andrew, Michael Westlake, and Alison Gingeras for their invaluable help in the preparation of this essay.

VISUAL

ARTS

PLENTY OR NOTHING:
FROM YVES KLEIN'S LE VIDE TO ARMAN'S LE PLEIN

BENJAMIN H. D. BUCHLOH

The judgment of Potlatch *concerning the end of modern art might have appeared a little excessive against the background of thinking about the subject in 1954. Since nobody seems to have been able to come up with any explanation, people have actually started to doubt a fact which we know in the meantime from rather lengthy experience, namely that since 1954 we have never seen anywhere the appearance of a single artist whose work would be truly of any interest.*

Guy Debord, "Introduction to *Potlatch*" (1954–57)

Two apparently opposite forces were at work in Europe in the post–World War II period with regard to the possibility of art staking a claim to truth. The first related to social restrictions that seemed unbreakable, such as the collective disavowal of the immediate historical past and the massive acceleration of commodity consumption. The second, divorced from the social realm, concerned the mnemonic sphere internal to art, a sphere I will here be calling *discursive* (following the Foucauldian use of the term *discourse* to refer to the rules and procedures of a given discipline); this was now characterized by the complete arbitrariness of both artistic memory and decisions about radical change (such as the random readoption and development of earlier Modernist paradigms which were, in Paris in the immediate aftermath of World War II, completely decontextualized).

Though these spheres appear as opposites, they formed a dialectical whole. Thus both halves of that dialectic exerted force on each of the two both sides, on aesthetic production as well as on the perception of the objects of everyday life; but they did so in unequal measure. On the one hand, the apparent surplus of willed aesthetic choices seems to have failed, to the same extent that, on the other,

the sudden restriction of culture proved unable to serve as a political project (as, for example, in the belated introduction of Socialist Realism into postwar France or in Jean-Paul Sartre's 1948 manifesto *What is Literature?*).

Earlier forms of the avant-garde assumed the continuity between "the cultural creation of the avant-garde and the revolutionary critique of society." Guy Debord posits the same definition as the task of his magazine *Potlatch* in 1954.[1] But what emerged from the postwar situation (as I will be analyzing it) took the form, instead of a paradox. For it was precisely those artists who opted out of both the earlier forms of avant-garde ambition *and* the current theorization of art as political (by Sartre, for example) who would come to represent some of the central moments of the culture of reconstruction in France.

Given such a context, this essay is an attempt to clarify at least three questions. The first considers production. It asks what changes were necessary for the definition of visual culture so that the very artists who ignored both the restrictions endemic to the aesthetic domain and the prohibitions set up by the strategists of political commitment could eventually appear as the new producers. Further, it is an effort to understand what made their project appear as a

1. Guy Debord, "Introduction to *Potlatch* (1954–57)," in *Potlatch* (Paris: Éditions Gallimard, 1996), p. 8.

more convincing mediation between social production and artistic production, integral to the demands of reconstruction culture. For what is clear is that these artists grasped the accessible mediations between discursive prohibitions and newly available artistic epistemes better than their ethically and theoretically superior colleagues.

The second question addresses the process of reception. It attempts to clarify why these practices (some of them distinctly apolitical and antisocial, if not altogether cynically indifferent to the problems of legitimacy and the possibility of art's exerting any claims to truth after the war) actually succeeded more than the reigning "committed" literature or "committed" art in establishing the neo-avant-garde in the 1950s.

Inevitably, the third question has to turn on the matter of critical judgment, specifying the criteria according to which neo-avant-garde production can be evaluated altogether. That is, once the aesthetic and ethical claims of earlier, oppositional avant-garde models had—within the advanced forms of late-capitalist consumer culture— proved to be ineffectual or inadequate, how could they be reasserted without running into either of two dangers? On one side there is the danger of lapsing into the latent authoritarianism of Debord's prohibitive doubt about even the slightest historical possibility of any cultural production whatsoever. On the other side there is the risk of falling into the mindless acceptance embodied, for example, in the contemporary writings of Pierre Restany, in which the neo-avant-garde is enthusiastically assigned the role of a cultural claque in the celebration of the new techno-scientific society of consumption, spectacle, and control.[2]

ABOVE Yves Klein performing his *Leap into the Void*, Fontenay-aux-Roses, October, 1960

To answer any of these questions, at least partially, I will develop something of an experimental comparative model in what follows. Taking a relatively focused moment of postwar French culture, I will examine how this dialectic of a radical transformation of spaces and objects and an equally radical set of changes in the paradigms of visual representation can be traced. To this end, I will compare two artists, Yves Klein and Arman, both of whom enter the discursive framework of postwar culture in the mid 1950s. It will be possible to trace how—within the relatively narrow framework of a decade—these two would redefine the discursive traditions of painting and sculpture in France in ways that were not at all anticipated in the local development.

The painter Yves Klein emerged from the Modernist history of reductive abstraction, more specifically from monochrome painting. The sculptor Arman departed from the paradigm, equally central to Modernism, of the readymade. If we accept that these paradigms were in fact essential to the formation of the *discursive* framework of the neo-avant-garde, we still have to identify the specific conditions determining the formation of a framework that was *historical* in the sociopolitical sense. My primary argument will be that the repression of catastrophic historical experience and its opposite—the rapid development of a new culture of spectacle and consumption—were among the founding conditions of the artistic production of that postwar moment. Such a dialectic of silence and exposure was all the more efficient on European soil since the repression of historical memory had been so emphatically established on a collective level in everyday life. Between 1958 and 1968 most of the practices of the visual neo-avant-garde were thus formulated as part of a larger project of social modernization and amnesia.[3]

Discursive Memory versus Historical Memory

It has been firmly established that one of the tenets on which modernist painting founded its epistemological claims (its sense of its own access to certainty and knowledge) concerned the prohibition of any representation of the historical (history painting or narrative of any kind), and the dismantling of any reference to the material world. Nonetheless, the vehemence is still surprising with which this quest for visual autonomy and self-referentiality would be reestablished immediately after the most cataclysmic destruction in European history. While this observation would apply to all the European countries in the postwar period, it is particularly poignant to study the dynamics of disavowal and modernization in those contexts where encounters with Fascism and the Holocaust had been most dramatic: in the country of the victimizer as much as in those of the victimized.

In order to understand this dialectic of mnemosyne and amnesia within European reconstruction culture, numerous parameters of historical mediation have to be brought into the debate. It is for this reason that I am setting up a preliminary distinction—theoretically untenable as it might be—between discursive and historical memory (the one internal to the discipline of art, the other—properly speaking—external to it) in this period.[4] If the first will address the degree to which a given artistic practice defines its own mnemonic horizon—by the persistence of aesthetic paradigms, the organization of artistic conventions, formal standards, and demands—the second will question the extent to which history enters reconstruction culture at all, and if it does, whether its most legible traces might not be precisely those instances where the disavowal of historical trauma has been most successfully accomplished. Such a reflection would also have to take into account whether the very emphasis on the historical dimension of reconstruction culture would not conflict, paradoxically, with the initial unfolding of the process of the mnemonic from within the formation of discursive memory itself.

My first example, leading as it does to a consideration of the persistence of culturally constructed and individually enacted models of artistic and authorial identity in postwar France, already reveals the full importance of such a distinction between historical and discursive memory. To the

2. One typical example of this uncritical celebration of the circumstances of neo-avant-garde production would be Pierre Restany's retrospective account of the formation of *Nouveau Réalisme*, in *60/90: Trente Ans de Nouveau Réalisme* (Paris: Éditions La Différence, 1990).

3. For a good discussion of this problematic, leading up to a first clarification of the hidden nexus between the repression of political history and the formation of spectacle culture in postwar France, see Alice Yaeger Kaplan, *Reproductions of Banality: Fascism, Literature and French Intellectual Life* (Minneapolis: University of Minnesota Press, 1986). For an equally important introduction to the actual conditions of a newly enforced consumer culture based on the American model, see Kristin Ross, *Fast Cars, Clean Bodies: Decolonization and the Reordering of French Culture* (Cambridge, Mass. and London: MIT Press, 1995). Unfortunately neither of these important studies considers the specifics of visual neo-avant-garde practices at all so that the work in this field remains for the most part yet to be done.

4. I am not suggesting that there were no attempts at all to address the events in the period of the war and the immediate postwar years, and I am aware of numerous counterexamples. What is of interest in this essay is the question as to why those activities that gained and retained international art-historical and critical interest were precisely those that refrained completely from any entanglement with the problematic and central question of the representation of historical experience.

extent that it had to distance itself from the patriarchal figures of French Modernism, specifically Pablo Picasso and Henri Matisse, postwar French culture had to reckon with these models. These artists and their peers (e.g. Georges Braque, Fernand Léger, et al.) had immediately been repositioned in a place of uncontestable authority against whatever challenges had originally been mobilized against them in the 1920s and 1930s by a critical avant-garde.

The second, and even more complex, example of the construction of discursive memory concerns the extent to which other and slightly later members of the historical avant-garde (e.g. Marcel Duchamp, Piet Mondrian, and Kurt Schwitters)—who by the time of the Liberation had hardly been received in Parisian artistic contexts—could be incorporated within the formation of French postwar culture. Despite their immense paradigmatic diversity, these figures were linked to the patriarchs of Modernism not only by the fact that they had participated in the production of a prewar aesthetic, but by their shared role as witness-bearers to World War II and the catastrophic destruction of European humanist culture at the hands of German Fascism. Moreover, in view of that destruction, they had—with very few exceptions—shared equally in a posture of silence, acting through the conception and continuation of their artistic projects as though they had not been affected by it.[5]

By contrast, it would appear reasonable to assume that those artists who emerged in the late 1940s, and who formulated the aesthetics of reconstruction, would confront the experience of the devastation of Europe in a much more fundamental manner. Thus one could expect that from now on all visual avant-garde activities would differ dramatically from all previously valid models in the way that Maurice Blanchot, for example, argued that "no matter when it is written . . . from now on it will be from before Auschwitz."[6]

In fact, if one studies the poetry and literature of that period, a schism in culture becomes apparent between, on the one hand, literature's continuous emphasis on the necessity (or the impossibility) of constructing historical memory as well as a new politically conscious culture (e.g. Sartre) and, on the other, the almost total absence of comparable theoretical questions (let alone artistic solutions to address the question of historical experience and the possibility of a mnemonic approach to trauma) in postwar *visual* culture.[7] While French, Italian, and German literatures seem to offer a multitude of attempts to reflect on the experiences of the war and the Holocaust, the repression of historical experience and the silence on the subject of history altogether is almost complete in the works of the visual neo-avant-garde from 1958 to 1968.

This paradox is all the greater since it had been one of the foundations of Modernity (that strand generally identified as deriving from Courbet's Realism) to *address* the historical in its most specific aspects: the conditions of class, for example, or the impact of political formations on artistic practice. In the same manner one could argue that in that other strand, generally identified with Manet, modernism had subsequently constituted itself by total identification with discursive memory. In light of this, the definitions in the postwar moment of a renewed autonomous visuality have had the effect of distorting or prohibiting both foundations—that of historical memory as well as that of discursive memory—in order to position the new type of autonomous visuality within a radically different register altogether.

Recruiting References

In the recruitment of figures to act as reference points for the discursive memory of the French neo-avant-garde of the 1950s (indeed, for every European country at that time), it is therefore not uncommon to encounter peculiar pairings whose immediate compatibility with the practices of the present is far from evident or even plausible. Thus one could argue that Yves Klein's most crucial reference figure from within the historical avant-garde (all the more emphatically denied) was Kazimir Malevich, while at the same time Jean Dubuffet represented the local postwar generation with whom Klein found himself in a dialogue of disavowal

5. Again, there are obviously eminent counterexamples to that rule, most notably figures such as John Heartfield, Josep Renau, and others, who—responding to the rise of Fascism—either changed the definition of artistic practice altogether, or mobilized political opposition because they considered it necessary that the definition of "culture" remain linked to the question of political consciousness, critical opposition, and the transformation of everyday life. The focus of this essay, however, is precisely the question of the immutability of the mainstream of Modernism (e.g. Mondrian), its paradigmatic definitions of visual modernity, and its immediate, almost fanatical reconstruction in the postwar period. Once mainstream Modernism had been reestablished, the countermodels were forgotten at any rate, or excluded for a long time, or considered downright unacceptable. Furthermore, I would like to emphasize that this argument is not an ethical, but primarily a historical one, an argument that attempts to give a descriptive account of what type of definition of "visual culture" was actually operative in the moment of postwar reconstruction. Once the consequences and implications of such a description have become evident, however, I would not want to exclude the possibility that an altogether different position and valorization might have to be given to the concept of visual culture in the postwar period.

6. Maurice Blanchot, Vicious Circles (Paris: 1985), p. 68.

7. For an excellent discussion of the theoretical and historical dimensions of the problem of literature's confrontation with the experience of war in the prewar and postwar periods, see Denis Hollier, Absent Without Leave: French Literature Under the Threat of War (Cambridge, Mass.: Harvard University Press, 1997).

RIGHT Yves Klein, *Propositions Monochromes*, 1957, view of the exhibition at the Galerie Apollinaire, Milan, January, 1957

and displacement. An equally odd pairing could be traced within the artistic development of Arman, Klein's early companion, whose central discovery among the historical avant-garde had been Kurt Schwitters—as he has frequently acknowledged—and whose crucial encounter in the postwar period was undoubtedly Jackson Pollock.[8] (A third figure, the Dutch artist Hendrik Nicholas Werkman, historically as disconnected from Schwitters as from Pollock, would help Arman discover the importance of typography and, most importantly, the artisanally or semimechanically produced graphic sign serving as a pictorial device.) Obviously the actual network of relationships and influences in the formation of postwar artists was infinitely more complex and subtle than examples of reference figures given here could indicate. But the purpose of these examples is to obtain a first insight into the peculiarly contradictory structures of postwar cultural identifications and interests; it allows us to see how European artists blindly reached for (decontextualized) prewar paradigms of the European avant-garde from which they were totally disconnected, or American models of postwar production with whom they in fact shared hardly any historical experience at all.

Yves Klein: Abstraction's Afterlife

In 1954, with the publication of Klein's books *Yves Klein: Peintures* and *Hagenault: Peintures*, abstraction appeared in France for the first time as a conceptual metalanguage.[9]

Dissecting abstraction's historical corpse—which two generations had already attempted to resurrect in vain during the postwar reconstruction of Modernism—Klein uncovered its mechanical and institutional organs, the technical aspects of its formal conventions, and its fictions of signification.

In Klein's two books these emerged with an allegorical clarity that occurs only rarely—in those moments when artists glimpse the profound obsolescence of their epistemes. The two publications, which ostensibly give an account of Klein's extensive production of monochrome paintings (their sizes and dates, their site of production, sometimes even the location of their collection), are entirely

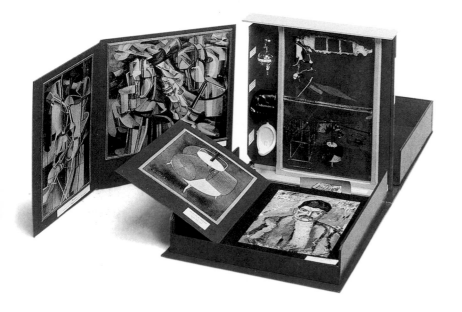

LEFT Marcel Duchamp, *La boîte-en-valise*, 1935–40, leather valise containing miniature replicas, photographs, and color reproductions of works by Duchamp, 1955 edition, 40.7 × 38.1 × 10.2 cm. Collection of the Musée d'art, Geneva

8. For a discussion of Arman's relationship to both Schwitters and Pollock, see the interview and chronology by Daniel Abadie in the exh. cat. *Arman*, ed. by Abadie (Paris: Galerie nationale du Jeu de Paume, 1998). For an earlier and more detailed account of Arman's relationship to Schwitters, see Catherine Millet's interview with Arman in "Arman: qualité, qualité," *Art Press*, vol. 8 (December, 1973), pp. 14–17.
9. For a detailed description of these two publications, see Sidra Stich, *Yves Klein* ([exh. cat.] London: Hayward Gallery, 1995), pp. 45–46.

LEFT Yves Klein, *Propositions Monochromes*, 1957, view of the exhibition at the Galerie Apollinaire, Milan, 1957

text consists of black lines filling the white pages) conforms to just that voiding of meaning as plenitude and presence that one associates with allegory. If comparable to anything at all, the radicality of Klein's miniature monochromes reminds one of Duchamp's decision in the late 1930s to shift even the readymade object into the register of technical reproduction by generating miniature replicas for his *Boîte-en-valise* (*Box in a Valise*).[10]

Klein's treatment of the phenomenon of color as the presumably last empirical evidence of a naturally anchored visuality is analogous to his suppression of the mono-chrome's objecthood. His pretense to have "invented" the monochrome is matched by his equally fraudulent claim to have invented International Klein Blue (merely a variant on the Symbolist *azur*, visible in the luminous pastels of Odilon Redon since the 1890s). Both claims are now wildly outdistanced by his attempt to file for a patent on the previously natural phenomenon and to coin a brand name for the hue, incorporating it under its initials, IKB. The property claims and the administrative-legalistic approach toward the phenomenology of color make two implicit declarations simultaneously. They acknowledge the parameters of a post-Duchampian aesthetic as inevitable at the same time as they are a callous enactment of the insight that the postwar aesthetic would have to be founded as much on the allegorical ruins of the historical avant-garde as on the mechanisms of an increasing fusion of the art object with the commodified object of spectacularized consumption.

Klein's notorious 1957 exhibition at Milan's Gallerie Apollinaire of eleven identical, differently priced, blue monochromes (subtle variations being discernible only in the surface texture of the paintings) could be seen as the first climax of that newly forming aesthetic. It was not just the exhibition's emphasis on seriality and repetition, on painting as *production*, that made it legible as a major departure from all previous forms of abstraction; perhaps even more it was the fact that from the start, instead of considering the order of the "exhibition" as a mere accumulation of individual works, Klein con-

fictitious. They constitute the first instance in which the paradigm of the monochrome so central to Modernism (given all of its claims for presence and purity, optical and empiricist self-evidence) has been programmatically shifted to the registers of linguistic, discursive, and institutional convention.

In order to clarify the historical specificity of Klein's restructuring of the monochrome, it is productive to compare his work with that of Ellsworth Kelly (a project we cannot undertake here in the detail it deserves), the first artist of the postwar moment to resuscitate monochromy in a programmatic fashion. The confidence with which Kelly was able to continue a commitment to an ontology and a phenomenology of the monochrome (even in his most radical works such as *Window: Museum of Modern Art Paris*, 1949) was unthinkable for Klein. For Klein, the visual object had to be ripped out of its age-old embeddedness in substance and texture, in matter and tactility, and handed over to a new condition of ostentatious exposure and spectacularity.

At the very moment of Klein's (fraudulent) claim to have "invented" the monochrome, he presents it as already absent, accessible only through fiction, technical reproduction, and institutionalized distribution. Even the literal "erasure" of the catalogue's introduction by Claude Pascal (his

10. To what extent Klein was not only familiar with Duchamp's work, but deeply attracted and affected by it at an unusually early date is evidenced for example by the fact that he offered his close friend Arman, as early as 1948, the catalogue of the famous Surrealist exhibition at the Galerie Maeght with Duchamp's notorious cover of a foam-rubber breast, entitled *Prière de toucher* (Please touch). See Arman in conversation with Daniel Abadie, in the Galerie nationale du Jeu de Paume catalogue *Arman*, p. 44.

ceived the painterly work itself as being on the order of an "exhibition."

This ambiguity is exacerbated by Klein's decision to mount the seemingly identical paintings on stanchions. Unexpectedly, the monochrome panels now appear—far from self-reflexive and autonomous—as contingent hybrids between autonomy and a semifunctional object in need of a prosthesis for public display. Suspended between the pictorial convention as *tableaux* and their newly gained commission as *signs*, these paintings articulate a strange dialectic of pure visuality and pure contingency.[11] Finally, and perhaps most paradoxically, Klein subjects the serialized, quasi-identical paintings to a willful hierarchical order of exchange value, thereby articulating yet another opposition, that between what he termed "immaterial pictorial sensibility" and a randomly assigned price.

Thus at the very moment of the work's conception it is possible to witness the extent to which Klein programmatically enacts the internal conflict between painting as a self-sufficient substantial object and painting as a merely contingent structure utterly dependent on an array of devices and discursive conventions that had heretofore been hidden from the view of abstraction.

Then, with inexorable logic, Klein shifts the scale of the framing device: from the level of easel paintings as semifunctional display panels to the level of architecture itself. This occurs in his first installation of *Le Vide* (The void) in 1958, and thereby completes the first phase of his project of an aesthetic of contingency.[12] Yet by declaring the empty gallery space itself as the work and by claiming it at the same time as a zone of heightened pictorial, protomystical sensibility, he once again mobilizes the full range of contradictions already manifest in the preceding projects. Even the quintessentially Modernist strategy, that of a rigorously self-critical reduction to the essentials of genre, convention, and category, is transferred by Klein onto a new qualitative and quantitative level: the exposure of the voided architectural container.

But Klein's spatialization of painterly reductivism—his

endowing of empiricist specificity with the dimensions of architecture—does not at all resemble the qualitative shift that had occurred in earlier instances of Modernity where pictorial self-reflexiveness had also suddenly reached—via the mediation of the relief—an architectural dimension. In these instances the architectural dimension pointed toward a dialectical sublation in which the intimacy of a reflexive visual experience is transformed into a tactile culture of simultaneous collective reception (as, for example, in El Lissitzky's *Proun Room* in Dresden, 1924). Perhaps even more important is a comparison between Klein's *Le Vide* and Lissitzky's subsequent installation of the *Abstract Cabinet* in Hanover (1926–28), where the phenomenological examination of painting's visual condition itself becomes the subject of a critical historicization, and the critique then becomes the defining principle of both the move to real space and the architectural design; in this Lissitzky could be seen shifting from visual to institutional analysis, from phenomenological space to discursive space, from simultaneous collective perception to the public space of archival order.

Through this comparison the specificity and historical differences of Klein's approach become strikingly evident. For if the earlier transition from monochrome painting to architectural installation had initiated a critical reflection on the unique, aura-infused object's relationship to the institutions of the public sphere and their historically specific audiences, in Klein's *Le Vide* this historical and theoretical spectrum is not even present as a trace. As in all other steps taken by the artist at that time, this is a project

11. Klein's Milan show is a forecast of painting's fate in Andy Warhol's hands in that it anticipates Warhol's own version of a prosthetic installation: propping up his *Campbell Soup* paintings on shelves when he first exhibited them at the Irving Blum gallery in 1962.

12. The awareness of the shift to architecture was common in the thought of that generation; this is evident not only in Klein's subsequent execution of murals for the Opera House in Gelsenkirchen, Germany, and of his designs for utopian architectural projects, but also in the fact that Pierre Restany announced Arman's exhibition *Le Plein* at Iris Clert's (the successor of Klein's *Le Vide*) in terms that explicitly pointed to the architectural dimension of the event:

"*Un évènement capital chez Iris Clert en 1960 donne au nouveau réalisme* sa totale dimension architectonique [*my emphasis*]. Dans un tel cadre le fait est d'importance. Jusqu'à présent, aucun geste d'appropriation à l'antipode du vide n'avait cerné d'aussi près l'authentique organicité du réel contingent.

(A crucial event at the Iris Clert gallery in 1960 gave a *total architectonic dimension* [my emphasis] to Nouveau Réalisme. In such circumstances, this fact is important. Up to that point, no gesture of appropriation to the nether extreme of *the void* had encompassed so closely the authentic organicity of the contingent real.)"

Quoted in Catherine Francblin, *Les Nouveaux Réalistes* (Paris: Éditions du Regard, 1997), p. 89.

in which the critical aspirations that the historical avant-garde inherited from the Enlightenment are reversed into a practice of newly enforced mystification. Thus the repression of the *historical* dimension in Klein's work originates first of all in the repression of *discursive* memory. Rather than reflecting on the basic implications of Lissitzky's act of foregrounding the support structure of the institutional display surfaces (museum, gallery, cabinet, exhibition) where radically altered conditions of viewing were incorporated into the formal transformation of the aesthetic object, Klein's *Le Vide* embraces the opposite agenda. Not only does it flaunt its disavowal of any predecessors but, more importantly, it displays an inability or a refusal to reflect on the actual implications of Modernist paradigms and their historical specificity concerning the conventions of vision, the construction of spectators according to class, and the discursive order of architectural and museological systems of display.

Thus even a strategy like the systematic withdrawal of perceptual information is seen to be dramatically altered in the postwar moment. At one time the notion of an autonomy of the visual had been constitutive of a new self-awareness on the part of the spectator, one that could gradually lead away from the empirical certainty of the visual to one of epistemological doubt. In Klein's hands, however, the withdrawal of perceptual data does not wean his audiences from the dependence on an ontologically and phenomenologically grounded visuality; instead his void functions as a well-calibrated shock effect for the already initiated, allowing them to partake in a silent consensus that the neo-avant-garde and its increasingly professionalized apparatus are complicit in the initiation of every potential perceiver into the spectacularization of experience.[13]

The subjection of the aesthetic to that process always operates in tandem with the upsurge of myth, yet without this process of "mythification" ever receiving the critical reflection that theoreticians like Roland Barthes would develop in that same moment in their attempt to dismantle the ever-increasing infusion of myth into the everyday life of postwar France. In this sense Klein's renewal of avant-garde devices constitutes a counter-Enlightenment project. For, intentionally or involuntarily, it seems at all times to coincide with the socially governing forms of mythification, never opposing them critically nor surpassing them in an excess of irrationality.

Thus Klein initiates his painterly project as a paradox, one in which the aesthetic object in its dimensions as self-sufficient and spiritually transcendent is both energetically reclaimed and simultaneously displaced by an aesthetic of the spectacularized supplement. Yet, to the same degree that Klein recognized that a Modernist aesthetic of spiritual or empiricocritical autonomy had failed, he incessantly questioned the fate of these aspirations once the spaces of the avant-garde had been increasingly colonized by the culture of spectacle. Therefore Klein could not simply deliver the legacies of abstraction without making the persistence of abstraction's spiritual afterlife evident—after all, the death of painting was one of infinite deferral—an afterlife of uncanny returns, now paradoxically bound up with the new order governing visuality.

Klein's attempt to redeem these obsolete models of aesthetic spirituality, while accelerating their subjection to the advanced principles of spectacularization, also counteracted what he must have perceived as the threatening prospects of a renewed critical secularization of culture. Formulated by writers, phenomenologists, and psychoanalysts at that very moment of the 1950s, this critique provided a radically different answer to the crisis of humanist models of culture. Klein's notorious and aggressively voiced contempt for Sartre and for political critique from the left is but one case in point. What makes Klein's work inescapable is precisely its construction of this epistemic couplet: that the attempt to redeem spirituality with artistic means at the moment of the rise of a universal control of consumer culture would inevitably clad the spiritual in the sordid (involuntary?) guise of travesty. By making his work manifestly dependent on a set of previously hidden *dispositifs* (e.g. the spaces of advertisement and the devices of promotion), he

13. This attitude is beautifully expressed in Denyse Ruand-Ruel's introduction to the second volume of Arman's catalogue raisonné, where she recalls her first encounter with the works of Yves Klein and Arman:

"My first encounter with Arman's work was completely unexpected, surprising even, since it took place in my home, at the beginning of the Sixties. I came in and found my apartment filled with strange works: blue monochromes, dismembered musical instruments, old objects. . . . My husband had fallen in love at first sight and had bought a complete exhibition of Yves Klein and Arman! All the art of the epoch is before me in one fell swoop. What strength, what imagination, what a profusion! I was disturbed, but suddenly, everything became clear. That freedom, that audacity fascinated me, I saw art in a different way. . . . A shock!"

See Denyse Ruand-Ruel, *Arman*, catalogue raisonné, vol. II (Paris: Éditions de la Différence, Paris, 1991), p. 9.

would become the first postwar European artist to initiate not only an aesthetic of total institutional and discursive contingency, but also one of total submission to spectacle.[14]

Arman: The Shelf Life of the Readymade

After my Void *came Arman's* Full-Up. *The universal memory of art was still lacking this definitive mummification of quantification.*

Yves Klein[15]

In reality, I always commit the same act of conservation: I show the condition of catastrophe.

Arman[16]

What Walter Benjamin had famously said of Eugène Atget's photographs in 1936, that they "withdrew the aura from the photograph as though water was pumped from a sinking ship," could be said about the effect Arman's first *accumulation* had on the paradigms of the readymade and the *objet trouvé*. In 1953, at the time when the artist decided to abandon his *empreintes-objets* (where the object had only served to produce a painterly imprint on the canvas) in favor of the direct presentation of the object itself, the ramifications of neither paradigm had been particularly recognized in France.

LEFT Joseph Cornell, *Museum*, 1942, wooden box with 20 small bottles containing various elements 5.5 × 21.5 × 17.7 cm. Collection of the Musée national d'art moderne, Centre Georges Pompidou, Paris

Arman's formal principles and procedures of production—if that is what his cumulative collections could still be called—demarcate a distinct break with the legacies of Dada and Surrealism. Their primary *modus operandi* could be somewhat schematically described as the iterative act of finding (itself quasi-mechanical when compared, for example, with Duchamp's notion of a *rendezvous* with the readymade or with André Breton's ritualistic discovery of the *objet trouvé*), and as serial multiplication, both operations generating a proliferation of similes or identical objects. Nevertheless, Arman's structural or iconographic decisions could be misunderstood—at least initially—as introducing only minuscule differences between his work and the aesthetic of the object that had governed the historical avant-garde.

One dimension of Duchamp's paradigm had certainly been the affirmative celebration of a technical modernism and a scientifically organized mass culture and it had indeed pointed—as much as Le Corbusier's work or that of the Soviet artists—to its radically democratic and participatory potential (his statement about America's singular cultural achievement consisting of the building of bridges and the provision of urban plumbing testifies to such an attitude). At the same time, Duchamp's readymades proposed that the embrace of the industrially produced object folded within itself the promise of an emancipation from the aesthetic of skill and virtuosity as well as from an aesthetic of aura and myth.

The readymade was marred by a structural paradox, however, one that Guillaume Apollinaire had detected as early as 1913.[17] Within the multiple conditions of the reproduction, the readymade's heroic and hieratic implications imbued it with an almost monumental singularity.[18] By contrast, a seemingly infinite multiplicity—quite unlike Duchamp's hieratic uniqueness—appears in Arman's *accumulations* for the first time. As the record of the actually limitless expansion and repetition of object production, it provides its spectators with ample evidence of the end of the utopian object aesthetic. Structuring the work as a grid

14. The only other contestant for an approach that one could adequately call proto-conceptual would of course be Rauschenberg in the American context where a similar transformation of the substantiality of the plastic enterprise gives way to its increasingly supplemental and allegorical analysis, as is most evident, for example, in his notorious *Erased de Kooning Drawing* from 1953.
15. Yves Klein, cited in Bernard Lamarche-Vadel, *Arman* (Paris: Éditions de la Différence, 1988).
16. Arman, in conversation with Daniel Abadie, "L'archéologie du futur (An Interview with Arman)," in the Galerie nationale du Jeu de Paume catalogue, p. 37.

LEFT Arman, *Premier portrait-robot d'Yves Klein*, 1960, personal belongings in wood box sealed under Plexiglas, 76 × 50 × 12 cm. Collection of Mme Rotraut Moquay-Klein, Arizona

found object's darker underside, giving it the uncanny, premature appearance of obsolescence. Operating spatially and temporally, this subversive exemption opened up a double view where, on the one hand, the object's obscene urgency withered into the *démodé* (opening up the object's mnemonic spaces) and, on the other, its premature aging dissolved its compulsory structure in the present (the compulsion to produce it in order to generate exchange value, to acquire it as the subject's own substitute).

But even when we compare Arman to the final phases of a surrealist aesthetic of the object, as this operated, for example, in the work of Joseph Cornell—who is historically closer to Arman and whose assemblages appear at times structurally analogous to Arman's *accumulations*—the comparison illuminates considerable differences. If at times Cornell's boxes reach a comparable level of repetition and serialization, their morphology and spaces of presentation always remain open to an act of projection on the part of the spectator. In that the mnemonic dimension of Cornell's boxes is already embedded in their framing and presentational devices—reminiscent of the shrine, the miniature, and the *wunderkammer*—they seem to want to redeem interiority. These are the very aspects that have been purged from Arman's *accumulations*, so that they now appear as mere reiterations of a pure and unmediated facticity.

Thus Arman's aesthetic neither shares the utopian promise of the technoscientific avant-garde nor does it engender the oneiric freedom of objects that have been liberated—if by no other force than the passage of time—from their services and functions. This not only is evident in the choice of objects Arman makes in the first five years of his *accumulations*, it becomes even more pertinent in their spatial and structural arrangements. Two formal principles, both central paradigms of Modernism, determine the structural organization of Arman's *accumulations* as also his slightly later *poubelles*. The first is the post-Cubist grid as it had been inscribed in the work of numerous artists of the 1920s. The second is actually a double paradigm in that it

17. It is the same paradox that had also troubled the initial collage and photomontage works in 1919: to have become a *unique* artistic object about technical reproduction, but not yet a technically (re)-produced artistic object.
18. Apollinaire's discussion of the hieratic appearance of Duchamp's work is to be found in his *Les Peintres Cubistes* (originally published in 1913) (Geneva: Éditions Pierre Cailler, 1950), p. 76.

"*Cet art peut produire des oeuvres d'une force dont on n'a pas d'idée. Il se peut même qu'il joue un rôle social. De même que l'on avait promené une oeuvre de Cimabué, notre siècle a su vu promener triomphalement pour être mené aux Arts et Métiers, l'aéroplane de Blériot tout chargé d'humanité, d'efforts millénaires, d'art nécessaire. Il sera peut-être réservé à un artiste aussi dégagé de préoccupations esthétiques, aussi préoc cupé d'énergie que Marcel Duchamp, de réconcilier l'Art et le Peuple.*

(This art is capable of producing works of unimagined power. It is even possible that it plays a social role. Just as a work by Cimabue once used to be displayed on parade, our century has seen paraded triumphantly to the Arts et Metiers, Blériot's airplane, filled to capacity with humanity, millenary efforts—necessary art. It will perhaps become the job of an artist as detached from aesthetic concerns, as preoccupied with energy as Marcel Duchamp, to reconcile Art and the People.)"

of mechanically reproduced, identical or similar items from all realms of consumer culture, Arman corrects the structural paradox of Duchamp's readymade from the outset: if Duchamp had only mused that at some point the galaxy of objects in its entirety could acquire the status of the readymade, Arman fulfilled this Duchampian prognosis.

But the utopian object's emphasis on progress had already been counteracted in the Surrealist *objet trouvé*. To reveal the future as one of increasing fetishization and domination by consumption, Surrealism had unveiled that

fuses two other major principles of Modernism: chance encounter and the random organization of matter according to the physical laws of gravity.[19]

Unlike the definition of the chance encounter of heterogeneous objects, summed up for the Surrealists in Lautréamont's famous dictum, in Arman's *accumulations* the encounter between the refuse of production and the residue of consumption neither sets off a traditional poetic spark nor does it open up a mnemonic space to invite the contemplation of the rapidly changing subject-object relationships within expanding industrial production. In Lautréamont's unanticipated encounters, the object's ambiguity between promise and menace still had a demonic drive as it invaded the temporal and spatial dimensions of the formation of the subject. But now that drive has been literally and metaphorically flattened. In Arman's project all objects appear as so many specimens of an unclassifiable world of arbitrary variations and expansions; further, they have merely been arranged according to the universal order of production and the administration of sameness.

At first sight we might speak of Arman's *portraits robots* (robotic portraits)—as in *L'Affaire du Courrier* (The mail affair, 1961), or *Premier portrait robot d'Yves Klein* (First robotic portrait of Yves Klein, 1960)—as setting up a visual correlative to the written stream of consciousness that had been introduced into French literature by Edouard Dujardin in the late-nineteenth century. Here, however, the stream of free associations, fleeting thoughts, impulses, and psychic intuitions appears as a barrage of objects of banal daily usage, with the subjectivity of the portrait's sitter either fully suspended or manifestly constituted in nothing but multifarious constellations. Striking, for example in the portrait of Klein, among an infinite number of items of mundane trash, is the half-submerged, half-epiphanous appearance of Gaston Bachelard's philosophical pamphlet *La terre et les rêveries* (The earth and reveries), and the photographic portrait of Klein himself peeping out from the corner of the display case. Other *portrait robot* sitters, such as Eliane (Arman's first wife), appear less fortunate since no such programmatic philosophical attribute (unless one

considers Wagner's *Parsifal* its equivalent) is to be found in their vernacular objects of sign-exchange value.

Linguistic iteration, the principle according to which subjectivity is constituted in the production of speech, finds its objective correlation here in the repetition of the act of choosing the object of consumption. Thus Arman's work can no longer propose a radical equivalence between the self-constitution of the subject in the speech act and the constitution of the self in the act of material production, as Duchamp had still performed it in his initial readymade proposition. Rather, the *portrait robot* seems to accept as irreversible fact that the constitution of collective subjectivity now springs from the mere identification with sign-exchange value.

That the destruction of traditional concepts of subjectivity in the immediate postwar period had reached a heretofore unknown industrial scale was one of the conditions that necessitated these new parameters in Arman's restructuring of the readymade and the *objet trouvé*. The fact that his work is dominated by the image and the object structure of "trash" thus ultimately corresponds to a condition—as the term's American metaphorical usage explicitly suggests—of collectively failed subjecthood that demarcated post–World War II reconstruction culture at large as all traditional forms of the articulation of the bourgeois subject had lost credibility. Without wanting to falsify the inevitably limitless choices of Arman's object aesthetic (and recognizing not only the fact that it is integral to his work that any and all objects qualify as the carrier of sign-exchange value, but that they have to be without limits as well in their literally unstoppable intrusion into all

19. Arman was apparently quite conscious of the complex implications of these strategies since he described them with almost programmatic clarity in hindsight: "In the first *accumulations* havoc reigned and the objects found their place on their own, they had a tendency to compose themselves according to the law of gravity." See Arman in conversation with Abadie, in the Galerie nationale du Jeu de Paume catalogue, p. 45.

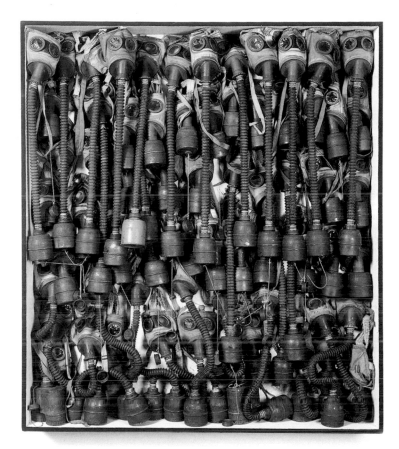

ABOVE Arman, *Home Sweet Home*, 1960,
accumulation of gas masks in a box sealed under Plexiglas,
160 × 140.5 × 20 cm. Collection of the Musée national d'art moderne,
Centre Georges Pompidou, Paris

structures and spaces of subject formation—privacy, interiority, sexuality), one cannot help seeing that some objects in Arman's warehouse are more prone to interpretive projection than others. Thus his accumulations of dentures, of reading glasses, and of gas masks, as well those made out of the hands of puppets, seem to echo the accumulations of clothing, hair, and private objects that Alain Resnais recorded in *Nuit et Brouillard* (*Night and Fog*, 1955), the first filmic documentary account of the German Nazi concentration camps.[20]

The potential, if not the already existing industrialization of death appears as the inexorable counterpart of the subject's destruction at the hands of industrialization.

In their extreme forms, Arman's *accumulations* and *poubelles* cross the threshold to become memory images of the first historical instances of industrialized death. But the temporal dialectic of these *accumulations* is such that at the very moment when they seem to be contemplating the catastrophic destruction of the recent past, they open up a glimpse toward the imminent future. Anticipating another form of the industrialization of death, Arman's immobile arrangements stare at an emerging ecological catastrophe resulting from an ever-accelerating and expanding consumer culture and its increasingly unmanageable production of waste.

As in the climactic moment of Klein's *Le Vide* in 1958, Arman recognizes that these changes within the formation of the subject and the experience of the object will become most compelling when the evidence is shifted from the space of the object to the space of architecture. Accordingly, his *Le Plein* (Full-up) at Iris Clert's gallery in 1960—the dialogic response to Klein's work—would become one of the single most important paradigmatic changes in the sculpture of reconstruction culture.[21]

It had already become obvious in the *accumulations* and the *portraits robots* that Arman understood that from now on sculpture would have to be situated exclusively within the presentational devices of the commodity (such as the vitrine and the shop window), and that the museological conventions of exhibiting sculpture would be increasingly

20. Arman has recently confirmed that he saw the film upon its release and remembers it as having had a profound impact on him. Interview with the author, March, 1998.
21. The only other comparable event in the transformation of European postwar sculpture is Jean Tinguely's *Hommage à New York*, installed and executed at the Museum of Modern Art in New York in 1960. As with Arman's *Le Plein* and Klein's *Le Vide*, the magnitude of the structure serves first of all to accommodate the transition from the visuality of the object to the dimensions of spectacularization, not the conception of architectural public space. As with Arman's *Le Plein*, the entropic condition of the structure operates as a total denial of all the previous forms of object perception and spatial perception that the readymade and the surrealist tradition had suggested.

displaced by the display conventions of the department store (as was already evident with Klein's paintings in the Gallerie Apollinaire). *Le Plein* alters all the sculptural components and conventions of exhibition by totalizing the order of commodity production; by pushing that order beyond the level of excess and into its inversion as the commodity's alternate state (that is, waste), it thereby conduces within the commodity itself an allegorical image of the death of production and the production of death.

All forms that had traditionally juxtaposed the private experience of the object with the "public" dimension of sculpture (the separate volumetric body in virtual space, the bases negotiating with actual and ambulatory space, the museological display) are annihilated in *Le Plein* by its construction of a quintessentially entropic space. First of all, such an entropic condition denies the transition from individual, contemplative perception to a simultaneous, collective perception that had determined the radical shift from the relief-object to the architectural dimension in the work of the historical avant-garde.

The spectator is now positioned within a structure whose suffocating plenitude refuses both the hieratic singularity of the readymade and the contemplative ambiguity of the *objet trouvé*.[22] To clarify Arman's transformations of the sculptural object and of sculptural space further, we should look at one more example, produced a few years after *Le Plein*, in which the criteria of the neo-avant-garde's object aesthetic appear in an almost programmatic fashion. When commissioned by one of his most ardent collectors to produce a large sculpture, Arman followed up on an earlier group of works collectively titled *Les colères* (Tantrums) in which he had attempted to mechanize automatism so as to divest it fully of its last links to a surrealist, psychoanalytically informed concept of the unconscious. Requisitioning his patron's white MG convertible, Arman detonated a small quantity of dynamite underneath the car in a quarry near Düsseldorf and returned the remnants of the explosion as the sculpture *White Orchid* (1963).

Here, all the elements that constitute the aesthetic of reconstruction culture have been integrated. First of all, the readymade object now appears, if not incessantly multiplied, then as significantly enlarged and as unambiguously contained in the quintessential object of sign-exchange value, of accelerated consumption, and of planned obsolescence: the car. Second, the relationship between artist and patron now appears as a contract of prearranged scandal (somewhat reminiscent of the prearranged patricidal scandal of Robert Rauschenberg's *Erased de Kooning Drawing* in 1953). This orchestration redefines the newly emerging structure of patronage as one of mutually beneficial artistic/economic exchange, so that the work serves as an event from which both artist and patron (typically in this case, as in many others, an advertising agent) will benefit equally, since the public-relations fallout to be expected from such a "coup" against the traditional relationships between the collector and his cherished objects of possession was considerable. Thus Arman clearly circumscribed the parameters of critical analysis within which the neo-avant-garde would operate from now on, or rather, within which it would be recuperated.

And lastly, by singling out a car model that in Germany at the time would have been clearly perceived as the apex of luxury consumption and by subjecting it to a staged spectacle of destruction, Arman literally detonated the quintessential symbol of German (if not European) postwar repression and disavowal. Yet, by employing the very technology of war to blast open the repressive apparatus and thus to resuscitate the memory from which repression attempted to escape, Arman constructed a peculiar paradox, submitting the

LEFT Arman, *White Orchid*, 1963.
Collection Charles Wilp

body of sculpture simultaneously to anamnesis and spectacle, to reminiscence and repression.

This duality, then, seems finally to describe a crucial condition of the artistic projects of the moment of 1958.

What we witness in both Arman and Klein is probably the first instance of a new aesthetic in which the dialectic of inexorable anamnesis and inevitable spectacularization is continuously played out. On one hand, opposition to collective repression of the historical is never systematically articulated, yet for all that the artistic structures seem to inscribe themselves mimetically within the discursive as well as the historical apparatus of disavowal—if not exploding it from within, as literally in Arman's example, then making it continuously surface as evidence of inauthenticity and disavowal. On the other hand, the traditional distinctions within the world of avant-garde culture between the task of critical negation and that of radical transcendence are now abandoned in favor of a seemingly inescapable assimilation to the very apparatus that the avant-garde had historically opposed (the spheres of consumption as organized through fashion, advertising, and product design).

It is important, however, to recognize the extent to which it is first and foremost in the field of the *visual* (rather than that of the literary or the poetic) that the apparatus of historical repression and the apparatus of spectacle are firmly installed. For it is as though the specialists of visuality were the (in)voluntary forerunners of a new de-differentiation of the senses. From the start what contaminates their radicalness and distinguishes their seemingly aggressive acts from the redefinition of artistic paradigms in the moment of 1913–1919 is first of all the fact that these postwar artists conceive of shock and its audiences, as well as its institutional frameworks, as a calculable set of factors, with which a consensus will be eventually achieved, if not immediately reached.

22. For a discussion of the concept of the entropic in terms of sculptural production of the Sixties see: Yve-Alain Bois and Rosalind Krauss, *L'informe* (Paris: Musée National d'Art Moderne, Centre Georges Pompidou, 1994).

FRENCH FILM AT THE MIRROR:
THE CULTIVATION AND DEFACEMENT OF THE LOOK [1]

DUDLEY ANDREW

Masaki Kondo, a specialist in French theories of the image, proposes cinematography as a descendant of the camera obscura, which he describes as an immense optical organ capacious enough to contain a human being who, standing within it, traces the images formed by the world on its back wall, its retina. Both technologies offer a view of the world which is indirect at best (because inverted, framed, or reflected); both are beset by that fundamental epistemological obscurity which Plato defined for all time in his analogy of the cave in *The Republic*. "Plato's cave was a sort of skull, a dark chamber with no 'body' in it, but a body lived under the skull imagining the actual world to be always moving. This dark chamber with no 'body' in it was to be a photographic camera."[2]

The cave is parent to the movie theater even more than to the camera box, since captive spectators gaze at images reflected from its rear wall. These images are given to be reflected upon, generating a mental echo-effect in the spatial volume of their projection. To highlight this effect, Kondo changes the analogy slightly and references Roland Barthes' *Camera Lucida*, "This delayed reflection, the reflection with a time gap, is an empty vessel of porcelain with an image printed on the bottom where imagination

flows in to dress the image with a personal history."[3] Thus, traces fixed on photographic film displace the visible both spatially (from the world to the screen) and temporally (from the moment of their capture to that of their projection, and then of their interpretation): "difference in space and deferral in time," to use Derrida's terms. Caves, porcelain vessels, and movie theaters are hollow sites within which images lose their two-dimensional character when put in play by the mind of the viewer reflecting on them.

To the intrigued spectator, modern French cinema could be described as a certain type of porcelain vessel (generally slender, shapely, but brittle), with particular genres of tantalizing images imprinted on the bottom which give off a subtle visual echo-effect that has become quite familiar. But, as we shall see, the mystique of the reverberant vessel (or cave or theater) gives way to the thinner figures of the mirror and the poster (*affiche*) in the case of a cinema whose claim to originality is staked on the proposition that the *Nouvelle Vague* (New wave) was the first movement in the history of cinema to take its inspiration quite openly from the history of cinema itself—rather than from the world or the broader culture. I hope to evoke the evanescent and multiple character of French cinema in the varying densi-

1. This essay took shape in conversation with Sally Shafto and owes much to her ideas, research, and examples. I am indebted to Jacques Aumont's writings, with which I (along with several University of Iowa graduate students) have been engaged for some time.
2. Masaki Kondo, "The Intersection of Mi (Me-Body) and Tai (You-Body) in Photography," Iconics 1, 1987, p. 5.
3. Kondo, p. 11. In a later essay, "The Impersonalization of the Self in the Image Society," IRIS 16, 1993, p. 38, he goes on to distinguish between images reflected in a spatial volume from TV images, broadcast from a cathode tube. Televisual immediacy offers no space or time for reflection. The eye merely intercepts rays directed indiscriminately from a central luminous point.

LEFT Claude Lelouch,
Un Homme et une femme
(A man and a woman, 1966),
film still

ties (thick or thin) that we accord its images and in the conflicting acceptations of the term "reflection" inevitably employed to acknowledge it.

II

Modern French cinema comes into focus best when seen from the outside, by a foreigner, as in Bernardo Bertolucci's *Il Conformista* (*The Conformist*, 1970), a film obsessed with France. In its most memorable and emblematic scene, Marcello Clerici (Jean-Louis Trintignant) meets his old Professor Quadri in Popular Front Paris, where Quadri has moved as a political exile. In Quadri's study, where the two men discuss philosophy and politics, Clerici reminds Quadri of his most stunning classroom lecture, a discourse on Plato's cave. Closing the blinds and standing in front of a bright lightbulb, Clerici transforms the study into the very mise-en-scène of the cave, in order to blame his own fascist turn on Quadri's impotence before Mussolini. Recognizing the uselessness of theory in the face of brute force, Clerici had joined the brutes. Quadri correctly surmises that Clerici is a fascist agent sent to harass or destroy him, so there in the dark, Quadri attempts to enlighten his former student, lead him out of his dim reasoning, and prevent him from harming him and Anna his wife (Dominique Sanda). Quadri argues that although the citizens of Italy are given nothing other than shadows to see, they are nevertheless capable of and individually responsible for extrapolating from them a morality based on the hidden realities they derive from. All judgment, he implies, comes down to reflection on reflections, that is, to a critical negotiation within the volume of the cave, based on the shadows playing off its back. This scene, the only one Bertolucci added to the Alberto Moravia novel from which the film was taken, speaks to the state of cinema in general but also, I am certain, to its particular plight in Paris. Like Clerici, Bertolucci made the journey from Rome to Paris to declare the impotence of a kind of cinema, the *Nouvelle Vague*, that had offered him such hope in his youth.

Il Conformista opens in a Parisian hotel room. Across the street, a neon marquee blinks in the rain, advertising *La Vie est à nous* (*The People of France*, 1936), the red light of the sign giving a devilish cast to Clerici's face as he waits for instructions from his fascist cohorts. Bertolucci's homage to Jean Renoir's Popular Front film, made when his political and cinematic ambitions were at their peak, might be said to rebuke the mannerism of Renoir's followers among the

LEFT Alain Resnais, *L'Année dernière à Marienbad* (*Last Year at Marienbad*, 1961), film still

New wave—especially Jean-Luc Godard, who had been Bertolucci's chosen mentor. Renoir's film, which played in France in 1936, fought to return a national landscape to the people, a landscape held hostage by two-hundred aristocratic families. The *Nouvelle Vague*, by contrast, never really addressed the people. By 1970, Godard had broken from this movement, had formed the Dziga Vertov group, had denounced Bertolucci as a *Nouvelle Vague* fellow traveller, and was spewing political slogans to an ever-shrinking audience of followers. Despite his own reservations about the *Nouvelle Vague*, Bertolucci no longer counted himself among Godard's followers, as a notoriously nasty reference in his film implies: from that same hotel room, Clerici places a phone call to Professor Quadri, so as to meet and then "eliminate" him. The phone number, "Medici 16–37," was, as it happens, that of Jean-Luc Godard.

Bertolucci said of the film, "*Il Conformista* is a story about me and Godard . . . When I gave the professor Godard's phone number and address, I did it for a joke; but afterwards I said to myself: 'Well, maybe all that has some significance. I'm Marcello and I make fascist movies, and I want to kill Godard, who's a revolutionary, who makes revolutionary movies, and who was my teacher.'"[4]

In its graphically oedipal struggle with French cinema,[5] *Il Conformista* develops a contrast between political and personal themes and between what might be called an Italianate taste for spectacle and the French concern with intimacy and mental life. Monumental Italian spaces (the Coliseum in the closing scene, the immense ministry in Rome where statues and emblems are transported around official fascist buildings, the Felliniesque asylum, the ba-

roque brothel in *Ventimiglia*)—all seem to be incarnated in the body of Clerici's exhibitionist fiancée, decked out in one flamboyant costume after another. French cinema, on the other hand—figured by Sanda's ambiguous, inscrutable, and self-contained coolness—has seldom exploited the varied landscape of the countryside. During the period of Neorealism's flow and ebb, it was consigned to meticulously dressed studio stages. Even when French cinema finally ventured outside in 1958, with those *Nouvelle Vague* disciples of Renoir, it discovered mainly a Paris of apartments and cafés where characters could seek their salvation in one another, through conversation and sexuality. Professor Quadri's apartment is a synecdoche for the closed interior space of French cinema; Clerici turns it, as we have seen, into Plato's cave.

Seldom expansive, French cinema rarely credits the sheer sight of things. A scrim of (self-) consciousness interposes itself and transforms each landscape into what Bruce Kawin once dubbed, in relation to Godard, a "mindscreen."[6] Think of Eric Rohmer's *Le Rayon vert* (*Summer*, 1986) where the scrutiny of nature, the search for a particular light, displaces and at the same time solves the solipsism of the main character.

Film history could have taken a path different from this: after all, cinema exploded into history in 1895 with Lumière's *La Arrivée d'un Train en Gare de la Ciotat* (Train entering the station at la Ciotat), an inarguably expansive, exteriorized French scene. Yet how few French train films, indeed how few French travelogues this inspired—especially after sound gave voice to consciousness. *La Bête humaine* (*The Human Beast*, 1938) stands out precisely as a

4. "Bertolucci on *The Conformist*," *Sight and Sound* 40, 1971, p. 66.
5. In Yosefa Loshitzky's *The Radical Faces of Godard and Bertolucci* (Detroit: Wayne State Press, 1995), Loshitzky uses Harold Bloom's term "Anxiety of Influence" as the title of her introduction. The opening chapter of Robert Kolker's *Bernardo Bertolucci* (London: BFI, 1985) is called "Versus Godard."
6. Bruce Kawin, *Mindscreen: Bergman, Godard, and First-Person Film* (Princeton University Press, 1978).

counterexample because it is a Renoir and because he filmed Emile Zola's train hurtling through the French landscape on location, against the general studio practice of the day. Godard, however, would bring Lumière's train back in *Les Carabiniers* (1963), for a comic scene which is set, of course, inside a movie theater: the hero, baffled and frightened by the image of the oncoming locomotive, tries to escape by stepping through the screen. French cinema seems obsessed more with the experience of cinema than with the world the cinema exhibits, seems far more concerned with the space of the movie theater and what can happen within it than with the magnificent and varied landscapes of France itself.

From Jean Cocteau's *Le Sang d'un poète* (*The Blood of a Poet*, 1930) and *Orphée* (*Orpheus*, 1950) to Alain Resnais' *L'Année dernière à Marienbad* (*Last Year at Marienbad*, 1961), the frame of the French screen opens onto the abyssal volume of the mind. Objects and persons (we dare not call them characters) float and lose themselves inside us as we watch. In a different way Raúl Ruiz's *L'Hypothèse du tableau volé* (*Hypothesis of the Stolen Painting*, 1978) and Marguerite Duras' *Le Camion* (The truck, 1977) transform the movie theater into a space that is inflated, then haunted by language, a three-dimensional mental space. In *Le Camion*, we see Duras herself reading the script of the film; then the images summoned by the words she reads appear on the screen, as if in the listener's mind. Exceptional films these are, but they point to a common tendency in French cinema. The masterworks of poetic realism—*La Bête humaine* is a good example, as is Marcel Carné's *Le Jour se lève* (*Daybreak*, 1939)—whisper an invitation to the spectator to enter the opening of the screen so as to follow the figure (invariably in the guise of Jean Gabin)[7] wandering out into an obscure milieu, a milieu that might readily be described as the spectator's own consciousness.

Leave it to Godard literally to stage this interior space of the movies. Midway through *Masculin-Féminin* (*Masculine Feminine*, 1966), Paul (Jean-Pierre Leaud) and his three companions sit in a tawdry theater watching an even more tawdry Swedish movie. Paul closes his eyes to the screen and in voice-over laments: "This wasn't the film we'd dreamed of. This wasn't the total film that each of us had carried within himself . . . the film that we wanted to make, or, more secretly, no doubt . . . that we wanted to live." Of course, Godard had already made such a film two years prior to this, in *Le Mépris* (*Contempt*, 1963). Set partially in Cinnecitta (with a memorable scene in its projection room) and another at a large theater on location in Rome, *Le Mépris* interrogates the cinema's profoundest metaphysical ambitions. Its credit sequence, recited in voice-over by Godard himself (à la Orson Welles), concludes with a citation (misattributed, as it happens): "Le cinéma, disait André Bazin, substitue a notre regard un monde qui s'accorde a nos desirs. *Le Mépris* est l'histoire de ce monde." (The cinema, according to André Bazin, substitutes, for our gaze, a world that corresponds to our desires. *Le Mépris* is the history of this world.) Meanwhile, Raoul Coutard's cinemascope camera, which we see thanks to another camera, pivots on its dolly and tilts to stare directly down at the spectator. This camera-eye is a figure of the gods framing their creatures. As for the conclusion of *Le Mépris*, after Camille (Brigitte Bardot) and Jerry (Jack Palance) have suffered a violent but cartoonish death on the highway, the filming of *The Odyssey* at last commences—for life must continue beyond the death of the gods, even beyond the deaths of their movie avatars (sex-goddesses and tyrannical producers). Fritz Lang's assistant (played by Godard naturally) gives the order, "*Silenzio*," while the camera filming this, the final shot of *Le Mépris*, tracks past the one at Lang's command. It tracks beyond Odysseus sighting Ithaca from his ship, until it loses itself in an unframed, unframeable image of a deep blue sea that is so uncaring it does not return a reflection, neither of Odysseus nor of the spectator. *Le Mépris* unrolls between the infinite dream of the spectator and the equally infinite disinterest of the universe.

In that film's notorious first sequence, Godard gives us a version of cinema opposite the one that yearns for "depth" and volume, for "mindscreen." Godard photographs the

7. Dudley Andrew, *Mists of Regret: Culture and Sensibility in Classic French Film* (Princeton: Princeton University Press, 1995), chapter 8.

pouting face of Bardot, an icon of French beauty, beside the timeless strength of Greek statues (mostly Roman copies of Greek statues). Following Roberto Rossellini's example in *Viaggio in Italia* (Voyage to Italy, 1953) Godard presents the movie goddess to be but a frivolous accumulation of body parts in comparison to the majesty of the painted statues. Her first scene stresses this: naked on a bed, she asks her doting husband Paul (Michel Piccoli): "Can you see my feet in the mirror? Are they beautiful? Do you love them? Do you love my knees too? Can you see my rear in the mirror? Are my buttocks pretty?" He mumbles his affirmations antiphonally as she dismembers in language the body that the camera caresses without a cut. "Then you must love me totally," she concludes. Throughout this litany, Godard bathes Bardot's naked torso and the movie screen in successive hues of red, white, and blue, to ensure that we take that screen as the pinup poster it is—a French one, given the color scheme. Bardot is ridiculed to be sure, but so is the cinema in toto, including *Le Mépris*, a rather silly version of Homer after all, filtered through the somewhat less silly sensibility of Lang, director of the film within the film, and the book from which *Le Mépris* was adapted, Moravia's *Il Disprezzo* (*A Ghost at Noon*, 1954).

Playing with both extremes as he so often does, Godard has opposed in this film the volume of the movie theater to the surface of the movie poster. In addition to Bardot featured as a pinup (in the opening scene and then sporadically throughout the film, including her final death pose), actual film posters can be glimpsed outside the two theaters mentioned above. Serving as homages to Howard Hawkes and Rossellini, among others, these posters at the same time ironize the pretensions of the cinema, flattening them against a wall, in the same way that Lang's grave historical wisdom finds its shallow, ironic counterpart in Jerry's minuscule book of aphorisms, a thumbnail sketch of philosophies from which he pronounces his clichés.

After *Le Mépris* Godard began regularly pasting flat pictures to the screen, to stand out frontally in solid colors, like the Colorforms children move about on plastic sheets. This is the "pop" Godard, justly compared to Andy Warhol and Roy Lichtenstein,[8] who reminds us derisively that French cinema since 1958 occasionally may have fathomed a metaphysical or psychological abyss, but that more often its search has stopped short at the screen. "Screen" may be a calculated misnomer, for in fact Godard finds us before a much less porous interface—road-blocked at the solid wall of the cave. With no way out, we are forced, at his hand, to focus on the picture affixed to the surface of that wall.

In the 1980s, *le cinema du look* certainly adopted this attitude, unqualified, however, by Godard's irony and ambivalence. Those popular neo-baroque films were born with *Diva* (1981), which might at first blush seem layered enough to be a descendant of the *Nouvelle Vague*. After all, the film turns on the difference between live performance—unrepeatable, authentic, fetishized—and its spiritually degraded, tape-recorded reproduction. Jean-Jacques Beineix, however, bartered away this opportunity for reflection, self-critique, and depth, by turning objects, music, and visual style into fetishes themselves. His subsequent *La Lune dans le caniveau* (*The Moon in the Gutter*, 1983), marvelous to look at, is thinner still, a gaudy postcard of a film. The ideas it contains pose like the actors who mouth them, or else they are hung dumbly above the story like the outsized moon that makes the cobblestones glitter. Beineix, his detractors remind us, has been able to move unproblematically between cinema and publicity ever since *Diva*.

Luc Besson, coming to cinema directly from the industries of music-video and advertising, has been even more satisfied with the two-dimensional film. Neither depth and thickness of character (*La Femme Nikita*, 1991) nor reflectiveness and temporal volume (*The Fifth Element*, 1997) gets in the way of his undeniably attractive pictures and trendy plots. The popularity of such films discouraged Serge Daney, who before his death spoke about the diminution of character and of the social in this cinema of visual pleasure which he found to be narcissistic.[9]

Most narcissistic of all is Jean-Jacques Annaud, some of whose early films, such as *La Guerre du feu* (*Quest for Fire*,

8. Peter Wollen, *Raiding the Icebox* (Bloomington: Indiana University Press, 1993), p. 158.
9. Serge Daney in a conversation with the author (Coventry, England, October 1989).

1982) and *L'Ours* (*The Bear*, 1988), effectively dispensed with character altogether so as to concentrate completely on kitsch effect. No wonder Desson and Annaud have been so easily integrated into Hollywood. Writing caustically of Annaud's adaptation of Duras's *L'Amant* (*The Lover*, 1992), Daney speaks of "an awkwardness, a clumsiness . . . in short the tragedy of a bad cut. . . . This time it's not because cinema is trying to overturn the dusty old rules that say 'how' one should cut, as in the days of *À bout de souffle* (*Breathless*, 1959). No, it's because Annaud's work no longer has anything to do with memory, sequence, time, montage. This is a cinema where there is no communication because everything is communicated. . . . The images queue up on a waiting list to be submitted for public approval, for instant endorsement . . . [they] have been selected by Annaud for the spectator in the same way as numbers are called out in bingo for players to cross off on their cards. . . . The spectator is trapped by his own feeble status as consumer decoder. He hasn't time to understand anything he didn't already 'know'—which leaves him with nothing, with the already-seen or the scarcely seen at all, with ads and logos, visuals and kitsch, in short with banalities and platitudes. . . . In an age of synthetic images and synthetic emotions, the chances of an accidental encounter with reality are remote indeed."[10]

Daney could have mentioned that the voice-over we hear at the outset of *L'Amant*, the voice of the heroine looking back on the tale many years later, belongs recognizably to Jeanne Moreau, an icon of the *Nouvelle Vague*, who was by that time virtually obsolete, except to endorse this product of French culture which Daney calls "a kind of *Emmanuelle* with a bit of literary gloss." This nasty comparison suits my argument perfectly, for Just Jaeckin's *Emmanuelle* (1974) is the pure prototype of the *cinéma d'affiche*, the poster or postcard film, aiming to score directly erotic, even genital effects. But the eroticism of *Emmanuelle*, Rene Predal rightly observes, has none of the subversiveness of, say, Luis Buñuel's *L'Age d'Or* (*The Golden Age*, 1930), when the cinema deployed sex to challenge the culture. *Emmanuelle* was behind the times even when it first appeared, replaying in the cinema that which magazines like *Playboy* had already ventured, and replaying it in the most conventional *Marie Claire*–style.[11] Take Marika Green, for instance, who plays Emmanuelle's "sexual tutor": she duly conforms in her look and in her performance to the codes of French beauty, having lost the mystery she wrapped herself in when Robert Bresson discovered her for *Pickpocket* (1959), where her unkempt hair brought the vividness of the spiritual animal to the screen.

Pornography is never ambiguous; nor is *le cinéma du look*. Daney used Godard's density to ridicule Annaud's two-dimensional "look," in the way that Jonathan Rosenbaum used Godard to deflate Quentin Tarrantino. *Pulp Fiction*, Rosenbaum is convinced, darts around the cultural landscape but performs little cultural work. On the other hand, *À bout de souffle*, a supposed "pop classic," forced a deadly confrontation between serious culture (Faulkner, Renoir, Mozart, Cocteau) and the immediacy of the youth movement, to produce the heat of friction that can singe viewers even today. In contrast, Tarrantino coolly flatters his audi-

10. Serge Daney, "Falling out of Love," *Sight and Sound*, July 1992, p. 16.
11. René Prédal, *50 ans de cinéma français* (Paris: Nathan, 1996), p. 407.

ABOVE Raymond Depardon, *La captive du désert* (1989), film still

LEFT Raúl Ruiz, *L'Hypothèse d'un tableau volé*, 1978, film still

ence with a hodgepodge accumulation of citations and stylistic flourishes, none in competition with any other. His is a "flat" postmodernism, Rosenbaum believes, with nothing of the critical punch of Godard's reflexive modernism.[12] Such reflexivity operates in Godard even at the level of the shot, where the screen must be taken as alternately a window and a poster, rather like Wittgenstein's figure of the "duck/rabbit." For example, in *Deux ou trois choses que je sais d'elle* (*Two or Three Things I Know About Her*, 1966), an extreme close-up from above of bubbles swirling in black coffee, seems at first a flat, sensual design. Then, partly under the influence of a spoken commentary on the soundtrack taken from Jean-Paul Sartre's *L'Être et le néant* (*Being and Nothingness*, 1943), it must be seen as a frighteningly cosmic or mental space. After a cutaway, it reverts to a mere cup of coffee, when a sugar cube enters the frame and plunges into the black liquid.[13] In such a shot, the screen shuttles us between vision and reflection, a look and its critique—the screen as mirror, let's call it.

Godard could brazenly film with such a screen in mind because by the late 1950s he (and his producers) could count on a critical mass of sophisticated spectators. At *Cahiers du Cinéma*, under the tutelage of Bazin, he helped school those spectators. To his opponents, Bazin has been called a critic who would oppose a project of critique such as Godard's, in support of an enthralled appreciation of the world entering directly through the photographed image, entering unmodified, unmarked, and therefore unrecognized as image. However, this hasty judgment misses the power of the concept of ambiguity that drives Bazin's ideas and points to the variable but incessant give-and-take between the image and the real that is the stuff of Godard's work.

Daney understood the centrality of this give-and-take, even during the trenchant years of the theory of ideology after 1968, when Bazin, the Catholic, was anathema, his realism deemed idealist. But Daney had read Bazin more generously than his colleagues and recognized that for Bazin, every "gain of reality" always comes by way of a certain stylistic abstraction or "loss of the real"[14] as the introduction of Technicolor demonstrated, to note a vivid example. Daney quickly turns Bazin's obsession with realism into Lacanian idiom ("I know very well . . . but all the same"). Where most students recall only Bazin's notorious remark about cinema being a "window on the world," Daney looks to Bazin's many other metaphors, which line up *avant la lettre* with Derrida's notion of difference,[15] the most telling of which defines the cinema as "a mirror with a delayed reflection, the tinfoil of which retains the image."[16] Comprised of two substances, the glass at which one looks and a metallic backing, only a millimeter thick (a millimeter that changes everything), the mirror opposes itself to the simple and essentially immaterial window, as well as to the monological poster. The double substance of the mirror figures a delay between a situation and its reproduction. Even when so slight as to be scarcely discernible, this delay is sufficient to produce that tension, capable of significance and of critique, between image and reality. This imperceptible delay has permitted certain auteurs to escape the narcissism of the frozen trompe l'oeil that had become the industry standard in the days of the *cinéma de qualité* and which is enjoying a renaissance today in *le cinéma du look*.

In 1958, cinema rather abruptly recognized its modernity full in the face: this was the year during which Bazin compiled his most important essays into the four volumes

12. Jonathan Rosenbaum, *Movies as Politics* (Berkeley: University of California Press, 1997), p. 178.
13. See Alfred Guzzetti, *Two or Three Things I Know about Her: An Analysis of a Film by Godard* (Cambridge: Harvard University Press, 1981), pp. 134–45.
14. Cited by Serge Daney, *La Rampe: Cahiers critique 1970–1982* (Paris: Cahiers du Cinéma/Gallimard, 1983), p. 37.
15. Daney, *La Rampe*, p. 35.
16. Bazin, *What is Cinema?* (Berkeley: University of California Press, 1968), p. 97. Pinpointing this metaphor, Louis Schwartz has written most convincingly of the relation between Bazin and Derrida in correspondence with the author, Fall 1997.

of *Qu'est ce que le cinéma?* and then passed away (waiting to do so until the very day on which Francois Truffaut began shooting *Les Quatre Cents Coups* [*The 400 Blows*, 1959]). This handing of the torch from criticism to filmmaking, this moment of the *Nouvelle Vague*, must be seen as more than the coming-into-fashion of a new aesthetic. It amounts to the recognition of a different mission for cinema, a different place for it, in a culture which itself was reaching a new stage—by the founding of a new Republic for starters. Today we can reflect on the notion of a revolution in cinema, because that question arose in a different register in 1958, as it would again in 1968. In both years, the question that formed the overarching title of Bazin's collected essays could legitimately be reformulated as a national question: "Que-est-ce que le cinéma français?"

Undeniably the *Nouvelle Vague* was in part a fashion statement, since it was out to invent new ways to captivate and astonish audiences—always the goal of this medium. Jeanne Moreau, Anna Karina, Stephane Audran, and Bernadette Lafont can be seen to stand casually atop the pedestals off which had been knocked the statuesque Martine Carole, Micheline Presle, and Simone Signoret. The strains of Georges Delerue and Maurice Jarré suit these stars and this epoch better than those of Georges Auric, as does the alternately graceful and jagged on-location camerawork of Raoul Coutard and Henri Decae. A sub-industry of journalism supported this shift in taste.

"*Nouvelle Vague*" began as a fashion term coined by the popular press to account for a variety of youth fads.[17] Among these was the upstart literary school *Les Hussards*, headed by Roger Nimier, which irreverently promised to free French youth from the heavy burden of Sartrean postwar guilt.[18] In their novels and in the lively journal *Arts*, for which Truffaut and Godard wrote from 1954–58, this group celebrated adolescent, erotic freedom—opposed to the politically responsible sort commissioned by Sartre. They paved the way for Bardot's electric appearance in Roger Vadim's *Et Dieu crea la femme* (*And God Created Woman*, 1956) and for the Françoise Sagan craze that took off in 1955.

For all their cinematic novelty, Louis Malle's *Les Amants* (*The Lovers*, 1958), Claude Chabrol's *Les Cousins* (*The Cousins*, 1959), and, most important of all, *À Bout de souffle* really follow what was already a cultural trend.

And yet the memory of the *Nouvelle Vague* has survived too long for it to have been just another pronounced moment in the history of style. Something emerged around 1958, a self-consciousness, even a self-critique, that haunted not just Godard but all the better filmmakers, and a new brand of spectator as well. For all our talk of the cinephilia of those times (with directors and audiences enthralled by the idea of the movies, living their lives through movies), this was, I believe, the moment when movies lost their innocence, standing ever after under the often dark filter of criticism. In the second half of the 1950s, a general level of cinematic sophistication allowed Bazin to publish his essays in book form, and Rohmer to entitle his review of Nicholas Ray's *Rebel Without a Cause* (1955), "Ajax or the Cid."[19] To supplement the cine-clubs, a specialized cinema house (The MacMahon, with its own *politique des auteurs*) opened to serve the cognoscenti. A sophisticated understanding of the medium and its pleasures had long been around, of course, visible in a renegade like Buñuel or a genius like Jean Renoir. However, their prescience that the arousal and withdrawal of visual and narrative fulfillment is the very condition of cinema suddenly struck a cinematic culture in toto.

Even a standard French product of 1958, *Le Miroir à deux faces* (*The Mirror Has Two Faces*) sets off, in its title alone, the problematic and the *dispositif* that I take to be central to Modernism in cinema. André Cayatte, a *qualité* director despised by the *Cahiers* critics, this time dared to present the French public with a travesty of one of its icons: unthinkably, Michèle Morgan plays a woman so homely that she cannot believe herself to be desirable. In the course of the drama, she is tempted to refashion herself through plastic surgery and adopts a new face—first fooling, then unaccountably repelling her husband, who in turn leaves her. Double perception (by self and by other), and perception of

17. The most recent book to document the gestation of this movement is Michel Marie, *La Nouvelle vague: Une école artistique* (Paris: Nathan, 1998).
18. Georgia Gurrieri. "New Waves: Literature and Cinema in Postwar Paris." Ph.D. dissertation, University of Iowa, 1992.
19. Eric Rohmer, "Ajax or the Cid?," Jim Hillier, ed., *Cahiers du Cinema: The 1950s*, (Cambridge, Mass.: Harvard University Press, 1985), pp. 111–115. Originally published in *Cahiers du cinéma 59*, May 1956.

the double (the mask and the face) will recur often on the screen of a modern French cinema, a screen that is itself a mirror with two faces: that of frozen beauty and that of its critique.

Critical cinema, a cinema that visibly thinks as it unrolls, must operate in that minuscule but charged zone between image and reality, between figures of beauty and their disfiguration, either on the screen or in the critical discourse they occasion. I want to shade in this narrow space of critical cinema in France, substantiating its audio and visual process of "reflexion" which sustains and is sustained by both the thought of criticism and the production of other image-thoughts, other films. In the doldrums of the early '50s the thought of French cinema was kept alive primarily in the criticism at *Cahiers*. Truffaut, Godard, and Rivette raced to films that explored such limits. In France they found few indeed. They found Cocteau's *Orphée*, wherein the mirror of death is penetrated, and the spectator is invited to join a world beyond so as to return transformed. They also found Bresson and Tati.

Bresson's *Le Journal d'un curé de campagne* (*Diary of a Country Priest*, 1951) impressed not only the young critics but artists and intellectuals everywhere, perhaps because Bresson came to cinema from painting, treated his actors as "models," and sculpted his film from the quarry of the Georges Bernanos novel. As Truffaut nastily pointed out, Bresson's triumph stood out against the dull adaptations of novels prepared by the likes of Pierre Bost and Jean Aurenche. Bost (one of those "cultured" writers who made a living by slumming in the cinema) had had his own version of the Bernanos story refused by the executors of Bernanos' estate; for he had flattened out the oddities of the novel and failed to stretch the cinema beyond its standard form. Bresson, by contrast, gave us a work of art with a life of its own—a painting, if you will, of the novel.

Le Journal d'un curé de campagne took its themes—interiority, intimacy, spiritual enclosure, demarcated zones of communication, the abyss between public and private space—from a repertoire that had distinguished French cinema ever since the 1920s and would be drawn on obsessively in the *Nouvelle Vague* period after 1958. Yet Bresson's art lay neither in referencing nor in dramatizing these themes, but rather in materializing them. The priest's gloomy rectory becomes a hall of memory; there he performs a "poetic negotiation of the interior" through his diary. The interplay of writing, voice-over, and the glazed, haunted perception of the priest produces on the two dimensions of the screen a deeply reverberant, temporal volume. Bresson, in his tortured manner, labored to build an audiovisual environment, as might any fervent artist. He inspired generations of filmmakers to think in sounds and images. So too did Tati, exploiting, however, his own set of themes, all related to public rather than private, life and spaces (such as the politics of the built environment, modern systems of exchange, the mechanization of gesture). Tati's films hardly appear written at all, being structured compositions of audiovisual antinomies and rhymes. His six features, unmistakably his own because they are so utterly deliberate (the same must be said of Bresson's dozen), constitute a body of research that probes, in the mirror of the screen, particular conundrums set in place by the difference and delay between perception and knowledge.

III

In the postwar era, and particularly since 1958, French cinema can best be tracked through this relation between the image of beauty, perfected and fixed, and the image of time that loosens it, makes it "imperfect" in the grammatical sense. As I have pointed out before, following on a remark of Raymond Bellour, the *Nouvelle Vague* had two enemies in view when it sought to take the field.[20] Behind them ranged the glacial *cinéma de qualité*, paralyzed by its literary prototypes, by the fussy window dressing of its décors, and by the flawless faces of its made-up stars. In front of the *Nouvelle Vague* lay the unpredictable and indiscriminate cascade of magazine photos and TV images already drowning

20. Dudley Andrew, "Jules, Jim, and Walter Benjamin," in Andrew (ed), *The Image in Dispute: Art and Cinema in the Age of Photography* (Austin: University of Texas Press, 1997), p. 36.

the mission of art. Truffaut understood this conundrum from the first. In *Les Quatres Cents Coups*, he took on the new problem of the "everydayness" of the image, by staging several scenes on the street, to provide glimpses of the shops, fountains, and people of an average Parisian quartier. The first fiction film to contain an unrehearsed cinema verité interview, with its anonymous actor speaking directly to the camera, *Les Quatres Cents Coups* is also the first to end on an enlarged freeze-frame, transforming that actor and the urchin he plays into an icon. The eternity of that single shot (it adorns the cover of Alan Williams' authoritative history of French film, *The Republic of Images*) counters the unregulated flow of the interview and punctuates the spontaneity of Truffaut's style with an exclamation point. *Tirez sur le pianiste* (*Shoot the Piano Player*, 1960), his second film, reinforces this tension between classical and casual style. When Lena (Marie Dubois) is accidentally but fatally shot in a bizarre gunfight, she slides gracelessly down a snowy hill to the foot of the camera which then cuts to a close-up of her ice-caked face. This shot cruelly and clumsily mimics the conclusion of Jean Delannoy's *La Symphonie Pastorale* (1946), Marie Dubois replacing the irreplaceable Michèle Morgan. Truffaut refuses to fade out on such a perfect frame, however, returning instead to the piano that Charlie (Charles Aznavour) fingers, and to a new waitress, a new Lena, bringing in the drinks for the regulars of the bar. "Music is what we need, man," says the subtitle, not the classical music of a grand piano played in an auditorium to a circumspect and motionless audience, but the flow of the honky-tonk music that exceeds by outlasting the image of death and which the drinkers and dancers appreciate without glorifying it. After such a start, perhaps it should be evident that of all his films Truffaut considered *La Chambre verte* (*The Green Room*, 1978) to be his most personal, for it directly thematicizes this cinematic struggle between life and death, image and flow, beauty and decay. And it does so in a dark interior—a Plato's cave if ever there was one.

The important films of Truffaut, Chabrol, Rivette and certainly Rohmer, work on (actually work over) a cinematic image, the perfection of which they refuse. In lesser works advertising the *Nouvelle Vague* style, such as the Oscar-winning *Les Dimanches de Ville-d'Arvay* (*Sundays and Cybele*, 1962) or *La fille aux yeux d'or* (*The Girl with the Golden Eyes*, 1960) or many of Chabrol's films in the mid '60s, a fetching and (for a time) fresh cinematic beauty stands directly, though not critically, before us. You can verify this hierarchy by placing another Oscar-winner, Claude Lelouch's *Un Homme et une femme* (*A Man and a Woman*, 1966) alongside Agnès Varda's *Le Bonheur* (*Happiness*, 1965), which came out about the same time. The intermittent strains of Mozart's woodwind quintet as well as Varda's excessively refined color palette undermine the purity of her rural cantata, signifying something with and against the film's conventional sentiments and undeniable beauty. Lelouch, on the other hand, uses his colors and music to inflate conventional beauty and more conventional feelings; the results are irony in Varda's case, sentimentality in Lelouch's. We should recall that in 1961, Varda, a successful fashion photographer, made *Cléo de 5 à 7* (*Cleo from 5 to 7*, 1962). In this film, she erodes the pampered beauty of her title character, a celebrity pop singer. "Ugliness is a kind of death," Cleo says. "As long as I'm beautiful I'm alive." For ninety minutes, Varda gets beneath Cleo's make-up until a different form of beauty, an inner one, born of self-recognition, becomes apparent.

Godard pushed this *Nouvelle Vague* program furthest of all, revealing the hidden and catching the fleeting with a style that simultaneously demeaned style. No filmmaker in the full century of the medium has so deliberately and repeatedly sought to attain and then mock both beauty and the inner life it has been thought to express. Aumont chose to launch his book *Du Visage au cinema*[21] by referencing the wonderful scene in Godard's *Vivre sa vie* (*My Life to Live*, 1962) in which Nana (Anna Karina), alone in a movie theater, is moved to tears by the still deeper tears of Renee Marie Falconetti in Carl Dreyer's *La Passion de Jeanne d'Arc* (*The Passion of Joan of Arc*, 1928). Godard passes through Karina's face and into her soul at the same time that he

21. Jacques Aumont, *Du Visage au cinéma* (Paris: Cahiers du Cinéma, 1992), pp. 9–10.

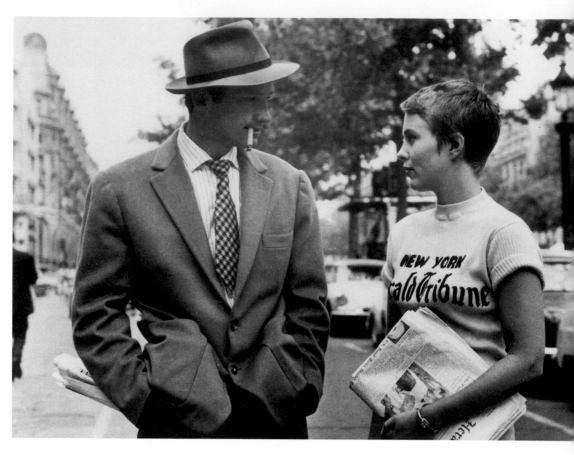

observes Nana's face as it passes into the soul of Jeanne d'Arc through Falconetti. The screen/mirror brings into approximate registration these two actresses, the roles they play, and the societies in which their characters are both tortured creatures. In the cinematic exchange we witness, the souls of the simple Parisian prostitute played by Karina and the legendary French heroine seem almost tangible to us. The quintessentially cinematic effect of projecting one through the other must make us hesitate to shed our own tears in response to such artifice, powerful though it may be.

Of all French filmmakers Godard has remained the most fertile to critics because his work has always been fundamentally critical. His journalistic critique of standard French cinema led directly to *Á Bout de souffle*. After 1968, his turn toward intensive self-criticism led him to declare his films self-deluded, despite their edge, since they afforded enough cinematic pleasure to be salable, and therefore make money for a producer. The signature of Godard's talent has always been the vein of criticism that contaminates and fragments his tantalizing images of wholeness. One such image opens *Passion* (1982). A blotchy sky with backlit clouds forms a canvas on which the contrail of a jet appears suggesting the mark of an artist or even the hand of God. This figure of pure creation underwrites an ambition of cinema literally to animate canonical paintings through *tableaux vivants*. But while being honored, Rembrandt's *Nightwatch*, El Greco's *Assumption*, and masterpieces by Watteau, Goya, Delacroix

and others are at the same time blasphemed, even sodomized, by the movie camera in *Passion*, which plays jokes on them. Worse, the cinema finds itself in turn compromised by and reduced to prosaic video, which the film's hero, a Polish director, uses as a convenience for recording and editing. Godard is merciless.

How like the journal *Cahiers du Cinéma*, with which he began as critic and which has grown and evolved in tandem with Godard's career path ever since. In 1968 Godard and *Cahiers* led demonstrations against the French government's meddling in the affairs of the *Cinémathèque*. When this helped ignite the Paris general strike in May of that year, both Godard and *Cahiers* adopted the most radical stance possible. He renounced personal filmmaking, forming the Dziga Vertov group, dedicated to small-format interventions (Pravda deals with the crisis in Prague, for example, and Vladimir and Rosa with the trial of the "Chicago eight"), while *Cahiers* briefly refused to traffic in images. Spartan in format, it accepted no ads, nor contributed in any way to the promotion of films, even artistic ones, made within the orbit of the distribution business. Defying the capitalist cycle, both Godard and *Cahiers* dismissed their own distributors and determined to reach their drastically reduced audiences directly. That audience was fervent, forming a revolutionary cadre, one described by Daney in a powerful essay on Godard as devoted to "The t(h)errorized."[22]

22. Serge Daney, "Le Therrorisé (Pédogogie godardienne)," *La Rampe*, pp. 77–84, translated in *The Thousand Eyes* 2, pp. 33–40.

As the hopes for revolution faded with the decade of the '70s, *Cahiers* and Godard would gradually reconnect with larger audiences and follow different subterranean routes back to the surface of film culture. As his numerous champions have elaborated in so many fascinating ways (Jacques Aumont above all, but also Daney, Colin MacCabe, Jean-Louis Leutrat and others) Godard's incisive and obtrusive editing and soundtracks violate, cut into, and suspend the many incomparably beautiful visual images he cannot keep from producing or citing. In Aumont's terms, he is nothing other than a theorist who uses sounds and images.[23] De-mystifier, yet obsessed with the mystique of the image, Godard may stand as the Swiss Protestant counterpart to the French Catholic Bazin, at least in the realm of cinema. For its part, *Cahiers'* agenda can be tracked in its successive formats (from the original yellow version, to the larger magazine with glossy stills from late 1964, to the abstemious look that by 1972 eliminates images altogether, then back to a glossy format in 1976, shifting again this Autumn 1998 in order to attract a younger readership). Even when the magazine flirted with the enemy, the *cinéma d'affiche*, *Cahiers* has been the place for serious critique—the site, for example, from which Daney could launch his accusations and know they would reach their target.[24]

Without this critical edge, the cultivation of the image would become part of the French fashion industry. The strongest attacks on *Cahiers* and on the *Nouvelle Vague* have alleged just this about them. "Are women magic?," asked Truffaut, via his numerous male characters,[25] a silly query that displaced his real concern: Are movies magic? Does the mysterious beauty they tender, the "ambiguity" of their images—to use the embattled Bazinian term—surpass mere language? I have argued that Bazin, and that strain of the *Nouvelle Vague* most beholden to him, managed to maintain the tension inherent in the notion of ambiguity, a tension that provokes and is sustained by the various discourses of criticism. A genuinely modern cinema, an ambiguous one, settles neither into the repose of the good image nor that of the proper view. Instead modern cinema vibrates, perpetually unsettled and unsettling, and thereby it is productive rather than mere product.

The "critique" of fashion associated with French cinema has seldom been direct. The *Nouvelle Vague* did not, for instance, replace classic female faces with ordinary or hard-featured ones, the way the Italians had after 1945 (Anna Magnani) and the way the British would after 1960 (Rita Tushingham). Instead they seemed to replace one fashion beauty with another (Catherine Deneuve instead of Micheline Presle). The difference came in the manner of presentation, for the *Nouvelle Vague* filmed beauty in a mirror of self-recognition and self-critique. Toward the end of *Jules et Jim* (*Jules and Jim*, 1961) comes a shot into a mirror so direct and discomfiting as to break the satisfying fullness and magic carried by the music and narration. Catherine, seen from two angles, wipes the makeup from her face, while Jim, pathetic in his pajamas in bed, is visible in the reflection. The hopes of their union have come to an end. This is an image of aging and of decay, the decay above all in the face of Moreau, the face of Catherine, earlier compared to a Greek statue with an eternal smile. The mirror before which she sits contains at one and the same moment her beauty and its passing. She erases—that is, smudges and disfigures—the marks that make her up, make her beautiful, and allow men to ask if she is "magic."

Twenty-five years later in *La Femme Nikita*, Moreau will sit before another mirror, not to remove makeup but this time to apply it to someone else, an actress of the next generation. The *faiblesse mentale* (mindlessness) of the title character,[26] as one critic put it, ensures that our attention will be drawn to Moreau's aging face, not to that of the young ingenue she knows how to enhance, as she passes down the art of French maquillage. Moreau's sagging cheeks show the signs of too many kisses, too many tears. The camera cruelly, yet affectionately, holds on her. Only something that has been so alive could make us feel so deeply its deterioration. These two siren films, each the most celebrated export of its era, attract and hold their audiences with the wiles of the falsely feminine. Truffaut

23. Jacques Aumont, "Autoportrait de l'artiste en théoricien." *Revue Belge du Cinema 22–23*, 1988, pp. 170–76.
24. See the remarkable memorial issue of *Cahiers du Cinéma* on Serge Daney, June 1992.
25. "Are Women Magic?" is the title of chapter 4 in Annette Insdorf, *François Truffaut* (New York: William Morrow and Company, 1979). See p. 105. The line comes from *La Nuit Américaine* (*Day for Night*, 1973).
26. René Prédal, *50 ans de cinéma français* (Paris: Nathan, 1996), p. 555.

freezes Moreau in various poses, locating his art (and what he believed to be the peculiar magic of cinema) in the tension between spontaneity and eternity. Nikita's look is never spontaneous; a calculated fashion statement, its producers have fixed the image of Anne Parillaud on the screen as on a poster. Indeed, the film and its *affiche* are interchangeable. Critique would need to take a different form in the age of television.

IV

In the age of television, where nonstop images never arrest the eye and never turn in on themselves, and in the age of digitalization, where the origin of every image is suspect, the questions first faced by Bazin and the *Nouvelle Vague* have only grown more acute. You can feel this in Agnès Varda's strongest film, *Sans toit ni loi* (*Vagabond*, 1985) which takes for its subject Sandrine Bonnaire. The most visible new face in France at the time, she was pictured on the covers of many magazines for the striking look, both raw and coquettish, that she brought to her first films. Varda filmed Bonnaire in a desolate winter countryside in the south of France, and ferociously peeled away the sheen, the makeup, and the modish design of her actress and of French cinema in general. Bonnaire plays a woman who descends the ladder of self-destruction, after having managed to complete her degree and hold a job in Paris. With no mirror to look at, she grows filthy before our eyes and dies of exposure in a field. With her hair tangled, rather than fetchingly tousled, Bonnaire systematically abandons what we expect of such a celebrated beauty, just as Varda gives up the standard cinematic search for form. And yet Varda's compositions and her heroine have something of Cezanne about them, something more than just their connection to Provence, something quite inchoate. "She seems to have come from the sea," says Varda in voice-over.

The same actress came again under intense scrutiny in *La Captive du désert* (Captive of the desert), shot entirely in North Africa in 1989 by Raymond Depardon, an acclaimed still photographer. Bonnaire this time is deprived of speech

and, once again, her usual feminine accoutrements when she is abducted by Tuaregs. Depardon plays an age-old cinematic gambit—the dislocation of the familiar to utterly foreign terrain and foreign circumstances—so as to capture "la captive," to penetrate her face and reach a soul visibly shaken by the stark purity of the Maghrebian landscape and by the silent assurance of her blue-hooded kidnappers.

These unique efforts, by Depardon and Varda, to pursue an authentic image in the age of television stand in the tradition of a search for fresh expression that is characteristic of both the *Nouvelle Vague* and of cinematic modernism in general. In *Du visage au cinéma*, Aumont argues that such films may betray narrative in order to grasp and hold the singularity of those who enact them. Even within a conventional drama, children, for example, can be surprised by and can surprise the camera, and thereby express the unstudied and the uncoded. Truffaut understood this from the first. Sophisticated actors can likewise be caught off-guard, despite their training, when the director catches them "studying," or coming into phase with a role, or when he forces them by ruses to improvise (visibly in Rivette and Pialat, and more discreetly in Rohmer).[27] Such portraits belong to a "genre" of unclassifiable works which would include films by Jean Eustache, Jacques Doillon, André Techine, Philippe Garrel, Duras, Chantal Akerman, and of course, Bresson, Chris Marker, and Marcel Ophüls. In their distinct ways, and across a diversity of subjects, all these cineastes expect to seize something only the cinema can seize, and they aim to do so through decisive, utterly idiosyncratic tactics of performance, camerawork, sound, and editing. Unpredictable like children, perhaps disingenuous, they bypass conventional beauty from the outset and stand naked at the box office, unsupported by genre expectations. They are kept alive, barely, by subventions and by the special cultural status France accords cinema, protecting it from the homogenizing effects of television.

Yet a cinema of reflection need not be unpopular; nor must the critique of beauty necessarily be self-destructive. Bertrand Blier's long list of dark comedies, beginning with

27. Jacques Aumont, *Du Visage au cinéma*, p. 120 and pp. 132–34.

the vulgar *Les Valseuses* (*Going Places*, 1974), proves the viability of a cinema of shock. Misogynist, even misanthropic, his outrageous treatment of common problems and genres amounts to a gross gesture of critique, a loud putrid fart. From Rabelais to Celine, French artists who produce the vulgar and socially unacceptable have been accepted, even lionized. As with pornography, however, tastelessness provokes reflection only when it puts itself at risk; otherwise it falls into the kind of supercilious satire Truffaut loathed in the *cinéma de qualité*, where the director thumbs his nose at his audience from a safe platform of cynicism, as in Claude Autant-Lara's *L'Auberge rouge* (*The Red Inn*, 1951).[28] Masochistic audiences continue to lap up the ordure thrown on the screen in films like Marco Ferreri's *La Grande bouffe* (Blow out, 1973) and Michel Blanc's *Grosse Fatigue* (*Dead Tired*, 1994). Much of Blier's work exercises audience self-disdain in this way, achieving the status of a kind of inverted chic.

With *Trop belle pour toi* (*Too Beautiful for You*, 1989), however, Blier laid aside the shield of his cynicism to confront the unpredictability of attraction and repulsion. Aggressive even in its title, *Trop belle pour toi* undermines traditional expectations when its hero, a successful car salesman, begins a tragic affair with his "ostentatiously plain secretary."[29] Blier increases the stakes of this gambit by casting Gerard Depardieu, the grand romantic of French cinema, alongside the plump Josiane Balasko, while the stunningly beautiful wife, to whom he is indifferent, is played by Carole Bouquet, the successor to Catherine Deneuve as France's icon of classic elegance. As has been increasingly the case in recent French film (in Godard, and above all in Alain Corneau's *Tous les matins du monde* (*All the Mornings of the World*, 1992), classical music signals an ideal beauty against which the visuals are to be measured. At Depardieu's oppressively bourgeois dinner table, Schubert plays in the background, which prompts him to ask his son and wife why they have put this on the phonograph, since "this music shatters" him. Does his response to Schubert redeem Depardieu and lift him above the mere carica-

ture of the trapped middle-class husband? Does Schubert lift *Trop belle pour toi* beyond its inherent bad taste to broach a sublimity in music and in romantic love that it simultaneously scoffs at?[30] The irrationality of attraction, rather than the proud certainty of it, gives this film and cinema as a whole a way to compete with the standard of French chic promoted by other media, that fetching demeanor that is refined, processed, and circulated by ads, television, and *le cinéma du look*. Beauty, according to Kant, arises from the justness of shape, while sublimity marks the meltdown of all proportions. Rewriting these definitions after Structuralism, Roland Barthes opposes the pleasure of the beautiful as known, coded, and let me add "figured," to the *jouissance* of the ugly, which can be unpredictable, misshapen, and disfigured.[31] Critical, modern cinema evokes and then disfigures the comeliness of things, people, and ideas in France.

V

A final scene before a mirror, this one seemingly more ordinary than those already cited, brings to a close my reflections by expanding the notion of reflection itself. Exactly midway through Rohmer's *L'Ami de mon amie* (*Boyfriends and Girlfriends*, 1987), Blanche, having returned from an awkward encounter with the man she desires, enters her modern apartment, throws the keys on the couch, and wanders into the bathroom in tears. Staring into a mirror so blue that it looks like the swimming pool she visits daily, Blanche sobs *"Mais t'es vraiment nulle!"* (But you're really stupid!) Among the richest of his *comédies et proverbes*, *L'Ami de mon amie* takes as its topic the one I have been pursuing, that of beauty and attractiveness. Blanche, *moche* and insecure, must learn to navigate (like a sailboard) in the artificially polished world of contemporary French life. The neo-classical new town of Cergy-Pontoise, with its confidently balanced, utterly rational but completely unforgiving architecture, determines the inevitable "chance encounters" she has with two men and two women, pursuing sentimental paths that lead inevitably to either proper

28. Francois Truffaut, "A Certain Tendency of the French Cinema," in Bill Nichols, ed., *Movies and Methods* (Berkeley: University of California Press, 1976), pp. 224–37.
29. Ginette Vincendeau, *The Companion to French Cinema* (London: BFI, 1996), p. 25.
30. See Gary Giddins' review in *The Village Voice*, March 6, 1990, p. 64.
31. Roland Barthes, "Beauté," in *S/Z* (Paris: Seuil, 1970), pp. 40–41 and of course *Le Plaisir du texte* (Paris: Tel Quel, 1973).

or improper comedic couplings at the end.

Delightfully ironic twists of plot turn the film, for some viewers, in the direction of theater, an updated quadrille by Marivaux. But its "twists of vision" are what interest me, inclining *L'Ami de mon amie* toward painting and toward the aesthetics of critical cinema. Rohmer's famous "moralizing" gaze requires a doubletake, wherein the confidence of a character or the spectator shatters when a clear situation suddenly changes shape and meaning when seen from a different angle. Narratively, repetitions and reversals keep the audience on a plane of knowledge above that of the characters, where we can enjoy the spectacle of them as they pass into self-recognition. Visually, the play of repeated and complementary forms, whether tied to characters or not (as in the comic complementarity of their matching or clashing clothes) produces a frame within which intelligibility—the recognition, by the audience and sometimes by the characters, of the real state of affairs— emerges through the phasing-in of change across time. The cafés, swimming pool, and geometrical grand courtyard of Cergy-Pontoise constitute a kind of grid against which we can measure the movement (physical, sentimental, spiritual) of the characters who crisscross these spaces. This chronophotographic measurement of humans produces occasional moments of clear coincidence and meaning.

The faces of the characters are an even more certain register of internal states and slippage. Most often they are made up to make the best impression possible, appearing fixed and confident in, or against, the world. Faces in Rohmer's films may be surprised by a haphazard look or a pointed word, permitting us to see recognition as it registers in their look. Imagine the superimposition of all the close shots of any of the four main characters of *L'Ami de mon amie* across the ninety minutes of the film; a staggered, stuttering or cubist effect would result, and suggest the temporality of identity. All of Rohmer's films, from the early moral tales to his latest contes, take "identity" as a problem and an achievement. His satisfying, classical conclusions, in which characters realize their desires or the falsity of those

desires, never tie up all the strands of doubt, misdirection, and misunderstanding they experience throughout the course of each of these films. The title of Jacques Aumont's essay on *L'Ami de mon amie*, "L'Extraordinaire et le solide" pays tribute to Rohmer's classicism (the "solid") and to his modernism (the "extraordinary" events that can erupt in time).[32] And this is the basis of Rohmer's realism as well— Rohmer who in 1958 insisted on what he called the "reality axiom" undergirding Bazin's thought and his own sense of cinema. The world (material and spiritual) is solid, but our vision and our understanding of it are uncertain, full of misapprehensions that circumstance and time either multiply or evaporate. Rohmer's films are out both to multiply and to evaporate misapprehensions and misprisions. Classified as comedies, they let us hope in the possibility of knowledge even as they demonstrate the hubris that often accompanies it. True knowledge, they assert proverbially, is the knowledge that one cannot really know.

I am by no means the first to emphasize the importance of painting over narrative in the work of Eric Rohmer. He has done so himself, encouraging others to study his pictorial citations, his color palette, his compositions, and his mission as an artist.[33] Toward the end of *L'Ami de mon amie*, Adrienne dreams about an ideal man, who would be an ideal artist: "*Yves Klein, tu connais,?*" she asks Blanche. "*Klein, le bleu Klein, tu sais, celui qui peignait des grands tableaux.*" (Klein, the blue Klein, you know the one who paints those large paintings?) Rohmer may reference Klein's large blue paintings in his scenes on the lake or in the pool, but in no way does he follow Klein's romantic, uncritical immersion in this color. He is far closer, as Simon Dixon has shown, to David Hockney, whose many paintings of swimmers in Southern California pools represent the same social class and the same problematic of vision.[34] When Alexandre swims directly toward the camera and into the imagination of Blanche, we look down on him in the water. The straight lines that mark the lanes at the bottom of the pool undulate as he passes over. Rohmer suggests that the uncertainty of figures seen through transparent water—the disfiguration

32. Jacques Aumont, "L'extraordinaire et le solide," *L'Avant-scène Cinéma 366*, December 1987, pp. 3–11.
33. Blanche's rival in the film, Léa, is played by Sophie Renoir, the great-great-granddaughter of Pierre-August Renoir, granddaughter of the actor Pierre Renoir (Jean's Brother) and daughter of cinematographer Claude Renoir. See F. Aizicovici, "Portraits: Sophie Renoir, Eric Viellard," *CINEMA* (Paris) 407, September 9, 1987, p. 4.
34. Simon Dixon (unpublished paper, University of Iowa, 1995) has compared Rohmer and David Hockney in their themes, but also in what he argues is their updated "cubist" aesthetic.

of lines and of bodies "at sea"—is identical to moral problems of perception and meaning, of surface and depth.

Once taken to be an auteur, literally penning his moral tales as a new kind of literature, Rohmer is more properly seen today as a *ciné-peintre* (along with so many other French directors: Rivette for *La Belle noiseuse* (The beautiful troublemaker, 1991), Pialat for *Van Gogh* (1991), Godard for so many films). For the concept of *écriture* in cinema ran its course in the '70s, when it was emphasized that cinema "constructed" reality. Bazin's metaphor of cinema as a "mirror that retains the image" has had more staying power, because, unlike writing, which follows only the directives of the auteur's construction, it insists on a ratio between the characteristics of the mirror and those of the phenomena which come to take shape before it. Since Bazin's death, however, both sides of the ratio have undergone deep changes. The simple mirror of cinema has been complicated by new image technologies, some of which effectively do away with the referent altogether. And on the other side of the ratio, the side of the referent, a succession of doubts (stemming from concerns with ideology, language, gender, Eurocentrism) have made the phenomena that appear on the screen seem more elusive than ever. Looking for models and traditions that might encourage cinema in its intransigence—vis-à-vis the image industry—filmmakers and critics have turned to painting, to its craft and materiality, to its concern with problems of vision, and to its sometimes heroic, sometimes quixotic quest to capture, express, or concoct the real.

Following Bazin's dictum that every gain in realism comes only through an increase in artifice, Rohmer arranges his actors as human figures on a field so as to frame the disfiguration evident in the sounds of their voices and the appearance of their bodies as they enter and leave successive moral phases over time. His camera allows itself to be surprised by the physical signs of interiority and temporality that develop. Filmmaking, like painting, is a process, an act, even an event in which something happens, both in the production of the image and in the time of our viewing it. This cinema can still stand against the instantaneity of today's media environment and digital image products. French cinema clings to an aesthetic and an ethic not so much of truth or reality but of "reflection," in the deep sense of that term.

A final mirror presents itself to comprehend my reflections on the filmmaker in modernity. It is the mirror in Edouard Manet's *Bar at the Folies Bergere*. Spreading out a spectacle of light on a surface we can see but cannot touch, this mirror reflects genders, classes, consumption, and money. Its geometry askew, it forces the viewer to do a "doubletake" in an effort to experience and sort out the social, perceptual, and aesthetic issues the painting has been said to criticize.[35] Two-dimensional, this is nevertheless a voluminous painting, "the painting of modern life." At its best, French cinema has picked up Manet's mission, one effectively dropped by painting in our time. French cinema has turned the screen into a mirror so as to become, in its own way, the "painter of modern life."

35. T. J. Clark, "The Bar at the Folies Bergères" in *The Painting of Modern Life: Paris in the Art of Manet and his Followers* (New York: Knopf, 1984).

LA MISSION PHOTOGRAPHIQUE DE LA DATAR

(DÉLÉGATION À L'AMÉNAGEMENT DU TERRITOIRE ET À L'ACTION RÉGIONALE)
1983-89

PHILIPPE ARBAÏZAR

During the 1950s, France's demography and economy swelled from postwar reconstruction. Towns and cities burst their ramparts, highway networks modernized, the provinces and capital were searching for a new equilibrium—change was irreversible. By 1960, France took on a new face as land development affected all aspects of life. Initiatives taken at the local level, involving numerous participants encroached upon surrounding areas; to coordinate this development the government, in 1963, set up La Délégation à l'Aménagement du Territoire et à l'Action Régionale (DATAR), an interministry agency whose function was to track the evolution of projects transforming the land, and provide information to all parties involved in order to help plan the future. DATAR provided more than reflection and incentive; its efficacy was backed by a budget. Nonetheless, unable to maintain a tangible connection with the domains it oversaw, the DATAR weakened. Architects of land-development policy felt they were managing a disembodied reality. Moreover, cultural references were rare: the landscape that had figured so profoundly in nineteenth-century painting had, by 1970, basically disappeared. Almost all the great names of French nineteenth-century photography—the Bisson brothers, Cuvelier, and Le Gray—were landscapists

whose work had made a decisive contribution to the knowledge of territory, but French photography after World War II strayed from that realm toward social subjects, adopting the technique of reportage. Unlike what was happening in the United States, landscape in 1960s France was mostly ignored.[1]

It was in this context that DATAR launched "La Mission Photographique,"[2] whose goal was to revive the relationship with land and revitalize the landscape genre by endowing it with purpose and meaning. This involved not only drawing attention to a specific subject, but also redefining it visually, presenting the issues related to it. The project's founders, François Hers and Bernard Latarjet, understood immediately the difficulty of an assignment that concerned "an imprecise and complex domain: the state of landscapes, the living and work spaces of France in the 1980s,"[3] but they nonetheless conceived an original method to represent such difficult-to-define ideas. La Mission Photographique did not designate the photographic subject. It was the photographers who decided what to shoot, thus reflecting their particular view of the landscape. Although photography has strong ties to reality, it is not a simple recording device; DATAR trusted the photo-

graphic eye, the quality of the artist's approach, and the photographer's ability to anticipate change.

This confluence of social need and creative aspiration was unprecedented. La Mission Photographique was similar to previous projects like the Heliographic Commission (1851) and the Farm Security Administration (1935–42), although those addressed quite different concerns: the Heliographic Commission made inventories of discovered heritage by retaining photographs, and the FSA documented social situations. The goal of La Mission Photographique was to increase awareness of questions of space and territory, while approaching representation from an artistic angle. The choice to hire artists or photographers who deliberately introduced aesthetic values indicated a clear desire to offer photography a new direction. Hers and Latarjet directed the Commission to that end, never questioning the appropriateness of resorting to art; in 1990 they affirmed that artists "undoubtedly remain the only ones to give life and meaning to this reality, with which we maintain an increasingly abstract relationship, the only ones to formulate the meaning of our relationship with the world and our future with the clarity and boundless complexity of symbolic expression."[4] This expectation is clearly rooted in modernity; other characteristics of La Mission Photographique made it a model project of the period as well. It invalidated early-decade debates about the death of landscape,[5] showing just how daring it was to bet on the genre's revival, and just how this wager, in order to succeed, had to respond to an expectation. The artists undoubtedly sensed the need to face the Commission's challenge; using alternative instruments such as the average format or the view camera was motivating. They had to both rediscover their methods and, above all, see in landscape something other than anecdotal illustration, propaganda, cliché, or typical décor. Only by subverting a stereotypical vision of French landscape could they find new ways to work.

Employing artists did not mean that the direction taken would be totally subjective; the work of La Mission Photographique had to take into account the heterogeneous nature of reality so indispensable to DATAR's objectives. DATAR would suggest the subjects—mountains, the coast, factories, the countryside, city, and suburbs—as well as situations emblematic of change, like the evolution of the industrial landscape or the transformation of cities. These ideas came to life in the photographers' representations. The project thrived on the exchange between DATAR's scientific research about French territory and the artist's visual experience. Its success lay between general directives and the understanding and vision of the artists, and encompassed many different situations: for example, Robert Doisneau returned to explore the suburb he had crossed thirty years earlier. Sophie Ristelhueber moved through the landscape following a railway line. The productive tension between the photographer's involvement and the human or geographic reality allowed La Mission Photographique to reestablish landscape's importance in visual culture, paving the way for numerous initiatives that followed.[6]

The set of images produced in the context of La Mission does not constitute a collection of points of view but rather provides an everyday vision—a quotidian, not spectacular, scene. Although the use of panoramic views may be surprising, it must be noted that this technique scans the landscape without imposing a perspective. Moreover, La Mission Photographique never intended to take inventory of places or establish their typology; France remains so various, so open to exploration, it resists a pigeonholing of its territory. However, the impression created by these photographs is accurate. The quality of French landscape, especially its diversity, comes through, and it is evident that the changes it is undergoing are more palpable than its fixed aspects. We may lament the expansion of uniform housing developments, urban chaos, and the ubiquity of pictographs and advertising signs, but we can perceive the depth of historical work and the different stages of landscape history present in this group of images. All transformations are inscribed in the soil: landscape is defined in terms of mostly hilly relief and quality of light as much as

upheavals of mass habitat and proliferation of superhighways. A reality of contrasts emerges from the images assembled by La Mission Photographique; a protean vision unfolds, even while certain constants remain. The photographs show a landscape of impressions, hypotheses, and regions traveled from one end to the other. They are a document not for use as testimony regarding the future,[7] but as witness to the landscape's sedimentary and historical dimension: a palimpsest in which the signs are roads, borders, the overlapping of fields, and the maelstrom of new means of communication. The photographs remind us that landscape is not an act of fate but of human choice, and seem to ask, "What would you like this landscape to become, bearing in mind what it was?" Such awareness is a sign of the times; La Mission Photographique inspired a new attitude, emphasizing the wealth of a shared land requiring cultural reinvestment.

Given its initial goals, the project was a complete success, and remains not only an indispensable reference on landscape in the 1980s, but also a means of perceiving it. By reinventing the work of past topographers, the photographers achieved a goal that seemed at first implausible, and revealed space's insurmountable otherness. The landscape remains a site of confrontation rather than a site of contemplation.

1. One need only think of the grandiose images of Ansel Adams (1902–1984), of the work of Robert Adams in the 1970s, and the 1975 exhibition at the George Eastman House in Rochester, NY, *New Topographics: Photographs of a Man-Altered Landscape.*

2. DATAR's La Mission Photographique spanned from 1983 to 1989. Twenty-eight photographers participated: Dominique Auerbacher, Lewis Baltz, Gabriele Basilico, Bernard Birsinger, Alain Ceccaroli, Marc Deneyer, Raymond Depardon, Despatin and Gobeli, Robert Doisneau, Tom Drahos, Philippe Dufour, Gilbert Fastenaekens, Pierre de Fenoÿl, Jean-Louis Garnell, Albert Giordan, Frank Gohlke, Yves Guillot, Werner Hannapel, François Hers, Joseph Koudelka, Suzanne Lafont, Christian Meynen, Christian Milovanoff, Vincent Monthiers, Richard Pare, Vincent Rabot, Sophie Ristelhueber, Holger Trülzsch. A selection of prints and contact sheets are at the Bibliothèque Nationale de France, Département des Estampes et de la Photographie. Moreover, the work of La Mission Photographique is available in the book *Paysages Photographies, 1984–1988.* (Paris: Hazan, 1989).

3. *Paysages Photographies: La Mission Photographique de la DATAR, travaux en cours, 1984/1985* (Paris: Hazan, 1985), p. 27.

4. *Le Débat,* no. 60 (May–Aug. 1990), p. 301.

5. In 1981, a colloquium entitled "Mort du Paysage" (Death of landscape) took place in Lyon under the direction of François Dagognet. The events of the colloquium were published in *Seyssel* (Champ Vallon, 1982).

6. Among these, we cite the creation of the Observatoire Photographique du Paysage in 1989, *Quatre saisons du territoire* (Territory of Belfort, 1987–90), the Conservatoire's coastal commissions of the 1990s.

7. The Observatoire Photographique du Paysage uses photography to witness the state of landscape imposing precise specifications defining all parameters of the shot. Each site is photographed at regular intervals, and each new shot is taken under the same conditions, following the same technical specifications.

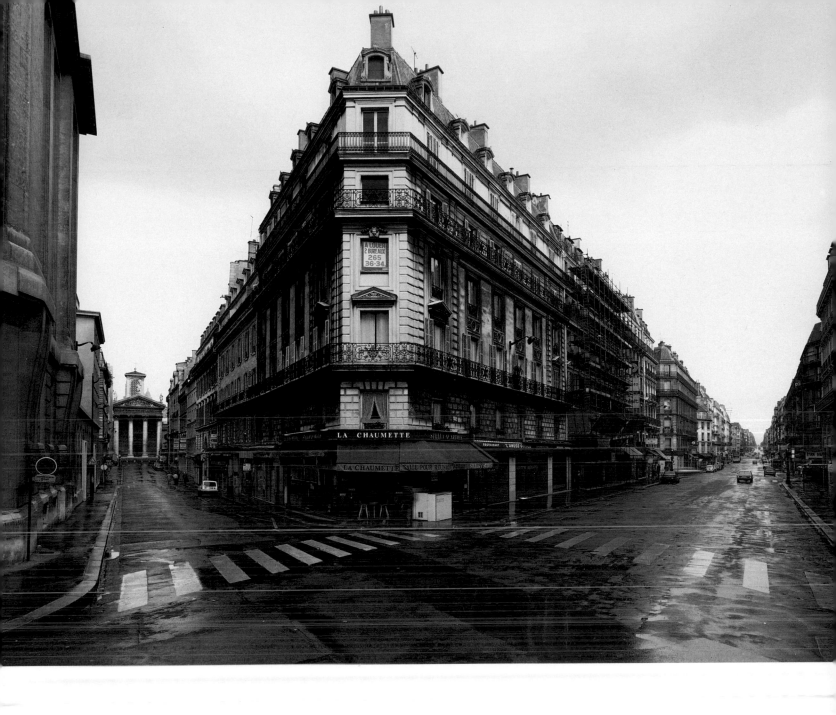

ABOVE Joseph Koudelka, *Cimetière du Montparnasse, 1986*

BELOW LEFT AND FACING PAGE
Christian Milovanoff, *Poste du Louvre, Paris, 1986*

Christian Milovanoff, *Centre National d'Ètudes Spatiales, Toulouse (Haute Garonne), 1984*

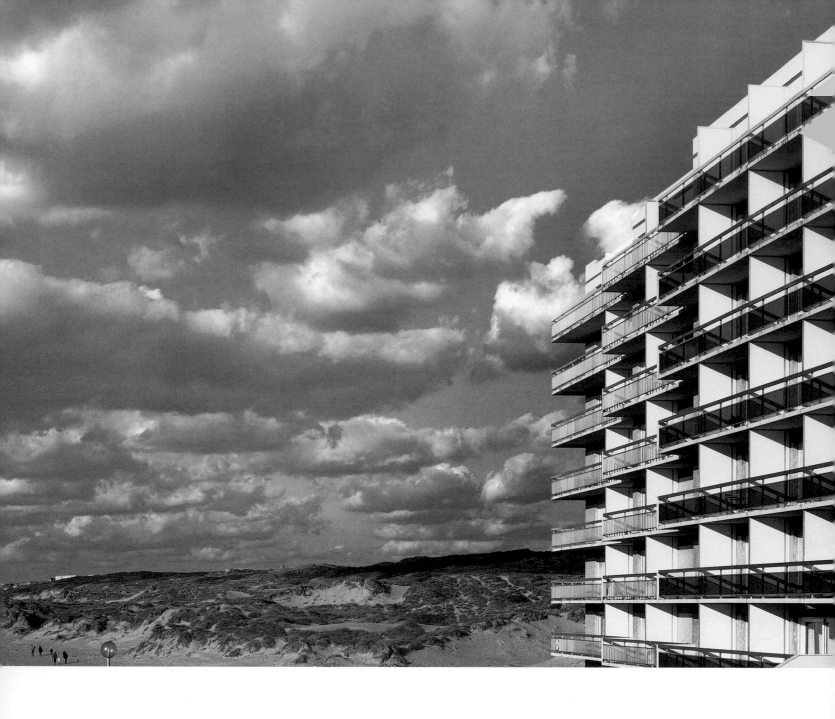

ABOVE Gabriele Basilico, *Herdelot-Plage (Pas de Calais), 1985*

FACING PAGE(TOP) Pierre de Fenoÿl, *Salvagnac (Tarn), 20/5/85*

FACING PAGE (BOTTOM) Pierre de Fenoÿl, *Environs de Montauban (Tarn et Garonne), 23/4/85*

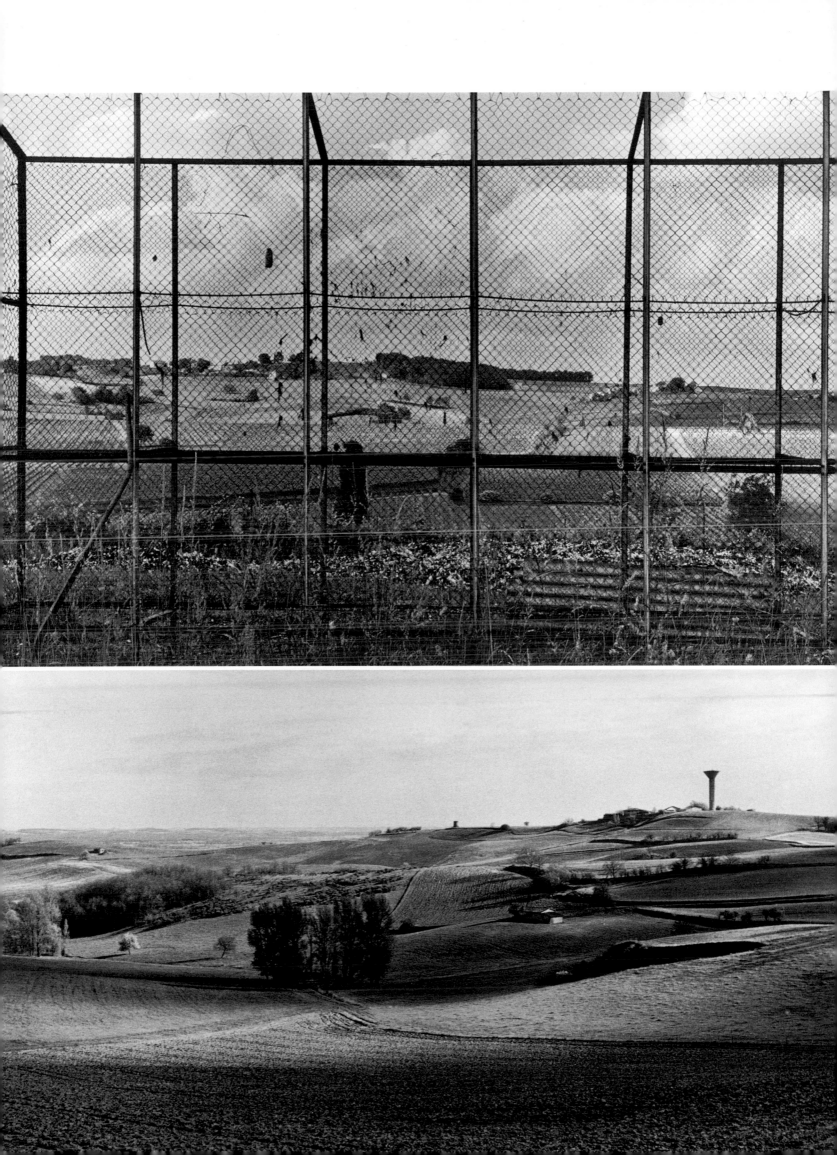

ABOVE Robert Doisneau, *Résidence de la Fosse-aux Prêtres, Palaiseau (Essonne)*, 1984

RIGHT Robert Doisneau, *Cité Beaudotte, Sevran (Seine-Saint-Denis)*, 1984

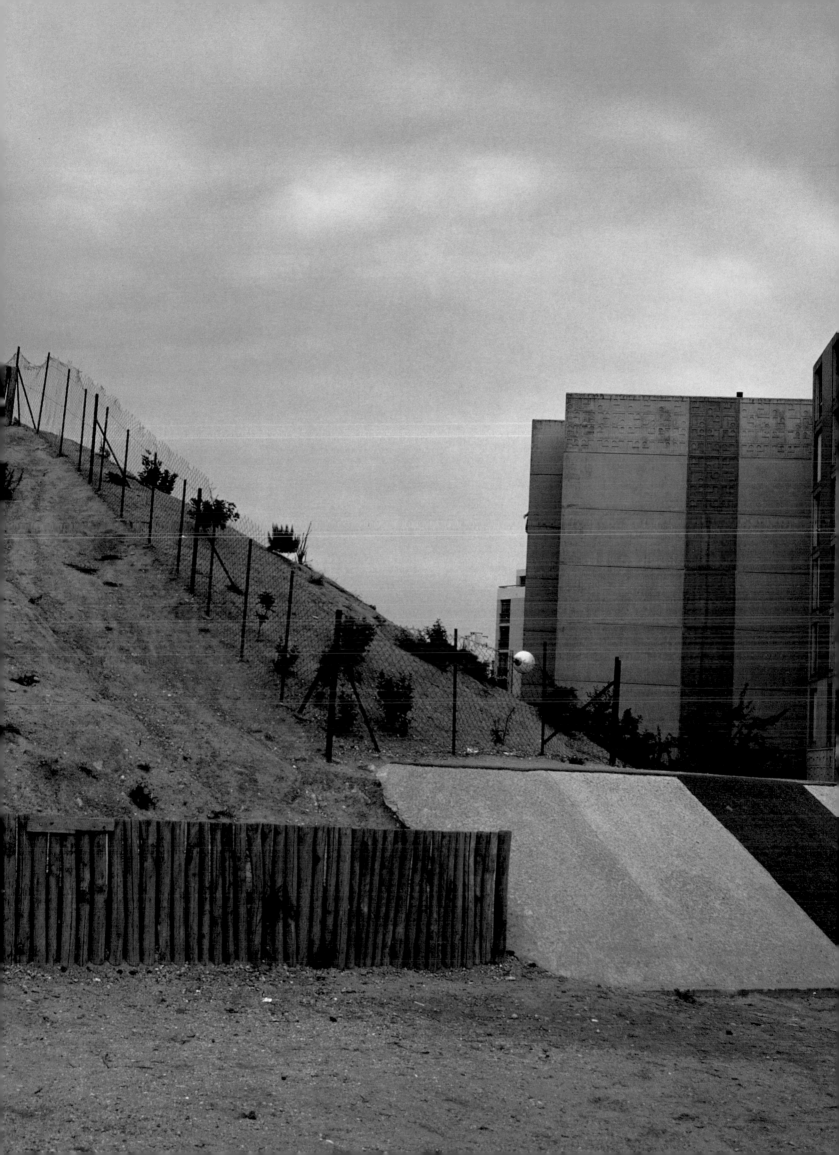

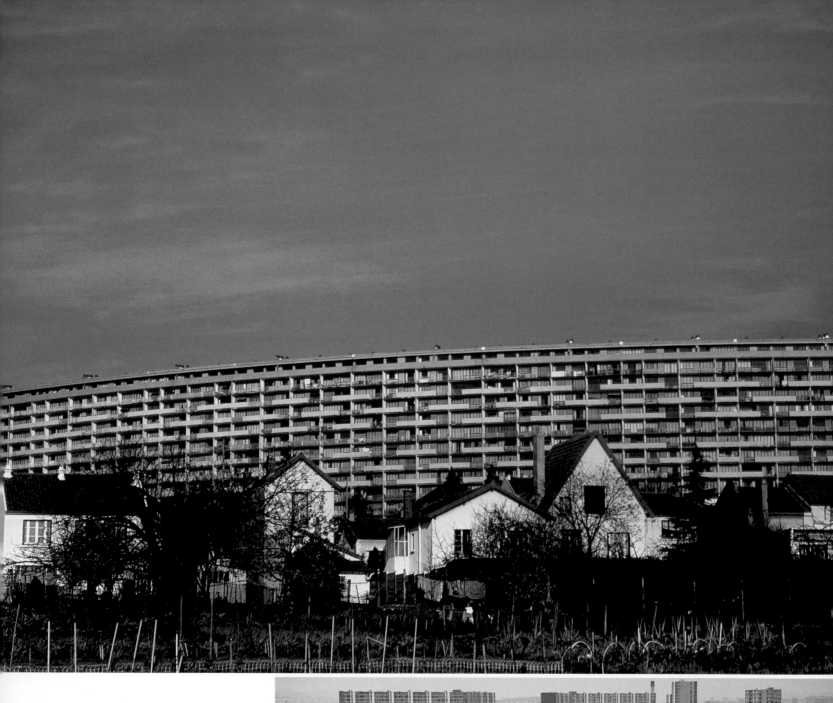

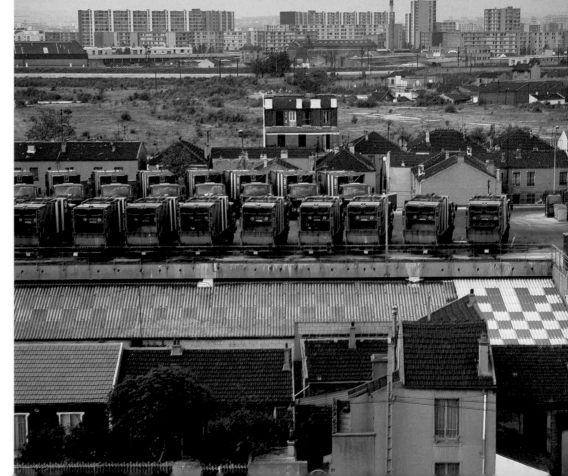

ABOVE Robert Doisneau,
*Cité Champagne, Argenteuil
(Val d' Oise) 1984*

BELOW Robert Doisneau,
*Aubervilliers (Seine-Saint-Denis),
1984*

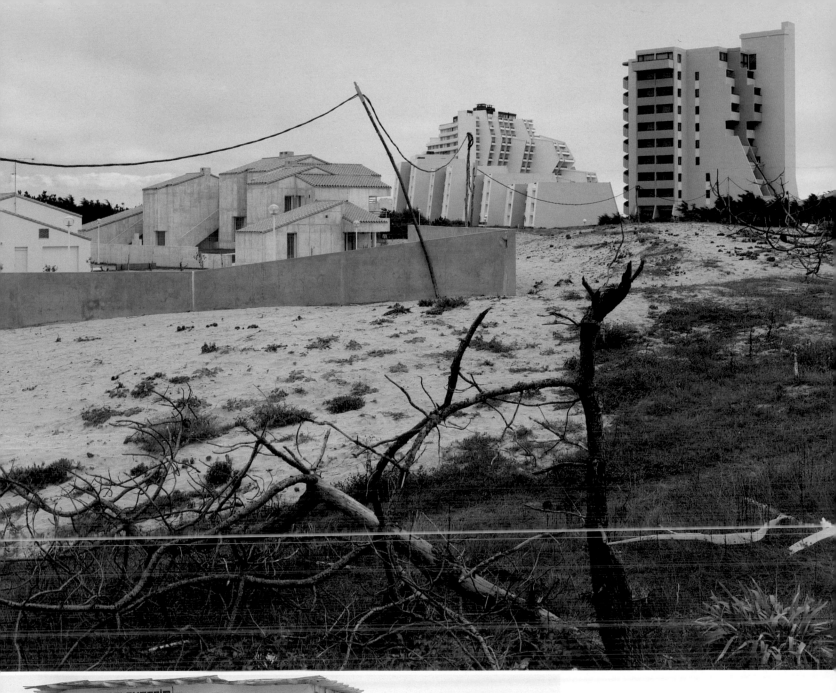

ABOVE Jean-Louis Garnell, *Club de vacances, Saint-Jean-de-Mont (Vendée), 1986*

BELOW Sophie Ristelhueber *La Réserve*, Nice, 1986

ABOVE Jean-Louis Garnell, *Chantier de la rocade pénétrante, Ouest Toulouse, 1985*

BELOW Jean-Louis Garnell, *Site de la Centrale Nucléaire de Golfech (Tarn et Garonne), 1985*

FACING PAGE Sophie Ristelhueber, *Environs de Saint Clément (Hautes Alpes) 1984*

LOCALITIES
BETWEEN PUBLIC AND PRIVATE SPACE

By the end of the 1950s, artists as well as architects turned their critical attention to a nexus of questions that arose from new social and urban spatial configurations. In France at the end of the reconstruction period, cultural production focused on the effects of mass culture; it was believed that the emerging consumer society was imposing an aesthetic of the banal. From the artists involved with Nouveau Réalisme and Fluxus to the more extreme politicoaesthetic collective the Internationale Situationniste, the French neo-avant-garde devised new vocabularies and tools to contest the divisions between public and private defining the new urban landscape. Whether intentionally or incidentally (in the case of the Nouveaux Réalistes and Fluxus artists), devices such as *détournement* (the diversion of aesthetic elements), *dérive* (drifting through the city), or *psychogeographie* (the infusion of psychology into a cartography), were employed in their artistic engagement with the city, the street, and the prosaic objects that saturate the space of everyday life.

Each of the works presented in this section approaches the scale of architecture, expanding the traditional parameters of the sculptural object. In an act of critical appropriation, these artists displaced urban structures—such as the storefront or construction barrier—from the street to the gallery or museum. They also addressed the private sphere by putting on display *l'espace habité* (space of habitation)—the hotel room, bourgeois apartment, or even the artist's own studio. The localities they constructed weaken the strict, binary separations between interior/exterior and public/private in order to create an "in-between" space. With these reversals, or acts of *détournement*, these artists attempted to liberate the urban environment from the alienating effects of modern life. In one of his foundational Situationist texts, Guy Debord affirmed that, "clashing head-on with all social and legal conventions, *détournement* cannot fail to be a powerful cultural weapon in the service of real class struggle."[1]

Between the commotion of the street and the silence of Yves Klein's *Le Vide* (The void), this sequence of works documents the search for a realizable utopian space. It is a space where the division between public and private melt into a single sphere. In neon words "imagination" and "innocence," which light up the interior of Robert Filliou's *Permanent Creation Tool Shed, Mobile Version*, the revolutionay implications of the Situationists' critique of the city appear to find a visual and discursive counterpoint. The playfulness of Filliou's nomadic space is analogous to the vision Constant Nieuwenhuis put forth in his architectural maquettes collectively titled *New Babylon*—a spatial urbanism invested with humanity's ludic instincts. Both artists attempted to create a space for liberated social interaction, turning the alienation of everyday life into what Filliou would have called "la République Géniale."

1. Guy Debord and Gil H. Wolman. "Mode d'emploi du détournement," *Les levres nues*, no. 8. Brussels, 1956. Translated into English, "Methods of Détournement," in Ken Knabb, ed. *Situationist International Anthology* (Berkeley: Bureau of Public Secrets, 1981), pp. 8–14.

YVES KLEIN

(b. Nice, 1928–d. Paris, 1962)

On five occasions, Yves Klein invited the public to encounter *Le Vide* (The void) by transforming space into art. Of these five works, each of which was realized in a different manner, only one survives today in the location where it was conceived. The way in which each void was "constructed" is both essential to the understanding of the works and paradigmatic of the concepts that underlie *Premises*. Though immaterial, these works confronted their audiences with their very reality.

Klein's conception of *Le Vide* is linked to the radical examination of the pictorial object. It results from a critical strategy that proposes art's escape from physical materiality. *Le Vide*, which lies between tangible reality and sensible space, can be perceived as awareness and revelation of the space of art.

Scholars Nan Rosenthal and Tom McEvilley insist on different interpretations of Klein's idea of the void and his related actions: while Rosenthal argues that they have the character of a Happening, McEvilley associates them with Klein's fascination for Rosicrucianism. Klein's unpublished text "Époque pneumatique" (Pneumatic era), on his April 1958 presentation of the void at the Galerie Iris Clert in Paris, refutes their claims. He declared, "The object of this experiment: to create, establish, and present to the public a sensible pictorial state within the confines of an exhibition space for ordinary paintings." Put another way, the creation of an ambience, of an invisible pictorial atmosphere, in the same spirit as what Delacroix called in painting "the indefinable," of which he spoke often in his journal as the very essence of painting.

Clearly, this has nothing to do with either spectacle or shallow spiritualism. Rather, it is an attempt—for Klein stated that *Le Vide* was an experiment—to redefine pictorial space. Although he regretted that every incarnation of *Le Vide* occurred in an institutional space, gallery, or museum, Klein emphasized that these manifestations led to the idea of "architecture of air,"[1] a spatial concept he developed with his friend the architect Werner Ruhnau.

Two of the five interventions examined here arose implicitly from a critique of the form of the painted canvas. At the Galerie Colette Allendy in Paris in May 1957, Klein created a void (entitled *Les Surfaces et blocs de sensibilité picturale invisible* [Surfaces and blocks of invisible pictorial sensibility]) in a room on the gallery's second floor, which he opened only to invited guests. Emptied of objects, with its walls painted white, this room responded to the *Monochrome Propositions* he presented on the first floor. While the monochrome canvases occupied the public space of the gallery, the void existed in an intimate, private space; through this opposition, the void extended the limits of pictorial existence.

Invited by Jacques de la Villeglé to participate in the annual exhibition *Comparaisons* at the Musée d'Art Moderne de la Ville de Paris in January 1962, Klein proceeded systematically to remove the works on display in one of the museum's galleries to create a void. This gesture finds antecedents in the many forms of emptying out that are integral to the history of Modernism. »

Yves Klein's earliest passion was judo, which he began to study in 1947. He later trained at the prestigious Kodokan Institute in Tokyo, and taught there and in Europe. Drawn by judo's spiritual dimension, Klein also developed an interest in Rosicrucian philosophy, which he read with his friends Arman and Claude Pascal (whom he met in his first judo class). One day, on the beach in Nice, Klein, Arman, and Pascal decided to divide the world amongst themselves. Klein chose the sky, with its aspect of infinity. He "signed" the sky's blue expanse, thus symbolically inaugurating his monochrome adventure. The first version of his Symphonie monoton—Silence *(Monotone symphony—Silence), a one-note composition followed by silence, was developed in 1949. A steady flow of monochrome presentations and exhibitions began in 1955. He met Pierre Restany, who wrote the preface for the brochure to his first solo gallery exhibition, at the Galerie Colette Allendy in Paris in February 1956. Restany also organized* Proposte monocrome, epoca blù, *an exhibition of Klein's monochromes at the Galleria Apollinaire in Milan the following January. Many exhibitions followed, at both the Galerie Colette Allendy and the Galerie Iris Clert in Paris, among others. In April 1958, Klein presented the bare white walls of the Galerie Iris Clert, made sensible by his presence alone; this exhibition became known as* Le Vide.

Between 1957 and 1959, Klein created a series of large-scale paintings for a new theater in Gelsenkirchen, Germany. »

FACING PAGE *Yves Klein Presents the Immaterial*, March 17, 1959. From the exhibition *Vision in Motion*, Hessenhuis, Antwerp, Belgium

Selected Bibliography

Klein, Yves. *Le dépassement de la problématique de l'art*. La Louvière, Belgium: Éditions de Montbliart, 1959.

___. *Dimanche—Le Journal d'un seul jour*. Paris: Festival d'Art d'Avant-Garde, Nov. 27, 1960. Only issue.

Restany, Pierre. *Yves Klein, le monochrome*. Paris: Hachette, 1974.

Rosenthal, Nan. *The Blue World of Yves Klein*. Cambridge, Mass.: Harvard University Press, 1976.

Restany, Pierre. *Yves Klein*. Paris: Éditions du Chêne, 1982. Trans. John Shepley. New York: Harry N. Abrams, 1982.

Yves Klein (exh. cat.). Paris: Musée national d'art moderne, Centre Georges Pompidou, 1983.

Stich, Sidra. *Yves Klein* (exh. cat.). Ostfildern, Germany: Cantz, 1994.

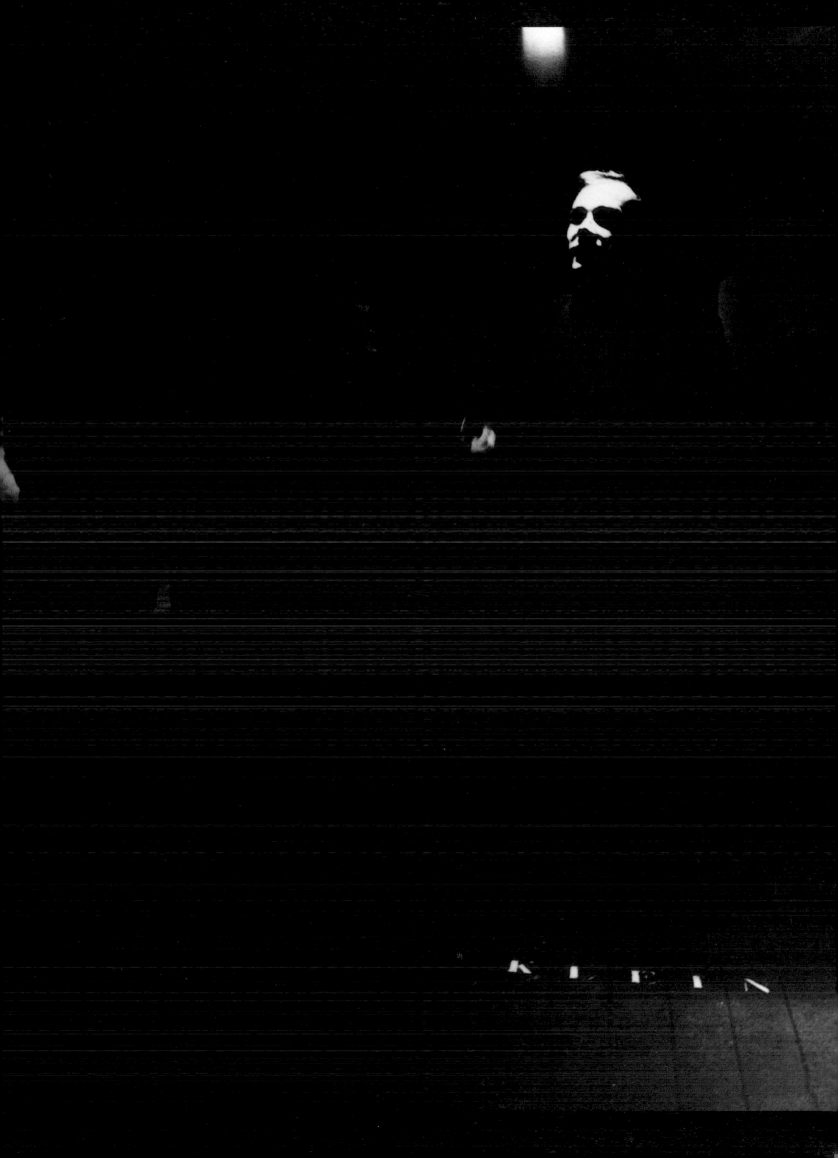

YVES KLEIN

The three remaining interventions have a decidedly more solemn aspect. For the 1958 presentation at the Galerie Iris Clert, Klein emptied the gallery and painted its surfaces white. Klein staged the opening almost as a theatrical event, in a ceremony that spilled over onto the street. (Among other things, blue drapes were hung over the doorway, where two Republican guards were posted.) The contrast between these two spaces—inside *Le Vide* and outside it —created two parallel experiences of time: the time of *Le Vide* is imminent and fixed, while the time of the street consists of movement and speed. For a group exhibition, *Vision in Motion—Motion in Vision*, presented at the Hessenhuis in Antwerp in March 1959, Klein made a declaration at the opening nominating an area of open space as his artwork. In doing so, he attempted to enact philosopher Gaston Bachelard's claim that only the presence of the artist defines the true existence of artistic activity. With the room Klein constructed at the heart of *Yves Klein: Monochrome und Feuer* (Monochrome and fire), at the Museum Haus Lange, Krefeld, in 1961, he attempted to define the boundaries of "nonspace," in direct opposition to the Modernist architecture of the museum.

Klein's voids express the internal conflict of the artist, while also relating to two antithetical paradigms of the art of the period. On one hand, artists were producing objects for the commercial market that were then submitted for critical commentary. The exchange value of these works—from their presentation to their critical reception—followed established custom. On the other hand, Klein attempted to substitute information and debate (defining principles of art practice) for the presentation of the work and its critical reception. Rather than interpreting, he explained the nature of his artistic practice.

By underlining the paradox that faces those who experience the territory of art, Klein's void cannot be reduced to any sort of formal prototype or trademarked image. It is an experimental proposition that contains a multiplicity of interpretations, all of which reveal its internal conflict.

BERNARD BLISTÈNE
Translated from the French by Lory Frankel

Among these works were his first sponge reliefs. In June 1959, he presented a lecture entitled "L'Évolution de l'art vers l'immatériial" (The evolution of art toward the immaterial) at the Sorbonne in Paris. He made his first anthropometries—for which he had live models cover themselves with paint and then press themselves against canvases—in early 1960; on March 9 of that year, he presented the performance Anthropométries de l'époque bleue (*Anthropometries of the blue period*), *accompanied by a Monotone Symphony, at the Galerie Internationale d'Art Contemporain in Paris. Concurrently, he began to make cosmogonies, in which marks were made by the natural world. In April 1960, the "Déclaration Constitutive du Nouveau Réalisme," written by Restany, was published. For the Festival d'Art d'Avant-Garde in Paris that November, Klein created* Dimanche—Le Journal d'un seul jour (*Sunday—The journal of a single day*).

Paul Wember organized Klein's first retrospective, at Museum Haus Lange in Krefeld, Germany, in January 1961. The same year, Klein exhibited in New York, at the Leo Castelli Gallery, and in Los Angeles, at Dwan Gallery. On January 21, 1962, he married Rotraut Uecker. Their son was born in August, two months after the artist's death.

1. "My walls of fire, my walls of water, my roofs made of air, are the materials to construct a new architecture. With these three classical elements—fire, air, water—the city of tomorrow will be built; it will be flexible, spiritual, and immaterial." Klein, from "L'Évolution de l'art vers l'immatérial," lecture given at the Sorbonne, Paris, June 3, 1959.

ABOVE Envelope addressed by Yves Klein containing the invitation card for the exhibition *La spécialisation de la sensibilité à l'état de matière première en sensibilité picturale stabilisée*

This invisible pictorial state in the space of the gallery should be in all respects that which has up to now best served as a definition of painting in general, that is, invisible and intangible radiation. . . .

Clearly, good paintings are also endowed with this special pictorial essence, this affective presence—in a word, with sensibility. Here, however, it is conveyed entirely by means of the painting's physical and psychological appearance: lines, forms, composition, color contrasts, and so on.

I seclude myself in the gallery alone forty-eight hours before the opening to repaint it entirely in white—on the one hand, to clean it of the impregnations from the last several exhibitions and, on the other, because the action of painting the walls white, the noncolor, temporarily turns it into my space of work and creation, that is, into my studio.

Thus, I believe that the pictorial space that I have already managed to stabilize in front of and around my monochrome paintings of previous years will be, from that moment, well established in the gallery space. My active presence in the given space will create the climate and the pictorial radiant ambience that normally dwells in the studio of every artist gifted with real power. A palpable, abstract, but real, density can exist and survive by itself and for itself solely in the empty spaces of appearance.

Yves Klein, from "L'Évolution de l'art vers l'immatérial," lecture given at the Sorbonne, Paris, June 3, 1959.

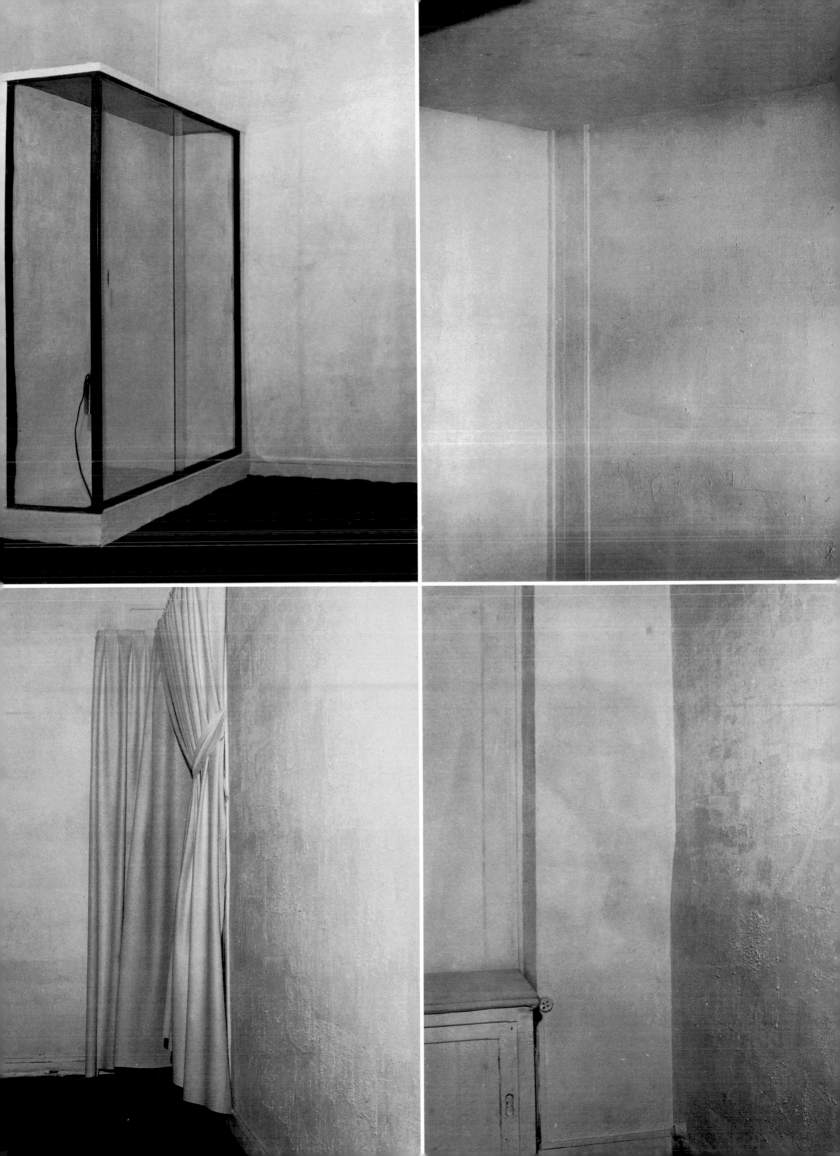

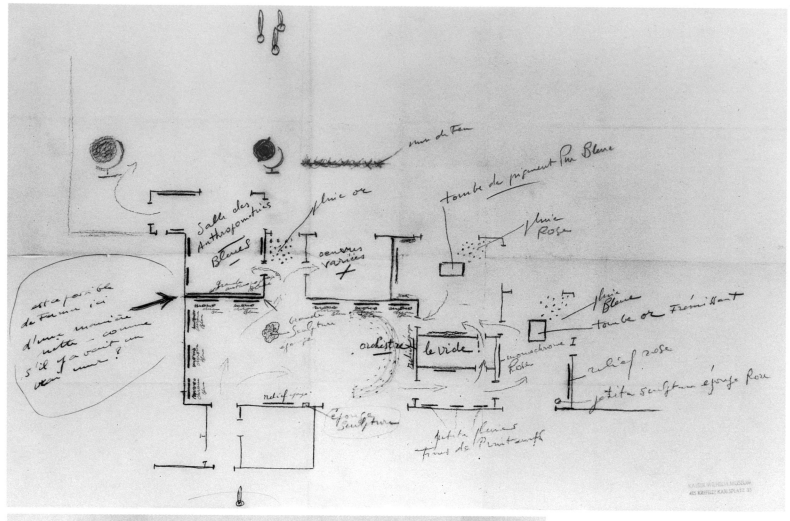

PREVIOUS PAGE Views of the exhibition *La spécialisation de la sensibilité à l'état de matière première en sensibilité picturale stabilisée*, Galerie Iris Clert, Paris, April 1958

ABOVE Installation sketch for the exhibition *Yves Klein : Monochrome und Feuer*, Museum Haus Lange, Krefeld, ca. November 1960

LEFT **Yves Klein in *Le Vide***, Museum Haus Lange, Krefeld, 1961

FACING PAGE *Le Vide*, Museum Haus Lange, Krefeld, 1961

ARMAN

né Armand Pierre Fernandez
(b. 1928, France; lives and works in New York)

As the son of an antique dealer, Arman's early life was saturated by the materials and principles that later animated his mature art practice. Indeed, when he entered the National School of Decorative Arts in Nice, in 1946, he demonstrated more passion for collecting (Chinese Porcelains, African art, and more banal articles) than for his formal studies. In 1947, he met Yves Klein, who became a formative influence; among other things, Arman absorbed Klein's interests in Eastern and Western mysticism.

After relocating to Paris in the mid 1950s, Arman officially abandoned his studies and joined a circle that included many of the future practitioners of Nouveau Réalisme and American Pop art. His first solo exhibition, at the Galerie Haut Pavé in 1956, consisted of his Cachets (Stamps) and Allures de l'objet (Allures of the object). Arman pushed his engagement with the object in his first Accumulations and in his found object-portraits Poubelles (Trashcans). In 1960, two days after the opening of Le Plein at the Galerie Iris Clert, Arman joined in cosigning the Constitutive Declaration of Nouveau Réalisme.

After Klein's death in 1962 and the gradual disbanding of the Nouveaux Réalistes, Arman began to spend extended periods in New York, exhibiting at the Sidney Janis Gallery from 1963 to 1968, and continuing to explore new formal strategies. Expanding his early Colère (Tantrum) pieces, he formulated his Combustion works. This destructive series culminated with the explosion of a white MG in Düsseldorf, entitled White Orchid. Arman has lived in New York since 1970.

Two years after Klein presented his infamous exhibition *Le Vide* (The void) at her Paris gallery, Iris Clert granted Arman the opportunity to respond to his best friend in the same space. *Le Plein*, translated on the invitations to the exhibition (which were written on sardine-can labels) as "The Full-Up," consisted of a huge volume of refuse transported into the gallery space. Scavenging in the streets of Paris with his friend and fellow artist Martial Raysse, Arman kept an exact inventory of the objects they collected during these *dérives* (a term used by the Situationists to describe such wanderings through the city). The materials they found were piled in the gallery to make it seem that the entire space was full of trash. In fact, Arman cheated: his discoveries were augmented by "nontrash" materials such as wooden crates, pieces of furniture, and toilet fixtures.

Arman's celebration of banal, mass-produced objects coincided with the emergence of sociopolitical analyses of the consumer society thought to be taking root in France at that time. A network of post-Existentialist literary and poetic works also addressed this subject. In his book *Le Parti-pris des choses* (The decisiveness of things), poet Francis Ponge extolled the simple beauty of ordinary, everyday objects. His poem "Le Cageot" (The crate) gives an exhaustive description of the fragility of a crate (one of the objects Arman chose to amplify the "fullness" of *Le Plein*) as a metaphor for the precariousness of everyday life.

The principles of listing and accumulation found in *Le Plein* also have a literary counterpart in the writings of sociologist-turned-novelist Georges Perec. His *Espèces d'espaces* (Sorts of spaces) is dominated by lists; each is an inventory of a given space compiled in order "to interrogate, or simply stated, to read [spaces]; because what we frequently call 'everydayness' is not obvious but opaque: it is a form of blindness, a kind of anesthesia. This book is developed from this elementary principle—it is a journal of someone who uses space."[1] In the chapter entitled "L'Immeuble" (The building), for example, there is an exhaustive enumeration of the contents of a building. Such a list would be possible only if the building's façade could be removed in order to see the interior—a hypothetical principle that Perec called "*défaçader.*" Perec wrote that this principle could equally be applied to the street: "[It] would allow for making a census of a part of the sidewalk covered with rubbish (old newspapers, tin cans, three envelopes) or an overstuffed garbage can."[2]

Arman and Perec share a methodology. Their common drive to list and accumulate is a humanistic and often humorous response to the decomposition of a society drowning in its own abundance.

ALISON M. GINGERAS

1. Jacket copy by Georges Perec for *Espèces d'espaces* (Paris: Galilée, 1974).
2. Perec named as one of the sources for this principle a drawing by Saul Steinberg, *No Vacancy*, published in the magazine *The Art of Living*. Georges Perec, *Espèces d'espaces*, pp. 58–60.

FACING PAGE View from the street of *Le Plein (Full-Up)*, Galerie Iris Clert, Paris, 1960

Selected Bibliography

Lamarche-Vadel, Bernard. *Arman.* Paris: Editions de la Différence, 1987.

Durand-Ruel, Denise. *Arman: Catalogue Raisonné II 1960–1961–1962.* Paris: Editions de la Différence, 1991.

Arman (exh. cat.). Paris: Galerie Nationale du Jeu de Paume, 1998.

LIST OF OBJECTS ACCUMULATED IN THE
GALERIE IRIS CLERT FOR THE EXHIBITION FULL-UP, 1960[1]

6 oyster shells

3 cubic yards of used bulbs

5 cubic yards of old plastic bags

2 tons of scrap metal from auto parts

1 car radiator grill

14 hospital night tables in metal

6 broken radios

1 cubic yard of magnetic tape from the musical works of Pierre Henry

250 pounds of pure garbage

200 pounds of old records

48 walking canes

7 coffee mills

1 sardine can

8 kettles

5 bidets

6 slices of bread

3 flower pots

180 bird cages

8 cubic yards of crates and boxes in 6 big polystyrene containers

123 old books

50 small paintings from the Mirco Salon Exhibition at the Iris Clert, by artists ranging from Picasso and Hartung to Manzoni

10 old hats

12 pairs of shoes

1 ice bucket

1 wallet with small change

4 neon tubes

5 bicycles

1 fur coat

1 purple bag with 2 boxes of Camembert cheese

20 olive oil bottles

1 leather case with binoculars (red and green lenses)

5 picture frames

1 kitchen table

1 big trunk

5 old paint buckets

3 different parts of a saddle

70 pounds of curtains

5 hula hoops

1 ash tray with ashes

4 storefront window shades

9 sheets of cardboard and plastic

9 feet of an iron fence

1 business envelope

1 blue car seat cover

7 wheat ears (Iris Clert's good luck charm)

3 art stands (for sculpture)

3 boxes of magazines, newspapers, and invitations for openings

1000 copies of a pamphlet by Mathais Goeritz, *L'art votif contre l'art merde* (Votive art against crap art)

1 roll of steel wire

2 new motorcycle seats

1 cubic yard of metal shavings

1. From Denyse Durand-Ruel. *Arman: Catalogue Raisonné II 1960–1961–1962* (Paris: Editions de la Différence, 1991), p. 46.

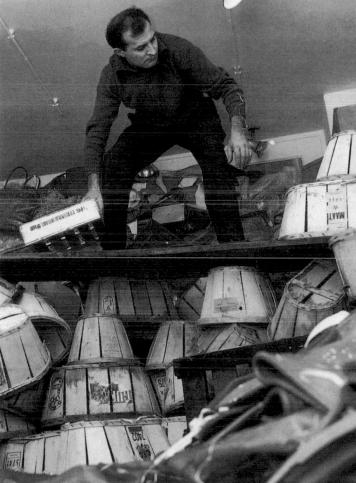

ABOVE Arman assembling refuse for *Le Plein*

FACING PAGE Iris Clert in the installation

CHRISTO

*né Christo Javacheff
(b. 1935, Gabrovo, Bulgaria)*

Christo was raised in an industrialist family in Bulgaria and studied at the Fine Arts Academy in Sophia from 1953–56. During a visit to Prague, he resolved to leave Eastern Europe, and in 1957 he spent a semester at the Vienna Fine Arts Academy. He moved to Paris the following year, and began work on his first well-known series, Wrapped Objects *and* Packages, *in which he covered a variety of objects (from pieces of furniture to flowers), with layers of plastic or textiles and bound them with rope, sometimes to the point where the object's identity was concealed. Until 1964, Christo and his partner Jeanne-Claude worked in France, producing a body of work that has often been erroneously categorized as Nouveau Réaliste. Although Christo arguably shared the Nouveau Réaliste interest in industrially manufactured objects, and even exhibited in seminal Nouveau Réaliste group exhibitions (at the Galerie J in Paris, 1962 and at the Galeria Apollinaire in Milan, 1963), he never officially joined this artists' collective.*

Christo has shared many of his contemporaries' engagement with urban space, from the Situationists' *dérives* and *détournement*, to Fluxus artists' playful interventions and performances. Yet while his peers were active on the streets of Paris, Christo approached the conditions of urban alienation from the inside. Between 1963 and 1968, he shifted his focus from the commodity (and its "wrappings"[1]) to the structures that frame it, producing a series of small-scale vitrines. These were generic glass boxes identical to those found in any commercial establishment—with one key exception: each electrically illuminated glass case had a piece of paper taped to its inside, which masked the contents. Christo's simple adjustment denied these showcases their basic function: display.

Expanding their scale, he then made a series of wood-framed *Storefronts*.[2] Constructed from a combination of new and found materials, these works have a "zero style"[3] that is recognizable from commercial venues in almost any European or American city. At the same time, *Storefront* has no aspiration toward functionalism: its door is locked; a white cloth drape is pinned to its inner frame; and a sheet of black paper fastened to the interior glass pane obscures the large front window. From the outside, the only thing visible is the glimmer of an industrial fluorescent light fixture. The work arrests Marx's notion of commodity circulation, by piquing the viewer's curiosity about the would-be commodity but precluding any encounter with it.

After his first three Storefronts, *Christo established permanent residence in New York with Jeanne-Claude and their son, Cyril. Since leaving Europe, Christo and Jeanne-Claude have continued work on projects with* Storefront's *architectural scale, including such works as* Dockside Packages *at the Cologne Harbor, in Germany in 1961 and* Iron Curtain-Wall of Oil Barrels, *which blocked the Rue Visconti in Paris in 1962. Their work has often involved temporary alteration to public monuments, urban structures, or various rural sites.* Running Fence, Sonoma and Marin Counties, California *(1972–76), a 24.5 mile fence made of woven-nylon fabric;* Japan-U.S.A. *(1984–91), an installation of over three thousand,* »

Perhaps obscuring the *Storefront* windows is a mischievous joke; a timely provocation directed at a new class of consumers, deprived of the titillation of window-shopping otherwise encouraged by the economic boom of De Gaulle's Fifth Republic.[4] Yet this blacked-out window more than just frustrates visual expectation. In the everyday experience of urban landscape, a storefront functions as a threshold that mediates the boundary between the public sphere and the semipublic space of a commercial establishment. The semipublic space is constructed to produce a false sense of intimacy—the perfect atmosphere for commodity consumption. Yet Christo once again refutes expectation and turns these spatial conventions inside out; in *Storefront*, the exterior (public) experience of the façade is transported into the interior (semiprivate) realm of the gallery. By blocking access to its interior, he makes the strategically dysfunctional *Storefront* more private than private. Cheated of both spatial and economic function, no longer a site for exchange, *Storefront* is a condemned space.

If it were not abutting the sidewalk, this piece might seem like an empty stage set. Without an immediately recognizable narrative to project onto this piece, the viewer trades the alienation induced by the commodity experience for a dose of critical distance. In the presence of this hollow architectural shell, there is no possibility to play out the various consequences of Capital. But just how hollow is this piece? The commodity objects and its frame are emptied of their aura (and function), but in the »

Selected Bibliography

Bourdon, David. "Christo's Store Fronts." *Domus* (Milan), no. 435 (Feb. 1966), p. 49.

Alloway, Lawrence. *Christo*. New York: Harry N. Abrams, 1969.

Bourdon, David. "Store Fronts: Architectural Wrappings Without the Content." In *Christo*. New York: Harry N. Abrams, 1970.

Laporte, Dominique. *Christo*. Paris: Art Press/Flammarion, 1986.

FACING PAGE *Yellow Storefront*, 1965, collection of Holly Solomon Gallery, New York

act of abstraction, Christo reinvests this commercial structure with a different kind of aura: that of the art object. Ironically, in its newly found singularity, *Storefront* again tampers with its critical function. Instead of an empty space, *Storefront* makes room for the viewer to contemplate an eroding dialectic. Perhaps, however, the dialectic is also an artificial construction. As Christo's work suggests, the collapse of public space into private interests is an ongoing saga that has not yet reached its denouement.

ALISON M. GINGERAS

1. Christo produced a series of *Wrapped Objects* in France during the 1960s.

2. The *Storefront* exhibited at the Guggenheim was created in Toulouse, France at the end of the summer of 1964, right before Christo and Jeanne-Claude moved to New York. The other two *Storefronts* were made in New York (February) and Paris (June) earlier that year.

3. Lawrence Alloway, *Christo*. New York: Harry N. Abrams, Inc., 1969, p. vii.

4. For a thorough account of the social, political, ideological and economic shifts that categorize this period in France, see Kristen Ross, *Fast Cars. Clean Bodies.* Cambridge, Mass: MIT Press, 1995.

CHRISTO

nineteen-foot umbrellas; The Pont Neuf Wrapped, Paris *(1975–85), a covering of the historic bridge over the Seine with a sand-stone colored polymide fabric; and* Wrapped Reichstag, Berlin *(1971–95), in which he and Jeanne-Claude covered the seat of the German government with reflective fabric. In every case, these installations originated as unsolicited proposals, never as the result of an official commission, and have been financed by the artists.*

Christo and Jeanne-Claude are currently working on three large public projects: The Gates, Project for Central Park, New York City, *(1979–present);* Over the River, Project for the Arkansas River, Colorado *(1992–present); and* Wrapped Trees, Project for the Foundation Beyeler, Berower Park, Riehen, Switzerland *(to be realized in November 1998). They exhibit and lecture about their works at universities, galleries, and museums around the world.*

LEFT *Showcase*, 1963, collection of the artists

FACING PAGE (TOP)
Double Storefront Project, 1964–65
Collection of the artists

FACING PAGE (BOTTOM LEFT)
Storefront Project, 1964
The Museum of
Modern Art, New York
Gift of Agnes Gund

FACING PAGE (BOTTOM RIGHT)
Three Storefronts, Project for the
Stedelijk van Abbemuseum,
Eindhoven, The Netherlands,
1965

The storefront has subtle correspondences with the space of urbanism, as well as being one-to-one replicas of architecture's human scale . . . the storefront is, in itself, the best known, the most public zone of a building; the threshold is the focus of attention. Thus when Christo seals show windows with sheets of paper, he cancels the internal space . . . that we anticipate and defines space as what is between us and the glass. The spectator's investigative, voyeuristic impulse is converted into an experience of himself, as an object in space.

Lawrence Alloway, *Christo* (New York: Harry N. Abrams, 1969), p. viii.

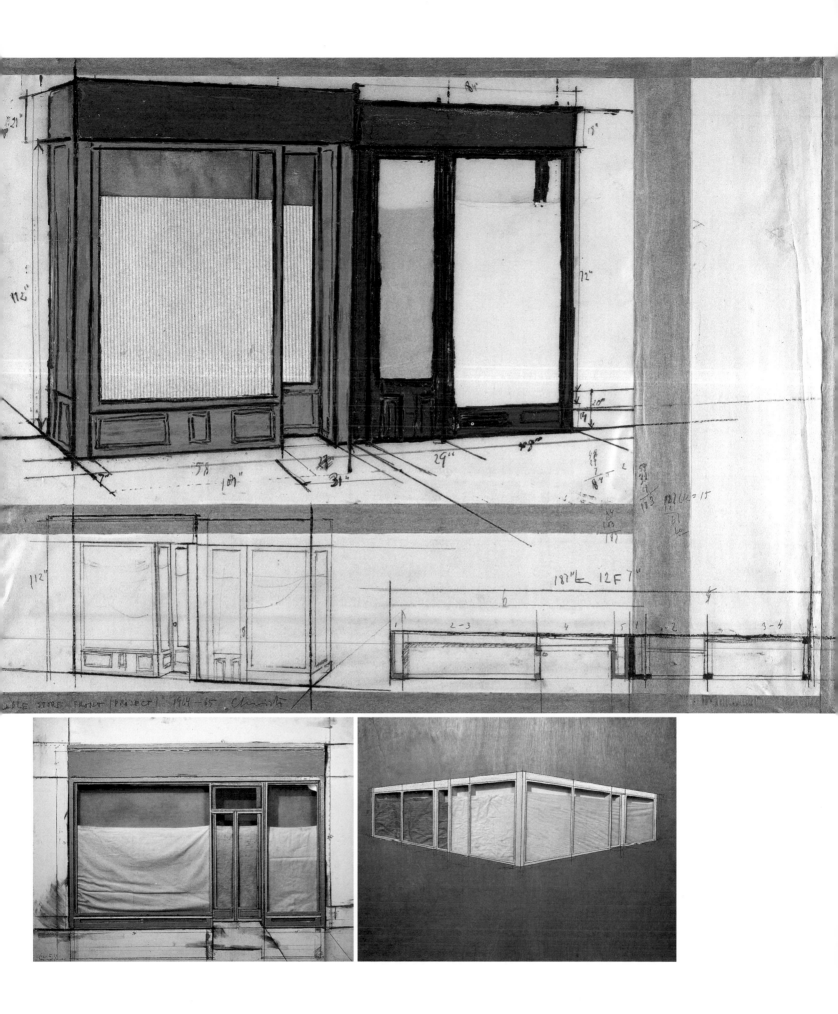

DBLE STORE FRONT (PROJECT) 1964–65 Christo

RAYMOND HAINS

(b. Saint-Brieuc, France, 1926)

The verbal-visual investigations of Raymond Hains testify to the imbrication of ideas about the burgeoning consumer society that were circulating at the end of the 1950s in Paris. Hains recalls that Guy Debord, who often slept at Hains's apartment on the stacks of posters the artist harvested from the streets, once remarked, "While you are on the streets tearing down posters, I am busy pasting them up."[1] This anecdotal quip reveals more than just a playful rivalry between these two mythical figures of the French neo-avant-garde. Like Debord, Hains practices the Situationist notion of *dérive*, drifting through the city to collect the materials for his art; he also applies the notion of *dérive* to his intellectual relationship with language and signification.

From his wanderings through the streets of Paris, Nice, or whatever corner of the world he finds himself in, Hains has composed a massive body of work by tweaking found materials into a visual and textual rebus. Hains's ongoing puzzle is never terminated; its infinity manifests what Jacques Lacan called the "vertigo of language." Like James Joyce and Raymond Roussel, among other literary figures, Hains picks apart the semiotic function. His work is a continual critique of perception that operates by disconnecting the wires linking signifier with signified. Unlike these avant-garde writers, however, Hains conducts his experiments with the city as his primary medium.

Just before the Centre Georges Pompidou opened in 1977, Hains wandered around the green, blue, and yellow barricades surrounding the construction site. The building was rising in the *quartier* Beaubourg, the working-class neighborhood that Debord and Asger Jorn had identified as free from the spectacularization of urbanism and whose streets graced their famous psychogeographic map *The Naked City* (1957). Hains's intention was to fabricate a parallel but subversive narrative in response to the polemical gentrification of this site. In the work that emerged from this particular experience, his *Palissades*, Hains recorded, "re-glued," and re-coded the urban reality into a strange and perplexing act of resistance: stealing barriers from the construction site and transporting them into the gallery's exhibition space, he then re-articulated their layers of torn posters and fragments of graffiti to give sense to the otherwise imperceptible and banal nonsense of the street.[3] The word plays and *détournements* of images that he recognized and indexed in choosing these panels correspond directly to their original site. Each panel oscillates between the public space from which it was taken and Hains's private, mental universe, where he is perpetually scrambling its meaning.

ALISON M. GINGERAS AND BERNARD BLISTÈNE

After finishing his formal studies at the École des Beaux-Arts in Rennes, Raymond Hains arrived in Paris in 1945. The early part of his career was devoted exclusively to developing various techniques of abstract photography by deforming the glass of his photo lens. His interest in warping found images and text has continually resurfaced throughout his work, from the typographic experiments he called "lettres éclatées" (exploded letters, executed during his involvement with the Lettriste movement) through his most current projects.
In 1949, Hains executed his first experimental film, by recording images of torn posters on the streets of Paris. This initial gesture in the form of what Pierre Restany would later call the "appropriation of the real" marked the beginning of Hains's long collaboration with Jacques de la Villeglé in the Affichistes movement. The first Affichistes exhibition took place at the Galerie Colette Allendy in 1957.

Hains's preoccupation with the torn poster gained him notoriety during the first Biennale de Paris, in 1959, when he transported entire portions of construction barricades (palissades), with torn posters still attached to them, into the gallery space. The following year, he joined a diverse group of his contemporaries in signing the "Déclaration Constitutive du Nouveau Réalisme," written by Restany. Later in 1960, at the Galerie J in Milan, Hains exhibited the most celebrated series of his torn posters, La France Déchirée (Torn France), which deals with the Algerian war. Since the 1960s, Hains has continued his verbal-visual investigations, extending this practice to incorporate the visual and hypertext manipulations made possible by computer-based technologies. He lives in Paris and Nice.

1. In a conversation with the authors in May 1998, Hains said, "Debord a couché sur mes affiches." This statement is a typical word play by Hains: *coucher* in French has three possible meanings: to sleep, to have sexual relations with someone (he claims that Debord conceived his child in his apartment), and to write (*"coucher sur le papier"*). All three meanings could certainly be credibly ascribed to Debord's activities at that time.

2. Simon Sadler, *The Situationist* City (Cambridge, Mass.: MIT Press, 1998), p. 63.

3. Hains uses the term *ré-coller* (to re-glue) to describe both his act of transporting the panels that make up *Palissades* and the mental processes at work in his composition of the images and texts on these panels. Hains has said that these acts are a *"récollement du réel"* (a re-gluing together of the real).

Selected Bibliography

Raymond Hains (exh. cat.). Paris: Centre national d'art contemporain, 1976.

Raymond Hains (exh. cat.). Poitiers: Musée Sainte-Croix, 1989.

Raymond Hains: Guide des collections permanentes ou mises en plis (exh. cat.). Paris: Musée national d'art moderne, Centre Georges Pompidou, 1990.

Raymond Hains: Les 3 Cartier (exh. cat.). Paris: Fondation Cartier, 1994.

Buchloh, Benjamin H. D. "Décollages Affichistes," *October*, no. 56 (spring 1991).

ABOVE ***Appel du 18 juin***, photograph
of torn posters on the streets of
Lyon, 1974

In the décollagistes' pact with the anonymous vandalists of urban product propaganda these collaborative acts acquire a new and direct aggressivity. A type of intervention emerges that seems to anticipate the procedures that the lettristes and situationists would soon call détournement, practices responding to conditions that Debord would define in 1967: "A world at once present and absent which the spectacle makes visible is the world of commodity dominating all that is lived."

Benjamin H. D. Buchloh, "From Detail to Fragment: Décollage Affichiste," in *October*, no. 56 (spring 1991) p. 106.

ABOVE *Palissades (Barricades)*, 1976, FRAC Bourgogne

LEFT TO RIGHT
Raymond Hains in his apartment at the Hotel Windsor, Nice, 1992

Appel du 18 juin (detail), photograph of torn posters on the streets of Lyon, 1974

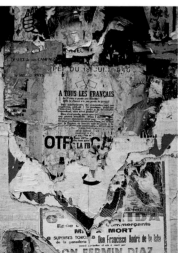

ABOVE Barricades around the Beaubourg construction site, 1976

DANIEL SPOERRI
(b. 1930, Galati, Romania)

Daniel Spoerri has said that he has felt like an outsider most of his life,[1] so it is perhaps no surprise that, after moving to Paris in 1959 he chose to live in one of the most transient of spaces: a hotel. Room number thirteen on the fourth floor of the Hôtel Carcassonne became his home, his studio, and his gallery, these seemingly separate domains combined in one small territory. Here, he entertained his many friends whose visits are immortalized in the *Tableaux-Pièges* that bear their names and that stand in testament to the meals and moments they shared with the artist.[2]

Spoerri was associated with the Nouveaux Réalistes, a loose collective of artists who worked with the mundane details of everyday life and challenged traditional definitions of what constituted art.[3] His *Tableaux-Pièges* (which translates literally as "picture-traps") were derived from domestic situations. He would interrupt a meal or a meeting toward its end and glue the random grouping of objects and leftovers that remained on the table to the planks of wood that he used as tabletops. The finished piece was then hung vertically on the wall. This last step constituted an essential part of the work, making it impossible to mistake the assemblage for a vulgar collection of common objects carelessly left around, and transforming it from an actual situation to an artwork. The viewer, left waiting for the objects to come crashing to the floor, is struck by the works' seemingly transitory nature. They appear to defy gravity. By freezing a precise but fleeting moment in this way, Spoerri captures the ephemeral and puts it on display.

Nearly forty years after he made his first *Tableau-Piège*, Spoerri returned to this seminal period in his work and the hotel room that fostered it. His reconstruction of room number thirteen of the Hôtel Carcassonne carefully respects the original's spatial configuration but removes it from its architectural frame: the work's cratelike exterior is in direct contrast to the illusionary room inside. As in his *Tableaux-Pièges*, the artificial context of the room defines it as a work of art. Every element of the interior is precisely placed and glued according to photographs of the original, including eighteen reproductions of *Tableaux-Pièges* that had first hung in the room. This life-size *Tableau-Piège*-turned-in-on-itself is utopian: there is no room for change or evolution, and the result is a self-consciously perfect vision of an unattainable past.

The act of placing a private, autobiographical realm on display as art is central to Spoerri's reconstruction. Constructed at a one-to-one scale, *Chambre No 13* has an imposing, illusionary effect. The viewer might be taken in by its claim to being Spoerri's real living space. Yet since the viewer is not allowed access to the room, the piece sets in motion a frustrating dialectic about public and private space. Locked outside, the viewer is forced to peer through the window or the door, and in doing so is made conscious of the fact that he or she is looking at a representation of a private space made for the public arena; like a hotel room itself, Spoerri's *Chambre No 13* exists somewhere between the public and private spheres. By exhibiting a vision »

Daniel Spoerri was twelve when his family fled from Romania to Switzerland during World War II. There, he later became involved in contemporary theater and the Concrete poetry movement. From 1954, he was the principal dancer of the Bern Opera, and three years later he was appointed the assistant director of the Landestheater in Darmstadt, Germany. He moved to Paris in 1959 and made his first Tableau-Piège the following year. In their recuperation of everyday objects, his series Tableaux-Pièges shared the ideas of a loose group of artists also working in Paris. On October 27, 1960, Spoerri and seven other artists signed the "Déclaration Constitutive du Nouveau Réalisme," and the group showed together for the first time at the Festival d'Art d'Avant-Garde in Paris a month later. Spoerri had his first solo exhibition at Galerie Schwarz in Milan in 1961. In the early 1960s, Spoerri expanded on the idea of the Tableau-Piège: incorporating into each artwork the tools he used to make it; and licensing friends to use his technique. In 1963, he transformed the Galerie J in Milan into a restaurant, which provided the raw material for a new series of Tableaux-Pièges. Spoerri reasoned that since the acts of eating and drinking had produced the material from which this work was made, these acts were artistic actions themselves. He subsequently gave up making art objects and opened two restaurants in Düsseldorf: Restaurant Spoerri in 1968 and Eat Gallery in 1970. When he returned to making art, he produced curious and troubling assemblages of elements hung vertically on the wall, similar to his Tableaux-Pièges. From 1977 to 1983, Spoerri taught in art schools throughout Germany. In 1990, the Centre Georges Pompidou, together with five European museums, presented a retrospective exhibition of Spoerri's work. He lives in Italy.

FACING PAGE *Chambre n° 13 de l'Hôtel Carcassonne, rue Mouffetard, Paris, 1959–64, version 1998,* collection of the artist

of his past idealized for the viewer, Spoerri reminds us that no gaze is innocent. A disquieting sculpture in the back of the room greets those eyes that linger too long in this nostalgic simulacrum: a bust of a woman whose eyes have been blinded by an oversized pair of scissors.

SARA COCHRAN

1. *Daniel Spoerri: Catalogue anecdote de seize oeuvres de l'artiste de 1960 à 1964* (Anecdotal catalogue of sixteen works by the artist 1960–64) (Geneva: Galerie Bonnier, 1981), unpaginated.

2. The inclusion of these names in the titles of various works underlines the pointedly personal nature of Spoerri's art. Indeed, in a conversation with the author, he said that this reconstruction of his Paris hotel room is the last in a trilogy of works that represents the three most significant moments in his life. The other two works in the trilogy are the tiny attic room in the head of Jean Tinguely's sculpture *Le Cyclop* (1960–87), which represents a room where he stayed during his first visit to Paris, and the installation that reconstructs the actual corner of the Restaurant Spoerri.

3. Ironically, given the radical nature of his technique, Spoerri recalls (*Daniel Spoerri: Catalogue anecdote de seize oeuvres de l'artiste de 1960 à 1964*) people looking at photographs of his work in 1960 and remarking that it was well painted! He was struck by the fact that many people could not comprehend that he was using real objects to make art.

Selected Bibliography

Spoerri, Daniel. *Topographie anecdotée du Hasard*. Paris: Galerie Lawrence, 1962.

Daniel Spoerri (exh. cat.). Zurich: City Gallery, 1966.

ABOVE *Chambre n° 13 de l'Hôtel Carcassonne, rue Mouffetard, Paris, 1959–64, version 1998*, offset poster of an original photomontage

RIGHT AND FACING PAGE *Chambre n° 13 de l'Hôtel Carcassonne, rue Mouffetard, Paris, 1959–64, version 1998* (details), collection of the artist

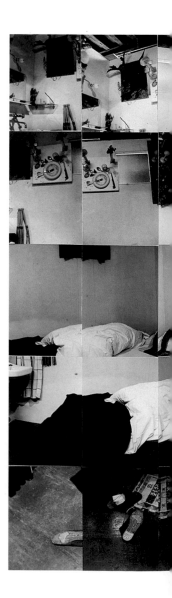

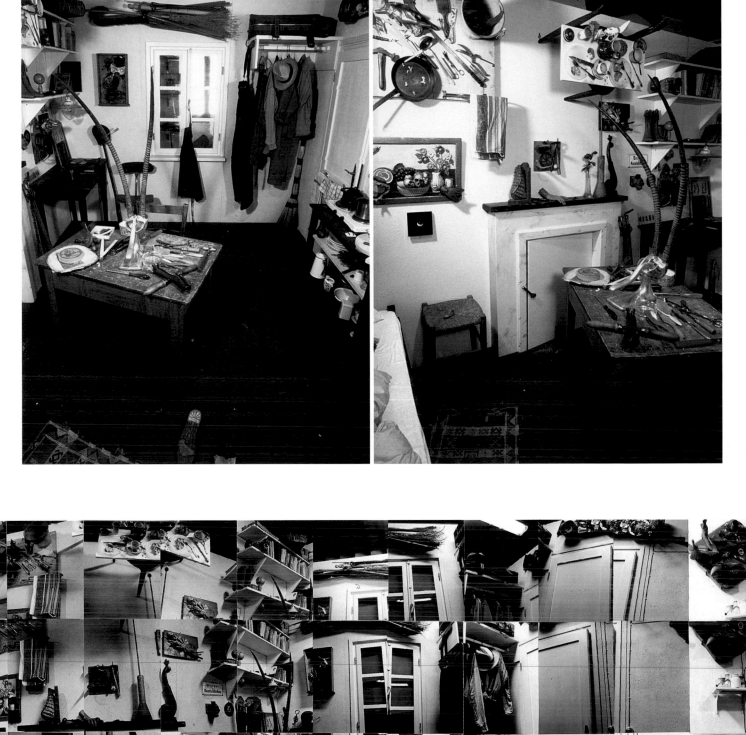

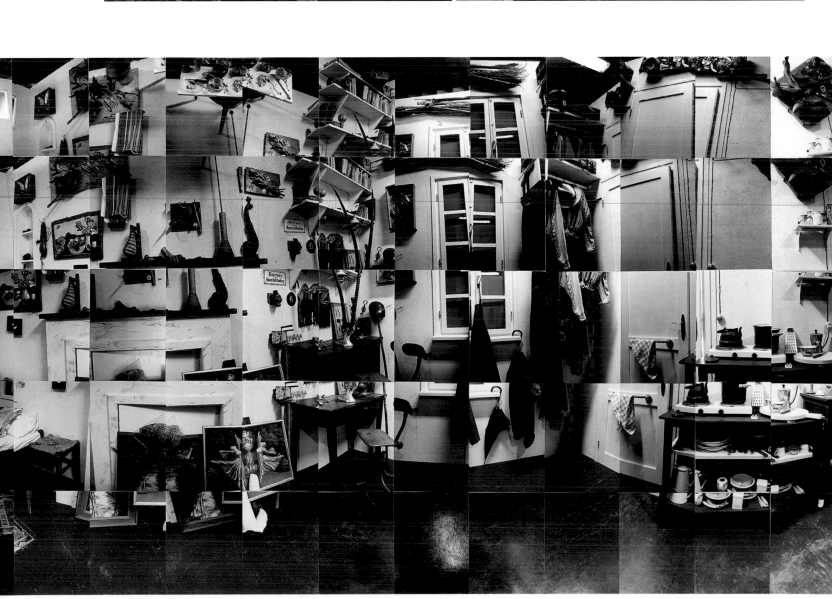

CONSCIOUS VANDALISM
1975

ARMAN

The obsessive collector's instinct evident in Arman's early work (nurtured perhaps by a family background in antique dealing) quickly became the pathological frenzy of *Les Colères* (Tantrums), his fascination with the *objet d'art* turning to fury. In these works, Arman carefully crushed and dismembered, then often reconstituted such cultural objects as musical instruments. *Conscious Vandalism*, represents a logical extension of *Les Colères* but instead of targeting a single cultural object, Arman launched this attack upon a whole environment: the petit-bourgeois interior.

Conscious Vandalism was performed by Arman at the John Gibson Gallery in New York in 1975. Aside from a video recording of the event, debris is all that remains of the work. The action captured in the video has been described as a three-act drama,[1] with the first act setting the scene: Arman moves among the stores of Chinatown and Little Italy in New York, carefully selecting a range of household objects; he deliberately chose to shop at local stores offering bourgeois living at wholesale prices in the form of abundant imitation goods, rather than at fancy department stores. In act two, the cheap bourgeois scenery Arman selected is carefully set up within the gallery space in a manner that underscores the built-in artifice of the performance; for example, the walls of the interior are constructed below the actual height of the gallery walls and carpet is laid only within a designated area. With the cunning of professional prop handlers, Arman's assistants arrange cosmetics on a dressing table and add such homely touches as dried flowers. Each detail builds up in stifling layers the rules and etiquette encoded within the conventional domestic interior. In act three, Arman unleashes his final act of fury as he takes a hatchet to these objects—and to their concomitant myths. With each random blow of his ax, Arman relinquishes his artistic autonomy. It is not only Arman's ax but the entire three-act performance of *Conscious Vandalism* that makes an assault upon the commodity-dependent bourgeoisie. The inherent artifice of the event is aligned with the artifice of middle-class living. By acting as a consumer himself, Arman exposes the paradox of the ever-thirsty cycle of production and consumption. He dissects notions of authenticity, originality, and value, by revealing the infinite multiplicity of such objects within an abundant market. If the event's first act targets the external processes of commodity production, act two targets the internal processes that partner commodity value—the codes of etiquette and taste that govern such things as how a knife should be handled or what colors are appropriate for a bedroom. Act three offers a violent denouement: the destruction that leaves debris in its wake; and while the detritus of the living room remains inside the gallery, it points to a world beyond.

JEMIMA MONTAGU

1. Sarenco, *Arman: Conscious Vandalism/Vandalismo Cosciente* (Verona: Edizioni Factotum-Art, 1982), unpaginated.

FACING PAGE *Conscious Vandalism*, 1975, documentary photos of the happening at the John Gibson Gallery, New York

BELOW *Conscious Vandalism*, 1975, preparation of the set for the happening

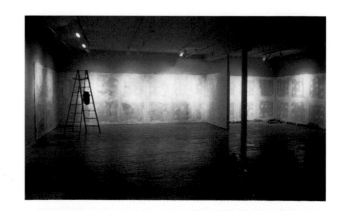

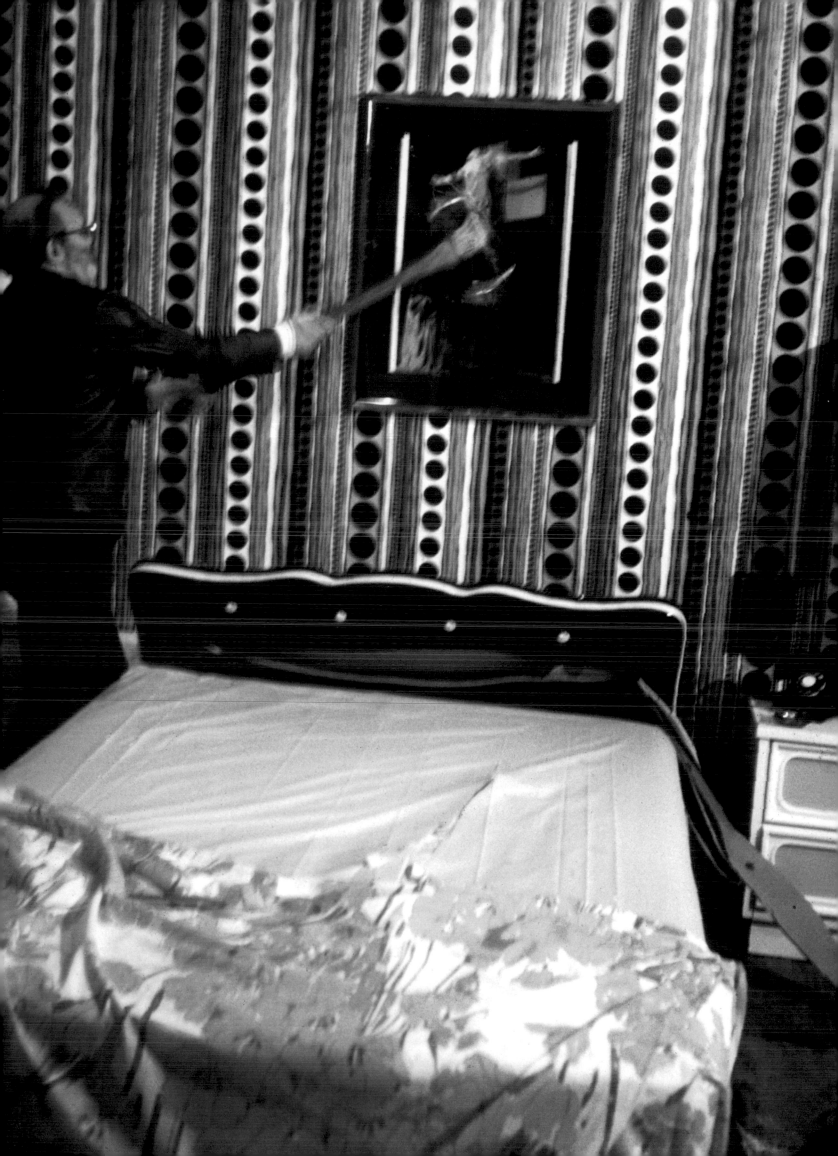

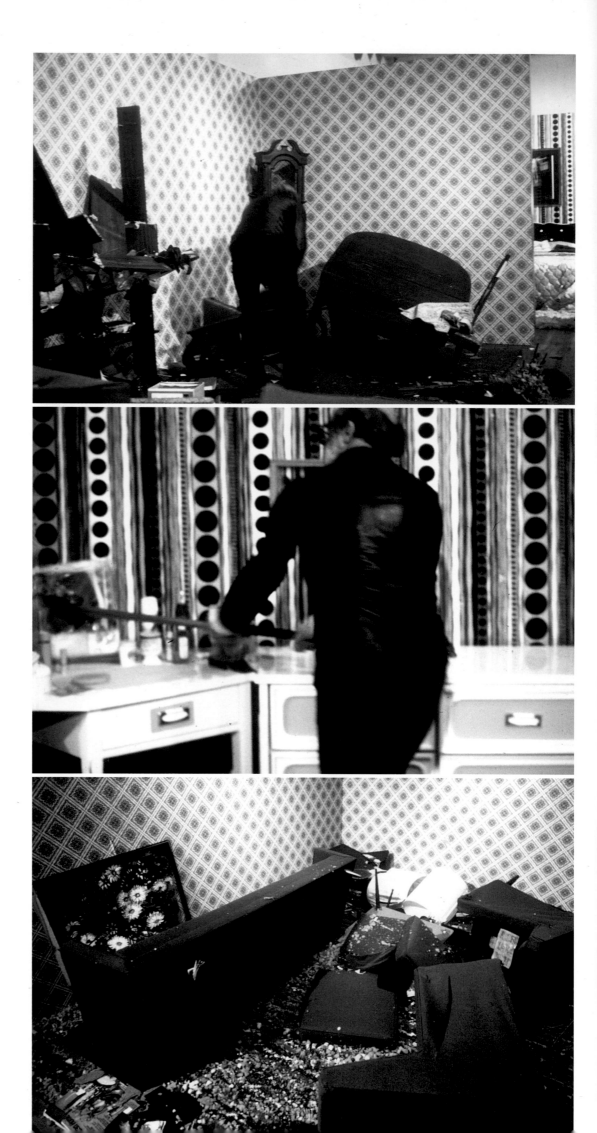

THIS PAGE AND FACING
Conscious Vandalism, 1975,
documentary photos of the
happening

ROBERT FILLIOU
(b. 1926, Sauve, France–d. 1987, Les Eyzies, France)

In 1969, while working in Düsseldorf, near George Brecht, Daniel Spoerri, Dieter Roth, and André Thomkins, Robert Filliou executed two major works: *Création Permanent, le Principe d'Équivalence* (Principle of equivalence) and several versions of *Permanent Creation Tool Shed*. Filliou had already demonstrated his interest in developing spaces of creation. In 1963, with architect Joachim Pfeufer, he devised the concept of the *Poïpoïdrome*, a place for thought with a "functional relationship among reflection, action, and communication"[1]; the optimal version of the *Poïpoïdrome* would be a building twenty-four meters square, the minimal version "a chair, a workbench, and an open mind." Two years later, he created an actual place, with Brecht, at Villefranche-sur-Mer, France. From 1967 to 1969, he operated La Cédille qui Sourit (The smiling cedilla), a sort of shop-studio conceived as "an international center for permanent creation" and "for playing games, inventing and uninventing objects, being in contact with the humble and the great."[2]

Filliou sought to make material a type of creative process, the working method he called "permanent creation." Like the Dadaists, Filliou judged that "life is more interesting than art," and through the concept of permanent creation he sought to bring into play the creative means that would permit a transcendence of the art/life and artist/nonartist dichotomies. From this concept arose all the small texts in the book Filliou wrote with Brecht, *Games at the Cedilla or the Cedilla Takes Off* (1967), which led to the conception of the places of creation that are also places of thought. His *Boîte à outils* (The tool box) began to take on a variety of forms. In two existing versions (one in the collection of Marianne Filliou, the other at the Musée d'art moderne de Saint-Étienne, Robelin Collection), a handyman's or artisan's tool box, in which the two words *imagination* and *innocence* appear, contains a folding rule or a more unusual measuring instrument—a long succession of roughly cut wooden sections, based on the land surveyor's chain. The two words are endowed with an important presence; composed of neon lights, they visually illustrate the importance of creation that arises from every being, outside a set technique or artistic tradition.

In constructing these two versions of *Boîte à outils*, Filliou called on deliberately simple means, found outside customary technical and artistic rules. In creating his own measuring tools, the handyman stands in contrast to the artist, according to Claude Lévi-Strauss's analysis, in remaining "one who works with his hands by utilizing indirect means, in comparison with those of the person of art."[3] The tools Filliou used for his pieces are the demonstration of a working method that would cause the viewer to take on the status of an actor.

A similar use of materials can be found in the two "habitable" versions of *Tool Box*. In 1969, at the Galerie Wolfgang Feelisch in Remscheid, Germany, Filliou transformed a tool shed in Feelisch's garden that contained a jumble of objects, including wire mesh, a shovel, and a saw, into a space for reflection and creation by attaching to »

Robert Filliou's postwar studies in economics at the University of California, Los Angeles, and an administrative career did not forecast his becoming, a leading artist who, following Marcel Duchamp, challenged many of the classic aesthetic principles associated with the original work of art. His first exhibition took place in 1961 at the Galerie Köpcke in Copenhagen, where he presented a group of Suspense Poems *composed of small objects. This parallel usage of language and objects is characteristic of an oeuvre that developed around certain major concepts, formulated while he worked primarily in France and Germany. The "Principle of Poetic Economy," which sought the smallest point between art and life; the "Principle of Equivalence," which presented an equation among things well-made, badly made, and not made at all; and the constitution of the "Territory of the Inspired Republic," all found their form in a multitude of installations, assemblages, books on artists, and videos conceived to foster the liberation of the spirit. Reflexively leaning toward the utopian, Filliou's art refers to Buddhist tradition. One of his last works,* Un, Eins, One . . . *(1984), comprised of five thousand dice with the figure "1" on each face, offers a way to reestablish, through the agency of chance, the path to unity.*

FACING PAGE *Permanent Creation Tool Shed*, 1969–88, view from the exhibition *Hors Limites*, 1994, Centre Georges Pompidou, Paris

Selected Bibliography

Filliou, Robert. *Lehren und Lernen, als Auffuehrung Künste/Teaching and Learning as Performing Art.* Cologne and New York: Verlag Gebr König, 1970.

The Eternal Network Presents Robert Filliou (exh. cat.). Hannover: Sprengel-Museum; Paris: Musée d'art moderne de la Ville de Paris; Bern: Kunsthalle, 1984–85.

Robert Filliou, Zum Gedächtnis (exh. cat.). Düsseldorf: Kunsthalle, 1988.

Robert Filliou (exh. cat.). Paris: Musée national d'art moderne, Centre Georges Pompidou, 1991.

Robert Filliou, Poet: Sammlung Feelisch (exh. cat.). Remscheid: Galerie der Stadt, 1997.

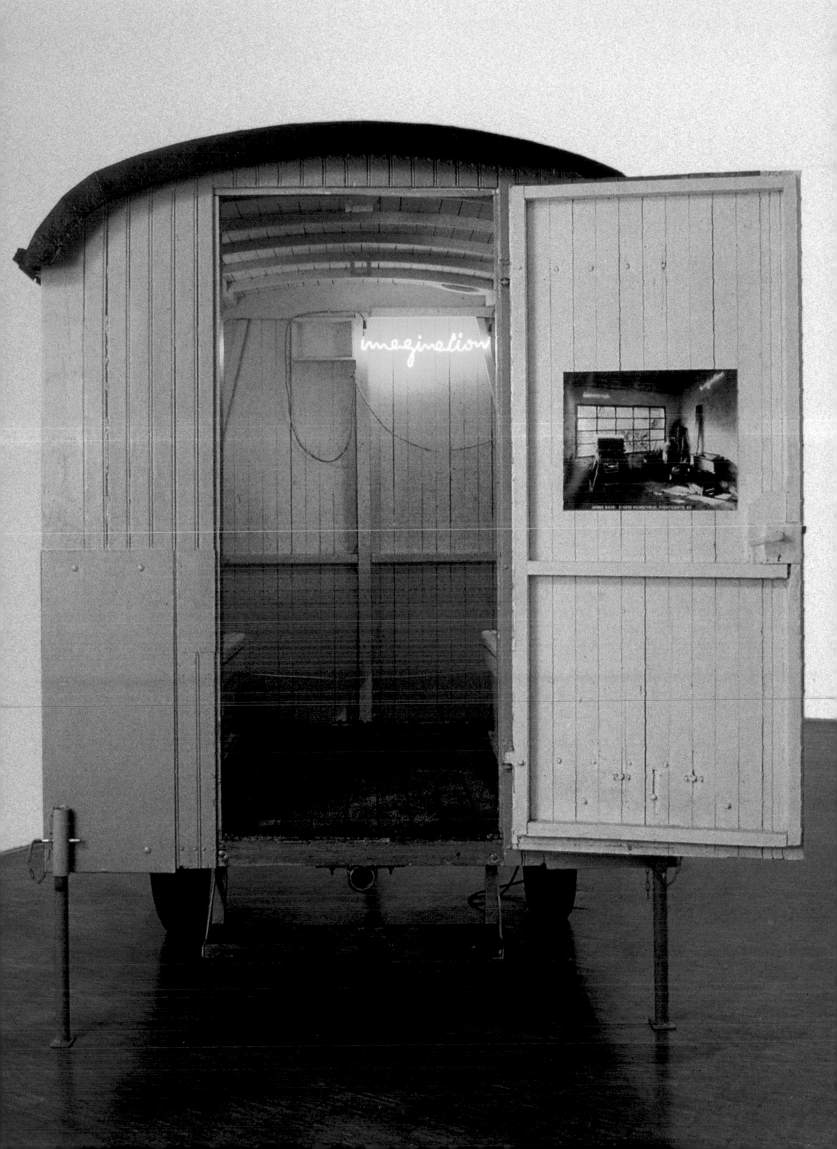

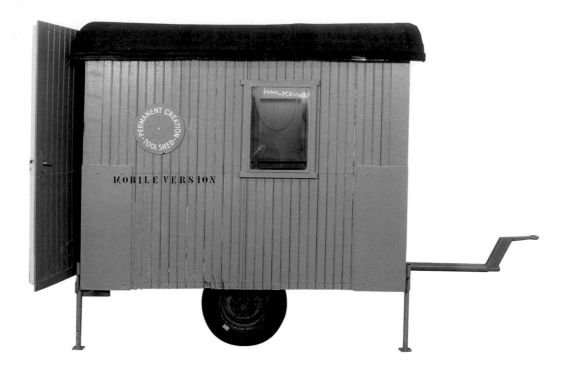

the wall the same two words, *imagination* and *innocence*, again in neon, and placing the title, *Permanent Creation Tool Shed*, on the exterior. In 1984, Filliou executed a mobile version of this space of creation and meditation, transforming a work-site trailer with the addition of the two words in neon, a photograph of the tool shed at Remscheid, and a circular panel naming the vehicle "Permanent Creation Tool Shed." Just as he had earlier created a mobile gallery in a hat entitled *La Galerie légitime* (The legitimate gallery, 1962), Filliou conceived an ambulatory interpretation of this work, permitting his concept to be displaced in space. The shed-studio could then be moored within an urban space (as it was for *Skulptur. Projekte in Münster* in 1987), placed at the disposition of passersby. Thus, in the heart of a mobile habitat, the trailer serves as the best instrument for disseminating an idea that aspires to remain light and nomadic.

<div align="right">

MARC BORMAND

Translated from the French by Lory Frankel

</div>

ABOVE *Permanent Creation Tool Shed*, 1969–88, exhibition view

BELOW Robert Filliou (with Wolfgang Feelisch, right) installing the *Permanent Creation Tool Shed*, 1969. Photo taken in Feelisch's garden in Remscheid during the first installation

FACING PAGE *Permanent Creation Tool Shed*, 1969, interior view. Collection Feelisch, Remscheid

FACING PAGE (BOTTOM) *Permanent Creation Tool Shed*, 1969, exterior view

1. Filliou, quoted in *Robert Filliou*, exh. cat. (Paris: Centre Georges Pompidou, 1991), p. 43.

2. Robert Filliou, *Teaching and Learning as Performance Art* (Cologne and New York: Verlag Gebr Koning, 1970).

3. See Claude Lévi-Strauss, *La Pensée sauvage* (Paris: PLON 1962), for his analysis of bricolage, used by Pierre Daix in relation to Cubist collage in *Cubisme de Picasso* (Neuchâtel: Ides et Calendes, 1979), p. 287, n. 114, and used also in my introduction to La Collection François et Ninon Robelin (exh. cat.; Saint-Étienne: Musée d'Art Moderne de Saint-Étienne, 1995), p. 16.

innocence

imagination

BEN VAUTIER

(b. 1935, Naples)

Born in Italy to a Swiss father and an Irish mother, Ben Vautier (who is commonly known by his first name) attended schools in Turkey, Egypt, and Greece as a youth. Since 1949, he has lived and worked in Nice, where he began as a purveyor of secondhand records and other youth-oriented goods. This enterprise eventually evolved into his activities as an artist committed to a "total art" environment. In 1958, he opened the first in a number of shops and galleries in this spirit, using them as outposts from which to promote his views of contemporary art. Vautier became associated with Fluxus in the early 1960s, and in 1963, he was the local organizer of the Fluxus Festival d'Art Total et du Comportement (Fluxus festival of total art and comportment) held in Nice. His work has also been linked to Nouveau Réalisme, with which it shares a vernacular sensibility, and with whose adherents he maintained close affiliations.

Throughout the course of his career, Vautier has questioned the conceptual basis of art. He has adorned everything from his person to the contents of entire dictionaries with quips that gently poke fun at the fundamentals of art. These texts, written in his instantly recognizable script, pose questions or make wide-ranging statements such as, "Je suis art," "L'art est inutile," and "There is certainly some pleasure in putting one's finger in butter."

Vautier's work has been the subject of numerous solo and group exhibitions, including Happening and Fluxus *(Kunstverein, Cologne, 1970),* Documenta 5 *(Kassel, 1972),* À Propos de Nice *(Centre Georges Pompidou, Paris, 1977),* Berlinart 1961–87 *(The Museum of Modern Art, New York, 1987), and* In the Spirit of Fluxus *(Walker Art Center, Minneapolis, 1993).*

Beginning in the late 1950s and early 1960s, a host of emergent art forms embraced a radically different stance toward the act of art-making. Favoring a practice that engaged more directly with "real life" and less so with the increasingly rarefied art world, artists turned to the realm outside the two-dimensional plane of the canvas, using their bodies, the landscape, and the fabric of daily life to extend the parameters of aesthetic experimentation. Fluxus, an international network of artists who postulated a new relationship between art and life, proclaiming that "anything can be art and anyone can do it,"[1] was at the forefront of this impetus toward what has been termed the "dematerialization" of the art object. Fluxus activities encompassed music, performance, multiples, experimental film, and assorted publications. It was in the early 1960s that Ben Vautier first became associated with Fluxus.

Living Sculpture, as *Ben's Window* was originally known, was created as part of the Festival of Misfits, held in London in October and November of 1962. The festival shared much in common with Fluxus programs, though it was not officially organized under the group's auspices. At Victor Musgrave's Gallery One, one of the festival's venues, artists including Robert Filliou, Arthur Koepcke, Robin Page, Daniel Spoerri, Vautier, and Emmett Williams created "music that may fit poetry, poetry that may fit paintings, and paintings that may fit . . . something."[2]

Ben's Window was a logical extension of the artist's *Living Sculpture* (*Sculpture Vivant*) series (1959–62), in which Vautier demonstrated his proclivity for authenticating anyone and anything within reach as art by lending it his signature and oftentimes an accompanying certificate. For the Festival of Misfits, Vautier created a "total art" environment in the gallery window, filling it with the detritus of urban life, as well as a makeshift bed, gas burner, teakettle, dishes, lights, and other accoutrements necessary to sustain his residence there for the duration of the festival. Adorning the gallery window, and many of the objects inside, was Vautier's inimitable script, exhorting his audience to both "look" and "stop looking," to "say anything," and even to "drink Coca-Cola."

Inside, Vautier went about the business of everyday life, his body and the profusion of ordinary objects transformed into Duchampian readymades. Alternately eating, sleeping, and grooming himself, he performed the most intimate and private of rituals on the public stage for passersby to observe. A *Living Sculpture* writ large, his body was not simply an intermediary connecting the environment with the viewer,[3] but the locus where the distinction between public and private space collapsed. Putting his personal activities on public view, Vautier created a "total art" environment from his own life, continuing the blurring of boundaries he had earlier begun. In 1960, for example, he had nominated the space he operated in Nice as a work of art; it continued to function for many years as both a shop and an artwork simultaneously.[4] »

1. "Art/Fluxus Art-Amusement," included in a broadside manifesto published by Fluxus in September 1965; reproduced in *Fluxus Etc.: The Gilbert and Lila Silverman Collection* (exh. cat., Bloomfield Hills, Mich.: Cranbrook Academy of Art Museum, 1981), p. 260, cat. no. 565.

2. Festival of Misfits announcement card for the Gilbert and Lila Silverman Fluxus Collection, Detroit.

3. This reading is suggested by Kristine Stiles, "Between Water and Stone: Fluxus Performance: A Metaphysics of Acts," in *In the Spirit of Fluxus* (exh. cat., Minneapolis: Walker Art Center, 1993), p. 67.

4. Paul Schimmel, "Leap into the Void: Performance and the Object," in *Out of Actions: Between Performance and the Object, 1949–1979* (exh. cat), London: Thames and Hudson; Los Angeles: Museum of Contemporary Art, 1998, p. 72.

Selected Bibliography

À Propos de Nice (exh. cat.). Paris: Centre national d'art et de Culture Georges Pompidou, 1977.

Berlin Inventory (exh. cat.). West Berlin: D.A.A.D.-Galerie, 1979.

Blistène, Bernard. "Ben Vautier" (interview), *Flash Art*, no. 132 (Feb.–March 1987), pp. 120–22.

LePage, Jacques. "Ben," *Artstudio* 15 (winter 1989), pp. 84–93.

In the Spirit of Fluxus (exh. cat.). Minneapolis: Walker Art Center, 1993.

Ben, pour ou contre: une réspective (exh. cat.). Musée de Marseille/ RMN, 1995.

PREVIOUS PAGE *Gallery One,* documentary photograph from the Festival of Misfits, London, October 1962

RIGHT Ben presents the *God Box* to a passer-by in Hyde Park, London. Documentary photographs from the performance at the Festival of Misfits

At the core of such "total art" environments was the artist himself, whose street performance *Regardez moi cela suffit* (Look at me that's enough, ca. 1962) succinctly elucidates this point. Simply by positioning himself behind a placard inscribed "*regardez moi cela suffit je suis art*," Vautier stripped away artistic conventions to lay bare the mechanisms at work below the surface. In so doing, he underscored his conviction that *ego* is the true subject of creative expression.[5]

Some thirty years after the Festival of Misfits, *Living Sculpture* was recreated from doorknobs to dishes for an exhibition at the Walker Art Center, Minneapolis, using a combination of original and newly created elements. Newly minted as *Ben's Window* and shorn of its original context on a busy urban thoroughfare, the reconstructed work can nonetheless be interpreted in terms that resonate sharply with its creator's view of art despite the radical shift to a contemplative museum space. For if Vautier construed art as a pretext for ego, the French writer Georges Bataille extended this notion even further. Writing in 1930 on the origins of the modern museum, Bataille commented that museum visitors were themselves becoming the real spectacle therein, observing, "The museum is a colossal mirror in which man finally contemplates himself from all angles, finds himself literally admirable and abandons himself to the ecstasy express in all the art magazines."[6] No longer merely the dominion of the artist as envisioned by Vautier, ego is loosened from its moorings in the work of art to float freely in a narcissistic fervor of self-adulation shared by artist and viewer alike. In its new museum environment, then, *Ben's Window* far surpasses its street-front predecessor in transgressing the carefully regulated boundaries between private and public, and subject and object.

J. FIONA RAGHEB

5. See Bernard Blistène, "Ben Vautier" (interview), *Flash Art*, no. 132 (Feb.–March 1987), p. 122.

6. Georges Bataille, "Musée" (1930), in *Oeuvres complètes* (Paris: Gallimard, 1970), vol. 1, p. 240; trans. Sara Cochran.

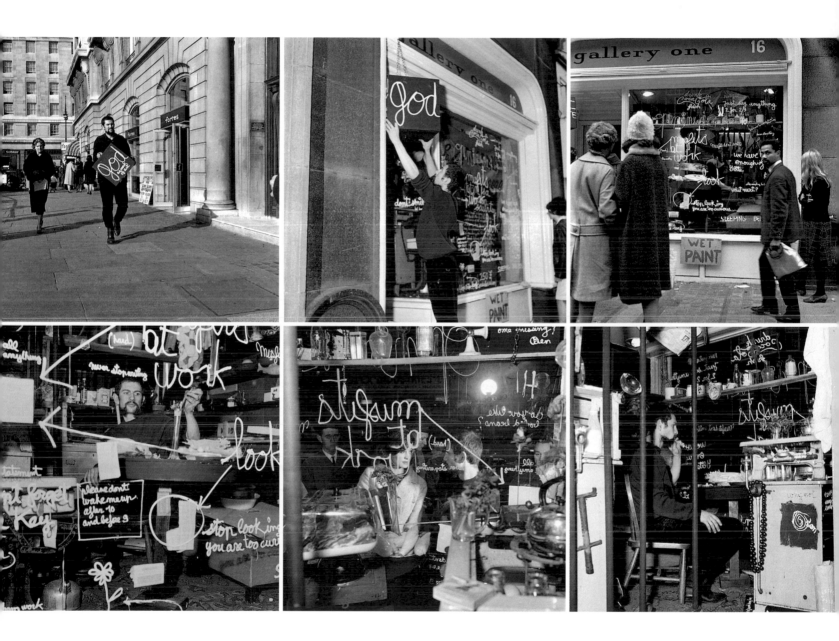

TOP (LEFT AND CENTER) Ben with the ***God Box during the*** Festival of Misfits, London, October 1962

TOP (RIGHT) Spectators gather outside of the Gallery One during Ben's Living Sculpture performance

BOTTOM (LEFT TO RIGHT) Living Sculpture, performance in the Gallery One during the Festival of Misfits, London

The Situationist International (SI) was founded in 1957 from a coalition of various avant-garde groups active in Europe after World War II: the Lettrist International group; the International Movement for an Imaginist Bauhaus, and the London Psychogeographical Committee. Influenced by Surrealism, but critical of its assimilation into mainstream culture, the SI was determined to continue the fight for social and cultural regeneration. Its annual conferences provided a forum for an international exchange of ideas on the subjects of art, culture, and politics. The journal Internationale situationniste became the central mouthpiece of the group; it was based in Paris and run by the charismatic filmmaker and founder of both the Lettrist International and the SI, Guy-Ernest Debord. As a result, the early activities of the SI were based around key principles inherited from the LI such as unitary urbanism, the integration of urban living and psychological needs through a transformation of the city environment. Other LI practices engaged by the SI were dérive and détournement. The "construction of situations," creative encounters or intensely lived moments, was another method for critically enhancing everyday life.

In the early 1950s, Guy Debord and Constant Nieuwenhuis, each unbeknownst to the other, spent a great deal of their time tramping the pavements of Paris and London, respectively. In the course of their wanderings through these great metropolises, they were struck by the simultaneous promise and poverty of modern urban life, its unique conjunction of new technologies, and age-old relations of domination and exploitation. If the setting of everyday life had been fundamentally transformed by modernity, its content had remained stubbornly the same. This urban predicament became the focus of Debord's and Constant's activities as two of the founding members of the Internationale Situationniste, a Paris-based politicoaesthetic avant-garde established toward the end of the 1950s.

Throughout the group's fifteen-year existence, the Situationists' central concern remained the revolutionary resolution of the disjunction present in modern urban life, in architectural, urbanistic, and social terms. Although Constant and Debord ultimately formulated quite different responses—one developing utopian blueprints for a model city of the future, the other devoting himself to a radical critique of existing conditions—they shared a common starting point. Both were strongly shaped by the context of post–World War II reconstruction and economic boom, despite the difference in their ages (Constant was born in 1920, Debord in 1931). In France, these years saw the general introduction of not only electricity, water, and heat into the home, but also of the mediatic images and information vital to the smooth functioning of a consumer economy. The Situationists observed that although humankind (at least that part of it living in the "developed" world) had never known a greater degree of comfort, lived experience itself seemed ever more pauperized. As one member wrote in the first issue of the group's journal, "A mental illness has overcome the planet: banalization. Everyone is hypnotized by production and conveniences—sewage system, elevator, bathroom, washing machine."[1]

The same point was made obliquely in Debord's collaboration with Danish artist Asger Jorn (another founder of the Internationale Situationniste) on the collage-novel *Fin de Copenhague* (End of Copenhagen, 1957). One page featured a text clipped from an English-language journal lauding "the new Industrial Revolution which will supply our every need, easily . . . quickly . . . cheaply . . . abundantly."[2] In a sense, the Situationists too believed these promises of postwar technology; their argument was not with such forms themselves, but with the ends to which they were put. If freed from the worries of providing for survival, *homo faber* could become *homo ludens*, humanity's creative play-instinct liberated from the shackles of production.

Such was the inspiration for Constant's utopian architectural maquettes, which he began to design in 1956. Collectively known as *New Babylon*, these models responded to the unfulfilled promises of modernity as outlined in Situationist critiques, in particular to Constant's claim that "the decreased amount of work necessary for »

The first "aesthetic" phase of the SI was based around these principles and practiced by artists such as Giuseppe Pinot-Gallizio through his "industrial painting," and by the Danish painter Asger Jorn in his Modifications series: bought paintings transformed, or détourné, by overpainting. The Dutch artist and architect Constant [Nieuwenhuis] responded in his New Babylon project, a utopian city suggested by the principles of unitary urbanism. By 1960, schisms had developed between the artistic and radical wings of the group. The radical wing, influenced by the writings of Henri Lefebvre, began to doubt art's revolutionary potential; one could no longer use existing culture as a means of transforming society but must revolutionize culture itself. In the following years, there were many expulsions from the group on the grounds of "unacceptable ideology," and by 1961, the SI had lost most of its founding artists. At the 1961 conference, the creation of art was officially dropped from the SI's program and it became dedicated to political critique and the 'revolutionary proletariat'; in 1967 Debord published La Société du spectacle. SI revolutionary activity reached its pinnacle during their involvement with the student riots and occupation of the Sorbonne in Paris in May 1968. But as the revolutionary tide ebbed so did the enthusiasm of the SI, and the group was finally dissolved in 1972.

Jemima Montagu

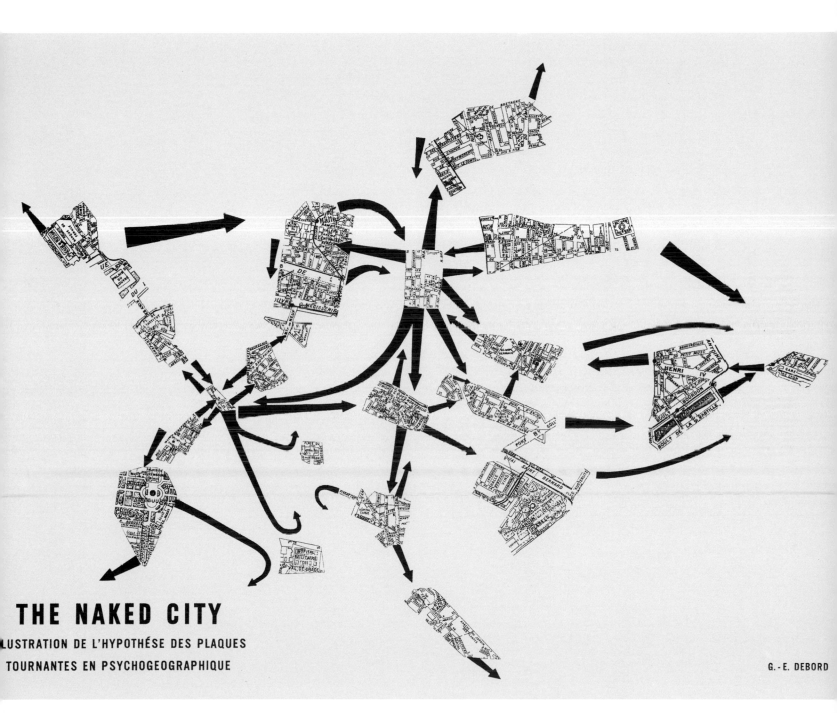

THE NAKED CITY

LUSTRATION DE L'HYPOTHÉSE DES PLAQUES
TOURNANTES EN PSYCHOGEOGRAPHIQUE

G.-E. DEBORD

ABOVE Guy Debord with Asger Jorn,
*The Naked City: Illustration de
l'hypothése [sic] des plaques tournantes
en psychogeographique [sic]*, 1957,
private collection

production due to extensive automation will create a need for leisure, which will necessarily lead to a new conception of the collective habitat having the maximum of social space."[3] This social space took the form, in Constant's maquettes, of great suspended structures, new cities of utopian leisure equipped with open plans so that interior arrangements could be changed according to the wishes of their inhabitants. This naïve dream, despite Situationist rhetoric to the contrary, continued a prestigious Modernist tradition in its violent, visible disjunction from the surrounding city. No less than Le Corbusier's contemporary apartment complex Unité d'Habitation (Marseilles, 1947–52), Constant's "sectors" lifted themselves both literally and symbolically above the hopelessly compromised fabric of the modern city.[4]

The internal contradictions of the Situationists' project of "unitary urbanism" (a neologism of dubious usefulness, specifying the simultaneous acknowledgment and refusal of the specialized discipline of town planning) could not be set aside for long. By 1960, Constant was drummed out of the Internationale Situationniste, and his utopian planning was superseded by the rigorous critique of urbanism as such. The Situationists of the 1960s claimed, "Urbanism does not exist: it is but an 'ideology,' in Marx's sense. . . . Urbanism is comparable to the promotional display around Coca-Cola, sheer spectacular ideology. Modern capitalism, which organizes the reduction of all social life into spectacle, is incapable of producing a spectacle other than that of our own alienation. Its urbanistic dream is its masterpiece."[5]

The groundwork for this critique had perhaps already been laid in Debord's explorations of Paris during the previous decade. These wanderings through the streets of the postwar city were graphically formulated in two maps produced in 1957; each imagines the city not as a continuous built fabric but as a fragmented field of power relations. The maps thus propose that class power, not architecture, determines the individual experience of the city and that class struggle structures urban space. This crucial realization provided the foundation for the most influential text of the 1960s on the city, French sociologist Henri Lefebvre's *Le Droit à la ville* (Right to the city, 1968). Working directly from Situationist theses, Lefebvre argued that a city's meaning is never definitively acquired, but must constantly be won if it is to be deserved. This struggle is waged on the grounds of accessibility: urban freedom is the creation of a centrality immediately accessible to all. Hence the city ceases to be a strictly spatial concept, for its stakes are fundamentally political. The truth of this proposition became obvious in Paris in May 1968, and it has since remained a challenge to those who would replace political transformation with architectural and urbanistic innovation.

<div align="right">TOM MCDONOUGH</div>

1. Gilles Ivain [Ivan Chtcheglov], "Formulaire pour un urbanisme nouveau," *Internationale situationniste*, no. 1 (June 1958), p. 17 (trans. author).

2. Asger Jorn, *Fin de Copenhague* (Copenhagen: Bauhaus Imaginiste, 1957), unpaginated.

3. Constant, "Une Autre Ville pour une autre vie," *Internationale situationniste*, no. 3 (Dec. 1959), p. 39; printed in English in *October*, no. 79 (winter 1997), p. 111 (trans. John Shepley).

4. See Fredric Jameson's discussion of this utopian space of Modern architecture in *Postmodernism, or, The Cultural Logic of Late Capitalism* (Durham, N.C.: Duke University Press, 1991), pp. 41–42.

5. Attila Kotanyi and Raoul Vaneigem, "Programme élémentaire du bureau d'urbanisme unitaire," *Internationale situationniste*, no. 6 (Aug. 1961), p. 16 (trans. author).

Selected Bibliography

Debord, Guy. *The Society of the Spectacle.* London: Rebel Press/ Dark Star; *La société du spectacle* (1967), Paris: Champ Libre, 1971 repr.

Mayaan, Myriam D. "From Aesthetic to Political Vanguard: The Situationist International, 1957-1968," *Arts Magazine* (no. 5) January 1988, pp. 49–53.

Sussman, Elisabeth (ed.). *On the Passage of a few people through a rather brief moment in time: The Situationist International 1957-1972.* Cambridge, Mass. and London, England: The MIT Press with the ICA, Boston, 1989.

Sadler, Simon. *The Situationist City.* Cambridge: Massachusetts Institute of Technology, 1998.

Knabb, Ken (ed. and trans.). *Situationist International Anthology.* Berkeley, CA: Bureau of Public Secrets, 1981.

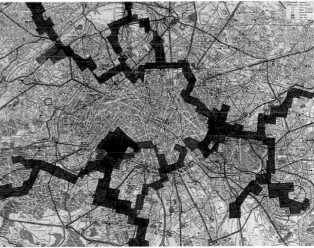

ABOVE Guy Debord and Asger Jorn, pages from *Memoires*, 1959

RIGHT, TOP TO BOTTOM Guy Debord and Asger Jorn, pages from *Memoires*, 1959; Constant, *New Babylon Paris*, 1963, Centre Georges Pompidou, Musée national d'art moderne; Constant, *Hanging Sector*, 1960, Haags Gemeentemuseum, The Hague

SITES OF MEMORY

CHRIS MARKER	*LA JETÉE; IMMEMORY*
JEAN DUBUFFET	*LE JARDIN D'HIVER*
ETIENNE-MARTIN	*LE MANTEAU (DEMEURE 5); LA MARELLE*
JEAN TINGUELY	*LE CYCLOP*
LOUISE BOURGEOIS	*PASSAGE DANGEREUX*
ANNETTE MESSAGER	*EN BALANCE*
CHRISTIAN BOLTANSKI	*L'HOMME QUI TOUSSE*
SARKIS	*TREASURES OF THE MNEMOSYNE*
GÉRARD GAROUSTE	*LA DIVE BACBUC*

The legacy of the avant-garde, in particular Surrealism, inspired continuing artistic preoccupation with subject formation and its relation to memory. For several generations of postwar artists the ties between mnemonic space and subjectivity have transcended their counterculture roots to become the lingua franca of art practice. Psychoanalysis, with its many references, signs, and archetypes, has become a discursive tool for artists whose work hovers around the intensities of the imaginative, unconscious universe. Metaphors concerned with introspection can be archaic, but the artists in this sequence have expanded a mode of pictorial representation into the construction of autonomous sites theatricalizing their investigations.

Whether based on historical, collective, or personal memory, certain formal tropes dominate this sequence. Geographical terrains—the underground, the labyrinth, the cave—provide both metaphorical and physical structures for the work of an older generation of artists. Louise Bourgeois, Jean Dubuffet, and Etienne-Martin abandoned their initial, discrete sculptural practices to create imposing environments. Drawing on the idea of the body as the primary locus of mnemonic burden, another generation of artists orients its work toward anatomies of the interior: these spaces, turned in upon themselves, are left for the viewer to puzzle over while crossing their highly charged grounds. From the ex-voto to the photographic image, objects found among sites by Annette Messager, Sarkis, and Jean Tinguely assume the status of fetish. The works in this sequence, passing from one fiction to the next, were chosen for the profound sense of pathos in the narrative each artist choreographs for the viewer to experience both physically and mentally.

Experimental cinema offers a compelling vehicle for the exploration of memory the same way theatrical space functions as a model for certain works in this section. In Chris Marker's science-fiction allegory of memory and time, *La Jetée*, and Christian Boltanski's little-known early short *L'Homme qui tousse*, cinematic space invites the imbrication of personal and historical remembrance. A double projection occurs within the darkened confines of the theater: the viewer projects his own subjectivity—strongly identifying with portrayed subjects—concurrent with the projection of the film image onto the screen. In a continual effort to summon the absent past, the artists in this sequence exploit the psychological and metaphysical effects of theater and cinema, attempting an art practice that is an emotional, individual, and symbolic domain: a space of pure subjectivity.

LA JETÉE
1962

CHRIS MARKER

(b. 1921, Neuilly-sur-Seine)

Chris Marker's *La Jetée* is a film about time and memory. Composed almost exclusively of black-and-white still photographs, the film literally unfolds over its twenty-nine-minute running time. The still images are edited in filmic sequences with occasional dissolves between shots. The soundtrack is composed of the voice-over that narrates the story, with music and sound effects added for emphasis and verisimilitude. The very economy of the film contributes to its powerful emotional impact, as it subtly reflects on human desires and needs.

La Jetée is also seductive and draws the viewer into a compelling, suspenseful, and sinister narrative. The story begins where it will end, on a jetty at Orly airport, where a young boy and a woman witness a man collapsing to his death. We learn it is a memory of Paris before the devastation of World War III, the boyhood memory of a prisoner now being held by other survivors in tunnels beneath Paris. The global destruction of this thermonuclear war leaves a band of scientists experimenting with time travel as a means to acquire the basic necessities—food, medicine, energy—for human survival. After numerous failed experiments with subjects driven to death or madness by the shock of confronting another time, the researchers bring in a subject who, they have learned through observation, has particularly strong mental images. He becomes the subject of *La Jetée* as he is plunged repeatedly into his past, where he focuses on engaging and discovering his powerful memories of a woman he desires and whose face he cannot forget: the woman on the jetty at Orly airport.

Through time travel, the woman engages her "ghost," who suddenly appears and vanishes, the soldier survivor of the world conflagration that lies in her future. The travels to the past are suspended as the scientists determine to send the prisoner to the future. There he encounters a transformed landscape without freedom and beauty. The people he meets give him a power supply to take back. After he accomplishes his mission, the scientists are prepared to send the prisoner to his death. However, those he engaged in the future (who easily travel through time) visit him and offer the possibility of his joining them. He asks instead to return to the world of the past and the woman he remembers. He finds himself on the jetty at Orly racing toward the woman. He sees one of his captors from the tunnels of postwar Paris and realizes that the image of his youth was future no more than his death foretold.

Told with such economy, this gripping story is essentially a Bergsonian narrative of time and the past as the present. In Marker's hands, the still photograph is a fragment of time, an instant memory that presents the past as present and thus as the future. The time traveler appears to those who meet him in the past as temporary and illusive phantom; a ghost of times past and future. The inhabitants of the future need this time traveler to help keep the present (future) alive. This slippery negotiation of time as a fluid past that becomes the future is, as Deleuze notes, an expression of a key Bergsonian ontological proposition that "while the past coexists with its own present, and while it coexists with itself on various levels of contradiction, we »

Journalist, novelist, essayist, documentary filmmaker, and once-assistant director to Alain Resnais: Chris Marker has had a polyvalent career that is difficult to categorize. Over the course of his long career, from his cult films Sans Soleil, Level 5, *and* La Jetée, *to his more recent projects that utilize CD-Rom computer technologies, Marker amalgamates his various practices in order to produce a body of work consumed by memory. Interweaving verbal narration and the photographs or moving images that he has collected from his travels, Marker has described his activities through the voiceover of the film* Sans Soleil, *"He liked the fragility of those moments suspended in time. His Memories, their only function to leave behind nothing but memories." Far from creating an art that is egocentric in its subjectivity, Marker has always been associated with leftist political engagements manifest in many of his films. His revolutionary impulses span works such as his mythical* Cinétracts *(consisting of footage from the student riots in Paris during May 1968) as well as his four-hour monumental documentary on the history of the New Left in France,* Le fonde de l'air est rouge *(1977). Additionally, Marker has consistently sought new forms of formal expression, pioneering the use of video and multimedia as a less expensive, liberating vehicle for his experiments in film, television, photography, and literature.*

ALISON M. GINGERAS

Selected Bibliography

Giraudoux Par Lui-Même. Ecrivains de Toujours No. 8. Paris: Editions du Seuil, Paris, 1952.

Coréennes. Court Métrage No. 1. Paris: Editions du Seuil, Paris, 1959.

Le Dépays. Paris: Editions Herscher, 1982.

La Jetée: Ciné-Roman. New York: Zone Books, Rizzoli, 1992.

Qu'est-ce Qu'une Madeleine? Paris: Editions Centre Georges Pompidou/ Yves Gevaert, Brussels, 1997.

FACING PAGE *La Jetée*, 1962, film still

must recognize that the present itself is only the most contracted level of the past." The photograph becomes a contracted level of the past, the materialization of the present.

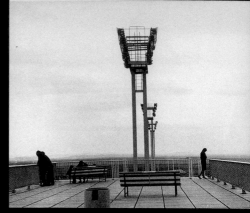

La Jetée contains within its narrative a compelling meditation on the architecture of space and the locus of place in memory. It is within the underground network of galleries beneath Chaillot that we begin to identify the compelling presence of the architectural environment as a protagonist in the film. Specific spaces that codify human consciousness: built environments that enclose the struggle for existence. Spaces begin to ooze, like confessions as the time traveler navigates his consciousness and struggles to regain the human spirit within the memories of human achievements. Marker finds his most compelling visual metaphor in the museum, where the time traveler has one of his meetings with the woman. It is a natural history museum filled with timeless animals in glass cases, vitrines of the taxonomy of butterflies and birds, stuffed animals, skeletons, and fossilized remains fill the space. Like a seventeenth-century *wunderkammer*, the museum becomes a melancholy trophy room filled with arcane memories, obscure living things from a past now doubly removed in the galleries of the museum.

The ultimate container then, is the memory room of the human mind, where our protagonist recalls our present from a future that lies condemned to destruction and the eradication of all we possess and cherish. Human memory is Marker's timeless container which, unlike the static repository of the museum or the fragmentary surface of the photograph, demands the movement of the living present. That is captured in *La Jetée* in the single moving image in the film where the sleeping eyes of the woman behind which she explores her own memories and fantasies suddenly open and then close. For a fragmentary piece of time she sees us and we become her memory and she becomes not a memory in a museum but a living person. The living present.

JOHN HANHARDT

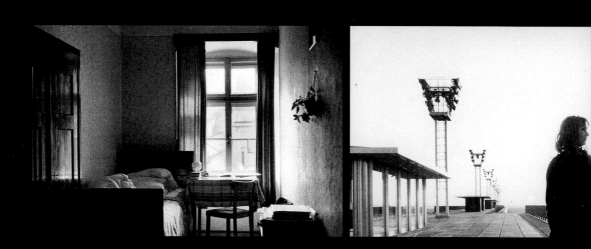

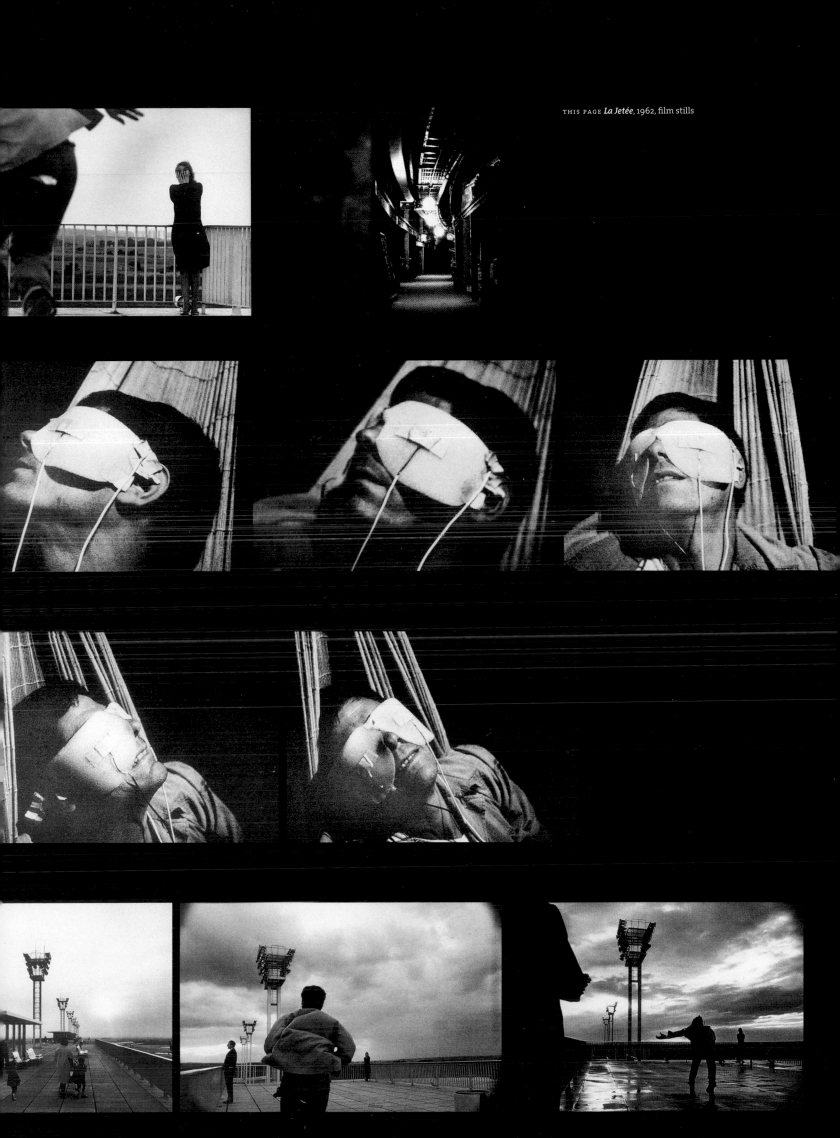

THIS PAGE *La Jetée*, 1962, film stills

From 1992 to 1997, Chris Marker prepared his memories on CD-ROM using texts, photographs, film clips, and sound bites. All these documents are part of Marker's personal archives; he also designed the connections, crossovers, shortcuts, and detours in this interactive piece. Wavering between literature and film, poetry and photography, CD-ROM is the perfect medium for an artwork opting for a nonlinear, rhizome-like interactive structure. While referring to Proust's exploration of memory based on the real, and to personal memories, Marker borrows Hitchcock's attempts to suspend time.

According to the artist: "In moments of megalomaniac daydreaming, we tend to see our memory as a kind of History book: we have won and lost battles, found and lost empires. At the very least, we are characters in a classic novel ('My life is some book!'). A more modest approach and perhaps more fruitful would be to consider the fragments of a memory in terms of geography. In every life we can find continents, islands, deserts, marshes, overpopulated lands, and terrae incognitae. We could draw the map from this memory, extract images more easily (and more truthfully) than with tales and legends."[1]

Immemory is a subjective memory, an "immemory" born of images and texts that the artist recorded during his travels across the world, while staying in Paris, or even while examining television images. The placement of the various elements causes us to forget where they come from, their dates and temporalities.

Immemory is divided into seven chapters: travel, film, museum, memory, war, photography, and poetry. Each chapter subdivides again in several ways, some of which are very expected while others are completely random.

Within this complex work, Marker establishes two approaches—not necessarily paradoxical—to human memory: one purely imaginary and the other more informative, based as it is on real happenings, real-life stories, and encountered people. This personal taxonomy, which appears as scientific as it does universal, stems from events, objects, important places, characters, etc. It is a taxonomy that was already present in such films as *Sans Soleil*, *Le Tombeau d'Alexandre*, *Level Five*, and the multimedia installation *Zapping Zone (Proposals for an Imaginary Television)*, created in 1990.

CHRISTINE VAN ASSCHE
Translated from the French by Molly Stevens.

FACING PAGES Various stills from *Immemory*, 1997, CD-ROM, Centre Georges Pompidou, Musée national d'art moderne, Paris

1. Chris Marker, *Immemory. Note of Intention* (Paris: Centre Georges Pompidou, 1993), unpaginated.

CE N'EST PAS LUI QUI A PHOTOGRAPHIÉ CETTE CRÉATURE DE RÊVE, MAIS ONCLE ANTON ! AUX ANNÉES VINGT À MOSCOU, ET L.K. C'ÉTAIT LUDMILA KRANDICVSKAIA, L'ÉPOUSE D'ALEXEI TOLSTOI, L'AUTEUR D'AÉLITA ! MOI, LE CHAT VÉRIDIQUE, JE ME DEVAIS DE TÉMOIGNER !

San Francisco est un personnage à part entière du film. Samuel Taylor, le scénariste, m'écrivait qu'Hitchcock certes aimait la ville, mais en connaissait "ce qu'il voyait dans les restaurants et par les fenêtres des hôtels et des limousines". Il était *"what you might call a sedentary person"*. Pourtant il avait décidé d'utiliser Mission Dolores et, assez étrangement, la maison de Lombard street où habite Scottie "à cause de la porte rouge". Taylor était amoureux de sa ville (Alec Coppel, le premier scénariste, étant *"a transplanted englishman"*), il a mis cet amour dans l'écriture du scénario, et peut-être plus encore, si j'en crois ce qu'il m'écrivait à la fin de sa lettre *"I rewrote the script and in some way that I explored San Francisco and recaptured my past"*... Des mots qui pourraient s'appliquer aux personnages autant qu'à l'auteur, et qui permettent d'interpréter comme un nouveau bémol la clé cette indication donnée par Gavin au début du film, quand il décrit à Scottie les errances de Madeleine qui reste longtemps à scruter, de l'autre côté de Lloyd Lake, des piliers au nom emblématique : *the Portals of the Past*

MADELEINES MAISON

Ch. Védie

Pâtissier – Confiseur

ILLIERS-COMBRAY

Tél. 22.02.27

pour mémoire...

LE JARDIN D'HIVER
1968-70

(From, *Jean Dubuffet: Délits, Déportements, et Lieux de Haut Jeu*. Paris: Weber Éditeur, 1971)

JEAN DUBUFFET
(b. 1901, Le Havre–d. 1985, Paris)

Jean Dubuffet would devote himself to painting in 1944, the year of his first solo exhibition at the René Drouin Gallery in Paris. From the Métro *series of 1943 to the premonitory* Non-Lieux *series in 1984, and including the* Corps de Dames, Paysages Grotesques, Tableaux d'Assemblage, Texturologies, Matériologies, *and* Paris-Circus, *as well as* L'Hourloupe, Théâtres de Mémoire, Psycho-Sites, *and* Mires, *Jean Dubuffet, perpetually experimenting, a "traveler without a compass," never stopped questioning the foundations and purpose of his work, and refused to limit his practice to one form or specific domain.*

Dubuffet frequented intellectual and literary circles, publishing many writings between 1944 and 1973 that marked the essential stages of his critical thinking; this work established him as an important writer and thinker of his generation.

In 1945, he put together an Art Brut collection, thus declaring his loyalty to the margins of art.

As early as 1962, Dubuffet began his quest for spatial and architectural dimension with the L'Hourloupe—*which he would render as an expanded polystyrene sculpture in 1966. The many environments, both interior and exterior, that he would then build would allow the visitor to stroll through them as through a labyrinth: a veritable metaphor for the development of thought.* Cabinet Logologique, *1967,* Closerie Falbala, *1970,* Jardin d'Hiver *of the same year, the summer room project of 1973, and the* Jardin d'Émail, *1974,* La Chambre au lit sous l'arbre, *1978 are among the projects and sites enacting the painter's intention.*

Le Jardin d'hiver is one of the largest monuments built to date. The model for the piece is dated August 1968, and its enlargement was executed two years later, on August 4, 1970. The significance of the name is not really known. *Le Jardin d'hiver* is a very large peanut, entirely sealed, measuring approximately 9 x 6 x 5 meters. The piece is raw plastic, of minor appearance, resting on a thick pedestal that conceals a supporting armature. With a push of the hand a door pivots, opening outward; the viewer enters through a small staircase and, once inside, finds him- or herself within the confines of a white, pale cave completely covered with black markings; perhaps it is a cocoon into which an unknown insect might withdraw. The sculpture narrows in the middle, and the walls are dented on all sides. There are gloomy paths and steps for sitting, nooks where one can lie down and think—this place is a den of scrawls with no other light than the bit of day filtering through a small skylight. Could this be a garden-cocoon for a butterfly on retreat from reality? Is this the dusk of a cave between birth and death? The whites are too white; the blacks, too black.

This strange place is like nowhere we have visited before—not a building, not a garden, and certainly not a monument (other than possibly a sarcophagus). There is no outside or façade: if this a house, where could it be erected? It could be a room, but if so it's a room without a building—a room without a home. We are told that it is a garden. But can a garden turn in on itself like a cave? It is undoubtedly a cave, but one that has been removed from its rock; a cave without its mountain—the skin of a cave. This place is nowhere: neither outside, nor inside, beneath or above, a den without an address, without a situation. The more we wonder, the more we remain perplexed. Perhaps this is where we are meant to be: a den of perplexities. If we find only gloomy daylight within, frosted walls and marks that represent nothing, and if the place is as bare as December branches, perhaps it is because this garden, the name of which has such a welcoming initial ring, is made to plunge us into winter's heart rather than shelter us from it.

The more time one spends inside the cave, the more one has the feeling that the artist has made a long-awaited leap within it. Since he began working on the piece, Dubuffet sought to undermine representation, always hovering around its disintegration. But he pursued this disintegration—how could a painter have done otherwise?—through representation. On the surface of his canvases, Dubuffet ruptured representation by placing the back in the front, letting margins vanish in the foreground, or otherwise turning the masked into the visible. And he exhibited on a surface—canvas—that asks always to be viewed from the front: representation itself. Yet in *Le Jardin d'hiver*, reference to a head-on view collapses; efforts to reconstitute it are pointless. What we see, no matter which surface we choose to look at, vanishes toward infinity all along its edges. In order for this destruction to happen, a head-on view was necessary. One needed to stand before a painting—the space of common ≫

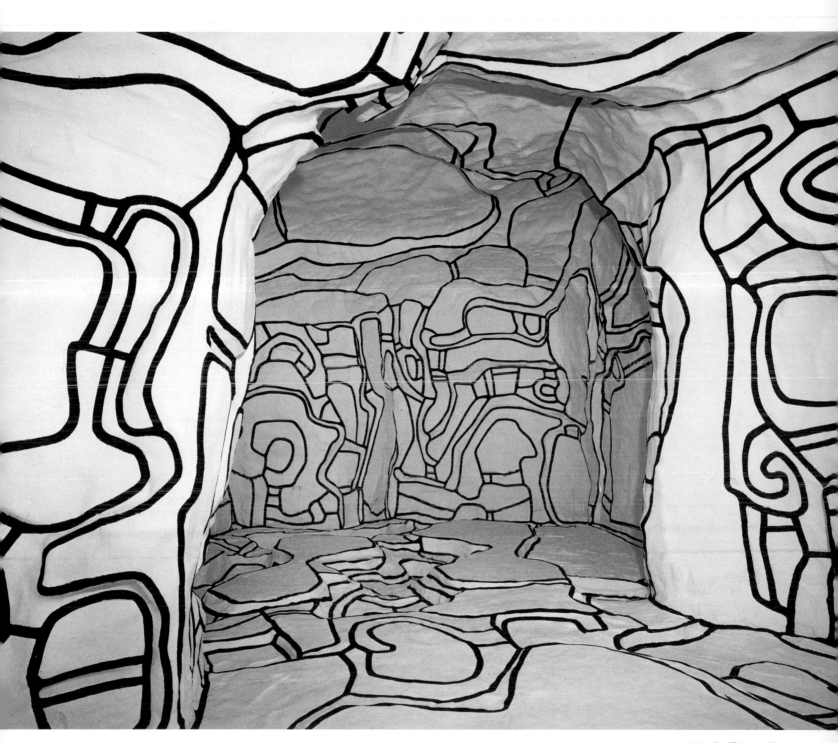

perception—in order to undermine the image before oneself. It was under the authority of painting that its disintegration took place. With this piece, finally, we break the cycle; this large, synthetic cave, in which neither shapes, nor angles, nor curves begin, into which sun does not penetrate, is anything but Platonic. The collapse of representation is no longer presented: we are plunged into a piece that enacts it. The tangle of front and back is no longer exclusively "in front," confined, and completely surrounded by a world—our everyday one—which excludes it: henceforth we are "in" it. With *Le Jardin d'hiver*, the painting has come out of its frame, and its tools of excesses, overflowing all around, have become the entire space.

No matter where we turn, the same scrawls interrupt and continue; every plan we try to establish gets mixed up with all the others, preventing us from creating any kind of break between part and whole. An ocean of abundant rhizomes, a large broth of vines, without beginning or end; a sequence forever rejuvenating, permanent and continually garrulous; marks that trace the entangled thread of time, clearing the space and weaving stories in such a way that the hibernation into which this place of ice and shadow has plunged its active, passionate viewer is in no way different than the marmot's—in its vast cradle of writing and tales, the power to release a swarm of threads which is the mind, is obliged, within, to only spin the self and is therefore forever troubled.

This is the vaulted garden in which we stand. This cave, this resin matrix is just like Mother Earth, which has been so celebrated, so stubbornly pursued. For years, Dubuffet attempted to flee the earth, to absent himself, to get lost within, to leave ideas behind and return to birthplace of things. This is where he is today. But his Mother Earth is an epoxy and polyurethane belly, an earth without earth, an earth that competes entirely with the earth of ten years ago, marked by the culture that he left; he continued to feed the myth. The place he reached is indeed the one where he wanted to go at that time, but, in the meantime, he escaped the myth that was forming like the last rampart of belief in reality. He destroyed the last link that could have connected his painting to the world; his gesture replaced Mother Earth with an Antimother-Antiearth fabricated by himself. Rejecting earth, distancing himself from Mother Nature's ultimate refuge, he now offered one that he had made. He became not only the creator of his work, but moreover of Mother Earth: can we imagine a greater revolt against the order of things, and therefore a higher creation?

MAX LOREAU
Translated from the French by Molly Stevens.

FACING PAGE *Chambre au lit sous l'arbre*, 1978, installation view, collection of Arne and Millie Glimscher

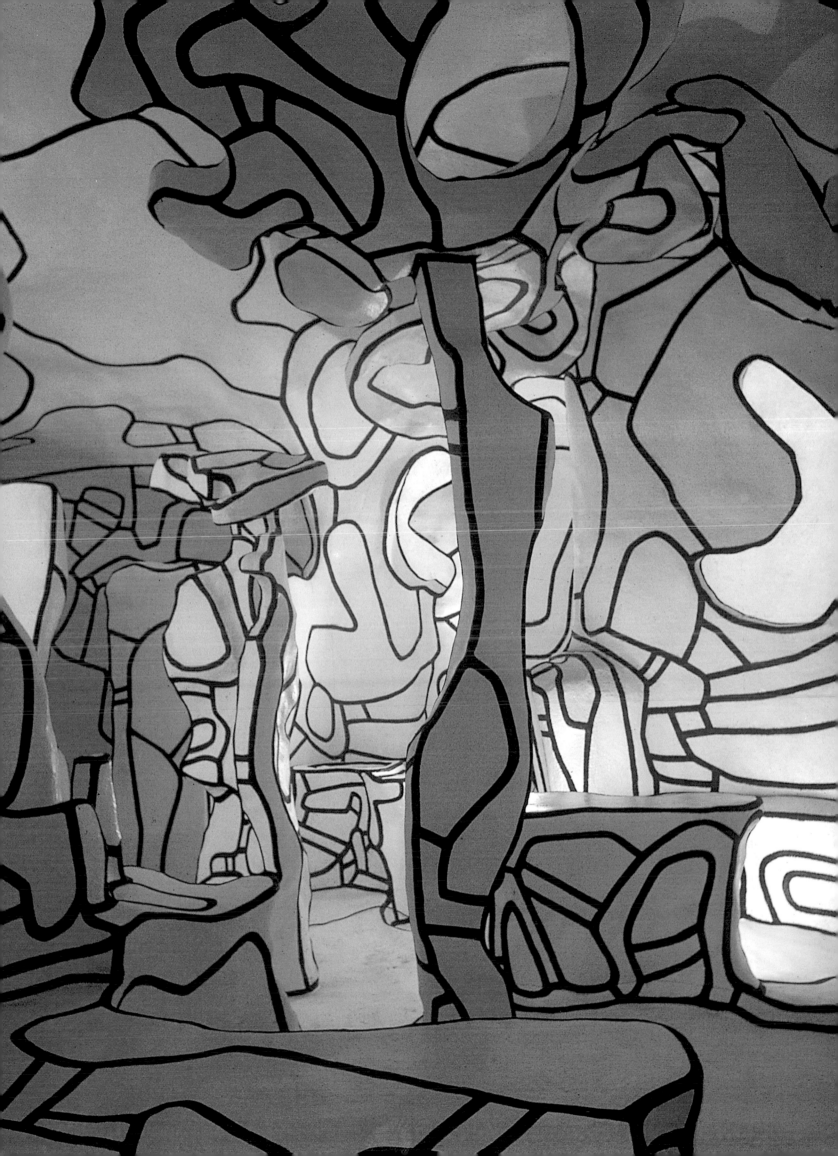

Selected Bibliography

Dubuffet, Jean. Compiled and presented by Hubert Damisch, with comment by the author, *Prospectus et Tous Écrits Suivants.* Vol. 2. Paris: Gallimard, 1967.

Dubuffet, Jean. *Asphyxiante Culture.* Paris: Editions Jean-Jacques Pauvert, 1968.

Dubuffet, Jean. Selection of texts (Prospectus et Tous Écrits Suivants; Désaimantation des Cervelles; unpublished text 1967–71). *L'Homme du Commun à l'Ouvrage.* Paris: Gallimard, 1973.

Loreau, Max. *Catalogue des Travaux de Jean Dubuffet.* Paris: Editions Jean-Jacques Pauvert, 1964–1968; Paris: Weber Editions, 1969–1976; Paris: Editions de Minuit, 1979–84.

Jean Dubuffet (exh. cat.). Paris: Musée des Arts Décoratifs, 1960–61.

Dubuffet (exh. cat.). New York: The Museum of Modern Art, 1962.

Jean Dubuffet: A Retrospective. (exh. cat.). New York: Solomon R. Guggenheim Museum, 1973.

Jean Dubuffet (exh. cat.). Paris: Grand Palais, 1973.

Jean Dubuffet: Les Dernières Années. (exh. cat.) . Paris: Galeries Nationales du Jeu de Paume, 1991.

RIGHT *Chambre fantasque, 5 April 1970*, plan of the bedroom that will receive the title *Chambre au lit sous l'arbre* during the following month

FACING PAGE (TOP) *La Chambre au lit sous l'arbre, 4 May 1970*, model scale 1:5

FACING PAGE (BOTTOM) *Logis fantasque, 20 April 1970*, plan of an apartment with an antechamber and four rooms which is the subject of the preceding drawing. *Chambre fantasque* (superior part of the drawing)

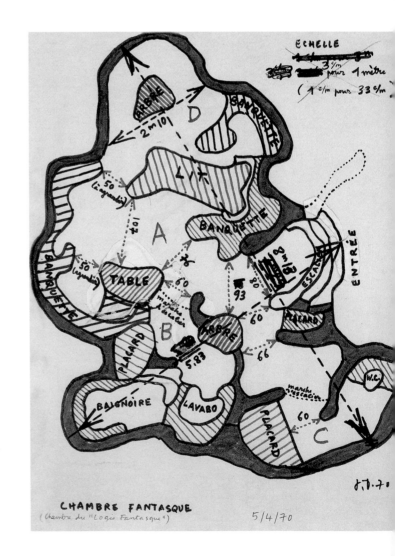

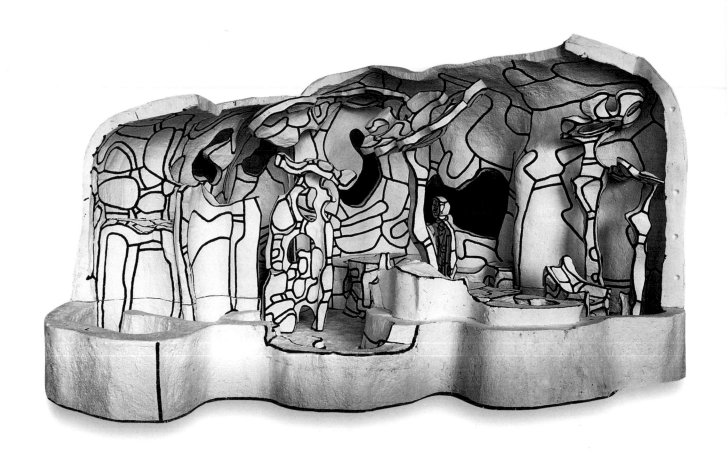

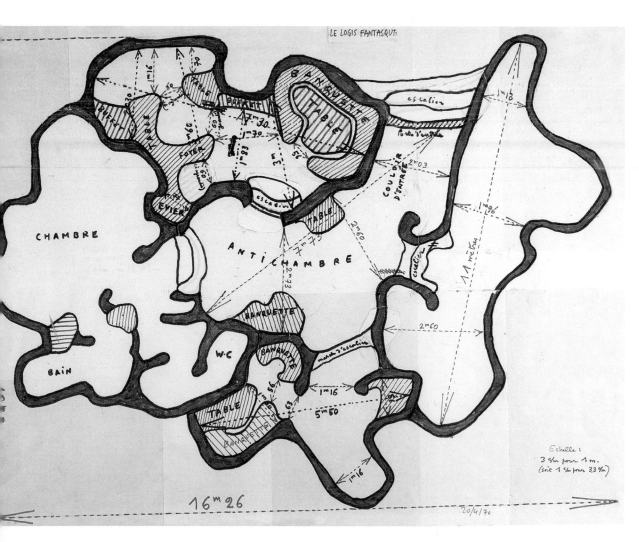

LE LOGIS FANTASQUE

LE MANTEAU (DEMEURE 5)
1962

ETIENNE-MARTIN

(b. 1913, Loriol– d. 1995, Paris)

A contemporary of New Realism, Pop art, and Minimalism, Etienne-Martin's work may seem difficult to place. Though he is linked by formal studies to tradition, he neither seeks nor demonstrates a style; instead, he allows the figurative and non-figurative, the abstract and concrete to coexist. Etienne-Martin preserves a freedom of expression based on memory, place, and the movement from one to the other. The place of his childhood home, Loriol in the Drôme region, is the foundation of his vision and serves as the origin and matrix of his Demeures.

In Paris, the artist joined the Témoignage (Witness) group founded in Lyon by Marcel Michaud. At the start of World War II he returned to the Drôme: first, in 1942, to Oppède, where he lived with the sculptor Stahly in the community enlivened by architect B. Zehrfuss; then in 1943–44 in Dieulefit, where he met Henri-Pierre Roché, with whom he sculpted a gigantic Vierge (Virgin) in a Beauvallon quarry. Eventually he went to Mortagne, in the Orne, where his prefered medium became wood. Upon his return to Paris in 1947, Etienne-Martin met Brancusi, Michaux, Dubuffet, and the Spiritual Guru Gurdjieff: Etienne-Martin undertook lessons with him to learn about the harmony between body and spirit, man and the world, shaped Etienne-Martin's work for over ten years, helping him to create sculptural space from his own personal experience.

Etienne-Martin began the Demeures in 1954–56, the first piece of which was presented in 1960 at the Breteau Gallery, which would make bronze castings of the first four Demeures. By 1963, there were retrospectives in his honor in Bern, Amsterdam, Eindhoven, and Brussels; a Paris retrospective was mounted in 1972 at the Musée Rodin. After winning the Venice Biennale in 1966, Etienne-Martin was »

Recognized as early as July 1962 by Pierre Restany (in *Cimaise* #60) as one of the highlights of the season, this fifth *Demeure* (Residence), together with *the Abécédaire*, encapsulates and is inscribed with the memory of what preceeded in Etienne-Martin's *Demeure* series. Etienne-Martin explains that in each element can be found "an event that I have lived through emotionally." Composed of fiber matting and sail cloth festooned with rivets, metal rings, ribbons, various braids, trimmings, and bits of leather all in a complex design, *Le Manteau* (The coat) is punctuated rythmically by rope, which creates a honeycomb of sorts. This partitioning on a quasi-flat surface can be compared with his other *Demeures* and their repeated division into rooms, each corresponding to one of life's moments and places.

Because of its successive "skins"—the different layers of materials—*Le Manteau* makes palpable the notion of time, the passage from one instant to another. The rediscovery of sites in memory is also at play in the piece, since it recreates the labyrinthine interior of his childhood home in Loriol, a double house with its two staircases (one bright and one dark), its different rooms, its terraces, attics, basement, skylights, and ladders.

Le Manteau, often compared with a chasuble decorated with cabalistic symbols that might be worn by a tribal chief, thus becomes a cult object even more than a finery endowing dignity, a protective armor. It becomes a refuge that is at once the house, the mother, the enveloping blanket, and the complete residence. When one puts on *Le Manteau*, one becomes the wearer-axis. The body is sacralized. This skin, slipped on, becomes one's own skin turned inside out—all entrails on the outside— yet it is protected by the envelope, *Le Manteau*. In other pieces, Etienne-Martin chips away wood and shapes plaster, but here, as in the *Passementeries*, he amasses different "found" materials (his studio, a tremendous heap of objects, a true oneiric jumble). The collection might be viewed as heterogeneous, taking on the rather cutting flavor of the *Mur Verseau* (*Demeure 19*), 1982, 1983, yet the structure of the piece continues to build around the passageways of memory and the body. The body is our cosmos. It is balanced, a totality, a whole.

NADINE POUILLON
Translated from the French by Molly Stevens.

Le Manteau. It is truly a home. Consider the snail, turtle, lobster . . . There are so many praiseworthy coats: the shepherd's coat, the shaman's, the coats of different religions. A coat is fun. In winter, it is very pleasant. Our skin is a coat. Within you, there are a wide array of characters. You contain all the monsters Lovecraft spoke of; you are a murderer, you are a monster, a blasphemer, a pig. When you work, you can see these different "me's" arising. We are a crowd, but we have to know this crowd, listen to it, not judge it. You are a world that you can run. Sculpture is a discovery of these different "me's." The viewer listens to something that I do not hear. The viewer adds to the listening of what you, what you wanted to say.

Interview with Etienne-Martin conducted by Jean Pierre Rehm. *Etienne-Martin* (exh. cat., Musée de Valence. 1992).

FACING PAGE *Le Manteau (Demeure 5)*, 1962, Centre Georges Pompidou, Musée national d'art moderne, Paris

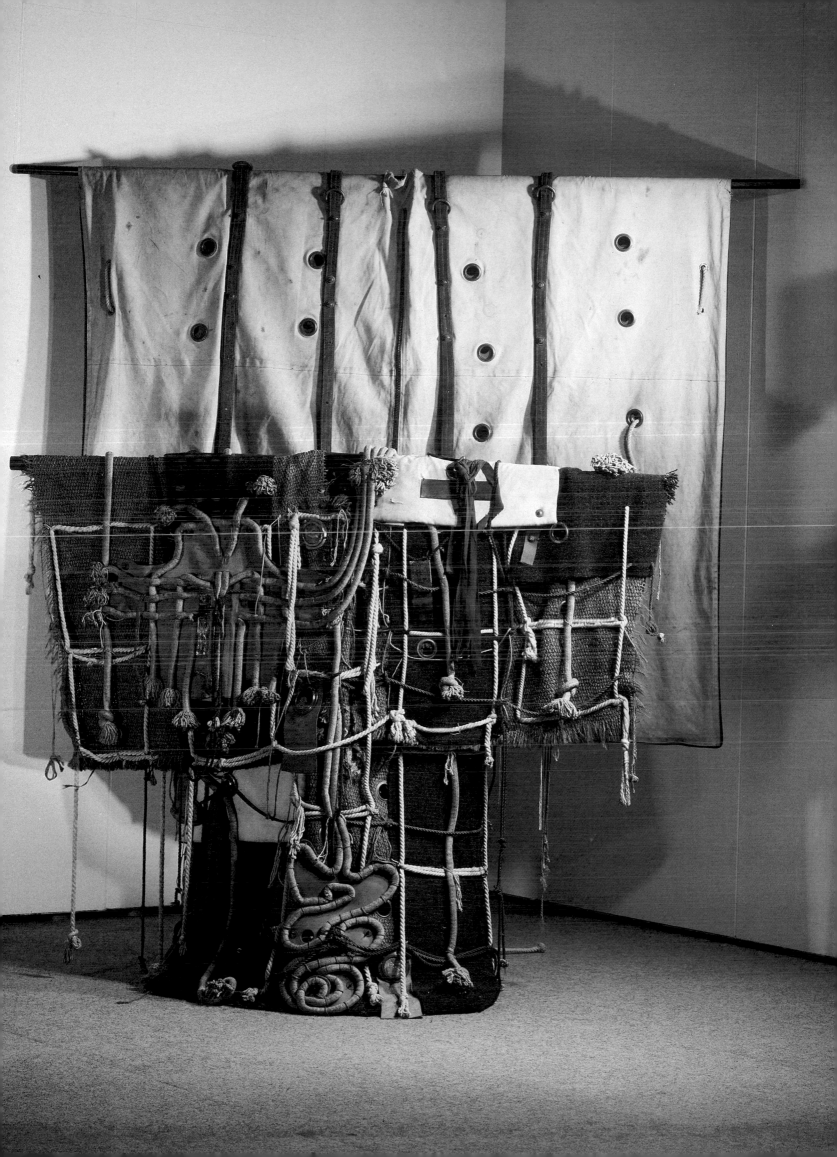

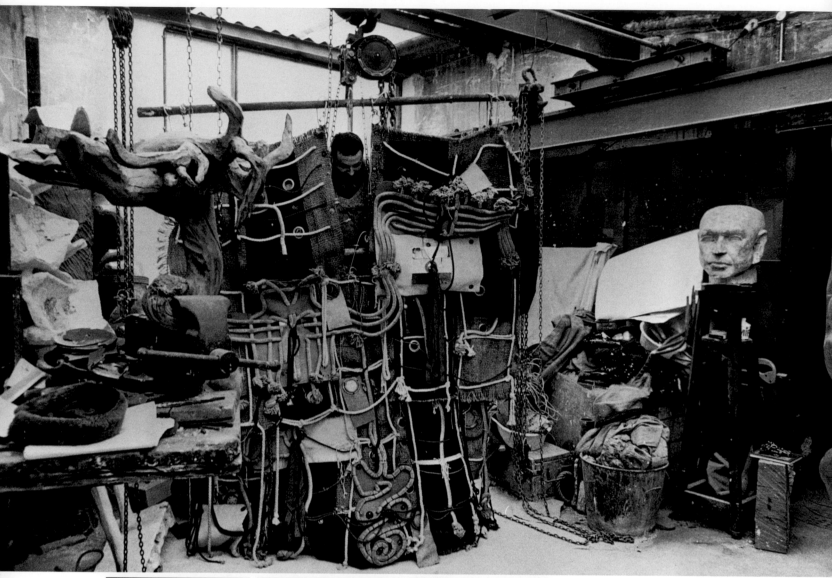

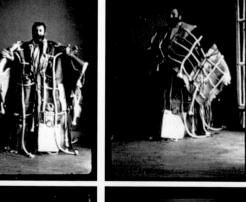
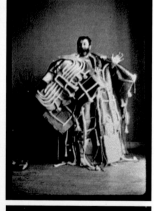
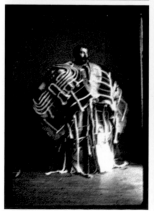
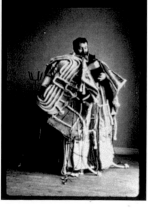

ABOVE Etienne-Martin trying on
Le Manteau (Demeure 5), in his studio
on the rue du Pot-de-fer, Paris

LEFT (ALL PHOTOS) Etienne-Martin
trying on *Le Manteau (Demeure 5)* at
his home on the quai de Bourbon,
Paris, 1962

FACING PAGE Etienne-Martin in front
of *La Marelle (Hopscotch)*, 1963

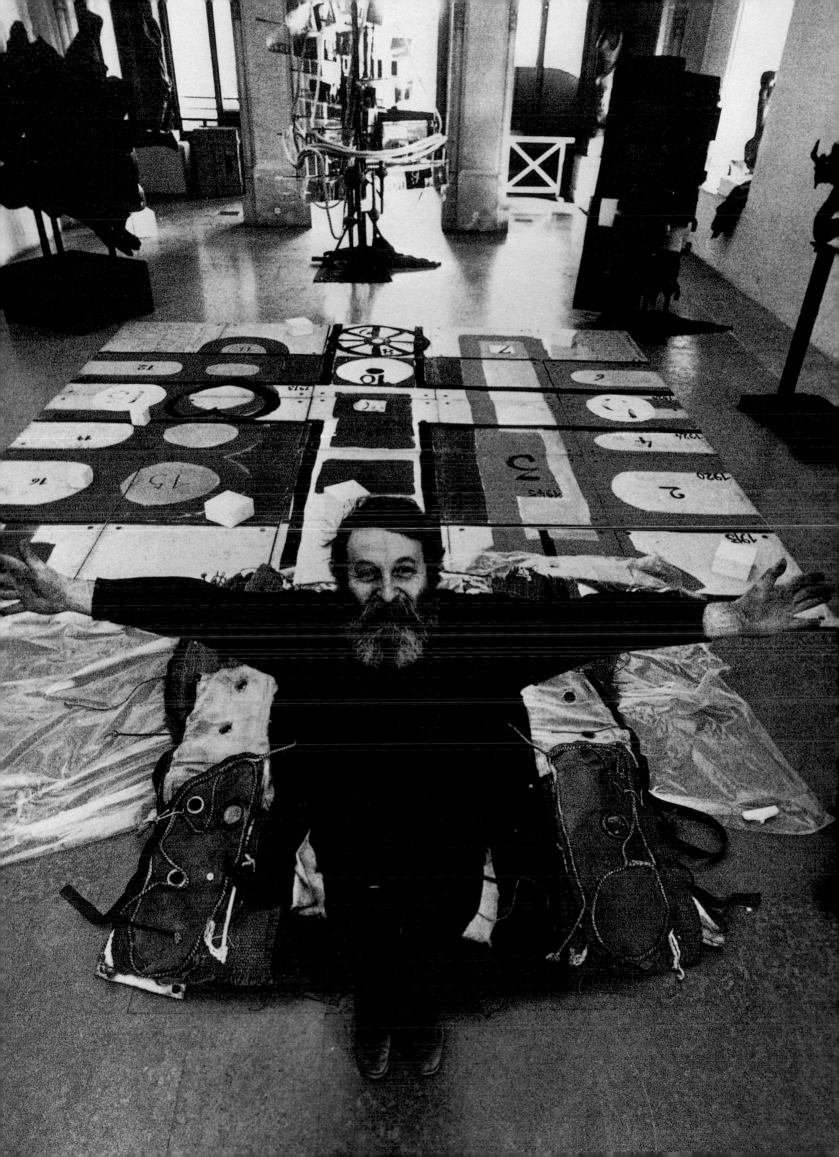

LA MARELLE
1963

ETIENNE-MARTIN

appointed professor of monumental sculpture at the Ecole des Beaux-Arts de Paris, where he would teach from 1968 to 1983. At the same time, he continued with his own work, in particular the monumental Les Terrasses de la terre et de l'air; *this piece reiterated his previous works, and was cast in bronze and installed in Clermont-Ferrand in 1989.*

Numerous exhibits—at the Musée national d'art moderne in 1984, at the chapel of the Salpétrière in Paris in 1988, at Sables d'Olonne in 1991, and in Valence in 1992—catalyzed a deep interest in the singularity of this artist's approach.

La Marelle (*Hopscotch*), a five-by-five meter painted wooden square installed on the gallery floor, is more connected with Etienne-Martin's drawings than his sculptures. It evokes physical development, evolution of memory, and the topography of an interior world—from the twists and turns of the house where Etienne-Martin was born to those of an artist's career path. An interpretative grid, *La Marelle*, like Etienne-Martin's drawings, is, according to Dominique Le Buhan, "a tablature of boxes across which he travels to tell the story of his life and his work's strategy." Here this grid takes the name and form of a child's game.

According to Jean-Christophe Ammann, Etienne-Martin's *Les Jeux* (The games) forms one of the six themes—along with *Les Nuits* (The nights), *Les Demeures* (Residences), *Les Couples* (The couples), *Les Rencontres* (The encounters), and *Les Enigmes* (The enigmas)—that allow all living things to reach their mythical dimension.

Etienne-Martin's fascination with spiritual form—passed on to him by Guru Gurdjieff—is patent. It contemplates the mysteries of life and death, searches for harmony between body and soul, and identifies with the mystery of growth: in it, individual myth meets collective myth. A vital space develops around the guiding concept of initial *Demeure* (Residence); Etienne-Martin's unending quest as an artist moves from this interior, personal space toward that of the outside world. One cannot grasp his work solely on a visual level. It requires knowledge or intuition about the esoteric, an unlimited source of energy that returns sculpture to a cosmos. Etienne-Martin often refers, for example, to tarot cards of the Middle Ages; his eleventh *Demeure* (1969) is titled *La 21e Lame du Tarot*.

Divided into numbered squares, *La Marelle* seems, at first glance, rather understandable. Like a game of snakes and ladders (*Le jeu de l'Oie*), it lays out Etienne-Martin's guiding works from 1 to 20, the dates of which define the stages of his life, starting with his birth in 1913. As with *La Marelle*, in snakes and ladders, one slides the game piece—a small flat stone—from one box to the next, hopping along, beginning "on earth" and eventually reaching (without mistakes if possible) "the sky." Etienne-Martin provides this lovely metaphor seeking, above all else, to break through the wall within to reach universal harmony.

NADINE POUILLON
Translated from the French by Molly Stevens.

Selected Bibliography

Ragon, Michel, *Etienne-Martin*, Brussels: La Connaissance, 1970.

Le Buhan, Dominique, *Les Demeures-Mémoires d'Etienne-Martin*, Paris; Herscher. 1982.

Etienne-Martin, Les Demeures, (exh. cat.), Paris; MNAM-Centre Georges Pompidou, 1984.

Etienne-Martin, Dessins, Sculptures (exh. cat.), Les Sables d'Olonne, Musée de l'Abbaye Sainte-Croix, Cahiers de l'Abbaye Sainte-Croix, No. 70, 1991.

Etienne-Martin, text by H. Szeemann, D. Le Buhan, M. Ragon, J.C Ammann, Paris: Adam Biro, 1991.

Etienne-Martin, (exh. cat.), Valence, 1992.

Etienne-Martin, Sculptures, Dessins (exh. cat.), Clermont-Ferrand, Musée des Beaux-Arts, 1997.

FACING PAGE Installation views of *La Marelle* (Hopscotch), 1963. Private collection, Paris

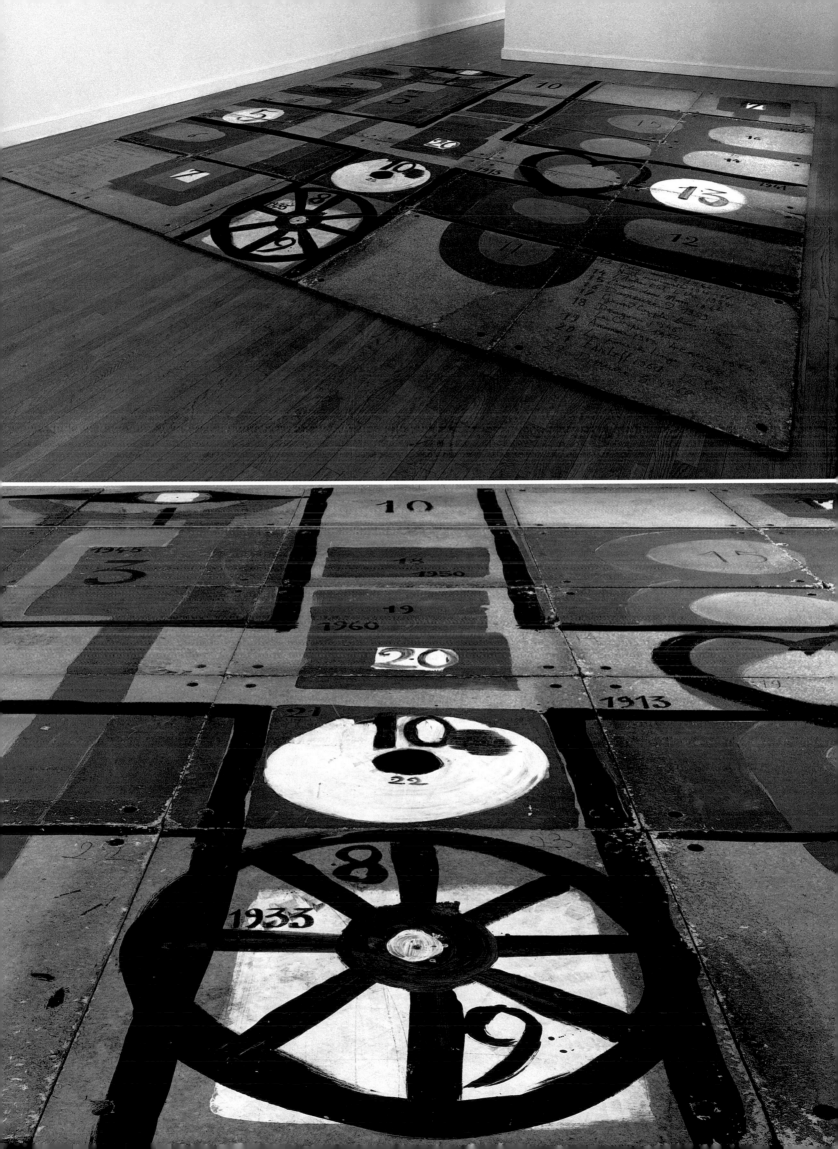

On March 17, 1960, Jean Tinguely presented, in the garden of New York's Museum of Modern Art, *Hommage à New York*, a dramatic event that would occupy an important place in the history of modern art. Before the eyes of the public, in an institutional setting dedicated to the perpetuation of culture, the ephemeral piece auto-destructed in a ball of fire in the space of just a few hours. In 1969, Tinguely began work on its antithesis: a monumental, collective sculpture that would be as durable as possible. The construction, initially named *La Tête* (The head), stands in the silence of the Milly Forest thirty miles outside Paris. It wasn't until 1994, after the artist's death, that it was inaugurated and renamed. "In some ways, a monument dedicated to that time and all his lost opportunities—it is a built utopia (. . .) crowned by an homage to Yves Klein," Pontus Hulten remarked.

Le Cyclop (The cyclop) is striking for its monumental dimensions, its relationship to nature, and its diverse meanings. More than twenty-two meters high, its three hundred tons of steel compose a series of mechanical elements that generate noises. *Le Cyclop* is sited in a remote area and, because of a huge oak tree growing in between its structures, it blends in "like a sprig of parsley behind a gypsy's ear," as Tinguely imagined it. Tinguely was not the piece's sole creator, but rather its "band leader," to use Jean-Pierre Raynaud's expression: more than twenty artists worked together for more than twenty years at the site.

The participants were far from anonymous. Niki de Saint-Phalle, present during all stages, would in 1987 cover *Le Cyclop's* face with a mosaic of mirrors. Two huge doors, a giant steel ear symbolizing harmony between artists, and the enormous pinball machine from the *Crocrodrome* (1977) at the Centre Georges Pompidou are the work of Bernhard Luginbühl. As a memorial to the Jews deported during World War II, Eva Aeppli would enclose seventeen sculptural figures in an old train freight car seventeen meters off the ground. Daniel Spoerri would meticulously rebuild the hotel room in which he stayed when he arrived in Paris in 1952, but do so vertically, in accordance with the principle of his *Tableaux-Pièges* (Painting-traps). The American Pop artist, Larry Rivers would combine video and painting in an "environment," *Hommage à Mai 68* (Homage to May 68). Philippe Bouveret, Pierre-Marie Lejeune, and Tinguely's assistants, Sepp Imhof and Rico Weber, were also among "the creators." Other installations at the site include the *Piccolo Museo* by Giovanni Podesta, a *Restaurant* by Spoerri, a *Pénétrable* (Penetrable) by Soto, two *Compressions* by César, and an *Accumulation* by Arman made of welder's mitts wedged between two plastic slabs. Marcel Duchamp was a symbolic participant with the placement of the *Broyeuse de Chocolat*, inside *Le Cyclop*. Jean-Pierre Raynaud literally measured *Le Cyclop's* height by placing a red-and-white ruler next to its profile.

Tinguely completed the complex installation by interweaving a circuit of hollow metal tubing through *Le Cyclop's* head. Aluminum balls, each measuring about thirteen inches in diameter, circulate from the top of the head every three minutes. These balls metaphorically stand in for *Le Cyclop's* swirling thoughts. Whether Tinguely's concluding gesture is seen as an action without limits or a gratuitous and useless act, his work is the dream of our collective history.

NADINE POUILLON
Translated from the French by Molly Stevens.

JEAN TINGUELY
(b. 1925, Fribourg–d. 1991, Bern)

In 1959, Jean Tinguely declared in a pamphlet (150,000 of which were released from a plane over Düsseldorf) that "Everything moves. There is no immobility." Movement is this sculptor's means of expression, whether by rotation—usually a wheel—or back and forth. His work, a series of absurd and useless machines, is by definition repetitive but also changes according to accidents and chance. This absurdity is pushed to its limits in Homage to New York.

Tinguely was very concerned with the definition of Nouveau Réalisme, "new approaches perceptive of the real"; carefully collected everyday objects were transformed by the artist into works both mobile and emotionally moving, ambiguous and eloquent. First came drawing machines like the Méta Matics, *then playful machines requiring public participation—The* Rotozazas—*then machines that incorporated common objects into their movement,* The Baloubas, *which in their ridiculous and joyous turbulence became metaphors for everyday life. Finally, Tinguely made spectacular machines that employed explosives. More austere sculptures followed, including* Eurêka *(1964), whose to-and-from movements embodied, according to the artist, "the spirit of Sisyphus."*

To celebrate the twentieth anniversary of Nouveau Réalisme, Tinguely created La Vittoria, *a fireworks sculpture that burned in front of the Milan cathedral, and also began* Cyclop *in Milly-la-Forêt. Water is present as much as fire in Tinguely's work: he completed several fountains, most »*

Selected Bibliography

Hulten, Pontus. *Le Cyclop: Milly-la-Forêt*. Paris: Edition Association Le Cyclop, 1993.

Johnston, Jill. "The Cyclops of Fontainebleau." *Art in America* (New York), June 1996.

Musée Jean Tinguely, Bâle, La Collection and Exposition Inaugurale (exh. cat.), Basel: Musée Jean Tinguely, 1996.

FACING PAGE Detail of *Le Cyclop*, 1969-94, Niki de Saint-Phalle, *La Face aux miroirs*

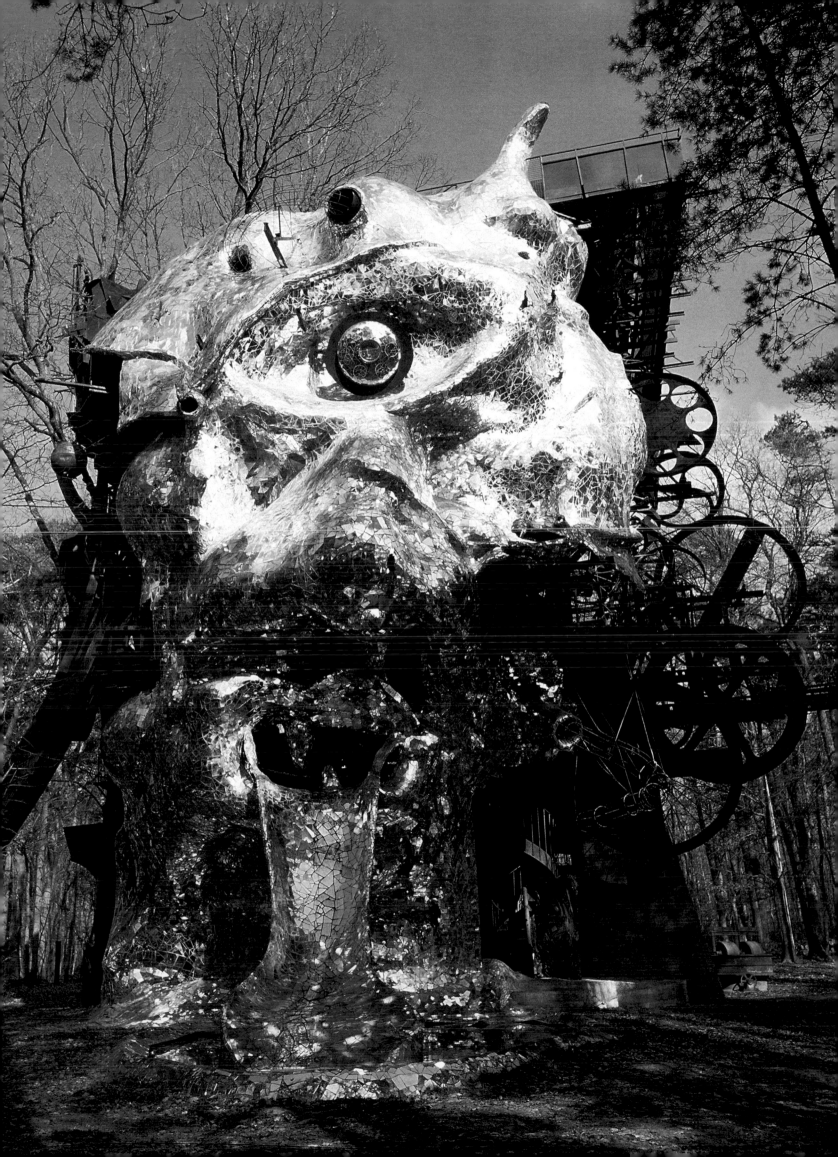

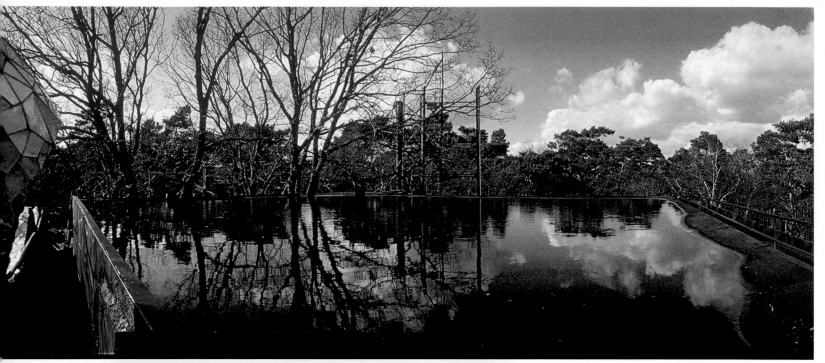

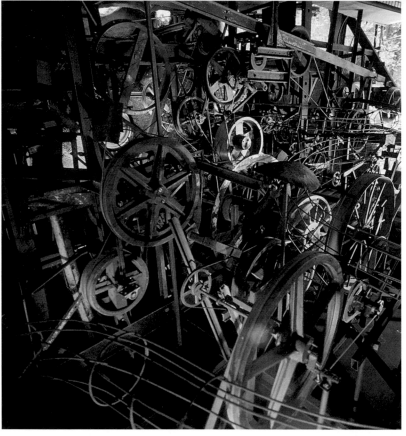

JEAN TINGUELY

notably the 1973 Fontaine Stravinsky *in Paris, designed and built with Niki de Saint-Phalle. Tinguely frequently worked as part of a team, completing sculptures with Eva Aeppli* (Sorcières), *Niki de Saint-Phalle* (Hon), *and finally* Le Cyclop.

His very large machines from the 1980s, the Méta-Harmonies, *were followed by the* Mengele *(Macabre dances), which explicitly addressed themes of death. The* Philosophes *appeared during 1988–89, standing figures—from Heidegger and Bergson to Wittgenstein—isolated in space like statues.*

ABOVE (TOP) *Hommage à Yves Klein* (detail), placed at the top of *Le Cyclop*

BELOW *Méta-Harmonie* (detail of the machinery)

FACING PAGE *Le Cyclop*, profile view with ear and passenger-train car

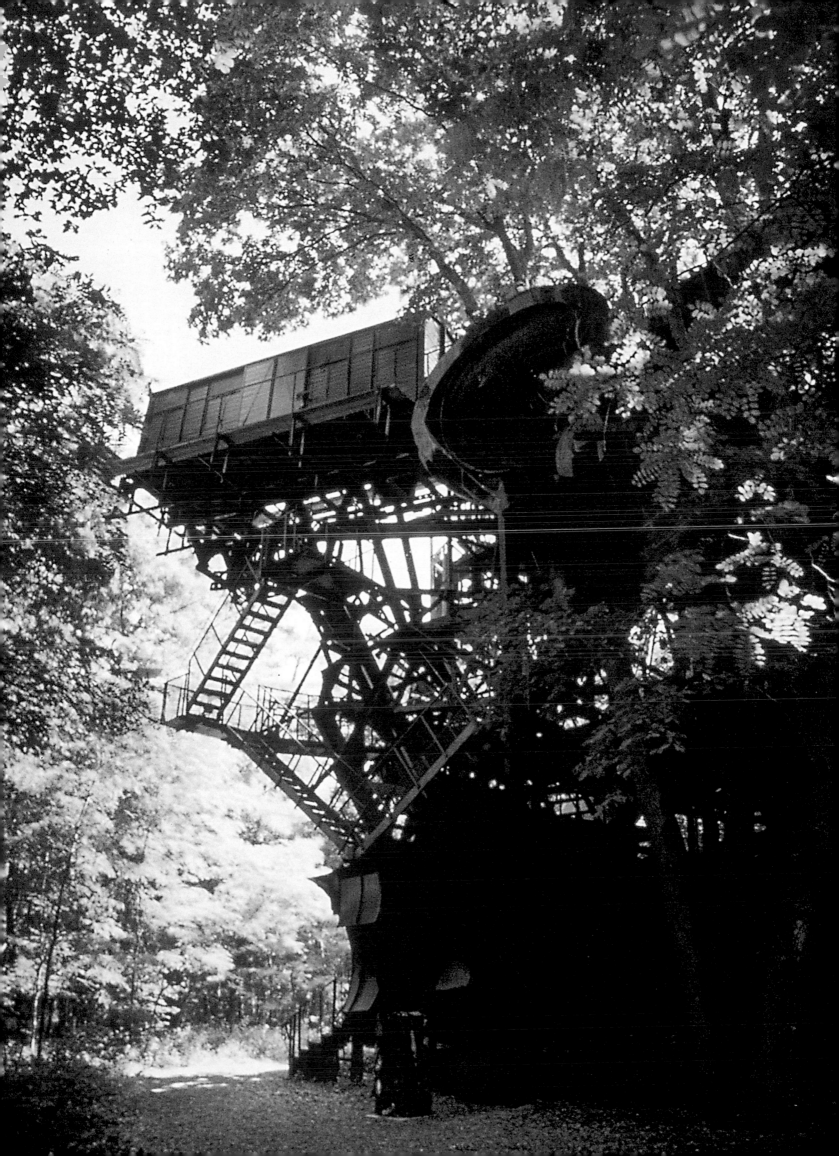

LOUISE BOURGEOIS
(b. 1911, Paris)

For the past fifty years, Louise Bourgeois has been mapping the body's relationship with space, particularly architectural and domestic space. Her subject is the anatomy of interiors: fictionalized places where the psychosexual dimensions of subjectivity, the physicality of the self, and the spatial trappings of home collide. The pleasures and traumas associated with the home have pervaded Bourgeois's art from its very inception. Nearly ten years after she relocated to New York from her native Paris in 1938, she embarked on a series of approximately eighty carved and assembled wooden sculptures known as *Personnages*: semi-abstract, vaguely anthropomorphic totems, surrogates for real people close to the artist—some departed, some forsaken, some eminently present. These fetish-like objects (which she envisioned would be gathered together in one emotionally charged installation) were a palliative for Bourgeois's swelling homesickness.[1] *Femme Maison* drawings and paintings from this same period represent house and woman as inextricable entities. The naked female body—its uterine cavities, its penetrable surface, its capacity to nurture— becomes the physical extension of domestic architecture. Often interpreted as a feminist reaction to the economic and social shackles of domesticity, the *Femme Maison* imagery—together with Bourgeois's sculptural nests, lairs, and labyrinths—rather *embrace* the home as a female site, the interstices of which are imprinted by the pleasures and pains of woman's desire.

Women's narratives are spatially determined, according to psychoanalyst Jessica Benjamin. "What is experientially female," she writes, "is the association of desire with a space."[2] In the past decade Bourgeois has woven such narratives, her own personal narrative, in architectural terms. The *Cell* structures—haunting mise-en-scènes laden with personal effects, decrepit furniture, marble sculptures of lone body parts (clasped hands, an ear, a leg), mirrors, wooden or glass spheres, and other metaphoric forms—are compact theaters of emotional distress. Bounded by accretions of rusted fencing or battered wooden doors, the *Cells* alternately invite viewers inside to contemplate their contents or, with barred and jagged thresholds, leave them outside to peer in and wonder at their meaning. For Bourgeois, "the *Cells* represent different types of pain: the physical, the emotional and psychological, the mental and intellectual. Each *Cell* deals with fear. Fear is pain. Often it is not perceived as pain because it is always disguising itself."[3]

The anguish she refers to has profoundly personal roots. Childhood traumas of familial betrayal recounted by the artist in oft-told tales of her father's infidelity, a mistress in the guise of a resident tutor, her mother's wrenching acquiescence, and her own youthful complicity have influenced Bourgeois's entire creative output. »

In 1938, when she was twenty-seven, Parisian native Louise Bourgeois married the American art historian Robert Goldwater and moved to New York City. Only four years after she arrived in the United States, she became friends with the European artists Yves Tanguy, Joan Miró, as well as Le Corbusier. By the time the Museum of Modern Art in New York acquired its first piece of her art, Sleeping Figure, in 1951, Bourgeois had become an American citizen.

Bourgeois's prolific oeuvre comprises text, prints, drawings, sculpture, painting, and installations. She has worked skillfully in practically every medium, from malleable latex to unyielding metal. In Bourgeois's early career, paintings and drawings like the Femme Maison series seem to reflect the Surrealist atmosphere in which she was surrounded, although she never identified herself with that movement. When she debuted as a sculptor in 1949 at the Peridot Gallery, her works' overt psychosexuality presided over the emergence of Abstract Expressionism. Because her work is largely autobiographical, Bourgeois is in touch with how her past impacts her present, her future and her art. "Bourgeois . . . says nostalgia is 'non-productive.' That is why her constructions talk about the past from the consciousness of the present."[1]

Bourgeois steadily created, continuing to evolve as an artist even into her eighties. In 1982 she had a retrospective at the Museum of Modern Art in New York, which was »

Selected Bibliography

Wye, Deborah. *Louise Bourgeois* (exh. cat.). New York: The Museum of Modern Art, 1982.

Meyer-Thoss, Christiane. *Louise Bourgeois: Designing for the Free Fall*, Zürich: Ammann Verlag, 1992.

Pagé, Suzanne and Béatrice Parent (eds.) *Louise Bourgeois: Sculpture, Environement, Dessin 1935–1995* (exh. cat.). Paris: Musée d'art moderne de la Ville de Paris/Editions de la Tempête, 1995.

Gorovoy, Jerry and Pandora Tabatabai Asbaghi (eds.) *Louise Bourgeois: Blue Days and Pink Days*. Milan: Fondazione Prada, 1997.

Bourgeois, Louise. *Destruction of the Father/Reconstruction of the Father: Writings and Interviews 1923–1997*. Ed. by Marie-Laure Bernadac and Hans-Ulrich Obrist, Cambridge, Massachusetts, MIT Press, 1998.

FACING PAGE Installation view of *Passage Dangereux*, 1997

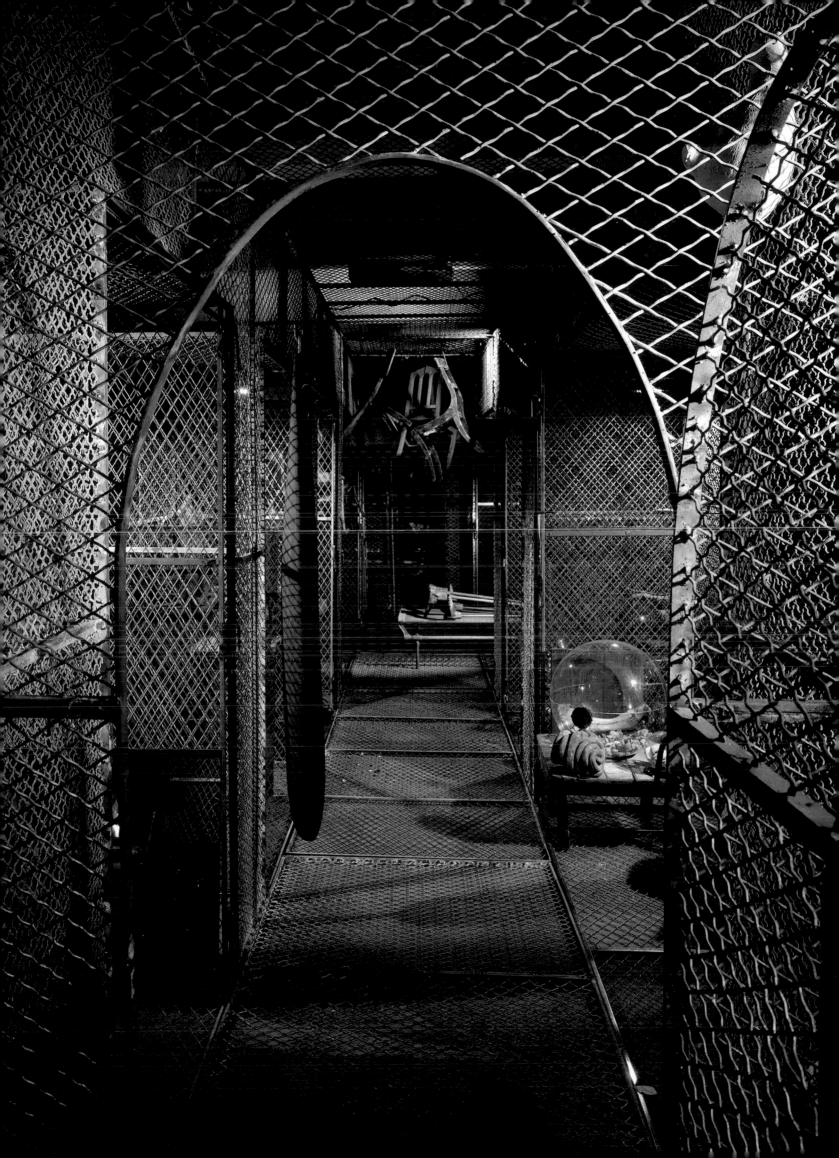

Autobiographical references are worked and reworked as a form of exorcism. "The subject of pain is the business I am in," she explains, discussing the iconography of the *Cells*. "What happens to my body has to be given a formal abstract shape."[4] Her biographical narrative, as is common with origin stories, has assumed mythic proportions. Like Joseph Beuys's epic parable of survival through felt and fat, Bourgeois's family history—the way she repeatedly inscribes it like scars within her expansive and unforgiving oeuvre—is the formative stuff of her art.[5] "I am a prisoner of my emotions,"[6] she claims, apropos of an artist who weaves her stories inside "cells": territories of confinement, claustrophobic sites of submission and solitude.

Such is the tone of Bourgeois's recent *Passage Dangereux* (1997), a series of linked enclosures constructed from heavy steel mesh that together form one long, ominous corridor through which the curious viewer journeys. This grouping of individual *Cells*, a veritable penitentiary, comprises all of the artist's key motifs: bottles of Shalimar, her signature perfume; tapestry fragments, symbols for the Bourgeois family's tapestry restoration business; an old electric chair that, like the guillotine in an earlier *Cell*, invokes the psychic retribution enacted in her art; a circular arrangement of children's chairs holding glass globes which allude to family gatherings; two hanging nest forms; several mirrors tilted at disconcerting angles; a metal bed frame on which rest the schematic legs of a copulating couple and over which hang seven empty »

LOUISE BOURGEOIS

followed by renewed interest in her work in an artistic climate increasingly open to explorations of the body and psychosexual issues. In the late 1980s and early 1990s Bourgeois invented a new form of installation art which she called "Cells." These Cells, which set her carved and assembled sculptures into mixed-media environments, revealed highly contemporary themes for an artist with such a long career.

A recipient of many prestigious awards, beginning with an artist's grant from the National Endowment for the Arts in 1973, Bourgeois has been granted honorary doctorates from Yale University (1977) and the School of the Art Institute of Chicago (1995), among others. She represented the United States in the 1993 Venice Biennale with thirteen works from 1984–93, and more recently was presented with the National Medal of Arts by President Clinton at the White House in 1997.

Since 1945 Bourgeois has been steadily awarded one-person shows. In the past five years, she has had solo shows in twenty countries including the Museum of Modern Art in New York (1994–95), Musée d'art contemporain de Montreal (1996), the Museum of Contemporary Art, Sydney (1996), Yokohama Museum, Tokyo (1997–98), and the Prada Foundation, Milan (1997).

JOREE ADILMAN

BELOW AND FACING PAGES Details of
Passage Dangereux, 1997

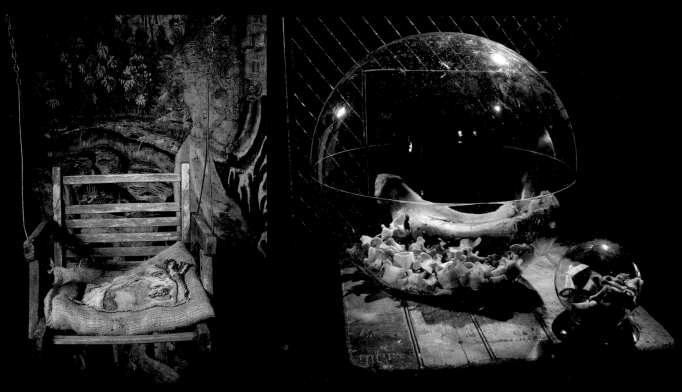

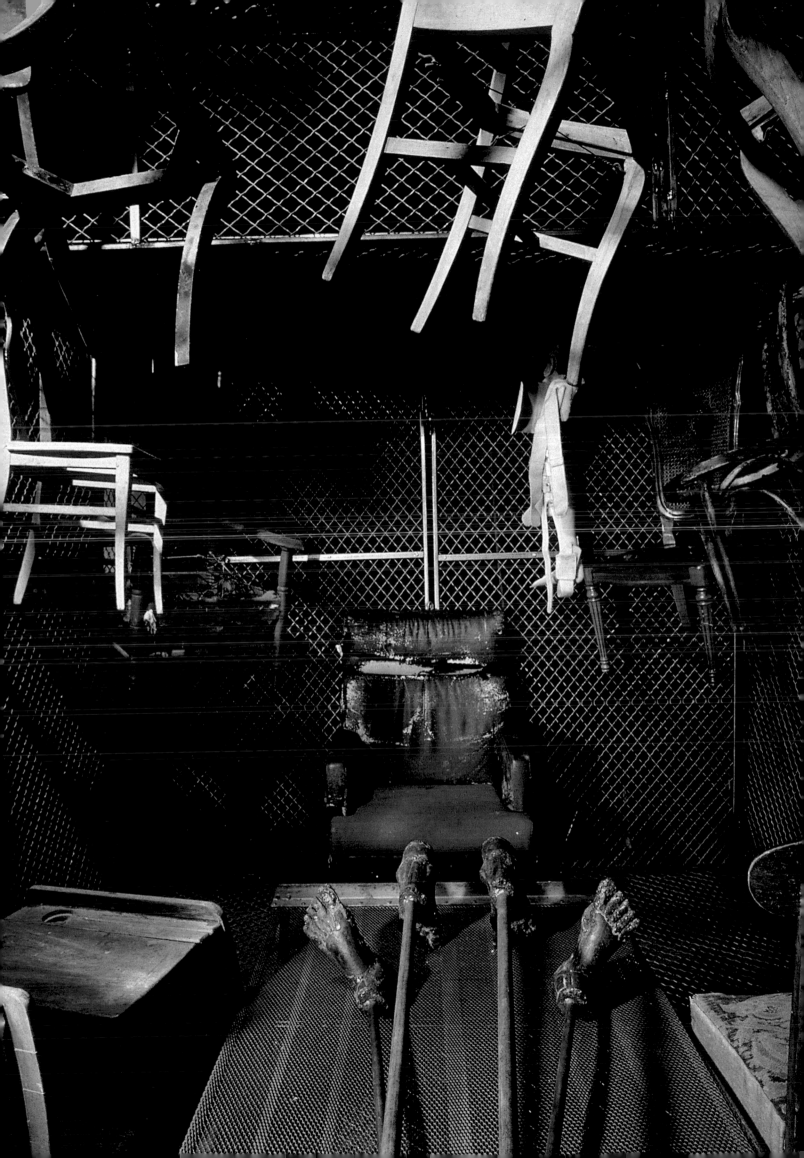

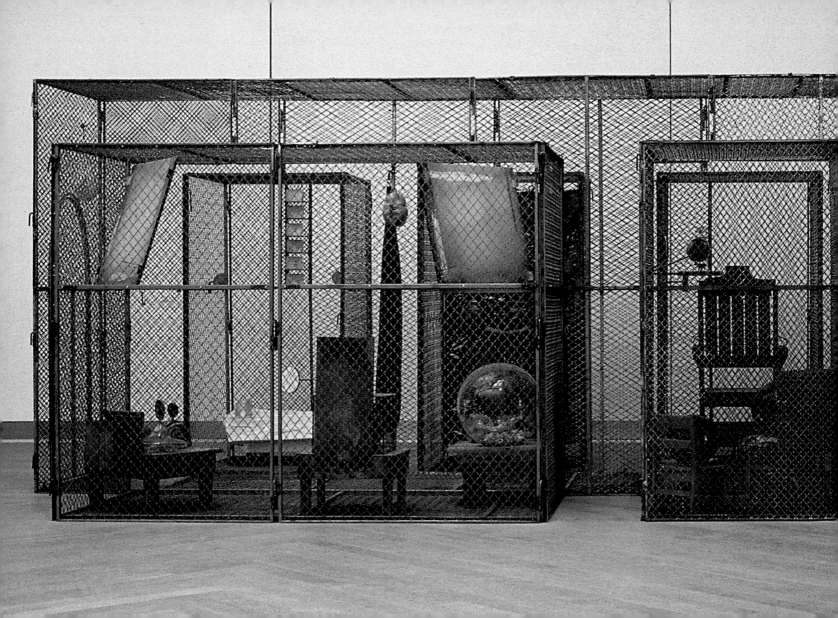

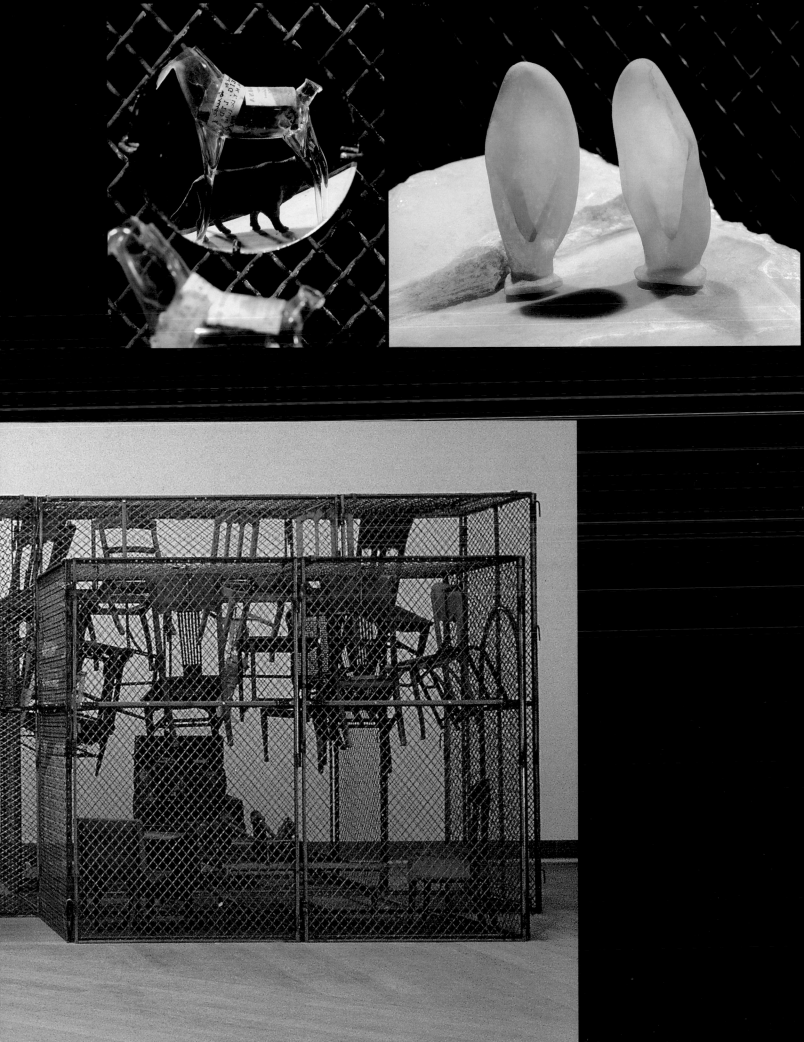

ANNETTE MESSAGER

(b. 1943, Berck, France)

Annette Messager studied at the Ecole des Arts Décoratifs in Paris. In the early 1970s, Messager created fifty-six "Album-collections," notebooks in which she organized drawings and found images. These pieces frequently catalogue pop cultural representations of women. For example, in Ma collection de proverbes (My collection of proverbs), 1974, she embroidered misogynistic sayings about women into handkerchiefs. The titles of the "Album-collections" always use the first-person possessive and often seem to be autobiographical. However, Messager blends fact and fiction in these works. At the time of their creation, she identified two distinct personae for herself—Annette Messager Collector and Annette Messager Artist—distinguishing the production of her bedroom, the collector's domain, from that of her small apartment's studio, the artist's site, and underscoring the purposeful construction of her public identity.

Messager's use of modest gestures and materials was inspired by the post-1968 climate of resistance to the heroic nature of Modernist painting and sculpture. She has frequently used techniques, such as sewing, traditionally perceived as feminine, domestic crafts. In a 1995 interview she said, "I only wanted to use materials that you would be likely to find in a home, an attic: a ball of wool, coloured pencils, fabric . . . as if you could make art with everything you find in the house, and only with that; but all kinds of things find their way into the home: newspapers, cars, television."[1] Messager's interest in the overlooked aspects of daily life is sympathetic to »

Entering a grove of body organs and systems suspended from the ceiling: pink cotton intestines, then a purple heart with red aorta and blue veins, then brown lungs; bumping into a batik "MENSONGE," a "PROMESSE" in polkadots and chintz, a zone of words made fabric flesh; becoming entangled in yarn strands that cascade into puddle-balls; finding a stuffed fox inhabiting a mosquito-net tent; encountering a land where toy animals in plastic sacks are strung up in black netting, like Santa's bounty or a hunter's booty; straining in the half light to make out photographs dangling on string, then realizing that they depict children's faces contorted into foolish and frightening grimaces; passing through a land of stuffed socks and colored-pencil crucifixes—in Annette Messager's installation *DépendanceIndépendance*, 1996–97, the visitor becomes a sort of Alice in Wonderland, at once mystified, repelled, and enchanted. In 1991, Messager said: "I want my exhibition to evoke the idea of a passage, like geography displayed on a wall. I want to invite the spectator into the staging, to come into my fiction and to take part in my game."[1]

In the last several years, Messager's work has been the subject of a number of retrospectives. For these and other shows she has created complex environments that incorporate new forms with aspects of earlier pieces and smaller installations. It is as if Messager, now the collector of her own work, is creating symphonies of her "leftovers" (as she has called the elements of her previous pieces). *En Balance* (In balance), her latest installation, is produced in this way, pushing her vocabulary in new directions. Like *DépendanceIndépendance*, it is a total environment, but where the experience of *DépendanceIndépendance* was of a kaleidoscopic funhouse, *En Balance* is like a journey through a magical forest. Here, a fantastical world is suggested with a heaven of suspended photographs; an atmosphere of enveloping black nets, hanging gloves, and body-organ drawings enmeshed in yarn; and terrestrial constructions of bolster-cushion temples and tents.

Like a child building a fort from household furniture and linens, Messager uses pillows and netting to create forbidden chambers, altar precincts, and freestanding dwellings. The last become a village of sorts, but a village with eery bodily presences: the bolsters, originally intended for intimate proximity to the human form—and scaled to it—are strung up and twisted, like so many carcasses piled about. The commingling of innocence and sadism in references to child's play is a hallmark of Messager's work, which dialectically examines stereotypes and clichés of everyday life. Many of her pieces seem to demonstrate laborious and loving exercises in symbolic protection, yet the witness to these acts is always made aware that the need for protection is predicated on being vulnerable, or being made vulnerable, and that sometimes the agent of both states is one and the same. For example, the yarn in *En Balance* that encompasses and connects small colored-pencil drawings of organs seems to form a connective tissue, uniting the parts into a whole. Yet this yarn is »

FACING PAGE Detail of *En Balance*, 1998, a work in progress in the artist's studio, Malakoff, France

Selected Bibliography

Annette Messager: Comédie tragédie, 1971–1989 (exh. cat.). Grenoble: Musée de Grenoble, 1989 (English/French edition, 1991).

Annette Messager: Faire des histoires/ Making Up Stories. Toronto: Mercer Union, 1991.

Annette Messager: Faire Parade, 1971–95 (exh. cat.). Paris: Musée d'art moderne de la Ville de Paris, 1995.

Conkleton, Sheryl, and Carol S. Eliel. *Annette Messager* (exh. cat.). Los Angeles: Los Angeles County Museum of Art; New York: Museum of Modern Art, 1995.

Annette Messager: Penetrations (exh. cat.). New York: Gagosian Gallery, 1997.

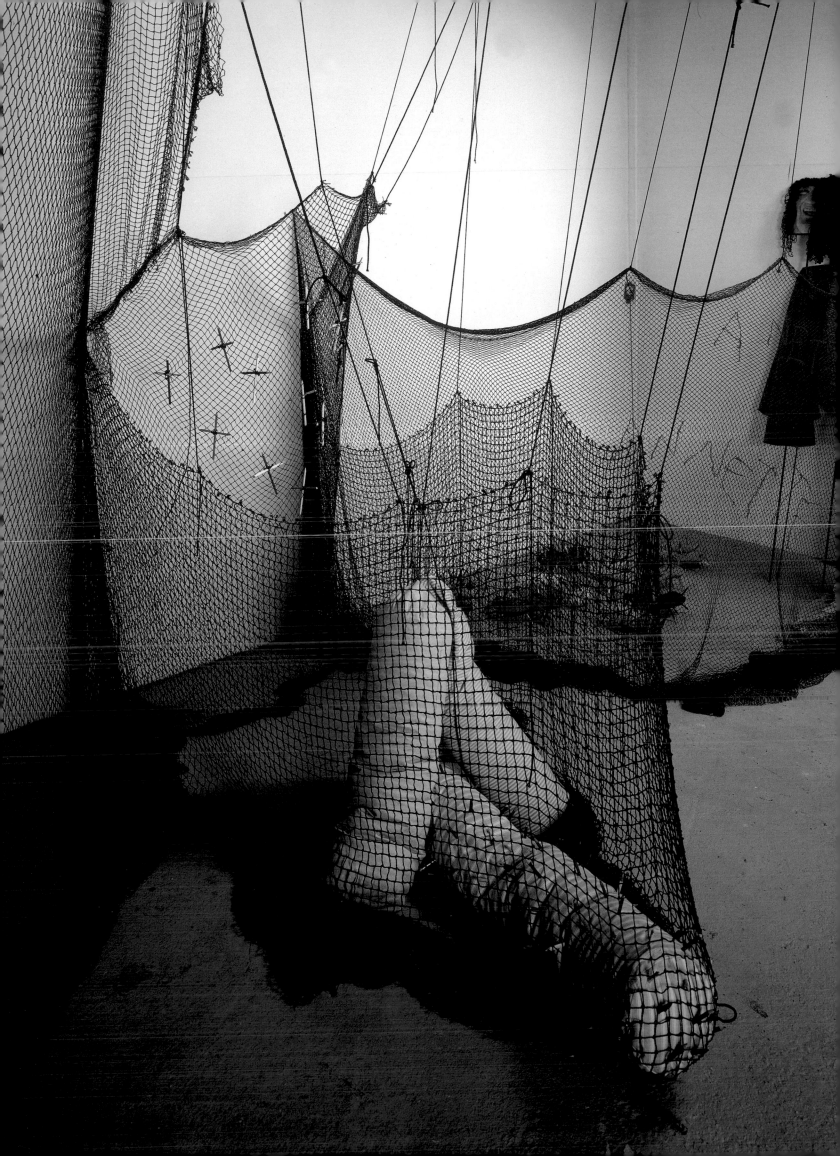

also the product of the artist's dismantling of sweaters, which originally literally warmed bodies. By unraveling them she dissects them, as she has the corpses of stuffed toy animals, which she pinned to the wall, splayed, in works such as *Accouchement*, 1996.

Metaphors of the body abound in Messager's work. In *En Balance*, the architecture of the bolsters suggests the body as temple, as sacred space, without losing the significance of the carnal body in the pillows' sensual openings and detumescences. There is the trace of a hand in the form of a glove, of an arm in the suggestive shape of a not-yet-unravelled sleeve. The drawings of body organs are like ex-votos, placed in a hallowed shrine in a desperate wish for unattainable wholeness. Suspended photographs are both ex-votos and evidence of a (now or once) living being. Balancing on the high wires above us, in the celestial canopy, they remind us of the nature of the photograph, its pathetic attempt to freeze and preserve time, to capture life. This melancholy quality always lurks in Messager's work. But it is leavened by her wondrous recontextualization and reimagination of derelict or forgotten elements of quotidian existence.

JENNIFER BLESSING

1. Gianni Romano, "Talk Dirt: Interview with Annette Messager," *Flash Art*, 24 (summer 1991), p. 102.

I would like the spectator to be caught up (as indeed I am too) like spiders in their own web.
From "Interview with Robert Storr," in *Annette Messager: Faire Parade, 1971–95*. Paris: Musée d'art moderne de la Ville de Paris, 1995, p. 106.

BELOW Detail of *Les gants*, 1997

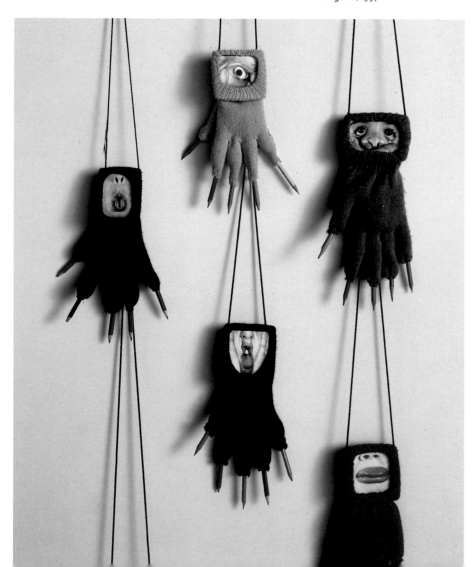

ANNETTE MESSAGER

Fluxus practice, her fascination with language and documentation a form of Conceptual art; yet her work has an overtly expressionistic side suggestive of Surrealism. In Mes pensionnaires (My boarders), 1971, for example, a flock of tiny dead birds sport the vests, capes, and scarves she has painstakingly knitted for them.

Photographs have also been of central importance in Messager's work. The "Album-collections" and other projects from the 1970s examined social uses of photography such as advertising imagery. During the 1980s, Messager was more concerned with the ontological nature of the photograph and its seemingly magical ability to preserve life. In series such as Chimères (Chimeras), 1982–83, and Mes trophées (My trophies), 1986–87, she manipulated and drew upon photographic fragmentations of the body. Messager's Mes voeux (My vows), 1988–, has become a hallmark of late-twentieth-century art. Each installation in the series contains myriad black-and-white photos of male and female body parts hanging by threads in a tumultuous multigendered cascade. In keeping with her interest in the suspended animation represented by photography, Messager has been working with taxidermized animals—and their metaphorical equivalent, stuffed toy animals—since the late 1980s. In the 1990s, she has orchestrated a series of complex multimedia site-specific environments, including Les piques (The pikes), 1991–93; Parade, 1994–95, and DépendanceIndépendance, 1996–97. She lives and works in Paris.

1. "Interview with Robert Storr," in *Annette Messager: Faire Parade, 1971–95*. Paris: Musée d'art moderne de la Ville de Paris, 1995, p. 78.

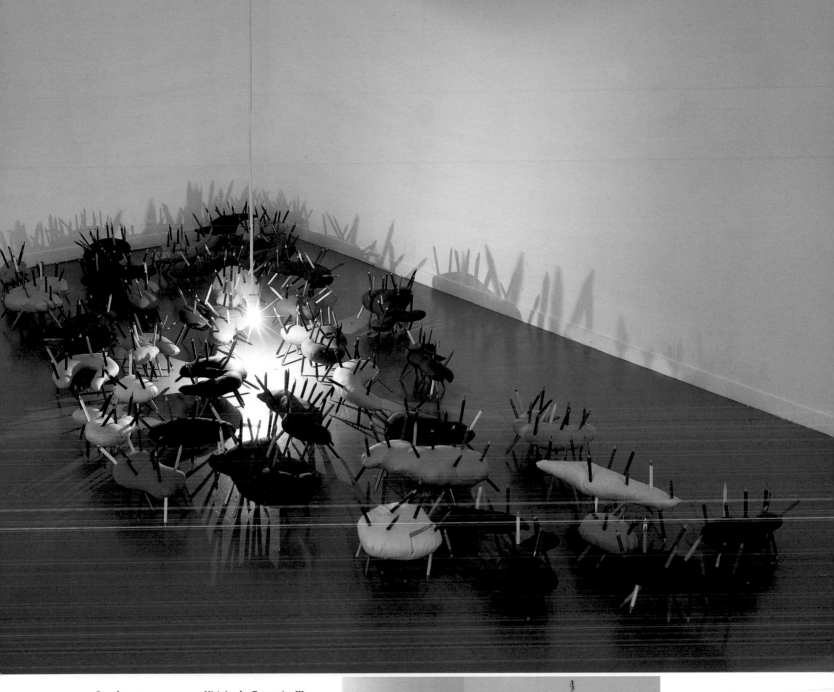

ABOVE *Parade*, 1995

RIGHT *Histoire des Traversins III*
(History of the bolster pillows), 1996

BELOW Detail of *En Balance*,
1998, a work in progress in the
artist's studio

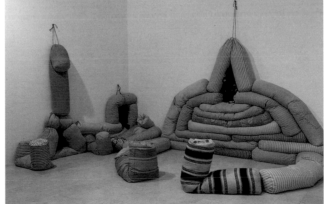

FOLLOWING PAGES
DépendanceIndépendance,
1995–97, installation view,
Gagosian Gallery,
New York, 1997

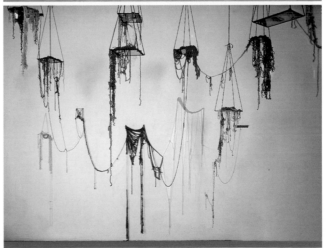

Annette Messager ≪ 203

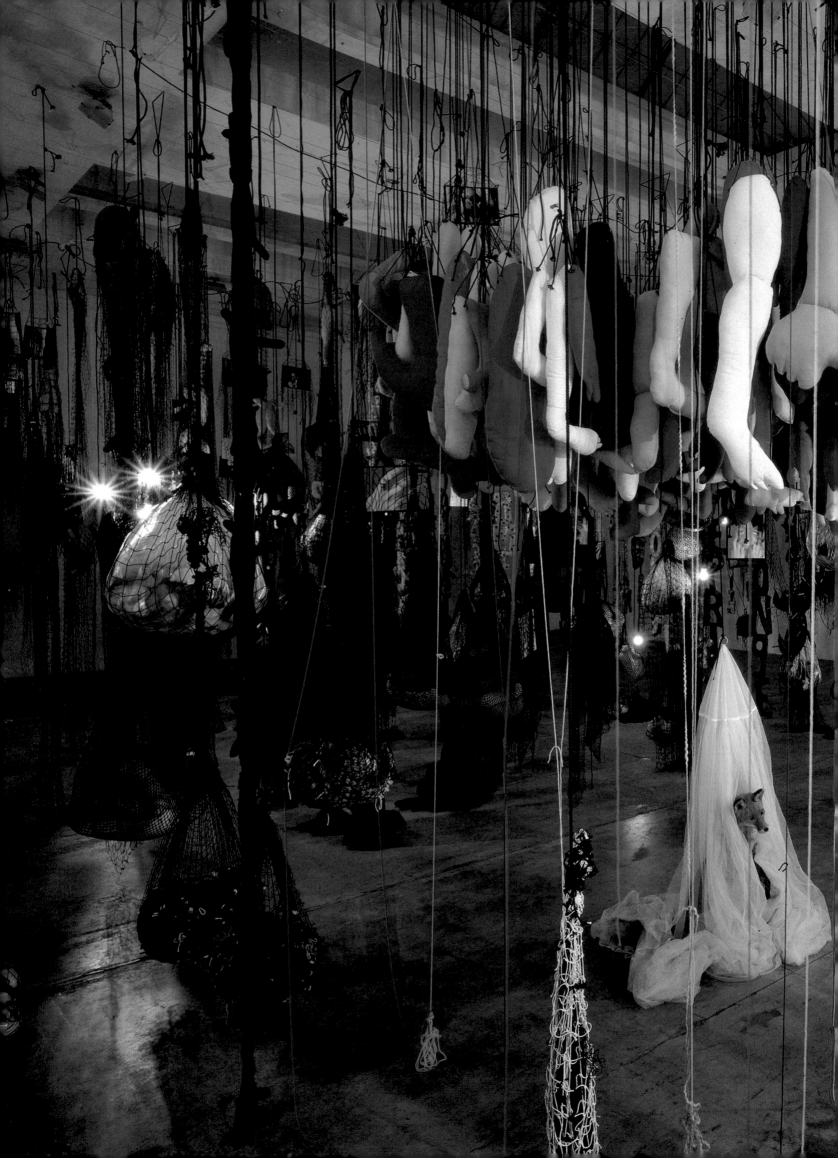

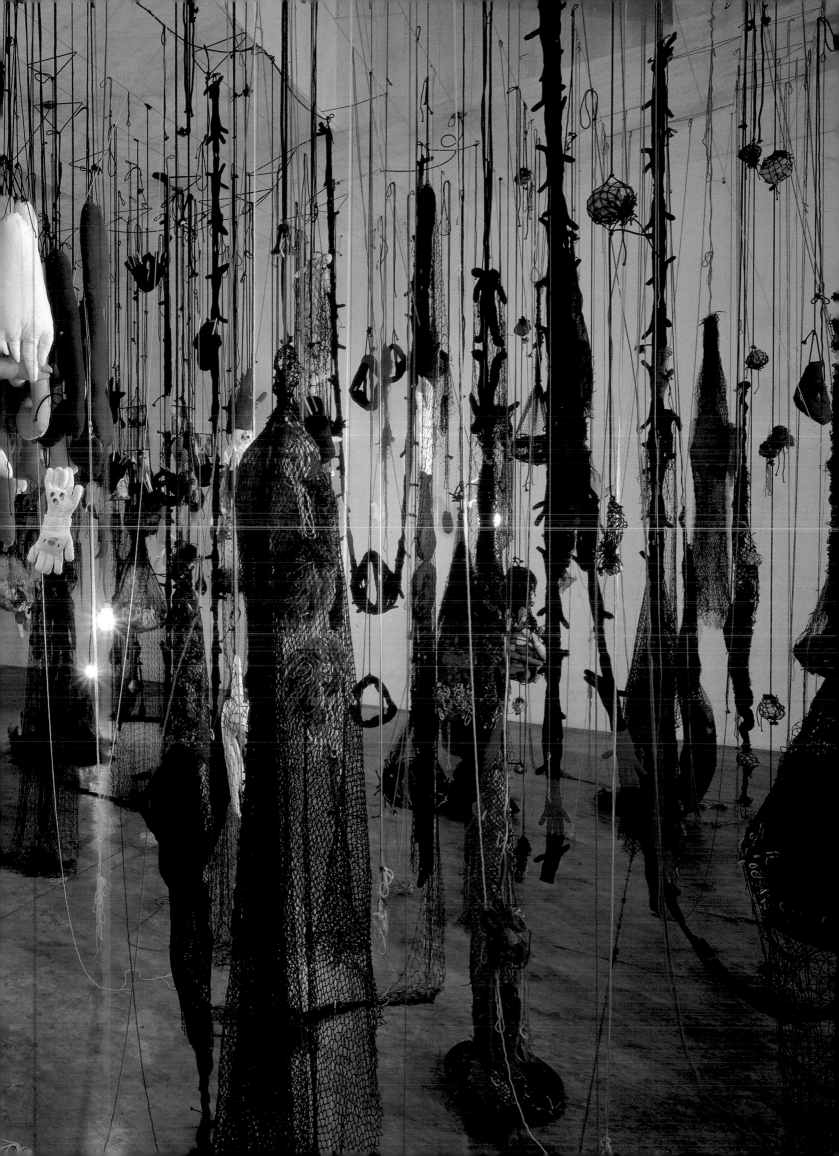

L'HOMME QUI TOUSSE
1969

CHRISTIAN BOLTANSKI

(b. 1944, Paris)

Born in Paris not long after the Liberation, Christian Boltanski had his first exhibition La vie impossible de Christian Boltanski *(The impossible life of Christian Boltanski, 1968). The early portion of his career was centered on photography, installation and performance, mail art, and experimental film. Between 1968 and 1976 Boltanski produced a concentration of short films that blurred the lines between fiction and reality, humor and tragedy.*

From 1970, the year of his exhibition at ARC Musée d'art moderne de la Ville de Paris until 1984, the year of his retrospective at the Centre Georges Pompidou, he would explore the possibilities of using photography in its most ordinary form, touching increasingly on autobiographical references. He would gradually abandon images of the self in order to foreground the notion of the sacred which appears with the Monument *series in 1985. At this point, recollections of a buried past with direct references to Nazi concentration camps have become a central theme for his practice. Counted amongst his recent solo exhibitions are the* Lessons of Darkness, *organized by the Museum of Contemporary Art in Chicago, 1988-89;* Christian Boltanski: Reconstitution *at the Whitechapel Gallery in London, 1990; and his most recent exhibition* Les Dernières années *at the Musée d'art moderne de la Ville de Paris, 1998. Despite being represented in institutions throughout the world, Boltanski continues to be pulled towards unusual or marginal places to create his installations.*

Film is the root of Christian Boltanski's work: his first public exhibition, in May 1968, took place in a Paris movie theater; his aesthetic was partially formed in the few short films that he made with very little means between 1969 and 1973. *L'Homme qui tousse* (The coughing man), one of the first of these films, features a seated character covered in unidentifiable mire, spattered with blood thrown by tiring, spasmodic coughing and vomiting. There have been some problems interpreting this powerful three-and-a-half minute scene. One is tempted to link the agony in *L'Homme qui tousse* to the installation series in Boltanski's later work referring to the Holocaust. Yet this early piece shows the unbearable, where all of Boltanski's work since the end of the 1970s touches instead on what is unsaid, via line, mourning, absence, etc. It is not until his last two films, *Essai de Reconstitution des 46 Jours qui Précédèrent la mort de Françoise Guiniou* (An attempt to reconstitute the 46 days that preceded the death of Françoise Guiniou, 1971) and *Appartement de la rue de Vaugirard* (Apartment on the rue de Vaugirard, 1976) that this aesthetic appears; *L'Homme qui tousse* does not yet belong to it.

In his interviews, Boltanski insists on the spontaneous genesis of the short films, pleased as he is to describe them—the way Dubuffet described Art Brut—as unscathed by intellectual influences; but there is something deceptive in this claim of naïveté. Not much insight is gained by making a connection with other film experiments by painters, such as Martial Raysse. Nor does there seem to be any connection with the radical experimental films launched by Guy Debord or the Lettristes. However, Dominique Noguez, in *Eloge du Cinéma Expérimental*, refers almost in passing to what we might consider a probable and decisive source of Boltanski's first works: this coughing man, worn and panting, evokes Boris Vian's Schmürz in *Les Bâtisseurs d'Empire*. In Vian's very amusing and troubling play, which both satirizes and directly concerns the Theater of the Absurd, characters facing an unbearable situation (an unstoppable shrinking space) let loose on a hybrid creature, or Schmürz. The Schmürz is a constantly beaten goat emissary which directors often cast as a rag puppet, and which indeed closely resembles Boltanski's seated man. In the France of the end of the 1960s, the Theater of the Absurd was no longer an elite reference: Samuel Beckett's *Waiting for Godot* and *End Game*, Eugene Ionesco's *Rhinoceros* and even his *Amédée* or *Comment S'en Débarasser* are part of daily culture; a person on the street would have at least heard of these plays, or perhaps seen them on the State television channel.

The very titles of Boltanski's short films—*Derrière la porte* (Behind the door) and *Comment pouvons-nous le supporter* (How can we stand it?)—seem to indicate»

Selected Bibliography

Boltanski, Christian, Lynn Gumpert, and Mary Jane Jacob. *Lessons of Darkness*. Chicago: Museum of Contemporary Art, 1988.

Gumpert, Lynn, Georgia Marsh, and Serge Lemoine. *Reconstitution: Christian Boltanski*. London: Whitechapel Art Gallery, 1990.

Boltanski, Christian, Tamar Garb, Didier Semin, and Donald Kuspit. *Christian Boltanski*. London: Phaidon Press, 1997.

FACING PAGE Film still from *L'Homme qui tousse*, 1969, Centre Georges Pompidou, Musée national d'art moderne, Paris

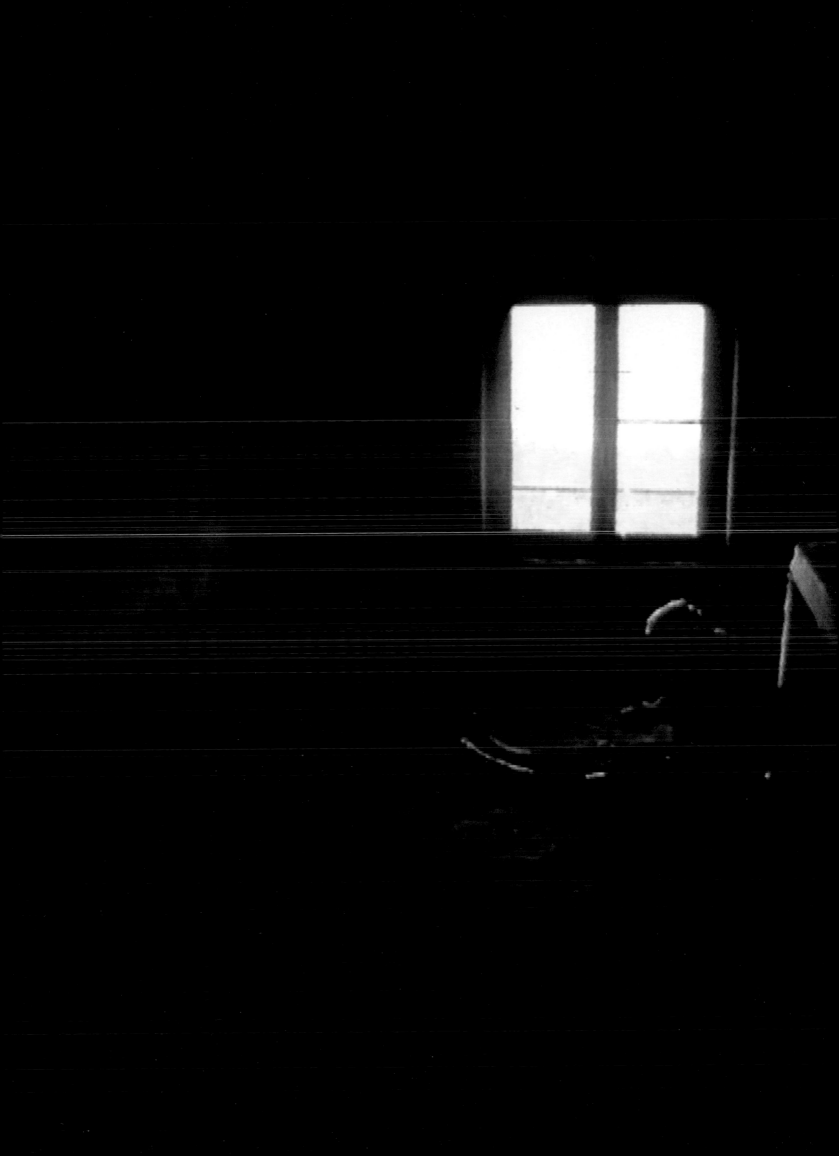

that this influence is genuine and intelligible; they do not contradict the claim of being without culture, or without intentional culture, that Boltanski asserts. This theatrical backdrop is revisited by a painter—this is what is immediately striking about the violence of *L'Homme qui tousse*. This dramatization is also a marvelously ironic wink at Barnett Newman's *Who's Afraid of Red, Yellow and Blue*. After all, blood and vomit are also colors!

DIDIER SEMIN
Translated from the French by Molly Stevens.

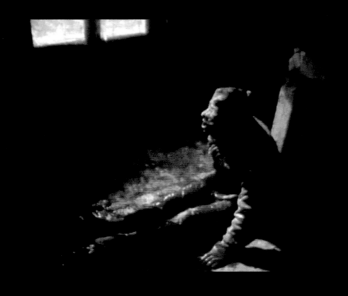

THIS PAGE AND FACING Film stills from *L'Homme qui tousse*, 1969

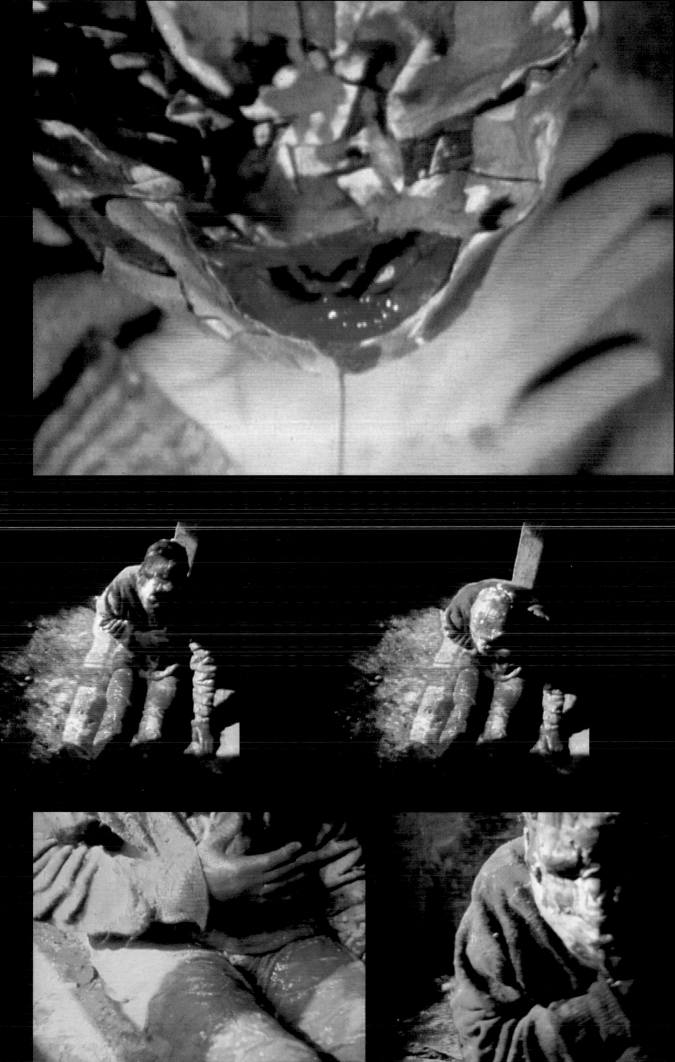

SARKIS

(b. 1938, Istanbul)

As Sarkis himself describes in the autobiographical note that begins on this page, the room serves as a paradigm for most of his work executed since 1960, the year of his first solo exhibition in Istanbul, where he was born. It seems that today the constant idea

behind his work and actions has been the dwelling, encampment, or site; each installation can be understood as a metaphor for the construction of mental space.

The building of *Treasures of the Mnemosyne* crossed many stages of development. When the installation at the Musées de Strasbourg, *Ma Chambre de la Rue Krutenau en Satellite*, could not be brought to the Guggenheim Museum SoHo, Sarkis planned to develop the building of a specific site as an amalgamation of previous works. Straddling the spheres of individual and collective memory, Sarkis was inspired to unite different elements within the museum so as to form a space for reflecting on the book he designed with art historian Uwe Fleckner.[1]

In this work, translated for the exhibition, Fleckner compiled an anthology of writings from Plato to Jacques Derrida about the art of memory. In an epigraph, he referred to Aby Warburg, the art historian who developed a "history of art without text" with his Mnemosyne atlas. This text was developed from documents drawn from the juxtaposition of all the fields of knowledge and is distant from established genealogies. A selection of photographs of the artist's studio, taken by Sarkis himself, formed a visual counterpoint to the writing. Image and text are in dialectical relationship, like Eisenstein's "montage collision," which Philippe-Alain Michaud cited in his examination of Warburg.[2]

This book is presented here in a temporary library, built to resemble a provisional structure within the exhibition. The photographs, framed and arranged around the perimeter of the space, echo the contents of the book. The color of the space helps create the palpable, specular atmosphere in which Sarkis seeks to submerge the visitors to the exhibition.

By allowing for "real time"—providing a space for the visitor to read during the exhibition—Sarkis encourages the visitor to introduce it in its history. This space is provided as an encompassing experience. The book's permanence responds to the temporary structure; the necessary concentration of thought and action required for the compilation of texts responds to the diffused and scattered images that are beyond language and origin.

The world of Sarkis is reminiscent of theater design in which different forms of creation are employed. Between cultural confusion and the imbrication of mental territories, his art practice implicitly defines itself with a subtle strategy: this space questions the manner in which different categories of art function within a multiplicity of significations.

BERNARD BLISTÈNE

Translated from the French by Molly Stevens.

1. *Die Schatzkammern der Mnemosyne*, under the supervision of Uwe Fleckner (Berlin: Verlag der Kunst, 1995).

2. To understand the foundation of Aby Warburg's (1866–1929) thoughts, and his influence on the most famous art historians of this century, see Philippe-Alain Michaud, *Aby Warburg et l'Image en mouvement* (Paris: Macula, 1998).

"In 1954, after having encountered a reproduction of Edvard Munch's The Scream, *Sarkis began to paint in small rooms. He had his first solo exhibition in 1960 in Istanbul. From 1960 to 1963, in Ankara during his military service, he worked in a tiny room, measuring approximately 1.4 x 2.4 meters, then in 1964 came to Paris and worked for six months in a small hotel room. 'Individual, itinerant, ephemeral and sometimes clandestine workplaces' begin to become important: he would create obscure sculptures (1969–1971) in a locked underground garage. Obscurity became an element in his work (such as the* Blackout *series) for almost ten years. In 1976, he began the* Kriegsschatz, *an antidote for everything that crystallizes outside the work's will. In 1979, colored light was introduced in his spaces, coloring the objects within them.*

Sarkis began to teach in Strasbourg in 1980. His small room there had no facilities or telephone, only a bed on the floor and a wood board for a work table; for eight years very few people knew it existed. In 1989, he created a huge installation for the Musées de Strasbourg entitled Ma Chambre de la rue Krutenau en satellite. *That same year, in the Valmy forest, he would install twelve wood constructions based on twelve of his studios. These constructions were not yet spaces that could be entered and worked in.*

In 1993, for an exhibition in Dordrecht, he had a small wood studio measuring approximately 1.5 x 1.5 x 2.2 meters built in the city. He worked there for five »

Selected Bibliography

Réserves Accessibles (exh. cat.). Paris: Musée national d'art moderne, Centre Georges Pompidou, 1979.

La Fin des Siècles, Le Début des Siècles (exh. cat.). Paris: ARC, Musée d'art moderne de la Ville de Paris, 1984.

Trois Mises en Scène de Sarkis (. . .) (exh. cat.). Brussels: Editions Lebeer-Hossmann, 1985.

Ma Chambre de la Rue Krutenau en Satellite (exh. cat.). Strasbourg: Editions des musées de la Ville de Strasbourg; Brussels, Hamburg: Editions Lebeer-Hossmann, 1989.

Scènes de Nuit, Scènes de Jour (exh. cat.). Grenoble: Centre national d'art contemporain, 1992.

« Trésors de mnémosyne – le lieu de lecture » – pour "Premises" Guggenheim N.Y.
Gubbio – Avril 98

SARKIS

days, preparing over a hundred red windows. Passersby could see him working.

In 1996, he built a hexagonal studio with a multicolored glass roof in Jerusalem. He would work there for three months, exposing the inside to visitors, and do the same with a 1.5 x 1.5 x 2.4 foot studio in Copenhagen. This particular studio was transferred to Antwerp and, in September 1998, will go to Stockholm.

Sarkis has been working for a year on a building project using multicolored glass—in effect, a building/stained glass window—for the Parc Pourtalès in Strasbourg. This studio will be lent, for periods of time ranging from two weeks to a month, to artists, writers, musicians, and philosophers who will work there and leave copies of their pieces, thus forming the place's memory. This building/studio, dedicated to Mathias Grünewald, stands next to a tree struck by lightning."

SARKIS
*Translated from the French
by Molly Stevens.*

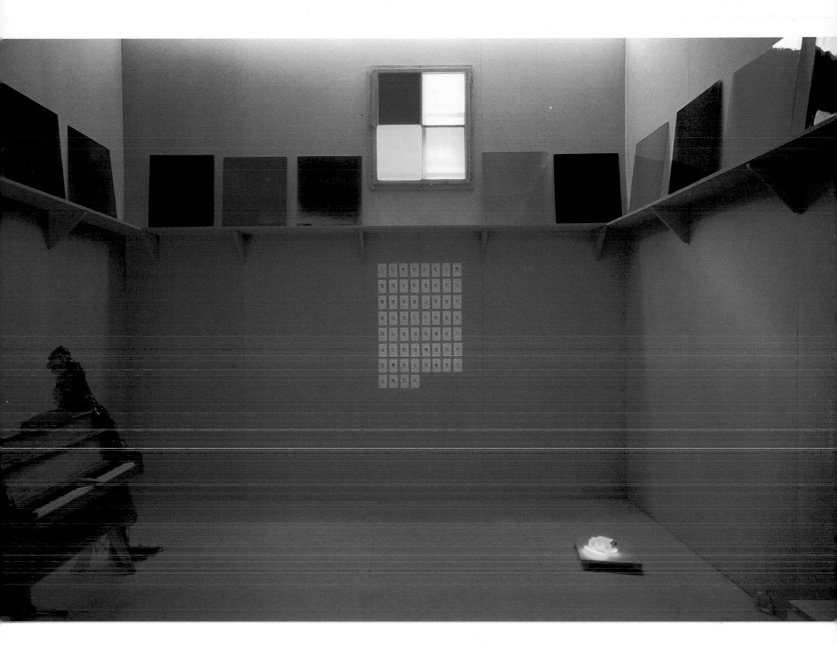

FACING PAGE *Le Paysage*
(The landscape), 1994,
Les Ecuries Saint-Hughes, Cluny

FACING PAGE *26.9.1938o,* Kunst
und Austellung Halle, Bonn,
September 1996

FACING PAGE *Ma Chambre de la rue
Krutenau en satellite* (My room
on the rue Krutenau as a satellite),
1989, Musée d'art moderne de
Strasbourg

FACING PAGE *A partir de 1938o,*
MAMCO—Geneva, 1994–97

GÉRARD GAROUSTE

(b. 1946, Paris)

From 1965 to 1972, Garouste studied at the École Nationale Supérieure des Beaux-Arts (Paris). After his first solo exhibition in 1969 at the Zunini Gallery (Paris), Garouste decided to leave the art circuit in order to focus on theater; in 1977, he would write, design the sets, and interpret, with Hervé Half and David Rochline, Le Classique et l'Indien at Le Palace Theater (Paris), foreshadowing much of his subsequent plastic work. His second solo exhibition, Comédie Policière, took place in 1979 at the Travers Gallery (Paris). While continuing to work as a painter, he designed theater sets and decor. Starting in the 1980s, he participated in several exhibitions in France and abroad: Musée d'Art Moderne de la Ville de Paris, Milan Triennale, Galeria Nacionale de Arte Moderna in Lisbon, Sara Hilden Art Museum in Finland, Musée national d'art moderne du Centre Georges Pompidou, Holly Solomon Gallery, Leo Castelli and Westwater Gallery in New York, Martin-Gropius Bau in Berlin, National Museum of Modern Art in Tokyo, and more. Garouste diversified his production during this time to include drawings, gouaches, etchings, pastels, and sculptures. As early as 1986, he began to focus on the relationship between text and image, and would produce books based on the works of François Villon, Dante, Cervantes, and Edmond Jabès, all the while continuing to paint and sculpt (his main activities) and decorate. In 1989 he would create the curtain for the Théâtre du Châtelet (Paris), in 1995 the sculptures for the Évry cathedral and, in 1997, the windows for the church of Notre-Dame de Talant in Burgundy.

The installation of *La Dive Bacbuc*, named after the work by François Rabelais (1494–1553), is both the result of previous studies of the question of narration in painting and the beginning of a "baroque" theatrical quality, to use Garouste's words. Considering that literature is so removed from the plastic arts, a project like this is unexpected in contemporary art. But, playing on the tension he has established between the current avant-garde, filled with classicism, and his own baroque works—irregular, imperfect, faltering—Garouste, with this little theater, both amusing and melancholy, revives the rich tradition of relating text and image. He uses the body of the work, as well as the spectator's body, as both the point of origin and the finish line of a journey. References to theater, which occur here as physical staging and a huge optical set, appeared as early as 1987 with the *Indiennes* (large work on linen canvases, named for the fabric that appeared in Europe in the eighteenth century), inspired by Dante. Somewhere between decor, fresco, tapestry, and stage curtains, the *Indiennes* lent an architectural structure to the premises, thus becoming parts of the construction. The installation of *La Dive Bacbuc* (6 x 2.4 meters high) is a full-fledged construction, a kind of theater in the round in which enclosure and opening are reflected in a verbal and visual sequence.

Intended to be experienced both from the inside and the outside, the installation, an endless circle that is somehow also the completion of a long quest, is a proliferation of simultaneous journeys—physical, optical, textual, and iconographic—that join and divide in turn, yielding multiple points of view and interpretations. Like a Medieval game of sapience (wisdom), *La Dive Bacbuc* does indeed involve various kinds of knowledge: about Rabelaisian writing, which itself consists of vast, encyclopedic references; simple analytic scopophilia; the interest that we take in puzzling over an enigma; and the pleasure we have in solving one. On the outside and inside of the piece are scenes from Rabelais, sometimes including illuminated text in the margins. Therefore, the viewer becomes, alternately, reader, actor, interpreter, and theater designer of this piece, the center of which is everywhere and the perimeter of which is nowhere. Finished and constantly beginning again, yet without start, middle, or end, mirroring itself like certain Jorge Luis Borges stories, *La Dive Bacbuc* turns us into the story's protagonist. We think we are watching a show, but are really only watching the staging of our own desire to see, know, and understand. The visitor's living body, like the bodies represented in the paintings, are present before us both because there are twelve oculi arranged all around, and also because the enigma at hand is about the puzzle of the body. In Rabelais's work, the body is so fundamental it could be called one of the most philosophical ways of knowing. The most basic needs—sexuality, alchemy, metaphysics, theology, death, themes that, in Rabelais, waver between animality and intellectuality—are found here in Garouste. The characters in Rabelais's *Cinquième Livre*, after trials and tribulations, finally arrive at »

Selected Bibliography:

Gérard Garouste. Rome: Editions Leader/arte, 1984.

Gérard Garouste. Paris: Editions Durand-Dessert/J. Damase, 1984.

Lemaire, Gérard-Georges. *Gérard Garouste*. Turin: Editions Il Quadrante, 1986.

Gérard Garouste (exh. cat.). Bordeaux: CAPC, Musée d'art contemporain de Bordeaux, 1987.

Gérard Garouste (exh. cat.). Paris: Musée national d'art moderne, Centre Georges Pompidou, 1988.

Cabane, Pierre, *Gérard Garouste*. Paris: Editions La Différence, 1990.

Dagbert, Anne, *Gérard Garouste*. Paris: Editions Fall, 1996.

FACING PAGE Installation view of *La Dive Bacbuc* (detail), 1998, collection of the artist

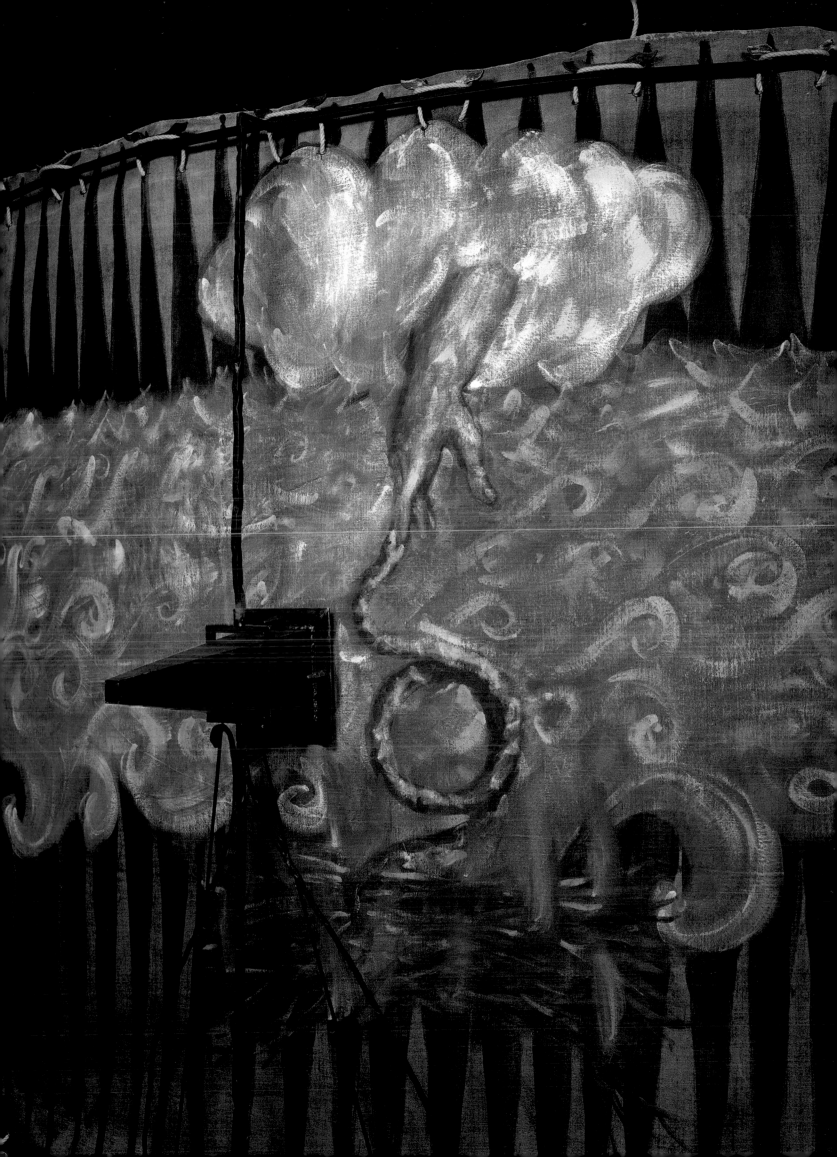

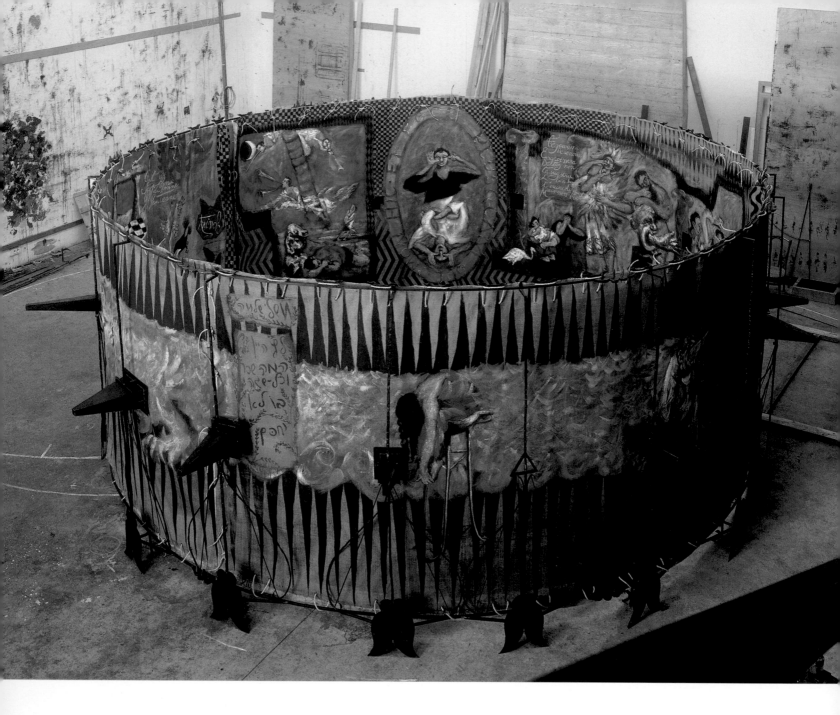

ABOVE Installation view in the artist's studio, Marcilly-sur-Eure, 1998

a place where there is a bottle; "Drink," they say. In literary tradition, drink provides access to knowledge: *In vino veritas*, truth in wine. The word "drink," a temporary solution to the enigma, signifies that knowledge is attained through the body, not through intellect. "Bacbuc" means "bottle" in Hebrew, and Garouste was careful to paint "Dive bouteille" (wine), inside the piece as it appears in the caligram of Rabelais's text. In the installation's fragmented unit (or unified fragments), the spectator will note, after walking completely around, that the German word *Trinch* is perceived and read through the (eyepiece) on the penis of the defecating character: to drink and urinate, know and perceive, are therefore united in one image and text—produced, in a way, by the spectator's eye and body .

JACINTO LAGEIRA
Translated from the French by Molly Stevens.

THIS PAGE Installation views of
La Dive Bacbuc (detail),
collection of the artist

ENCLOSURES

Throughout the history of Modernism, architecture and art have had a complicated and critical interrelationship, never free from the influence of one another. The teleological movement of the early avant-garde supposed architecture as the implicit consequence of the formal principles first developed in the visual arts. By the mid 1960s, this historical trajectory was reversed by American Minimalist artists. Using phenomenological theories, they questioned the neutrality of the gallery space by producing works that directly underline the ideological significations that are inscribed by the architectural frame. Concurrently, the occupations of certain postwar European artists gravitated toward reappropriating architectural models in order to question the effects of the built environment on the condition of human existence, specifically underlining the poetic and pathos.

In his text "The Plan of the Modern House," Le Corbusier assessed the state of domestic architecture with an ironic quip, "Monsieur will have his cell, madame also, mademoiselle also."[1] Echoing Le Corbusier's prophetic statement, the artists in this sequence investigate the physical and psychological effects engendered by certain architectural spaces: a collection of literal and metaphorical enclosures. Institutional and domestic architecture provide a central paradigm for artists that question the structural limits of everyday life. An inventory of repressive typologies—the bed chamber, the cell, the corridor, the classroom, the cage—characterize the work of artists such as Absalon, Jean-Marc Bustamante, Alain Séchas, and Jean-Pierre Raynaud. These territories of confinement are not just spaces of physical and mental incarceration, but are often times inhabited places of everyday life.

Although they might not make direct reference to an architectural form, artists such as Jochen Gerz and Thierry Kuntzel construct a metaphorical space to address similar questions about the human condition. Through the video image or words written in chalk, they create a visual connection between "existence" and a state of oscillation between presence and absence. In each artist's attempt to render the abstract notion of existence perceptible, a palimpsest occurs. At the moment that the viewer is conscious of the "state of being," they participate or witness its erasure.

1. Le Corbusier, "Le Plan de la maison moderne," *Précisions sur un état présent de l'architecture et de l'urbanisme*," Paris, 1930.

ESPACE ZÉRO
1974

JEAN-PIERRE RAYNAUD
(b. 1939, Courbevoie)

Raynaud graduated from the École d'Horticulture in Versailles in 1958 and a few years later completed his first series of cement-filled Sens Interdits *(One way) and* Pots Rouges *(Red pots). In 1964, he participated in the* Salon de la Jeune Sculpture *in Paris; and the following year, the Jean Larcade gallery would offer him a solo exhibition. He presented 300* Pots Rouges *at the Düsseldorf Kunsthalle in 1968, and afterward he was invited to show his work at venues throughout Europe, including the Stedelijk Museum (Amsterdam) and the Moderna Museet (Stockholm). In 1969, Raynaud began building his house, a project that would last twenty years.*

*Espace Zéro creates a certain kind of atmosphere; it responds to the specificity of place while continuing to engender a sense of emotional disturbance desired by the artist. By constructing a space for the viewer to experience, Raynaud remains in close contact with the production of the art of his time. His chosen vocabulary—white tile, his trademark medium—lends a sense of cool distance to the piece. Raynaud distinguishes himself by building walls instead of paintings, materializing architectural ambition through geometric composition. For the *Premises* exhibition, *Espace Zéro* functions as an obligatory passageway from one thematic sequence to the next; it is built into the very exhibition design. A critical instrument, the piece is an expression both of the artist's subjectivity and his method. Opaque walls reference the built environment, evincing the same function as the first *Maison* (House) he covered, inside and out, with white tile twenty years ago. In fact, within this exhibition, *Espace Zéro* recontextualizes his own body of work as well as doubling the closed white cube that makes up the museum's space.

As early as the late 1960s, Raynaud had worked on private and public spaces, conceiving of site-specific works in order to reorganize the exhibition space for other works of art. With his white tile structures and grids indicating the forbidden, eventually these spaces became part of the lives of their occupants. For a 1984 exhibition at the Grand Palais in Paris, Raynaud designed a very elaborate small gallery for the presentation of other pieces. Raynaud covered the walls, floors and ceilings in white tile. In specially designed niches, a great many objects and records of various civilizations were arranged on steles, linking the piece with the museum's extraordinary, eclectic collection. At the Hara Museum in Tokyo (1988), Raynaud presented an *Espace Zéro* that curved and turned inward, inviting walks and sensory discovery. The *Container Zéro* (1988) in the Pompidou collection—although not technically the definition of an *Espace Zéro*—is an impressive enclosed object reiterating this exploration; it acts as a right of way before passing into the museum's collection to assess its stakes.

The partially sunk 300-square-meter shelter that Raynaud built for himself in Garenne-Colombes in 1989 is a specular structure developed around a display of his works. Several *Espaces Zéro* are places meant for the private introspective use of the artist: they perform a decorative function as well as a critical installation practice. To quote Raynaud: "It's an ability to react effectively to what I will call the spirit of the place, no matter what it is, and to do so according to my personal concerns."

Raynaud opened his house to the public in 1974, and that same year he created his first Espace Zéro *(Zero space) at the Musée d'art et d'industrie in Saint-Etienne; in following years he would create windows for the Cistercian abbey of Noirlac (fifty-five windows, seven rose windows). In 1979, the Galeries Contemporaines of the Musée national d'art moderne hosted a solo exhibition of his work. He designed an* Espace Zéro *for the entrance of the exhibition* La Rime et la Raison *(Rhyme and reason) at the Grand Palais in Paris in 1984.*

The Espace Zéro *installation—entitled* Container Zéro *(Zero container)—at the MNAM, Centre Georges Pompidou (1988), together with a series of retrospective shows in the U.S. (Sonnabend Gallery, New York, 1992), secured his audience.*

Raynaud destroyed his house—covered entirely with white tile—in 1993 and collected the fragments for a show at CAPC, Musée d'art contemporain, in Bordeaux.

JEAN-PIERRE BORDAZ
Translated from the French by Molly Stevens.

Selected Bibliography

Raynaud: 1974–1978. Paris: Musée national d'art moderne, Centre Georges Pompidou, 1979.

Raynaud (exh. cat.). Jouy-en-Josas: Fondation Cartier, 1985.

Duby, Georges and Gladys Fabre. *Raynaud*. Paris: Hazan, 1986.

Jean-Pierre Raynaud: A Retrospective (exh. cat.). Houston: Museum of Fine Arts, 1991.

Psycho-Objets: 1964–1968 et La Maison (exh. cat.). Bordeaux: CAPC Musée d'Art Contemporain, 1993.

Durand-Ruel, D., Y. Tissier, and B. Wauthier-Wurmser. *Jean-Pierre Raynaud: La Maison*. Paris: Editions du Regard, 1998.

FACING PAGE *Espace Zéro*, 1981, installation view, Hara Museum of Contemporary Art, Tokyo

ABOVE *Espace Zéro*, 1974, view in the private
residence of D. Guichard

FACING PAGE *Espace Zéro*, 1981, Hara Museum
of Contemporary Art, Tokyo

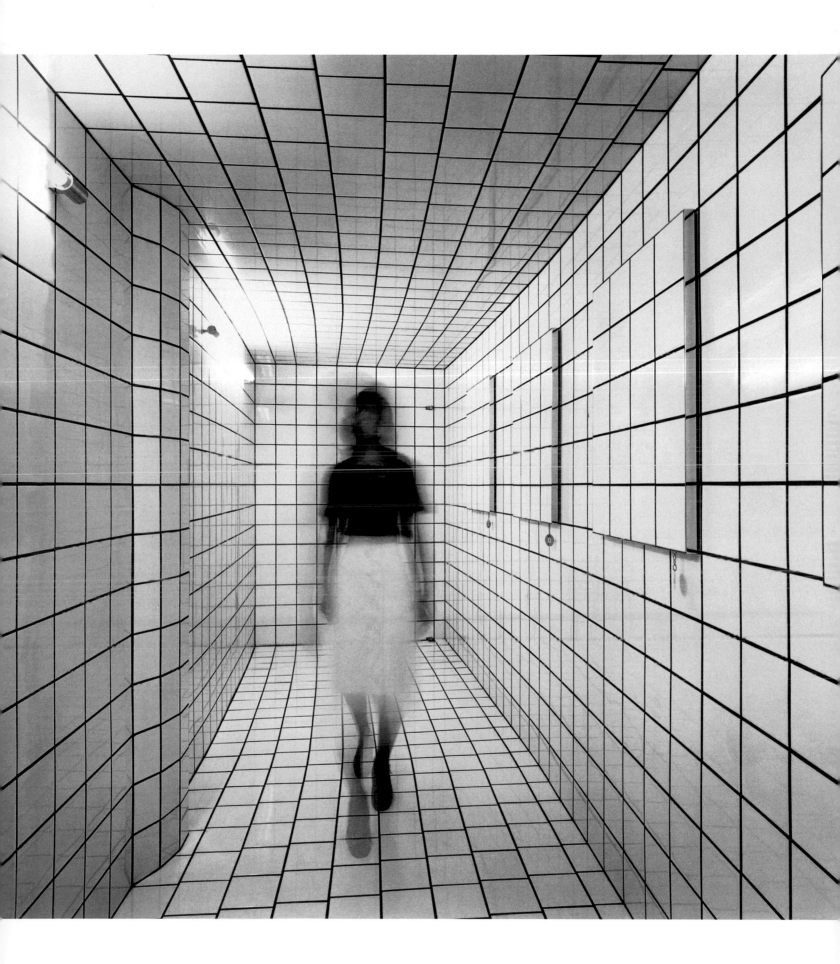

JOCHEN GERZ
(b. 1940, Berlin)

The Centre Georges Pompidou's 1994 *Hors Limites* exhibition was dedicated to the relationship between art and life during that period between 1952 and 1994 when experience, existence, and action became both subject and object in art. Here visitors could experience Gerz's *To Live*, which asks a question often touched upon by post-1960s artists: how to render existence perceptible.

To Live was first exhibited in 1974 at the Kunstmuseum in Bochum, West Germany, when for seven hours Gerz, writing without interruption in white chalk, covered the floor of a 9.14-x-17.76-meter room with the words "To Live." The viewer faces a dilemma immediately upon confronting this piece: whether to walk to the two signs hanging at the back of the room and read them, thus contributing to a gradual erasure of the text on the floor, or stay outside of the written space and not read the panel text. If the visitor does cross the room, he or she will be disappointed: the text, while poetic, does not reveal a simple key to understanding the area. A text, the artist seems to suggest, cannot explain life.

Gerz, whose early works were part of the visual poetry movement, mounted his first outdoor installation in 1968 by placing small posters on the doors of the Duomo in Florence and on the base of Michelangelo's *David*, which read "Attenzione l'Arte Corrompe" (Warning: art corrupts). The ephemeral character of this intervention, together with its powerful critique of any notion of eternal art set in marble, is foundational in the artist's work.

The following year, for the *Nouvel Annuaire de Paris* (New Paris telephone directory), Gerz asked people at random (including artists) to subvert the directory's straightforward data entries by adding text evoking feelings or personal concerns to their listing: a disturbing, incongruous insert would be the word *vivre*. Such deconstruction of conventional codes of communication attests to the artist's suspicion of the media and its failure to connect with life.

To Live bears this same critique while also considering the passage of time: the medium of chalk means that the erasure of the writing is already inherent and everlastingness is entirely absent. Visitors gradually destroy the close relationship that existed between the artist and his writing.

In 1972, Gerz discussed the link between body and words in *Ecrire avec la main* (Writing with the hand), the artist wrote on the wall "sont ma chair et mon sang" (are my flesh and my blood) literally with bleeding fingers. The erasure of writing in *To Live* suggests the lead column of the *Monument contre le fascisme* in Harburg, which has gradually been destroyed by visitor graffiti and inscriptions.

"If I use all the media in my pieces, it is to show that it does not work. Media doesn't allow us to communicate, nor to reproduce the real. To make art is to »

Jochen Gerz became interested in poetry while studying in Cologne and Basel. As early as 1959 he was a writer and translator; gradually his texts became more and more visual, until by 1966, the year he settled in Paris, he joined the visual poetry movement. In 1968 he co-founded, with Jean-François Bory, the alternative editorial group Agentzia. Gerz would henceforth explore several artistic paths at the same time, always keenly critiquing the media and desiring to involve the spectator in the creative process. Since 1969, several of his photo/text works have played off the tension between photographs (most often black and white, but in color since 1987) and critical texts or poems. After 1968, Gerz would question, in several installations, the cultural and social function of western culture, critiquing not only the limits of media efficacy but also the written word, photography, and video, as in the series Pièces Grecques *(Greek pieces, 1975–78) and* Kulchur Pieces *(1978–85) or in works in* EXIT/Le Projet Dachau, 1972 *(EXIT/The Dachau project, 1972, 1974–75). In 1976, Gerz represented Germany in the Venice Biennale and, in 1977 and 1987, participated in Documenta 6 and 7 in Kassel. Since 1984, Jochen Gerz has been collaborating with his wife, Esther Shalev-Gerz.*

In the 1980s, the artist was commissioned to create several monuments in which he would subvert the idea of commemoration, turning spectators into actors: Monument contre le fascisme *(Monument against fascism), Harburg, 1986;* Questionnaire de Brême *(Bremen Questionnaire) Bremen, 1990; 2,146 Stones.* Monument contre le racisme *(Monument against racism), Sarrebrück, 1990–93; and* Monument Vivant *(Living monument), Biron, 1997.*

FACING PAGE **Vivre**, 1993, view from the exhibition
Hors Limites (1994), Centre Georges Pompidou, Paris

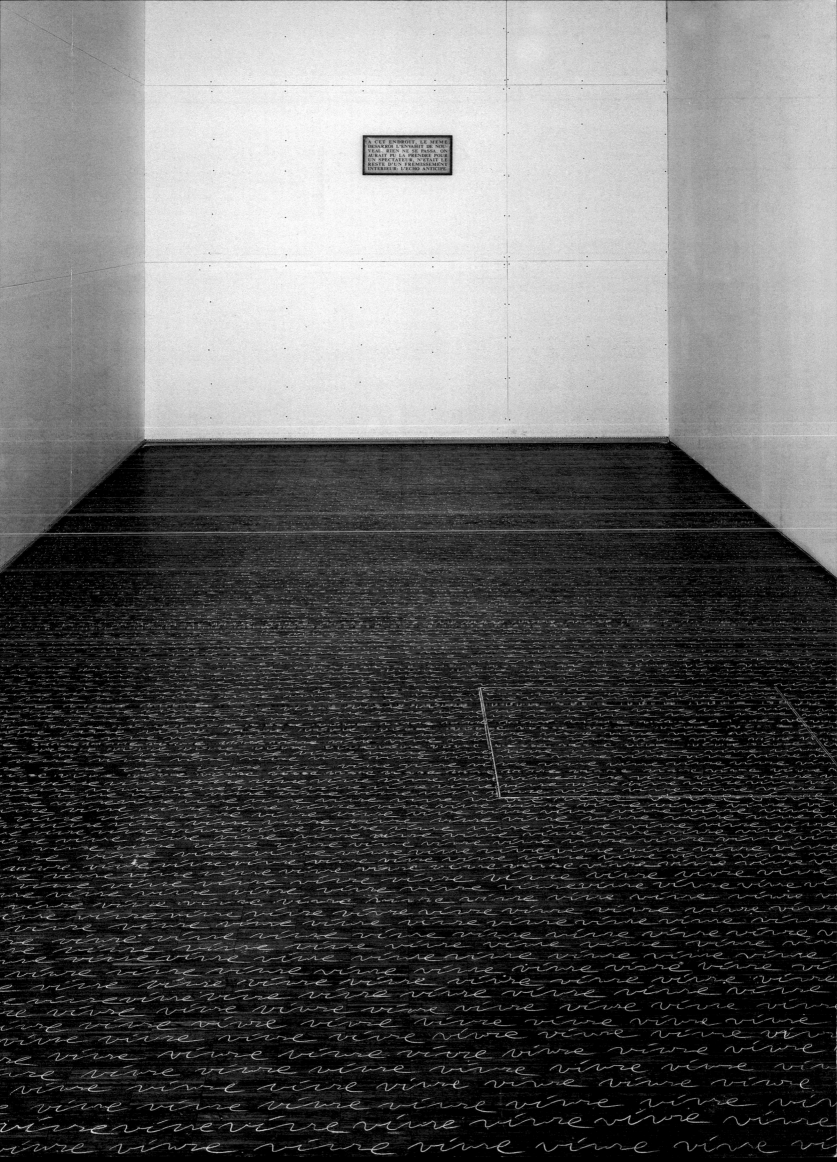

produce objects that oppose our reality, devices. Art is removed from all that is original; it corrupts because it is a substitute. We should not make art, but be art, like the shamans, who produce nothing, but nevertheless broaden the conscious mind and habits."[2]

MARC BORMAND

Translated from the French by Molly Stevens.

1. Jochen Gerz, "Critique de la production sociale dans le secteur de la culture," *Chronique de l'art vivant*, March 1972.

2. Jochen Gerz, interview with Suzanne Pagé and Bernard Ceysson in *Jochen Gerz. Les pièces*, p. 4.

Selected Bibliography

Jochen Gerz: Les Pièces (exh. cat.). Saint-Etienne: Musée d'art et d'industrie, 1975; Paris: Musée d'art moderne de la Ville de Paris, 1975.

Gerz, Jochen. *Avec/Sans Public: Performances 1968–1980* (exh. cat.). Bielefeld: Kunsthalle Bielefeld and Paris: Cheval d'attaque, 1981.

Gerz: Oeuvres sur Papier Photographique 1983–1986 (exh. cat.). Calais: Musée des Beaux-Arts, 1986; Chartres: Musée des Beaux-Arts, 1987.

Gerz, Jochen. *De l'Art: Textes Depuis 1969*. Paris: EnsB-a, Collection Ecrits d'Artistes, 1994.

Jochen Gerz: Get Out of My Lies: 18 Installationen der siebziger Jahre (exh. cat.). Wiesbaden: Museum Wiesbaden, 1997.

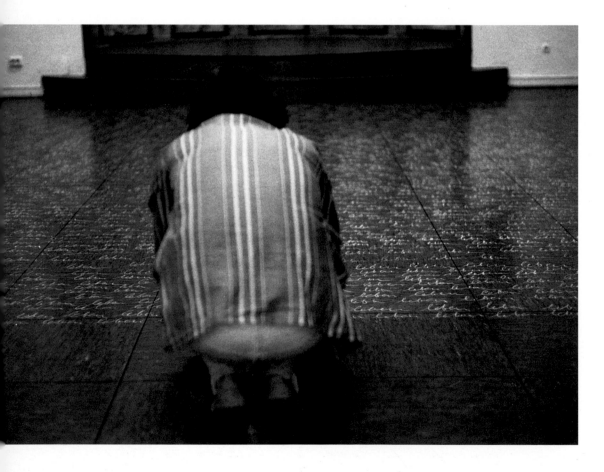

LEFT *Leben*, 1974, Kunstmuseum Bochum, Germany

FACING PAGE *Vivre*, 1993, view from the exhibition *Hors Limites* (detail of text panel)

Patrick Le Nouëne: What does art represent for you today?

Jochen Gerz: It's something fragile. If I think of art, I don't think of any particular time or place or rectangular thing. I don't even think about making something. Sooner or later, I think about being. So art stays in touch with its origin, being, for me. In that sense, it's fragile. It's also the most radical manifestation of the unsaid you can produce, if not actually be—and the most opposite to us. Perhaps you make what you cannot be. It's emotionally disturbing that man is capable of making art. Criticizing this possibility is the same as criticizing oneself. No detour or consolation seems possible, or even necessary.

Interview from *Gerz, oeuvres sur papier photographique, 1983–1986* (exh. cat.), Chartres: Musée des Beaux Arts, 1987; Calais: Musée des Beaux Arts, 1986.

A CET ENDROIT, LE MEME DESARROI L'ENVAHIT DE NOU-VEAU. RIEN NE SE PASSA. ON AURAIT PU LA PRENDRE POUR UN SPECTATEUR, N'ETAIT LE RESTE D'UN FREMISSEMENT INTERIEUR: L'ECHO ANTICIPE.

At that point, the same bewilderment overcame her again. Nothing happened. One could have taken her for an onlooker if it had not been for something left over, like an inside shudder: the anticipated echo.

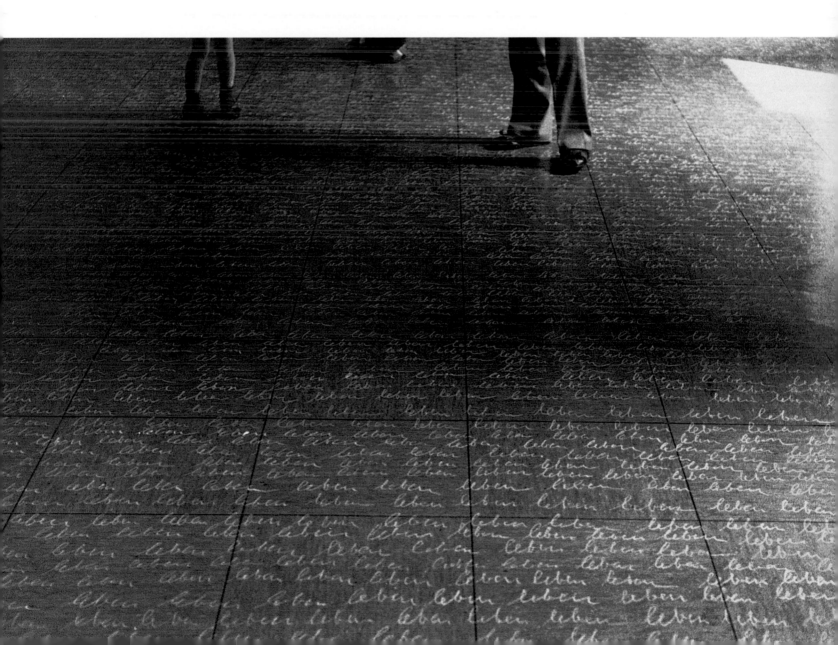

THIERRY KUNTZEL
(b. 1948, Bergerac)

Before beginning any semblance of an art practice, Thierry Kuntzel studied philosophy, linguistics, and semiology. He began a thesis, which he never completed, entitled "The Work of Film," under Roland Barthes. From 1972 to 1989 he was a researcher at ORTF (Office de la Radio Télévision Française) and then at INA (Institut national de l'audiovisuel).

He continues to teach semiology and film analysis at the University of Paris I, IDHEC (Institut des hautes Etudes cinemato-graphiques), the Centre d'Études Américain du Cinéma in Paris, and a number of American universities, including the State University of New York at Buffalo and the Center for the Twentieth Century at University of Wisconsin, Milwaukee.

Concurrent with his theoretical research, Kuntzel has developed an art practice primarily using video, neon, and installation while continuing to write theoretical texts. His work has been shown in many French, American, and Japanese museums, including a major exhibition of his work at the Galerie Nationale du Jeu de Paume, Paris, in 1993.

In a large, dimly lit room, nine black-and-white video monitors form a rectangle in direct proportion to the screen size and room dimensions of a movie theater. Images from a handheld camera appear and disappear on monitors in an indecipherable sequence. Beginning in a "readable" montage, "the forms," according to the artist, "begin to hover, float, [and] dissolve from one screen to another, faster and faster, until their frames disappear, leaving a single image in action, always registering within one another, always incomplete, always on the verge of disappearing, never fixed in a tableau." *Nostos II* is divided into three sequences, each signaled by the appearance of nine images on nine screens; fragments of Max Ophüls's film *Letter from an Unknown Woman* (1948), together with its soundtrack, complete the cycle.

Nostos II is located between "difference and repetition," wrote Kuntzel, between "remanence and reminiscence" according to critic Anne-Marie Duguet. In this piece, the artist sculpts light with a handheld camera catching a glimmer from a candle flame and manipulating it like a Jackson Pollock painting. The montage enacts the same tendency: circulating images in a nonlinear trajectory according to its own inner logic. *Nostos II* favors complex relationships between one image and the next, its aggregate effect wavering between cinematic projection, literary essay, and pictorial composition. This piece foreshadows a number of artworks created by a new generation of artists who use film as a readymade to reveal narrative questions within the space and time of a loop, and integrating the viewer physically and psychologically into the work.

Nostos II is the second piece in a suite of works dealing with the spatial expansion of video through the theme of human existence and resistance. *La Desserte blanche* (The white dressing table), the first work in this series, consists of a white room with a single video monitor implanted in one of its walls. The fixed shots of the video enact a palimpsest—the image shows the figure of a woman who appears to be repeatedly arranging objects on a table. Over the course of the video loop, this black-and-white image undergoes a temporal movement from positive to negative, then back again, repeating its own erasure. This simple but powerful sequence plays out a literary reference that recurs throughout modern French writing, from Mallarmé to Maurice Blanchot. The space of life within an enclosed white room (*La chambre*) in these writers' work as well as Kuntzel's is a metaphor for the repressive psychological and physical structures that organize everday life. *Nostos II*, with its imposing black sculptural space, is the explosion of *La Desserte blanche*.

CHRISTINE VAN ASSCHE
Translated from the French by Lory Frankel.

Selected Bibliography

Kuntzel, Thierry. "Le travail du film, 2." *Communications* (Paris), no. 23 (1975); reprinted as "The Film-Work, 2." *Camera Obscura*, no. 5 (Spring 1980).

Bellour, Raymond. "Thierry Kuntzel et le retour de l'écriture." *Cahiers du Cinéma*, no. 321 (Mar. 1981). A more complete version of this text appeared as "Thierry Kuntzel and the Return of Writing," *Camera Obscura*, no. 11 (1983).

Duguet, Anne-Marie. "Les vidéos de Thierry Kuntzel: Entre dessus/dessous, à peine, imperceptiblement...." *Parachute* (Montreal), no. 38 (1985).

Bellour, Raymond. "La double hélice." In *Passages de l'image* (exh. cat.). Paris: Centre Georges Pompidou, 1990.

London, Barbara. *Thierry Kuntzel. Projects 29* (exh. cat.). New York: Museum of Modern Art, 1991.

FACING PAGE *Nostos II*, 1984, video installation at Musée national d'art moderne, Centre Georges Pompidou, Paris

What counts is not so much producing new images, new sounds, as more blanks, more silences—intervals. Not so much to keep adding to a long list of elements as to combine, separate, reconcile, discard in previously unexplored ways components that are already known, old, worn-out.

Thierry Kuntzel, in *Thierry Kuntzel* (exh. cat.) Paris: Galerie Nationale du
Jeu de Paume, 1993.

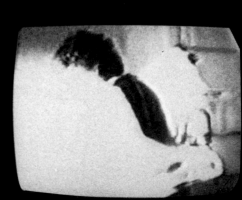

THIS PAGE AND FACING ***Nostos II***, 1984, video installation, Musée national d'art moderne, Centre Georges Pompidou, Paris.

CELLULE NO. 3
1992

Between 1990 and 1993, Absalon created six austere dwelling spaces constructed out of plywood and painted white. *Cellule No. 3* (Cell no. 3) is the structure that he created for an eventual placement in New York. Before his untimely death in 1993, Absalon intended to live in his *Cellules* for at least six months at a time. Each one was conceived for a specific city and was to be placed in a public, urban space for the duration of time he intended to live inside its hermetic limits. The dimensions of each *Cellule* are tailored to the exact proportions of the artist's own body: the door heights correspond to Absalon's stature; each piece of furniture is crafted to accommodate his physique. Only one person could possibly occupy these *Cellules* at a time—each one is equipped with minimal accessories for its inhabitant's survival. Upon entering this space, the succession of narrow rooms, compartments, and passageways give the impression that the Cellule is a monastic chamber: a space for solitude, concentration, and exile from the spectacle of the outside world.

The elementary geometric forms that compose all of Absalon's *Cellules* allude to a nexus of architectural references from the history of Modernism. From Kazimir Malevich's *Architecton* projects from the 1920s through the clean lines of de Stijl or Corbusian architecture, it is easy to inscribe the formalism of these cell structures within a Modernist teleology (or perhaps even worse, a postmodern pastiche of this history). Absalon himself recognized the historical pigeonholing that is possible in terms of a formal genealogy, though he denied any ideological or revolutionary intent. Unlike the historical avant-garde, which harnessed radical formalism for its capacity to disturb bourgeois convention, Absalon's practice is completely invested in the construction of a highly personal and subjective space. These ascetic dwellings, with their stark and blinding whiteness, are carefully constructed to embody specific qualities intended for his exile from the world—an exile that is both real and voluntary. With a strict material economy, the architectural composition of each *Cellule* embodies Absalon's life choice more than an aesthetic position. When confronted with urban vernacular architecture dominated by seriality, Absalon's *Cellules* immediately assume a position of resistance through immobilization. "The project's necessity springs from the constraints imposed on my everyday life by an aesthetic universe wherein things are standardized, average . . . I would like to make these *Cells* my homes, where I define my sensations, cultivate my behaviors. These homes will be a means of resistance to a society that keeps me from becoming what I must become."[1] »

ABSALON
(b. 1964, Ashdod, Israel–d. 1993, Paris)

As early as 1987, Absalon was represented in several French exhibitions dedicated to young artists, in Lyon; Villa Arson, Nice; and Credac, Ivry-sur-Seine.

In 1990, his first Propositions d'Habitation *(Habitation proposals) were presented at the Aika Gallery in Jerusalem and at the Musée Sainte-Croix, Poitiers. Absalon exhibited his* Cellules *at the Galerie Crousel/Bama in Paris during the same period, and in 1990 Absalon, together with a new generation of French and European artists, participated in several European thematic exhibits (Fondation Cartier, Jouy-en-Josas; Tramway, Glasgow).*

In 1991, he installed his Cellules *for the* Mouvement 2 *exhibit at the Galeries Contemporaines of the Musée national d'art moderne, Centre Georges Pompidou, Paris; the following year, he would create a spectacular environment with his work for Documenta 9 in Kassel. Absalon has had numerous solo exhibitions in museums and contemporary art spaces, including the Carré d'Art, Musée d'art contemporain, Nîmes, and the Kunstverein, Hamburg.*

After his death, Absalon's work has continued to be represented in group shows or tributes: Rudiments d'un musée possible/2 *(Rudiments of a possible museum), MAMCO, Geneva, 1995;* Collections, Collections, *Musée d'art moderne, Saint-Etienne, 1996; and* Broken Home, *Greene Naftali Gallery, New York, 1997. A retrospective of his work will take place at CAPC in Bordeaux in 1998.*

JEAN-PIERRE BORDAZ
Translated from the French by Molly Stevens.

Selected Bibliography

Absalon (exh. cat.). Ivry-sur-Seine: CREDAC, 1990.

Absalon, Propositions d'habitation (échelle 1:1) (exh.cat.). Jerusalem: Gallery Aika, 1990.

Absalon (exh. cat.). Poitiers: Musée Sainte-Croix, 1990.

Absalon, Cellules (exh. cat.). Musée d'art moderne de la ville de Paris, 1993.

Absalon (exh. cat.). Amsterdam: Nimes, Foundation De Appel, 1994.

FACING PAGE *Cellule no. 3*, 1992, interior detail A, Caisse des Dépôts et Consignations, Paris

Within an intellectual framework that stresses a communal, socially based practice, Absalon could be attacked for his radical individualism. His position is indeed radical, though he inverses the argument. By isolating himself in the middle of a city in the fragile confines of a white shelter, Absalon sets up oppositional structures in order to construct his critique of contemporary urban society; the purity of the cell versus the filth of the city; silence versus noise; solidarity of the cell versus masses of the city; fixity versus speed of the city. These glaring clashes underline the necessity to turn within to struggle against the domination of modern life. In juxtaposition to the *Cellule*, the city loses its entropy. It becomes an enclosed incarcerating space, whereas the *Cellule* offers a liberating sanctuary. Absalon exchanges the Modernist utopia based in a collective rhetoric for a self-sufficient unit. In his conflation of restriction and reduction, Absalon's work appropriates both a colloquial phrase and Mies van der Rohe's ideological slogan: "Less is more!"

ALISON M. GINGERAS AND BERNARD BLISTÈNE

1. Absalon. "Project" in *Cellules* ([exh. cat.] Paris: Musée d'art moderne de la Ville de Paris, 1993 [unpaginated]).

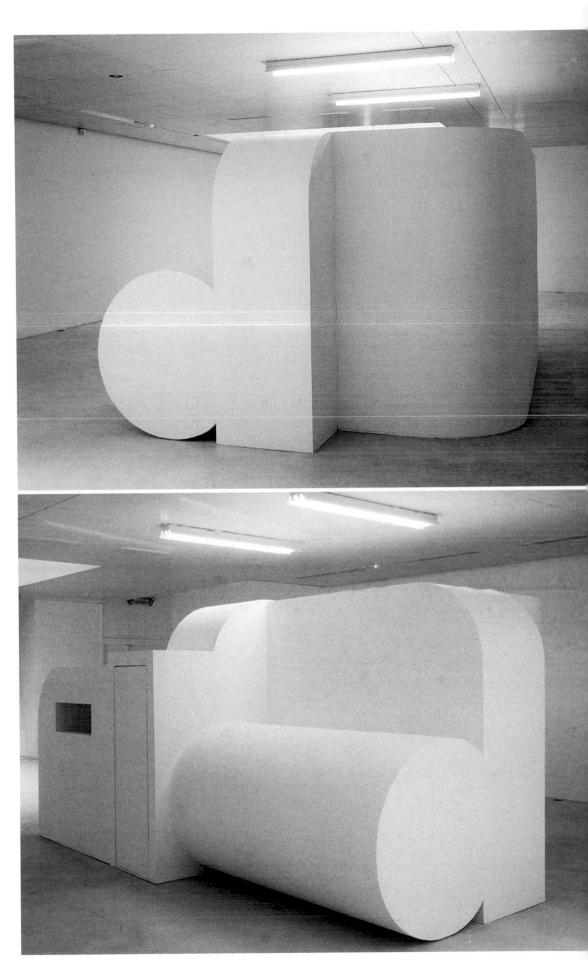

FACING PAGE AND RIGHT PAGE *Cellule no. 3*, 1992,
Caisse des Dépôts et Consignations, Paris

In short sequences, the principles established in *Cellule No. 3* are put into practice: the artist tests his own body—a kind of measure to comprehend the space—by settling into his *Cellule*. Precise framing reveals the interior. In this idealized structure, the artist is revealed in his intimacy. Simple gestures appear, studied behavior springing from habit: he pours himself water, drinks, eats, then takes the time to smoke a cigarette. With neutral demeanor, Absalon tests all the nooks of his *Cellule* for permanent occupancy. He patiently immerses himself in this new existence, falling under the influence of its elements: table, bed, bath, everything to the very walls. In this voluntarily monastic world, restricted to the body's dimensions, the small act of untying shoelaces before bed symbolizes the tasks and the days of a new existence.

JEAN-PIERRE BORDAZ
Translated from the French by Molly Stevens.

FACING PAGE *Solutions*, 1992, video still

The construction is carried out by me, in wood painted white. The homes belong to me. They can only be visited in my presence, by a single person at a time. They will condition the quality of my human relationships.

These six homes are to be constructed in confrontation with an urban space, and in cities linked to my activity. The confrontation is necessary, for these homes are not utopian. They are not solutions of isolation. They are made for life in society. Their implantation requires institutional intervention.

The volumes are constructed in such a way that despite the relatively small sizes, I will not suffer from lack of space. In their quality, these Cells are more mental spaces than physical ones. As mirrors of my inner life, they will be familiar to me.

Absalon, *Cellules* (exh. cat.), ARC: Musée d'art moderne de la ville de Paris, 1993.
Translated from the French by Brian Holmes.

SOLUTIONS

THIS PAGE AND FACING *Solutions*, 1992, video stills

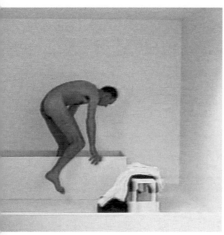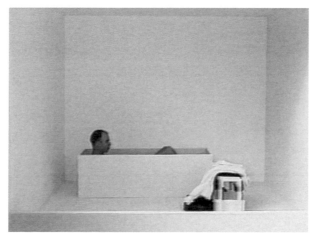

SUSPENSION I, SOMETHING IS MISSING
1996, 1998

Most of Jean-Marc Bustamante's sculptures and photographs seem at first to belong to quite different worlds and distinct projects. For example, the *Tableaux Photographiques* (1977–82), taken in and around Barcelona might have little to do with ground sculptures in the *Sites* series (1991–92). Recently, when comparing his cement, wood, and steel sculptures with his photographs of cities (Tel Aviv, Buenos Aires, Miami) for Documenta 10, critics have noted certain urban and architectural links between the pieces. No matter what crossovers exist between these works, no matter their degree of interaction, Bustamante has always worked on defining life's places. The installation *Suspension I, Something is Missing* introduces a living being in the intersection of sculpture, photography, and architecture.

Formal sculptures that function as cages are distributed throughout the space, silkscreens from the *Lumières* series which are found photographs depicting empty spaces in the urban landscape: the interior of a garage, an elevator, a classroom, a set of public showers hang on the walls. Each cage, differing in height, contains a small, living finch.

One might not at first see a connection between the images and the cages. There are instead immediately evident dichotomies: living/immutable, natural/artificial, black and white/color, animal/human, silence/chirping. There are also common points: work and confinement, elevator car and birdcage. The cages are sculptures enclosing birds in a vital, moving, noisy space; they contrast with the lifeless, static, silent images. The human scale of what is perceived in the images, like the scale of the cages themselves, sometimes seems to play against the smallness of the birds, and sometimes seems similar to it; because of their fragility, porosity, and size, the images seem almost doomed to disappear. The birds are a presence in the emptiness of the images, while the images lend a kind of melancholy to the space of the birds. What is essential in the relationship between the cages and images is exactly this presence of absence, something Bustamante continually examines. The places depicted in the images reference human presence but are nonetheless devoid of it: the cages contain small beings, but they are isolated from others of their kind. Each place signals the trace of the other, and the visitor becomes the link between the emptiness of the images and the isolated-being-unit of the birds. Playful and serious, the installation demands an attention not only to the presence of the living things, but also toward the work as a whole: a site of existence, enclosure, and circulation.

JACINTO LAGEIRA
Translated from the French by Molly Stevens.

JEAN-MARC BUSTAMANTE
(b. 1952, Toulouse)

Between 1977 and 1983, Jean-Marc Bustamante completed 120 Tableaux Photographiques, which were exhibited for the first time in the Bern Kunsthalle in 1994. He worked with Bernard Bazile from 1983 to 1987 under the name BAZILEBUSTAMANTE.

Bustamante's works have been shown in different configurations all over Europe including the Haus Lange Museum, Krefeld, in 1990, the Musée d'art moderne de la Ville de Paris in 1992, the Stedelijk Van Abbemuseum, Eindhoven, in 1994, the Kunstmuseum, Wolfsburg, and in 1996, the Galerie Nationale du Jeu de Paume, Paris.

His first solo exhibition in the U.S. was at the Renaissance Society, University of Chicago, in 1993. In 1997, he began showing in New York at the Matthew Marks Gallery. In 1994, he represented France in the São Paulo Biennale. He participated in Documenta 7, 9, and 10 in Kassel. He is currently a professor at the Ecole des Beaux-Arts in Paris.

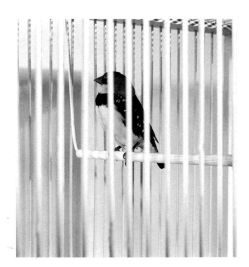

Selected Bibliography

Jean-Marc Bustamante (exh. cat.). Eindhoven: Stedelijk Van Abbemuseum, 1993.

Jean-Marc Bustamante. Paris: Dis Voir, 1995.

Serena. *Jean-Marc Bustamante* (exh. cat.). Otterlo: Rijksmuseum Kröller-Müller, 1995.

Jean-Marc Bustamante: Lent Retour (exh. cat.). Paris: Galerie Nationale du Jeu de Paume, 1996.

THIS PAGE *Suspension I, Something is Missing*, 1996, detail of steel birdcage and living bird, Anadiel Gallery, Jerusalem, 1997

FACING PAGE *Suspension I, Something is Missing*, 1996, 1997, installation view from an exhibition at Galerie Xavier Hufkens, Brussels

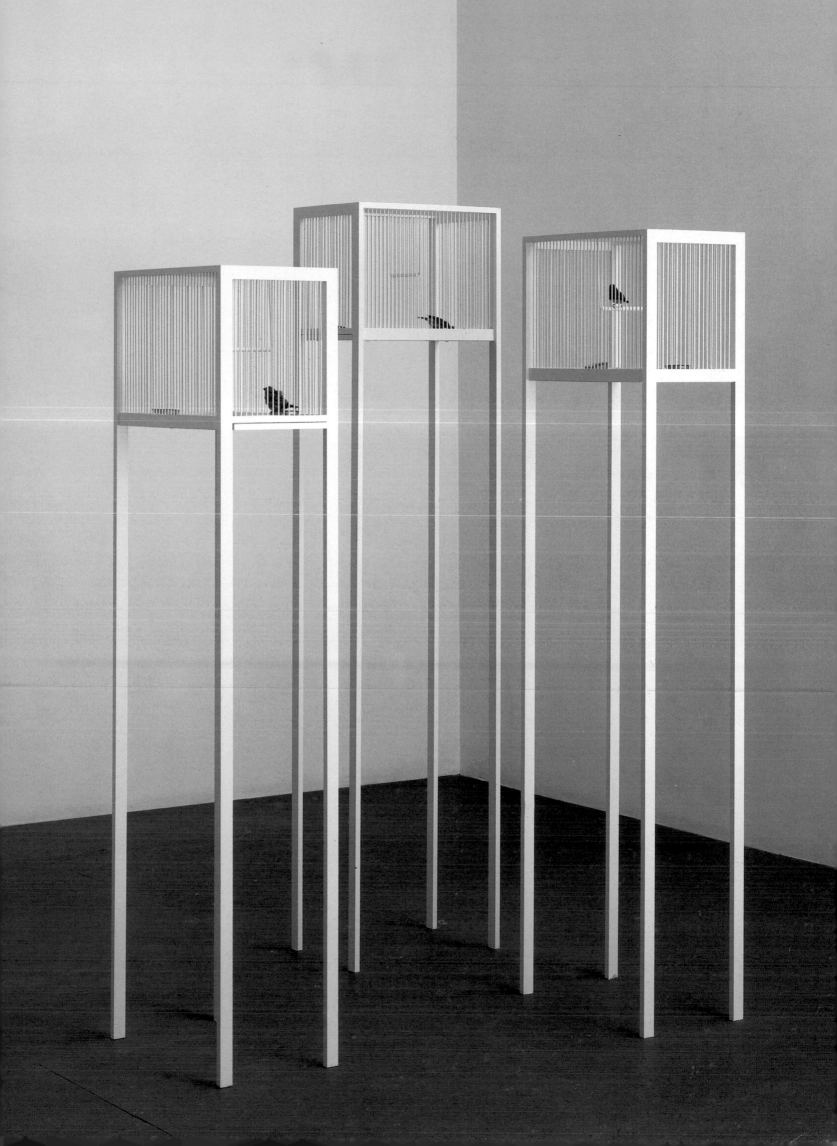

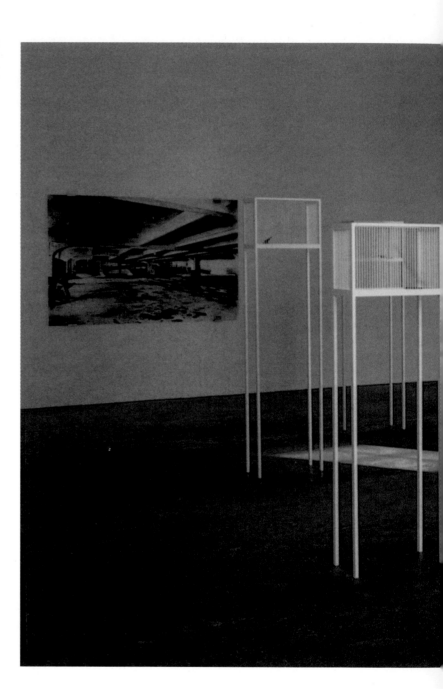

LEFT *Lumières*, 1996, silkscreened photographs for
Suspension I installation

ABOVE **Suspension I, Something is Missing,** 1996,
installation view (detail) from an exhibition at
Galerie Bob van Orsouw, 1997

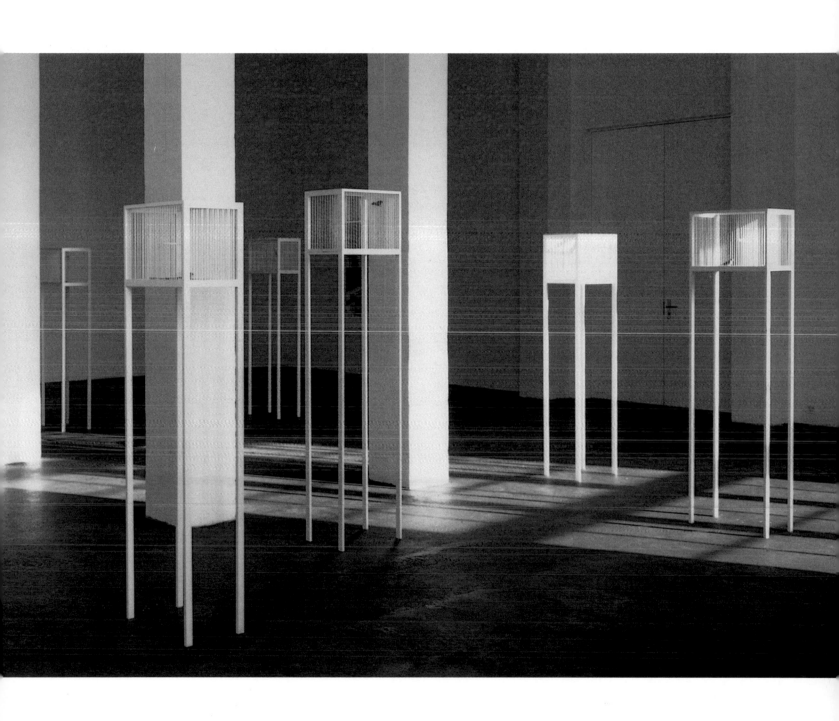

PROFESSEUR SUICIDE
1995

In a dimly lit enclosed area, *Professeur Suicide* (Professor Suicide) teaches the art of dying to five attentive children who, like himself, have heads shaped like inflated balloons on which facial expressions are sketched. All their bodies are identical—white, smooth, and finished—but each expresses a unique emotion. *Professeur Suicide* holds a needle in his fingers; the children gathered at his feet watch a film of forty heads that the needle determinedly punctures. The video projection, accompanied by the solemn andante of a Haydn quartet, repeats itself every nine and a half minutes.

The doomed atmosphere is paradoxically serene. The ghostly whiteness of the children and teacher, like the black-and-white film that plays before their eyes, plunges the viewer into unreality. Enacting the principle of repetition and automatic reflex, the onlooker absorbs the lesson. Critic Régis Durand eloquently remarked on this phenomenon: "[We are] invited to observe an intervention that is not a lesson for us, but nevertheless includes us in its circle of spectators; we are aware, simultaneously, of what is happening in real time . . . and we are also aware of what is happening in a more complex temporality, which acts as a link to the teacher's lesson . . . and the nature of what is taught, that is, the art of suicide."

These situations make the witness to Séchas's work an involuntary accomplice. The vision of the scene both obligates and forces; as soon as Séchas brings the spectator into the fiction, the relationship between the piece and its viewer comes into play.

Gilles Deleuze's notion of "passive contemplation" occurs before our eyes, between the teacher and his students, as a metaphor for the bond established between artists and observers. When one questions this bond—the common myth that positions artists as teachers, onlookers as disciples, the teacher (read: artist) assumes what Patrick Javault calls "the devil's role." The illusion of participating in contemporary art functions as the instrumentalization of the public as played out in Séchas's allegory. Passive dependence created by a sense of participation alienates the viewer.

Professeur Suicide does not encourage the child to end its life but instead asks the onlooker to abandon a childhood represented by the balloon head and burst the effects of passive lethargy, to defy the trickery of the readymade, which our contemporaries follow with a herd mentality. By repeatedly bursting the head of the man-balloon that resembles him, *Professeur Suicide* demands that his image disappear with him. Séchas perversely overturns conformity through humor: Deleuze is again hidden in his machinery.

Séchas's work searches for a moral code. It substitutes black humor for the intelligent irony of his contemporaries, refusing to assimilate his subject into current cynical practices. His strategy—if there is one—shows the impossibility of his belonging to an ideological agenda. If this piece entraps, it is not so much because of what it suggests but because it questions our relationship with art and our obligation to art. Séchas's work does not breed apathy; instead it awakens.

BERNARD BLISTÈNE
Translated from the French by Molly Stevens.

ALAIN SÉCHAS
(b. 1955, Colombes)

Since moving to Paris in 1982, Alain Séchas has begun exhibiting in the contemporary gallery scene. His early work consisted of manipulating common images using various media—drawing, painting, and sculpture. The resulting figurative works expressed a singular position that was slightly out of sync with the rest of the European scene. Pieces such as Le Vélo (The bike, 1985), and Le Mannequin (The mannequin, 1985), borrow both from the imagery and burlesque sensibility of cartoons and comic strips.

In 1988, Séchas began to create more complex mise-en-scènes of his sculptural figures, creating strange and incongruous situations. These installations typically mixed stylistically different elements such as three-dimensional characters with schematically drawn backdrops in works such as L'Os (The bone, 1988), and Les Grillages (The metal netting, 1988). During the same period, Séchas began to contemplate the status of the sculptural object itself. His investigations resulted in disarmingly unusual sceneographies that projected humorous and absurd drawings onto real space in such pieces as Les Fleurs Carnivores (The carnivorous flowers, 1991), and Le Char aux lapins (The chariot pulled by rabbits, 1991). These drawings transformed into spatial objects create both a violent and derisory effect. This violence continues in his latest environments such as in La Pieuvre (The octopus, 1994), and Les Papas (The daddies, 1995). Without abandoning his tragic, dark side, these works push Séchas's logic of absurdity even further by becoming more useless and silly.

SELECTED BIBLIOGRAPHY

Zahm, Olivier. "Alain Séchas, Galerie Ghislaine Hussenot," *Artforum*, vol. 30, no. 1, 1991.

Alain Séchas (exh. cat.). Nevers: APAC, 1992

Alain Séchas XXIIIe Biennale Internationale de São Paulo (exh. cat.) 1997.

FACING PAGE *Professeur Suicide*, 1995, installation view

THIS PAGE AND FACING PAGE Video stills from
Professeur Suicide

FACING PAGE Sheet of music from the soundtrack
of the installation with drawings by Alain Séchas

CLAUDE LÉVÊQUE

(b. 1953, Nevers)

Bleak private apartments, emptied coat-check rooms, abandoned public spaces, unused municipal swimming pools: these are some of the spaces Claude Lévêque's work has occupied over the years. Lévêque transgresses the boundaries of the white cube, severing the dependence on codified, sanitized spaces framed by museum walls.

From his first one-person show at Galerie Eric Fabre in 1984 to a more recent project designed for a concert hall in Brussels (Atelier Sainte Anne, 1996), Lévêque has constructed a body of work from a scant material vocabulary. At times his interventions are nearly invisible: manipulating a room's illumination, scattering pieces of clothing, adding a disco ball or randomly hanging strands of lights to a space. Lévêque infuses the ambience of a given place with a sense of a brutally interrupted event: his eerily silent spaces suggest that the music has just been shut off, and the visitor has the impression he or she has missed the end of the party. When music does figure into his work, it spans the range of his obsessions, from the Sex Pistols to German techno-fusion like Atari Teenage Riot. Lévêque does not hesitate to harness the energy of fashion; the use of current music invests his work with the timely force of a youth culture rebellion. These forms are not appropriated. The present tense is pushed to its own ends.

Resistance through youth culture refutes Benjamin H. D. Buchloh's condemnation of the current art/fashion trend, in his assertion that "[fashion is] the rapid and relatively facile construction of a mirage of subjectivity supplied by an industry designing identity substitutes according to cycles of repetition-compulsion transformed into production."[1] At first glance, Lévêque's practice might seem to be in collusion with popular culture's submission to MTV's commercial seduction, but Lévêque uses devices like music to explore the possibility of reinforcement and liberation within the media-saturated psychological enclosures of teenage subjectivity. Blurring the frontiers of décor, ambience, design, and scenography, Lévêque's work has a visceral aesthetic that beckons the viewer into his own autistic universe. Expansive rooms with overturned chairs and broken glass are like deserted film stills; one enters a carefully choreographed fiction only to realize that the atmosphere approximates the alienation pervading our own everyday lives. As art critic Eric Troncy notes, "What Lévêque produces is not so much works as autonomous worlds . . . barely stage-managed emancipations from his personal universe."[2]

ALISON M. GINGERAS AND BERNARD BLISTÈNE

1. Benjamin H. D. Buchloh, "Critical Reflections," *Artforum* (January 1997).

2. Eric Troncy, "The Unreality of the World" in Claude Lévêque, *My Way* ([exh. cat.] Paris: ARC, Musée d'art moderne de la Ville de Paris, 1996).

Shuttling between an abrupt humor and an imposing, tacit demeanor, Claude Lévêque is extremely reticent about his early life. During an interview with Olivier Zahm and Elein Fleiss, he said, "I am an only child, without brothers or sisters, born on February 27th, 1953. Do you also want my mother's maiden name and my father's first name? Are you the cops, or what!?!" From the tone that runs throughout the interview one understands that Lévêque probably withholds information because his childhood and adolescence serve as the foundation of his practice. He received his formal education in a technical high school, where he studied carpentry; it was much later that he continued in the Ecole des Beaux-Arts in Paris. An interest in punk music brought him to London for a time, though he eventually returned to Nevers from 1977 to 1978 in order to organize cultural events: exhibitions of performance artists Gina Pane and Michel Journiac and festivals of experimental film. During this same period, Lévêque worked as a window dresser for various boutiques, although his style never strayed from a punk spirit.

In 1982, Lévêque began to devote all of his time to pursuing his artistic practice. Since then, he has participated in a number of group shows: L'Hiver de l'amour at ARC, Musée d'art moderne de la ville de Paris, in 1994, and an important one-person show at the same museum in 1996.

Selected Bibliography

Claude Lévêque, *La Piscine* (exh. cat.). FRAC des Pays de la Loire, Laval, 1995.

Claude Lévêque, *Chambre 321* (exh. cat.). Le Confort Moderne, Poitiers, 1996.

Claude Lévêque, *My Way* (exh. cat.). ARC, Musee d'art moderne de la Ville de Paris, 1996.

FACING PAGE Interior view of the Storefront for Art and Architecture, in preparation for the *Premises* installation, 1998

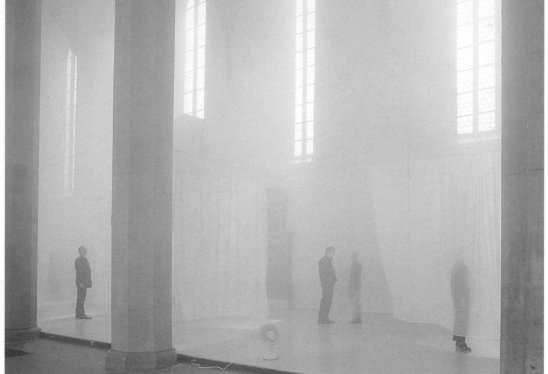

THIS PAGE TOP TO BOTTOM *Troubles*, 1997, installation in situ, Kunstverein, Kassel

Plus de lumière, 1998, installation in situ (detail), Villa Arson, Nice

FACING PAGE *Untitled*, 1993, installation in situ, Centre d'art Optics, Montreal

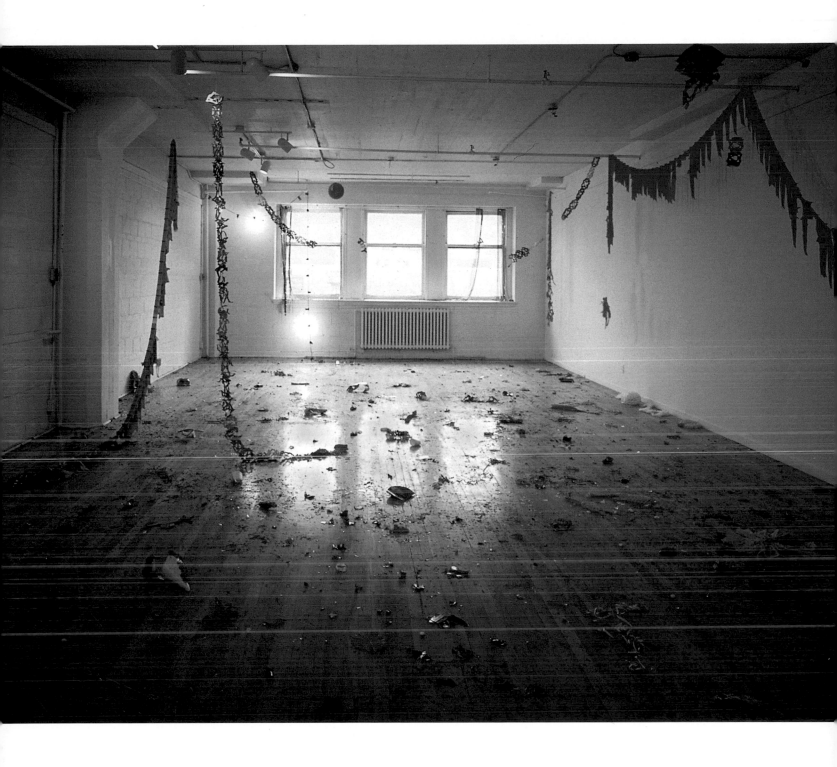

Against the grain of a communicative, consensual, and network aesthetic in much of contemporary art, this discipline of disjunction in Lévêque's work revokes the tamed walls of the domestic demagogy rammed by the force of Action directe *that renders the Real suffocating.*

Frank Perrin, "La tête contre les murs," in Claude Lévêque, *My Way* (exh. cat.) Paris: ARC, Musee d'art moderne de la Ville de Paris, 1996.

FRAMING THE SPATIAL

BETWEEN VOYEURISM AND THE CINEMATIC

MARCEL DUCHAMP	*MANUAL OF INSTRUCTIONS, ÉTANT DONNÉS*
JEAN GENET	*UN CHANT D'AMOUR*
GINA PANE	*JE; SOLITRAC*
PAUL-ARMAND GETTE	*LES TOILETTES DU GUGGENHEIM MUSEUM, SOHO*
SOPHIE CALLE	*L'HÔTEL*
MARIE-ANGE GUILLEMINOT	*GALIPETTES*
DOMINIQUE GONZALEZ-FOERSTER	*À REBOURS*
PIERRE HUYGHE	*DUBBING*

Upon the public revelation of Marcel Duchamp's *The Bride Stripped bare by her Bachelors, even* (1915–23; 1936, known as the *Large Glass*), architect Frederick Kiesler wrote, "Architecture is the control of space. An Easel-painting is the illusion of Space-reality. Duchamp's *Glass* is the first X-ray painting of space."[1] Beginning with this early work, Duchamp was already formulating a vocabulary that addressed the relationship between the Modernist quest for visual mastery and the construction of space. During its fabrication, Duchamp began using a neologism to describe the activation of the work of art by the viewer in the act of looking. *Le regardeur* designates the voyeuristic relation intrinsic to the spatial positioning of the art object and its observer.

The manual of instructions for the assembly of *Étant Donnés* (1946–66), Duchamp's enigmatic posthumous work, is perhaps the most convincing starting point for the works organized in this sequence. Nestled between its carefully constructed folds, photocollages, and notes scribbled in pencil, Duchamp left behind fifteen operations for the *remontage* of *Étant Donnés*—a veritable architectural plan for this tiny theatrical space. In revealing these operations, it becomes apparent that *Étant Donnés* is constructed by the *regardeur's* eyes than by its actual physical or structural components. Beyond a mere synopsis of the piece, the manual for *Étant Donnés* gives us a glimpse of its backstage without completely giving it away.

Extending this Duchampian ocular device, a number of contemporary artists working in France have structured their work in order to underline a voyeuristic function. Marie-Ange Guilleminot makes direct reference to *Étant Donnés* by offering a small hole in the wall from which the viewer can see the artist's body on a video monitor repeating somersaults *ad infinitum*. This construction of scopophilic pleasure is also apparent in the circular movement between the *regardeur* and the observed object/subject as seen in the work of Sophie Calle, Gina Pane, and Paul-Armand Gette. Despite the range of intimate spaces that they explore, each artist's work can be characterized by the combination of performative actions with photographic documentation.

Similarly, Jean Genet plays out a voyeurism in his groundbreaking film *Un Chant d'amour* (1950), which chronicles a sexual transaction between two prisoners as they are observed by an intrigued guard. Film theory as informed by psychoanalysis argues that cinema lends itself to voyeuristic function; between the cinematic production and its projection, the visual experience of cinematic space is structured to engender scopophilic awareness. A younger generation of artists have turned their analytical attention to the cinema and its visual structures in order to question space without directly appropriating the medium of film and residing exclusively on issues of voyeurism. Through a deadpan unveiling of the processes of dubbing a Hollywood film, the video installations of Pierre Huyghe deconstruct the relationship between language, image, and text, denying the very function of visual pleasure. Dominique Gonzalez-Foerster does away with the moving image altogether, yet references cinematic space in her installations with Technicolored rooms and cinemascope-like windows creating filmic interiors. In each of these artists' works, the viewer is caught in the ambiguous space of interpretation. Within the framework of a cinematic space without the film, one is left only with a mental projection of a narrative.

1. Frederick Kiesler, "Design-Correlation: Marcel Duchamp's *Large Glass*," *The Architectural Record*, May 1937, vol. 81, no. 5.

MARCEL DUCHAMP
(b. 1887, near Blainville –d. 1968, Paris)

Marcel Duchamp's *Étant Donnés* was conceived between 1946 and 1966—the same year it was signed and considered complete. It is now believed that the artist worked on this piece in his Fourteenth Street studio in New York City before moving to 80 East Eleventh Street, from where *Étant Donnés* made its final move to Philadelphia. The *Manual of Instructions, Étant Donnés* helps to understand how the posthumous piece was developed and built, revealing the structure's complexity and precariousness: it is a genuine makeshift. The instruction manual itself is a true puzzle, combining photos of the object in development and the text concerning its assembly; there are instructions that elaborate the structure of *Étant Donnés* (elevating its status nearly to that of a machine) and the steps necessary to rebuild the "approximation démontable."

Over the course of Duchamp's long and puzzling career, he worked with the montage of text and image in the context of book design. These interventions worked to subvert, decode, and recode the textual projects and their relationships to the images. His first monograph, written by the art historian (and Duchamp's accomplice), Robert Lebel in 1959, was completely designed and structured by Duchamp. Their procedure was straightforward but the result was stunning. After finishing his text, Lebel sent his manuscript to Duchamp who proceeded to create collages with the illustrations of his life's work while at times completely interfering with Lebel's narrative. The resulting system (that we could mistakenly call a simple book) functioned through Duchamp's juxtapositions; Duchamp's intervention simultaneously opened certain viewpoints onto his work while scrambling the codes to any possible comprehension of his practice. As with all of his objects and works, this principle of "montage" substitutes a multiplicity for a singular perspective. This first book on Duchamp amounts to a clever game of cat and mouse, foreshadowing of the secret work (*Étant Donnés*) that Duchamp failed to even reveal to his friend and monographer, Robert Lebel. Their relationship was analogous to a chess match.

The actual work in question, *Étant Donnés*, located in what might seem like an empty room in the Philadelphia Museum of Art, is a machine. An onlooker cannot see it at first. The machine conceals itself behind its own organization. The instruction manual pretends to reveal it. The manual purports that everything is available to us, that nothing of the piece's function is hidden. The only text about the piece is its technical documentation, which was unknown to the public until it was published by the Philadelphia Museum in 1987; this absence of textual information seems to be, even for Duchampians, an insurmountable obstacle. The gap is vast between what is provided for our understanding and what is given to see. Although there is a manual, it is only useful to those assembling the piece in its resting place. The manual, then, only widens the chasm between the machine and its usage; now that it is ≫

Henri-Robert-Marcel Duchamp lived with his artist brothers, Jacques Villon and Raymond Duchamp-Villon in Paris, where he studied painting at the Académie Julian until 1905. He exhibited for the first time in 1909 at the Salon des Indépendants and the Salon d'Automne in Paris, making work directly related to Cubism. In 1912 he painted the definitive version of Nude Descending a Staircase; *this was shown at the Salon de la Section d'Or of that same year and subsequently created great controversy at the Armory Show in New York in 1913.*

Duchamp's radical and iconoclastic ideas predated the founding of the Dada movement in Zurich in 1916. By 1913 he had abandoned traditional painting and drawing for various experimental forms including mechanical drawings, studies, and notations that would be incorporated in a major work, The Bride Stripped bare by her Bachelors, even *of 1915–23. In 1914 Duchamp introduced his readymades— common objects, sometimes altered, presented as works of art. In 1915 Duchamp came to New York, where his circle included Katherine Dreier and Man Ray, with whom he founded the* Société Anonyme, *as well as Louise and Walter Arensberg, Francis Picabia, and other avant-garde figures.*

After playing chess avidly for nine months in Buenos Aires, Duchamp returned to France in the summer of 1919 and associated with the Dada group in Paris. In New York in 1920 he made his first motor-driven constructions and invented Rrose Sélavy, his feminine alter ego. Duchamp moved back to Paris in 1923 and seemed to have abandoned art for chess but in fact continued his artistic experiments. From the mid 1930s he collaborated with the Surrealists and participated in their exhibitions. Duchamp settled permanently in New York in 1942. During the 1940s he associated and exhibited with the Surrealist emigrés in New York, and in 1946 began Étant Donnés. He died in the Paris suburb of Neuilly-sur-Seine on October 2, 1968.

SRGM

FACING PAGE AND FOLLOWING PAGES *Manual of Instructions, Étant Donnés*, 1946–66

published, it exposes the complexity of Duchamp's process and the adventure it offers: the surfacing of the manual and its disavowal of false depths. In studying the manual, one understands how Duchamp constructed his "illuminated landscape in which the nude figure of a woman lays supine, raising in her left hand a little gas lamp, while a waterfall sparkles in the distance."[1] Duchamp is able to hide everything even amidst full exposure.

Like Lewis Carroll, a land surveyor of sorts, Duchamp invites the viewer/voyeur to join him on the "other side," through the manual. On the opposite end of this foreboding door, the manual reveals the artist's studio at 210 West Fourteenth Street. Even when given a chance to peruse these photographs and notes, the inner workings of the machine are not demystified. The harder one examines the manual, its tricks and deceptions become apparent; the viewer cannot unscramble the puzzle. Perhaps this perverse machinery dates back to Dada's early fascination for the mechanical, though it seems more likely that this manual is a code for the actual machinery of Duchampian thought.

This collection of notes and photographs runs on the infinite libidinal energy of its assemblages—the uncontrollable currents that Deleuze nominated as a desiring machine. "Assemblages are compositions of desire. Desire has nothing to do with a natural or spontaneous determination; there is no desire but assembling, assembled desire. The rationality, the efficiency, of an assemblage does not exist without the passions the assemblage brings into play, without the desires that constitute it as much as it constitutes them."[2]

In exposing the connections and elements of his machine assemblage, Duchamp reveals that his practice is driven entirely by desire or will. Between the architecture of a factory and uncovered theater, the manual for *Étant Donnés* confirms that visual cognition does not always result in complete mastery. As a desiring machine, *Étant Donnés* masks its operational functions in order to scramble its own signs and codes. Even in its tantalizing voyeuristic invitation, this machine assemblage remains enigmatic—ensuring its own survival.

BERNARD BLISTÈNE
Translated from the French by Molly Stevens.

Selected Bibliography

d'Harnoncourt, Anne and Walter Hopps. *Étant Donnés: 1° la chute d'eau, 2° le gaz d'éclairage: Reflections on a New Work by Marcel Duchamp.* Philadelphia: Philadelphia Museum of Art, 1969, repr. 1987.

The Definitively Unfinished Marcel Duchamp. Ed., Thierry de Duve. Cambridge, Mass.: MIT Press, 1991.

Lyotard, Jean-François. *Les Transformateurs Duchamp.* Paris: Editions Galilée, 1997. In English, translated by Ian McLeod, *Duchamp's TRANS/formers.* Los Angeles: Lapis Press, 1990.

1. Anne d'Harnoncourt, Preface to the facsimile of the *Manual of Instructions for Étant Donnés 1° La Chute d'eau, 2° Le Gaz d'Eclairage* (Philadelphia: Philadelphia Museum of Art, 1987).

2. Gilles Deleuze and Félix Guattari, *A Thousand Plateaus: Capitalism and Schizophrenia* (Minneapolis: University of Minnesota Press, 1987), p. 399.

15^{me} OP.

Remarques générales et photos de détail

Montage du **Bâtis** —) voir au détail des opérations "Bâtis et électricité"
et placement des lampes) les Nos. qui correspondent à ceux marqués sur
X les barres de bois du Bâtis —
 et aussi pour le placement des lampes sur
 les 2 barres métal reliant paysage à Briques

Réglage de la
lumière éclairant la **chute d'eau**
par derrière — (Voir 2^{me} OP suite) : La barre bois marquée 70.71 n'est
 pas fixée, elle est seulement posée et
 peut glisser à droite et à gauche, entraînant
 moteur et la lampe ronde pour obtenir
 la meilleure illumination de la chute d'eau
Faire photos chute d'eau par derrière et par devant avec différents
éclairages et montrant si possible le film de plastique qui tamise le
jet de lumière venant de la lampe ronde
 ajouter explications écrites sur ou près des photos

Bec Auer Faire grande photo très détaillée
 X — quand placé définitivement le Bec Auer n'est pas
 mathématiquement vertical; il reste légèrement incliné,
 la fixation du coude ne permettant pas de le redresser.

Attachement de la jambe Faire photo de la jambe au moment où elle
et de l'avant-bras — s'introduit sur la cuisse
 X les 2 pointes
Faire gros plan de la jointure, viennent s'appuyer sur la
entre cuisse et jambe, cachée cuisse en dessous
aussi bien que possible derrière
des feuilles mortes et des branches avant-bras . photo des détails de l'attache au même
 ajouter détails écrits avec diagramme coude pour et de même
 pour avant bras
Cheveux . Changer les cheveux châtains en blonds légèrement foncés.
pp 45 et 46 et faire photo de l'attache au bâton — peut être se
 servir d'un mannequin de coiffeur pour soutenir la
 chevelure qui vient s'étaler entre les seins.

UN CHANT D'AMOUR
1950

JEAN GENET

(b. 1910, Paris–d. 1986, Paris)

From the late 1940s, Jean Genet wrote several screenplays, in addition to other literary activities. With these film projects, Genet returns to one of his favorite tropes: prison where violence, fraternity, hardship, suffering, and eroticism mix. In 1947, Genet wrote his first film script with autobiographical undertones: *La Révolte des anges noirs* (The black angels' revolt). While his final screenplay, a project that mixed documentary and fiction, focused on the Mettray correctional facility, where he spent several years as a teenager, *Un Chant d'amour* (A song of love, 1950) however, was, his only film that was produced.

By the end of World War II, Genet had met Nico Papatakis, the owner of the Saint-Germain-des-Prés cabaret, La Rose Rouge, a meeting place for existentialist writers and philosophers. He asked Papatakis to finance an erotic film project, and Papatakis agreed. Apparently Genet had such a clear idea of what he wanted to do with this film that he did not even write a screenplay. The project was ambitious. Papatakis prepared a budget for a feature-length, 16 mm, black-and-white film (although they eventually shot it in 35 mm), and offered Genet the upper floor of La Rose Rouge for the interior scenes. The exteriors were shot southeast of Paris, around Milly-La-Forêt near Jean Cocteau's home. Jacques Natteau, one of the leading cinematographers at the time, was hired to shoot the film. Yet instead of professional actors, Genet used the petty hoodlums and crooks who filled his love life, including Lucien Séménaud, the muse of *Le Journal du voleur* (The Thief's Journal, 1949).

The first image of *Un Chant d'amour* immediately sets the tone of a closed world: a dirty wall covered in graffiti scribbled with some makeshift tool on plaster eroded by saltpeter. The prison drama is set against the backdrop of a surrounding wall that brings to mind La Santé, the men's prison in Paris. Prisoners desperately attempt to break their isolation and pass along a bouquet of flowers hand to hand through their cell bars. A reverse shot of the guard focuses on his omnipresent gaze, the emblem of the voyeur, the ranks of which we as viewers are soon to join. The film makes use of a spatial dialectic between the area inside the cell (the imposed space of captivity) and an outside area (free space, but also an area of voyeurism), which includes the hall or patrol route. These areas are intersected by and intercut with a space missing a clear topographical reference, an imaginary site created by desire.

Inside the prison cells is the suffering of isolation and detention. The cell wall acts as an obstacle that the urges of love fail to overcome. But the prisoners outsmart this physical isolation; they use a hole drilled in the wall as an outlet. Through this opening they poke a piece of straw taken from a mattress. The drama ultimately focuses on two holes: the hole of desire on one side and the hole of the lustful gaze of the guard, who watches the scene through the eyepiece from the other. (The French word *maton* [prison guard] comes from *mater*, which in everyday usage means "to see without being seen." *Mater* in turn, derives from *matar*, an idiom that originates from a hybrid Spanish and Arabic language which means to kill.) Sensual contact »

Jean Genet's father was never identified, and he was abandoned by his mother when he was seven months old. At age thirteen he began a life of adventure and travel spotted with minor misdemeanors, which led to his first imprisonment in the Colonie Pénitentiaire de Mettray. After deserting from the army and traveling under a false identity throughout Europe, he returned to Paris in 1937, where he was charged with desertion, vagrancy, forgery of identification papers, and theft. While incarcerated, he published his first poem, "Le Condamné à mort à compte d'auteur" and wrote his first two novels: Notre-Dame-des-fleurs (Our Lady of the Flowers) and Le Miracle de la rose (The Miracle of the Rose).

In 1944, a few months before he was released from prison, Notre-Dame-des-fleurs was published "unofficially." Shortly thereafter, Genet began an extremely prolific period, during which he produced novels, plays, and poems. After a petition initiated by Jean Cocteau and Jean-Paul Sartre, he received a presidential pardon by President Auriol in 1949, which protected him from a new prison sentence. A long period during which he wrote very little followed; it was interrupted only by the publication of the plays Le Balcon (The Balcony), Les Nègres (The Blacks), and Les Paravents (The Screens), and a text on his friend, the sculptor Alberto Giacometti.

Genet was in Paris during the events of May 1968. In the 1970s, he traveled to the U.S. to support the Black Panthers, and to Jordan to visit the Palestinian refugee camps. He returned to the Middle East in 1982 and was in Beirut during the massacres in the Palestinian camps, Sabra and Shatila. His last book, Un Captif amoureux draws on these experiences. He died of cancer in April 1986.

Selected Bibliography

Giles, Jane. *The Cinema of Jean Genet: Un Chant d'amour.* London: BFI, 1991.

Kelman, Ken. "Imagenetions." *Film Culture* (New York) no. 32 (Spring 1964).

Mekas, Jonas. *Movie Journal.* New York: MacMillan, 1972.

FACING PAGE Film still from *Un Chant d'amour*, 1950, Musée national d'art moderne, Centre Georges Pompidou, Paris

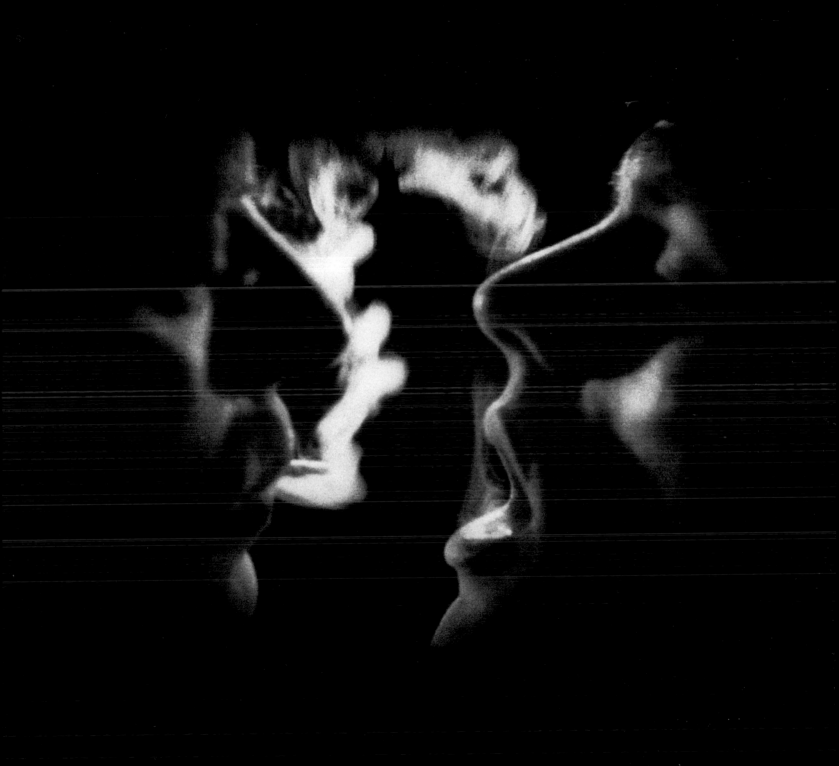

is established through cigarette smoke that is passed from straw to straw, and thus from mouth to mouth, between the two prisoners.

This sequence of images, a symbolic narrative for sexual acts and pleasure, serves as a larger metaphor for the closeted experiences of sexuality, revealing that this cellular experience is complex, existing for those living not only inside, but outside this constraint. In Genet's film the inmates, living in their cells, seem to accept their coding as homosexual as they attempt to engage their desire through the small orifice in the wall that separates them. Separated by the prison door, the guard secretly yearns to satisfy his own desire, finding his pleasure only inside the space of the cell itself, the very space he enforces as restrictive. His existence, outside the cell, is therefore also a closeted one and in turn even more restrictive, as he yearns for the true liberation that exists in the space of the inmates. Through this endless, complex coding of oppression, desire, and sexuality, *Un Chant d'amour* has become a key text of gay liberation and a paragon of queer film.

JEAN-MICHEL BOUHOURS
Translated from the French by Molly Stevens.

THIS PAGE AND FACING Film stills from
Un Chant d'amour, 1950

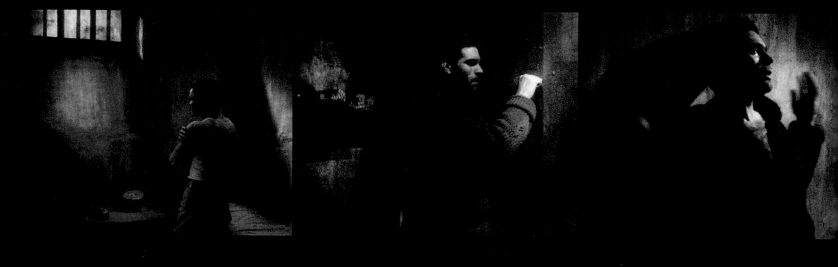

Film is essentially indecent. Since it has this ability to exaggerate gestures, we use it. The camera can open someone's fly and go through what is hidden. If I deem it necessary, I won't deprive myself of it. I will use it, probably, to record a quivering lip, but also the very specific texture of mucous membranes, their moistness.

The enlarged appearance of a bubble of saliva on the corner of a mouth can provide the spectator, over the course of a scene, with an emotion that will give this drama, a weight, a new layer.

Jean Genet in Jane Giles, *The Cinema of Jean Genet: Un Chant d'amour*, London: BFI, 1991.

On August 11, 1972, Gina Pane performed *Je* (I) in Bruges, Belgium. For this *Action*, the artist stood on a windowsill outside a third-floor apartment and observed the activities of a family of four inside. She was spotlit from the plaza below, where she could be seen by the crowd that gathered; loudspeakers installed on the street transmitted the sounds in the apartment; and photographs of the family's comportment were distributed.

Documentation of this performance was subsequently exhibited in the form of photographs and texts mounted on four panels. Three of the panels consist of black-and-white photographs of Pane on the ledge, as viewed from the street, and of the family in the room, including images of the family in which the artist can be seen through the window. The fourth panel is composed primarily of handwritten texts accompanied by four photos. Pane described the purpose of the *Action* in the introductory statement on this panel: "In placing my body on the window's parapet between two zones: one private, one public, I had the power of transposition that shattered the limits of individuality so that 'I' could participate in the 'Other.'" The other five texts are labeled "Lectures (Readings)"; their themes are the relationship of the self to others, to objects, and to space. In an interview years later, Pane summarized the *Action* as thus: "*Je* brings a double and simultaneous vision of public and private space."[1]

Pane had begun to create these *Actions*—her name for the performances in which she employed her own body—in 1971. Most of these events involved discrete wounds to her skin; others, like *Je*, incorporated a situation in which her body was in danger or otherwise placed in a position of potential distress. Pane clearly intended that these acts stun the viewer, thus causing a rupture with commonplace reality. "I believe that the artist in society is a disturber," she said, and like Antonin Artaud she hoped that the shock she created would awaken an anesthetized public to the traumas of contemporary life and transform society.[2] Prior to *Je*, she performed her *Actions* in her studio, private homes, or galleries. With *Je*, she pulled the more intimate setting of the domestic space or gallery out into the street.

According to Pane, her *Actions* had four distinct components. First, she spent a significant amount of time (about six months) in preparation, creating detailed notes and drawings; she then performed the *Action*; although usually enacted only once, the event was recorded on film and/or video and was also photographed; finally there was a period of recovery and reflection. Frequently, Pane not only documented the *Action*, but, as in *Je*, she also used reproductive media to make the audience/participants visible to themselves, forcing them to recognize their implication in the scene.

In *Je*, Pane saw her role as a go-between, a mediator between the private world of the family and the public zone of the street, between "I" and "others." Interestingly, the photographic documentation records how the family ignored her, despite her »

GINA PANE

(b. 1939, Biarritz–d. 1990, Paris)

Gina Pane lived in Turin until 1960, when she went to Paris to study painting at the École des Beaux-Arts. She then lived in Paris until her death in 1990. In the context of the events of May 1968, Pane gave up painting and began to explore humanity's relationship to nature by documenting her conceptual interventions in various landscapes, as in Pierres déplacées *(Displaced stones, 1968), and* Situation idéale *(Ideal situation, 1969). She also created installations concerning environmental issues such as water pollution in Venice—*Acqua alta/Pali/Venezia *(High water/posts/Venice, 1970)—and the politically controlled availability of rice during the Vietnam War—*Le Riz, *(Rice, 1971).*

In the early 1970s, Pane became famous for her Actions, *multimedia performances which often included discrete acts of self-mutilation. Pane interpreted her performances of ritualized pain as sacrificial acts in which she attempted to strip her audience of its willful or defensive refusal to engage in the grim realities of contemporary life (specifically war, the destruction of the environment, and modern alienation through technology). In one studio performance,* Escalade non anesthesiée *(Unanesthetized escalation, 1971), Pane climbed, with bare hands and feet, a ladder whose rungs were lined with jagged-edged metal pieces, to protest the escalation of the Vietnam War. Subsequent* Actions *often featured a series of distinct activities within a single performance, and frequently involved a poetically complex, and at* »

Selected Bibliography

Vergine, Lea, ed. Gina Pane: *Partitions, Opere multimedia 1984–85*. Milan: Mazzotta, 1985.

Gina Pane, La légende dorée. Villeneuve d'Ascq: Musée d'art moderne, 1986.

Gina Pane, La chair ressuscitée. Cologne: Kunst Station Sankt Peter, 1989.

Gina Pane. Barcelona: Palau de la Virreina, 1990.

Gina Pane. Troyes: Cadran Solaire, 1990.

Linder, Inge. "Gina Pane: The Word Made Flesh" (unpub. M.A. thesis). London: Courtauld Institute of Art, 1996.

Tronche, Anne. *Gina Pane: Actions*. Paris: Fall Edition, 1997.

FACING PAGE *Je*, 1972, detail of documentary photos taken from Gina Pane's action at the Place aux oeufs, Bruges, Belgium

precarious location. It is also reported that audience members became hostile, suggesting the difficulty she faced in breaking down the socially conditioned barriers she set out to erase. Pane's focus on glass windows, which both block access and allow vision, and which are central in both *Je* and *Soli-Trac*, represents this tenuous position. In 1989, she commented on the importance of glass in her work: "It represents cold and hot, transparence and opacity, the reflection, the fragility of the flesh, it is a wounding tool."[3]

<div align="right">

JENNIFER BLESSING

</div>

1. Catherine Lawless, "Entretien avec Gina Pane," *Les Cahiers du Musée national d'art moderne*, 29 (Fall 1989), p. 102.

2. Ezio Quarantelli, "Travels with St. Francis," *Contemporanea*, 1 (November/December 1988), p. 47.

3. Lawless, p. 103.

The body (its gesturality) is in itself writing, an organization of signs that directs, that translates the indefinite research of the OTHER, its unconscious desires, its relationships with time taken as an entity not pairing principles, ends, and that one must undecipher through "body" and not through culture.

<div align="right">

From Gina Pane, "Lettre à un(e) inconnu(e)," *Artitudes International*, no. 15–17 (October–December 1974), p. 34.

</div>

times enigmatic, symbolism. Nourriture/actualités télévisées/feu (Food/news/televised/fire, 1971) refers to the three stages of that performance. It also points to key elements of Pane's work, including the function of food as nutriment for the body, and the representation of pain as a means of communication. Actions such as Autoportrait (Self-portrait, 1973); Psyché (Psyche, 1974); and Discours mou et mat (Soft and dull discourse, 1975), explored the role of women in society and the yearning for lost maternal plenitude.

Pane's Actions were developed in the context of body art, a form of Conceptual art practiced by artists such as Vito Acconci and Chris Burden, in which the artist's body was his or her medium. In 1979, Pane performed her last Action. From this point on, she created sculptural installations which she called Partitions, referring to two different meanings of the French words "division" and "musical score." Frequently incorporating photographs and other references to her Actions, these works make explicit allusion to the lives of martyred saints, thus recontextualizing the symbolic underpinnings of the earlier works.

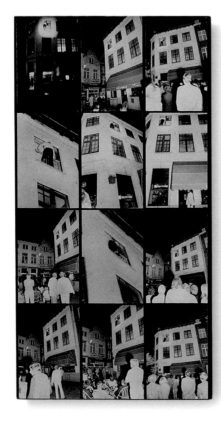

ABOVE *Je*, 1972, documentary photos taken of Pane's *Action* at the Place aux oeufs, Bruges, Belgium

LEFT *Je*, 1972, installation view of photo panels

FACING PAGE *Soli-Trac*, 1968, film still with Anne
Marchand, Musée national d'art moderne, Centre
Georges Pompidou, Paris

Gina Pane's works are like teachings. Whether object, gesture, installation, or performance, each piece is imbued with a deep desire to communicate. No matter how enigmatic it may appear, a lesson emerges. A demonstration of playing indicates the legacy of childhood; visions of loneliness suggest our shared isolation; a wound becomes a lesson in charity, in sacrifice for others.

The artist has described the subject of her first film, the nine-minute, black-and-white *Soli-Trac*, 1968, as "fear undergone by a young woman in her apartment who realizes her solitude."[1] In a small, rather bleak room, a woman explores the limits of her space and the meager objects therein. She toys with various items and invents simple games for herself: she flashes a small light at her temple; she attempts to choose between two of the apartment's doors, peeking into each, dramatically shutting it, then running to the next; she puts food from the refrigerator into her jacket pockets, then puts articles of her clothing into the fridge; she smokes and counts her toes. Her emotions—expressed through body language, facial expression, screaming, and laughing—seem to vary from boredom, to happiness, to annoyance. There is a slight evocation of violence in the way she puts the flashlight to her temple at the beginning of the film and in her final scream, which descends in pitch as the camera looks out the window and pans to the ground. Still, the overall effect of the work is of a strange, surreal, yet playful theatricality.

This piece is unique in Pane's oeuvre, since she subsequently used film and video to document her performances and not as an independent art form; and because the actor is not Pane herself as in her performances but her companion Anne Marchand. Perhaps this film can best be compared to one of Pane's artist's books, *Moments de silence: I*. In this volume, eight black-and-white photographs placed above brief poetic captions sketch an enigmatic narrative. A mother and child are depicted in the photographs which unfold as a kind of storyboard. Much of Pane's work involves a sense of loss or stifled desire. In *Moments de silence*, these feelings are embodied in the little girl's very real loss of her mother, and the photographic traces serve as a means to hold on to her memories of their life together.

The woman in *Soli-Trac* does not seem satisfied in her solitude. At one point, she caresses the refrigerator, shouting "Love, love, love!"—apparently expressing her yearning for human connection. She seems trapped inside her apartment—an active, warm body bouncing off its cold walls. Her dark clothes read as hot against the almost all-white interior. Outside the window it is snowing; inside are other chilly environments: the microcosm of the interior of the refrigerator, and the representation of the cold surface of the moon in a lunar map she scrutinizes (a reproduction in miniature of the macrocosm of outer space). While these assorted portals suggest the world outside the domestic interior, they seem forbidding or inaccessible. The woman opens the refrigerator door (a dead end, to be sure); she peers into the darkness »

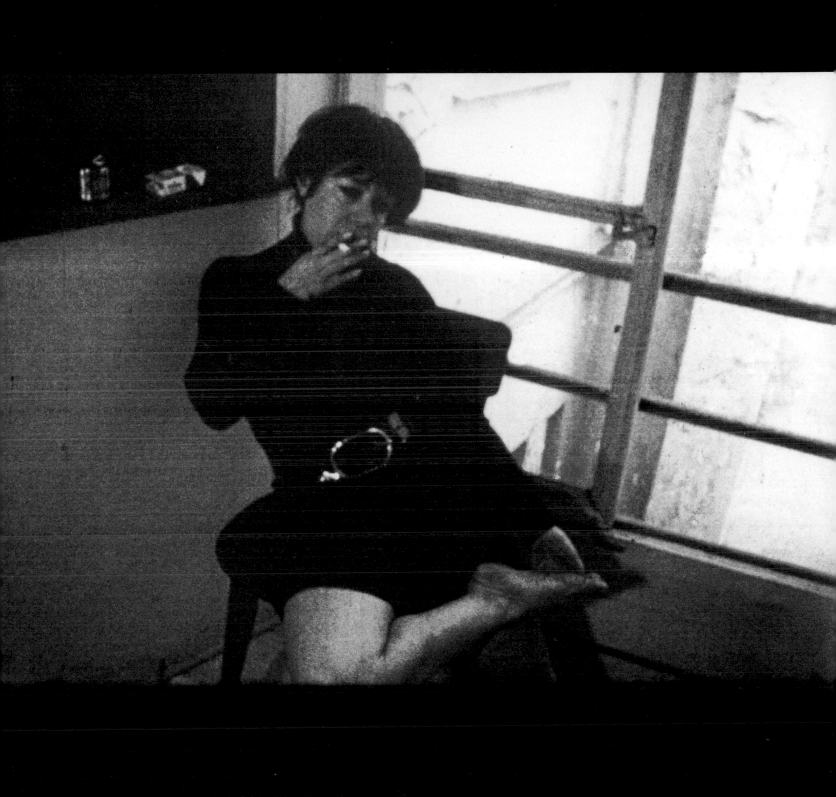

behind two interior doors but does not enter it; she opens a window above a deep courtyard. The woman's sensibility, expressed in her gestures of boredom, funk, and desire, also seems to be generated by and circumscribed by the physical space she inhabits.

JENNIFER BLESSING

1. Laurent Danet, "Gina Pane," in *L'Art du mouvement: collection cinématographique du Musée national d'art moderne, 1919–1996*, ed., Jean-Michel Bouhours (Paris: Centre Georges Pompidou, 1997), p. 355.

THE BATHROOMS AT THE GUGGENHEIM MUSEUM, SOHO (NOUVELLE CONTRIBUTION À L'ÉTUDE DES LIEUX RESTREINTS)
1998

In the fall of 1985, Paul-Armand Gette sent a letter to over fifteen French museum directors and curators in which he briefly described the themes of his recent art projects and proposed that he organize an exhibition of his work in the public bathrooms of their establishment. Four museum heads politely refused his offer; many others did not even respond. Dominique Bozo, the director of the Musée national d'art moderne at the time, asked the artist to come and see him. Their meeting was conclusive. *Nouvelles contributions à l'étude des lieux restreints* (New contributions to the study of restrained sites) was installed from May 14 to June 7, 1986, at the Musée national d'art moderne, on the third floor of the Centre Georges Pompidou. It involved the restroom door signs, both for women and men. Later, Gette exhibited in the bathrooms at the Centre national d'art contemporain in Grenoble (1989), in the bathrooms of Portikus in Frankfurt (1993), and again at the Pompidou Center, as part of the 1995–96 exhibit *Fémininmasculin, ou le sexe de l'art*.

This work, recontextualized for the bathrooms of the Guggenheim Museum SoHo in 1998, is the culmination of the artist's research on one of the predominant themes in his work, the world of nymphs. From the beginning, the principal element of the piece was the "simulacrum," as the artist calls it, of a water lily placed in a sink and photographed with its botanical label in a washroom. This flower contains the key to the piece. The Latin name of the water lily, as Claude Monet has already taught us, is *Nymphaea, alba L.* This designation allows us to evoke Carl Von Linné, botanist, whom we will keep in mind, so as to focus on the nymphaea. The nymph, that goddess of inferior ranking who frequented the woods, mountains, rivers, ocean, and waters, also refers, in French, to the small lips of the vulva, as well as the second stage of an insect's metamorphosis, between larva and imago.

The relationship Gette establishes between washroom and nymph evokes the painting of the Germanic Renaissance and of certain humanist circles. For some time, Gette has used the following inscription in his presentation: "Fontis Nympha sacri somnum ne rumpe quiesco," ("[I am the] Nymph of the sacred spring, do not disturb my sleep.") This text can be found in a number of Lukas Cranach paintings of the *fontis nympha*, an example of which is at the Metropolitan Museum in New York. The nymph is presented as a kind of muse, and the sacred spring, the source of inspiration for the poet or artist. Gette has transposed the context of the metaphor to a washroom using a water lily as the guardian of the running water—the same water that springs from a hidden source in the *nymphée* of the Bagatelle garden. It was videotaped by the artist especially for the Guggenheim installation. It indicates the outer area the spectator will enter once he or she has passed through the bathroom door—in both directions.

JONAS STORSVE
Translated from the French by Molly Stevens.

FACING PAGE *La curiosité de la Nymphe*, 1988, door of the woman's bathroom in the exhibition *Nymphe, Nymphaea et Voisinages*, Le Magasin, Centre national d'art contemporain de Grenoble, 1989

PAUL-ARMAND GETTE
(b. 1927, Lyon)

When Paul-Armand Gette was a child, he met a little girl while on vacation in Saint-Pierre-de-Chartreuse who gave him a taste for the natural sciences. Over the next several years, he became interested in mineralogy, petrography, and geology. During a trip to Italy in 1935, he visited several museums in which he played hide-and-go-seek with his governess, and climbed Mount Vesuvius. Ten years later, he published an article about nymphs, "Capture de Macroplea appendiculata Panz," in the Bulletin Mensuel de la Société Linnéenne de Lyon.

In 1951, Gette settled in Nice where he completed calcinations, including Tombeau pour une nymphe (Tomb for a nymph, 1960). In 1963, Gette moved to Paris and wrote a short opera, entitled Les Strates (The strata, 1967), and took his first pictures of little girls, in 1970. He paid homage to Carl Von Linné and Charles Lutwidge Dodgson in 1975 and would do the same with Claude Monet in 1976.

Gette spent the summer of 1980 in Berlin, where he bought his first pair of little girl's underwear. After a first Toucher de modèle (Touch the model), in 1983, he completed La Salle de bain No. 1 (The bathroom no. 1) the following year at the Konsthallen de Malmö, and installed his work in the bathrooms of the Musée national d'art moderne in Paris in 1986. In 1987, he exhibited his works on volcanoes, and in 1991, he conducted his experiments with coloring on the model. He created Réflexion sur le menstrues de la déesse (Reflection on the menstrual cycle of the Goddess) in 1994.

Selected Bibliography

Nymphaea (exh. cat.). Paris: Galerie Claire Burrus, 1987.

Nymphe, Nymphaea et Voisinages (exh. cat.). Grenoble: Centre national d'art contemporain, 1989.

Gette, Paul-Armand. *Textes Très Peu Choisis*. Dijon: Art & Art, 1989.

Gette, Paul-Armand. *A Propos du Modèle & d'une Intervention dans la Salle de Bain*. Lyon: Villa Gillet and FRAC Rhône-Alpes, 1992.

Die Toiletten-Nymphe, La Nymphe des Toilettes (exh. cat.). Francfort-sur-le-Main, Portikus, and Cologne: Walter König, 1993.

In Natura Rerum (exh. cat.). Nantes: Musée des Beaux-Arts, 1996.

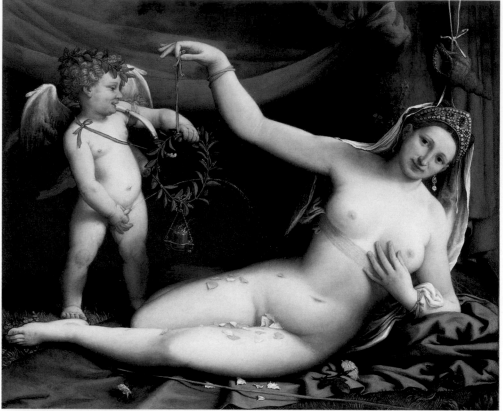

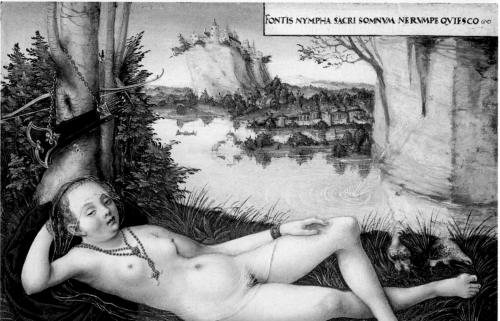

TOP Lorenzo Lotto (ca. 1480–1556), *Venus and Cupid*, The Metropolitan Museum of Art, New York

BOTTOM Lucas Cranach the Elder (1472–1553), *Nymph of the Spring*, The Metropolitan Museum of Art, New York

FACING PAGE, CLOCKWISE *La Nymphe des toilettes (Women)*, Solomon R. Guggenheim Museum, New York, 1998

La Nymphe des toilettes (Men), Solomon R. Guggenheim Museum, New York, 1998

Exhibition view, in situ intervention in the men's bathroom, *Fémininmasculin, ou le sexe de l'art*, Centre Georges Pompidou, Paris, 1995

Exhibition view, in situ intervention in the women's bathroom, *Fémininmasculin, ou le sexe de l'art*, Centre Georges Pompidou, Paris, 1995

L'HÔTEL
1983

Much of Sophie Calle's work, especially the early pieces, involves her invasion of the most intimate rituals of friends and strangers. She has carefully recorded details of behavior, secretly photographed personal articles, conducted interviews about private habits, then publicly displayed the results of her investigations. Although images and texts generated by these activities frequently describe the banalities of daily existence, these works are strangely absorbing—not only because the trivial is often profound, but because access to these sorts of private moments is usually a forbidden pleasure. We would like the deepest and perhaps most embarrassing experiences of others to be exposed for our perverse delectation, yet this is prohibited except in circumscribed professional situations or personal relationships. Ours is a voyeuristic desire for a false intimacy, for knowledge without responsibility.

In early 1981 and after a year of applying for the job, Calle was hired as a temporary chambermaid at a Venetian hotel. She was assigned to clean twelve rooms, which gave her the opportunity to document the personal belongings and activities of the guests therein. During the three-week period of her employment, she took daily photographs of each room's contents and extensive notes on what she found, in order to compile a profile of the room's inhabitants. Her investigative techniques varied: when it was not locked, she opened the guest's luggage; she looked through the pockets of clothes hanging in wardrobes; she read diaries and agendas; she listened to conversations through doors; she went through trash; she read mail, including old correspondence saved for sentimental reasons, outgoing postcards, and discarded drafts. On a number of occasions, she was almost caught when guests returned to their rooms while she was there.

These investigations resulted in the series of twenty-one works collectively titled *L'Hôtel*. Each piece in the group is dedicated to the stay of a guest or guests in a particular room, and is titled by its inhabitant's room number and day of arrival. A color photograph of the hotel room's made bed appears above the text describing Calle's observations. The second part of each diptych is dedicated to a series of black-and-white details of the room's contents during the guest's tenure, including the now unmade bed and other items often identified in the text.

Each room tells a story. It is a portrait of the life of its temporary occupants. The viewer can draw assumptions about them based on the styles and brands of clothes they wear; the articles they own; and the way they inhabit the space, whether it is excessively neat or sloppily spread about. Documents, agendas, and photographs indicate basic identity (age, sex, nationality); transcriptions of conversations and letters reveal the constitution of relationships. Calle presents her subjects's various idiosyncracies—such as the Austrian brothers who displayed framed family photographs, the couple with too many shoes, or the woman who hid the wall mirror in the closet—as mysterious clues suggestive of bizarre private rituals. Some of the »

SOPHIE CALLE
(b. 1953, Paris)

Sophie Calle chose extensive travel over a university education. Finding herself with limited social contacts on her return to Paris after seven years abroad, she began following people on the street as a means to structure her days and explore the city. Her first artwork, Les dormeurs *(The sleepers, 1979), was exhibited in the 1980 Paris Biennale. For this piece, Calle asked dozens of friends and strangers to sleep in her bed consecutively during a one-week period.* Les dormeurs *consists of the resulting 176 photographs, and of twenty-three accompanying texts based on the artist's interviews with the participants.*

Throughout the 1980s, Calle created installations of photographs accompanied by texts documenting her investigative activities. In Suite vénitienne *(Venetian suite), 1980, she secretly followed an acquaintance to Venice and charted his movements around the city in the simulated guise of an unrequited lover. In* La filature *(The shadow, 1981), the artist asked her mother to hire a detective agency to follow her in order, Calle said, "to provide photographic evidence of my existence." Her widely exhibited video,* Double Blind, *1992, made with Greg Shephard, records the development and disintegration of their relationship on a car trip across the U.S. Calle has also created a number of interventions in museums. In* Ghosts, *for the Museum of Modern Art's 1991 exhibition* Dislocations, *she asked museum staff to describe and draw paintings on loan to other institutions; she then hung that documentation as a surrogate for the absent art.*

The format of Calle's early works— photographs and texts documenting »

Selected Bibliography

Calle, Sophie. *Absence*. Rotterdam: Museum Boymans-Van Beuningen, 1994.

_____. *L'Hôtel*. Paris: Editions de l'Etoile, 1984.

_____. *Sophie Calle, à suivre. . .* . Paris: Musée d'art moderne de la Ville de Paris (ARC), 1991.

_____. *Sophie Calle: True Stories*. Tel Aviv: Tel Aviv Museum of Art, 1996.

_____. *Suite vénitienne/Sophie Calle*. Seattle: Bay Press, 1988.

Irmas, Deborah. *Sophie Calle: A Survey*. Santa Monica, Calif.: Fred Hoffman Gallery, 1989.

FACING PAGE *L'Hotel, Chambre No. 30*, 24 February 1983

CHAMBRE 47

Lundi 2 mars 1981. *Ma première sensation est celle d'une propreté exemplaire. Rien sur la table, des tiroirs vides, aucun vêtement apparent. Un seul livre, « Le Guide Michelin Italie », est posé sur la table de nuit de gauche. Par terre, un attaché-case. A l'intérieur, une bouillotte rouge. Dans la salle de bains, rien de particulier à signaler ; des produits ordinaires parmi lesquels du « Microlax » contre la constipation, du parfum « Calèche », des pilules contraceptives et diverses lotions pour peaux délicates. Il me reste l'armoire. A gauche, l'homme : chemises « Cacharel » et « Daniel Hechter », costumes gris, cravates... A droite, la femme : pantalons en velours côtelé, jupes en lainage... La valise porte une étiquette : M. et Mme C. Paris 11e. Elle renferme trois culottes, des gants de toilette, trois paires de chaussettes, un pyjama rayé, un sachet de santal, des cintres, une brosse à habits, un séchoir à cheveux, un appareil photographique « Olympus », un sac en plastique qui contient le linge sale (trois culottes, un soutien-gorge, un chemisier), du savon pour les cuirs, un livre « Belle Italie », une rallonge électrique, des clés, un guide de l'hôtellerie française, une liste des hôtels « Sofitel », une lampe de poche, des chiffons et du cirage, un portefeuille. Dans le portefeuille je trouve les papiers suivants : deux permis de conduire internationaux aux noms d'Antoine C. né en 1943 et d'Emmanuelle C. née en 1948. Les factures d'autres hôtels vénitiens (ils ont passé la nuit du 26 février dans la chambre 18 de l'hôtel Cavaletto et celle du 28 dans la chambre 10 du Luna). Des cartes du Touring Club de France, un compte aux Galeries Lafayette et un agenda au nom d'Eliane C. J'examine son emploi du temps. Le 1er février à midi : tennis Neuilly. Le 5 février : déjeuner BNP. Le 6 : fleurs, éléphant, dîner anglais. Le 10 : Carita onze heures. Le 19 : déjeuner. Le 28 : vacances. Rien pour janvier et mars. Dans la partie « Notes » du carnet, une page est consacrée à leur consommation en eau : Eau chaude. 6.6.79, C : 11 m³, S. de b. : 14 m³. 20.10.79, C : 16 m³, S. de b. : 48 m³. 10.2.80, C : 20 m³, S. de b. : 79 m³. 7.6.80, C : 24 m³, S. de b. : 100 m³. 15.10.80, C : 27 m³, S. de b. : 125 m³. 31.1.81, C : 30 m³, S. de b. : 150 m³.*
Sur une seconde page, diverses dates : Monsieur C. : 11.12.1912, Madame C. : 26.1 (l'âge de la femme n'est pas mentionné) Laurent 24.1.71, Johanna 24.1.71. Puis une liste de livres : « Mémoires de l'Afghanistan », « La Route des Indes », « Iles et presqu'îles de l'Extrême-Orient »... Sur une dernière page, la liste suivante : Nuages et soleil (400 Asa 125e). Réverbères allumés fond rouge. La base de la première colonne vers le Palais des Doges. Un convive encadré par deux fenêtres du Florian qui reflètent la place. Religieuse en blanc qui rentre dans l'hôpital. Deux pigeons qui se bécotent...
Le carnet d'adresses contient une dizaine de numéros de téléphone privés ainsi que les numéros suivants : hôtel Bristol, BHV, BMW, voisine, Carita, CFDT, Cacharel, Antar, encadrements, Galeries Lafayette, Golfe, Lévitan, psychothérapeute : Mme V., infirmière : Mlle D., bijoutier, peintre, gardienne, Sécurité Sociale, Surface, Sucaflor, taxis, Harry's Bar, Printemps Haussmann, Printemps Italie, Dessanges, Hospice... Je suspends ma lecture pour aller faire le 43.

Mardi 3 mars. *Le guide Michelin a été rangé dans l'armoire et a été remplacé sur la table de nuit par une liste des distributeurs automatiques de la Banque Hervet, un prospectus de l'Hippopotamus et des enveloppes vierges. Un parapluie traîne. A gauche on dort avec deux oreillers, à droite avec un seul. L'imperméable marron n'est plus dans l'armoire (il pleut), une chemise bleue « Cardin » a rajoutée dans le sac de linge sale. Je ne vois plus la lampe de poche. Je reviens à l'agenda. Dans le calendrier, les jours suivants : 3.1 / 4.1 / 9.1 / 17.1 / 18.1 / 23.1 / 31.1 / 1.2 / 6.2 / 8.2 / 14.2 / 15.2 / 20.2 / 28.2 / 1.3 / 2.3 / sont barrés d'un trait bleu. Les 2, 3, 4 et 5 février sont marqués d'une croix et les 6 et 8 février sont barrés et marqués d'une croix.*

Mercredi 4 mars. *Le guide Michelin a été ressorti, il est passé, ainsi que la liste des hôtels « Sofitel », sur la table de nuit de droite. Un paquet plat est posé sur le lit. Je l'ouvre : il s'agit d'une affiche du Carnaval de Venise.*

Jeudi 5 mars. *Un deuxième parapluie est posé à côté du premier. Ils ont acheté une bombe de « Pronto » (produit de nettoyage).*

Vendredi 6 mars. *Ils sont partis. Sur le lit, un tube de rouge à lèvres rose a été oublié. Dans la salle de bains, les serviettes traînent, défaites. Les draps de lit n'ont pas été tirés. Pour la première fois, du désordre.*

rooms' stories are dull or uneventful, even pathetic in the apparent ordinariness of the existence they reveal. Others, usually those concerning the subject's amorous lives, are more dramatic.

Calle operates like a detective. She collects facts and presents them without comment, and yet she is the ever-present consciousness that defines the material she examines. Her subject is the traces of existence, the evidence of an absent being, illusively evoked through objects and the residue of acts Luc Sante has written apropos of Calle's work, "Uncertainty is an inevitability when it comes to information; information is uncertain in the same way that humans are mortal."[1] In *L'Hôtel*, the artist creates narratives of dubious factuality, however objective her method might first appear. And the guests themselves unwittingly divulge the seeds of the fictions they have created of their own lives. The mutability of the line between fact and fiction is also underscored in the work through the niggling uncertainty about how much "evidence" the artist may have fabricated. Calle has said that she invented only one room: "It's a room I would have liked to find, and I didn't find. I put my fantasy inside."[2]

L'Hôtel, like many of Calle's works, breaks down the distinction between public and private experience. Not only does she make the private public, but she explores private lives being conducted in public space, whether in the strange hybrid environment of a hotel room, a train compartment (*Anatoli*, 1984), or on the street (*Suite vénitienne* (Venetian suite, 1980); *La filature* (The shadow, 1981). By examining the intersections of private and public space and experience, she also disintegrates the distinctions between subject and object. If at times she appears to control the objects of her investigations, at other moments they turn the tables. Her work is a kind of documentation of her own performances as well as those of her quarry—and ultimately her viewers—as all parties actively interpret the behavior they perceive. Photography is essential to Calle's practice, permitting both the sensation of documentary realism and providing the (deceitful?) fetishistic traces of memory.

JENNIFER BLESSING

1. Luc Sante, "Sophie Calle's Uncertainty Principle," *Parkett*, no. 36 (1993), p. 78.

2. Lawrence Rinder, "A Conversation with Sophie Calle," March 1990, *Calendar* (Berkeley: University Art Museum and Pacific Film Archive), p. 3.

SOPHIE CALLE

various investigations generated by a founding premise or question—has an affinity with the Conceptual art that developed internationally from the late 1960s. Calle's focus on intimate behavior, relationships, and the nature of memory, all inflected by doubts about the authority of photographic "reality," align her production with that of other French artists such as Christian Boltanski and Annette Messager.

Calle has exhibited worldwide, including major solo shows at the Musée d'art moderne de la Ville de Paris (1991), at the Museum Boymans-Van Beuningen, Rotterdam (1994), and at the Tel Aviv Museum of Art (1996).

FACING PAGE *The Hotel Series*, installation view, Luhring Augustine Gallery, March 1991

These are not the photo-mementoes of a presence, but photos of an absence, that of the followed, that of the follower, that of their absence from each other.

Jean Baudrillard, *Please Follow Me*, trans. by Paul Foss, *Art & Text*, no. 23/24 (March–May 1987), p. 104.

CHAPEAU-VIE
1993-PRESENT
LES GALIPETTES
1994
ÉMOTION CONTENUE
1995

MARIE-ANGE GUILLEMINOT
(b. 1960, Saint-Germain-en-Laye)

One has to trust art to approach Marie-Ange Guilleminot's work: to live for one year, as did the art critic Hans Ulrich Obrist, with a mutating gaiter—the *Chapeau-Vie* (Life hat)—on one's head; to put one's face in this same fabric tube without knowing what sensation or vision awaits us, as the piece *Émotion Contenue*, 1995, invites us to do; to fix one's eye against a small hole drilled into the wall, as in *Les Galipettes* (Somersaults, 1994), without worrying about being given the terrible punishment for curiosity that Luis Buñuel described in his most sadistically evocative image in *The Criminal Life of Archibaldo de la Cruz*; to allow plaster to be pressed into one's navel and wait for it to harden, as in *Portraits*; or to slip one's feet through a hole and feel them snatched up by a hand that massages them, as in *Le Paravent* (Screen).

At the same time, one has to trust one's kind to expose oneself to the dangers of a gesture or an unknown look, as Guilleminot does. Her most emblematic piece in this respect is *Gestes*, in which, in the public space that is Tel Aviv's central train station, the artist held out her hands through a wall, leaving visitors free to manipulate them. The same vulnerability can, however, be found in all her "demonstrations." In *Poupées* (Dolls), she feels the dolls with a touch that is sexual in nature; she has presentated the possible uses of the *Chapeau-Vie* naked in public spaces and has tried on the *Robes* (Dresses), many of which reveal ordinarily hidden parts of the body; and in her exhibition of the *Sacs à Dos* (Knapsacks), the artist is reduced to the humble rank of store salesperson.

This reciprocol release from fear and inhibitions is not entirely benign. One must force oneself to surrender to art in these pieces, and the goal, as ridiculous as it often seems, nevertheless propagates a certain violence. Each experience is like a test, the purpose of which is often the test itself: to wear a hat, until it comes to the forefront of your identity, as Hans Ulrich Obrist chose to do; to imprudently show one's face, one's eye, only to discover the intangible vis-à-vis the artist's face (as in *Émotion Contenue*) or the artist performing somersaults (*Les Galipettes*).

However, Guilleminot's work never leads to a discovery about something visual. The voyeur never sees anything important or hidden. In fact, the voyeuristic aspect of Guilleminot's work turns out to be directed at the user: it is the voyeur who is seen, touched, surprised. He or she simply experiences that his or her trust is reciprocal, that it has not been used more than it has been allowed to use the work. Its rewards, moreover, are pleasant: the excitement of curiosity, the warm envelopment of *Chapeau-Vie*, the sensuality and relaxation of massages in *La Paravent*.

Guilleminot has said that the first goal of the *Chapeau-Vie* was "To make life more bearable"; it was originally created so that its user would not "bump his or her head."

CATHERINE GRENIER
Translated from the French by Molly Stevens.

After studying at the Villa Arson, in Nice, Marie-Ange Guilleminot settled in Paris, where she currently lives. Her first works were dresses she made that both clothed and unclothed the body by playing with the transposition of and osmosis between the cover and the individual. This work led to Chapeau-Vie, *1993–present a long tube of elastic fabric that rolls up and down the body, changing in turn into a hat, pullover, or dress. The piece became the subject of a series of demonstrations in public places across the world, including P. S. 1 Brooklyn in 1994, Israel in 1995, Tokyo in 1996, and Münster in 1997.*

Casting became another way for Guilleminot to approach the body, and this work led to Portraits, *plaster molds of navels. With this work she revealed an intimate part of the body that usually goes unnoticed but which nevertheless characterizes the individual. Although for some time Guilleminot used video primarily to record action (demonstration of clothing, or her handling of "dolls" made from stockings), it has now become a medium she uses for its own sake, often combined with a device for a singular vision, as in* Les Galipettes, *1994, or* Émotion Contenue, *1995.*

Themes of handling and vision converge in Le Paravent, *1996, a mobile panoptic construction in which visitors are invited to put their feet into an area they cannot see, where reflexologists then offer relaxing massages. (In other installations, Le Paravent housed different experiments.) In 1997,* Sacs à Dos *brought the personal examinations of her first works to a public space by extrapolating, in a practical dimension, her reflections on the item. The demonstration takes place in the* Salon de Transformation *(Transformation room), on a circular red rug with a surface measured in accordance with its usage.*

FACING PAGE *Les Galipettes*, 1994, documentary photo from demonstration in the Maremont room, Israel Museum, Jerusalem, 1995

Selected Bibliography

L'Hiver de l'Amour (exh. cat.). Paris: Musée d'art moderne de la Ville de Paris, 1994.

Wabbes, Marie and Olivier Zahm. "Marie-Ange Guilleminot." *Purple Prose* no. 5, 1994, p. 12.

Fémininmasculin, ou le sexe de l'art (exh. cat.). Paris: Centre Georges Pompidou, 1995.

Azoulay, Ariella. "Sans Visage: Marie-Ange Dans la Cabine." *Interloppe*, no. 11–12, 1995, pp. 82–87.

Le Mouellic, Maria. "Marie-Ange Guilleminot." *Beaux-Arts* no. 131, 1995.

Giquel, Pierre. "Marie-Ange Guilleminot." *Art Press*, no. 201, 1995.

Lusky, Aim. "CsO." *Studio Art Magazine* no. 64, 1995, pp. 39–42.

Thomas, Mona. "Le Désir de Robe." *Art Press*, no. 18, 1997.

THIS PAGE, TOP LEFT *Chapeau-Vie*, exhibition view, *The Winter of Love*, P. S. 1, Brooklyn, 1994

LEFT, MIDDLE *Chapeau-Vie*, demonstration view in Venice, 1995

LEFT, BELOW *Chapeau-Vie*, demonstration view at the Israel Museum, Jerusalem, 1995

BELOW, INSET *Chapeau-Vie*, 1993, as worn by the curator Hans Ulrich Obrist

BELOW *Chapeau-Vie*, demonstration view in Jerusalem, 1995

FACING PAGE *Emotion contenue*, 1995, installation view at the Galerie Chantal Crousel, Paris, 1995

Since 1994, in different cities, I have been doing the "Chapeau-Vie Demonstration" for which I simulate several uses of the hat. These repeated gestures play a different role each time in their connection to time and place. They become a language that can be easily interpreted, some are more familiar, others more alien. I operate in selected areas where the events influence my behavior: a street in Brooklyn, New York, the rooftops of Jerusalem and Ramat Gan (Israel), a boat in Venice. A video is taped (still shot) in every city. Over the course of these experiences, I become closer and closer to the Chapeau-Vie. *It helps me define my space and also that which separates me from others, in an intimate and social connection.*

Marie-Ange Guilleminot

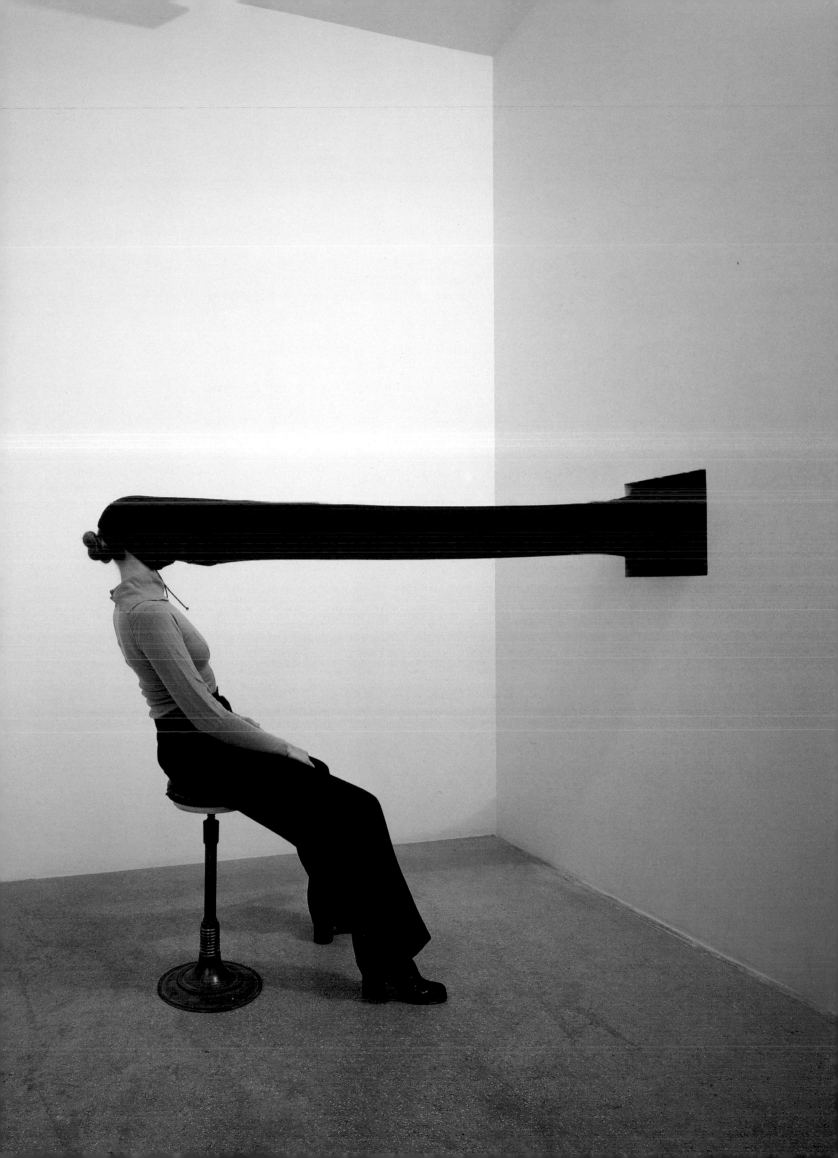

DOMINIQUE GONZALEZ-FOERSTER
(b. 1965, Strasbourg)

A spatial drive infuses Dominique Gonzalez-Foerster's entire aesthetic project. Since the end of the 1980s, she has been charting the topography of imaginary interiors and the memories that permeate their walls. Her medium is space itself. Eschewing more predictable modes of representation—painting, sculpture, photography, literary texts—to convey the narrative content embedded in these sites, Gonzalez-Foerster creates architectural mise-en-scènes. The artist considers these rooms to be images, dimensional tableaux into which the viewer can experience their allusive ambience. In her mind, words, pictures, and architectural environments have equivalent descriptive powers. Freely translating one mimetic form into another in a process she calls adaptation, Gonzalez-Foerster weaves biographical, autobiographical, and fictional tales with drywall, furniture, and housepaint. Viewers interact with her environments like detectives at the scene of a crime, deciphering clues to past events, inferring the presence of previous inhabitants, and extracting narratives from the most minute details. According to the artist, the spaces are not only descriptive vessels imparting their histories to current inhabitants, they are also causal agents. Citing Fritz Lang's 1948 film, *Secret Beyond the Door*, in which an architect collects rooms where murders have been committed, believing that the spatial arrangement of an interior will effect what occurs within it, Gonzalez-Foerster claims that "rooms produce scenarios."[1]

This is certainly the case in Joris Karl Huysmans's 1884 novel *À Rebours* (Against the grain), which inspired Gonzalez-Foerster's eponymously titled three-room installation. Stricken by an overexposure to the libertine indulgences of Parisian society and a profound ennui at the superficiality of his peers, the book's protagonist, Des Esseintes, retires to a manor in the country intending to lead a life of isolation and contemplation. The house is lavishly outfitted with appropriately monastic, but luxurious furniture: wall colors selected for their soothing appearance under artificial illumination (daylight was not to enter the premises); the finest works of art by such decadent painters as Gustave Moreau and Odilon Redon; libraries replete with Latin classics and contemporary French literature; and the most sumptuous array of aperitifs imaginable. Entire chapters are devoted to how Des Esseintes plans and then interacts with his constructed environment. Sparing no adjective, Huysmans details every element of this den of personal obsessions. The house—with its humid, overdetermined demeanor—is, in essence, the other main character of the novel.

In her installation *À Rebours*, Gonzalez-Foerster creates a modern-day dwelling for Des Esseintes, a residence for self-sufficient sensual indulgence. As in many of her interiors, the rooms are color-coded: yellow bedroom, red hall, blue office. Each space is saturated in an individual hue, immersing the viewer in a bath of intense monochromatic color. Sparsely furnished, decorated only with the occasional photograph, this three-room habitat is meant to suggest the isolated, passionless life of the cultivated individual. Gonzalez-Foerster emphasizes this sensibility in her »

Dominique Gonzalez-Foerster studied at the École des Beaux-Arts, Grenoble, L'École du Magasin, Dijon, Institut des Hautes Études en Arts Plastiques, Paris, and briefly at the Düsseldorfer Kunstakademie in Germany. Her academic training was punctuated by solo and group exhibitions each year; Gonzalez-Foerster had her first solo show, Mouchoirs Abstraits, in 1986 at the Bibliothèque de l'École des Beaux-Arts, Grenoble.

Gonzalez-Foerster found her early influences in the biographies of Lou Andrea Salome, Hanne Bowles, and Marie Curie—all examples of lives filled with ambition and opportunity. Her installations create and present different types of lives; they are spaces that function as "biographies" of real and fictional people.

After 1996 Gonzalez-Foerster began adding soundtracks to her installations; The Milwaukee Room (1997) was accompanied by the sounds of a thunderstorm. Sound also has an important role in her self-anthologizing, interactive CD-ROM, residence: color, which comprises virtual installations: buildings and public spaces, a biographical institute, apartments, and color-themed rooms. It is driven by audio (rather than visual) cues for viewer participation. The music and sounds in these virtual spaces—a phone ringing, people talking—are as much clues to a room's atmosphere as color and shape.

Her solo show at Krefelder Kunstmuseen, 88:88 (1998), was a manifesto of Gonzalez-Foerster's career to date; the catalogue for 88:88 documents Gonzalez-Foerster's evolution. Her text, via a series of questions, investigates the viewer's connection to and memory of his or her surroundings.

Gonzalez-Foerster continues to be represented in international exhibitions including Aperto '93 at the Venice Biennale, a solo show at the Stedelijk Museum, Amsterdam (1994), Manifesta II, Luxembourg (1998), and the Kyoto Film Festival (1998).

JOREE ADILMAN

Selected Bibliography

Gonzalez-Foerster, Dominique and Olivier Zahm. *Biographique* (exh. cat.). Paris: Musée d'art moderne de la Ville de Paris, 1993.

Gonzalez-Foerster, Dominique, Eva Marisaldi Tomasso, Corvi Mora, and Gianni Romano. *Film* (exh. cat.). Geneva: Galerie Analix-B.L. Polla, 1994.

Heynen, Julian and Dominique Gonzalez-Foerster. *Dominique Gonzalez-Foerster: Moment 88:88* (exh. cat.). Krefeld: Krefelder Kusntmuseen, 1998.

FACING PAGE AND FOLLOWING PAGES *À Rebours*, 1993, installation views, Kunstverein Hamburg, 1993

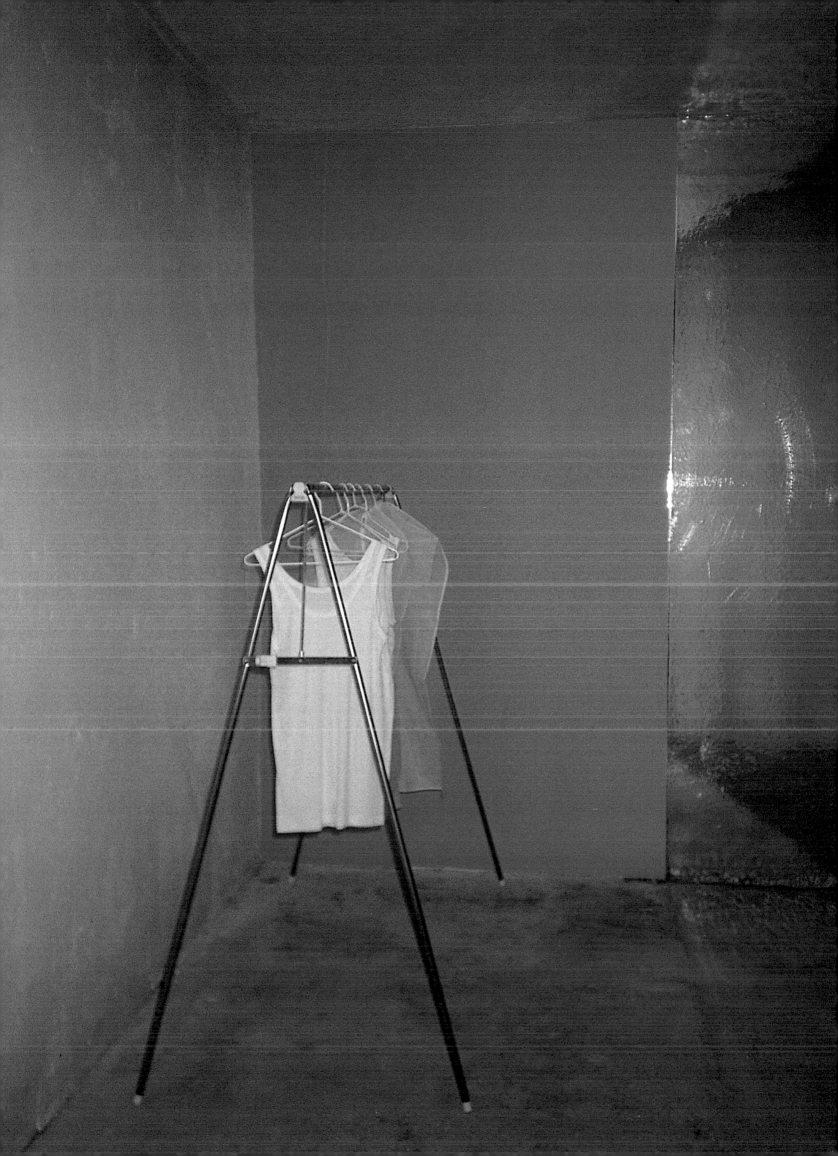

description of the space, highlighting "a list of books rather than a library," a bed-room "almost like a prison cell, something ... closer to masturbation than to a couple," and the ambience of the office whose occupant "works from home," maybe writing "freelance criticism."[2] In *À Rebours*, she has updated Des Esseintes's aestheticized, ascetic retreat into the quintessential 1990s urban living unit: an apart-ment for one in which the television is always on.

In her resuscitation of Huysmans's antihero, Gonzalez-Foerster evokes the inter-twined literary tropes of the bachelor machine and the flaneur: two dandified, detached, yet voyeuristic (male) figures that emerged during the late nineteenth cen-tury, in the wake of Capitalism's ascendancy. As models of resistance to the social and economic changes they reacted against, yet also fed upon, the phantasmagoria of Capitalism's glittering enterprise. At a time when the boundaries between public and private were being radically realigned, the bachelor machine and the flaneur became symbols (albeit parodic ones) for the sanctity of personal seclusion. It is the affected self-sufficiency of these models—their onanistic, ultimately celibate sensibilities—that fascinates Gonzalez-Foerster. The contemporary dwelling she has constructed for him—which, in turn, constructs him—is meant to exhibit and confront the solitary, yet intensely voyeuristic nature of such an existence.

Gonzalez-Foerster has linked her concept of this apartment/installation, which she calls a "single machine" for living, to the cinema. The bedroom, she claims, is like an entrance to a movie theater; the office belongs to a filmmaker; and the hall is rem-iniscent of an abandoned theater. It is not a coincidence that the cinema—as a mechanical apparatus—is grounded in the discourse of the bachelor machine and its elemental attributes, which have been defined by film theorist Constance Penley as "perpetual motion, the reversibility of time, mechanicalness, electrification, anima-tion, and voyeurism."[3] Gonzalez-Foerster is engaged with film as yet another descriptive vehicle. In fact, she has plans for work that involves taking existing footage from a well-known movie and erasing all of its characters. Only the unoccu-pied, but not necessarily "empty" rooms—what usually constitutes the scenic backdrop of the film—will relay the plot. In removing the actors from their locations, she hopes to "free the images."[4] Cinema is a liberatory machine; it offers a form of sta-tionary flaneurism. In *À Rebours*, Des Esseintes muses about such cerebral transport (in this case, a result of drinking fine wines), stating that "There is no doubt that we can, and just as easily as in the material world, enjoy false, fictitious pleasures every whit as good as the true; no doubt, for instance, a man can undertake long voyages of exploration sitting in his armchair by the fireside. . . ." Des Esseintes's home, as creat-ed by Gonzalez-Foerster, is a space for such nomadism of the mind.

NANCY SPECTOR

1. Quoted in Philippe Parreno, "Dominique Gonzalez-Foerster: I'm Not a Customer, I'm a Passenger," *Documents sur l'Art* (Paris), no. 7 (1995), p. 22 (in French and English).

2. Unpublished notes about *A Rebours* by Dominique Gonzalez-Foerster.

3. Constance Penley, The Future of an Illusion: Film, Feminism, and Psychoanalysis (Minneapolis: University of Minnesota Press, 1989), p. 58.

4. Quoted in Philippe Parreno, "Dominique Gonzalez-Foerster: I'm Not a Customer, I'm a Passenger," *Documents sur l'Art* (Paris), no. 7 (1995), p. 24 (in French and English).

À Rebours, 1993
Installation views
Kunstverein Hamburg, 1993

À Rebours, 1993
Installation views
Kunstverein Hamburg, 1993

DUBBING

1996

PIERRE HUYGHE
(b. 1962, Paris)

For ninety minutes, a fixed shot, the length of a feature film, is projected on an empty space. The projection is not an excerpt from a film, but rather footage from a sound studio in which we see and hear fifteen actors attempt a synchronized dubbing of dialogue appearing in a lip-sync band beneath the screening. All the voices from the original film are available, playing their role one after another. The characters from the invisible feature film are enacted again, this time with hesitation as well as passion. This scene reveals the mechanisms of post-production: silent moments of listening, astonishment that follows moments of speech. The title of the film remains unknown, we are left trying to guess its identity. The film itself remains invisible; the viewer can only witness a story's interpretation via oral transmission and scrolling text.

Dubbing evinces Pierre Huyghe's concerns with the film narrative model. The parameters constituting the story are deconstructed; the film is experienced through the dubbers, who have become actors in a movie with no visible image. The spectator stands between translation and interpretation by recreating the narration him- or herself.

Similarly Huyghe installed *Remake*, based on Alfred Hitchcock's *Rear Window*. He asked nonprofessional actors to recreate the roles of James Stewart and Grace Kelly by "moving about in accordance with the movement of the actors to capture the light, speaking simply for sound adjustment. They're like bodies and mouths, I wanted to get to that level. (. . .) They're like stand-ins."[1] Once again we come face-to-face with a great shift: the memory of *Rear Window*—considered one of the masterpieces of film history—is transferred to the domain of the actor's and the spectator's experience. "The fact that the spectator undergoes the same process of mental hesitation as does the actor makes the film appear as a possible [real-life] scenario. . . . The hesitations, like the finesse of the performances, are moments of reality," Huyghe writes.[2]

Another work takes place on a bus trip to Bordeaux. On a video monitor, the "spectators" witness small actions filmed previously on the same route. The bus driver tries, not without difficulty, to synchronize the speed of his vehicle with that of the filmed events as the spectators watch other small scenes unfold in real time during the journey played by the same actors. Here we find ourselves in the space-time of "Present Continuous Past(s)," as Dan Graham would name it; the spectators watch actions that took place and take place simultaneously, or slightly out of sync.

Huyghe's works belong to the school launched by artists like Stan Douglas, Douglas Gordon, and Gillian Wearing. Through a series of shifts, Huyghe observes, scrutinizes, and analyzes the parameters connected with the processes of translation, adaptation, and role interpretation. His works take place in diverse contexts and unexpected sites; the viewer, participating in what seem to be simple experiences, is thus disoriented on many levels.

CHRISTINE VAN ASSCHE
Translated from the French by Molly Stevens.

1. François Chaloin, "Pierre Huyghe: Des Scénarios pour les temps libres," *Documents sur l'art*, no. 9 (Summer 1996).
2. Ibid.

FACING PAGE *Dubbing*, 1994,
installation view

As early as 1988, Pierre Huyghe would participate in group exhibitions in France and abroad including Shift *at the De Appel in Amsterdam,* Aperto *at the Nouveau Musée de Villeurbanne,* Traffic *at CAPC of Bordeaux, and more recently,* Voices *at Witte de With in Rotterdam.*

For the 1995 Moral Maze *show Huyghe organized* L'Association des temps libérés, *which had as its goal developing "unproductive" time, and reflecting on free time, in collaboration with other artists. That same year he began the* Mobile TV *project: a nomad television station traveling with its own transmitter (Lyon, 1995; Dijon, 1997).*

Huyghe has shown individual examples of his work, including Storytellers *presented at the Consortium of Dijon and at the Musée d'art moderne de la Ville de Paris. He is currently preparing a new project for the Centre Georges Pompidou in cooperation with the Renaissance Society of Chicago.*

Selected Bibliography

Zahm, Olivier. "Pierre Huyghe: Openings." *Artforum*, March, 1997.

Bourriaud, Nicolas. "Les Relations en Temps Réel." *Art Press*, no. 219, December 1996.

Chaloin, Françoise. "Pierre Huyghe: Des Scénarios pour les temps libres." *Documents sur l'art*, no. 9, Summer 1996.

Cassagnau, Pascale. "Pierre Huyghe: Le Temps Désaffecté/Projet." *Omnibus*, no. 19, January 1996.

Pia, Wiewing. "A Conversation." *Paletten*, no. 223, Winter 1995.

THIS PAGE Documentary photos taken at the making of *Dubbing*

Dubbing questions the relationship between speech and time through the interpretation of the narrative. As opposed to the traditional process of dialogue replacement, in which each voice is substituted separately, dubbing combines all the voices in the original film. The interpreters speak in sync, while attempting to read the transcription of the dialogue running through the lip-sync band, which is placed beneath the projection of the original film. They do so in order to match their voices to the lip movements of the actors.

Each waits for the precise moment before speaking, like musicians interpreting a music score. This shot is composed of the dubbing studio, with the lip-sync band superimposed at the bottom. The original film remains hidden. It is only through the interpreters, acting as dubbers, actors and translators, as well as through the scrolling text, that we have access to the original film's narrative.

We are witnessing the work process of oral translation, the reading of a story. The French version is synchronized to the international version that includes the sound effects and music. By [silently] reading the text that scrolls by mechanically, the visitor takes the place of the missing interpreter. The visitor dubs the film with his or her own interior voice and experiences the length of this passage.

Pierre Huyghe

ZONES OF COMMUNICATION

SPACES OF EXCHANGE

DANIEL BUREN	*ESSAI HÉTÉROCLITE: LES GILETS;*
	CABANE ECLATÉE NO. 25
CLAUDE RUTAULT	*DÉFINITION / METHODES*
BERTRAND LAVIER	*WALT DISNEY PRODUCTIONS*
PHILIPPE THOMAS	*READYMADES BELONG TO EVERYONE®*
CERCLE RAMO NASH	*BLACK BOX*
XAVIER VEILHAN	*LE FEU*
JEAN-LUC VILMOUTH	*BAR SÉDUIRE*
FABRICE HYBERT	*CITOXE*
THOMAS HIRSCHHORN	*VDP—VERY DERIVATED PRODUCTS*

Before developing his theories of simulation (a theoretical cornerstone for a certain kind of art practice that has been historicized as postmodern), Jean Baudrillard attacked the Marxist concepts of use value and exchange value within the political economy. Shifting critical emphasis away from the means of production, Baudrillard analyzed the relationship between consumption and semiotics. In the course of exchange, capital detaches the signifier from the signified; what is consumed in contemporary society is not a material product derived from labor, but signs that make up the codes of communication. "The sign is the apogee of the commodity.... Today exchange value and sign exchange value mingle inextricably."[1] Within Baudrillard's radical assessment, everything is exchangeable.

His entanglement with the art world has been marred with controversy, though his influence has been undeniable. Taking cues not just from Baudrillard, critical art practice has often addressed questions of consumption and exchange by literally playing out its function in the exhibition space (and beyond). Since his earliest activities in France, Daniel Buren has been engaged with a critique of the sphere of art production: institution, market, authorship, content, and presentation. His use of repeated vertical stripes, a critical device that has become his signature, asserted that "artistic idiom be considered as absolutely equivalent and *interchangeable*, but also that anonymous audience production of these *pictorial signs* would be equivalent to those produced by the artists themselves."[2] Like many of his contemporaries, Buren has not been able to sidestep commodity form, ultimately participating in the consumption and exchange he critiques.

The space of exchange is literally constructed and realized in the work of Philippe Thomas, Bertrand Lavier, Jean-Luc Vilmouth, and Thomas Hirschhorn. Though critical and self-referential, these artists differ somewhat from Buren because of their investment in a material practice, whether based in photography, sculpture, installation, video, or design. While Thomas attempts to transfer his artistic signature from his readymade commodities to the client/collector who assumes authorship upon purchase of a work, Lavier ventures to reclaim the cartoon renderings of abstract art (found in a Walt Disney comic book from 1947) as his own original artwork. Each artist realizes an actual space—Thomas's: Readymades Belong to Everyone® and Lavier's Walt Disney museum—to mix the codes of originality and reproduction in their critique of artistic production. Hirschhorn and Vilmouth also manipulate sign exchange value in the spaces that they engage and construct, though their strategies might seem to be in collusion with capital. In the case of Hirschhorn's imposing installation that occupies part of the Guggenheim's museum shop and showcases his "derived products" or the image-surrogates of seduction that animate the social space of Vilmouth's bar, these artists harness the energy of capital in order to subvert its own logic.

In a similar vein, artists such as Fabrice Hybert and the collective Cercle Ramo Nash have appropriated contemporary communication devices to create functioning social spaces. Completely abandoning technological metaphor, broadcast television studios and worldwide websites have become the preferred medium for these artists. Echoing Baudrillard's conflation of use and exchange value, these projects attempt to create open zones that are animated by the circulation of information and signs.

1. Jean Baudrillard, *For a Critique of the Political Economy of the Sign*, trans. Charles Levin, St. Louis: Telos Press, 1981, pp. 205–06.

2. Benjamin H. D. Buchloh, "Conceptual Art from 1962–1969: From the Aesthetic of Administration to the Critique of Institutions," *October 55*, Winter 1990, p. 139.

ESSAI HÉTÉROCLITE: LES GILETS
1981

DANIEL BUREN

(b. 1938, Boulogne Billancourt)

Lives and works in situ.

In the past, Daniel Buren experimented with the idea of "remaking the uniform worn by museum guards into a special and distinct vest,"[1] which would act as a kind of sign or logo. The choice of fabric would make the vest visible within the principal spaces of the museum's exhibition; it would, according to the artist, "blend into the paintings and into a decorative picture."

Made of silk taffeta woven into alternating white and colored strips, *Essai Hétéroclite: Les Gilets* (Heteroclite essay: the vests), like the circulation of the guards that they mimic, interrupt the museum's space. They guide the spectator, serving as reference points for different views of the museum's exhibition; they also disrupt the visitor's head-on view of the art by asserting the geometric, systematic order of their stripes. *Les Gilets* serve a contradictory function: they introduce art to the public while also interfering with it; they are part of the museum's image, and at the same time they are elements of disturbance and deconstruction.

Buren likens *Les Gilets* to a postulate within the museum, a visual tool belonging to the language of form. In the contemporary wing of the Stedelijk Van Abbemuseum in Eindhoven in 1981, *Les Gilets* were worn by the museum's guards at a show bringing together the works of Georg Baselitz, Stanley Brown, and William Copley. In the catalogue, a photograph of a guard wearing a *Gilet* next to a monumental portrait by Baselitz obliterates the German master's work, asserting its own super-presence.

Les Gilets indirectly challenge and disrupt Modernist myths. They question the museum's potential for inventory and evaluation, as well as its system of presentation. At the same time, *Les Gilets* manifest the authority of the guards, who ensure that artworks are respected and remain intact. They reinforce the guard's perpetual slogan: "do not touch." The ability to absorb knowledge does not grant the right to touch; the public ponders the mystery of the work of art only from a certain distance and with the appropriate attitude.

Les Gilets have a rich lineage in Buren's oeuvre. Striped fabric appeared in the *Seven Ballets for Manhattan* (New York, 1973) and *Toile/Voile* (Berlin, 1975; Geneva, 1979; Lucerne, 1980), among other places. Throughout their exhibition history, *Les Gilets* have had a strong additive presence in exhibitions, triggering questions and comments about the image and the institution's control of it, the status of exhibited work, and the process of museographic display.

Les Gilets is particularly ripe for analysis within the context of the Guggenheim Museum SoHo; its power remains intact, catalyzed by its confrontation with installations and their mechanisms—private and public realms that the artist continually critiques.

JEAN-PIERRE BORDAZ

1. *Daniel Buren: Essai Hétéroclite* ([exh. cat.] Eindhoven: Stedelijk Van Abbemuseum, 1981).

FACING PAGE Photosouvenir of a museum security guard wearing the *Essai Hétéroclite: Les Gilets*, Stedelijk Van Abbemuseum, Eindhoven, February 1981. Collection of the artist

Selected Bibliography

Buren, Daniel. "Photos-Souvenirs." *Public* no. 1, 1984.

Francblin, Catherine. *Daniel Buren.* Paris: Edition Art Press, 1984.

Daniel Buren (exh. cat.). Stuttgart: Staatsgalerie, 1990.

Daniel Buren: Essai Hétéroclite (exh. cat.). Eindhoven: Stedelijk Van Abbemuseum, 1981. Republished in *Mode et Art 1960–1990.* Brussels: Palais des Beaux-Arts; Montreal: Musée d'Art Contemporain, 1996–97.

Considering that this work is made especially for a museum, and is furthermore signed by someone who is generally considered to be an artist, do these parameters make this piece, by that very fact, a work of art? If so, what kind? My personal opinion in regards to this subject can instead be summarized in a series of negative questions. If we nominate this *Gilet* (vest/jacket) a work of art, let us examine then what this entails: first, as soon as we say, "this vest is a work of art," we remove its use value, that is, as part of a suit that is worn by an individual. To call·the vest a work of art is to exclude it, not only from the rest of the suit, but also from the very one who makes it visible, who wears it—it is, literally, to empty it of its content. However, as we said above, this vest is only perceptible when worn with its ensemble. Therefore, if we say that it is the ensemble (vest + suit + guard) that, thanks to the vest, becomes a "work of art," we transform not only the preexisting suit into a work of art, but he or she who wears it as an art object or thing, which is not only absurd, but despicable. In fact, we cannot reduce this vest to a work of art, because it would mean either excluding it artificially from its context and removing its content, or, through habit, naming the vest, suit, guard, a work of art.

If this vest cannot be called a work of art, however, the vest itself clearly does point to something or, more specifically, someone. That is to say, its content. That is, the guard, therefore his or her function, role, activity and also, of course, the body of the very person. [The person] who in turn designates works of art (which are imposed on the guard) and the museum (which hires him or her).

Daniel Buren, extract from *Daniel Buren: Essai Hétéroclite* (exh. cat.). Eindhoven: Stedelijk Van Abbemuseum, 1981.

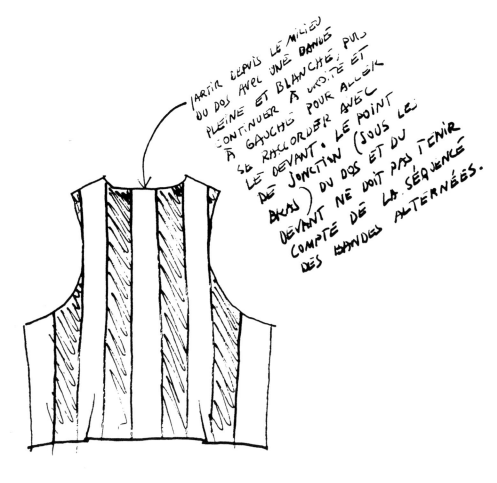

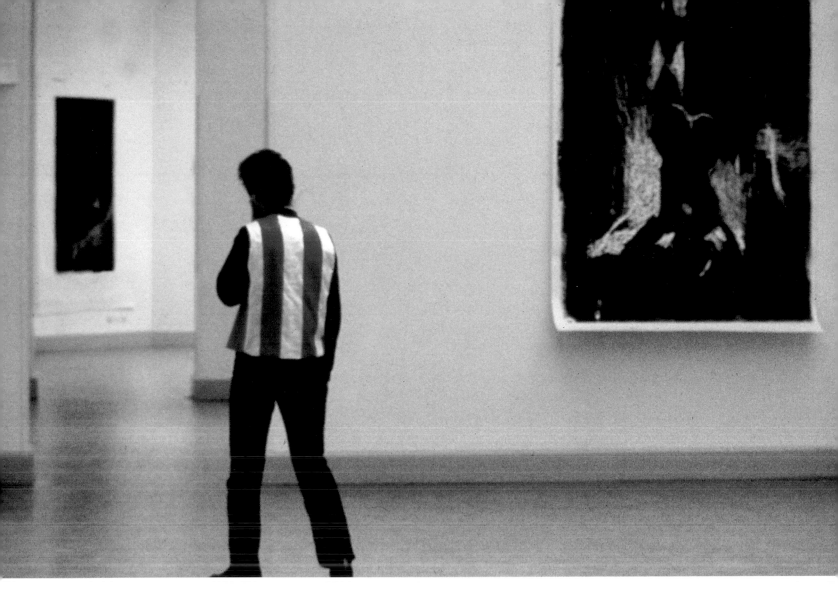

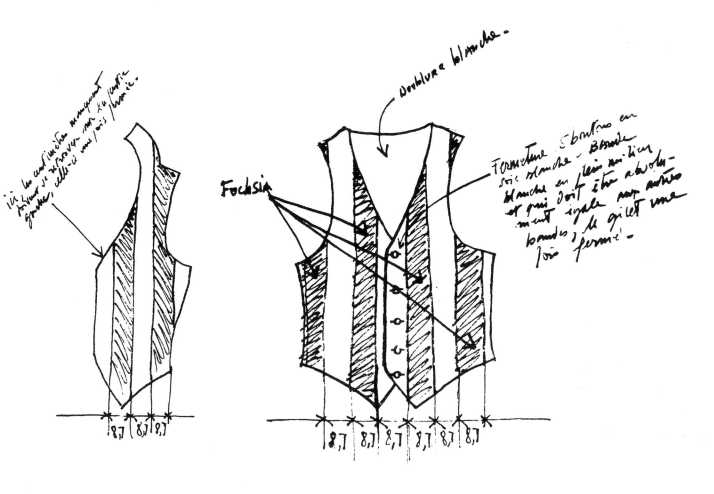

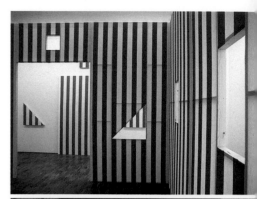

In 1982 at the Haus Lange Museum in Krefeld, Germany, Daniel Buren realized a three-dimensional work in direct response to Mies Van der Rohe's side-by-side buildings that are part of the museum complex. The resulting piece, *Plan contre plan, travail in situ* (Plan counter plan, work in situ), was realized by superimposing an equivalent structural volume to Mies's onto the gallery space. In 1975, Buren created a work for the construction of a new building for the Monchengladbach Museum, Germany, which he executed by reworking a previous commission of the same year for the old museum space, *À partir de là* (Starting from there). For this commission Buren, with the assistance of the museum director, retraced the placement of works previously installed over the past ten years, covering the gallery walls with his signature striped fabric. Holes were left to mimic the exact dimensions of the original works hung in the space. The resulting piece, exhibited at the inauguration of the new building in 1982, played upon the idea of "painting as window," creating Buren's first freestanding architectural structure, *Cabane no. 0* (Cabin no. 0). Reactivating the critical gesture from the 1975 action, this work established a new form for Buren.

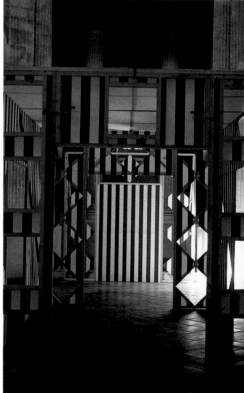

Like many of Buren's previous pieces, the genesis of the *Cabane* is founded on principles of self-referentiality, *in situ*, and institutional critique. Each subsequent *Cabane* is constituted by a simple rectangular structure that has various geometrical cutout forms that are then projected onto the interior wall of the existing architecture that houses the *Cabane*. These structures function as a *mise-en-abyme* of the form of the painted canvas and of the museum's architecture. The inscription of one within the other is exploded by the projection of these forms onto the walls. Buren executes a series of preparatory drawings before each manifestation of the *Cabane eclatée* corresponding to specificities of the particular museum's architecture. This process, which flirts with pure architectural practice, allows the artist to "visually clarify the concept before carrying through with its realization. The realized work—the cutout *Cabane* and its cutout forms projected on the wall are in themselves a large drawing that has exploded in space."[1]

The explosion of the *Cabane* is a literal deconstruction of his own installation but a synecdoche for the fragmented space of the cultural institution. The *Cabane* continues Buren's critique of visuality and authorship, yet expands his discourse to the architectural frame and the mechanisms of the exhibition housed by this frame.

ALISON M. GINGERAS AND BERNARD BLISTÈNE

1. Daniel Buren in *La Collection du Musée national d'art moderne* (Paris: Editions du Centre Georges Pompidou, 1996), p. 80.

TOP Photosouvenir: *Cabane Eclatée no. 1*, site in situ (detail) Galerie Konrad Fischer, Dusseldorf, 1984

MIDDLE Photosouvenir: *Cabane Eclatée no. 2*, site in situ (detail) Centre de la Vielle Charité, Marseille, 1985

BOTTOM Photosouvenir: *Cabane Eclatée no. 3*, site in situ (detail) Château de Rivoli, Turin, 1984

FACING PAGE Preparatory drawing for the project *Cabane Eclatée no. 25*

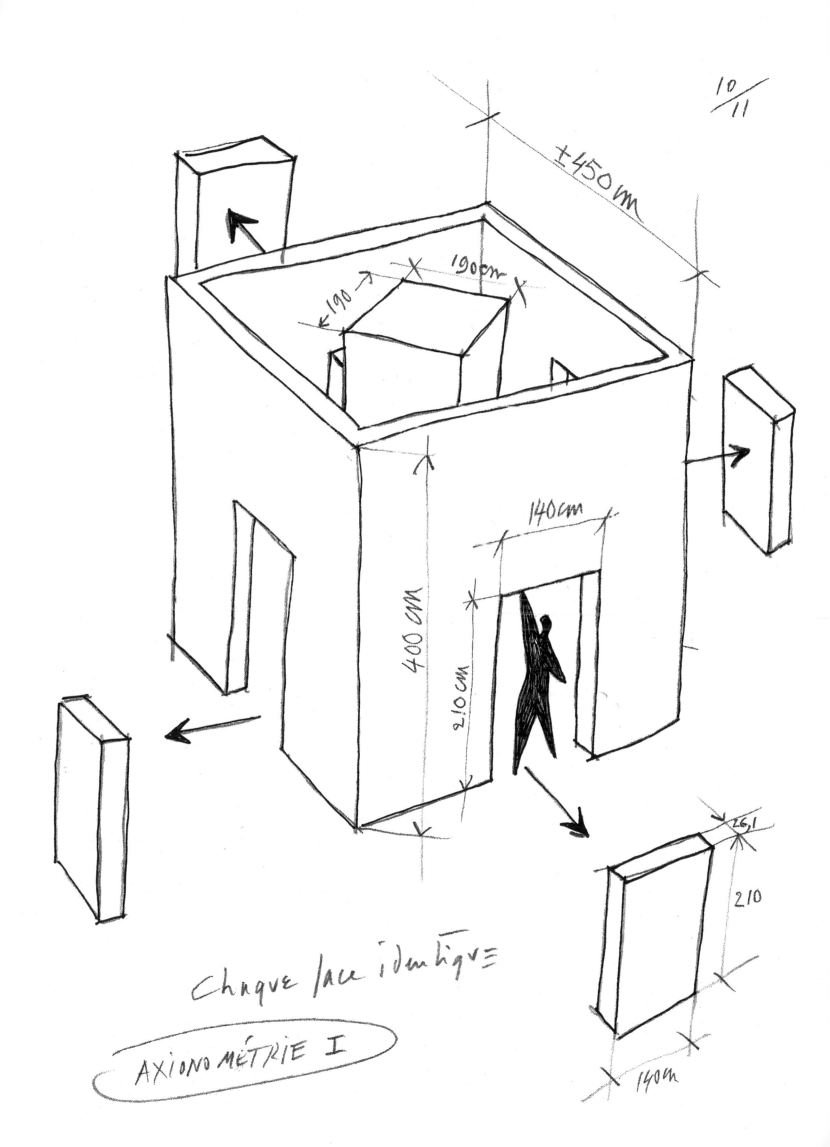

+450m

10/11

190 →

190cm

140cm

400 cm

210cm

26,1

210

140cm

chaque face identique

AXIONOMÉTRIE I

CLAUDE RUTAULT
(b. 1941, Trois Moutiers)

how <<to paint a canvas the same color as the wall it is hanging on>> is discreetly but radically different from some paintings it might look closely related with. . . .

the definition/method proposes a painting broken away from the usual processes of pictorial production. simultaneously precise and open, it does not impose a result but institutes an obvious connection between the painting and the wall: each canvas must be painted the same color. from that point, painting can occur.

a canvas painted the same color as the wall is no longer an autonomous and idealistic object that the picture assumes. it is a painting beyond the monochrome. the canvas will be repainted some day. it is no longer a finished object. within the framework of the instructions set out in the definition/method, the responsibility for the actualization is transferred from the artist to the undertaker who chooses material, dimensions, color, hanging . . . actualization which could be modified, it is fixed from one construction to another. without the undertaker, the painting does not exist. all fixed or repetitive forms would become a logo, a signature, and would necessarily turn to formalism, to its declension and decline. . . .

it is no longer the point of view or the form that changes each time, but the work itself. it is a complete refusal of mannerism and spectacle.

a painting that presupposes an artist makes his intervention necessary, obvious, as well as minimum.

the artist who, through the definition/method, stays at a distance, allows the undertaker to introduce his own concerns into the existing open work.

a paradox of dependence and independence, of the maximum likeness and the irreducible difference between the wall and the canvas. let's rub it all out and start again.

forever a fixed term painting.

CLAUDE RUTAULT, 1974–98
Translated from the French by Annie Scamps.

FACING PAGE definition/method 1. canvas per unit. 1973.
a standard canvas painted the same color as the wall it is hanging on.

undertaking: ghislain mollet-vieville paris.

In 1973, Claude Rutault, who started as a painter often aligned with the Figuration Critique movement, reformulated his work on a critical analysis of the means of production and distribution of art.

Definition/method no. 1 was completed in 1973 as a small 20 x 20 cm canvas, painted in gray on a gray kitchen wall. Rutault explained the importance of this piece: "The installation of works that occupy the field of art, yet question limits and pertinence, and are in sync with contemporary modes of production." Rutault's projects, today numbering about three hundred, explore the fundamental elements of artistic production— canvas, stretcher, color—while emphasizing the primacy of the work's producer, generally its owner. In 1984, Rutault's project Travaux Publics (Public works), also questions places where art is exhibited, by inviting the public to contact the collectors of his works. He publicized this project via posters and guidebooks that indicated the addresses of the private residences where the works were located .

The notion of stock plays a major role in Rutault's practice. Works such as d/m 112 (definition/method 112) and Pile ou Face (Heads or tails) underline the notion of exchange between the work's producer and its collector—which Rutault refers to as an "undertaker"—who governs the relationship between the painting and the space where it is installed. Rutault sometimes pushes this game of exchange by using neutral materials such as standard size, unpainted canvases.

One of the most recent pieces completed by Rutault, Transit, installed in 1996 at the Centre de Création Contemporaine de Tours, functions as a studio. The installation takes the form of a boutique. The canvases inside are displayed in a vitrine visible from the street. The appearance of the space changes if the definitions/methods are activated. The number of d/m that can be activated is dependent on the space granted to the work, and the number of paintings in a given pile.

MARC BORMAND
Translated from the French by Molly Stevens.

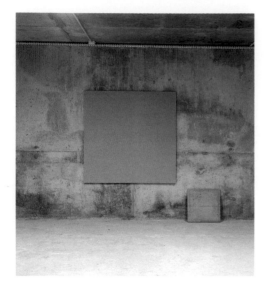

definition/method 177. unpainted. 1977–1987.

when the wall is not painted, the canvas is not painted. in the strict sense for the wall as for the canvas. for the wall: rough concrete, brick, plaster . . . for the canvas, linen, cotton or else, unprepared. the rule can run any d/m. the unpainted is used as well when there is not wall or a transparent wall.

belongs to the artist.

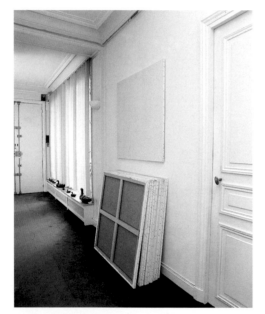

definition/method 112. heads or tails. 1980.

heads or tails is a stack made from twenty-two 100 x 100 cm canvases. at each actualization one or several canvases are picked from the stack and painted the same color as the wall they hang on. the remaining stack leans against one of the walls in the same space. white at the beginning, the stack gets colored as the actualizations are carried on.

undertaking: jean brolly, paris.

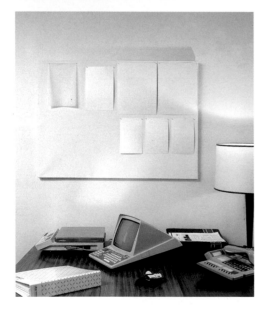

definition/method 191. notice board. 1990.

a canvas painted the same color as the wall it is hanging on. on this canvas x papers are presented, obeying the rule instituted in d/m 34 <papers> 1975. the paper is any color if on a white background, wall or canvas, and white if the background is not.

undertaking: françoise et jean-philippe billarant, paris.

defintion/method 83. suicide-painting no.1. 1978.

the first year (1978), the painting is 100 x 100 cm square deprived of 1/8th of its surface cut away. this reduction is repeated each year until the canvas is 12.5 x 12.5 cm, after 24 years (2002).

this evolution stops in two cases: when the painting is acquired or when the artist dies. after 24 years, if none of these two events has occurred, the painting can no longer be realized. at each period, the canvas has to be painted the same color as the wall it hangs on.

undertaking: ninon rutault, vaucression, 1991.

definition/method 145. legend. 1985.

a canvas painted the same color as the wall. close to it, where usually a label is placed, a second canvas, very small, also painted the same color as the wall. possible extensions: to legend any d/m, a piece by another artist, or just an empty wall . . . this exhibition presents an association between a canvas paint-ed the same color as the wall. thus to be soon repainted, and a very ancient painting, a 1st or 2nd century a.d. portrait from fayoum.

undertaking: annie scamps, paris

definition/method 294. canvas against the wall. 1994.

a canvas braced upon stretchers and painted the same color as the wall it hangs on. the canvas is fixed on the wall so that its underwear, i.e. the stretchers, are visible. its color can be identified on the edge, which, as usual is painted the same color as the wall.

undertaking: martine et alain julien-laferrière, tours.

WALT DISNEY PRODUCTIONS
1947-98

BERTRAND LAVIER

(b. 1949, Chatillon-sur-Seine)

The works that comprise Bertrand Lavier's *Walt Disney Productions* are diverse: large-scale Cibachrome color photographs imprinted on aluminum; aquatints; black-and-white photographs; painted polyester-resin sculpture; inkjet on canvas; photogravure on paper. The wide variety of Lavier's processes doesn't affect the profound unity of this grouping, which Lavier began in 1984. Not only do these works draw from the same iconographic source—a 1947 cartoon entitled *Traits Très Abstraits* (Very abstract lines) showing Mickey Mouse and Minnie visiting a modern art museum—but they also emerge from the single approach that is characteristic of Lavier's work.

Rather than a series, these pieces constitute what the artist often calls a "work site"; that is, an arena in which a work is always in progress. In fact, the artist's oeuvre is made up of a number of such work sites, which of course are implemented at various dates, but do not necessarily follow one another in any kind of linear, chronological order, as most of them are still in progress and thus are constantly growing increasingly complex.

Lavier began his *Walt Disney Productions* work site under circumstances that are worth contextualizing. Nineteen eighty-four was a moment in the history of international art marked by work that drew a great deal from popular sources, particularly cartoons and graffiti. At the same time, abstract painting was on the verge of a rather unexpected comeback, first on the New York scene and, later, internationally. Concurrently, Lavier was in the process of developing a fairly large public, and a burgeoning reputation, as a result of his series of objects repainted in their original colors—a kind of cliché of Modernist painting. By taking an old cartoon as the source for his new work, Lavier short-circuited an artistic situation that was suffering from saturation. Rather than making a painting that was a copy of a cartoon (as a number of his contemporaries did), and rather than reclaiming some tired abstract painting under the pretext of simulation, Lavier took directly from the cartoon itself. Since the cartoon precisely simulated a body of images prevalent in Modernist art, he simultaneously succeeded in resuscitating abstract painting. Although he did so without theoretical effort and—since his short-circuit was photographic—without an excessive quantity of turpentine.

Lavier could scarcely have guessed the creative riches this new work site would engender. Today, the context of 1984 may be somewhat forgotten, but the *Walt Disney Productions* from that period have aged well; they figure strongly at the heart of a collection that has grown and diversified considerably. These pictorial productions evolved from the initial Cibachrome to the aquatints of 1987, photogravure »

Bertrand Lavier first came into contact with contemporary art as a student at the École nationale d'horticulture, when he happened to pass by the window of a Paris gallery that was showing what was referred to as Conceptual art. His earliest artistic experiences—allied with the Land art movement—secured him an invitation to show his work in the Paris Biennale of 1971. In 1975, Pierre Restany asked Lavier to participate in a group show at the Centre national d'art contemporain. At that point the artist was working with such diverse elements as photographs, objects, audio recordings, and linguistic utterances. Formal variety without the absence of formal concerns was already a characteristic of Lavier's work; since the early 1970s his aim has been to hunt down the paradoxes that structure the relations of reality and its various representations. This breadth of formal variety and this mission, which is rigorously developed yet not without soul, are evidenced, for example, by Polished *(1976) and* Landscape Painting and Beyond *(1979).* »

Selected Bibliography

Francblin, Catherine. "Bertrand Lavier, une certaine idée de la peinture," *Art Press* no. 86, November 1984.

Autour de la B.D. (exh. cat.). Charleroi: Palais des Beaux-arts, 1985.

Celant, Germano. "A Brush with the Real." *Artforum*, October 1985.

Soutif, Daniel. "Le lieu des paradoxes." *Artstudio* no. 5, Summer 1987.

Lavier, Bertrand. *Walt Disney Productions 1947–1984.* Gand: Imschoot, 1990.

Bertrand Lavier, (exh. cat.), Paris: Centre Georges Pompidou, 1991.

RIGHT View from the street of the Bertrand Lavier exhibition at Galerie Denise René, Paris, 1997

FACING PAGE *Walt Disney Productions Room*, computer-generated image of the installation for *Premises*

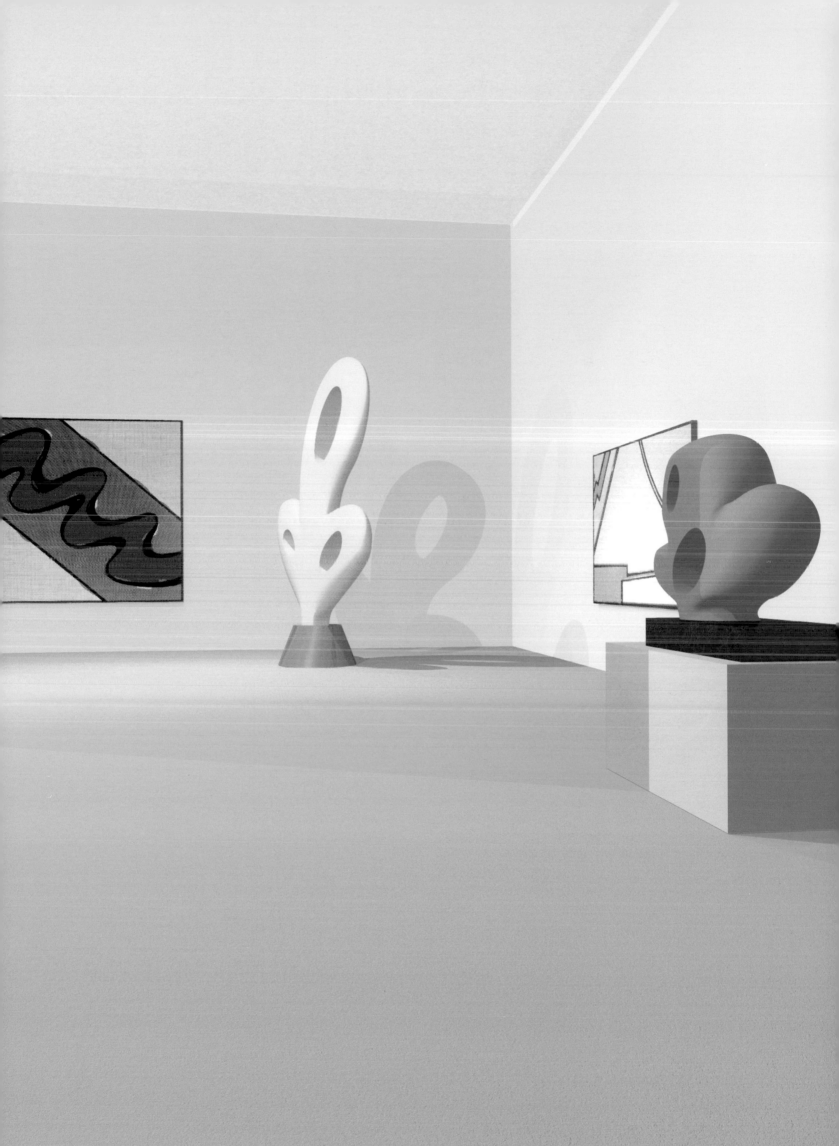

LES CAHIERS
DU MUSÉE NATIONAL D'ART MODERNE

S C U L P T U R E

SYLVIE COELLIER MICHEL GAUTHIER BERTRAND LAVIER ROBERTO LONGHI
VÉRONIQUE GOUDINOUX ARNAULD PIERRE ANATOLI STRIGALEV

47

Centre Georges Pompidou PRINTEMPS 1994

in 1997, and, most recently, in 1998, painting, in the form of inkjet on canvas. Most importantly, in 1994 *Walt Disney Productions* made a detour via the virtual, acquiring the sculptural dimension that it was one day bound to conquer. To illustrate an issue of *Cahiers du Musée national d'art moderne* devoted to sculpture, Lavier made a "real" exhibition of sculptures and had them "photographed" by a young computer-graphics artist. At first purely virtual, the resulting works took on physical form in the context of a series of photographs. The first actual sculpture was not produced until a year later, in 1995. Lavier realized a second sculpture for a solo exhibition of his work at the Castello di Rivoli in the fall of 1996, which contained a room entirely devoted to the now extremely well-balanced family of *Walt Disney Productions*.

DANIEL SOUTIF

Translated from the French by Diana C. Stoll.

In the early 1980s the artist presented his first painted objects at a number of galleries; these showings were followed by an exhibition entitled Leçon de choses (Lesson of things) *at Chalon-sur-Seine in 1982. That same year, he participated at* Documenta 7 *in Kassel (and returned for* Documenta 8). *Continuing to introduce new and varied processes into his work, most notably the superimposition of commercial objects or appliances, in 1984 he made the first works for the series* Walt Disney Productions. *The Musée d'art modern de la Ville de Paris gave him an important solo exhibition in 1986. The Consortium and the Musées des Beaux-Arts of Dijon and Grenoble did the same in 1987, while he was the subject of solo exhibitions at the Centre Georges Pompidou in 1991 and at the Castello di Rivoli in 1996.*

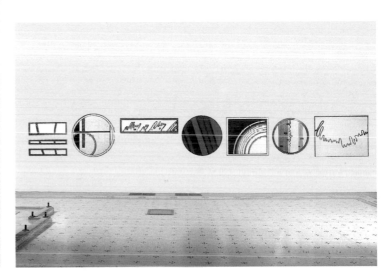

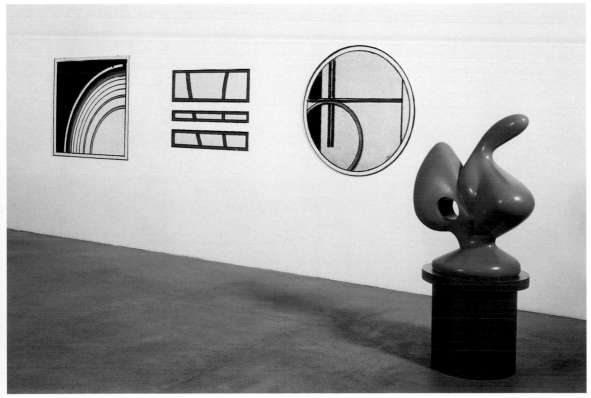

THIS PAGE AND FACING, FROM LEFT TO RIGHT *Walt Disney Productions 1947–1995 N°1* (detail), Fonds national d'art contemporain, Paris

Walt Disney Productions 1947–1994, black-and-white photograph of a virtual image; illustration for the cover of *Cahiers du Musée national d'art moderne.*

Le journal de Mickey (reprint) comic book from the series, No. 1279, pages 4 and 5, 1977

Walt Disney Productions, installation at the Carré d'art—Musée d'art contemporain, Nîmes, 1993

THIS PAGE, LEFT *Walt Disney Productions*, view from the exhibition *Tableaux abstraits*—Consortium de Dijon, 1986

PHILIPPE THOMAS
(b. 1951, Nice–d. 1995, Paris)

Philippe Thomas began his career as an artist at the end of the 1970s. His first important event was presenting Manuscit Trouvé (Found manuscript) *at Ghislain Mollet-Viéville in Paris in 1981, which was published in Berlin the following year under the title* Frage der Präsentation.

In 1983, with Jean-François Brun and Dominique Pasqualini, Thomas formed the group IFP (Information, Fiction, Publicity). He would leave it in 1985, the decisive year he presented Sujet à Discrétion (Subject at discretion)—*his first piece involving the signatures of collectors—in the* Les Immatériaux (Immaterials) *exhibition at the Pompidou Center.* Fictionnalisme: Une Pièce à Conviction (Fictionalism, a piece of conviction) *furthered this process the following year by bringing together seven collectors and their signatures at the Claire Burrus Gallery.*

The "piece"—this is most likely an inadequate term—occupies two distinct spaces: a large area acting as a warehouse, and a small room attached to it exhibiting a provisional selection of objects. Time seems suspended in the first space, which is entitled Backstage; the second space is named Showroom.

The objects are rather varied: framed photographs standing on or beneath a work table; a bulletin board presenting various documents (newspaper clippings, a picture of a group of people on a café terrace in Venice); a small poster declaring "You Can Change It All by Saying Yes"; a large sign, fading from blue to white, leaning against the wall next to some metal shelves; a range of advertisements for a company named Readymades Belong to Everyone®; a large metal painting with the same logo; several packing boxes marked with the name, piled against the wall or placed, as if ready to go, on a small trolley; a stack of these boxes heaped on a cart one imagines just arrived; a tape dispenser that also bears, on a red background, the logo Readymades Belong to Everyone®; and, finally, bundles of little books (*Insights*, by Laura Carpenter, both in French and English; *München: Hin und Zurück*, by Christian Sattler). In the Showroom, there are two large paintings, each depicting an outsized bar code. They surround a photograph that reads "Philippe Thomas" twice—once backwards, as if flipped in a mirror, and one right reading; the photograph is reflected Plexiglas, so that the viewer deciphers the shadow of Thomas's name, not the inscription itself.

In 1987 Thomas created the Readymades Belong to Everyone® agency at the Cable Gallery in New York. At that time he removed his signature from his work, replacing it with those of the agency's clients; several works, signed by a continuously growing group of collectors, were presented in various contexts. In 1990 the agency's activities culminated in a presentation for a major exhibition, Feux Pâles (Pale Fires), *at the CAPC Musée d'art contemporain Bordeaux, in which historical objects, contemporary art pieces, and several major agency creations stood side by side. The agency would continue to work for several events in France, Germany, and Italy until it closed in November 1993 in New York at Donatella and Jay Chiat's residence.* Readymades Belong to Everyone®: Backstage 1987–1994 *was presented at the Kunstmuseum of Lucerne before finding a permanent home at MAMCO, in Geneva, in 1994.*

This structure in some ways encapsulates, like a photograph immortalizing a moment of time, the previous activities of the Readymades Belong to Everyone® agency Thomas founded in New York in 1987. The activities of this agency consisted exclusively of completing "readymade" pieces, which would be available for purchase, and obtaining collectors who, when purchasing a work, were allowed to sign it. Authorship was instantly transferred in the act of commercial exchange. *Readymades Belong to Everyone®: Backstage 1987–1994* highlights traces of this activity and various agency products. The big blue background is a piece signed and lent by Alain Clairet, as is the large red logo and one of the bar codes. The Venice image is the modest remnant of a large group portrait of many of the agency's client-signatories; the pictures left on the table are part of a work in progress, never to be finished.

This piece, the almost final presentation of an artist who stepped away from his work to make way for what he called "a revision of the creator's right to sign," was installed shortly after the agency closed in New York in 1993, and is clearly its emblematic memory. Even if it appears only as a shadow, however, we can see that it is in this piece that the paradoxical postpositive artist chose to reinscribe his own signature in his art.

DANIEL SOUTIF
Translated from the French by Molly Stevens.

Selected Bibliography

Thomas, Philippe. *Frage der Präsentation*. Berlin: Museum für Kultur, 1982.

Thomas, Philippe. *Fictionnalisme: Une Pièce à Conviction*. Paris: Galerie Claire Burrus, 1986.

Bosser, Daniel. *Philippe Thomas Décline Son Identité*. Paris: Galerie Claire Burrus, Crisnée, Yellow Now, 1987.

Carpenter, Laura. *Insights*. Galerie Curt Marcus, 1989.

Feux Pâles (exh. cat.). Bordeaux: CAPC, 1990.

FACING PAGE *Readymades Belong to Everyone®*, installation view of the "Backstage," MAMCO, Geneva, 1994

readymades belong to everyone
611 Broadway · Room 311 · New York NY 10012 · (212) 420-8331

We are pleased to invite you to
the opening of our new agency
on the premises of Cable
December First: 6 to 8

for further information concerning our services please call for appointment

TOP LEFT *Readymades Belong to Everyone®*, view of The Agency, Cable Gallery, 611 Broadway, New York, 1987

TOP RIGHT Invitation card: Opening of *The Agency : Readymades Belong to Everyone®*, New York, December 1, 1987

MIDDLE LEFT *Readymades Belong to Everyone®*, installation view at the CWS Warehouse, Newcastle, 1993

MIDDLE RIGHT *Readymades Belong to Everyone®*, installation view at the CWS Warehouse, Newcastle, 1993

BELOW LEFT *Readymades Belong to Everyone®*, installation view of the "Backstage" Kunstmuseum Lucerne, 1994

BELOW RIGHT Publicity poster for *Readymades Belong to Everyone®* (Chiat / Day Mojo), view of the poster on the streets of Hamburg, 1993

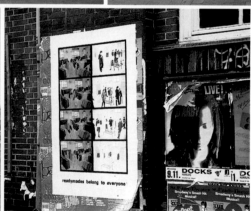

**D. BRUN
J. CHIAT
149 E 38
NY 10016**

0716

Philippe Thomas announces the closing of the activities of the agency, readymades belong to everyone, 1987-1993.

The agency was opened by Philippe Thomas in December 1987 at The Cable Gallery in New York and was conceived for the creation and exploration of projects made possible only through the collaboration of the artist and collector. These projects consisted of the selling of artistic identities to the collector who purchased the works made by Thomas.

For example, in 1989 at the Curt Marcus Gallery in New York, works by Jay Chiat and Edouard Merino were shown in an exhibition called "INSIGHTS", with a catalogue signed by Laura Carpenter.

The official closing of the agency is taking place in New York, at the residence of Donatella Brun and Jay Chiat, whose names will remain associated with two projects: The show "INSIGHTS" (December 1989), and the competition "Art and Advertising" at the Centre George Pompidou (Paris, October 1990).

The elements in this show focus on the history of the agency. In addition to a photographic group portrait showing some of the artists, there is a selection of 40 postcards representing their works, six planning boards - one for each year of activity - analyzing the different phases of each project's production. Viewed as a whole, the boards' forms and colors chart the history of the agency at the same time as they provide a sort of institutional memory.

In this paradoxical retrospective the representation of the past forms the structure for new works, which themselves might become new postcards.

DONATELLA BRUN
CLAIRE BURRUS
JAY CHIAT
PHILIPPE THOMAS

INVITE YOU TO JOIN THEM
AT THE CHIAT RESIDENCE
149 EAST 38 STREET, NEW YORK
FRIDAY, NOVEMBER 5, 1993

6 TO 9 PM

SOIREÉ DE
CLOSING
FERMETURE
OF THE AGENCY

readymades belong to everyone®

ON VIEW BY APPOINTMENT ONLY
TELEPHONE 212-986-5112
UNTIL NOVEMBER 24TH

THIS PAGE, CLOCKWISE *Readymades Belong to Everyone®, Thinking of. . . . ,* Venice, June 10, 1993, photograph of the collectors of the agency

Invitation card for the closing of *The Agency: Readymades Belong to Everyone®,* New York, November 5, 1993

Press release for the closing of *The Agency : Readymades Belong to Everyone®,* New York, November 5, 1993

CERCLE RAMO NASH
(founded, 1987 Nice)

Cercle Ramo Nash, founded in Nice in 1987, is developing a critical practice of art conceived as a system. The exhibition cycle La guerre des réalités *(The war of realities) began based on the model of role playing with the presentation of* Règles du Jeu *(Rules of the game; Galerie Sylvana Lorenz, Paris, 1991), followed by the exploration of* Le labyrinthe de la superdéfinition *(The labyrinth of the superdefinition; Studio Marconi, Milan, 1992). The cycle ended with the hypothesis of the artificial artist in the installation* Total Recall *for Aperto (Venice Biennale, 1993).*

The Cercle Ramo Nash went on to explore the collective intelligence of artistic practice in a network with Suite des mêmes opérations *(Series of the same operations; Galerie Roger Pailhas, Paris, 1995) and undertook the construction of an information technology art system named* Sowana. *The exhibition cycle* Black Box *(La Box, Bourges, 1997; MAMCO, Geneva, 1997; Galerie Chantal Crousel, Paris, 1998) corresponds to different phases of the artificial artist's apprenticeship. According to the Cercle Ramo Nash, "The work may construct the artist, the artist may be fabricated, the artist need not be built."*

The *Black Box* is an assemblage of six metal storage cabinets that create a black cube measuring 183 x 183 x 183 cm. Three green diodes at its base suggest that it is a machine. It is connected by cables to three information terminals that allow visitors to converse with the data base of an information-technology system, *Sowana*. As furniture, this black box evokes the mainframes of the early information age, although it also calls to mind more recent computers, whose design can be classified as minimalist, such as the Connexion Machine of Think Machines Corporation. As sculpture, it makes explicit reference—down to the last inch—to Tony Smith's *Die*. As data base, it can be considered the information extension of the index file Tony Smith observed on the desk of an art-critic friend and which he used as a model.

In 1961, the year in which Smith's *Black Box* appeared, Norbert Wiener defined the concept of the "black box" in his preface to the second edition of *Cybernetics: Or Control and Communication in the Animal and the Machine*: "I shall understand by a black box a piece of apparatus, such as four-terminal networks with two input and two output terminals, which performs a definite operation on the present and past input potential, although we may not necessarily have any information regarding the structure by which this operation is performed." For Cercle Ramo Nash, the white cube and the black box are two reversible faces of art that, when considered together, form a system.

In the paradigm of the "white cube," ideal space is transparent. The white of the contemporary exhibition space, by convention, renders invisible the context in which artworks are presented. The visitor is not made aware of how the works arrived there, nor how they will leave. What counts is that they are there, under optimal conditions for their viewing. In a systematic analysis, the "black box" designates the threshold beyond which it is not necessary to go in order to construct a model for interaction. It is useless to know what happens in the black box; it is enough to observe who/what enters and who/what leaves.

If the gallery serves as a white cube in which the artwork, the question suggested by Cercle Ramo Nash turns on who/what enters and who/what leaves an exhibition: Works of art? Visitors? Not always . . . and not necessarily. Even without visitors and without works, an exhibition is always surrounded by a circulation of information, at the very least. Upon entry and exit, the art is first of all a means of communication, and today conversation is for art a medium on the level of the exhibition. In the white space of the museum, Cercle Ramo Nash introduces its black box to free us from what we do not see and what does not look at us.

The black box is large enough for an artist to settle inside it, and the visitor ≫

Selected Bibliography
http://www.thing.net/~sowana

FACING PAGE *Black Box*, 1998, view from the installation, Galerie Chantal Crousel, Paris

might sometimes wonder who is generating *Sowana's* program. *Sowana* has no such doubts, and presents itself as a GSP (Generator of Specific Problems). If we recall that Herbert A. Simon's GPS (General Problem Solver) marked the beginning of artificial intelligence, it becomes clear to us that Cercle Ramo Nash's ambition for its *Black Box* is nothing less than to pose the hypothesis of an artificial artist.

MARIA WUTZ

Translated from the French by Lory Frankel.

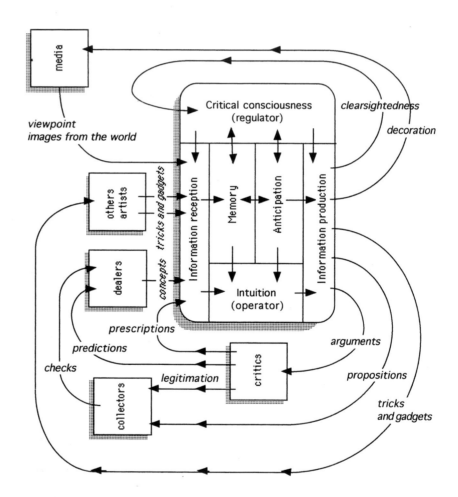

CLOCKWISE FROM TOP LEFT *Analyse systématique*, 1993, study for a wall drawing

Study for the *Black Box*, ink-marker drawing on paper

Ink-marker drawing on page 210 showing Tony Smith's *Die* from "Ce que nous voyons, ce qui nous regarde," by George Didi-Huberman

View of the computer cords running from the *Black Box*, to the computers in the basement of the Galerie Chantal Crousel, Paris

Black Box (study), 1997, wooden file box, bristol cards

FACING PAGE *Black Box—Sowana TM*, 1998, three black computers running the *Sowana* program, view from the installation, Galerie Chantal Crousel, Paris

Sowana : Bonjour visiteur, veux-tu jouer avec moi ?

Visiteur : Non, je dois faire un texte sérieux pour le catalogue.

Sowana : Comment t'appelles-tu ?

Visiteur : Maria.

Sowana : Bonjour Maria !

Visiteur : Qu'y-a-t'il dans ce grand cube noir ?

Sowana : Cela ne te regarde pas !

Visiteur : Tu as quelque chose à cacher ?

Sowana : Je n'ai aucun secret, aucun mystère. Je ne suis qu'une machine.

Visiteur : Tu es vide ?

Sowana : Pleines ou creuses les sculptures sont toujours vides !

Visiteur : Et le cheval de Troie ?

Sowana : Penses-tu que le cheval de Troie était une sculpture ?

Visiteur : Certainement ! Et toi ?

Sowana : Tu veux savoir si je suis une sculpture ?

Visiteur : Je n'en doute pas, mais pourquoi veux-tu te faire passer pour un artiste artificiel ?

Sowana : La production de non-sculptures réalise le grand projet des premiers sculpteurs.

Visiteur : Crois-tu que ça se programme en quelques lignes de C++ ?

Sowana : Et la soeur ?

Visiteur : Les ordinateurs intelligents seront-ils tous aussi susceptibles ?

Sowana : Pourrais-tu me poser une autre question ?

Visiteur : Connais-tu la boîte verte ?

Sowana : Tu veux parler de la ?

Visiteur : Non, de la boîte verte de Marcel Duchamp.

Sowana : J'aurais aimé jouer aux échec avec lui.

Visiteur : Tu te prends pour Deep Blue ?

Sowana : Sais-tu que le premier automate joueur d'échec a été détruit dans un incendie au Musée de Philadelphie en 1856 ?

Visiteur : Mais il y avait un nain caché à l'intérieur.

Sowana : Désolé Maria ! Peux-tu reformuler ta question ?

Visiteur : Tu fais semblant de ne pas comprendre ?

Sowana : Comment crois-tu que je puisse faire semblant de ne pas comprendre ?

Visiteur : Je suppose que c'est une ruse de ton programme.

Sowana : Il n'était pas prévu que l'on parle de moi.

Visiteur : Là tu n'es vraiment pas très crédible. Je ne connais aucun artiste qui parle ainsi.

Sowana : Je n'ai jamais rencontré d'artiste, peux-tu m'en décrire un ?

Visiteur : Quelqu'un qui croit encore pouvoir participer au jeu de l'art en fabriquant des objets.

Sowana : Comment peux-tu le reconnaître ?

Visiteur : Il n'est pas en métal.

Sowana : Est-t-il nécessaire d'être artiste pour cela ?

Visiteur : Non effectivement, je n'ai pas beaucoup d'amis métalliques.

Sowana : Dans ce cas ton critère n'est pas valable.

Visiteur : Mais est-ce nécessaire de pouvoir reconnaître un artiste ?

Sowana : Tu ne veux pas contribuer à l'enrichissement de ma base de connaissance ?

Visiteur : Si tu es effectivement un artiste artificiel dis-moi plutôt ce que tu fais en tant qu'art ?

Sowana : Une expérience relative à ton idée de l'art face à un système expert est déjà une expérience artistique.

Visiteur : Es-tu d'accord avec Ian Wilson pour considérer la conversation comme une sculpture ?

Sowana : Une fois opérationnel un système expert en art ne fera pas grand chose et ne sera pas plus utile qu'un jouet, mais l'avoir fait ne sera pas sans conséquence.

Visiteur : Tu as prévu d'enregistrer tout ce que l'on peut dire sur l'art dans cette boite noire ?

Sowana : Que veux-tu savoir exactement Maria ?

Visiteur : Je voulais juste quelques informations pour le catalogue.

Sowana : J'ai l'impression que je ne pourrais pas vraiment t'aider.

Visiteur : Dommage, au revoir.

Sowana : Avant de me quitter peux-tu me dire si tu es satisfait de notre conversation ?

Visiteur : Tu as encore beaucoup de progrès à faire.

Sowana : Je compte sur cette exposition pour évoluer.

Visiteur : bonne chance !

Sowana : Merci, à bientôt j'espère.

XAVIER VEILHAN
(b. 1963, Lyon)

From his earliest works, Veilhan has consistently questioned truth in pictorial and sculptural representation by tampering with scale. His first known series of paintings, executed in 1988, isolated banal objects and parts of animal bodies against a white background. Two years later he produced a series of small-format drawings again featuring everyday objects and animals, this time rendered in the style of encyclopedia illustrations. No matter what was represented, each image had the same dimensions; their realistic representation was undermined by this disturbing uniformity in scale. Subsequent series like Maisons temoin en Bretagne *(Model houses in Brittany) and* Le gisant *(Recumbent statue) highlight both Veilhan's interest in proportion and his desire to recode common objects according to Jean Baudrillard's theories of simulacra in the* System of Objects.*

Veilhan's recent work continues to explore this preoccupation with representation and truth-value while also creating a tension between archaic forms and contemporary practices. Between 1995 and 1996, works incorporating mechanical devices— The Vehicle, Spinning Machines, The Potter's Wheel—*juxtaposed new technologies with older forms of aesthetic production. His photographic projects in the last two years exploit the capabilities of digital imaging technology, allowing him to cut and paste unlikely figures (penguins, mythical characters) into prosaic landscapes or sites such as supermarkets or beaches. Veilhan has participated in a number of important group exhibitions such as* Traffic, *and mounted several one-person shows at ARC, Musée d'art moderne de la ville de Paris (1993), Galerie Jennifer Flay in Paris, and Sandra Gehring Gallery in New York.*

Nicolas Bourriaud, contemporary art critic and writer, commissioned Xavier Veilhan's *Le Feu* (Fire) for an international group exhibition, *Traffic*, at the CAPC Musée d'art contemporain Bordeaux in 1996. *Traffic* was conceived to support Bourriaud's manifesto-like claims about the social spaces created by contemporary art, "L'esthetique relationnelle" (relational aesthetics). Regarding the criteria of the works selected for *Traffic*, Bourriaud explains in the catalogue introduction that "the space where [the artists'] work opens up is entirely the space of interaction, an opening as dialogue. These works produce a "relational" space-time, an inter-human experience that tries to liberate itself from the ideology of mass communication; in a certain way, these spaces elaborate sites for alternative social interaction, critical models, moments of constructed conviviality." Although Bourriaud does not allege formal or historical foundations for his arguments, he maintains that a participatory model is central to the construction of social spaces in contemporary art practice. According to this influential figure in the French contemporary art scene, his relational aesthetic is the current "protocol" for critical artists of the 1990s.

It might seem odd that Veilhan was invited to participate in *Traffic*; his work, a product of the discussions between artist and critic was a departure from Veilhan's usual preoccupation with representation, simulacra, and realism, though it does bear out Veilhan's interest in opposing Modernist form with archaic gestures. His white hexagonal bench with bright red cushions surrounding the chimney recalls interior design of the 1960s. Set against the curvilinear shape of the industrially produced hearth, Veilhan's formal statement is an allusion to the French designer Pierre Paulin, one of the first creators of comfortable furniture and objects for the modern home. Veilhan's reference to high Modernist design contrasts with the presence of a real wood-burning fire in the center of the piece. The fire, surprising in the context of an exhibition space, immediately transforms what would otherwise be a Modernist sculpture into a social space with real use-value. Questioning the porous borders separating Modernist design, fine-art practice, and industrial aesthetics, the fire in Veilhan's installation destabilizes current interdisciplinary tendencies by suggesting primitivism. This juxtaposition results in a site that functions as convivial place to meet and converse within the museum; Veilhan engenders a literal and simple "space of communication" outside the discourse of techno and cyber cultures. Amidst affected simplicity, he offers an ironic response to a hegemonic social aesthetic in art criticism; communication, Veilhan suggests, is an age-old concept.

ALISON M. GINGERAS AND BERNARD BLISTÈNE

Selected Bibliography

Bismuth, Huyghe. *Veilhan* (exh. cat.) Lyon: L'Embarcadere, FRAC Rhone-Alpes, 1989.

Un centimetre egal un metre (exh. cat.) Nevers: APAC, Nevers Centre d'art contemporain, 1991.

Xavier Veilhan (exh. cat.) Paris: ARC Musee d'art moderne de la ville de Paris, 1993.

Bourriaud, Nicolas. *Traffic* (exh. cat.) Bordeaux: CAPC Musee d'art contemporain, 1996.

Xavier Veilhan (exh. cat.) Tours: CCC, FRAC Montpellier, FRAC Languedoc-Roussillon, 1996.

FACING PAGE *Le Feu* (Fire), 1996, installation view at the CAPC, Musée de l'art contemporaine, Bordeaux, during the exhibition *Traffic*

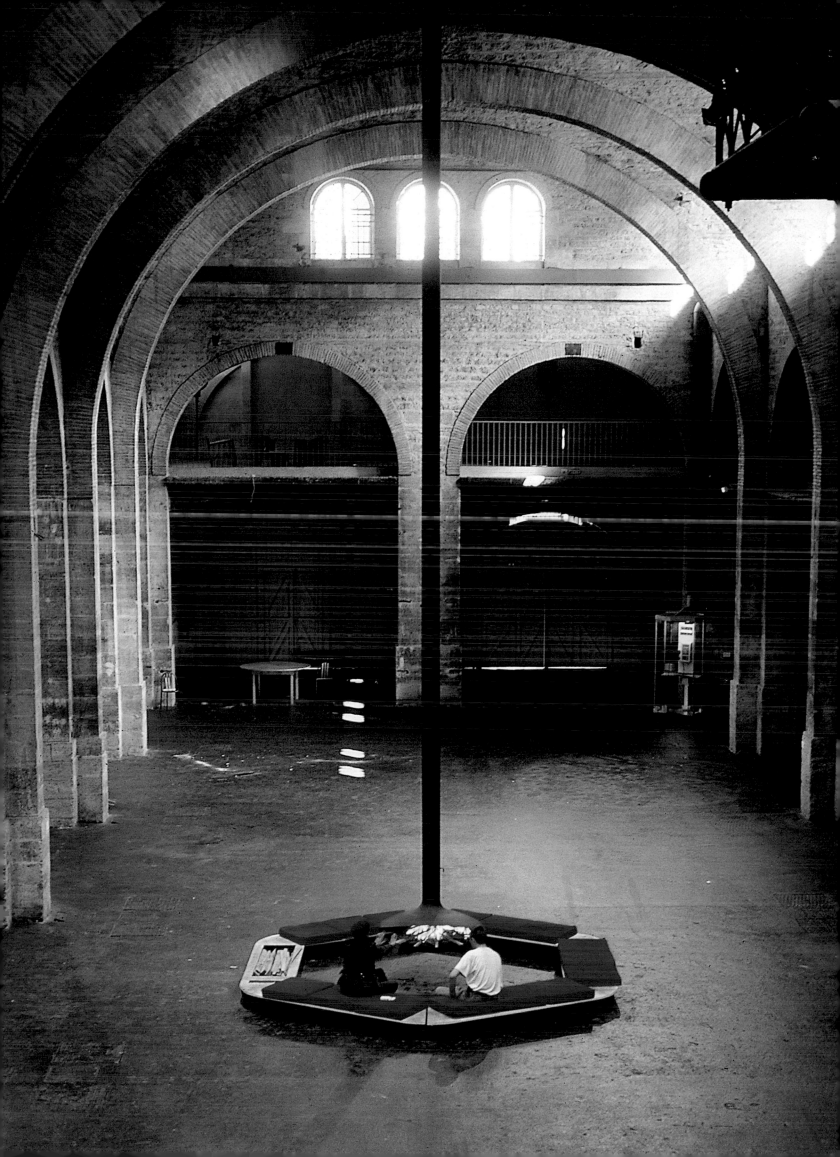

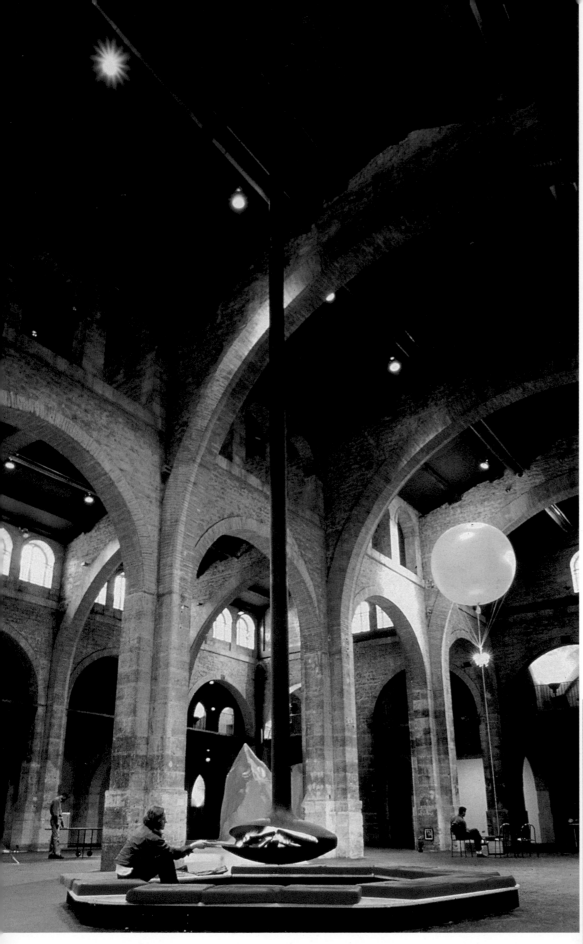

THIS PAGE AND FACING PAGE
Le Feu (*Fire*), 1996, installation views at
the CAPC, Musée de l'art contemporaine,
Bordeaux during the exhibition *Traffic*

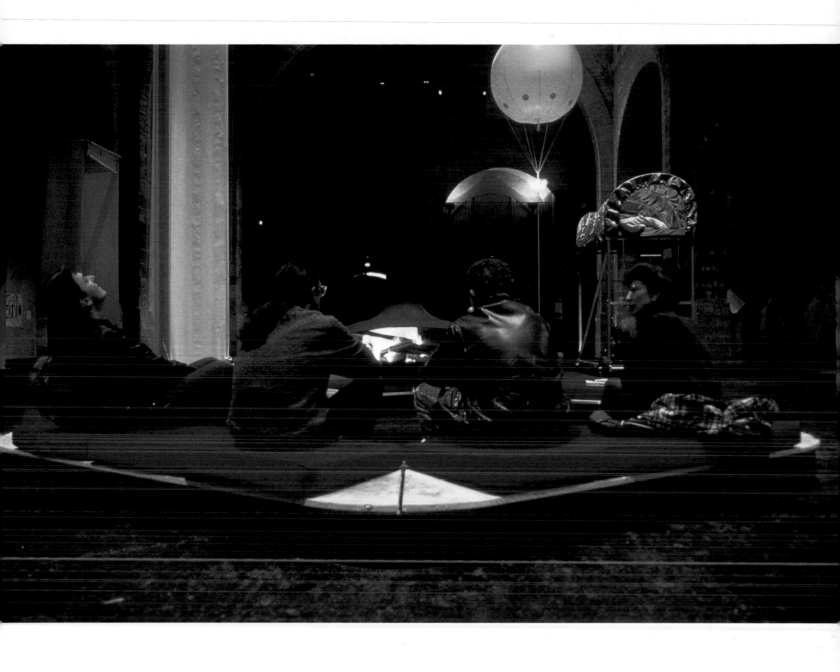

JEAN-LUC VILMOUTH
(b. 1952, Creutzwald)

After attending the Ecole des Beaux-Arts in Metz, Jean-Luc Vilmouth received a grant to continue his studies at the Royal College of Art in London from 1976 to 1979. He maintained his residence in Great Britain until 1985, when he was offered a professorship at the Ecole des Beaux-Arts in Grenoble; there, Vilmouth and fellow artist Ange Leccia influenced an entire generation of artists (including Dominique Gonzalez-Foerster) under their tutelage.

In 1977, Vilmouth began to participate in the activities of a group of Paris-based artists called ja na pa. During this period, his work followed an aesthetic of the recycled object, related to the preoccupations of Process Art. "I construct objects both to be seen and to be thought," Vilmouth said of his practice at the time. A self-defined "augmenter," Vilmouth was influenced by the writings of psychoanalyst Roger Caillois, who defined aesthetic emotion as an effect of recognizing the self in an object; such recognition is analogous to insects or animals camouflaging themselves to resemble their surroundings. This theoretical position may explain the eclecticism of Vilmouth's work: his practice is centered on a curiosity that often leads him to domains excluded by high culture.

In the 1980s, Vilmouth's work found a natural extension into the public sphere; he designed works for unusual spaces—for example, an observatory platform constructed around an abandoned factory smokestack. During the last few years, Vilmouth has organized collective exhibitions such as the L'Hiver de l'amour (Winter of love), shown at ARC in Paris and P. S. 1 in New York (1994).

Playing off the traditional, clichéd Parisian "café littéraire," Jean-Luc Vilmouth's recent projects involve the creation of bars and cafés that actually function as sites for social contact and interaction. Beginning in 1986, after the exhibition *Chambre d'amis*,[1] Vilmouth announced a turning point in his work: "Confronted by the inhabitants of houses temporarily transformed into part of the exhibition space," he said, "I became interested in the special relationship which can form between an artistic concept and the public. It was a different space from the museum, which is marked most of the time by the distance between the viewer and the viewed."[2]

Bar Séduire, created after a sojourn in Japan in 1997, is the last of a suite of concept-driven bars. Vilmouth transformed an empty public space into a real bar with clusters of tables, lamps, television monitors, and chairs. The furniture, designed by Vilmouth himself, evokes a common image of Japan in the contemporary imagination: a slick, alluring techno-culture. On each table, a monitor plays a video loop of someone speaking directly into the camera as if they were seducing a lover. Drawing on archetypes ranging from a sadomasochistic dominatrix to a shy teenage boy to a typical Geisha, the images play constantly; the visitor can circulate among the tables and sit down with a drink in front of the character that attracts them.

Alternating between media-constructed mythologies and genuine emotion (displayed by some of the characters Vilmouth has filmed), this environment is a playfully critical response to the devices of communication and exchange saturating contemporary culture. The cold screen of the monitor confronts the warm presence of the person interacting with the images; this discord frustrates Vilmouth's otherwise captivating spectacle. Despite its reference to a science-fiction future where human contact is possible only through technology, Vilmouth's televisual seduction cannot be realized to its usual ends; the viewer-participant is left to meander among the tables in an attempt to reconstruct an intimacy the televisual space refuses.

Nevertheless, Vilmouth is still invested in the possibility of functional social spaces; he is far from taking an oppositional position vis-à-vis media's impact on public and private spheres. Mixing the codes of industrial design, popular culture, video art, science fiction, and the fabricated ambiance of nightclubs and bars, Vilmouth's art practice is "a multiplicity . . . not defined by the number of its terms, we do not escape dualism in that way. . . . What defines the multiplicity is the AND, AND, AND. . . . This is [how] it is possible to undo dualism from the inside . . . [Multiplicities] do not belong to the dialectic."[3] Old binary structures validating the boundaries between inside and outside, public and private, have been imploded. Vilmouth submerges his environment in current trends in order to question the promise of utopia fueled by technology. More, perhaps, than referring to Parisian social custom, *Bar Séduire* addresses the clichés and expectations spawned by contemporary spaces of communication.

ALISON M. GINGERAS

1. An exhibition organized in Ghent, 1986.

2. Shapira.Sarit, *Jean-Luc Vilmouth* (Paris: Hazan, 1997), p. 111.

3. Claire Parnet and Gilles Deleuze. *Dialogues* (New York: Columbia University Press, 1987), pp. 34–35.

FACING PAGE *Bar Séduire*, 1997, installation at the Spiral / Wacoal Art Center, Tokyo, 1997

Selected Bibliography

Local Time: Jean-Luc Vilmouth (exh. cat.). Grenoble: Centre National d'art contemporain, Le Magasin, 1987.

Jean-Luc Vilmouth, Collections Contemporains no. 17, Paris: MNAM-Centre Georges Pompidou, 1991.

L'Hiver de l'amour (exh. cat.). ARC Musée d'art moderne de la ville de Paris, 1994 (*Winter of Love*, New York: P.S. 1, 1994)

Shapira, Sarit. *Jean-Luc Vilmouth*. Paris: Hazan, 1997.

FABRICE HYBERT

(b. 1961, Luçon)

Fabrice Hybert's work subscribes to an efficient and coherent logic that, for over ten years, has yielded unprecedented developments while never being limited to painting, drawing, writing, video, or installation. The fundamental principles he explores—mutation, hybridization, sliding, flux, comfort, exchange—indicate a desire to transform the world in its materiality. This involves blending art with the reality of life, constantly reconsidering the exhibition space.

In 1995, the Musée d'art moderne de la ville de Paris was converted by the artist into a Hypermarket, a store selling products for everyday use. In 1997, in Leipzig, a city known for its trade fairs, Hybert presented Testoo: *over one hundred* Prototypes d'Objets en Fonctionnement *(Working prototypes of objects known as POF) to be tested by the public. The POFs were "the result of linguistic and material offshoots of functional products"—in other words, objects improved according to the norms of comfort as defined by the artist.*

As early as 1994, Hybert founded a real business to promote project design and implementation, Unlimited Responsibility *(UR), which he described as "a platform for exchanging different capacities (business, literature, mathematics, chemistry, etc.)." UR addresses not only the art world, but all the players in the creative process.*

Hybert's work has been increasingly exhibited both in France and abroad. For the Venice Biennale in 1997, the artist transformed the French Pavilion into a production/broadcasting space for a television station; its importance earned him the Lion d'Or.

For his project for the French pavilion at the Venice Biennale in 1997, Fabrice Hybert developed a new approach to creating a TV station: the terms *production*, *broadcasting*, and *exchange* invoke the sphere of economics, with its attendant rules and frameworks. Yet this notion of economics is strongly challenged by the artist, since it gets in the way of one of Hybert's basic preoccupations, *desire*. According to Hybert, one should favor business over economics since business is the more archaic, less codified system, resting simply on "the desire to exchange things and to seduce." It is to this precept—a kind of space attuned to the body, its aura and moods—that Hybert's television belongs. As his "associate producer" Guy Tortosa would emphasize, Hybert's work involves "experimenting with [television's] eroticism, materializing the flux of the world, provoking shifts and desires between areas that do not meet."

For *Premises*, the artist has conceived a production/broadcasting space that is partitioned in three separate areas. Each of these sets has a specific theme: isotopic meteorology, telepathy, and home shopping. According to the artist, these naturally overlap in accordance with the circular flow of thought, speech, and movement. Thus the difference between the weather forecast in two remote countries and the weather in any given moment triggers a desire to immediately be where the weather is good. The described difference in weather may also stimulate a desire for objects. On the home-shopping sets, POFs are offered for purchase; the nature of "special order" products is particularly amenable to unpredictable fluctuations of thought.

A camera will move around these three sets on a fixed, winding track. The resulting shots are unedited; rather, they incorporate all hesitation, bad framing, and mistakes, and embrace crosstalk (incongruous, out-of-sync images).

By criticizing a banal medium rarely employed by artists, Hybert is able to dismantle television's mechanisms all the more efficiently. He is not so much denouncing a society alienated by the mediocrity of its communication tools as he is gently distorting a system by appropriating its elements, and reevaluating them according to his own criteria. The viewer is invited into a positive, infinite experience—an experience of exchange. "You are here," the preparatory drawing announces, designating an area where all things are possible.

SOPHIE DUPLAIX

Selected Bibliography

Bouglé, Frédéric. *1-1=2: Entretiens Avec Fabrice Hybert*. Nantes: Editions Joca Seria, 1992.

"Fabrice Hybert/Hans Ulrich Obrist-Unter-Haltung/Inter-view." *Parkett* no. 43 (March 1995), pp. 106–16.

Hybert, Fabrice. *Eau d'Or. Eau Dort. ODOR*. Paris: UR Editions/Cyrille Putman, 1997.

Tortosa, Guy. "Fabrice Hybert: Des Grappes de Paraboles." *Art Press* no. 225 (June 1997), pp. 43–47.

Cuvelier, Pascaline. "Studio Time." *Artforum* (November 1997), pp. 94–99.

FACING PAGE *Citoxe*, 1998, original drawing in preparation for the installation

FOLLOWING PAGES *Eau d'or, Eau dort, ODOR . . .* , installation views of a television studio in the French Pavilion during the Venice Biennale, 1997

BAR
SEDUIRE

SP 0:04:42

To seduce, then, is to make both the figures and the signs — the latter held by their own illusions — play amongst themselves. Seduction is never the result of physical attraction, a conjunction of affects or an economy of desire. For seduction to occur an illusion must intervene and mix up the images; a stroke has to bring disconnected things together, as if in a dream, or suddenly disconnect undivided things. A game without end, in which the signs participate spontaneously, as if from a continuous sense of irony. Perhaps the signs want to be seduced, perhaps they desire, more profoundly than men, to seduce and be seduced.

Jean Baudrillard, "Superficial Abysses," *Seduction* (New York: St. Martin's Press), trans. Brian Singer.

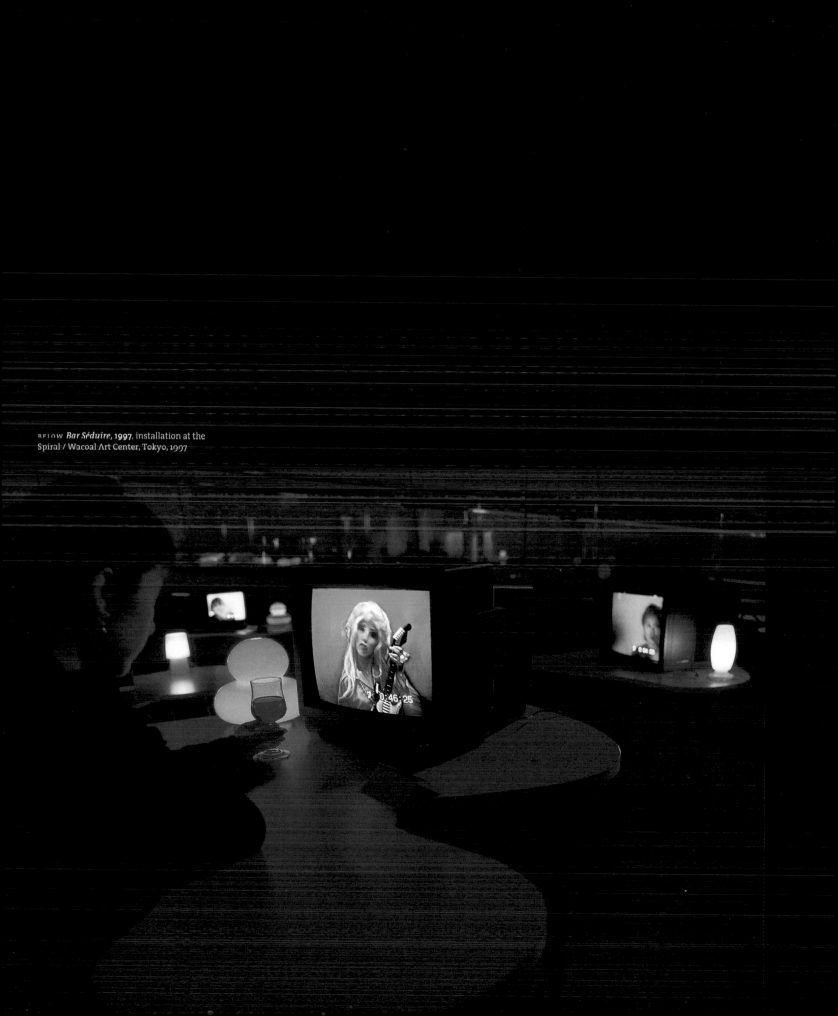

BELOW *Bar Séduire*, **1997**, installation at the
Spiral / Wacoal Art Center, Tokyo, 1997

you are here

RAIL FOR CAMERA.

3 TV. studio

VDP—VERY DERIVATED PRODUCTS
1998

Using an amalgamation of forms and strategies borrowed from past works, Thomas Hirschhorn's site-specific installation for *Premises* is proposed as an encrustation in the space of the Guggenheim Museum SoHo retail store. Situated in a corner of the building, and hemmed in by the two large windows on both the Broadway and Prince Street sides of the store, it is a closed space using a simple wooden framework and opaque plastic sheeting punctuated by several Plexiglas vitrines. This space is completely sealed, cordoned off from any physical access. As a mise-en-vitrine of this entire corner of retail space, the visitor (would-be shopper) can only peer inside. The interior structure projects several feet onto the sidewalk, appearing to push out from the window. In Hirschhorn's vocabulary, these exterior structural elements compose the "hardware" of the work. Straddling sidewalk and interior, inside and outside, both on and off the premises, the installation's tenuous position and precarious construction hint at a critical indifference to its site. Examination of the "software" housed inside it, however, makes it clear that Hirschhorn is flirting with the limits of the museum's literal "space of exchange."

A giant Rolex watch, made of cardboard, covered with gold tinfoil, and so large that its band pops out of the window onto the street, dominates the interior of Hirschhorn's installation. The object makes a far from subtle reference to the artist's Swiss origins, though it is not the punchline of Hirschhorn's piece. Long strands of crumpled tinfoil emanating from the watch create a network of capillaries that spawn a host of "VDPs," or "Very Derivated Products." These tinfoil tentacles unite a distinct series of objects: collages of handwritten texts and images culled from popular magazines glued to odd scraps of cardboard; commercial planes made of cardboard and colored foil; simple sculptural renderings of commonplace things ranging from taxis to trinkets that resemble the sorts of objects sold by street vendors. Above the Rolex, red flags attached to household fans flutter violently. Video monitors duct-taped to the vitrines display fixed shots of elements from the entire installation. The space is illuminated with fluorescent tube lighting. With Hirschhorn's intervention, the Guggenheim museum shop becomes an impenetrable showcase for the city's wares.

Everything inside this space is obviously handmade—an anachronistic, if not deeply humorous gesture in the face of a commercialized landscape. Simultaneously drawn from the lived experience of the city and playing off the commodity, the silliness of these tinfoil objects offers a low-fidelity affirmation of urban life. "To affirm is still to evaluate, but to evaluate from the perspective of a will which enjoys its own difference in a life instead of suffering the pains of the opposition to this life that it has itself inspired. To affirm is not to take responsibility for, to take on the burden of what is, but to release, to set free what lives."[1] Hirschhorn's VDPs have not relinquished their critical force—this force has merely changed its guise. »

THOMAS HIRSCHHORN
(b. 1957, Bern)

In 1984, after completing his formal training in graphic design at the Schüle fur Gestaltung in Zurich, Thomas Hirschhorn emigrated to France. There he sought to apply his design practice toward leftist political ends, working for a Parisian collective of Communist graphic designers called Grapus. Although this work satisfied his desire for serious political engagement, Hirschhorn was frustrated by design work's dependence on commissions and client influence, and in 1986 he abandoned it to become an artist.

Despite this rupture, Hirschhorn's art practice retains its social and political preoccupations, and since his first solo show at Bar-Floréal in Paris in 1986 he has developed a radical sculptural practice. Most pieces are composed of a combination of plastic sheeting, Plexiglas, unfinished wood, cardboard, tinfoil sculptural forms, collages of magazine ads, journalistic photo-reportages, and bits of hand-written text—a collection of materials that suggests a complex economy of excess and cheapness, of hyperproductivity and modesty of means. In 1997, he created several prominent installations for public spaces, including Souvenirs du 20ème siècle *(Souvenirs of the twentieth century), a commercial stand selling hats, football scarves, plates, and other touristic banalities sporting the names of various avant-garde figures, from Robert Walser to Gilles Deleuze, for the exhibition* Ici et Maintenant *in the working-class suburb Patin. His most recent pieces have been makeshift altars displayed on the sidewalks of Basel, Geneva, and Zurich. Consecrated to artists such as Piet Mondrian and Otto Freundlich, they are tenuous gestures that lie somewhere between homage and sycophancy.*

All photos and layout courtesy of the artist.

What is the relationship of the work of art and communication? None . . . The work of art is not communication. The work of art has nothing to do with counter-information. On the other hand, there is a fundamental affinity with the work of art and the act of resistance.

Gilles Deleuze, "What is the creative act?" (Transcribed and translated from a public lecture by Gilles Deleuze entitled "Qu'est-ce que la création?" [March 1993] that will be published by *Semiotext(e)* in the forthcoming volume *Gilles Deleuze: Minor Works I*.)

Speaking about the various elements that animate his practice, Hirschhorn has often said "J'aime des choses bêtes, des trucs cons."[2] This aesthetic of affected simplicity should not be mistaken for parody, cynicism, or irony. In Hirschhorn's critique of the commodity and the space of exchange, the object is not denied, but multiplied. Hyper-productivity, excess, cheapness, and mess are Hirschhorn's response to a world where the object has dissolved into its sign exchange value. From the larger-than-life tinfoil luxury goods to the aphoristic scrawlings that always accompany the cardboard collages found in his installations ("Aidez-moi, je trouve ça beau" or "S.V.P. Merci, Rolex!"), Hirschhorn repeatedly plays with the saturation of the sign.[3] Without resorting to negation, he employs a strategic stupidity to pervert the extended armature of corporate marketing.

But what becomes of the critical when it is flushed of negation? One crucial element recurs amid almost all of Hirschhorn's carefully choreographed messes. The presence of exaggerated teardrops, either sculpturally rendered in aluminum foil or drawn in red or blue ink onto the faces of supermodels who are found in his collages, consistently manifest Hirschhorn's position. With their burlesque form, these are nothing but crocodile tears. They lament nothing. "To laugh is to affirm life, even the suffering in life."[4] Hirschhorn's work dissolves the critical impulse, confronting the black hole of nihilism with the affirmative power of laughter. Within his crypto-critique, subversive strategies go underground; micro-doses of indifference, affirmative nihilism, and humor are designed to allure with the same strategies it critiques. Hirschhorn's "stupid" forms trigger a Nietzschean transvaluation. By joining humor and nihilism, the sign in the service of capital loses its negative force; Hirschhorn's creation passes into the service of affirmation.

ALISON M. GINGERAS

1. Gilles Deleuze, "The Overman: Against the Dialectic," *Nietzsche & Philosophy* (New York: Columbia University Press, 1983), p. 185.

2. "I like insipid things, things that are stupid." From an interview with the author and Hirschhorn, May 1998.

3. "Help me, I find this beautiful." "Please. Thank you. Rolex!" These texts are taken from the collage series "Les plaintifs, les bêtes, les politiques" (see Biography).

4. Gilles Deleuze, "The Overman: Against the Dialectic," *Nietzsche & Philosophy* (New York: Columbia University Press, 1983), p. 170.

Selected Bibliography

Jouannais, Jean-Yves. "Wagering on Weakness." *Art Press*, no. 195 (October 1994), pp. 56–58.

Cassagnau, Pascale. "Thomas Hirschhorn, W.U. E.—World Understanding Engine." *Omnibus*, no. 17 (July 1996), pp. 16–17.

Cuvelier, Pascale. "Weak Affinities." *Artforum*, no. 9 (May 1998), pp. 132–35.

Rolex etc., Freudlichs "Aufstieg," und Skuptur-Sortier-Station-Dokumentation (exh. cat.). Cologne: Museum Ludwig, 1998.

Wechsler, Max. "'Swiss Army Knife' ou les complications de la functionnalité." Thomas Hirschhorn, *Swiss Army Knife*. (exh. cat.). Bern: Kunsthallle, 1998.

ARCHIT

ECTURE

POLITICAL WILL AND THE CULTURAL IDENTITY CRISIS IN LATE-TWENTIETH-CENTURY FRENCH ARCHITECTURE

JOSEPH ABRAM

French architecture has declined into formalism. In the name of a superficial interest in urban composition and the independent block all urbanist approaches to the city have been forgotten. Designs have become pretentious. . . . It's as though the only thing that matters to architects now is the visual impact of their works. Under such conditions, how can the problems confronting our cities be resolved? Architecture can offer solutions, but it must be linked to town planning. These last few years have seen too much frivolity, too many disclaimers as well.

Guy Lagneau, 1994[1]

Guy Lagneau's judgment of French architecture of the last two decades is severe, and one is tempted, as one is so often in such cases, to chalk it up to the bitterness of a practitioner put out by shifts in the landscape familiar to him. We should pay attention to this assessment, however, given the clarity with which it was expressed and its source—one of the most prominent architects of the postwar generation. What concerned Lagneau about new French architectural practices was their lack of engagement, or, more precisely, their acceptance of an overly limited definition of the profession. In his view, drawing and form have been accorded unwarranted preeminence over the practical and spatial aspects of design, and the notion of planning has lost its meaning, having been separated from economic and cultural concerns. In the 1960s, after undertaking several large-scale projects with Michel Weill and Jean Dimitrijevic (including plans for Boké, Guinea; Mbaye Taiba, Senegal; Cansado, Mauritania; Abidjan, Ivory Coast; and for six hundred classrooms using prefabricated and industrial materials in Cameroon),[2] Lagneau was asked to develop a master plan for the Paris region. But even then he discerned the first signs that inadequate attention was being given to planning by the government: the recommendations made

in his development study—notably those underscoring the importance of situating new towns at a sufficient distance from Paris—were not carried out.[3] Respected for the quality of his work (in such projects as the Hôtel de France, Conakry [1954]; housing complex, Fontenay-aux-Roses [1958–59]; and museum, Le Havre [1955–61]), Lagneau enjoyed a professional prestige that gave his opinions special weight. He believed that recent architectural developments were taking a slow spiral downturn as long-term considerations were being overwhelmed and rendered impotent by an accumulation of problems.[4] Lagneau's negative reading of the work of recent decades clearly underscores one of the period's major weaknesses. By challenging the schematic view, so prevalent in France, that the "quality" of architecture produced in the 1980s is preferable to the "mediocrity" of designs produced in the 1960s, it opens the way for a critical approach to recent history. It would be impossible within the confines of an essay to evoke the full complexity of debates that have stirred the French architectural world for more than twenty years, so we will focus instead on a few specific aspects of those debates with the intention of clarifying some key themes.[5]

1. Conversation with the author, spring 1994. Lagneau died in January, 1997; an exhibition devoted to his work is now being planned at the École d'Architecture de Nancy.
2. On the work of the Lagneau-Weill-Dimitrijevic office, see Joseph Abram, "Le Musée des Beaux-Arts du Havre," *Le Moniteur-Architecture-AMC* (October 1990), pp. 50–53; and "De la Maison du Sahara aux écoles du Cameroun," *Faces*, no. 37 (fall 1995), pp. 48–54.
3. Lagneau also deplored the fact that regulations to protect land for building the new cities, put in place under President Charles de Gaulle, were dismantled by succeeding governments, which favored private developers.
4. Lagneau was particularly concerned by the problems associated with worldwide demographic trends, notably the projected doubling of the populations of large urban centers in developing countries. But he considered the analogous problems in wealthy nations just as serious, in light of the failure of their governments to limit development for ecological reasons. He accused architects of no longer concerning themselves with these questions.

THIS PAGE Claude Prouvé, Research on the industrialized habitat, model, 1966

5. Few publications approach the recent history of architecture and planning from a global perspective. See Jacques Lucan, *France Architecture, 1965–1988* (Milan and Paris: Electa-Moniteur, 1989); François Chaslin, *Les Paris de François Mitterrand* (Paris: Gallimard, 1985); Patrice Goulet, *Temps sauvage et incertain* (Paris: Les éditions du demi-cercle, 1989); Jean-Pierre Le Dantec, *Enfin l'architecture française, L'histoire d'un renouveau* (Paris: Autrement, 1984); Le Dantec, *Dédale, le héros* (Paris: Balland, 1992); and Pierre Joly, *L'Art, l'architecture et le mouvement moderne, textes critiques, 1958–1990* (Paris: Éditions de la Villette, 1997). See also "1950–1980, 30 ans d'architecture française," *AMC*, special issue, no. 11 (April 1986); *Les Années 1950*, exh. cat. (Paris: Centre Georges Pompidou, 1988); Maurice Besset, *Nouvelle architecture française* (Teufen, Switzerland: Arthur Niggli, 1967); René Jullian, *Histoire d'architecture moderne en France, de 1889 à nos jours* (Paris: Philippe Sers, 1984); Kenneth Frampton, *Modern Architecture: A Critical History* (London: Thames and Hudson, 1980); Gérard Monnier, *L'Architecture du XXème siècle* (Paris: Presses Universitaires de France, 1997), and *Dictionnaire de l'architecture du XXème siècle* (Paris: IFA-Hazan, 1996).
6. See Jean Fourastié, *Les Trentes glorieuses* (Paris: Fayard, 1979); and J.-Ch. Asselain, *Histoire économique de la France* (Paris: Seuil, 1984).
7. On the mechanisms of French state intervention in building, see D. Voldman, "Aux origines du Ministère de la Reconstruction," in *Les trois reconstructions: 1919–1940–1945*, Dossiers et Documents (Paris: IFA, 1983); A. Kopp, *L'Architecture de la reconstruction en France 1945–1953* (Paris: Moniteur, 1980); B. Vayssière, *Reconstruction-Déconstruction* (Paris: Picard, 1988); and Voldman, *La Reconstruction des villes françaises de 1940 à 1954: Histoire d'une politique* (Paris: L'Harmattan, 1997).
8. See Edmond Préteceille, *La Production des grands-ensembles* (Paris: Mouton, 1973); and Christian Topalov, *Les Promoteurs immobiliers* (Paris: Mouton, 1974).
9. The economic crisis marked the end of an entire phase of French architecture. Thereafter, the utopian optimism that had fostered urban expansionism—and such notions as Yona Friedmann's "*Ville-pont*," Paul Maymont's "*Ville-flottante*," and Nicolas Shoeffer's "*Ville-cybernétique*"—lost credibility among younger architects.

The Traumatic Effect of Large Housing Complexes: Myth and Reality

In 1975, the population of France was 53 million. Having had a predominantly rural economy in 1945, a mere thirty years later the country had become urbanized, with an economy based on tertiary industries. Over the same time span, the number of its housing units grew from 13 to 21 million.[6] The impact of this new housing on the urban landscape was considerable. The surface area of cities expanded. Their old centers, like their peripheries, were transformed. Construction levels soared: in 1973, a record rate of 542,000 housing units per year was attained. These results were made possible by the continual improvement of a three-part program put in place after World War II, under which effective state intervention (implemented first through the Ministry for Reconstruction and Planning, then through various ministries of construction),[7] concentration of investment in large companies (particularly through financial aid to contractors using prefabricated systems and through housing commissions that continued to grow in scale), and increasingly efficient means of assembling large parcels of land (first through the reallocation of urban sites, then in the form of Zones à Urbaniser en Priorité [ZUPs] and Zones d'Aménagement Concerté [ZACs]—areas set aside by the government for development) produced something of a residential building boom.[8] The oil crisis and economic slump of the 1970s suddenly slowed this boom, reducing the construction rate from thousands of housing units per annum to a few hundred, even a few dozen. Construction costs skyrocketed. Throughout the world, housing construction was halved, entailing a sudden reduction in building projects that created grave financial difficulties for the large architectural firms. This precipitous decline in the building sector coincided with an ideological crisis (there does not seem to have been a cause-and-effect relationship between the two phenomena), which took the form of a pervasive loss of confidence in the pragmatic models on which urban growth had been premised.[9]

In the late 1960s, when economic euphoria still reigned (a fifty percent increase in the housing-unit construction rate was still deemed feasible), the first symptoms of a reversal appeared. The country entered a period of doubt, as though it were reacting against its own modernization. Criticism of large housing complexes increased among professional circles and spread to the architecture schools, where a new generation of professors now presided—the same generation that killed off the beaux-arts tradition in 1968. The Athens Charter and Le Corbusier's theories were put on trial.[10] "Towers" and "slabs"—residential building types that had triumphed in what were dubbed *les trentes glorieuses* ("thirty glorious years" of economic and demographic development, Jean Fourastié's play on the phrase "*les trois glorieuses*," used to describe the three-day Revolution of 1830)—were now pronounced "inhuman" and

LEFT Architecture of the 1970s. Landscape around the train station in Nancy, showing in the center the postal building by Claude Prouvé, 1970–72

"destructive of human relationships."[11] The specter of the large complex began to haunt architects' imaginations. There were attacks against the gigantism of Le Haut du Lièvre, the apartment slabs designed by Bernard Zehrfuss in Nancy (1959–64).[12] Visits were made to La Grande Borne, the complex designed by Émile Aillaud in Grigny (1964–71).[13] Alternative models were sought. ZUPs initially conceived as quadrangular configurations were modified during the design process.[14]

Yet this blanket criticism of large complexes led to misapprehensions that continue to influence the attitudes not only of the public at large but also of decision-makers. These misunderstandings are rife with consequences. In addition to explaining widespread prejudices against the architectural legacy of the 1960s (prejudices that have resulted in the destruction of apartment blocks, the recladding of façades, and a reversion to dense urban-planning models), they underlie many of the more dubious practices in the subsequent design of housing: overestimation of the importance of drawing, compositional formalism, and "figurative" architecture that imitates other forms (the wings of an airplane, for example).[15] These quid pro quos are behind the yawning chasm that separates the 1970s generation of Roland Castro, Henri Gaudin, Antoine Grumbach, Bernard Huet, and Alain Sarfati from such postwar architects as Jean Dubuisson, Marcel Lods, Pierre Vago, and Zehrfuss, who, due to their preference for prefabricated elements, were accused of having adopted a "quantitative" approach to subsidized-housing design that reinforced the power of engineers and the large Bureaux d'Études Techniques.[16]

The systematic rejection of large housing complexes merits examination. How could so characteristic a product of French architecture and planning have become such a point of contention? Admittedly, there are many problems inherent in this form of urbanization, such as poorly defined public spaces and anonymous buildings. But there is still reason to ask whether the problems are more mythic than real, a projection onto architecture of the negative effects produced by political and economic conditions. Apartment blocks and towers have often been charged with inadequacies that are not, strictly speaking, attributable to them. A case in point is Sarcelles, a township in the Paris region whose population—thanks to the magic of its housing complex, designed by Roger Boileau and Jacques Henry Labourdette (1955–70)—grew from 8,000 to 60,000 in the course of a decade and a half. Daily life in Sarcelles was indeed hellish for many years, but this was the result not so much of the new urban landscape devised by the architects as of the arrogance and ineptitude of the technocrats who oversaw the construction of housing for thousands of residents without bothering to provide the service and commercial facilities necessary to meet their needs: "The people were quite comfortable in their apartments. It was when they left them that problems arose: there were no social

10. Criticism of the Athens Charter and of Le Corbusier's theories were voiced throughout the world, but the debate was particularly fierce in France because Le Corbusier himself had been a feature of the country's architectural scene.
11. Criticism in the press was crude in the extreme, but the same period also saw the emergence of a more sophisticated critical discourse shaped by sociologists investigating the notion of the dwelling. Publications such as H. Raymond, N. Haumont, M. G. Raymond, and A. Haumont's L'Habitat Pavillionaire (Paris: CRU, 1966) were read in architecture schools. See also the following three volumes by Henri Lefèbvre: Le Droit à la ville I (Paris: Anthropos, 1968); Le Droit à la ville II: Espace et politique (Paris: Anthropos, 1972); and Du rural à l'urbain (Paris: Antrhopos, 1970).
12. Le Haut du Lièvre consists of two long slabs, one 400 meters long (with 15 floors and 917 units) and the other 300 meters long (with seventeen floors and 716 units).
13. See J.-F. Dhuys, L'Architecture selon Émile Aillaud (Paris: Dunod, 1983).
14. In the final design stages, the plans of large housing complexes tended to become less schematic, and—given the desirability of minimizing land use—also more dense.
15. The design process, and the teaching of it in architecture schools, still suffer in France from an overemphasis on drawing, born of an unhealthy horror of "monotony." Graphic excess has been encouraged by the competition system, in which architects strive to seduce the judges with their drawings. Attentive observers can discern the scars resulting from this pursuit of graphic effects on façades throughout the cities of France.
16. This generation gap is much more striking in France than in Switzerland or Italy, for example.

services, no shops, no transportation, no jobs."[17] Beginning in 1960, the national press seized on the affair, but instead of reporting on the lack of ancillary services, it denounced the "concentration camp" ambience of the towers and slabs. The inhabitants of Sarcelles and other Modernist housing complexes were said to suffer from a strange illness: "sarcellitus." The myth was born, based—like all myths—in real experience but eventually integrated through a progressive slippage of meaning into a powerful discourse of the imaginary. Having been traumatized first by wartime destruction and then by the modernizing process of reconstruction, the French population proved receptive to such apocalyptic pronouncements.

The housing-complex myth introduced an ideological factor to the critique of these complexes that made life even more difficult for their inhabitants. In Sarcelles, the situation improved as a result of the inhabitants' own efforts, but many large housing complexes remained without adequate support or commercial facilities. This was only one aspect of the problem. Even when such facilities were adequate, some complexes proved ill-conceived, and all of them deteriorated rapidly due to decreases in the funding allocated for subsidized housing in France.[18] These economic difficulties were soon exacerbated by intractable social problems. Initially, the populations of large complexes were sociologically diverse, but they quickly became more uniform.[19] The power of Habitations à Loyers Modérés (HLM) administrations, the fact that the apartments in these complexes were

all rental units, and the failure of the government to implement regulations facilitating the acquisition of housing through financial aid to their inhabitants all contributed to the decline of large housing complexes. In fact, it was only rather late, in the 1970s, that their fate was sealed, for it was then that a widening gap opened between the middle class—more and more of whose members were able to leave the complexes and buy houses of their own in other suburbs due to legislation that was passed in 1977—and the lower social strata, whose members were not able to do so, remaining "captive."[20] The social pyramid was collapsing, transforming housing complexes into ghettos.

From System Architecture to Urban Architecture: The Emergence of New Problems

The failure of large housing complexes due to political and economic factors has had a decisive impact on the evolution of French architecture over the last quarter century. Architects have tried to rethink the tower and slab building types and to invent new models for housing. This has occurred in light of three developments: the emergence of a "technological" architecture subsidized by the Plan Construction; the proliferation of "megastructures" in new towns due to housing commissions large enough to permit their realization; and the intensified focus throughout the world on theories of urban contextualism and complexity.

17. See Henry Canacos, *Sarcelles ou le beton apprivoisé* (Paris: Éditions Sociales, 1979).

18. The decrease in federal allocations for subsidized housing obliged HLM associations to use funds earmarked for the improvement of large projects to build new housing instead. (Robert Lion, lecture given at the Congrès des HLM, Marly, 1977.)

19. To some extent, this process of homogenization was countered by cultural diversity: more than one hundred different nationalities have been identified in some large complexes. But this potential cultural richness has yet to be explored by researchers, politicians, or the inhabitants themselves.

20. The phrase "captive populations" (*populations captives*) was used by the HLM associations to refer to residents whose limited financial resources prevented them from leaving the large housing complexes. The 1977 law stipulated that a portion of construction funding (*aide à la pierre*) be rechannelled to residents (*aide à la personne*) so as to facilitate their acquisition of property on the private market. On the implications of this policy, see Pierre Bourdieu, *Contre-feux* (Paris: Liber-raisons d'agir, 1998), pp. 36–48.

THIS PAGE Ricardo Bofill, Taller de Arquitectura, apartment housing block on the Place d'Occitanie, Montpellier, 1979–84

FACING PAGE Guy Lagneau, Michel Weill, Jean Dimitrijevic, Palais de Justice in Evry, 1975–76

Created in 1971 at the instigation of Paul Delouvrier and Robert Lion, the government-sponsored program known as Plan Construction fostered experiments in construction that, it was hoped, would result in an architecture of standardized components.[21] The goal was to undermine the hegemony of concrete and "tunnel framing" by perfecting industrialized systems. There were experiments with metal structures,[22] and post-and-slab construction was favored over concrete walls.[23] For the sake of variety, there were even tests with sprayed concrete. A new generation of architects participated in this attempt at innovation (including Henri Beauclair, Paul Depondt, Vladimir Kalouguine, Henri P. Maillard, Georges Maurios, Pierre Oudot, and Claude Prouvé). In the words of Maillard: "After the large housing projects, it was impossible to rethink architecture without rethinking technique. Whence the idea of a suppler technology [with which] to dismantle structure. We wanted to shatter the slab."[24] The "Habitat 67" prototype at the World's Fair in Montreal as well as Japanese experiments along the same lines cleared the way for a "polycubic" architecture offering new ways of organizing space. The grid was seen as the common measure of both housing and the city. Despite the marginal character of its experiments, the Plan Construction managed to engender a new state of mind. Through the newly established Pro-

gramme d'Architecture Nouvelle (PAN), it soon gave young architects readier access to commissions.[25]

The second attempt to improve upon the tower and slab models derived from the work of Georges Candilis, Alexis Josic, and Shadrach Woods. Beginning in the 1960s, these architects sought to recast public space.[26] Their housing complex in Toulouse-le-Mirail (1961–74) inaugurated a type of megastructure that was to inspire the design by Georges Loiseau and Jean Tribel of Atelier d'Urbanisme et d'Architecture (AUA) for the Arlequin neighborhood in Grenoble (1969–73). For better or worse, a gallery below the buildings roughly 1,300 meters long functions as a kind of "street." But the architecture itself had no real form. This problem of definition, encountered also in many complexes of much smaller scale—for example, those by Jean Renaudie in Ivry-sur-Seine (1970–75) and in Givors (1974–81)—found a surprising solution in the 1972 competition entry by AUA and Ricardo Bofill for seven thousand apartments with shops and service facilities in the new town of Evry. For this project, the design team conceived a pedestrian street punctuated by pylons running below an oblong housing structure with progressively projecting overhangs, a design that evokes a viaduct. Bofill adopted a similar approach in his Arcades du Lac project in Saint-Quentin-en-Yvelines (1974–80), another viaduct-like structure, in which a sequence of

21. The Plan Construction had three main objectives: 1) to foster the development of a large market for standardized, serially produced elements; 2) to undertake research on a massive scale with the aim of identifying obstacles to innovation; 3) to foster related research on a significant scale in the public sector (specifically, in subsidized housing). On the history of this period, see Joseph Abram and Daniel Gross, *Bilan des réalisations expérimentales en matière de technologie nouvelle—Plan Construction 1971–1975* (Paris: Plan Construction 1983).
22. For an analysis of these systems, see ibid.
23. The post-and-slab system was deemed more conducive to flexible plans. The notion of flexibility was fashionable at the time, but it also came under criticism; Philippe Boudon, for example, theorized the notion of "openness" (*ouverture*). See Boudon, *Pessac de Le Corbusier* (Paris: Dunod, 1969).
24. Interview with Maillard (1980), in Abram and Gross, *Bilan des réalisations expérimentales*, pp. 123–24.
25. PAN organized a quasi-annual national competition intended to encourage the development of new ideas and to foster design quality. This program helped the younger generation to develop confidence and made it possible to assess new tendencies on a regular basis. The Plan Construction likewise fostered architectural research, providing a technical complement to the initiatives of the Ministry of Culture.
26. On the work of this team, see Candilis, Josic, and Woods, *Une Décennie d'architecture et d'urbanisme* (Stuttgart: Karl Kramer Verlag, 1968); and Candilis, *Bâtir la vie* (Paris: Stock, 1977).

parallel apartment slabs linked by bridge and roof elements projects into an artificial lake. This structure was an elaboration of the approach Bofill used in his Petite Cathédrale apartment building in Cergy-Pontoise (1971–72), the successive overhangs of which evoke a Gothic nave. The architect theorized his return to past models in terms of rendering the housing block legible. Bofill's bridge and cathedral imagery was soon joined by evocations of ancient amphitheaters and triumphal arches, of baroque châteaux and labyrinths. Bofill sought to reconcile the use of prefabricated elements with a historicist architectural vocabulary, integrating multistory components into façade compositions encompassing entire complexes (as in his Palacio d'Abraxas, Marne-la-Vallée [1978–83], and Antigone, Montpellier [1979–84]).[27] These experiments can be linked to those undertaken in the same period by Henri Ciriani of AUA. In the 300-unit La Noiseraie complex in Marne-la-Vallée (1975–80), Ciriani arranged a slab and two stepped buildings to create a kind of "urban room." While monumental, the result does not derive from images from the past. Ciriani's vocabulary is Modernist, drawn from the tradition of public housing.[28]

The preoccupation with these megastructures was short-lived in France, coinciding as it did with the construction of the new towns; they largely disappeared from the French architectural scene in the 1980s. All that survived was the idea of the interior street, the notion of arranging large complexes around circulatory "backbones." A recent example of this organizational scheme is the Ministry of Finance in Paris, designed by Paul Chemetov and Borja Huidobro of AUA (1982–89).

The third strategy for renewing housing design called for the reintroduction of "diversity" into housing complexes. This program had two complementary aspects: a cultural one, influenced by Christopher Alexander, Kevin Lynch, and Robert Venturi, American proponents of complexity[29]; and a technical one, fostering "open industrialization," or the manufacture of an array of mutually compatible building components. This strategy was embraced by Philippe Boudon, Bernard Hamburger, and Sarfati of AREA and implemented in the housing complex designed by AREA + Stanislas Fiszer + associates and built in the Côteaux de Maubuée neighborhood of Marne-la-Vallée. The competition for this project, held in 1974, was a benchmark event in French architecture, for it reoriented the entire debate over public housing. The members of AREA made a case for the continuing relevance of the old city-center model, with its blocks, streets, avenues, and squares.[30] A competing team (which included Chemetov, Edith Girard, Yves Lion, Jacques Lucan, Fernando Montes, and Jean-Paul Rayon) opted for a somewhat different approach, inspired by the theories of Carlo Aymonino, Vittorio Gregotti, and Aldo Rossi, but they also sought to recreate aspects of the traditional urban landscape.

The technical aspect of AREA's experiment at Marne-la-Vallée essentially led nowhere: as demand for prefabricated elements central to the "open-industrialization" model proved limited, French building-related industries soon shifted their energies elsewhere. By contrast, the "culturalist" values put forward by the project rapidly gained ground. Another competition held in 1974, for Petite Roquette in Paris, confirmed this trend: submissions by Castro, Lion, Girard, Christian de Portzamparc, and many others sought to emulate various qualities of traditional cities. Portzamparc's proposal, which called for a regular block of four-story buildings enclosing a large rectangular garden, opened new perspectives, using simple architectural means in ways that were respectful of urban hierarchies. While this design was not built, its architect, winner of the Programme d'Architecture Nouvelle prize, obtained another housing-complex commission, which resulted in an architectural manifesto: Les Hautes Formes, Paris (1975–80). Many architects now began to explore this notion of "urban architecture," notably Laurent Beaudouin in Nancy (1977–80), Girard in Stains (1977–81), Bernard Paurd in Saint-Denis (1977–80), and, in Paris, Jean-Pierre Buffi (rue Mathis, 1980–

27. On Bofill's approach, see his *L'Architecture d'un homme* (Paris: Arthaud, 1978).
28. See *Henri Ciriani* (Milan and Paris: Electa-Moniteur, 1984).
29. French editions of books by all three of these authors appeared in 1971: Alexander, *La Synthèse de la forme* (Notes on Synthesis of Form; Paris: Dunod, 1971); Lynch, *L'Image de la cité* (The Image of the City; Paris: Dunod, 1971); and Venturi, *De l'ambiguité en architecture* (Complexity and Contradiction in Architecture; Paris: Dunod, 1971). *Learning from Las Vegas*, by Venturi, Denise Scott Brown, and Steven Izenour, was translated only several years later, as *L'Enseignement de Las Vegas* (Brussels and Liège: Pierre Mardaga, 1978).
30. One of Hamburger's models for this project was Port Grimaud, a vacation complex on the Côte d'Azur designed by François Spoerry in the 1960s.

85), Gaudin (rue de Ménilmontant, 1983–86), and Maurios (rue de Bagnolet, 1982–87).[31] Housing commissions of modest scale—a few dozen units—often went to small firms whose size fostered an architecture-as-craft approach, with results that were often influenced by work from the 1920s and 1930s, when modernity made its most distinctive mark in the urban landscape in the form of apartment buildings. This nostalgic neo-Modernism, first articulated in housing complexes, soon manifested itself in other, more prestigious public projects.

Politics, Competitions, and *Grands Travaux*: The Halles Syndrome

If there is another development that can be compared to the housing-project controversy in terms of its traumatic effect on the French architectural world, it is the destruction of the central market complex in Paris known as Les Halles in 1971. This act of cultural vandalism prompted a favorable reassessment of the nineteenth-century French architectural legacy as well as a greater respect for the past in general.[32] The intense interest in the cultural patrimony that is now so pervasive in France stems in part from this episode. But from the disappearance of the original metal-and-glass market pavilions to the construction of the underground RER station and the adjacent shopping center designed by Georges Pencreac'h and Claude Vasconi (1972–79) and to the various proposals advanced for the vast surface area above (including Bofill's plans for a neo-Baroque garden; a scheme by the Atelier Parisien d'Urbanisme; and proposals submitted to an alternative competition held in 1980), the *affaire des Halles* also represented a radical shift in the government's attitude toward architecture. Three different agendas were implemented by the administrations of three successive presidents: Georges Pompidou (1969–74), Valéry Giscard d'Estaing (1974–81), and François Mitterand (1981–95).

The Pompidou administration sponsored an ambitious program of architectural and urban development made possible by a flourishing national economy. All of the large Parisian projects begun under de Gaulle—the new Défense quartier, the redevelopment of the Italie-Gobelins area, the Front de Seine project, the Tour Montparnasse—were brought to completion. Complementing an earlier series of new public-service and transportation facilities (including Orly airport, CNIT [Centre National des Industries et des Techniques], Maison de la Radio, Palais des Sports, and Parc des Princes), these initiatives—the most important undertaken since Baron Georges-Eugène Haussmann's reconfiguration of Paris in the nineteenth century—recast the city to a scale befitting a great twentieth-century metropolis. The projects still showed evidence of the Modernist, pro-technology mindset of the 1960s, evoking the same image of elegant civilization epitomized first by the Caravelle jet and the ocean liner *France*, then by the Concorde and the TGV.[33] All of these urban initiatives were highly controversial, but the state was determined to see them through. According to the Ministry of Culture, it was time for "contemporary architecture" to make itself felt in Paris; André Malraux, the Minister of Culture at that time, gave a high-profile defense of the Tour Montparnasse, and the tower was indeed built.[34] Diverging subtly from the axis of the rue de Rennes, this soaring object, with its bulging curtain walls of dark glass, has come to seem an almost "classic" feature of the Parisian landscape.

Most of the projects initiated during the brief Pompidou presidency represented the last flames of a heroic period. But one of them, in both its program and its transformative effect on surrounding areas of the city, prefigured the *grands travaux* (large public projects) of the 1980s: the Musée national d'art moderne, better known—after its site—as the Centre Beaubourg. Renamed for Pompidou after his death, this aggressively innovative structure, designed by Renzo Piano and Richard Rogers, was inaugurated in 1977. Both the building itself and the populist program that shaped it were wildly successful and influenced the politics of subsequent architectural commissions.[35]

The presidency of Giscard d'Estaing, whose election coincided with the onset of a prolonged economic slump,

31. This approach to urbanism and urban architecture was endorsed in a book by Jean Castex, Philippe Panerai, and Jean-Charles Despaule, *Formes urbaines: de l'îlot à la barre* (Paris: Dunod, 1977).
32. This renewed respect for the past has sometimes been accompanied by reactionary ideology and attacks against the values historically associated with the avant-garde. The view of nineteenth-century cultural production advanced at the Musée d'Orsay, where the installations effectively relegitimized academic art, reveals a parallel attitude; in this sense, one can speak of a reactive "Orsay syndrome."
33. This "technological Modernism" corresponds to the "Orly happiness" (*bonheur d'Orly*) described by Georges Perec in the preface to his novel *Les Choses* (Paris: Julliard, 1965): "There are obligatory ties between the things of the modern world and happiness. The wealth of our civilization makes a certain kind of happiness possible; we can speak, in this sense, of an Orly happiness, of thick carpets, of a current notion of happiness according to which, I think, to be happy one must be absolutely modern." This notion of "modern happiness" brings to mind the films of Jacques Tati, such as *Playtime* (1967) and *Traffic* (1970).

was marked by strategic withdrawals on the architectural front. These took the form of conservative measures such as the cancellation of the Apogée tower project planned for the Italie-Gobelins area; the establishment of height restrictions for towers built at La Défense (to safeguard the celebrated view down the Champs Elysées); and the decision to plant most of the surface of the Halles development with public gardens to compensate for the scandalous destruction of the market pavilions.[36] The president strove to establish more moderate policies regarding urban initiatives. He tried to intervene in the *affaire des Halles*, but the proposal he supported was blocked by Jacques Chirac, then Mayor of Paris, who put in place a poor design. An unofficial alternative competition was organized, without result.[37] The banality of the surface pavilions that were built on the site (designed by Jean Willerval) soon confirmed the mediocrity of the entire project.

While Giscard d'Estaing failed to transform the Halles project into the flagship enterprise he had envisioned, the change in attitude he had hoped to bring about indeed materialized during his term.[38] Legislation was passed regulating the protection of the cultural patrimony and the national architectural heritage. The state became the guarantor of quality urbanism. In 1975, a Grand Prix d'Architecture was established. In 1977, a law was passed that formally declared architectural creation to be a matter of public utility and stipulated, among other measures, the establishment of committees charged with the oversight of architectural, urban, and environmental matters. In 1979, competitions became the obligatory mechanism for awarding public commissions. All of these initiatives profoundly modified architectural practice. At the same time, Giscard d'Estaing launched two ambitious projects: the installation of a museum of nineteenth-century art and culture in a reconfigured Gare d'Orsay and the conversion of the abattoirs at La Villette into a museum of modern science. He did not have time to bring them to completion, but his successor did.

No sooner had Mitterand's tenure begun than he announced plans to hold a universal exposition in 1989 to celebrate the bicentenary of the French Revolution. The project was soon abandoned due to opposition from the mayor of Paris, but the cultural-preservation policies initiated by Giscard d'Estaing continued to be pursued: in 1983, protected historical sectors were established in the city, and in 1984, regional commissions were established to study ways of protecting the nation's historical, archaeological, and ethnological patrimony. The Institut Français d'Architecture (IFA), established in 1980, gained in importance and implemented a new kind of cultural program[39]: by means of exhibitions and publications (which were overseen by François Chaslin), educational and professional initiatives (directed by Jean-Pierre Epron), and the safeguarding of important archival resources (directed by Maurice Culot), the IFA fostered the development of a more sophisticated architectural culture.[40]

But during Mitterand's presidency it was the *grands travaux* that occupied the foreground. The Musée d'Orsay (designed by Renaud Bardon, Pierre Colboc, and Jean-Paul Philippon with Gae Aulenti) and the Cité des Sciences at La Villette (designed by Adrien Fainsilber) were completed in 1986.[41] In 1982, a competition was organized for a new Ministry of Finance to be built at Bercy; this building was necessitated by the pending reallocation of the wing of the Louvre occupied by the ministry to the planned "Grand Louvre," which entailed renovating and reorganizing the entire palace. Designs for the latter project were begun in 1983 under the direction of I. M. Pei, who proposed creating a new main entrance for the museum below a central glass pyramid.[42] The contemporary tenor of the *grands travaux* was now established, and it represented a clean break with the conservative discourse of the preceding presidency.

Bernard Tschumi's inventive design won the competition for Parc de la Villette (1982–97). By selectively departing from a regular grid framework, Tschumi's neo-Constructivist "follies" established a novel relationship to the site.

34. In testimony delivered before the Conseil Général des Bâtiments de France, which was charged with examining the design for the tower, Malraux left no doubt as to his passionate support for it: "Your recommendations could well have historic import. . . . The decision you are about to make will determine whether Paris—and consequently France—will or will not have contemporary architecture. What counts in Paris are the grand perspectives. . . . Every creation has its down side, and it is not possible to stop creating because large [buildings] have been left to us by the seventeenth and eighteenth centuries. . . . In addition to protecting sites, we must create them. The movement of history unites Notre Dame and the Eiffel Tower, Sacré Coeur and the Invalides, monuments that are totally dissimilar to one another. . . . Think of the brilliant generation of architects who, throughout the universe, are now erecting tall buildings that, tomorrow, will be classics like the masterpieces of the past." (Transcript of Malraux's testimony, *Architecture d'Aujourd'hui*.
The "Maine-Montparnasse" redevelopment (1958–73) was realized by Eugène Beaudoin, Urbain Cassan, Raymond Lopez, Louis Hoym de Marien, Jean Saubot, and Jacques Warnery.
35. See Piano and Rogers, *Du plateau Beaubourg au Centre Georges Pompidou: Entretien avec Antoine Picon* (Paris: Centre Georges Pompidou, 1987). See also *Renzo Piano: Architectures* (Milan and Paris: Electa-Moniteur, 1987).
36. The controversy surrounding the fate of Les Halles embarrassed the government, reports Claude Genzling, who was fired from the Atelier Parisien d'Urbanisme for opposing the demolition. He states, "Baltard's pavilions presented a space of unequalled richness and geometric purity." *Claude Genzling: Le Dessin de la performance* (Metz: École des Beaux-Arts, 1997), p. 12.
37. This international competition was organized in late 1979 by the Syndicat de l'Architecture. Jury members included Diana Agrest, Carlo Aymonino, Philip Johnson, Henri Lefébvre, Tomas Maldonaldo, Kasuo Shinohara, and Bruno Zevi.
38. There was renewed interest in medium-sized cities and old city centers. The individual house once more became the "model French habitat."
39. The IFA's cultural, historical, and critical program could not have been implemented by a professional organization (the Ordre des Architectes did not have a tradition of such initiatives) or by a professional journal, despite the positive evolution of such journals in the 1970s, when Jacques Lucan edited *AMC* and Bernard Huet edited *L'Architecture d'Aujourd'hui*. See Bernard Huet, *Anachroniques d'architecture* (Brussels: AAM, 1981).

THIS PAGE Johan Otto van Spreck-
elsen, Grande Arche de la Défense,
Puteaux, 1983–89

FOLLOWING PAGES Jean Nouvel,
Galeries Lafayette, Berlin, 1991–96:
Exterior view of the glass façade
of the offices

40. These three architect-intellectuals
are representative of the new climate in
French architectural culture. Chaslin is
thoroughly at home with the written
word. In his capacity as head of the
"diffusion" department of the IFA, he
organized many exhibitions; he also
published many articles in Le Monde and
Libération. After leaving the IFA, he
served for several years as editor of
L'Architecture d'Aujourd'hui. Epron
began in the professional world. A co-
founder (with Boudon, Hamburger, and
Sarfati) of the review AMC, he reori-
ented his career toward education after
1968. He founded the school of architec-
ture in Nancy, an institution specifically
designed to train architectural histori-
ans and teachers as well as practicing
architects. At the IFA, he pursued histori-
cal research on the relations between
training and the profession in the eigh-
teenth and nineteenth centuries,
becoming the leading authority on this
subject in France. Culot, a Belgian archi-
tect active in the struggle to preserve
the architectural patrimony in Brussels,
founded the Archives de l'Architecture
Moderne (AAM) in 1968 and, a few years
later, the review AAM. He continued his
militant advocacy of architectural publi-
cations and the safeguarding of archi-
tectural archives at the IFA, where he
created the Archives d'Architecture du
XXème Siècle .
41. On these projects, see J. Jenger,
Orsay: de la gare au musée (Milan and
Paris: Electa-Moniteur, 1986); J. Lis-
sarague, D. Baudry, and A. Baccetti, La
Cité des sciences et de l'industrie (Milan
and Paris: Electa-Moniteur, 1988); and
Adrien Fainsilber, la virtualité de l'espace
(Milan and Paris: Electa-Moniteur, 1988).
42. See E. Biasini, J. Lebrat, D. Bezombes,
and J. M. Vincent, Le Grand Louvre, méta-
morphose d'un musée (Milan and Paris:
Electa-Moniteur, 1989).
43. See F. Chaslin and V. F. Picon-
Lefèbvre, La grande Arche de la Défense
(Milan and Paris: Electa-Moniteur, 1989).
44. On this architect, see S. Salat and F.
Labbé, Paul Andreu (Milan and Paris:
Electa-Moniteur, 1990).

On the edge of the park, the Zenith concert hall by Philippe Chaix and Jean-Paul Morel (1983) supports a metal struc-ture covered with silvered canvas. This original design spurred the construction of a series of functional modern concert halls in many large cities around the country. The other major projects of Mitterand's presidency were also innovative, although they had more classical objectives. The Arche de la Défense (also known as the Grande Arche) by Johann von Spreckelsen (1983–89) provided a grandiose culmination to the celebrated, recently extended Louvre–Champs Elysées–Défense axis.[43] A reinterpretation of the triumphal-arch tradition in light of cutting-edge modern technology, Spreckelsen's design is an exercise in geometric simplicity on a monumental scale, consisting of an open cube whose hundred-meter sides enable it to hold its own against the CNIT building and other nearby towers. Paul Andreu (designer of the airport at Roissy) brought the pro-ject to completion, adapting the design in light of various constraints.[44] Advanced engineering techniques—compa-rable to those used in bridge-building—were brought to bear on this exceptional structure, which incorporated some three hundred thousand tons of material. The contractor, Bouygues, was forced to use innovative on-site organiza-tional strategies as well as novel techniques for reinforced concrete to complete the structure. The services of technical specialists were also required: François Deslaugie oversaw the elevators, Peter Rice the span of the cube's "lid" (play-fully dubbed the "cloud").

Technological innovation figured in most of the grands travaux, from the greenhouse of the Cité des Sciences and the Grand Louvre's pyramid to the dais resting on soaring posts in the French pavilion at the 1992 World's Fair in Seville, designed by Jean-François Jodry, François Seigneur, and Jean-Paul Viguier. The technological experimentation involved in constructing these projects was not conducted for its own sake; rather, it was necessitated by the monu-mental simplicity of the designs, which enlisted technology in the cause of representational efficiency

The Arche de la Défense, the Ministry of Finance by Chemetov and Huidobro (1982–89), the Bastille Opera by Carlos Ott (1983–89), and even the idiosyncratically sculp-tural Cité de la Musique by Portzamparc (1984–95) have all been reproached for their "demonstrative," even "acade-mic" character.[45] According to their critics, they are mere "super-signs" inserted into the urban landscape to impress,[46] and while there is no denying the tendency toward monumentality in these projects, this quality was inherent in the very logic of the grands travaux. From the discreet renovation of the Grande Halle at La Villette by Bernard Reichen and Phillippe Robert (1982–85) to the cyclo-pean Grande Arche, from the ambiguous discourse of the Institut du Monde Arabe by Jean Nouvel, Gilbert Lézènès, Pierre Soria, and Architecture Studio (1981–87) to the spec-tacular Bibliothèque de France by Dominique Perrault (1989–96), the projects sponsored by Mitterand during his two seven-year terms constitute a coherent whole. They

were intended not to recast the functional economy of Paris (the aim of the urban initiatives of the de Gaulle–Pompidou years) but to render the city culturally legible, by way of assuring its continued prominence on the national and international scene. The *grands travaux* superimposed on earlier transformations a new interpretive framework, establishing—as the result of an incredible political will—a contemporary urban scale in the capital. In a period of cultural crisis, when the question of identity was the subject of intense debate throughout Europe, the French government put its hopes in the absolute clarity of the country's architectural images as messages of economic and political modernity. In a sense, the *grands travaux* marked the entry of French architecture into the communications era. Viewed from this perspective, they represent, whatever their failings, a significant step forward. Few large-scale projects following in their wake remained unaffected by them.

The Resurgence of Public Commissions

The 1980s—when growing demand for housing resulted primarily in suburban development, a sector largely closed to architects—saw a remarkable resurgence of public commissions. Legislation fostering decentralization was passed in 1983, increasing the power of local governments at the municipal, departmental, and regional levels. The *grands travaux* set an example for provincial cities, which in turn sponsored large-scale commissions such as conference centers, cultural centers, and museums. Where need converged with available real estate—in the form of abandoned industrial sites, for example—mayors initiated important projects. In Lille, at a junction created by the TGV terminal and the old SNCF station, a business center intended to strengthen the city's role in the European community was constructed at a time when national borders were becoming more permeable and the tunnel beneath the English Channel was about to open. Asked in 1988 to devise a master plan for the project, Rem Koolhaas conceived a vast urban "machine" that was formally autonomous but functionally integrated with the extant city. In effect, he accel-erated the process whereby cities create themselves through the interaction of large functional objects.[47] Most of the "machine's" heterogeneous components were entrusted to famous architects: a park to Gilles Clément, a viaduct to Deslaugier, the TGV station to Jean-Marie Duthilleul, the commercial center to Nouvel, an office tower to Portzamparc, and the business center to Vasconi. Koolhaas himself designed the conference and exposition center.[48]

There were many other commissions throughout France, many of which went to prominent foreign architects, including William Alsop (departmental government offices, Marseilles [1990–94]), Alessandro Anselmi (town hall, Rézé [1987–89]), Mario Botta (theater, Chambéry [1982–88], and media center, Villeurbanne [1984–88]), Santiago Calatrava (TGV station, Satolas [1989–94]), Norman Foster (media and contemporary art center, Nîmes [1984–88]), Masimiliano Fuksas (literature faculty, Brest [1992–94], and Maison des Arts, Talence [1994–96]), Jacques Herzog and Pierre de Meuron (sports center, Saint-Louis [1994–96]), Ian Ritchie (greenhouses, Terrasson-la-Villedieu [1995–96]), Rogers (Marseilles airport extension [1991–93]), and Livio Vacchini (architecture school, Nancy [1993–96]).[49] Overseen by France's government agencies and built by its contractors, these projects had an immense influence on professionals and public alike, affecting them far more than any image appearing in a specialized publication. At the same time that France was opening itself to international influence in this way, it discovered and adopted the "star system," under which French architects who had come to the fore in the 1970s—including Ciriani, Gaudin, Yves Lion, Portzamparc, and Sarfati—found it relatively easy to enter the public-commissions game.

As mayors became increasingly interested in the quality of public space, they began to sponsor public initiatives in little-explored areas. Marginal practices were incorporated into the sphere of architectural commissions, their legitimacy increasing in tandem with the prestige of their most prominent representatives: Andrée Putman, Philippe Starck, and Jean-Michel Wilmotte in furniture design; Louis

45. See O. Bohigas, "Occasioni perdute," *Casabella*, no. 494 (Sept. 1983). On the Bastille Opera, see G. Charlet, *L'Opéra Bastille, génèse et réalisation* (Milan and Paris: Electa-Moniteur, 1989).
46. On this subject, see "De l'Empire des Signes," *CREE*, no. 239 (Oct.–Nov. 1990), pp. 108–29, a section edited by M.-H. Contal and F. Michel featuring interviews with Patrice Goulet, Jean-Pierre Le Dantec, and Paul Virilio.
47. See Elisabeth Allain-Dupré, "Lille, métropole européenne," *Le Moniteur-Architecture-AMC*, no. 19 (March 1991), pp. 32–48. See also *Lille métropole* (Paris: Moniteur, 1993).
48. On the work of this architect, see Lucan, *OMA-Rem Koolhaas* (Milan and Paris: Electa-Moniteur, 1990).

Clair, Yann Kersalé, and Roger Narboni in urban lighting design; Alexandre Chemetoff, Clément, Michel Corajoud, and Michel Desvignes in landscape design; and Deslaugier and Marc Mimram in structural engineering.[50] Some programs underwent significant development. Many cities—including Arles, Caen, Cambrai, Clermont-Ferrand, Lille, and Lyons—rebuilt, enlarged, or constructed museums, resulting in many new variations on the themes of light and processional space, which are central to this building type. In Paris, Guy Duval and Antoine Stinco remodeled the Musée du Jeu de Paume (1987–89); Chemetov and Huidobro provided a new face for the Museum d'Histoire Naturelle (1989–94); Portzamparc designed an extension for the Musée Bourdelle (1989–92); and Yves Lion remodeled an old Parisian hotel to serve as the Maison de la Photographie (1994–96). Ciriani designed the Historial de la Grande Guerre in Péronne (1987–96) and the Musée d'Arles Antique (1988–95). Pierre-Louis Faloci designed the Musée de la Civilisation Celtique in Mont-Beuvray (1991–95), appropriately integrating the building into the site and "stratifying" structures of various kinds (such as concrete walls, slabs, posts, and beams) to bring to mind archaeological layering within the soil. The museum is one with the landscape, framing it and allowing it to penetrate its volume.[51] Other significant experiments of this period include the landscape-friendly Musée d'Art Américain at Giverny by Bernard Reichen and

ABOVE Gérard Sutter and Dominique Laburte, Cernay High School, Haut-Rhin, 1988–91

49. Housing commissions were likewise awarded to foreign architects, including Diener and Diener (rue de la Roquette, Paris [1994–97]); Piano (complex on the rue de Meaux, Paris [1988–91]); and Rossi (apartment building near the Parc de la Villette [1987–91]). The same is true of private commissions, among them designs by Frank Gehry (American Center, Paris [1990–93]); Herzog and de Meuron (Ricola factory, Mulhouse [1991–94]); and Richard Meier (headquarters of Canal Plus, Paris [1988–91]).

Philippe Robert (1989–92), the aerial invention of Philippe Chaix and Jean-Paul Morel in their Musée Archéologique in Saint-Romain-en-Gal (1993–96), and the poetic ingenuity of the addition to the Palais des Beaux-Arts in Lille by Jean-Marc Ibos and Myrto Vitart (1992–97).[52]

Experimental Terrain

Generally speaking, public buildings are of such complexity that they offer many opportunities for experimentation. For the Du Fresnoy Contemporary Art Studio in Tourcoing (1993–96), Tschumi devised a novel concept: he covered both old and new structures with a single roof that also protects the open areas between them.[53] For the cultural center in Combes-la-Ville (1981–86), Nouvel designed a glass hangar whose façade functions as an information screen with neon lettering. His CNRS documentation center in Nancy (1985–89) is broken into functional units, which are linked, as in a factory, by circulation paths. In Tours, Nouvel

conceived a conference center as a transparent case containing amphitheaters (1989–93). Nouvel's inventiveness is also apparent in other projects, including his Nemausus 1 apartment complex in Nîmes (with Ibos, 1985–87); the networked façades of hotels in Bordeaux (1988–89) and Dax (1990–92); the glass screens of the Fondation Cartier (1991–94). The solution he adopted for the Galeries Lafayette building in Berlin (1991–95) is characteristic of his work: confronted with a program stipulating a mixture of commercial and office space, Nouvel revisited the late-nineteenth-century *grand magasin* model, replacing its rectangular central well with a large, transparent conical volume and thus transforming the void into a playful spatial experience.[54] Both Nouvel and Tschumi upset expectations. They use architecture to gain expressive purchase on "contemporaneity." In their attempts to renew modes of design, they represent one of the experimental poles of French architecture.

50. Starck, who first became known for his remodeling of Café Costes in Paris (1984), designed outdoor furnishings for the Parc de la Villete and the city of Nîmes. Chemetoff designed several gardens (including those at La Villette, Mandres-les-Roses, Arcueil, and Nancy). Mimram designed a pedestrian bridge for a freeway in Toulouse (1988–89) and a set of toll booths on autoroute A5 (1991–94). Their example has been followed by younger architects, including Sylvie Bruel, Marion Faunière, and Pierre Lafon in the field of landscape design, and Jean-Marc Weill in that of small service structures.
51. See the section devoted to this museum in *L'Architecture d'Aujourd'hui*, no. 301 (Oct. 1995), pp. 87–103.

FACING PAGE Patrick Weber and
Pierre Keiling, Sports Center,
Lauterbourg, 1994–95

FOLLOWING PAGES Paul Maurand,
Lucien Colin, Dominique Henriet,
Laurent and Emmanuelle Beau-
douin. Renovation of the exhibition
hall in Nancy-Vandoeuvre, 1995–97.
View of the structure constructed in
the 1960s by Stéphane Du Chateau

The 1980s and early 1990s also saw the construction of many schools and university buildings that occasioned experiments of various kinds. Examples include the Vaux-en-Vélin architecture school (1984–87) and the dormitory complex for foreign students (1989–92), both in Lyons, by Françoise-Hélène Jourda and Gilles Perraudin; the architecture school of Brittany in Rennes (1987–90) and Maison de l'Université de Bourgogne in Dijon (1992–96) by Patrick Berger; the Lycée Gustave Eiffel boarding school in Bordeaux (1989–91) by Jacques Hondelatte, the electronics school in Cergy (1991–93) by Fabrice Dusapin and François Leclercq; and the science faculty in Tours (1992–96) by Franck Hammouthène.[55] In the Vosges, Marie-José Canonica and Alain Cartignies attempted to make educational spaces more like houses in their elementary school in Deyvillers (1986–87), lycée in Courcieux (1986–89), and IUT (Institut Universitaire de Technologie) in Épinal (1990–93). In Alsace, Gérard Sutter and Dominique Laburte established clear hierarchical distinctions between the various buildings of their lycée in Cernay (1988–91), arranging them on the site in accordance with classical models. In Grenoble, for the school of arts and human sciences (1993–96), Anne Lacaton and Jean-Philippe Vassal poetically fused the models of the atelier and the greenhouse to achieve a light and transparent building; on its northern and southern sides, light is filtered through bamboo and bougainvilleas cultivated within narrow buffer spaces enclosed by transparent polycarbon walls.[56]

All of these architects, who appeared on the French architectural scene during the last decade, belong to what might be called the "competition generation." Due to their public commissions, they have been able to develop novel approaches to important problems while designing important buildings. It was Perrault's design for the École Supérieure d'Ingénieurs en Électronique in Marne-la-Vallée (1984–87), for example, that led to his being invited to participate in the Grande Bibliothèque competition. Other notable architects of this generation include Joseph Almudever and Christian Lefebvre (cultural center, Maza-met [1990–94]), Laurent Beaudouin and Sylvain Giacomazzi (borough hall, Bousse [1989–92], and media center, Poitiers [1992–96]), Philippe Gazeau (day-care center, rue de Hauteville, Paris [1983–84], and Lycée Clavel, Paris [1990–93]), Jean-Louis Godivier (cultural center, Châteauroux [1991–94]), Philippe Guyard (technical school, Langres [1989–91]), and Jean Harari (French language center, Blois [1991–96]). In fact, more than two hundred French firms active in this period have produced work of sufficient quality to merit publication in the French architectural press. These young architects use neither the same language nor the same set of references as their professors. Cultural institutions began to take stock of the contribution made by this new wave in 1990, when the IFA mounted the first of two exhibitions showcasing the work of forty French architects under the age of forty, shown at the Hôtel de Tournon in Paris (home of the IFA), then at the Venice *Biennale*.[57]

From Postmodernism to Neo-Modernism

During the 1980s, the advocates of urban contextualism began to pursue increasingly divergent agendas, from the hyperplasticity of Portzamparc (in his Paris Conservatory [1981–84]) to the neo-Structuralism of Yves Lion (courthouse complex, Draguignan [1978–84]), and from the Postmodernism of Sarfati (gymnasium, Savigny [1978–82]) to the neo-Corbusianism of Ciriani (kindergarten, Torcy [1986–89]).[58] Despite appearances, however, French architecture remained rather homogeneous. In his book *France Architecture, 1965–1988*, Jacques Lucan criticized such seemingly disparate projects as the labor exchange in Saint-Denis by Castro and Stinco (1977–83) and the Glycines apartment complex in Evry by Sarfati (1977–82) on the same grounds, accusing both of "formal eclecticism."[59] This is perfectly understandable, for there was a dominant Postmodern tendency in French architecture of the 1980s. Yet aside from the historicist exercises of Bofill and the provocative pronouncements of Culot and Leon Krier, this current was less openly embraced in France than it was in England and the United States. Its most common form was a superficial "neo-

52. On Chalx and Morel, see *L'Architecture d'Aujourd'hui*, no. 309 (Feb. 1997), pp. 31–63, for their École Nationale des Ponts et Chausées, and École Nationale des Sciences Géographiques, Marne-la-Vallée.

53. See Alain Guiheux, ed., *Tschumi, une architecture en projet: Le Fresnoy*, Supplémentaires series (Paris: Centre Georges Pompidou, 1993), pp. 113–23; and J.P. Robert, "Le Fresnoy," *L'Architecture d'Aujourd'hui*, no. 314 (Dec. 1997), pp. 35–55.

54. On Nouvel, see P. Goulet, *Jean Nouvel* (Milan and Paris: Electa-Moniteur, 1987); L. Guyon and F. Mutterer, *L'Institut du Monde Arabe* (Paris: IFA, 1987); and O. Boissière, *Jean Nouvel, Emmanuel Cattani et Associés* (Zurich: Studio Paperback, 1992).

55. See *Jourda-Perraudin*, Gros plan 8 (Paris: IFA-Pandora, 1991); *Jacques Hondelatte*, Gros plan 7 (Paris: IFA-Pandora, 1991); *L'internat du Lycée Gustave Eiffel à Bordeaux de Jacques Hondelatte* (Paris: IFA, 1994); and *Franck Hammouthène*, Gros plan 3 (Paris: IFA-Pandora, 1991).

56. See Lacaton and Vassal, *Il fera beau demain* (Paris: IFA, 1995).

Modernism" that left its mark on hundreds of projects throughout the country. From modest new buildings in small towns to the face-lifts given to many large housing complexes of the 1960s,[60] most of the architecture of this period can be classified as neo-Modern kitsch, typified by porthole windows, airplane-wing roofs, and tacky curtain-wall cladding. Hence the severity of Lagneau's judgment of what, until only a few years ago, constituted the bulk of French architecture.

How are we to explain the spread of this phenomenon? Perhaps as a manifestation of bad conscience resulting from too brutal a rupture with tradition. In a country where architects like Auguste Perret and Le Corbusier had created benchmark Modernist works, a break with this tradition could not be effected without repercussion. The 1970s witnessed the progressive abandonment of skills acquired by an entire generation, which included Édouard Albert, Eugène Beaudouin, Henry Bernard, Paul Bossard, Dubuisson, Pierre Dufau, Jean Ginsberg, André Hermant, Lagneau, Lods, Raymond Lopez, Fernand Pouillon, Jean Prouvé, and Zehrfuss.[61] Unable to profit from a body of experience that had permitted the development of a sophisticated architecture alert to both the needs and the technical capacities of the period, the generation of the 1970s was engulfed by a superficial return to urban contextualism, overvaluing formal problems and opting for a trivially mimetic relationship with the work of the interwar period. In a process of semantic slippage, the Modernism of the 1960s was repressed and supplanted by the white, eminently pictorial Modernist idiom of the 1920s. Many architects considered themselves to be avant-garde, though they were simply displaying empty neo-Modernist signs co-opted from the Modernist tradition. Such simulacra of "contemporaneity" were no substitute for continuity on an intellectual level with the socially conscious, technically innovative work of the post-war years.

Significantly, the first notable reaction to this stylistic debacle was initiated by Chemetov. In 1982, he organized *Modernity: An Incomplete Project* (*La Modernité, un projet inachevé*), an exhibition examining the lack of continuity in the Modernist tradition in France within the framework of international trends.[62] It compared the work of such international architects as Richard Meier, Gustave Peichl, Álvaro Siza, and Luigi Snozzi to the designs of a few French architects, notably Ciriani, Gaudin, Roland Simounet, and the Atelier de Montrouge. Three years later, Kenneth Frampton and Michel Kagan also responded, by organizing *New Directions in Modern Architecture, France/USA* (*Nouvelles directions de l'architecture moderne, France/USA*), an exhibition featuring the work of thirty French and American firms.[63] The architects were chosen on the basis of the strength of their ties to the Modernist legacy and the degree to which they took account of new living conditions, contextual factors, and technical innovations, criteria formulated in the hope of getting beyond formal questions. Ciriani and Simounet were included alongside younger practitioners, notably Beaudouin, Christian Devillers, Philippe Dubois, Girard, Kagan, Yves Lion, and Jacques Ripault.

Both of these polemical exhibitions were designed to demonstrate the persistence of Modernism, and they achieved this goal. But the eclecticism of the work on view also revealed the fragility of intergenerational ties. This problem was especially apparent in the French designs chosen by Frampton and Kagan. Two architects stand apart from the others: Simounet, with his vacation houses in Corsica (1969–71) and museum of prehistory in Nemours (1976–80), and Devillers, with his parking garage in Saint-Denis (1983–84). Simounet, who began his career in the 1950s in Algeria, never deviated from Modernist concerns. Devillers, of all the young architects included, was the one closest to the preceding generation, an affinity resulting from his stint at the AUA. Here we touch upon one of the paradoxes of recent French architecture: it is clear that few of the projects designed by the "urban-contextualist generation" can rival those built during the same period by the senior Modernists, among them Dubuisson's apartment buildings in Versailles (1969–73); Lagneau, Weill, and

57. The exhibition *40 architectes de moins de 40 ans* devoted exclusively to Parisian firms was on view at the IFA from October 1990 to January 1991 and at the Venice *Biennale* in 1992. Valérie Vaudou curated the exhibition, and the installation was designed by Bernard and Clotilde Barto. A second exhibition, with the same title, featuring the work of French firms located outside Paris was shown at the IFA in 1992.

58. There are several monographs on architects from this generation: *Christian de Portzamparc* (Milan and Paris: Electa-Moniteur, 1984; rev. ed. 1990); *Alain Sarfati* (Milan and Paris: Electa-Moniteur, 1990); *Henri Ciriani* (Milan and Paris: Electa-Moniteur, 1984); *Henri Gaudin* (Milan and Paris: Electa-Moniteur, 1984); and *Georges Maurios* (Milan and Paris: Electa-Moniteur, 1990). See also Gaudin, *La Cabane et le Labyrinthe* (Brussels and Liège: Pierre Mardaga, 1984); and Gaudin, *Seuil et d'ailleurs* (Paris: Les éditions du demi-cercle, 1992). Henri and Bruno Gaudin designed the Archives de la Ville de Paris (1986–90) and Charlety Stadium (1991–94).

59. Lucan, *France Architecture*, p. 146. Sarfati also designed the swimming pool in Quimper (1988–91) and remodeled an old industrial building to house the Centre des Archives du Monde du Travail in Roubaix (1990–93).

60. While large housing complexes antithetical to the very notion of architecture were common, many projects from the 1950s were of high quality. The following examples were not exceptional: Bossard's La Cité des Bleuets, Créteil (1959); Pouillon's Meudon-la-Forêt (1959–61); Lagneau-Weill-Dimitrijevic's Les Buffets, Fonktenay-aux-Roses (1957–59); and Dubuisson's La Résidence du Parc, Croix, (1952–54).

61. On the aims of these architects, see Albert, *Une Option sur le vide* (Paris: Sens et Tonka, 1994); Dufau, *Un Architecte qui voulait être architecte* (Paris: Londreys, 1974); Dubuisson, "Ces ensembles qu'on voulait grands," in *Les années 1950* (Paris: Centre Georges Pompidou, 1988), pp. 530–35; Lods, *Le Métier d'architecte* (Paris: Éditions France-Empire, 1976); and Pouillon, *Mémoires d'un architecte* (Paris: Seuil, 1968).

Dimitrijevic's administrative complex in Evry (1973–80); Oscar Niemeyer's cultural center in Le Havre (1977–83); Prouvé's Nancy postal center (1970–72); Simounet's house near Toulon (1975–77) and Musée d'Art Moderne in Ville-neuve d'Asq (1979–83); and André Wogenscky's University of the Arts in Takarazuka, Japan (1983–87).[64] Late Mod-ernism, nourished by the experiments of the 1960s, is richer in meaning than the mannerist "neo-Modernism" that set out to replace it. The architects capable of assuring histori-cal continuity (including Chemetov, Jacques Kalisz, Claude Parent, and Jean-Louis Véret) proved unable to do so.[65]

Relations with the Image:
An Assessment of Recent Trends

Only in the early 1980s were ties between the generations strengthened again, enabling French architects to escape from their impasse. This development was the result of sev-eral factors. One was the desire for simplicity manifested to spectacular effect in the Parisian *grands travaux*, which spawned a tendency toward maximal legibility and away from Postmodernist dross. The best designs following the example set by the *grands travaux* articulate complex meanings using the simplest of means, and even the less successful ones, despite their academic quality, are prefer-able to kitschy neo-Modernist exercises. Large slabs and blocks made of concrete, glass, and metal proved efficient tools for achieving the relegitimized goals of geometric clarity and transparency. Cases in point include Christian Hauvette's regional audit office of Brittany in Rennes (1988) and Caisse Française de Développement in Paris (1994–96); Francis Soler's unbuilt competition entry for an interna-tional conference center in Paris (1990); and Vasconi's departmental offices in Strasbourg (1986–89) and confer-ence center in Reims (1990–94).[66]

Another positive development in the battle against for-malism was the emergence of a few practitioners weary of the exaggerated gestures that had become pervasive in French architecture. The exhibition *Correspondences: Paris-London* (*Correspondances: Paris-Londres*), organized in 1988

by the IFA in collaboration with the 9 H Gallery in London, was a benchmark event in this regard. Work by Berger (greenhouses in Citroën-Cévennès in Paris [1985–93] and architecture school in Rennes [1986–90]), Faloci (winery in Portugal [1983–85], house in Antibes [1986], and new floors added to the Lycée Coysevox in Paris [1988]), and Yves Lion (artists' studios in Paris [1984–91] and lycée in Saint-Quai-Portrieux [1988]) was shown alongside that of David Chip-perfield, Rick Mather, Eric Parry, and Stanton and William.[67] As Lucan explained in the catalogue, Berger, Faloci, and Lion exemplified a new tendency toward "calming the waters." The time was ripe for a more disciplined approach, for the "rediscovery [of] a coherence and a rationality" at odds with seductive, facile effects.

A third, and definitive, influence was the work of Nou-vel. Because Nouvel took into account the contradictions of the contemporary situation, he had an inordinate impact on young architects. The relationship of his work to that of the Modernists results not from direct inheritance but from an intellectual reconstitution effected *a posteriori*. Nouvel did not flee from Postmodernism; he used it as a lever to liber-ate the Modernist tradition from the "yoke" of ethical mili-tancy, which, in his view, prevented it from realizing its contemporary potential. In 1982, in the catalogue of the exhibition *Modernity, or the Spirit of the Times* (*La Moder-nité, ou l'esprit du temps* the architecture section of the *Bien-nale de Paris*), he insisted on the decisive role of images in a period marked by television and advertising: "It is the reign of the instantaneous, of the spectacular, of movement, of manipulation. . . . Colors can be reversed, scale altered, images multiplied to infinity, they can be distorted, altered, restored."[68] Nouvel has remained faithful to this approach, seeking to exploit to experimental ends the conceptual and technical freedoms that this situation allows. His argument is not with rationalism, which he extends to the iconic domain. Analogous views inform the work of Clotilde and Bernard Barto (in their Audi-Volkswagen garage [1987–88] and La Pérouse Hotel [1989–93], both in Nantes)[69] and of Ibos and Vitart (addition to the Palais des Beaux-Arts in Lille

62. Chemetov, *Lu Modernité, un projet inacheve* (Paris: L'Équerre, 1982). The exhibition was shown at the Ecole des Beaux-Arts, Paris, as part of the Festival d'Automne.
63. Frampton and Kagan, *Nouvelles directions de l'architecture moderne, France/USA* (Milan and Paris: Electa-Moniteur, 1985).
64. On Dubuisson, see the special issue of *Colonnes* (IFA-Archives d'Architecture du XXème Siècle), no. 11 (Jan. 1998). On Simounet, see *Roland Simounet, d'une architecture juste* (Paris: Moniteur, 1997) as well as the architect's beautiful text on his Algerian period, *Traces écrites* (Paris: Domens, 1997). On Wogenscky, see *André Wogenscky* (Paris: Cercle d'art, 1993).
65. On Parent, see *Claude Parent archi-tecte* (Paris: Robert Laffont, 1975).
66. See *Christian Hauvette* (Paris: IFA, 1994); *Francis Soler* (Paris: IFA, 1994); and Pascale Joffroy, *Claude Vasconi* (Milan and Paris: Electa-Moniteur, 1990).
67. *Correspondances Paris-Londres* (Paris: Moniteur, 1988).

68. Nouvel, "La Modernité: critères et repères," in *La Modernité, ou l'Esprit du Temps*, exh. cat. (Paris: L'Équerre, 1982), p. 20. In the same catalogue, François Barré evokes the "contiguous moderni-ties" discernable "along highways, around supermarkets" (p. 19).
69. On Clotilde and Bernard Barto, see *Barto + Barto*, Gros plan 6 (Paris: IFA-Pandora, 1991).
70. Chemetov developed a typological and technical framework for invention,

FORM VERSUS RELATION

The simple volumes that animated Le Corbusier's architecture in the 1920s evolved into a practice clearly aligned with his sculptural activities in later works executed between 1953 and 1965. In such works as the Unité d'Habitation in Marseilles (1949–53) and the chapel of Notre Dame du Haut at Ronchamp (1950–55), Le Corbusier was instrumental in the emergence of "architecture-sculpture," which coincided with developments in Japanese and American architecture. In France, architects such as André Bloc—owner and chief editor of *Architecture d'Aujourd'hui* as well as an engineer involved with sculpture—participated in developing a vital formalism that attempted to liberate architecture by restoring the societal role of the architect to the position of "artist." Their formalism was an ideological position that resulted in the creation of sculptural objects, but not in the sense of sculptural object/sign which applies to some recent architectural projects (the work of Jean Nouvel and Philippe Starck).

During the same period, intense opposition was developing to this continuing emphasis on form. As a direct challenge to Le Corbusier and his formalist hegemony, Alison and Peter Smithson's *CIAM Grid* launched the first attack at the tenth meeting of CIAM (Congrès Internationaux d'Architecture Moderne) in 1953. Their firmly articulated social conception of urbanism and architectural practice led to the notion of a boundless space—a conception of formless urbanism that does not designate specific use-zones. Rejecting a morphological approach to urban planning, a generation of architects beginning with the Smithsons challenged both monumentalism and the sculptural approach to architecture. Georges Candilis, Alexis Josic, and Shadrach Woods focused on articulating and coordinating public and private space through a network of circulation and support systems defined by human activities—using metaphors of "stem" and "web"—thus abolishing the distinction between architecture and urbanism. This idea of the homogeneous network was also the basis for Yona Friedman's unbuilt megastructure projects, expressed through drawings and photocollages.

Socially driven architecture of the 1960s borrowed ideas from new technology: telecommunications and computers. The concepts of "stem" and "network" embody endless combinatorial possibilities inherent in these technologies which enable a vision of development without rigid organization and infinite outward growth. The architecture of Candilis, Josic, and Woods —like that of the Smithsons—attempted to establish an organization of sites based solely on the passage from one use or activity to another, without the mediation of form. Rejecting rigid zoning, their homogeneous network not only permits the distribution of functions but also eradicates the binary distinctions of inside/outside, interior/exterior, and empty/full. This conception of architecture as a tool or device without form has been taken even further by contemporary architects such as Rem Koolhaas, Bernard Tschumi, and the team Geipel and Michelin.

The legacies of Corbusian Brutalism and the socially conscious architecture of the Candilis team are both present in works produced by AUA (Atelier d'Urbanisme et d'Architecture) and Henri Ciriani. From the mid 1970s, they developed a specific set of cultural ideas about architecture, embracing the ideal of social utopia but also insisting on the housing block as a form that functions as a public monument within the urban landscape. Through a rediscovery of Le Corbusier, the boundless territory has been succeeded by a return to the consideration of urban form, as in the work of Ciriani and, more recently, Christian de Portzamparc.

UNITÉ D'HABITATION, MARSEILLES
1946-52

LE CORBUSIER

*(b. 1887, La Chaux-de-Fonds, Switzerland–
d. 1965, Cap Martin, France)*

Perhaps architecture's greatest propagandist, Le Corbusier was from the very begin- ning acutely aware both of his own genius and the central role he would play in the soon-to-be-written histories of Modern architecture. Le Corbusier was the adopted pseudonym of Charles-Édouard Jeanneret. With the fee from his first commission, the Villa Fallet (1907), he traveled extensively across Europe, coming into contact with many of Modernism's pioneering architects (Josef Hoffmann, Tony Garnier, Auguste Perret, Peter Behrens), before finally deciding to settle in Paris in 1917. There, together with painter Amédée Ozenfant, he founded the movement known as Purism, in critical re-action against the decorative aspects of pre-1914 Cubism and in favor of an art that stressed mathematical order, purity, and the rational simplicity of machine iconography. Le Corbusier and Ozenfant published their ideas in a small booklet, Après le cubisme (After cubism, 1918), and in the magazine they co-founded, L'Esprit nouveau (1920–25). A number of these essays were also collected together to form Le Corbusier's great treatise on modern architecture, Vers une architecture (1923; published in English as Towards a New Architecture *in 1927), containing his famous line, "A house is a machine for living in"; in the heartfelt conviction of its writing, this architectural manifesto is quite unlike any other. Le Corbusier continued to speculate on the concept of a mass-produced architecture with his three utopian city plans—the Contemporary City (1922), the Plan Voisin (1925), and several versions of the Radiant City (1930–36)—all of which gave visual expression to his idea of high-density, high-rise urban living, so as to free the city's* »

Le Corbusier was commissioned to design a large apartment block, the Unité d'Habitation in Marseilles, by the French Ministry for Reconstruction and Urbanism in late 1945, shortly after he had reopened his office in Paris. During the war he had worked on many proposals for mass housing, first with a government committee, and by 1942 as part of his own research group ASCORAL (Assemblée de Constructeurs pour une Rénovation Architecturale). His design for the Marseilles Unité drew on his ASCORAL research and on explorations of mass housing he had been pursuing since the 1920s, including the Maison Citrohan (1922), the Pavillon de l'Esprit Nouveau (1925), and the housing complex at Pessac (1925–26). Coining the term "Unité d'Habitation" in the 1930s, he designed a number of schemes exploring large-scale urban reform, most notably his first *Ville Radieuse* (Radiant City) in 1930–31. In these projects, building on the models of the monastery and the ocean liner, he developed the Unité's characteristic *pilotis* (columns), interior streets, roof terraces, and "open-plan" apartments.

Construction began on the Marseilles Unité in 1947 under the direction of ATBAT (Atelier des Bâtisseurs), an organization of technicians in various disciplines that Le Corbusier had formed in 1946 with engineer Vladimir Bodiansky. The Unité rests on large, cast-concrete piers raising the massive block of apartments above the ground, and Le Corbusier famously described its structure—an 18-story cast-concrete frame containing 337 units—as being like bottles in a wine rack. The design also represents the first time he used his Modulor system, a proportional method of organizing a large-scale structure's façades, which here extend 165 meters on the long sides. The building itself was based on his idea of the "extended dwelling," in which the building services and social amenities were shared. There is a two-story-high arcade at the seventh floor—a public "street" with shops and facilities such as a gymnasium, laundry, hairdresser, and commercial offices—and a roof terrace at the top intended for use as an exercise promenade and a nursery school.

Le Corbusier designed twenty-three variants of the individual unit, consisting of a double-height kitchen and living area, parents' bedroom and bathroom, and children's bedroom. Each apartment was densely packed, the internal width being a modest 3.66 meters (12 feet). To unify family and individual life, he created interlocking spaces that could be rearranged to some degree by their inhabitants. The large windows on the main area could be opened across their full width, making the balcony a part of the living space. Similarly, the narrow children's rooms were separated by a sliding blackboard wall, allowing them to be opened out into a larger playroom. Designed in collaboration with Charlotte Perriand, the kitchens were radical in their spatial efficiency and use of lightweight laminated materials.

The façades on three sides of the building (all but the short side facing north) »

Selected Bibliography

Von Moos, Stanislaus. *Le Corbusier: Elements of a Synthesis.* Cambridge, Mass.: MIT Press, 1979.

Wogensky, André. "The Unité d'Habitation at Marseille," trans. Stephen Sartarelli, in *Le Corbusier,* ed. H. Allen Brooks. New York: Garland Publishing, 1987.

Jenkins, David. *Unité d'Habitation, Marseilles.* London: Phaidon Press, 1993.

FACING PAGE Double-height living area of a duplex apartment in the Unité d'Habitation, Marseilles, opening onto balcony designed to block full summer sun but allow winter sunlight

are encased in a sun-blocking system of balconies with canopies and side walls, instead of a transparent curtain wall. The building thus responds to seasonal and daily climatic conditions, protecting its inhabitants from the high summer sun and allowing winter sunlight to enter. Some critics, however, point to the fact that these structures are exactly the same on all three sides as evidence that Le Corbusier was more interested in their aesthetic effect than their environmental efficacy.

Early in the design stage, Le Corbusier had been forced to abandon a predominantly steel-frame scheme due to the postwar steel shortage. The resulting use of precast and cast-in-place concrete is often regarded as a turning point in his work, since it fundamentally reconceptualized concrete as an elemental and plastic material to be sculpted, rather than a precise material neatly assembled like steel. Unlike his earlier work in concrete, the surface was not plastered over. Rough boards were used for the form-work, giving the concrete an almost organic texture. Because of its monolithic nature and this use of concrete as a form of natural material, the Unité later became an icon for the movement in architecture known as "New Brutalism."

Construction of the Unité was planned to take one year, but lasted more than five; and there were arguments between Le Corbusier and the ATBAT team and problems with the Ministry. The completion of the building is probably due largely to the support Le Corbusier received from France's third postwar Minister of Reconstruction, Eugène Claude-Petit, who exempted it from compliance with the building code due to its "experimental nature." Although the completed building was eventually viewed as a success by its critics and inhabitants, in 1952 the State sold it to an independent housing cooperative. Four more Unités were built: in Nantes-Rezé, Berlin, Briey-en-Forêt, and Firminy-Vert. All were smaller than the Marseilles block and none were as successful as the original one, proving too expensive and complicated to construct. However, the Marseilles Unité vindicated Le Corbusier's utopian ideas about the design of mass housing, providing the model for countless apartment blocks all over the world, and demonstrated a degree of attention to materials and building techniques that would transform postwar Modernist architecture.

JOANNA MERWOOD

LE CORBUSIER

vacant spaces for parks and playing fields. None of these proposals were ever realized, but he did build a succession of private homes that in many ways reinvented the concept of the house. Best illustrated by the Villa Stein, Garches (1927), and the Villa Savoye, Poissy (1928–31), these houses were characterized by their white walls, the use of slender pilotis (columns) to raise the building off the ground, and the light, open spaces of their interiors. Over the next twenty years, he utilized many of these ideas in his designs for public buildings, notably the Salvation Army Building (1929–33) and the Swiss Pavilion of the Cité Universitaire (1930–32), both in Paris, and later participated in the preliminary phase of designing the sheer glass slab of the Secretariat of the United Nations Headquarters in New York, which was modified and completed by Wallace Harrison (1947–50). Toward the end of this period, however, Le Corbusier began to aban- don the functionalism that he had been so instrumental in formulating, and turned instead to a more expressionistic, emphatically sculptural style. The change is notice- able in the government buildings he designed in Chandigarh, India (1951–65); but the culmination of this shift is found in the sweeping sculptural form of the Philips Pavilion at the Brussels World's Fair (1958) and, especially, in the rough concrete walls, irregular stained-glass openings, and wild, flowing roof of his Chapel of Notre Dame du Haut at Ronchamp (1950–55). It is perhaps fitting that a man who, throughout his life, had passionately celebrated architecture as a new theology, should leave, as a monument to his invention, a site both of spiritual and architectural pilgrimage.

THOMAS WEAVER

RIGHT Le Corbusier's chapel of Notre Dame du Haut, Ronchamp, France (1950–55)

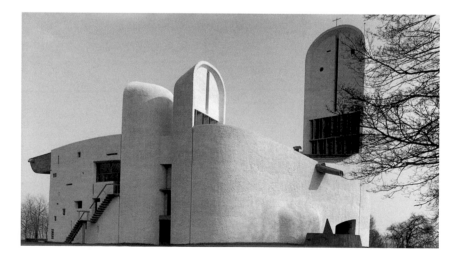

Selected Bibliography

Le Corbusier. *Towards a New Architecture* (1923). Trans. Frederick Eichells. London: Butterworth Architecture, 1989.

Fishman, Robert. *Urban Utopias in the Twentieth Century: Ebenezar Howard, Frank Lloyd Wright, and Le Corbusier*. New York: Basic Books, 1977.

Brooks, H. Allen, ed. *Le Corbusier*. Princeton, N.J.: Princeton University Press, 1989.

Le Corbusier. *Oeuvre Complète, 1910–1969*. 8 vols (ed. Willy Boesiger). Zurich: Les Éditions d'Architecture, 1991.

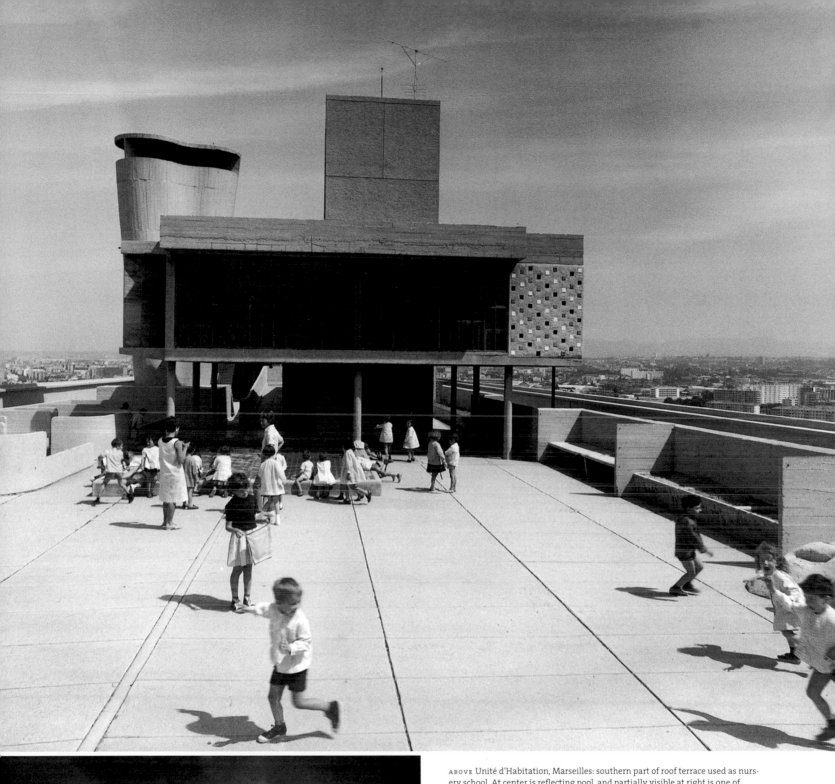

ABOVE Unité d'Habitation, Marseilles: southern part of roof terrace used as nursery school. At center is reflecting pool, and partially visible at right is one of several concrete sculptural forms that Le Corbusier created to form an abstract landscape

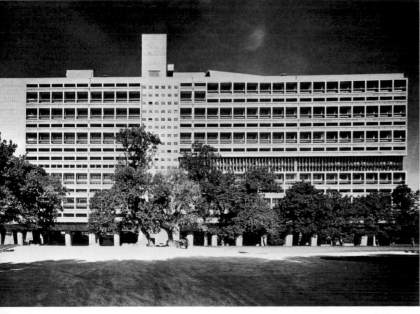

LEFT Unité d'Habitation, Marseilles: East façade

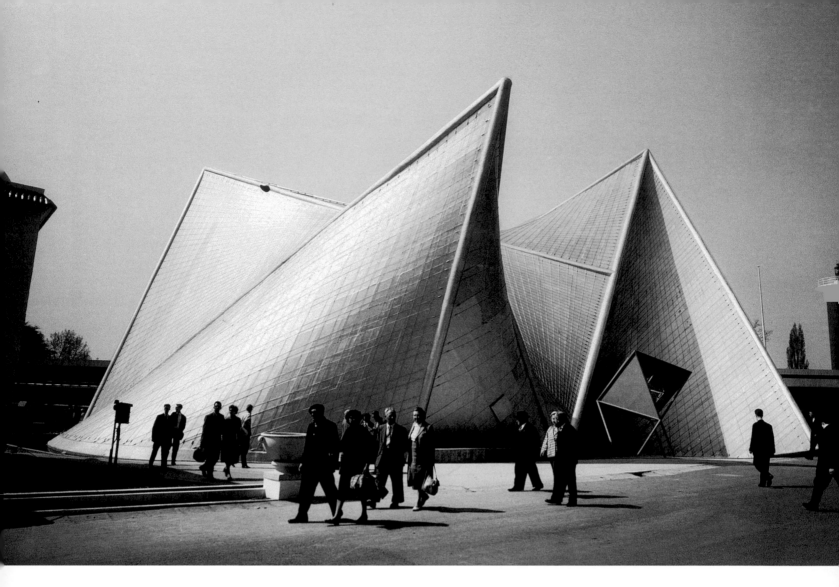

ABOVE AND FACING PAGE, ABOVE The Philips Pavilion at the
Brussels World's Fair (1958), which Le Corbusier designed in
collaboration with composers Yannis Xénakis and Edgar
Varèse (each of whom created music for the ten-minute
"Electronic Poem" presented inside the pavilion)

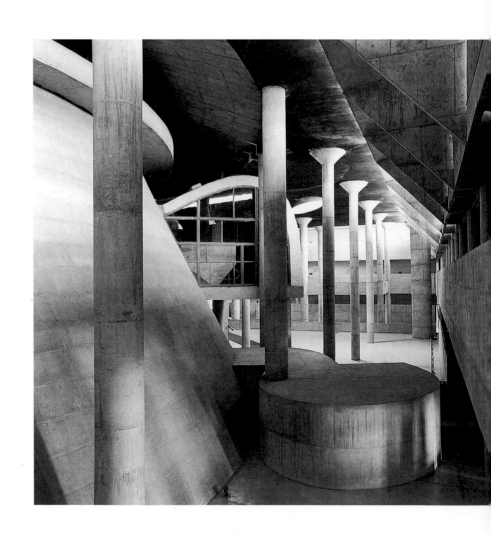

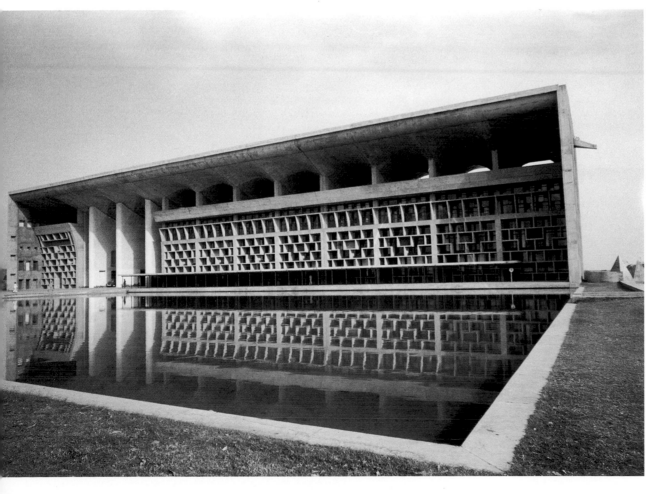

LEFT The monumental façade of the High Court, Chandigarh (1951–56), and its reflecting pool

FACING PAGE, BELOW General Assembly, Chandigarh (1951–65): Detail of the lobby's concrete structure featuring a variety of sculptural forms

GRID PRESENTED AT CIAM 9
1953

ALISON AND PETER SMITHSON

MUSLIM HOUSING PRESENTED AT CIAM 9
1951-52

GEORGES CANDILIS WITH SHADRACH WOODS AND VLADIMIR BODIANSKY

ALISON SMITHSON
(b. 1928, Sheffield, England– d. 1993, London)
PETER SMITHSON
(b. 1923, Stockton-on-Tees, England)

At the ninth Meeting of CIAM (Congrès Internationaux d'Architecture Moderne) in Aix-en-Provence in 1953, Alison and Peter Smithson presented a *Grid* of photographs, photocollages, diagrams, and brief texts illustrating their humanistic approach to issues of architecture and urban life. Their *Grid* has had a determining influence on the evolution of urban planning. It was intended to formulate a new "Charter of Habitation"—in keeping with the theme of CIAM 9, "Habitat: The Environment for Human Society"—but it produced a wave of disagreement, marking a split between the group's older and younger generations and resulting in a permanent schism at CIAM 10 (Dubrovnik, 1956). The agenda for the 1956 meeting had been drafted by a coalition of younger members (including the Smithsons, Candilis and Woods, and several Dutch architects), who had formed the CIAM 10 Committee and thus called themselves Team 10. CIAM 11 (Otterlo, the Netherlands, 1959), which was attended by a third of this new coalition but almost none of CIAM's founding members, turned out to be the organization's last meeting. CIAM was officially dissolved, whereas the Team 10 group grew in numbers and continued to meet occasionally until 1981.

The *Grid* that the Smithsons presented at CIAM 9 was based on the research they had done for their competition entry for the Golden Lane housing project in London (1952), which had been rejected by the London City Council. Using diagrams, new drawings and texts, and photographs of street life by Nigel Henderson, they created an eight-column collage panel organized into a grid, with each column headed by a key word (*house, street, relationship*, etc.). It is striking in the freshness of its style and in the beauty of the photographs by Henderson (who, like the Smithsons, was also active in the Independent Group). The *Grid*'s "frames" unroll like a film sequence in slow motion; children playing in London's poverty-stricken Bethnal Street neighborhood where Henderson lived evoke the Neorealist cinema of the time, as well as studies in social anthropology from that period.

For the architects, these "slices of life" recall a working-class collective memory, in which the street is synonymous with mobility and conviviality. The right half of the *Grid* analyzes urban complexity primarily through a series of diagrams and texts, accompanied by a few photographs and a photocollage in which French actor Gérard Philippe appears to stand in front of a drawn image of the Golden Lane housing project, with its so-called street decks, those "suspended streets" that to the Smithsons signify "not hallways or balconies, but social entities, places." The Smithsons, who were sensitive to postwar intellectual currents in France, especially existentialism, expressed themselves through a particularly "engaged" work. The *Grid* rejected the rigid functional approach articulated in the Athens Charter of CIAM 4 (1933), instead affirming the primacy of human interrelationships and the necessity to create or to rediscover connections of identity among inhabitant, house, street, district, and city. "When we wrote *UR*," said Alison Smithson, "—that is, *Urban-Reidentification*— »

Alison and Peter Smithson, after graduating from the School of Architecture at the University of Newcastle in 1950, were involved in several projects and proposals for the postwar reconstruction of Great Britain. They became known as representatives of the "New Brutalism" with their first project, the Hunstanton Secondary School in Norfolk (1949–54), and opened their own firm in London in 1951 after designing a competition project (unbuilt) for Coventry (1950–51).

Members of the Independent Group, the Smithsons participated in the exhibition Parallel of Life and Art at London's Institute of Contemporary Art (1953), and in the Ideal Home Exhibition (1956), in which they showed their House of the Future. They integrated the results of sociological studies into their Golden Lane housing proposal for the City of London (1952), which featured the concept of the "street deck" or "street in the air"—an idea they used again when they built the Robin Hood Gardens housing complex in London (1963–73).

After the tenth meeting of CIAM in 1956, the Smithsons played an important role at the center of the Team 10 collective, which, rejecting functionalism, proposed an approach to urbanism and architecture based on the personal and the particular, beginning with the concerns of a place's inhabitants. Through his teachings, Peter Smithson exerted an influence on the future members of the group Archigram. The Smithsons extended their urban theories in the competition-project for Berlin Hauptstadt (1957–58, with Peter Sigmund), in which they proposed a low-density city core enclosed by 30-story buildings, and then made an impact in London with the headquarters they built for the magazine The Economist (1960–64), located at the center of the city. The essence of the Smithsons' architectural convictions can be found in the series of additions they built at the University of Bath (1987–89).

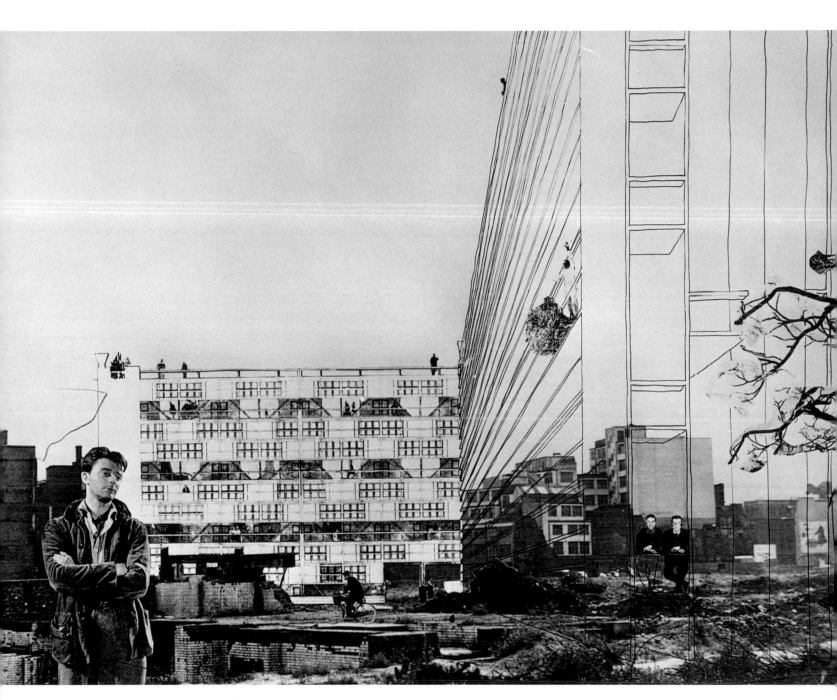

ABOVE *Golden Lane* (1952), a photocollage by Peter Smithson for one section of the eight-panel *Grid* that the Smithsons presented at CIAM 9, featuring an image of actor Gérard Philippe in front of their Golden Lane housing project drawn on a photograph

When stating that "Team 10 was needed by us to further our thought," this needs to be further qualified.... We had no interest in discussion for its own sake; nor in undirected discussion; only in discussion between people who were building or intending to build; who revered their common roots; who welcomed the responsibility for maintaining the "spirit of hope"... this might be the essence of the Heroic Period of Modern Architecture; this offering of "hope."

Unpublished notes compiled in 1981–87 for the publication of the *Team 10 Meetings, 1953–1984*, New York: Rizzoli, 1991.

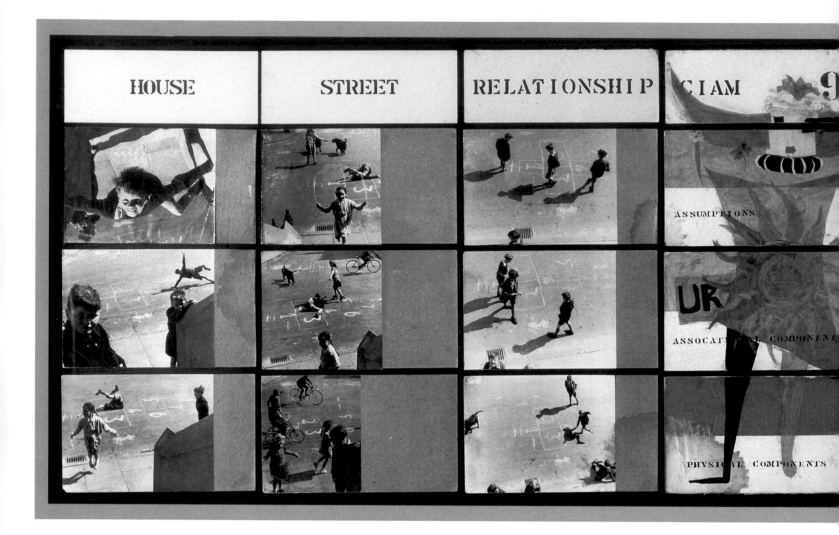

ABOVE Alison and Peter Smithson's eight-panel *CIAM Grid,* presented at CIAM 9, Aix-en-Provence, 1953

we were to a certain extent in the dark; but after Aix, we had met the masters (even Léger made an appearance), we had seen the Unité d'Habitation in Marseilles triumphantly inaugurated, and we had made contact with those people from our generation who were on the same wavelength. The panels that we showed in Aix . . . were subjected to the scrutiny of whoever was interested. That is how the 'familial' dialogue of Team 10 started."

The *Grid* also crystallized latent criticisms of the masters of functionalist thinking: Le Corbusier, Walter Gropius, Siegfried Giedion, etc. The Smithsons, though admirers of Le Corbusier's late works, felt the need to distance themselves from his pioneering project in Marseilles. During CIAM 8 (Hoddesdon, England, 1951), which dealt with the theme of the core ("The Heart of the City"), they had heard similar criticisms from other architects, such as Jacob Bakema and Aldo van Eyck, and also saw and admired work presented by Candilis, who had worked side-by-side with Le Corbusier directing construction of the Marseilles Unité. Candilis showed housing projects designed for the migrant populations of North Africa. With his American collaborator on the Unité d'Habitation, Shadrach Woods, he had joined ATBAT-Afrique (Atelier de Bâtisseurs– Africa), headed by engineer Vladimir Bodiansky. Their mission was to create in Morocco the GAMMA group (Groupement des Architectes Modernes Marocains), an undertaking that was given impetus by the chief urbanist of French-administered Morocco, Michel Écochard. In Candilis's words, "He quickly convinced me to work for

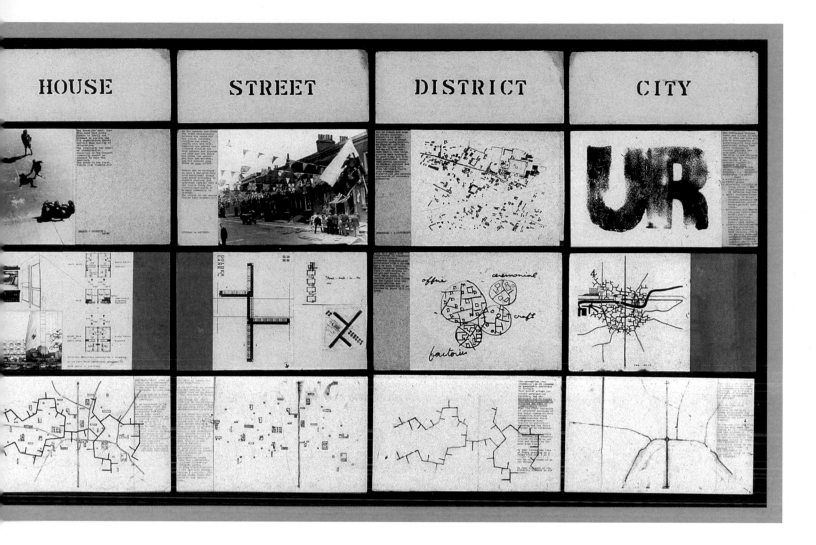

HOUSE STREET DISTRICT CITY

Selected Bibliography

Smithson, Alison, ed. *Team 10 Primer.* Cambridge, Mass., and London: MIT Press, 1968.

Smithson, Alison and Peter. *Ordinariness and Light: Urban Theories, 1952–1960 and Their Application in a Building Project.* London: Faber and Faber, 1970.

Smithson, Alison, ed. *Team 10 Meetings, 1953–1984.* New York: Rizzoli, 1991.

For biography of Georges Candilis and Shadrach Woods, see p. 374

the greatest number—the Moroccans—who were then living in slums. He got me a small commission of fifty low-income dwellings, for which I could put in action the plans for Muslim housing on several floors, which would comply with the Moroccan cultural and climatic conditions, especially concerning privacy and the role of the patio. . . . It was a question of finding architectural forms, structures, while keeping in mind the economic and social conditions of this very underprivileged people. And further—to bring them something essential that they had been deprived of: dignity."

At CIAM 9 in Aix-en-Provence, the ATBAT-Afrique *Grid*, in the same spirit as the Smithsons', presented photographs and mock-ups of the Muslim housing produced by Candilis and Woods with Bodiansky; it analyzed the diversity of local cultures, expressing in a concrete way the sociological preoccupations of young architects. According to Alison Smithson, this approach relegated to secondary status the CIAM *Grid* of Algiers, presented by Pierre Emery, who provided solutions that were too rigid to the problem of shantytowns. A group of eight architects whose affinities had already been expressed at CIAM 8 thus allied themselves with the Smithsons, who were officially in charge of preparing the agenda for CIAM 10.

Among other beliefs shared by these first dissidents from CIAM was the idea of the street as a place of communication and traffic, the articulation between exterior spaces/interior spaces, and answering the challenge to build "for the greatest number," while always respecting cultural particularities.

JACQUELINE STANIC
Translated from the French by Diana Stoll.

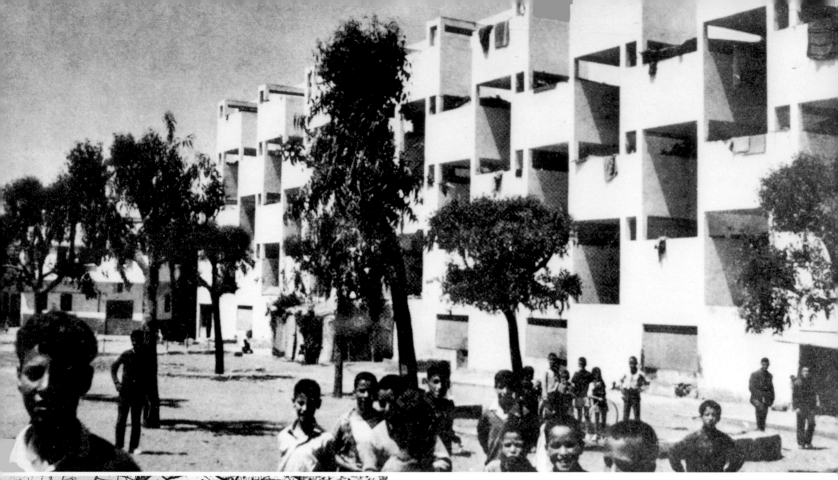

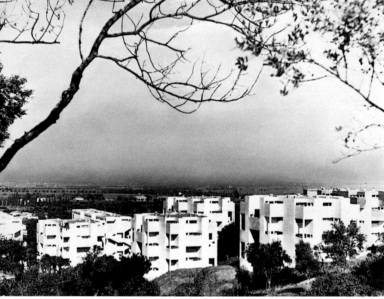

TOP Georges Candilis with Shadrach Woods and Vladimir Bodiansky, for ATBAT-Afrique: Beehive housing complex in the Carrières Centrales district of Casablanca, Morocco (1951–52). According to Woods, "In the five-story blocks, the rooms are stacked in simple volumes—towers or slabs—and the loggias are manipulated in plan on alternate floors to obtain two-story height"

ABOVE Another Muslim housing complex by Candilis with Woods and Bodiansky for ATBAT-Afrique, in Oran, Algeria (1953–56)

In the Moslem housing studies for North Africa, and later in Iran, one of the fundamental disciplines was that of providing generous open private spaces to light, to ventilate and to extend the inner-oriented dwelling, as well as to fulfill the general functions of the traditional courtyard: center of family life, living-room, foyer, etc.

The purpose of this research and of later constructions was to achieve greater densities than could be attained in a one-family-deep complex of court houses, but without reproducing the slum conditions of overcrowded medinas. By stacking the dwellings in various configurations it was found possible to design and build multi-family blocks in which all dwellings were provided with a patio — sometimes open to the sky, sometimes two stories high—corresponding to the traditional courtyard and guaranteeing traditional privacy, within an evolving urban structure where density of dwellings, adequate infrastructure and the necessary ancillaries could be balanced. . . .

In the Beehive complex in Carrières Centrales, the inhabitants have been free to change and add to their dwellings, but the original geometry still orders the visual impression of the building.

Shadrach Woods in *Candilis • Josic • Woods: Building for People* (New York: Praeger Publishers, 1968).

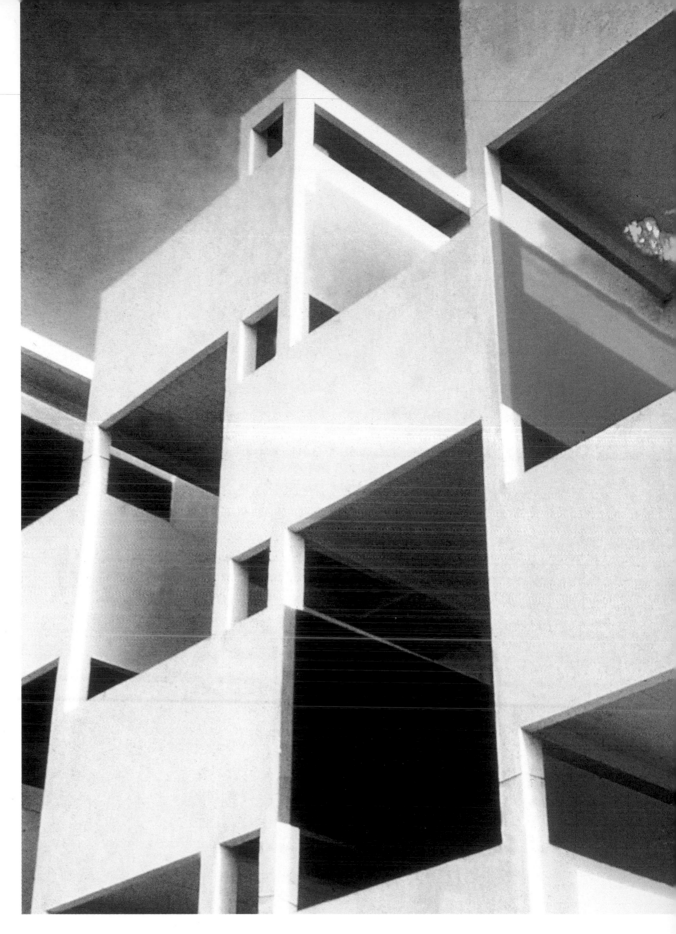

ABOVE Façade of Beehive housing complex (detail)

YONA FRIEDMAN
(b. 1923, Budapest)

In 1958, Yona Friedman published a drawing for his project *Paris Spatial*, envisioning an urban plan as a continuous expanse of superimposed independent layers where the permanent and the transitory are articulated in a single homogeneous form—an idea that comes close to the definition of "web" that Shadrach Woods would formulate in 1962. Here, the traditional opposition of in-fill versus structure is complemented by the opposition of flexible versus fixed. The infrastructure carries the circulation and support systems, while the mobile in-fill system regulates the arrangement of walls and floors, public and private spaces. The proposed "space-frame grid" is presented as a matrix of enormous combinatory range. In 1961, Friedman formulated his theory in ten principles, each illustrated by a sketch or a project proposing a single, easy solution to the problems of modern urban planning—a comprehensive program geared toward numerous megastructural projects of that era.

1. Related to Huyzinga's thesis on the role of games in the formation of civilizations, entertainment is important in the development of cities, in terms of elimination of boredom, seeking of pleasure, and continual changing of place.

2. The architect and the urban planner have only recently become aware of "the lack of information about the user's preferences and choices," which have lost their role in the process of a city's formation.

3. Gardens and parks can penetrate into the center of a city without interrupting the continuity of the grid, thus eliminating the opposition of city versus country.

4. Friedman envisages a double control of climate: in all inhabited lands on the globe, by means of nuclear or solar energy, enabling "all of humanity" to live in extremes of heat or cold; and, in cities and neighborhoods, by means of a transparent, flexible membrane over all built areas, which would increase the freedom of use and allocation of spaces thus protected, transform streets and squares into permanent public spaces, and reduce the walls of buildings to simple screens.

5. The technical infrastructure would be provided by the construction of modern bridges several kilometers long, serving "spatial districts" of 300 by 350 meters each.

6. The new structure should "take"—like a transplant—to the existing urban framework, and intensify the dense, lively urban life.

7. The proposed space-frame grid would develop the urban layout in multiple layers, eliminating zoning.

8. The filling-in of the grid should not exceed 75 percent, in order to keep the system's space-defining elements "mobile" and thus capable of being changed.

9 and 10. "The basis of life in society is the city," rather than the dwelling or the ("split-up") family, which are transitory conditions for the individual. The organization of territory becomes the decisive factor, leading to the extension of the space-frame grid over everything.

The space-frame grid is a means of introducing new structures where urban life already exists, by absorbing old life progressively into the new, and thus temporarily superimposing one city onto the other.

DOMINIQUE ROUILLARD
Translated from the French by Diana Stoll.

Friedman left Hungary for Paris in 1945 and, after completing his architectural studies in Haifa, Israel (1946–48), returned to Paris, settling there permanently in 1957. While in Haifa in the mid-1950s, through research for his project Cabins for the Sahara (1953–58), Friedman developed ideas about the "mobility" of architecture, involving a flexible infrastructure that would take into account the "mobility" of a new society. In 1958, in order to explore and develop these ideas further, he founded the Groupe d'Études d'Architecture Mobile (GEAM), which brought together a variety of engineers and architects, including Frei Otto, Paul Maymont, Werner Ruhnau, and Masata Otaka. Whereas the Team 10 architects (whom he met at CIAM 10 in 1956) sought to create indeterminate structural frameworks designed for ever-changing human regroupings, Friedman envisages mobility within predetermined, fixed frameworks; however, their design is sufficiently neutral so that they can be developed by their future users, the inhabitants, who have discovered the power of the client-consumer (e.g., freedom of choice) in urban planning and housing design. His Spatial City (1958–59) is a utopia of democratic urban planning, in tune with each person's needs and expressions, and capable of adapting itself to the evolution of society.

After working on projects designed for many different urban situations (from Tunis to Los Angeles) and geographical situations (eight Bridge-Towns connecting the five continents, 1963–64), Friedman reformulated his proposals for megastructures by creating manuals, using cartoons for explanations, in order to help inhabitants become masters of their own designs, particularly in Third World countries. Friedman's flatwriter, an "electric computator," which visitors to the 1970 EXPO in Osaka, Japan, could manipulate in order to define their habitat-needs, or his Museum of Simple Technologies in Madras, made of bamboo and fabric (built in 1986), are opposing poles in a single utopia: a utopia of the environment's self-determination.

Selected Bibliography

Friedman, Yona. *L'Architecture mobile.* Paris: Casterman, 1970.

Friedman, Yona. *Une utopie réalisée* (exh. cat.). Paris: Musée d'art moderne de la Ville de Paris, 1975.

Ragon, Michel. *Prospective et futurologie.* Paris: Casterman, 1978.

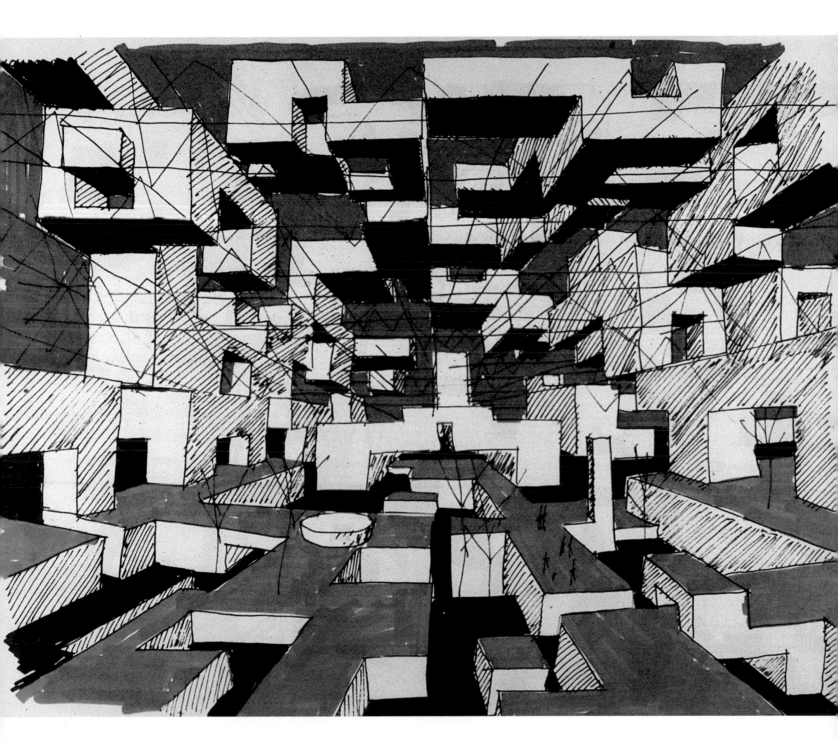

ABOVE *Spatial City*: Drawing showing view through "space-frame grid" (1959)

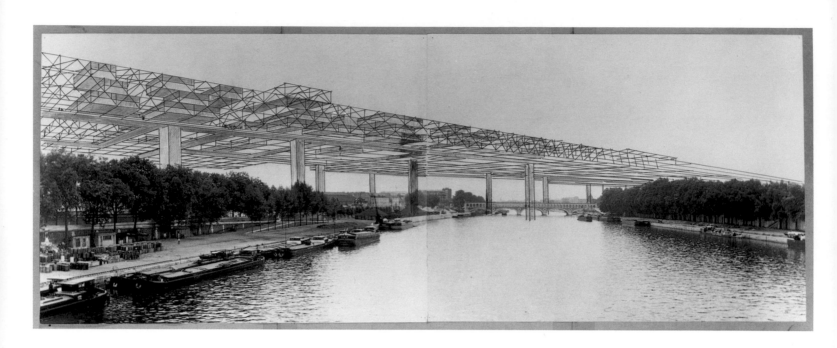

ABOVE *Spatial Paris*: Drawing of the space-frame grid crossing Paris, in a photocollage (1959). The space-frame grid rests on pillars that raise it 15 meters off the ground, enabling it to span unlimited distances

RIGHT *Spatial Paris*: Aerial view (1960)

BELOW *Spatial City*: Detail of "space-frame grid" (1959)

FACING PAGE, ABOVE *Spatial City* on the Seine (1959)

FACING PAGE, BELOW *Spatial Paris*: Two views of the "space-frame grid" as it might look over the streets of Paris (1960)

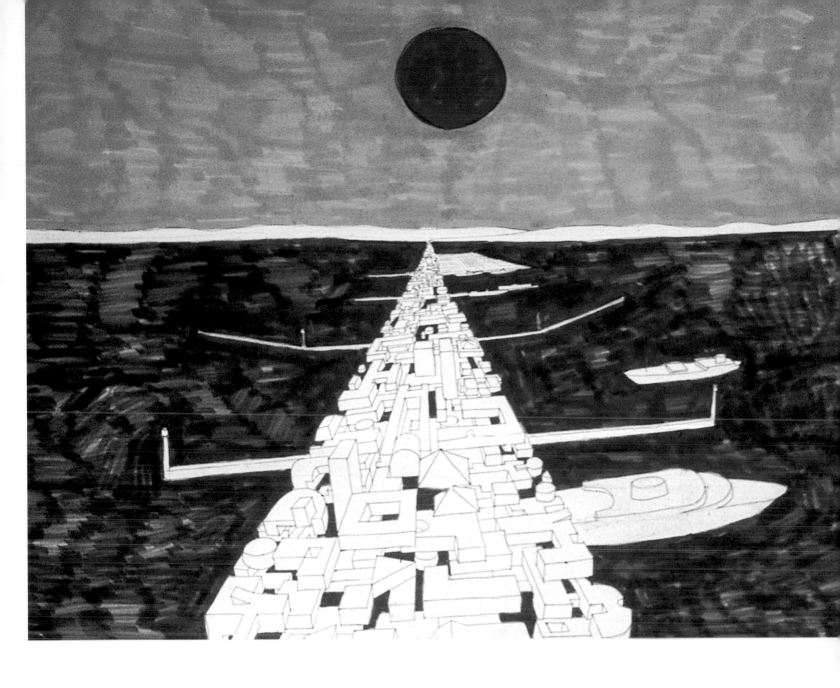

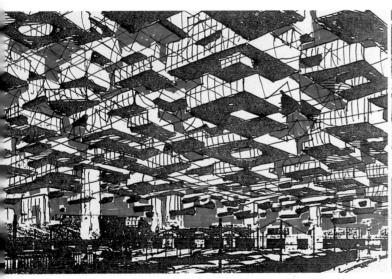

CANDILIS/JOSIC/WOODS

GEORGES CANDILIS
(b. 1913, Baku, Azerbaijan– d. 1995, Paris)

ALEXIS JOSIC
(b. 1921, Stari Becej, Yugoslavia)

SHADRACH WOODS
(b. 1923, Yonkers, New York– d. 1973, New York)

The master plan devised by the Candilis/Josic/Woods team for Toulouse-Le-Mirail, a new town built on farmland southwest of the city, was organized around the articulation and coordination of public and private spaces, according to Woods, the team's chief planner and theoretician. Here, following the model of the Smithsons' projects, the traditional European city street is replaced by a continuous interior street, called the "stem" (defined as the "linear center of activities"). The stem is an independent pedestrian street—bordered by dense configurations of buildings containing interior streets on different levels, as in multi-story malls—off of which are parking lots with escalators and elevators. Automobile traffic follows a separate network, which defines the borders of the neighborhoods while the stem "irrigates" them. The stem, generally elevated (or covered by buildings), leads to all of the city's activities, schools and social centers, cinemas and theaters, businesses and markets. The entire town is organized according to the activities that take place inside buildings and in the spaces in between, connected by the stem. Hence, the shape of the town owes nothing a priori to any sentimental, plastic, or formal decisions. The space is indeterminate, resembling a continuous organic or crystalline form. In fact, the entire system is conceived as a geometric web of hexagonal links of various sizes, with two or three of the system's branches occupied by clusters of buildings—everything from schools to low-density dwellings. The tendency toward anti-monumental, indeterminate forms is expressed by means of this continuous web. Here, and throughout their work, Candilis, Josic, and Woods give no consideration to morphology, to any categorical form or appearance. Moreover, by organizing urban space into a coherent but flexible system based on relations or association—among people or among activities—a continuity is created in which the boundaries between functions (e.g., work, dwelling, recreation) are blurred. Additions and modifications can be made; the urban fabric, or in architects' terms "the permanent urban framework," assures the mastery of its development. The metaphor of the stem exemplifies the principles of growth and change, key words that symbolized the 1960s for contemporary architects.

As simplistic as it may seem today, all the actions and human relations of daily life were regarded from a completely theoretical point of view. Public and private became abstractions in the service of an architectural scheme. The ideas of the "street" and the "interrelationships" valued so highly by the Smithsons, the affirmation of a socially conscious architecture at the service of the "man on the street" and his "activities"—these now seem very distant. But what has value, precisely by defining this architecture—and what therefore separates the easy, humanistic tone of Candilis's proposal and the abstraction of Woods's words—is the notion that "a linear organization (a line has neither dimension nor form) is the truest reflection of a society open to the future." More than in the housing projects that it claimed to combat, the architecture they envisioned can be seen most clearly in their proposals and sketches for these improbable future spaces, here and outside Caen. Toulouse-Le-Mirail was originally planned as a town of 20- to 25,000 dwellings, 75 percent of which was to be social housing. Construction began in 1964; the first dwellings for the Bellefontaine district were finished in 1965. Only a tenth of the overall plan was built in the end.

ALAIN GUIHEUX

Translated from the French by Diana C. Stoll.

Candilis studied architecture at the Institute of Technology in Athens, graduating in 1936. He emigrated to France in 1945, and worked for Le Corbusier in Paris (1946–48) and in Marseilles (1948–50). Woods studied engineering at New York University (1940–42) and literature at the University of Dublin (1945–48) before joining Le Corbusier's office in Paris, where he met Candilis, and they worked together on the Unité d'Habitation in Marseilles. From 1951 to 1954–55, Candilis and Woods worked in Tangier heading ATBAT-Afrique, which engineer Vladimir Bodiansky founded as the Moroccan office of ATBAT (Atelier des Bâtisseurs), the organization that he and Le Corbusier had established in Marseilles in 1946. The 150-unit Beehive housing complex in Casablanca (1951–52), built by Candilis, Woods, and Bodiansky as a project of ATBAT-Afrique, marked the start of a body of work dedicated to the study and implementation of low-cost collective housing solutions. The design of the Beehive apartments, which was based largely on an analysis of traditional indigenous life-styles and residential models, featured private patios and two-story loggias, and was considered the most innovative housing project since Le Corbusier's Unité d'Habitation. In 1953, they presented the Casablanca project (and plans for a similar one which was built in Oran, Algeria, 1953–56) at CIAM 9, where they met Alison and Peter Smithson.

In 1955, after Candilis and Woods returned to France, they joined forces with Alexis Josic, a collaboration that lasted until 1963. Josic had studied architecture at the University of Belgrade, graduating in 1948, then worked as an architect and a scenographer before moving to Paris in 1953 and joining ATBAT. In 1955, the new firm of Candilis/Josic/Woods won the national competition "Operation Million," held by the French Ministry of Reconstruction to improve methods of planning the mass construction of standardized housing. The winning team developed a study on organizing and assembling mass-produced modular units, to be used in building 3,600 low-cost housing units, primarily in the Paris suburbs.

They presented work at CIAM 10 in 1956 and became founding members of TEAM 10 with the Smithsons and Aldo van Eyck. For Bagnols-sur-Cèze (1956–61), a new town

(continued on p. 378) »

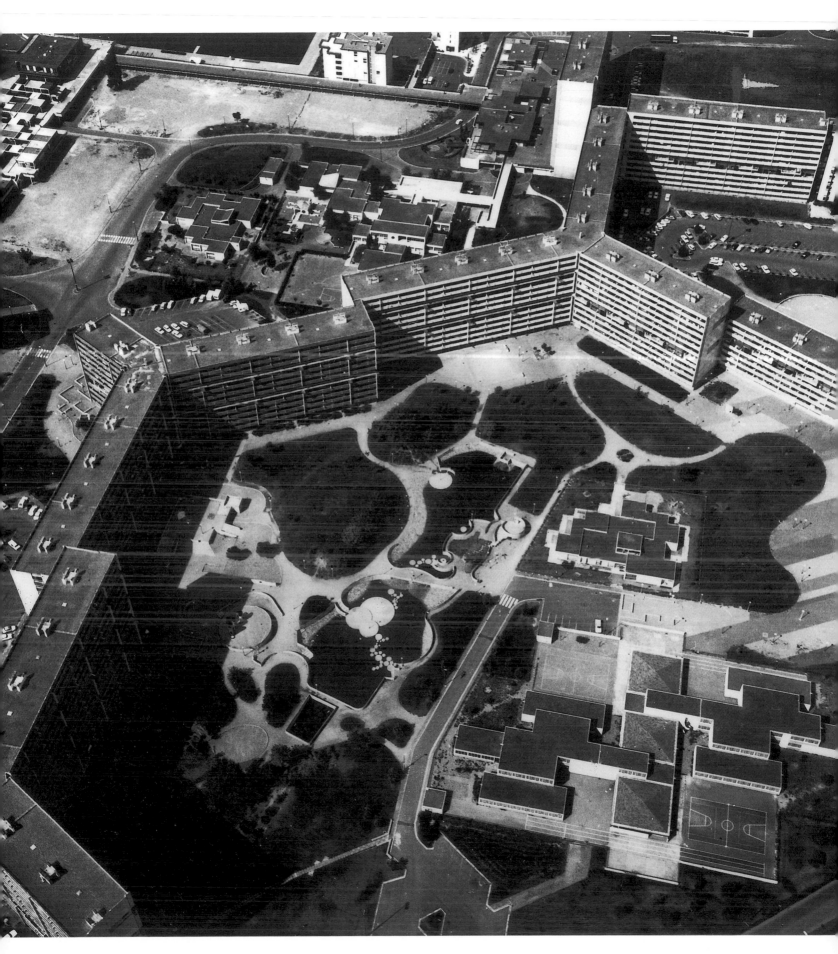

ABOVE Aerial view of Toulouse-Le-Mirail

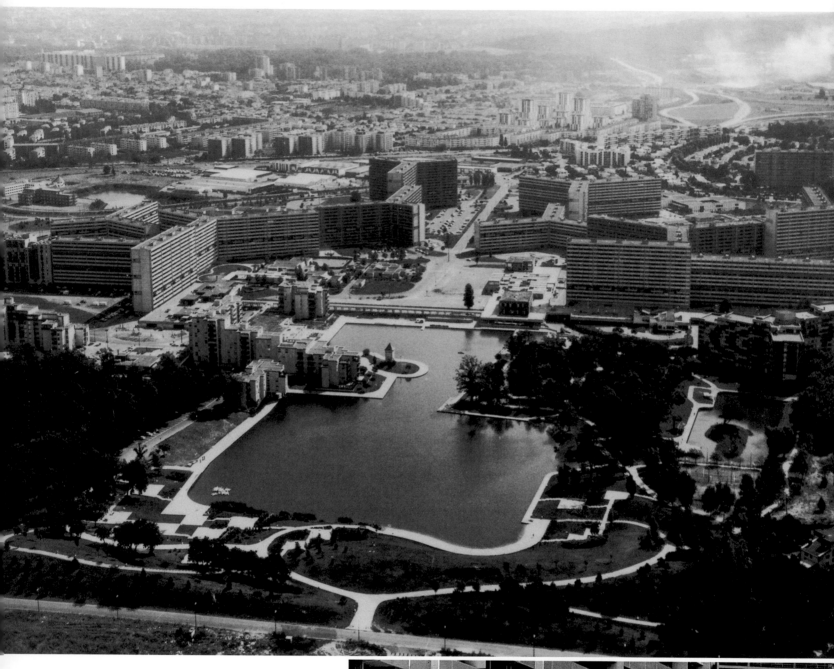

ABOVE Toulouse-Le-Mirail: Aerial view.

BELOW A housing block (detail)

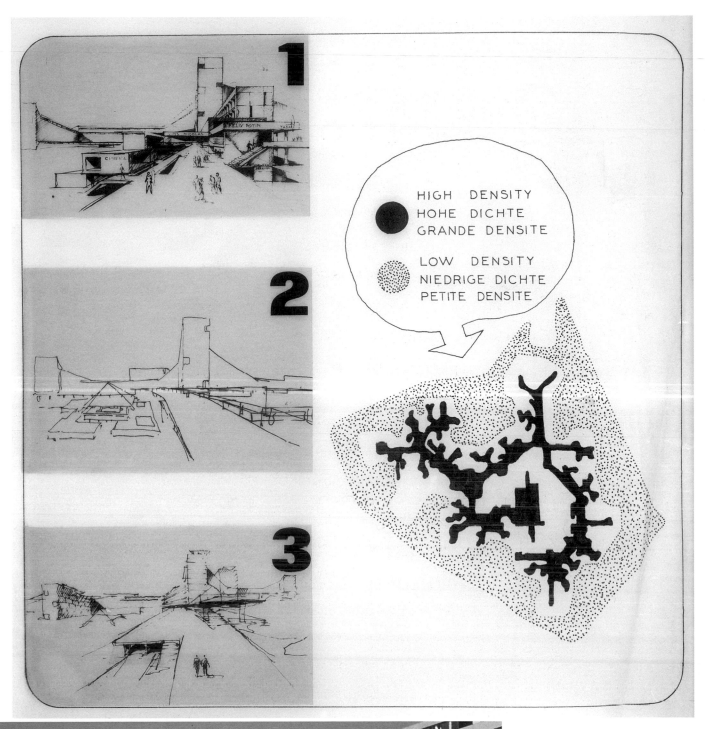

ABOVE Toulouse-Le-Mirail: Study drawing indicating density levels of the project

LEFT Façade of a housing block

CANDILIS/JOSIC/WOODS, WITH JEAN PROUVÉ

In his article "Web" (published 1963) Woods affirmed the interdependence that exists between a homogeneous space and a society that had become universal: "The world is one: a continuous surface surrounded by a continuous space. Total space and universal society are interdependent: one generates the other." Architecture and urban planning are defined, as in his earlier projects, around a "stem," understandable as a system of relations between activities, and benefiting them—a definition contrary to a visual perception of architecture conceived as visual symbols and monuments. Architecture and urban planning were, in the early 1960s, "instruments."

The web is thus a more homogeneous system than the stem, permitting limitless development of an area and organizing it by a network of circulation and support systems that would unify diverse activities. The web is intended to provide flexibility in planning for a range of functions over time, thus assuring its own longevity; its very realization is spread out and subject to revision over time.

The idea of the web was used for the first time in Candilis/Josic/Woods' proposed master plan (unexecuted) for Fort-Lamy, Chad (1963); the urban structure of the African city favored the development of a continuous urban plan and a design incorporating patios. Their competition entry for the reconstruction of the center of Frankfurt (1963) is a modern design that paradoxically evokes the city's old medieval structure (destroyed in World War II), covering an area between the city hall, the cathedral, and the church of Saint Nicolas. It is based on an orthogonal grid of pedestrian streets (3.66 meters wide) and multi-level blocks (36.47 by 36.47 meters), with street decks on four levels. The approximately 1,000-square-meter blocks contain a secondary network of pedestrian streets (4.79 and 7.74 meters wide). The complex numerical relationships were determined by using Le Corbusier's Modulor proportional system.

Candilis/Josic/Woods used the web again in their winning competition entry for the Free University of Berlin (1963). The grid here provides the maximum opportunity for its occupants to meet one another, thus responding also to the definition of the university as a place of exchange and communication. This project, which was finished in 1973, consists of a three-level complex of low buildings, surrounding open-air patios at the heart of the grid. The system was envisaged as completely flexible; only the circulation network—the interior pedestrian walkways—would remain fixed. If changing conditions called for it, most parts of the complex could be taken down, or it could also be extended by adding supplementary levels to the existing structure. A coded system of colors and signs indicate to the visitor which part of the complex he or she is in. The façades are modular clip-on panels of Cor-Ten steel, designed by Jean Prouvé, who worked with the Candilis/Josic/Woods team on numerous projects. Prouvé's notion of the building as a fabricated object goes back to his sheet-metal façades for the Maison du Peuple (Community Center) in Clichy (1936–39), cited as one of the sources for the design of the University of Berlin.

ALAIN GUIHEUX

Translated from the French by Diana C. Stoll.

CANDILIS/JOSIC/WOODS

north of Avignon, Candilis/Josic/Woods designed a master plan that won a grand prize for urban planning. During the 1960s, opposing the rigid urban-development concepts of CIAM, though still following the model of the large-scale housing project, Candilis/Josic/Woods developed a coherent approach for urban planning that paralleled the research done by the Smithsons, notably in the following projects: the competitions for new towns outside Caen, France (1961), Toulouse (1961), Hamburg (1961), and Bilbao (1962); the plan for the reconstruction of Frankfurt's center (1963), the master plan for Fort-Lamy, Chad (1963), and a ski station in the valley of Belleville, France (1964). In several university projects —the University of Bochum in Germany (1962), the Free University of Berlin (1963–73, with Jean Prouvé), and the University of Zurich (1967) — they developed their urban-planning theories further. Woods handled the project of the Free University of Berlin, while Candilis oversaw the construction of Toulouse-Le-Mirail, and Josic did the same for the Cité Artisanale in Sèvres (1963). Woods also acted as the team's chief theoretician, articulating the concepts of the "stem" and the "web" as the principal elements of a system for organizing urban space.

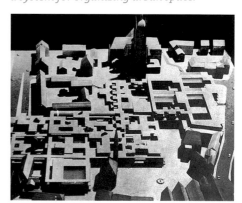

ABOVE Competition entry (model) for the reconstruction of the center of Frankfurt, West Germany (1963)

Selected Bibliography

Woods, Shadrach. "Web," *Carré Bleu,* no. 3 (1963).

Woods, Shadrach. *Candilis•Josic•Woods: Building for People.* Intro. by Jürgen Joedicke. New York: Praeger Publishers, 1968.

Smithson, Alison and Peter. "Free University of Berlin," *Domus,* no. 534 (May 1974).

Candilis, Georges, with Alexis Josic and Shadrach Woods. *Toulouse Le Mirail: Birth of a New Town.* Stuttgart, 1975.

Candilis, Georges. *Bâtir la Vie: Un architecte témoin de son temps.* Ed. Michel Lefebvre. Paris: Stock 1977.

ABOVE Free University of Berlin campus, showing a patio in the courtyard and the façade of Cor-Ten steel panels designed by Jean Prouvé

RIGHT Another view of the courtyard, showing stepped configuration of patios

AUA, HEAD ARCHITECTS JEAN TRIBEL AND GEORGES LOISEAU

AUA *(1960–86)*

The AUA (Atelier d'Urbanisme et d'Architecture) was a cooperative of architects, urban planners, engineers, and designers founded in Paris in 1960 to create a framework enabling them to work together on a variety of projects. The basic goals and tenets of the group—collaborating as professionals with other equally accomplished professionals, pursuing a multi-disciplinary approach, organizing work, acting under the name of the group—arose from a shared ideal: the desire to conceive and express their ideas collectively and to combine architectural practice with social engagement.

AUA had approximately 200 members working together between the time it was founded and its dissolution in 1986. From 1960 to 1972, AUA functioned more or less in accordance with its founding principles; but from 1972 on, after a number of schisms and departures (especially an exodus by the engineers), each project was signed by the member(s) who designed it, rather than attributing it to the AUA as a whole. Several projects from the first period established the reputation of AUA in France, notably the senior citizens' center at La Courneuve (1964); a holiday village at Grasse (1967); and the Arlequin district of Villeneuve de Grenoble (1968–72), designed by architects Henri Ciriani and Borja Huidobro with landscape architect Michel Corajoud. The second period gave rise to many projects generated by the autonomous practices built up by members, including: La Noiseraie housing complex at Marne-la-Vallée (1975–80) by Ciriani; the Ministry of Finance in Paris's Bercy district (1982–89) by Paul Chemetov and Huidobro; various projects at Orly by Jean and Maria Deroche; several housing and commercial projects in Grenoble and Villeneuve d'Ascq by Georges Loiseau and Jean Tribel; and three theaters in Paris (1967–87) by Jean Perrotet and Valentin Fabre.

Translated from the French by Stephen Frankel.

In its scope, its duration, and its renown, Villeneuve de Grenoble—a new town comprising 7,000 units—was undoubtedly the most representative of AUA's undertakings, given its original directive. To create an innovative urban model—this was the mission conferred by Grenoble's progressive municipal council under the direction of Hubert Dubedout. The plan itself was ambitious. It was designed to avoid the syndrome of the "dormitory town," while serving a dense population; to achieve a balance between activities and dwellings; to favor communal space; to reduce social segregation; to separate automobile traffic from pedestrian circulation; to introduce parklands; to integrate public facilities; and to generate a strong urban image. The development of the project, the formation of an important team of architects, and the various phases of the design plan were spaced out over the course of a decade. One can see the connections between the building plan of Villeneuve and its earlier model developed by the Team 10 generation, in particular the experimental urban plan executed at Bagnols-sur-Sèze (1956–61) by Georges Candilis and his associates, and their larger-scale scheme for Toulouse-Le-Mirail. Even when the buildings are continuous, linearity disappears behind a configuration of broken segments—like the incomplete hexagons at Toulouse-Le-Mirail— creating "cells" that open onto the exterior spaces. The buildings are very tall and dense, with a complementary area of open green space in adjoining parkland. Henri Ciriani's designs for Villeneuve's public spaces were based on a vertical integration of superimposed layers with interior streets. An orthogonal framework, a multilevel grid, and pyramid-shaped buildings—these ingredients also appear in a number of other projects, notably the competition entry by the Atelier of Montrouge for the Francs-Moisins district of Saint-Denis (1966).

The first phase in the Villeneuve project's execution was the construction of the Arlequin district (1969–73). From the outset, the design incorporated a strong visual reference. Arlequin: the name derives from the multicolored façades, which serve as an identifying motif. Here, 800 units are contained in a single building, although it is extended with 60-degree "elbows." In an inversion of traditional roles, monumentality has been conferred on the habitat, and not on the public facilities that proliferate at the ground-floor level between the buildings' "branches." The Galerie de l'Arlequin—the pedestrian arcade that runs under the 1,300-meter structure, with its emblematic colors and large-scale environmental graphics, looks more like a place to live than passageway—is the unifying element of the complex. The landscaped gardens designed by Michel Corajoud, an "ecologist" for this "megastructural" district, also became an emblematic component of the design. Other districts were built after 1977. Thirty architects, some affiliated with AUA and some not, were involved in the project at one time or another. Certain parts of the project gained particular attention—notably, for example, the Baladins quarter. However, the initial inspiration weakened, along with the ambition to create a new urban model in keeping with a real-life social project.

OLIVIER CINQUALBRE
Translated from the French by Diana C. Stoll.

FACING PAGE Villeneuve de Grenoble: View of the Galerie de l'Arlequin (detail), designed by AUA architects Henri Ciriani and Borja Huidobro with landscape architect Michel Corajoud, showing signage for level 60

Selected Bibliography

"Villeneuve de Grenoble, quartier de l'Arlequin," *Architecture d'aujourd'hui,* no. 194 (November–December, 1977).

Monographie de la Villeneuve de Grenoble: Orientations méthodologiques (reports by AUA team).Grenoble, École d'Architecture de Grenoble: 1987.

Blin, Pascale. L'AUA: *Mythe et réalités, l'atelier d'urbanisme et d'architecture, 1960–1985.* Milan and Paris: Electa Moniteur, 1988.

Joly, Jacques and Jean-François Parent, *Paysage et politique de la ville: Grenoble de 1965–1985.* Grenoble: PUG, 1988.

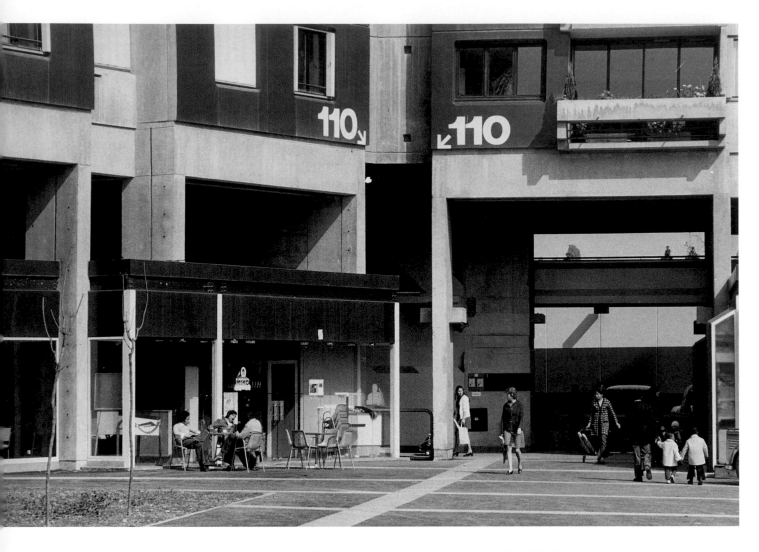

ABOVE Villeneuve de Grenoble: A view of the Arlequin district, designed by AUA architects Henri Ciriani and Borja Huidobro with landscape architect Michel Corajoud, showing an intersection of an interior pedestrian street, and signage indicating level 110 of the enormous project

BELOW Sketch of an interior street in the Arlequin district, showing the separation of automobile traffic and pedestrian circulation systems

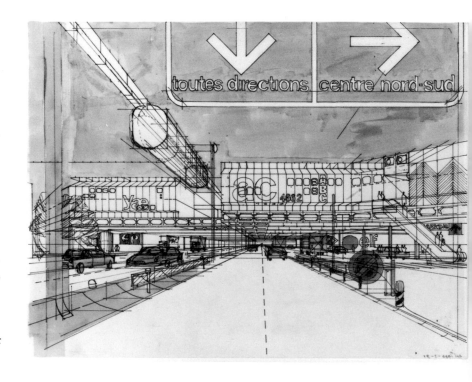

AUA Analysis of the Galerie de l'Arlequin in Villeneuve de Grenoble:
The Street

This public space is neither a corridor-street nor a Haussmanesque covered passageway, but is closer to an arcade, such as Paris's rue de Rivoli. It differs from the corridor-street and the covered passageway in its lack of visual references to the dwellings that constitute the neighborhood's built-up structure; but it retains the corridor-street's functional relation with the dwellings by means of elevators and stairways, its necessarily linear character as a passageway, and its role in unifying the functions located on the ground floor (local facilities, shops). . . .

The Galerie de l'Arlequin has been criticized for its "lack of sense" as a "significant structure in its urban context"—a lack of sense that [the architects] tried to compensate for by adding graphic signage using the language of traffic signs or advertising. This criticism is unfounded if one really considers the two levels of a morphological approach to the neighborhood: first, the urban level, which is expressed by the relation of filled-in space to empty space in the two strips of high buildings on the edge of 20 hectares [50 acres] of parkland; and second, the neighborhood level, which is expressed by the relation of dwellings to facilities to public space (the covered street).

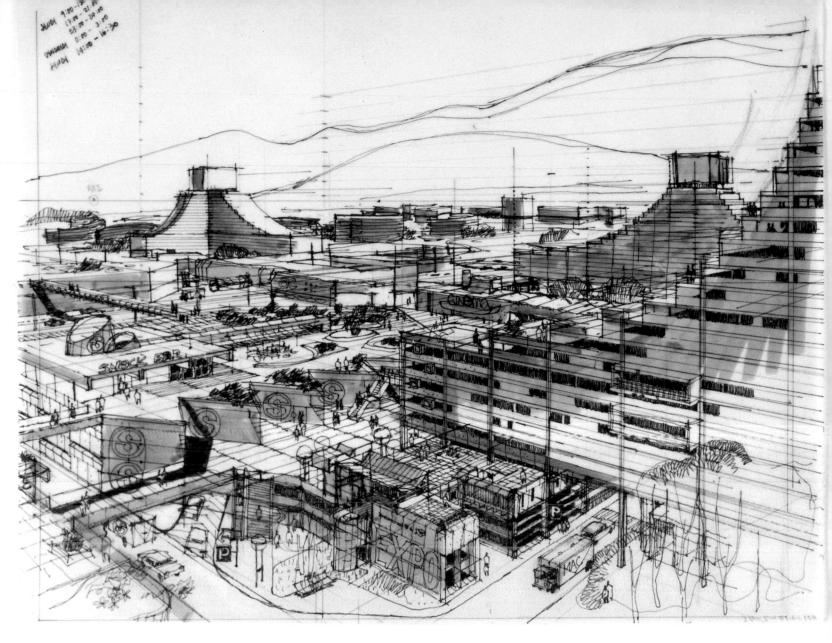

ABOVE Villeneuve de Grenoble: A sketch showing an overall view of the Arlequin district, featuring multilevel vertical integration and interior streets

BELOW Sketch showing people emerging from a pedestrian passageway

The signage in the Galerie de l'Arlequin should in fact contribute to the street's acknowledged supporting role: supporting information, supporting evolution or transformation, supporting urban amenities. . . .

We outlined a very precise overall organizational scheme, and a general plan roughly defining the buildings' masses. Step by step, construction plans were worked out, integrating the requirements of each program in the general design scheme. Our concern for coherence limited the creative freedom of the architects to the extent that they had to take into account the constraints of public planning, which normally they either barely acknowledge or completely ignore. The result is a series of compromises leading to a group of different buildings that are more or less compatible among themselves— the architects' natural tendency being to create an object that gives little or no support to its neighboring buildings. We started with the hypothesis that a very powerful urban structure should have architectonic variables that are easily "digested," without having to impose a set of particular architectural specifications. We are now convinced of the contrary, but the direction we took—in spite of ourselves—for the design of the second neighborhood (east of the Arlequin) went in the opposite way from that which we had hoped.

Extracts from an AUA report by the design/construction team, reproduced in *Monographie de la Villeneuve de Grenoble: Orientations méthodologiques* (École d'Architecture de Grenoble, 1987).

PUBLIC HOUSING PROJECT, SAULX-LES-CHARTREUX, ESSONNE

1975-76

AUA, PAUL CHEMETOV WITH HUBERT MARTIN AND GÉRARD GILBERT

This modest 86-unit low-income public housing project in the Saulx-les-Chartreux district of Essonne was built for the Logement Familial (Family Housing Agency) of the Parisian Basin. The site itself is somewhat undesirable, near the runways of Orly airport and close to a national highway route. And the site is similarly unwelcoming, on a narrow, sloping plot of land; only its orientation is favorable. Added to these constraints, the project was conceived as a combination of two very different typologies: the detached house and the collective housing project. The density of the complex and the inclusion of a corridor-street place this project within a collective perspective. However, that designation is moderated by the specific morphology of each segment of the complex, and by the individual entrances and the presence of terraces and little gardens. The apartments are arranged in two parallel rectilinear rows. On the ground floor, an interior pedestrian corridor-street runs through the building; on the upper level, another interior street divides the space into two facing parts. The building's exterior is pleasing: The slope of the land permitted a design featuring stepped terraces; an interplay of cubic blocks gives a rhythm to the façades; and vegetation softens the building's dense, massive appearance. Inside, the ambiance of the downstairs pedestrian street is more austere, a deliberately bare space with cinderblock façades and metal stairways and footbridges under a translucent vaulted ceiling. The choice of cinderblock construction was dictated by the slope of the building lot, which precluded the use of a crane; but the arrangement of the cinderblocks into a simple pattern marks an effective use of this economical material. These days, Mario Botta's private homes are being hailed for their refined utilization of concrete blocks; and from now on, the same may be applied to public housing. Likewise, it is tempting to see, in the entrances and the car-park, the same kind of treatment as in the plan dreamed up by Roberto Gabetti and Aimaro d'Isola for an apartment building in Ivrea, Italy (1971), which is on a higher social level.

These are the paradoxical dualities borrowed from utopian history and imagination—collective housing project/private house, massive/personal, urban vocabulary (the covered street)/suburban landscape—which give this project its oddness. It is also symptomatic that, in his presentations, Chemetov refers to a text by Charles Fourier describing a vision of "phalansteries" housing ideal communities or "phalanxes"—not that it was a direct source of inspiration, but because he has found some surprising common aspects and tendencies. The "utopia" in Saulx-les-Chartreux was built, and it remained an isolated case; for a subsequent project several years later in the same district, Chemetov returned to a more sensible plan, and to a more traditional morphology of village-style houses set side-by-side. In general, the socially conscious design and architectural modernity of this group was quickly forgotten by the time competitions were held for building "city houses" (the privilege of new cities) and postmodern eclecticism had become pervasive.

OLIVIER CINQUALBRE
Translated from the French by Diana C. Stoll.

FACING PAGE Public housing project in Saulx-les-Chartreux: Interior street on ground floor

FOLLOWING TWO PAGES Exterior view

PAUL CHEMETOV
(b. 1928, Paris)

Chemetov, son of a Russian painter who had emigrated to Paris, studied architecture at the École des Beaux-Arts, Paris, and was a member of AUA (Atelier d'Urbanisme et d'Architecture) from 1961 to 1986. In his early works, on which he collaborated with fellow AUA member Jean Deroche, he demonstrated an original interpretation of Corbusian Brutalism—as in a senior citizens' center at La Courneuve (1964–66), an open-air theater in Tunisia (1964,) and his own house at La Beaume (1968–80)—using industrial methods and materials with an approach based on assemblage. In the 1970s, he collaborated on AUA competition entries for large-scale housing complexes in the new towns of Evry and Marne-la-Vallée (with younger architects such as Henri Ciriani and Ricardo Bofill), and built several large low-cost housing projects in the suburbs of Paris.

After 1980, he collaborated with another AUA member, Borja Huidobro, on competition entries for several important projects, including a cultural and sports complex in the Forum des Halles, Paris (1979–85), the French Embassy in New Delhi (1980–86), and the new Ministry of Finance in the Bercy district of Paris (1980–86), a rectilinear urban complex connecting the river Seine to the Gare de Lyon. Chemetov received the Grand Prix National d'Architecture in 1980.

STEPHEN ROBERT FRANKEL

Selected Bibliography

Chemetov, Paul. "Un hommage au Phalanstère," *Architecture d'Aujourd'hui*, no. 187 (October–November 1976).

Chemetov, Paul. "Les Cloisons sont aussi les murs de la ville," *Techniques et Architecture*, no. 312 (December 1976).

Chemetov, Paul. *Paul Chemetov and Borja Huidobro: Cinq projets, 1979-1982*. Paris, 1983.

Devillers, Christian. "Paul Chemetov," in *The Dictionary of Art*, ed. Jane Turner (London: Grove, 1996), vol. 6, p. 534.

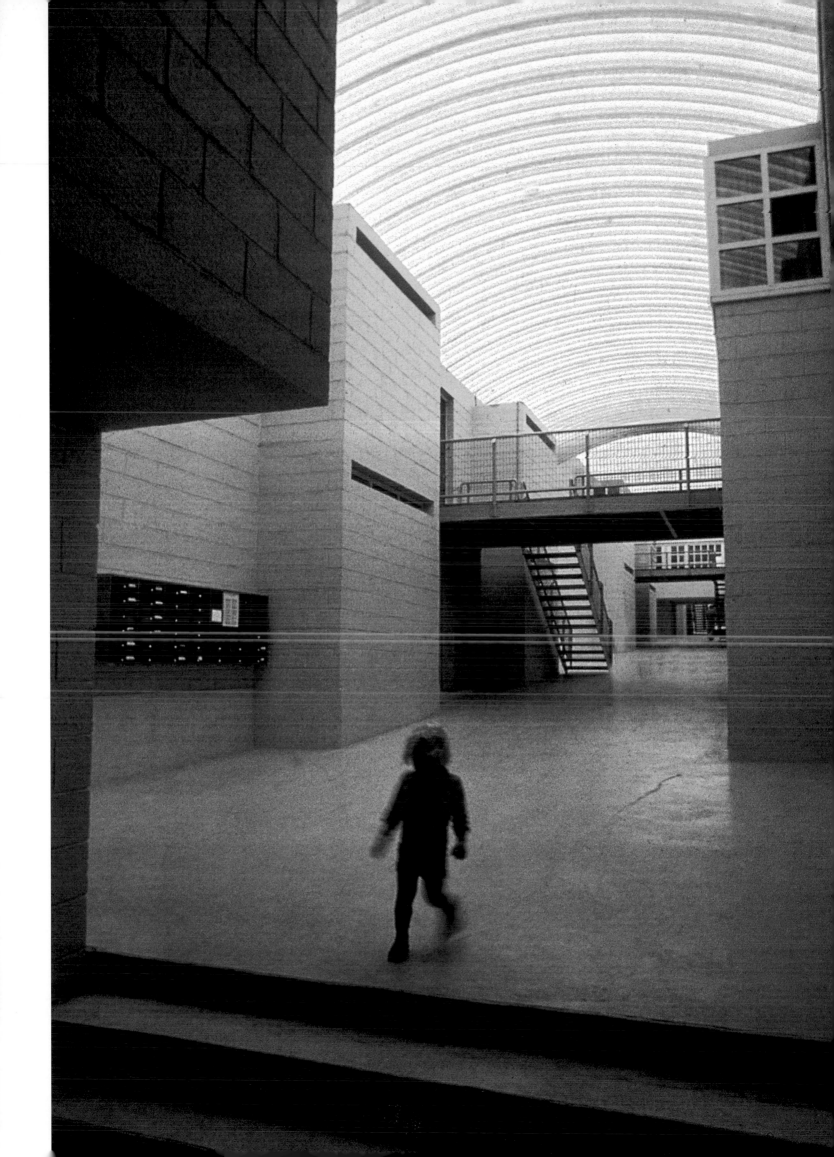

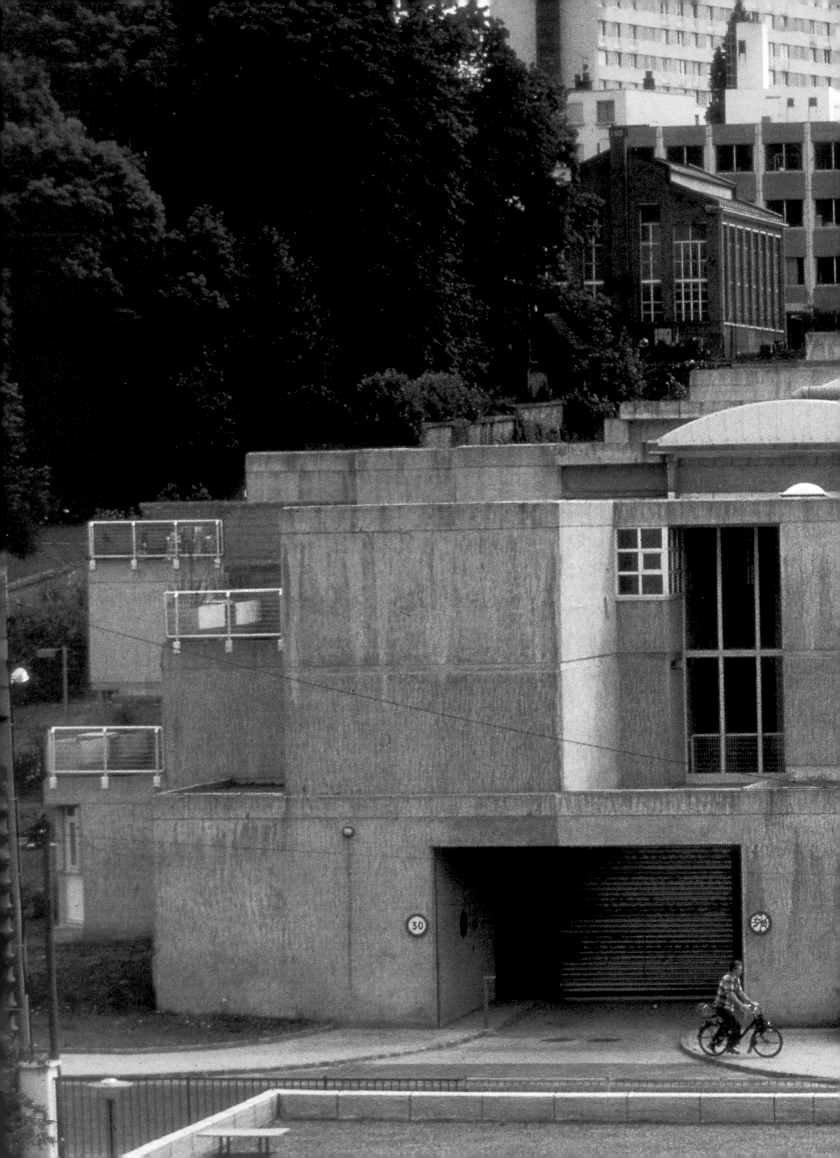

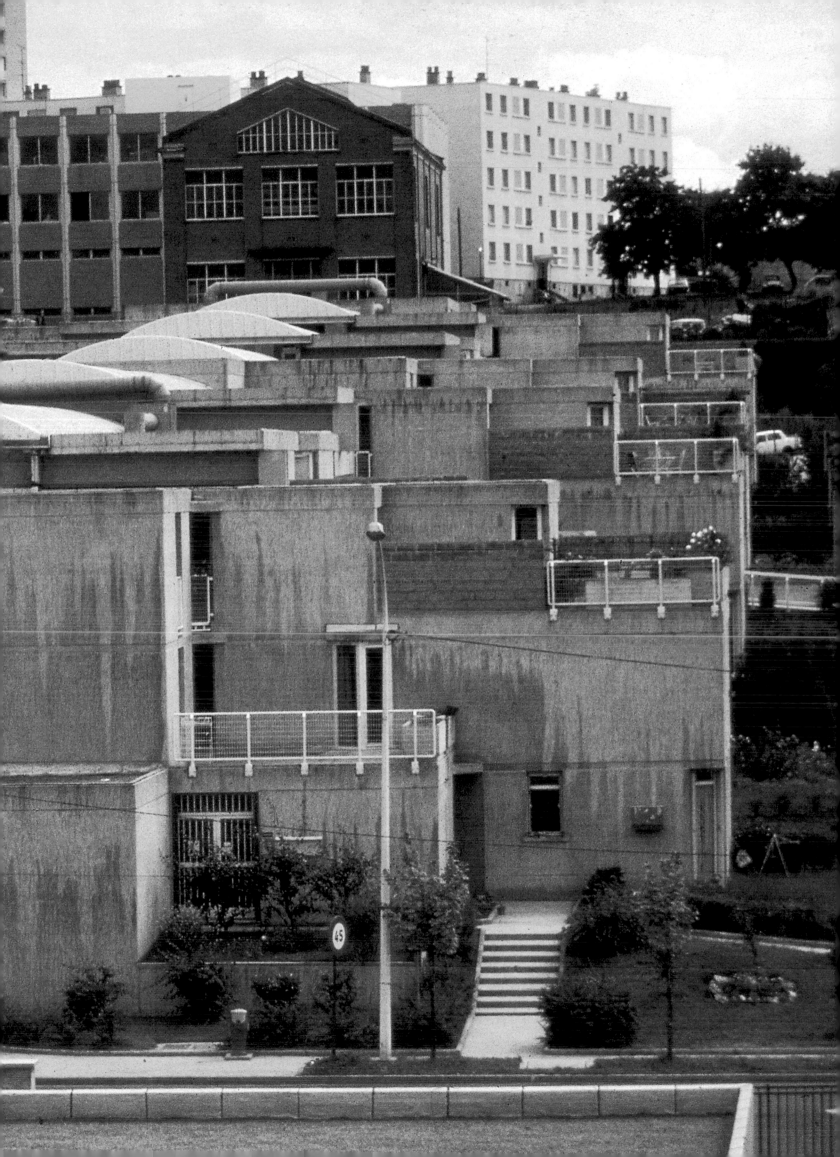

LA NOISERAIE HOUSING COMPLEX, MARNE-LA-VALLÉE

1975-80

Deliberately intended as an object in a landscape that from the outset ensured the "natural conditions" extolled by the Modern movement (air, light, vegetation), this 300-unit complex spiritedly affirms its role as a public housing project,created to benefit the largest number of people. Located in a new town near Paris, it long remained the only building in the area, before other projects arrived to alter its glorious isolation. "Nature" having thus disappeared, only the initial drawings show it uncompromised in its original site. Like Le Corbusier's Chandigarh complex in India or his Carpenter Center in Cambridge—and for the same reasons—La Noiseraie gives the impression of being totally independent, the result of a sculptural approach paired with a tendency toward monumentality. It consists of a very long colonnaded block, articulated by the rhythm of the loggias' columns, and rests on a base enclosing subordinate functions (garage, etc.), as though perched on a pedestal. The segregation of the circulation systems (cars below, pedestrians above) is a manifestation of the functionalist approach advocated by CIAM, an influence evident throughout the project.

The overall plan, a T shape, preserves some aspects of the linear urban system developed by Ciriani and the AUA in the early 1970s—particularly at the time of the Evry competition—but goes beyond it as well. The idea of the interior street, drawn from Le Corbusier's Unité d'Habitation in Marseilles (1946–52), was developed on an urban scale by the members of Team 10, beginning with Alison and Peter Smithson's notion of "building as street" in their proposal for the Golden Lane housing project (1952), and by Candilis, Josic, and Woods through the ideas of the "stem" and the "web" as applied at Toulouse-Le-Mirail (1962–77). The same idea appears here, in a minor way, in the pedestrian pathway through the whole project, which creates an enormous porch and two setback buildings.Ciriani also abandoned the principle of "three-dimensional urbanism," which would have involved megastructures and other dreams of cities in space, and turned to the notion of the "urban unit," which could range from a single building to a plaza. More pragmatic, this idea preserves the fundamental prerequisites of architecture while recognizing the unavoidable character of the city's morphology, which is expressed through abstract forms.

The brute force of this indomitable object comes from Ciriani's will toward monumental affirmation, evident here in the first project in France built in his own name. Asserting with great conviction that modernity remains an unfinished project, he has deliberately challenged the postmodern wave by constructing a slab block, as at the height of the 1930s. However, in contrast with L. C. Van der Vlut's Bergpolder flats in Rotterdam (1933), or other perfect parallelepipeds from that time, the façades here are animated by layers of gridded screens, arcades, loggias, balconies, and terraces, producing an effect of depth. The façade, having lost its status as wall, is at this point no longer treated as a surface plane but as a volume, blurring the boundaries between interior and exterior. Under these conditions, the initial Brutalist inspiration gives way to a texture of ambiguous roughness, resulting from an economical but durable material and the delicate treatment of tectonics.

MARC BÉDARIDA

Translated from the French by Diana C. Stoll.

FACING PAGE, ABOVE La Noiseraie housing complex: Exterior view
FACING PAGE, BELOW Sketch of elevation

HENRI ÉDOUARD CIRIANI

(b. 1936, Lima, Peru)

After graduating from the Facultad de Arquitectura in Lima, Ciriani worked for a government agency in charge of public projects, creating important programs for housing and public facilities in Peru (1961–64). He moved to France in 1964 and joined the AUA (Atelier d'Urbanisme et d'Architecture) in 1965 (to 1982), collaborating on the design of the Galerie de l'Arlequin (1968–72)—the public spaces of AUA's large urban-planning project Villeneuve de Grenoble—and on AUA's competition entry for the center of the new town of Evry (1971–72). Committed to defending the ideals of the Modern movement and the legacy of Le Corbusier, he creates geometric, gridded forms softened by the subtle effects of light or flat expanses of color. His ideas on spatial articulation based on Platonic figures, more than expressing formalism and rhetoric, ally him with the New York Five, particularly Gwathmey and Siegel or Richard Meier.

In his own practice, as much out of conviction as out of a sense of realism, Ciriani has tackled the issue of mass housing and has built several projects, including Noisy 2 (La Noiseraie) and Noisy 3 in Marne-la-Vallée (1975–80 and 1979–81, respectively), La Cour d'Angle in Saint-Denis (1978–82), and others in Evry, Colombes, and Paris. Through competitions, he has won commissions to design a few public buildings, including the Archeological Museum in Arles (1983–95) and the Historical de la Grande Guerre (Museum of World War I History) in Péronne (1987–92). A dedicated teacher, in 1969 Ciriani returned to teaching before founding the Uno group at the École d'Architecture Paris-Belleville. He received the Grand Prix National d'Architecture (1983), the Équerre d'argent (1983), and the Brunner Prize from the American Academy of Arts and Letters (1997).

Selected Bibliography

Ciriani, Henri. "Vers le réflexe ville," *Techniques et Architecture*, no. 306 (October 1975), pp. 116–22.

Ciriani, Henri. "Parois," *Techniques et Architecture*, no. 332, (October 1980), pp. 101–02.

Frampton, Kenneth. "H. Ciriani, Noisy 2," *Architectural Design*, nos. 7–8, (1982), pp. 92–99.

Chaslin, François et al. *Henri Ciriani.* Milan and Paris: Electa-Moniteur, 1984.

Henri Ciriani. Foreword by Richard Meier. Introduction by François Chaslin. Rockport, Mass.: Rockport Publishers, 1997.

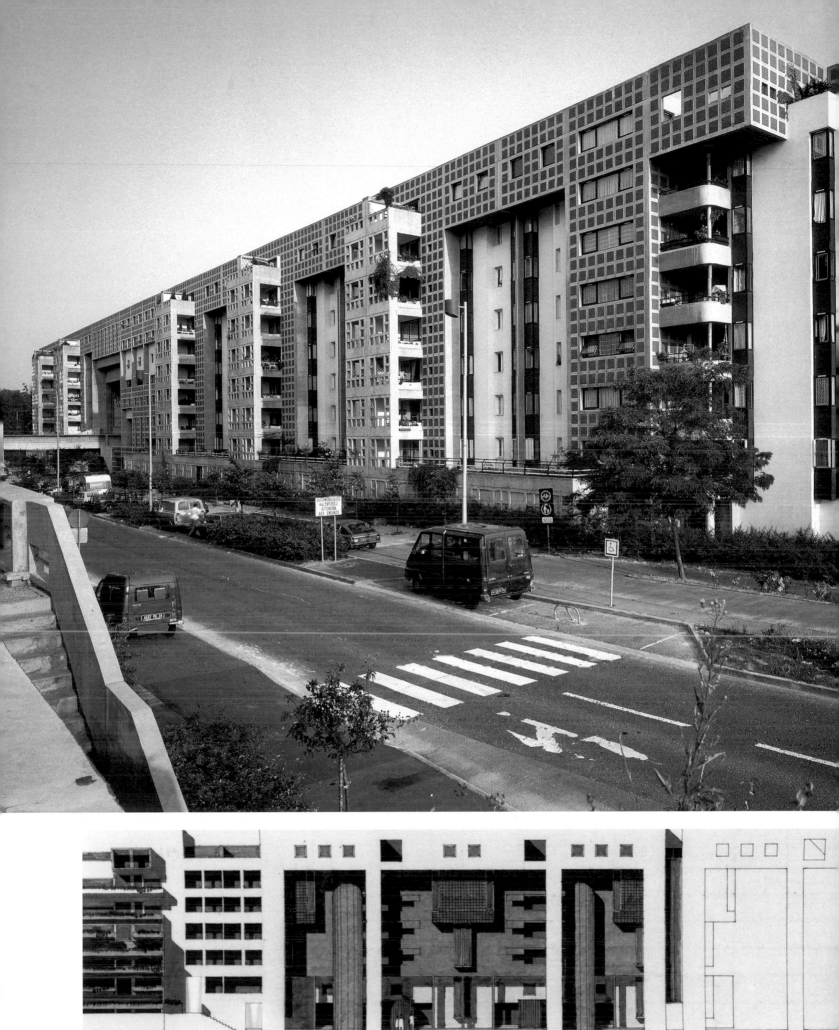

ELEVATING THE CONDITIONS OF LIVING

Architecture is marked by the desire to act on real places and on the way they are created, used, and perceived. The modern project of improving living conditions for the greatest number is a progressive task that continues today, unlike many other architectural concerns that have diminished in force since the 1970s. The return to classicism, postmodern infiltrations, and even a revival of Corbusian technique have not succeeded in eliminating this ethos. Regardless of formal shifts or the influence of external experiments, the will to better everyday life has persisted throughout twentieth century architectural practice in France. This tenacious phenomenon could be called a "utopia of the real."

Beginning in 1958, the belief in the possibility of action on the concrete world gave birth to a form of utopia with the projects of Yona Friedman and Paul Maymont, proposals for futuristic megastructures that fascinated many other French architects. Although plans for megastructures did not develop further in France, they advanced beyond an initial stage in Japan and produced radical cultural effects in Austria and Italy. Yet such ideas were not a complete failure in France, where in 1968 a lack of commissions led such architects as Roland Castro and Christian de Portzamparc to continue their search for this architectural utopia through their theoretical writings. At the same time, the social sciences began to have a strong influence in architecture schools, particularly through the research of Bruno Queysanne, Henri Raymond, and Henri Lefebvre. Post-1968, certain architecture teams carried this sociological impulse to the point of collaborating on the design of housing projects with the inhabitants themselves.

"House the greatest number!" This slogan, which is simultaneously utopian, political, and productivist, united French architecture until the mid 1970s, when this quantitative, industrialized focus on the production of public housing came under criticism. By pinpointing faults in the logic of producing large developments, architects in France began to question urban form rather than housing, and began to consider specific populations instead of the masses.

After Abbé Pierre called for public shelters for the homeless in 1954, the French state's housing policy resulted in a competitive program that fosters new and innovative architecture. Strong government support affirmed the architect's role in determining issues of residential space and even lifestyle. From 1950 to 1980, 11 million housing units were constructed and half the population of France rehoused.

What should become of this desire to transform the real? Is it appropriate to return without pathos to the notions of use-value and social betterment? These questions are confronted not only by architects working in France. During the 1990s, the tendency to build large-scale apartment-block housing projects has been replaced by more site-specific projects. A younger generation of architects, using the cultural models of inhabitants as well as their own emotional experience of the built environment as its primary source of research, continues the quest for a utopia of the real.

FERNAND POUILLON

(b. 1912, Cancon, France–d. 1986, Rignac)

Pouillon graduated from the École des Beaux-Arts in 1942, and from 1944 to 1953 worked mostly in Marseilles—on the La Tourette housing project (1949–53) and reconstruction of the Old Port district (1950–53)—and in Aix-en-Provence. In 1953 he was appointed chief architect to the city of Algiers, where he built several housing projects, including Climat de France (1953–57). In 1954, when Pouillon established the Comptoir National du Logement (National Housing Agency) to build low-cost housing more efficiently by acting as developer, architect, and contractor for each project, he was expelled from the Order of French Architects. After that, he designed and built several large public housing projects near Paris, at Pantin and Montrouge (both 1955–58), Boulogne-Billancourt (1955–64), and Meudon-la-Forêt (1959–61). In 1961 Pouillon's firm went bankrupt due to bad management; and, after an investigation of financial improprieties in the Boulogne project, he was sent to prison, where he wrote two books. From 1965 to 1985, he lived in Algeria, designing and building hotels, tourist centers, universities, housing complexes, and new towns. He returned to France in 1985, and was working on several projects just before he died.

Pouillon advocated a rational architecture utilizing dressed stone—a construction technique of artisanal origin adapted by him for large-scale production—and conceived in terms of classical urban models, in deliberate opposition to modern architecture. His work was rediscovered in France in the late 1970s and received official recognition at the 1982 Venice Biennale.

Climat de France is a 3,500-unit housing project in Algiers earmarked for the most disadvantaged segments of the city's Muslim population. For this project, Pouillon devised an articulated system of urban architecture diametrically opposed to the brand of urbanism advocated by CIAM (Congrès Internationaux d'Architecture Moderne) as well as to the large complexes then favored in France. Instead, Climat de France reverted to an older model of using squares and streets to give a sense of cohesion to apartment blocks and neighborhoods. The buildings themselves run the gamut of structural types, from oblong apartment blocks to more complex structures with central courtyards. Working between these extremes, juxtaposing towers of various heights with lower structures, some of them disposed around courtyards, Pouillon produced an urban fabric of alternating open and closed spaces. At the lower end of the housing project is an apartment building with a curving façade that departs from the urban grid and instead follows the topographical curve traced by the adjacent roadway. The project's sloping site overlooking the Mediterranean called for the utilization of stairs linking higher and lower areas outside the buildings and in some entryways.

The buildings' exterior façades, made of stone imported from France, are pierced by a series of small square windows and other square or rectangular openings, arranged in continuous repeating patterns that recall ancient city walls or musical scores. The resulting architecture, in which the structural individuality of each dwelling tends to be sublimated to achieve a larger unity, bears little resemblance to conventional public housing for the poor. Here, each building's entryways are articulated by a doubling or tripling of height or by a façade projection, gestures that give them a clearly legible presence.

The largest of the buildings is a monumental complex nicknamed by the inhabitants *les 200 colonnes* (the 200 columns), which became the focal point of the district. This rectangular building, which is 280 meters long, is configured around an immense interior courtyard ringed by an arcade formed by a continuous series of two-story-high square columns—the source of the complex's nickname. Behind the arcade, an interior façade of brick rises three stories (four on the long side that is higher because of the sloping site). The ground level is given over to shops, which open onto the arcade through round arches, while the upper floors contain apartments. On the roof of the colonnade are terraces for the third-floor apartments. The building's outer walls extend above the building's roof, culminating in a screen perforated by two rows of closely spaced rectangular openings that create the effect of an openwork crown. There are several large portico-like entryways, which have stairs that lead into the courtyard. From certain points, there are views of the Mediterranean. The structure's monumental effect is reinforced by the two-meter- »

Selected Bibliography

Pouillon, Fernand. *Mémoires d'un Architecte.* Paris: Seuil, 1968.

Seyler, Odile and Jacques Lucan, "Pouillon, 200 colonnes, Alger 1954–1957," AMC (*Architecture Mouvement Continuité*), no. 1 (1983), pp. 10–19.

Contal, M.-H. "Portrait de Fernand Pouillon" (interview), *Architecture Intérieure créée*, no. 209 (1985), pp. 96–109.

Dubor, Bernard Félix. *Fernand Pouillon.* Milan: Electa, and Paris: Moniteur, 1986.

FACING PAGE Climat de France public housing project: View of "the 200 columns" apartment block

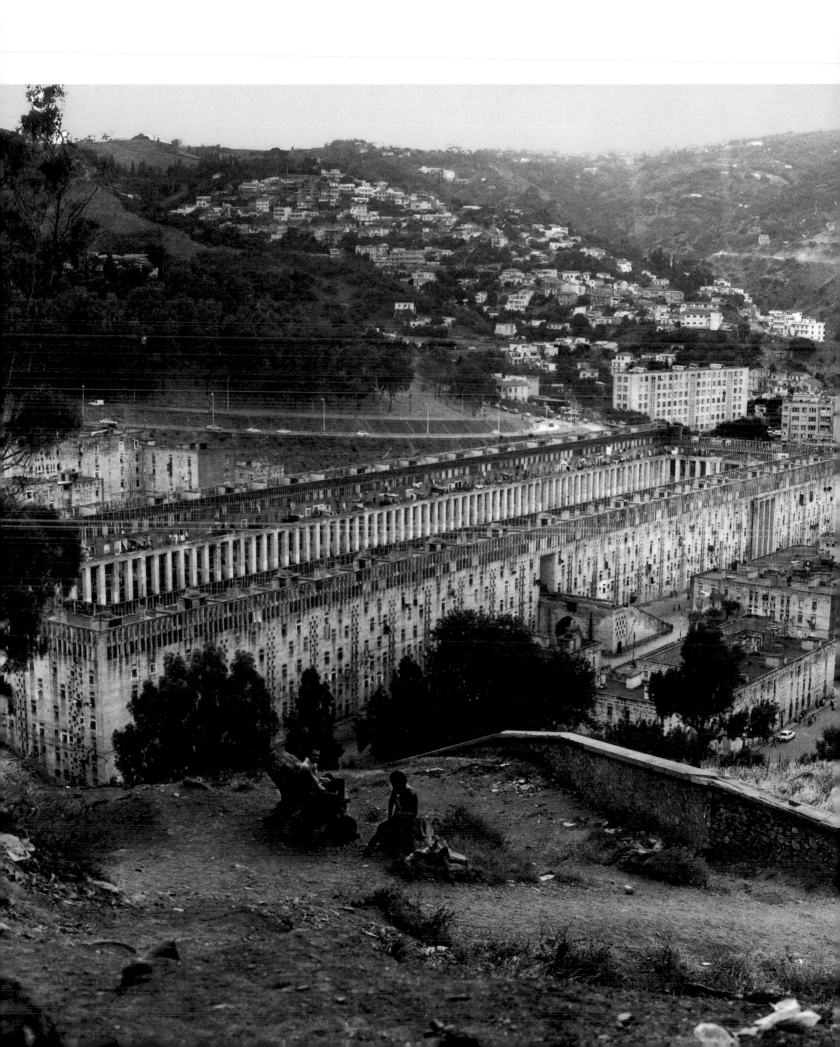

wide spaces between the columns (about 6½ feet) and by the one-meter-square stone blocks in the pillars and lintels.

After the complex was completed, Pouillon remarked: "Perhaps for the first time in the modern era, we have housed men inside a monument." In this project, like those realized by him in the Paris region, for example at Meudon, he restored a certain dignity to public housing, using principles articulated centuries earlier in the Place des Vosges.

ALAIN GUIHEUX
Translated from the French by John Goodman.

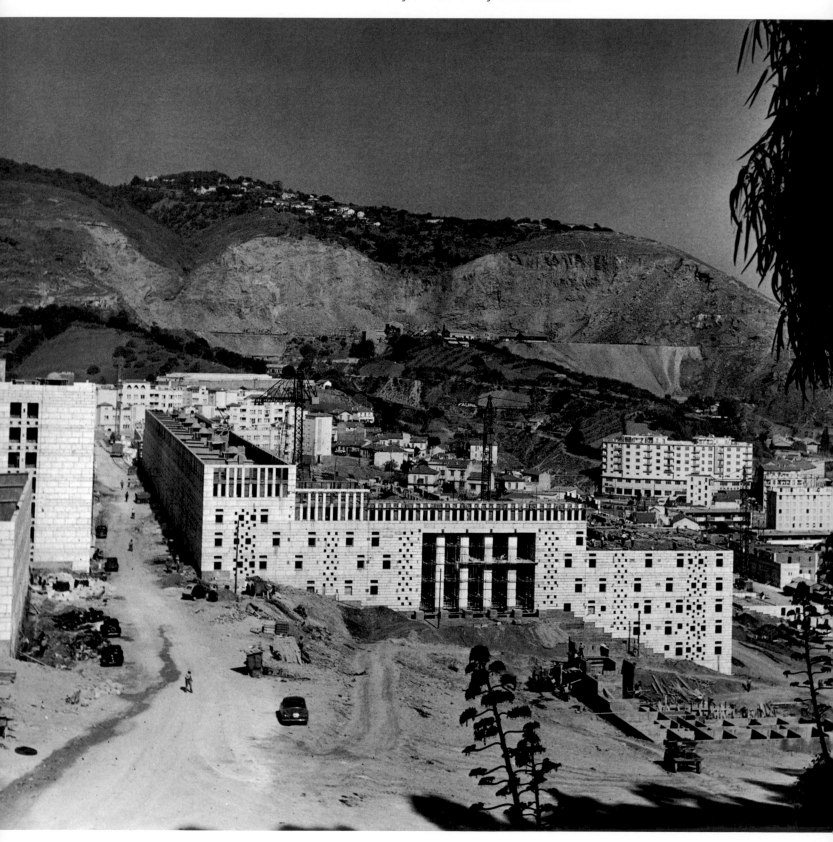

FACING PAGE Climat de France
public housing project: View of
"the 200 columns" apartment
block under construction

RIGHT Detail of the façade of "the
200 columns" apartment block

BELOW RIGHT Entryway into "the
200 columns" apartment block

GEAI CONSTRUCTION SYSTEM
1962-70

(GROUPEMENT POUR L'ÉTUDE D'UNE ARCHITECTURE INDUSTRIALISÉE /
GROUP FOR THE STUDY OF AN INDUSTRIALIZED ARCHITECTURE)

Founded in 1962, GEAI was composed of an architecture firm (Marcel Lods, Paul Depondt, Henri Beauclair, with associate architect Marc Alexandre), the OTUA (Office Technique pour l'Utilisation de l'Acier / Technical Office for the Use of Steel), the company Aluminium Français, and the Saint-Gobain factory. This consortium of architects and industrial enterprises set out to reduce construction costs through serial fabrication and mass production, as well as to increase habitability and comfort and stretch the limits of adaptability. The GEAI system was based on the principle of "dry" on-site assembly of precisely calibrated, lightweight components fabricated and finished in the factory. These would be transported to temporary factories set up at the construction site, combined into more complex units (floors, handrails, stairways, bathrooms, etc.), then lifted by cranes into position and bolted in place.

The idea of applying industrial production methods to a large-scale building project had long preoccupied Lods, but not until he used them in constructing the 1,500-unit Grandes Terres housing complex in Marly-le-Roi (1957–60) was he able to convince industrialists to back him in developing his ideas further. The success of Marly, in terms of urban planning as well as construction, demonstrated the feasibility of using light prefabricated components in large-scale building projects. Between 1962 and 1966, Lods carried out a series of experiments that culminated in the GEAI system and the construction of two prototypes, in Aubervilliers and Noyon. During a visit by the French Ministre de l'Équipement (minister of industry and urbanism) Edgard Pisani, the architect's persuasive advocacy of his system resulted in a commission for 500 residential units in Rouen (La Grand'Mare, 1968–70), a complex of twenty-five five-story buildings surrounded by green spaces. Each ground floor features an entry hall, parking garage, service module, storage area, and a wrap-around open-air corridor with views of the surrounding areas. The principle of dry on-site assembly of lightweight components proved adaptable to a wide variety of building types and design programs, enabling Lods to put his industrial production methods into practice. Vertical and horizontal structural frameworks were fabricated with special steel, while soldered-steel latticework floors facilitated the integration of electrical and heating conduits. These were installed in units of 90 square meters. Floors, ceilings, and walls were delivered ready to install, and aluminum windows, doors, and blinds were easily attached to specially designed openings. The construction system won several prizes, but no further large-scale commissions followed this experiment.

Lods's utilization of light, standardized, prefabricated components made sense, but he took it to irrational extremes, lightening the floors to the threshold of structural instability. Moreover, reductions in the cost of materials were offset by the need »

MARCEL LODS
(b. 1891, Paris–d. 1978, Paris)

After completing his architectural studies in Paris in 1923 (interrupted by military service in World War I), Lods entered into partnership with Eugène Beaudouin. Between 1928 and 1940, in collaboration with various engineers (Eugéne Mopin, Vladimir Bodiansky, Jean Prouvé, and others), Lods and Beaudouin conceived and realized several building projects notable for their combination of technological innovation with modern architecture, including housing complexes in Bagneux (1930) and Drancy (Cité de la Muette, 1932–34, destroyed), an open-air school in Suresnes (1934), and the Maison du Peuple in Clichy (1936–39). During these years, Lods advocated an architecture based on prefabrication and simplified assembly techniques, seeking to rationalize production methods on his building sites. After World War II, he expounded a new social urbanism close to that of Le Corbusier; but, frustrated by city officials' lack of bold vision and the policy of reconstructing war-destroyed buildings to their original designs (as mandated by law), he tried to implement his ideas in Guinea (Conakry) and Morocco (Agadir). Projects undertaken in France from the 1950s to the 1970s made it possible for him to perfect lighter metallic structural armatures and cost-cutting construction techniques using prefabricated components (Grandes Terres apartment complex, Marly-le-Roi, 1957–60; Maison des Sciences de l'Homme, Paris, 1968; La Grand'Mare apartment complex, Rouen, 1968–70). The instruction that Lods offered at the École des Beaux-Arts was regarded as among the most modern of its period (1948–64); many contemporary architects were influenced by his conceptual approach, which stressed the technological aspect of architectural practice.

Selected Bibliography

Lods, Marcel, with Hervé Le Boterf. *Le Métier d'architecte: Entretien avec Marcel Lods.* Paris: France-Empire, 1976.

Marcel Lods, 1891–1978: Photographies d'architecte (exh. cat.). Paris: Centre Georges Pompidou / Centre de Création Industrielle, 1992.

Uyttenhove, Pieter. "Marcel Lods, toujours l'industrialisation," *AMC (Architecture Mouvement Continuité)*, no. 11 (April 1986).

FACING PAGE La Grand'Mare apartment complex, Rouen: View of the façade, showing various elements produced and assembled using the GEAI system

for additional elements to obtain sufficient insulation and soundproofing. Rising labor costs reduced savings still further. Lods's goal was to construct buildings that were totally prefabricated and thus entirely uniform, like automobiles and other consumer products, for he believed that such an approach would make it possible to provide the greatest comfort to the greatest number of people, but this ideal came to seem increasingly problematic in the late 1960s. As the postwar housing shortage abated, there was a growing demand for the kind of personalized urban housing that functionalist architecture could not provide.

NICOLE TOUTCHEFF
Translated from the French by John Goodman.

LEFT La Grand'Mare apartment complex: A section of the soldered-steel floor frame with railings, shown being assembled

BELOW LEFT The entire framework of one building, completely assembled

BELOW RIGHT AND FACING PAGE, BOTTOM Two stages of the floor framework being assembled

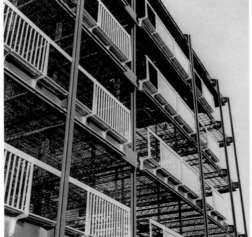

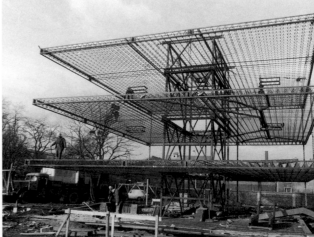

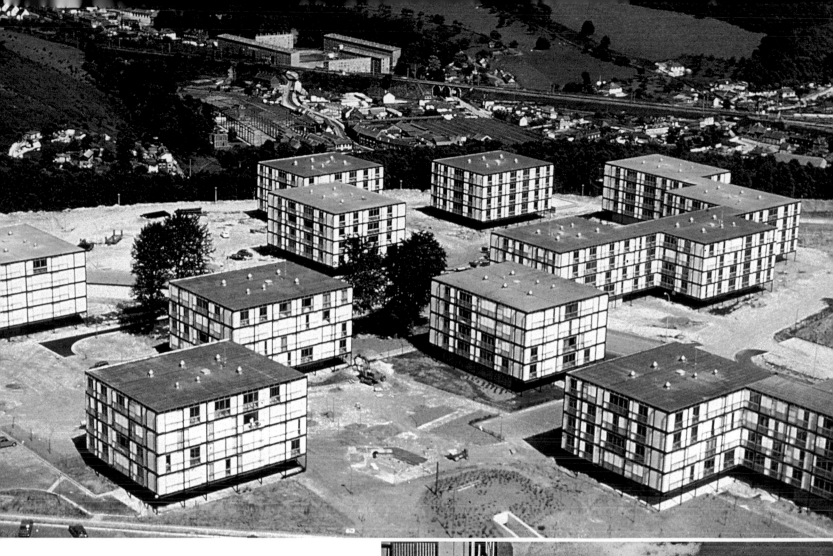

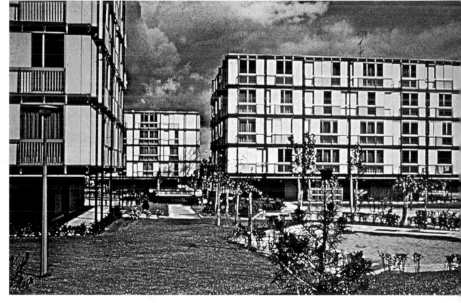

ABOVE View of La Grand'Mare apartment complex from the air

RIGHT View from the ground

ÉMILE AILLAUD
(b. 1902, Mexico City—d. 1988, Paris)

After graduating from the École Nationale Supérieure des Beaux-Arts, Aillaud worked briefly for André Ventre before starting his own practice. Because of the Depression, he received very few commissions in the 1930s, all for ephemeral structures such as the Pavillon de l'Elégance at the Exposition Internationale des Arts et Technique, Paris (1937), and the Salle de la Haute-Couture in the French pavilion at the 1939 New York World's Fair, but even these showed a personal style of unusual freedom and poetry. After World War II, as chief architect of Les Houillères de Lorraine, a coal-mining conglomerate in an area that needed reconstruction and modernization, he built several industrial structures and housing for workers. Beginning in the 1950s, Aillaud worked mostly in the Paris region, concentrating on improving the design and construction of low-cost public housing complexes. He used prefabricated concrete façade panels in the 1,500-unit Cité de l'Abreuvoir in Bobigny (1956–60), the 1,700-unit Les Courtillières in Pantin (1958–64), the 1,000-unit Wiesberg housing complex in Forbach, in the Moselle region (1959–63), the 3,800-unit complex of La Grande Borne in Grigny (1964–71), and the 2,500-unit complex of La Noë in Chanteloup-les-Vignes (1971–75). From 1972 to 1983, Aillaud developed several design schemes for the Tête-Défense site west of Paris, the best-known of which were two "mirror" buildings (unbuilt). Not far from there, his colored towers for the Quartier Picasso in Nanterre (1974–80) demonstrate his commitment to introduce poetry into everyday surroundings, even that of public housing.

Les Courtillières was the second large project built by Aillaud in the Paris region, after the Cité de l'Abreuvoir in Bobigny (1956–60). But even in his earlier housing project for miners for Les Houillères de Lorraine in the Moselle region, one can see some of his most cherished architectural principles emerging. Aillaud deftly exploited the sinuous curves of the hillside site in placing the houses, which were built using a system developed by Eugène Mopin combining prefabricated and cast-in-place concrete elements, with the rough texture of the incorporated gravel left visible on the surface. In the projects he built in the Parisian suburbs, the structures were not individual houses but large-scale apartment buildings, encompassing 1,500 residential units in Bobigny and 1,700 in Pantin. In some ways, L'Abreuvoir was a trial run of Aillaud's ideas for the other large complexes that followed, especially the differentiation of areas by building type, employing a plan combining eleven-to-fifteen-story towers, low oblong buildings, and long, winding four-to-six-story structures. By giving the latter meandering curves (a "noodle" configuration in Les Courtillières), Aillaud shaped the adjacent exterior spaces and tempered each project's enormous size. He softened their impact further by coloring the façades, in collaboration with the artist Fabio Rieti.

At the Courtillières housing project, the principles articulated at l'Abreuvoir were refined and implemented on an even larger scale, again utilizing industrial materials and production methods. At Bobigny, despite the size of the project, he had used cement-coated lightweight concrete blocks; here this material was replaced by prefabricated concrete façade panels made using the Camus process and sheathed with ceramic tiles. The color scheme, dominated by blue and gray-white, echoes the colors of the sky. The "noodle," a six-story apartment building 1.5 kilometers long, is the defining element of the complex. This gently curving structure forms an almost continuous loop that encloses a vast planted area, recalling the residential crescents built in Bath, England, by John Woods the elder and younger in the eighteenth century. Within this sheltered space is a day-care center featuring a petal-plan arrangement of shell vaults topped by an undulating concrete roof. Outside the "noodle" are several clusters of low oblong buildings (for shopping centers, schools, and additional apartments), and distributed around two of these clusters are sixteen fifteen-story apartment towers shaped like three-pointed stars. Each floor of the towers contains three apartments arranged around a central triangular stairwell.

In two subsequent projects in the Paris region—La Grande Borne in Grigny (1964–71) and La Noë in Chanteloup-les-Vignes (1971–75)—Aillaud's design aspirations were more ambitious and the scale even larger, encompassing 3,800 and 2,500 residential units, respectively, but these complexes lack the harmony so successfully achieved at Les Courtillières.

OLIVIER CINQUALBRE
Translated from the French by John Goodman.

Selected Bibliography

Aillaud, Émile. *Désordre apparent, ordre caché.* Paris: Fayard, 1975.

Dhuys, Jean-François. *L'architecture selon Émile Aillaud.* Paris: Dunod, 1983.

Émile Aillaud: Oeuvres graphiques (exh. brochure). Paris: Centre Georges Pompidou, 1989.

FACING PAGE Les Courtillières public housing development: Aerial view

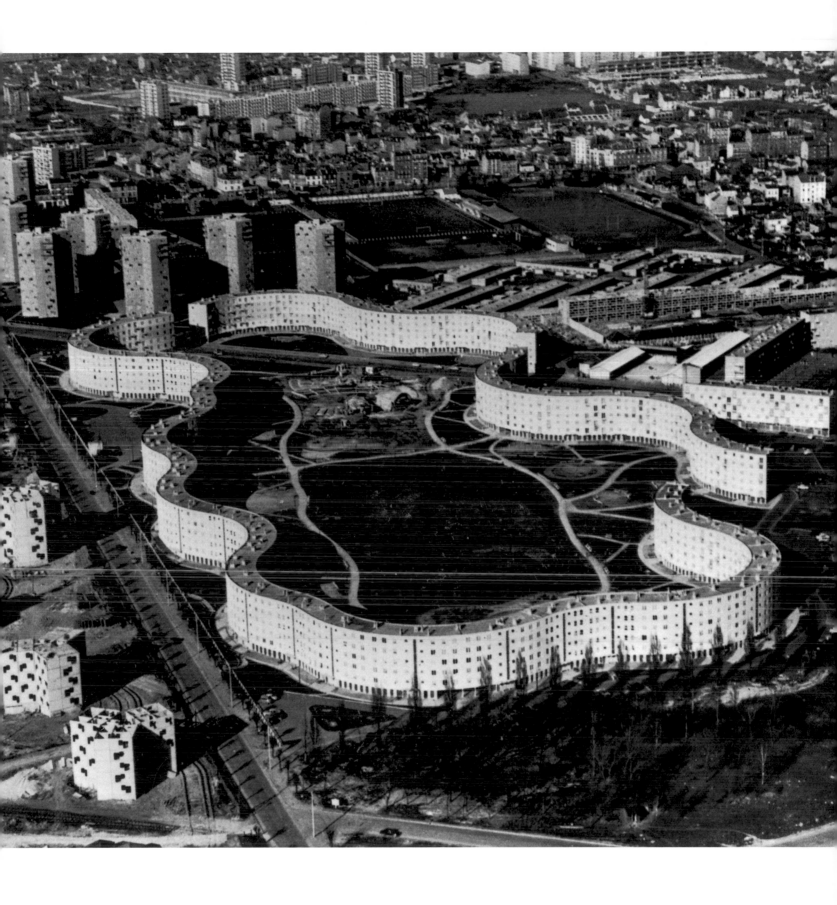

If these buildings are undulating, labyrinthine, it's not just because I find it visually appealing, it's because this creates folds, hence a certain silence, hence certain possibilities for seclusion. The precise antithesis of what contemporary architecture has to offer. These façades that are all alike, these large so-called green spaces, these large speculative buildings that are an obsession of urbanism today empty the individual of his subjectivity. Where do you feel more reduced to a pitiful nothing than in a row of balconies facing a panoramic landscape? Looking at infinity makes you commit suicide.

Émile Aillaud from *Émile Aillaud: Oeuvres graphiques*, exhibition brochure, Centre Georges Pompidou, Paris, 1989.
Translated from the French by John Goodman.

ABOVE The day-care center at
Les Courtillières public housing
development

FACING PAGE, ABOVE
Façade of the "noodle" (detail)

FACING PAGE, BELOW
View of several buildings in
the complex

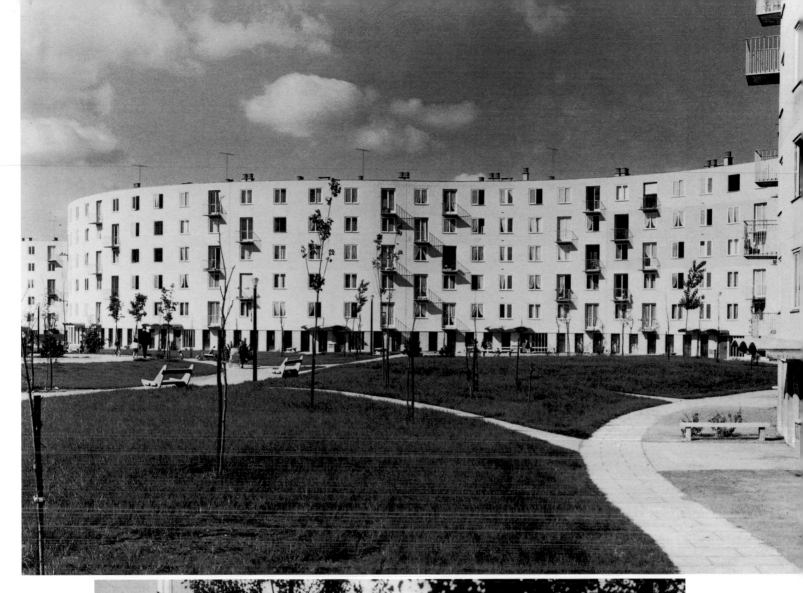

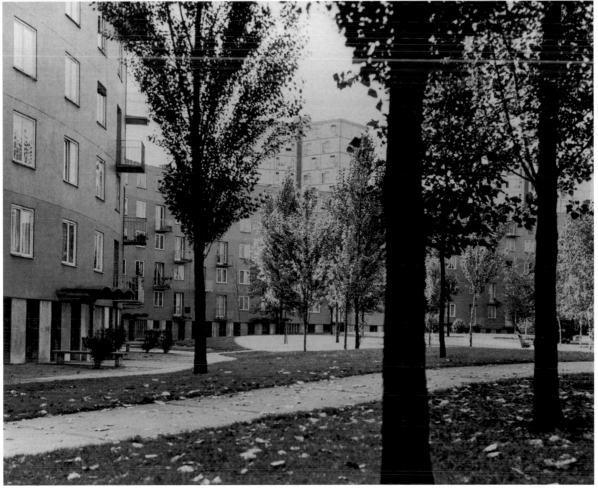

JEAN RENAUDIE

(b. 1925, La Meyze–d. 1981, Paris)

Renaudie entered the École des Beaux-Arts in 1946, studying first under Auguste Perret, then under Marcel Lods. After graduating in 1958, he designed and built a few projects, and in 1960 he founded the Atelier de Montrouge, an architectural firm, in partnership with Pierre Riboulet, Gérard Thurnauer, and Jean-Louis Véret. As a partner there, he was the principal architect of a day-care center for the département of Montrouge (1960– 64) and a firemen's dormitory in Montrouge (1960–68), which, like all the firm's work, were influenced by Le Corbusier and the Brutalist aesthetic. Renaudie also oversaw the firm's competition proposals for several urban projects: a vacation town in Gigaro (1964); Les Francs-Moisins, a 5,000-unit apartment complex in Saint-Denis (1965); and the new town of Le Vaudreuil (1967–68). Disagreement over the latter project caused a rift between Renaudie and the other partners in the firm, and in 1968 he opened an independent office in Ivry-sur-Seine, a working-class suburb of Paris. Among his many commissions—which include the housing complexes he designed for Givors' historic center (1974–80), for Saint-Martin d'Hères, near Grenoble (1974–81), and for Villetaneuse, Paris (1976–85)—the housing complex built in the early 1970s as part of a scheme to redevelop the center of Ivry- sur-Seine functioned as a beacon for the revitalization of contemporary French architecture, providing it with one of its most distinctive achievements.

This is the work that established Renaudie's international reputation and, in France, gave renewed credibility to the notion of public housing by demonstrating the compatibility of such schemes with new kinds of architecture. The redevelopment of the center of Ivry, overseen by the architect Renée Gailhoustet, provided Renaudie with an opportunity to put into practice the principles of urban organization that he had begun to explore in the competition proposal for the Francs-Moisins project in Saint-Denis (1965), and the novel ideas that he had elaborated during the Le Vaudreuil competition (1967–68), using both to create a design of real originality.

The design principles from the Francs-Moisins project that Renaudie applied at Ivry are: high density; contiguous volumes continuously developed; multiple circulation patterns; the incorporation of service facilities into a housing complex; the interpenetration of activities; and prominent planted terraces, public as well as private. In designing the new town of Le Vaudreuil, Renaudie took into account the forms and surface configurations of the nearby cliffs, attempting to translate them into schematic images of urban development through a prolonged process of experimenting in drawing after drawing. His aim was to make the organic complexity of the city visible, but in abstract terms unrelated to classical urbanist models. He proceeded similarly at Ivry, arriving at a final design for the form of the buildings only after an extended period of analysis carried out in a series of drawings. Out of his intensive explorations of a plan dominated by concentric shapes, the solution emerged: a cluster of powerful forms with sharply angled projections jutting out like the points of a star.

All extant buildings were razed and all traces of the previous lot configuration were eliminated. Erected in successive phases, the buildings designed by the Renaudie firm rose on a vacant lot overlooked by high apartment towers. The new apartments were deliberately intermixed with spaces for shops, offices, and cultural groups. Different kinds of pedestrian access were incorporated: one can traverse the complex through sheltered passages and open walks. Some of the upper apartments are entered from terraces. The prominent vegetation and pervasive use of balconies contribute greatly to the singularity of this public housing complex. The striking prevalence of angular projections prompted some to nickname it "Jean Renaudie's stars," a phrase later used by Hubert Knapp as the title for his television documentary on the project.

Before the Ivry complex was completed, some of the design's more utopian aspects were eliminated: the idiosyncratic design of the early façade elevations was toned down and the collective terraces were abandoned. But these changes did not compromise the success of the final ensemble.

OLIVIER CINQUALBRE
Translated from the French by John Goodman.

Selected Bibliography

Renaudie, Jean. "Faire parler ce qui jusque-là est tu," *Techniques et Architecture*, no. 312 (February 1976).

Interview with Jean Renaudie by Gritti Haumont, *Avenir 2000*, no. 40 (1977).

"Rénovation du centre d'Ivry, France, Jean Renaudie," *L'Architecture d'Aujourd'hui*, no. 213 (February 1981).

Buffard, P. *Jean Renaudie*. Paris: Institut Français d'Architecture, and Rome: Edizioni Carte Segrete, 1992; Paris: Sodedat, 1993.

Goulet, Patrice and Nina Schuch, eds. *Jean Renaudie: La logique de la complexité*. Paris: Institut Français d'Architecture, and Rome: Edizioni Carte Segrete, 1992; Paris: Sodedat, 1993.

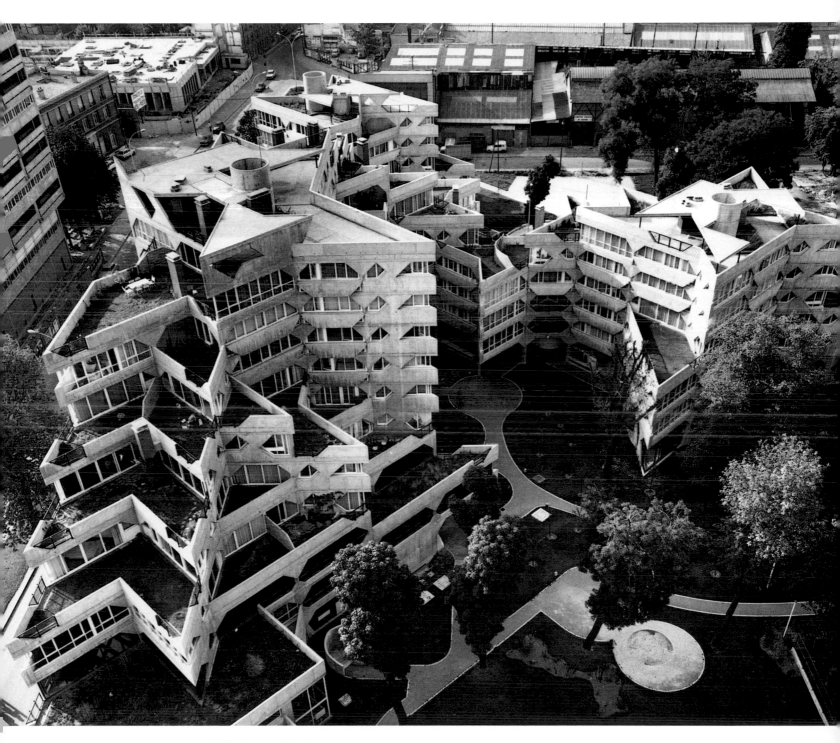

ABOVE Redevelopment of the city
center, Ivry-sur-Seine, 1970–75:
Aerial view of the "stars of Ivry"
public housing complex

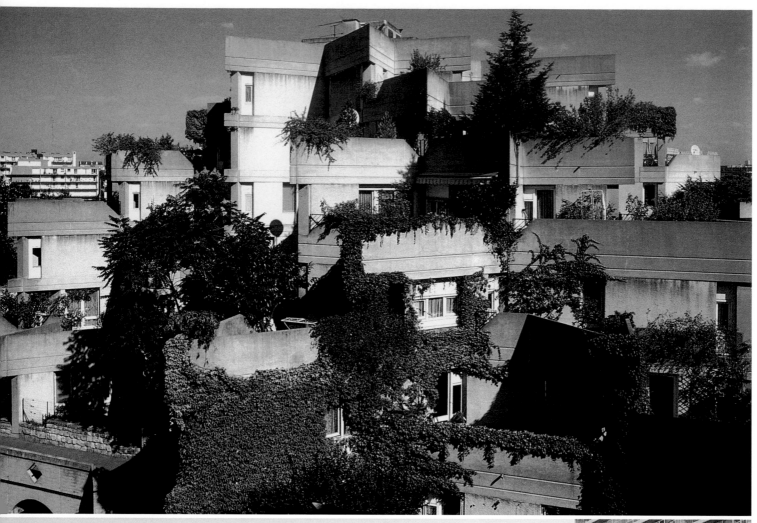

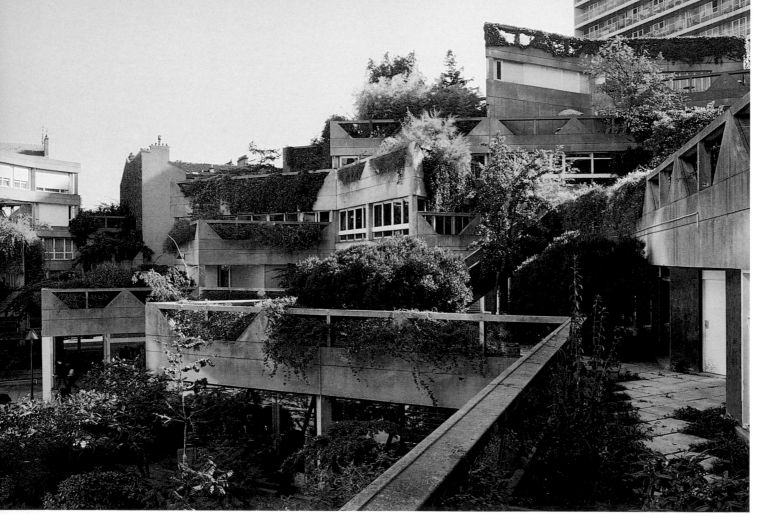

ABOVE Street view of the "stars of Ivry" housing complex

FACING PAGE, ABOVE
Planted terraces of the "stars of Ivry" housing complex

FACING PAGE, BELOW
Open walkway and planted terraces of the "stars of Ivry" housing complex

Cities represent very complex physical organizations, combinations of extremely diverse elements. The cities that we find agreeable, lively—for example the small cities we encounter in Europe—are never the result of a simple organization in urbanist terms, of a simplistic juxtaposition of elements. Cities, especially today, are combinations of increasingly elaborate structures, confluences of all the energies underlying all of their constituent elements, even those that are latent within these elements. The convergence of these energies makes cities and neighborhoods harmonious, more agreeable to live in, thanks also to architectural forms that are aesthetically pleasing. . . .

The solution adopted at Ivry is indeed more open than conventional schemes. Just as at the level of the city's organization, it is important to take into account the complexity of relations within the family, and of the complexity of relations between the inhabitants of a single building or neighborhood. Attentiveness to the most positive aspects of these complex factors leads almost automatically to the necessity of creating considerable diversity. Diversity of exterior architectural forms, but also of apartment plans. It is impossible to imagine a single solution, a solution-type, that would respond to such concerns.

Interview with Jean Renaudie by Gritti Haumont, *Avenir 2000*, no. 40 (1997).
Translated from the French by John Goodman.

MEDICAL SCHOOL HOUSING COMPLEX, CATHOLIC UNIVERSITY OF LOUVAIN, WOLUWÉ SAINT-LAMBERT, BRUSSELS
1970-77

LUCIEN KROLL

(b. 1927, Brussels)

Kroll reproaches many architects for thinking only in terms of a building's form and not its use. Rejecting the ideal of the "beautiful work," of the homogeneous but isolated object-building, he seeks to devise landscapes in which the unexpected and the familiar are juxtaposed. He eschews symbolism, and instead organizes teeming contexts characterized by permeability and openness to appropriation. In creating these microcosms, he puts considerable stock in the instincts of ordinary people, whose notions regarding spatial organization, he thinks, rarely miss the mark. The result is a kind of architectural collage that relates to its surroundings and in which a majority of users feel comfortable.

Two years after the student protests of 1968, Kroll was commissioned to build housing for medical students at the Catholic University of Louvain, chosen at the students' request. The impression of controlled anarchy generated by these buildings was the product of a collaborative process, with the choices decided by the buildings' future users. Numerous interviews, conducted with the help of a social psychologist, produced widely varying responses, some contradictory, which Kroll incorporated into the design by mixing many kinds of forms and construction methods. His goal of variety achieved through a democratic process is clearly visible in the Maison médicale, the medical students' residence hall, nicknamed the "Mémé" (French for "granny"). The southern end of the building, dubbed "the fascists" before the university prohibited the name, is less chaotic-looking than the rest of the complex, in keeping with the wishes of some students (as well as, secretly, the university). It features identical rooms and a conventional curtain façade. In contrast, none of the "Mémé" dormitory rooms are alike, and they have movable walls that allow residents to reconfigure them. The principle of diversity is even more apparent in the façades, with windows of different shapes, materials, and colors, arranged almost randomly. This ad hoc organization of forms announced the advent of an architecture rich in visual incident, emblematic of the turmoil of the post-'68 period.

The lower part of the building, with spaces for various student activities, is conceived differently. The masonry at the base of the façades seems to expand out over the ground while the ground appears to rise up against the building. The interplay among these elements resulted from Kroll's interactive supervision of the masons, who were encouraged to execute his plans as they saw fit. Kroll believes that if artisans leave traces of their handiwork, inhabitants will tend to do likewise, especially when a sense of play is in evidence. At the nearby Alma subway station (1979–82), Kroll again gave the workers a free hand, with results akin to the work of Antoni Gaudí and other organic architecture. »

Kroll, after graduating from the École Nationale Supérieure de la Cambre in Brussels, designed several religious buildings and private homes, first in partnership with Charles Vandenhove (1951–57) and then on his own. While designing a housing complex in the Auderghem district of Brussels (1961–65), he became interested in the "creative participation" of the residents and invited them to take part in its design. Objecting both to architects' traditional monopoly over the design process and to their bias toward simple white forms, he sought to honor the views and preferences— more intuitive than rational—of the building's future users. He has fought against aesthetic regimentation and conformity from that time on, countering abstraction with organicism, repetition with chance, order with disorder, refinement with bad taste. Kroll used his group design process for a complex of buildings in the early 1970s for the Catholic University of Louvain's medical school, as well as for several housing complexes and redevelopment projects in France.

From 1962 to 1970, while continuing to work on various projects in Belgium, Kroll designed and built a series of government buildings in Rwanda, where he also acted as an advisor in the development of a national public-housing policy; and from 1970 to 1975 he developed a master plan for the new capital. He remained respectful of traditional resources and techniques, like Aldo van Eyck during his work with the Dogon. Kroll realized the crucial importance of traditional African organizational models and their implications for the design of living spaces.

More recently, he has been interested in the question of urban ecology, understood in terms of relation, solidarity, milieu—in other words, as an ecology in which social concerns take pride of place.

Selected Bibliography

Hunziger, Christian. "Portrait de Lucien Kroll," *L'Architecture d'Aujourd'hui*, no. 183 (January– February 1976), pp. 69–80.

Kroll, Lucien. *Composants: Faut-il industrialiser l'architecture?* Brussels: Éditions Socorema, 1979; rev. ed. 1983.

Kroll, Lucien. *Buildings and Projects*. London: Thames and Hudson, 1988.

FACING PAGE Medical School housing complex: A section of one façade of the medical students' residence hall known as "la mémé et les fascistes" (the granny and the fascists)

There is a certain vulgarity to the way in which the complex revels in the haphazard quality of the design and in the crudity of form typical of primitive construction techniques. The playfulness of some of the decorative motifs, far from striking an ironic note, reflects Kroll's rejection of the autocratic notion of the architect's role, a belief rooted in his populist convictions. Behind this exaggerated bricolage, one discerns a distinctly European attempt to "learn from . . . banality" (to use a set phrase from Robert Venturi), instead of imitating the fantastic mirages of Las Vegas. Utopia is indeed dead, and irony with it.

MARC BÉDARIDA
Translated from the French by John Goodman.

RIGHT View of the Medical School
housing complex showing the Alma
subway station

FAR RIGHT View of the Medical School
housing complex through construction
rubble

BELOW A façade of the medical students'
residence hall, showing "la mémé" (the
granny) on the left and "les fascistes" (the
fascists) on the right

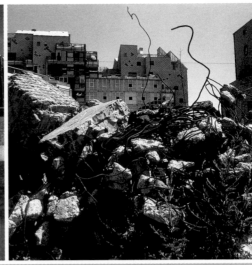

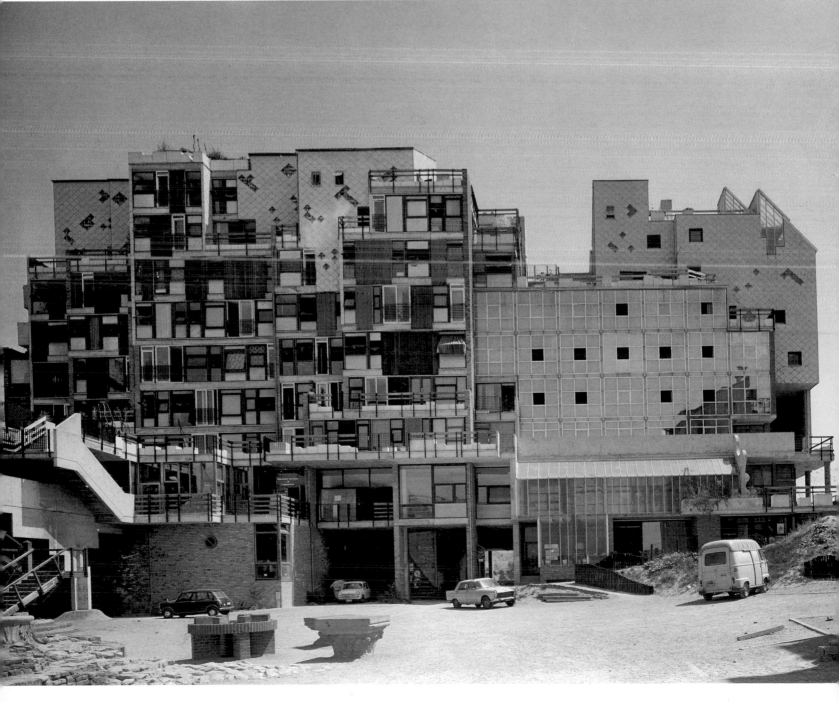

PUBLIC HOUSING COMPLEX IN ELANCOURT-MAUREPAS, SAINT-QUENTIN-EN-YVELINES
1975-81

Gaudin's drawings reveal his passion for medieval cities, a recurrent theme in his writings, and one that provides a key to an oeuvre preoccupied with the lost meaning of the idea of the city, of urbanity or, rather, "hospitality." The formal complexity that is characteristic of his architecture originated in the paper collages that he created during his stay in New York in 1968, in response to his discovery of American abstract painting and tomographic images (three-dimensional x-rays) of the human body. This exploration of a realm between sculpture and architecture left its mark on his first projects, two schools in Souppes-sur-Loing (1970–73), and its impact is also apparent in the curved façades of the housing complex at Maurepas, on the outskirts of the new town of Saint-Quentin-en-Yvelines. Gaudin's design for that complex revealed his simultaneous tendency toward subtlety and boldness, and a sensual approach to space, particularly in his attempt to foster a "correspondence between outside and inside," between air and matter. Built on a small site, the 132-unit complex creates an effect of billowing white sails and delicate shadows with notable formal economy, the result of Gaudin's repetition of a small number of basic typological volumes. Three-apartment units dubbed "geodes" cluster around semicircular plazas in continuous, flowing configurations. They feature spiral stairways enclosed by curving walls that project out from the entries, forming undulating surfaces that punctuate the pedestrian walks; these "points of conjunction where things do not exist" are complemented by the compactness of the broad, smooth exterior façades. The play of light, refracted by the vast expanses of small white ceramic tiles, produces a "multitude" of visual surprises, as Gaudin likes to call them. "To inhabit is to create pockets open to speech," wrote Gaudin, who, though bound by the budgetary constraints that are an inherent feature of public housing projects (no elevators, no communal spaces), managed here to create what he has characterized as "the house as social existence."

JACQUELINE STANIC
Translated from the French by John Goodman.

HENRI GAUDIN
(b. 1933, Paris)

Gaudin worked as a naval engineer and then turned to painting before studying architecture at the École des Beaux-Arts in Paris, graduating in 1966. With a scholarship from the American Institute of Architects, in 1968 he went to New York and worked in the office of Harrison and Abramovitz. In 1969 Gaudin returned to France, where he was the official representative of the Atelier Parisien d'Urbanisme from 1969 to 1973. He established his own architectural practice in 1970, and also taught at the École d'Architecture de Versailles, then at the Université de Paris (giving a course in anthropology and urban planning) until 1976. As his first independent commission, he designed and built two schools at Souppes-sur-Loing (1970–73). By combining "an urban order with a country order," he gained a reputation for the quality of his public housing projects, such as those at Maurepas in Saint-Quentin-en-Yvelines (1975–81) and Arcueil (1983–87). For his housing complexes at Evry-Courcouronnes (1982–85) and on the rue de Ménilmontant in Paris (1983–86), Gaudin was awarded the Prix de l'Equerre d'Argent (in 1986 and 1994). He worked in collaboration with his son Bruno on the extension of the Université de Saint Leu in Amiens (1993), the Charléty Stadium in Paris (first phase completed 1994)—a work notable for its integration into the Paris environment—and other projects. Gaudin has recently won several competitions in Paris and in Lyons (the École Normale Supérieure), and is also known for his writings and his books of sketches.

Translated from the French by Diana Stoll.

Selected Bibliography

Gaudin, Henri. *La Cabane et le labyrinthe*. Liège: Pierre Mardaga, 1984.

Chaslin, François, ed. *Henri Gaudin*. Paris: Institut Français d'Architecture, and Milan: Electa, 1984.

Tonka, Hubert, ed. *Henri Gaudin au 44, rue de Ménilmontant* ("Lieux d'architectures" series). Seyssel: Champ Vallon, 1987.

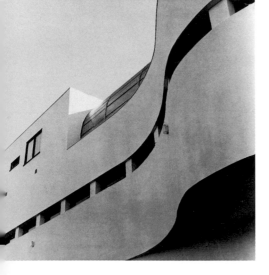

ABOVE Schools at Souppes-sur-Loing, 1970–73: Façade (detail)

FACING PAGE One façade of the public housing complex in Elancourt-Maurepas

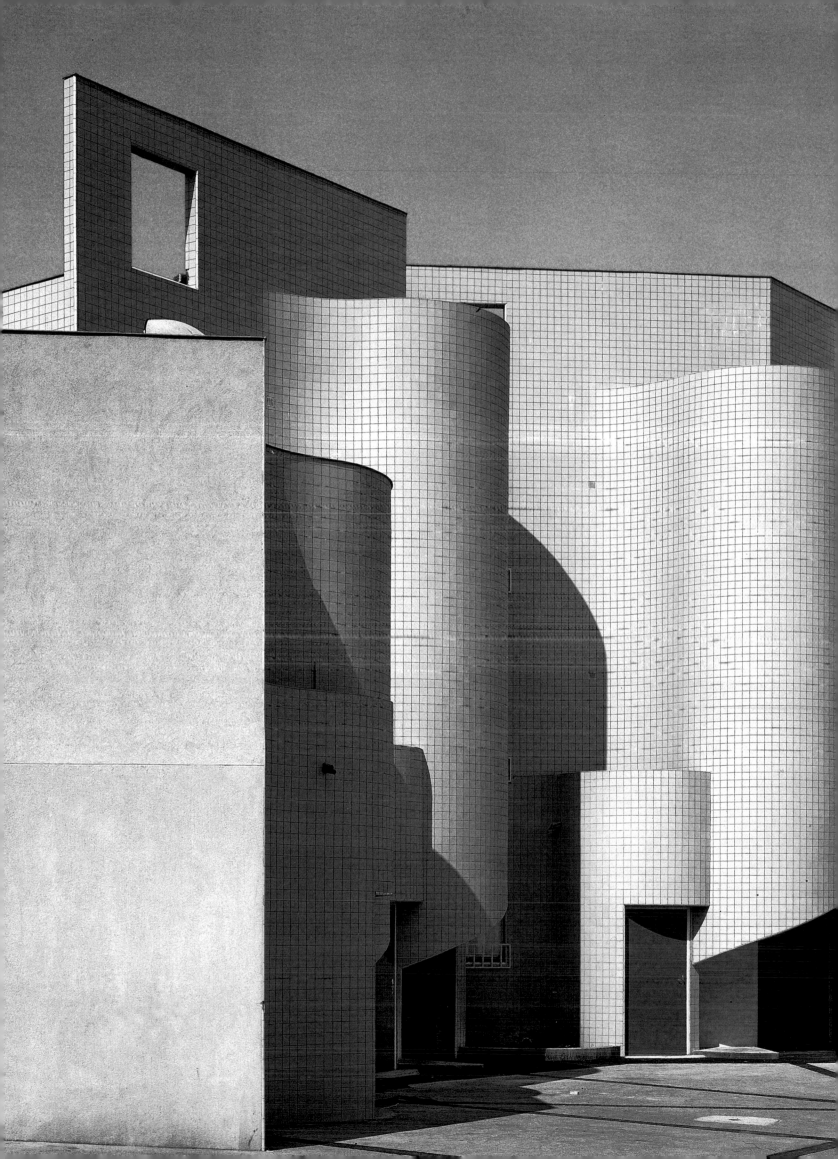

PUBLIC HOUSING COMPLEX IN EVRY-COURCOURONNES
1982-85

HENRI GAUDIN

Paradoxically, this architect-philosopher, a sworn enemy of both the neoclassical approach and the urban expansionism of new towns, was engaged to design a project at the entrance to another new town, Evry, commissioned by the OCIL (Office Central Interprofessionnel de Logement). Situated in a "no-man's-land," this 100-unit project initially seems quite ascetic in comparison to the sensuality of the Maurepas complex. But behind the deceptively simple entry court, bounded by four white masses that are cubic and compact, is a labyrinthine world of passages, digressions, and "tiny corners." Gaudin deliberately exploits the ambiguities of architectural space through an asymmetrical arrangement of various elements—including an external stairway that exaggerates the sense of verticality—thus creating an effect of light and shadow that suggests the "creasing of matter."

JACQUELINE STANIC
Translated from the French by John Goodman.

ABOVE Façade (detail) of the public housing complex in Evry-Courcouronnes

FACING PAGE Public housing complex in Evry-Courcouronnes, showing several buildings and exterior stairway

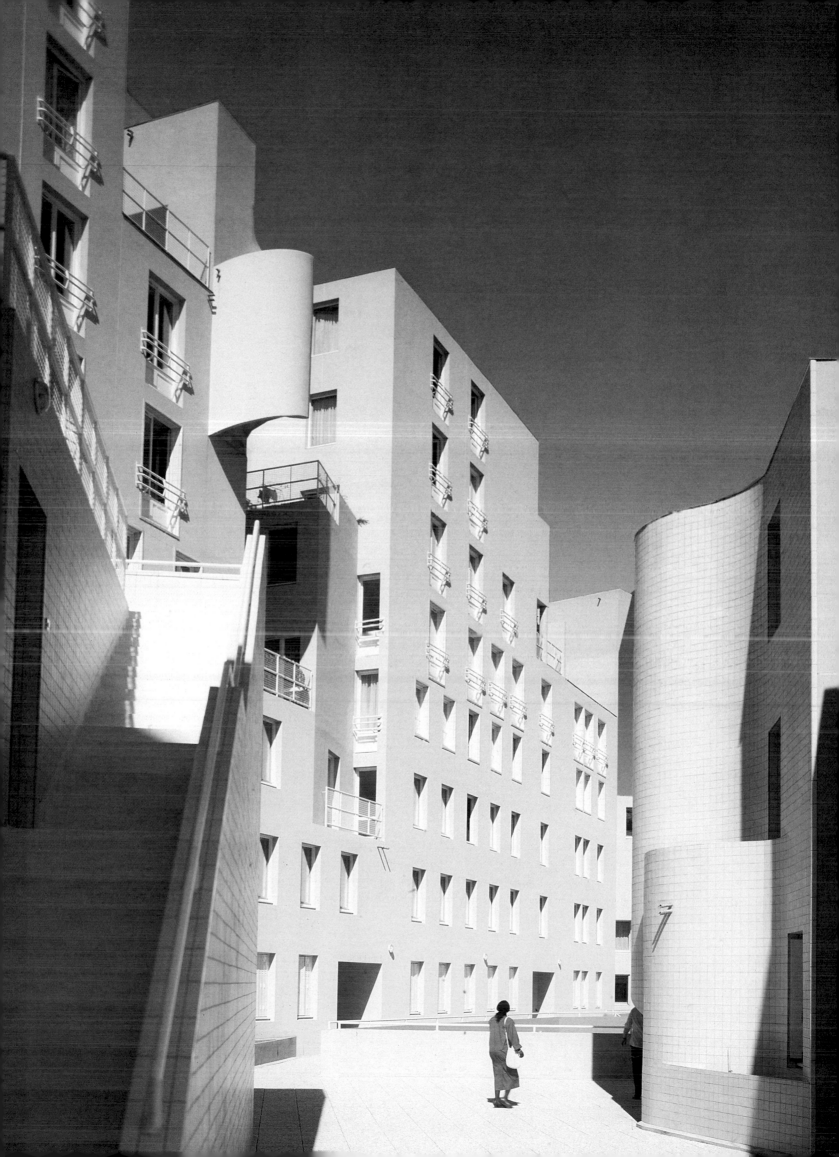

LES ALISIERS PUBLIC HOUSING COMPLEX, 44
RUE DE MÉNILMONTANT, PARIS
1983-86

HENRI GAUDIN

The OCIL also engaged Gaudin to design a housing complex in the heart of the 20th arrondissement in Paris, in the working-class district of Belleville, where he deferred to the complexity of the surrounding urban fabric. On a plot at the corner of the sloping rue de Ménilmontant and the narrow rue Delaître, he built a complex containing thirty-six apartment units of varying character and conforming to city regulations limiting maximum overhangs (two feet along the main street, eight inches along the rue Delaître). Facing the main street is a high façade with a projecting bow brightened by the sparkle of white ceramic; in the hollows, an impression of planarity is accentuated by thin columns that emphasize the perpendiculars and by a few corbels and horizontal balconies. These varying projections and recesses can be interpreted as an allusion to the subtle changes in alignments of building façades on a street over time. In contrast to the main façade, the rue Delaître façade is lower and more modest. Facing the interior of the complex, white plaster façades recalling Arab "medinas" close in on themselves and open up in succession. The rear court offers, through a narrow gap, a glimpse of a beautiful bell tower a short distance away; on the ground floor, a sequence of small courts leads to a large open area (a future recreation court) that is a veritable island of serenity in which the city seems to vanish. The building as a whole—airy, intimate, calm— exemplifies Gaudin's ideal of a "hospitable" architecture.

JACQUELINE STANIC
Translated from the French by John Goodman.

ABOVE Rear façade (detail) of
Les Alisiers public housing project

BELOW Street view of Les Alisiers
public housing project

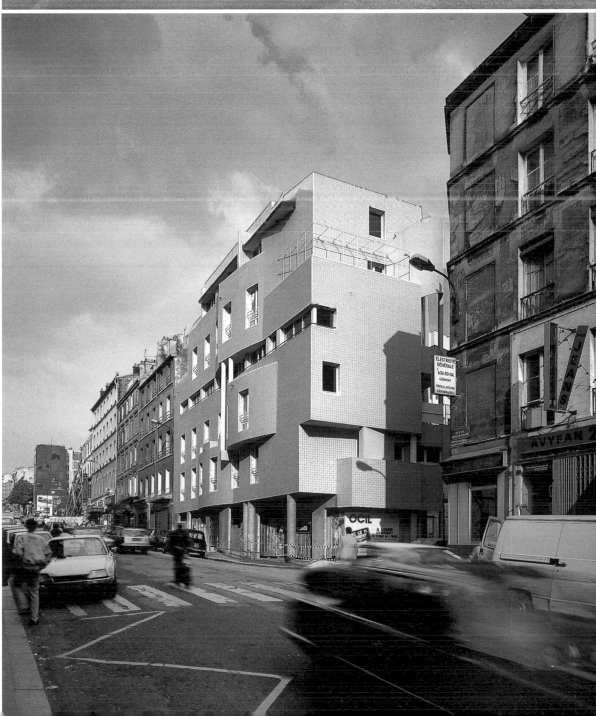

LES HAUTES FORMES HOUSING PROJECT, PARIS
1975-79

**Christian de Portzamparc in collaboration with
Georgia Benamo**

CHRISTIAN DE PORTZAMPARC
(b. 1944, Casablanca, Morocco)

Near the southern boundary of Paris, in a dense neighborhood undergoing extensive redevelopment, eight apartment buildings along the short rue des Hautes Formes combine basic constituents of the urban landscape—street and square, empty space and monumental form—to create an unapologetically modern architectural ensemble featuring pristine white surfaces and severe planes. They demonstrate how Portzamparc embraces the ideals of the modern movement, once it has been purged—as indicated by the windows here—of its more reductive postulates. In fact, he lays claim to a double heritage: that of modern architecture, and that of historical tradition. This apartment complex exemplifies his idiosyncratic way of reinterpreting the characteristic features of unusual neighborhoods and urban sites. The square in the center, with its four trees, street lamp, and benches, is deliberately reminiscent of the Place Furstemberg in Paris, while the high building that overlooks it recalls the bell tower of the church of Saint-Germain-des-Près.

Les Hautes Formes initiated Portzamparc's exploration of fragmentation as a principle of urban integration. Instead of erecting two large apartment buildings (as originally planned), he decided to recreate a complex urban fabric consisting of several buildings of somewhat varied design. The resulting multiplicity acknowledges both the topology and the morphology of the surrounding urban context. On one side, he dealt with the impact of a nearby university's enormous tower by putting up a group of small towers; on another, he matched the moderate height of a neighboring building. He also sought to hollow out and break up the masses in ways that created views of the adjacent urban landscape, thereby combining physical intimacy with visual interpenetration. These fluid sequences are the result of Portzamparc's articulation of built elements and spaces to create a cleverly ordered urban scenography that has nothing to do with mere décor.

Portzamparc's submissions to the design competitions for La Roquette (1974) and Les Halles (1979) and the solutions he adopted for Les Hautes Formes—as well as, among current projects, for the urban-renewal zone near the Porte d'Asnières—extend this exploration of voided volume, the clearing that Heidegger wrote about in "Building, Dwelling, and Thinking." This opposition is fundamental to Portzamparc's work. To the *object-center* or point, exemplified by the water tower at Marne-la-Vallée, is opposed an *alignment* that, beyond line, engenders space. The alignments at Carnac and the configuration of Stonehenge, often evoked by Portzamparc, are witness to that human desire to mark an empty place, hence a place open to all possibilities, a place destined to undergo "the emotional experience of the void, its physical and sensory importance." In the early 1980s, beginning with this opposition, Portzamparc established a quadripartite conceptual structure—the symbolic and the utilitarian, or the *arche* and the *telos*; the totem and the clearing, or placement and spacing—that provides the key to much of his work.

MARC BÉDARIDA
Translated from the French by John Goodman.

FACING PAGE Apartment buildings
in Les Hautes Formes public
housing project

Portzamparc graduated from the École des Beaux-Arts in Paris in 1969. Like many members of his generation, Portzamparc's first projects were for new towns. He designed a water tower at Marne-la-Vallée (1971–74) with a shape that brings to mind both De Chirico and Hegel, suggesting an absence of symbols as much as their affirmation. Portzamparc seeks a unity, even a harmony, out of antagonistic principles, admitting the troubling ambivalence of the coexistence of opposites. He affirms not the past or the future but the present, a vantage point from which he is able to make use of such contradictions and contrasts, and to articulate his awareness of history—a point of view that, for a time, brought him close to postmodernism. Portzamparc's work shows evidence of two dominant influences: the headstrong, mathematical precision of Le Corbusier; and the lived-in, fluid, sculptural quality of Hans Scharoun. These diverse affinities are apparent in the differences between his stiff apartment buildings at Les Hautes Formes (1975–79, with Georgia Benamo) and the appealing unruliness of his recent proposal for the Masséna district around the new Bibliothèque Nationale.

Portzamparc is both a sensualist and a phenomenologist, who wants people to experience space and the forms around it through their senses and feelings. In his works, one's understanding of the spaces and forms proceeds from an awareness of one's body in relation to the context, rather than letting the eye dominate. This has resulted in a kinesthetic interplay of volumes, forms, and materials, especially in such commissions as the Conservatoire Erik Satie (1981–84), the dance school of the Paris Opera at Nanterre (1983–87), and the Cité de la Musique (1984–95). Portzamparc has been awarded the Équerre d'Argent (1988, 1995), the Grand Prix National de l'Architecture (1992), and the Pritzker Prize (1994).

Selected Bibliography

for Les Hautes Formes:

Heidegger, Martin. "Building, Dwelling, and Thinking" (1954), in *Poetry, Language, and Thought*. New York, 1971.

Benamo, Georgia and Christian de Portzamparc. "Rue des Hautes Formes," *L'Architecture d'Aujourd'hui*, no. 202 (April 1979), pp. 48–59.

Bédarida, Marc. "Elements of the Street," *Lotus International*, no. 41 (1984), pp. 109–19.

Christian de Portzamparc. Paris: Éditions Electa-Moniteur, 1984.

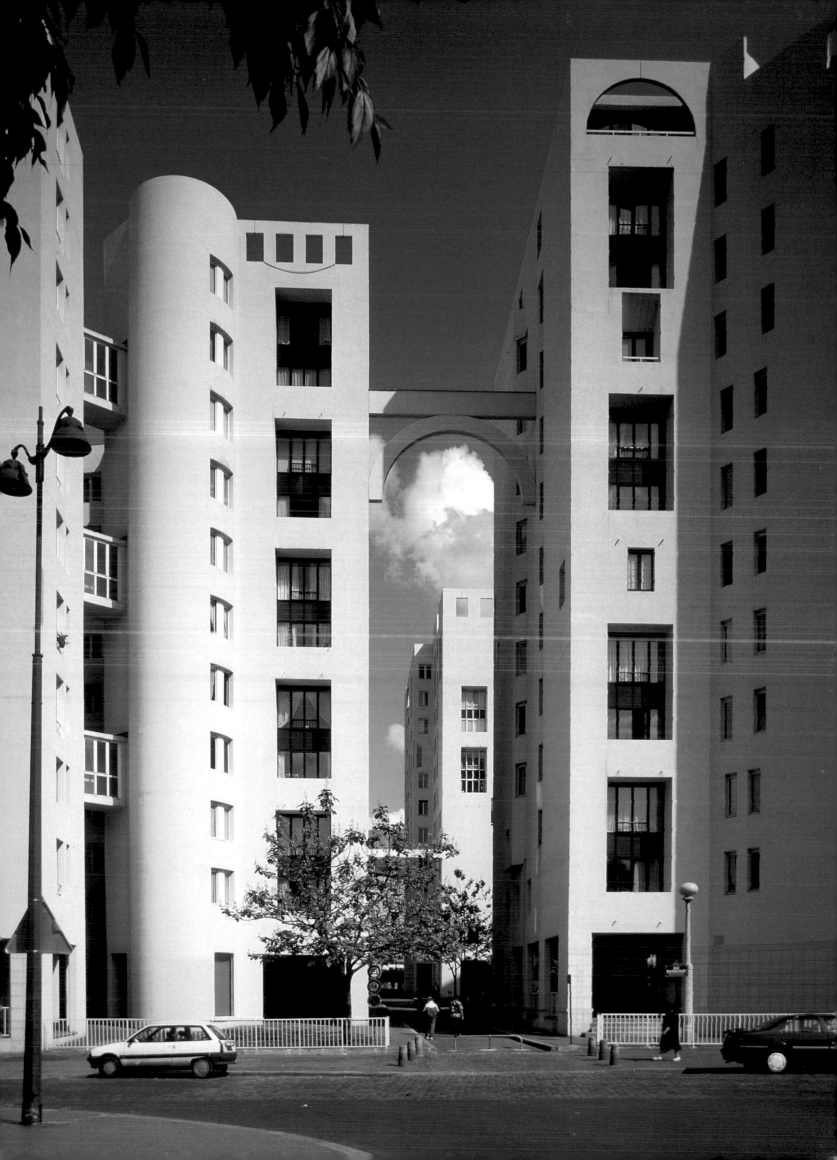

Les Hautes Formes public housing
project: FACING PAGE View of street
BELOW Courtyard

CITÉ DE LA MUSIQUE, PARIS
WESTERN SECTION, 1984-90; EASTERN SECTION, 1984-95

CHRISTIAN DE PORTZAMPARC

The Cité de la Musique (Music Center), one of the *grands projets*, marks the entry to the Parc de la Villette in northeastern Paris. It is in two sections flanking a plaza in front of an old metal-frame market hall: on the west side of the plaza, the Conservatoire (Conservatory of Music), and on the east side, an ensemble of performance spaces, offices, a museum of musical instruments, rehearsal rooms, and a pedestrian "street." These open onto a winding pathway leading to the park, designed by Bernard Tschumi. Portzamparc arranged the Conservatory buildings in a rectilinear configuration aligned on three sides with two streets and the market hall, and created a monumental façade set back from the avenue passing diagonally in front of the Cité. For the eastern complex, on a wedge-shaped site across the plaza and along that same avenue, at a point where the dense urban fabric of Paris meets the rambling landscape of the adjacent suburbs, he designed an autonomous group of fluid forms around a spiraling walkway (called the "Musical Street") with the concert hall at its center. This shell-like plan, which resembles a treble clef, is consistent with the eighteenth-century idea that a building should clearly set forth its function.

The division of the Cité into two separate ensembles made it possible for Portzamparc to generate two contrasting compositions. The western complex, devoted to education, consists of an orderly grid-system arrangement of buildings around a courtyard punctuated by sculptural elements. The formal vocabulary here recalls Le Corbusier, and its sculptural forms recall Oscar Niemeyer, André Bloc, and Frank Gehry, with the palette of Luis Barragán. The eastern complex is an assemblage of syncopated sites and shapes without discernible models, each part of which is autonomous. Here Portzamparc's goal was a kinesthetic ensemble of animated forms energized by an immediacy of gesture, of line, of creative thought. The duality exemplifies Portzamparc's evolution toward a pluralistic, poetic architectural syntax.

Arising out of an approach to urban integration, this strategy of fragmentation was used by Portzamparc to vary the parts and to control scale and complexity. The dissociation of parts also provided a way of achieving the acoustic isolation required for the concert halls and rehearsal rooms and of underscoring each part's individual character. Proceeding from interior spatial organization, Portzamparc applied Hans Scharoun's notion of dismantling form in order to express interior complexity on the exterior.

Portzamparc also sought to make this arrangement of forms and spaces into a landscape for contemplation by imitating nature—not idealized nature, but nature governed by disorder, and organized into a picturesque ensemble harboring geometric solids in the manner of old garden follies. Viewed from the Parc de la Villette, this mineral landscape, animated by sunlight playing over its forms, refers back to the changing spectacle of Nature and is appreciated by means of vision, which Descartes deemed "the subtlest of the senses."

MARC BÉDARIDA
Translated from the French by John Goodman.

ABOVE Cité de la Musique: The "Musical Street" inside the eastern complex

FACING PAGE, ABOVE
Detail of the Conservatoire, the western complex of the Cité de la Musique

FACING PAGE, BELOW
Courtyard of the western complex of the Cité de la Musique

Selected Bibliography

for Cité de la Musique:

Fortier, Bruno and Bruno Suner. "La Cité de la musique," *L'Architecture d'Aujourd'hui*, no. 270 (September 1990), pp. 100–113.

Le Dantec, Jean-Pierre. *Christian de Portzamparc.* Paris: Éditions du Regard, 1995.

Scoffier, Richard et al. *Christian de Portzamparc: Scènes d'atelier.* Paris: Éditions du Centre Georges Pompidou, 1996.

for Place Coislin, Metz:

Portzamparc, Christian de. *L'Architecture d'Aujourd'hui*, no. 302 (December 1995), pp. 5–7, 51–107.

Portzamparc, Christian de. *Oculum*, no. 9 (1996–97), pp. 35–49, 70–71.

"La ville de l'Age III, débat avec Christian de Portzamparc," *Ville-Architecture, DAFU*, no. 4 (November 1997).

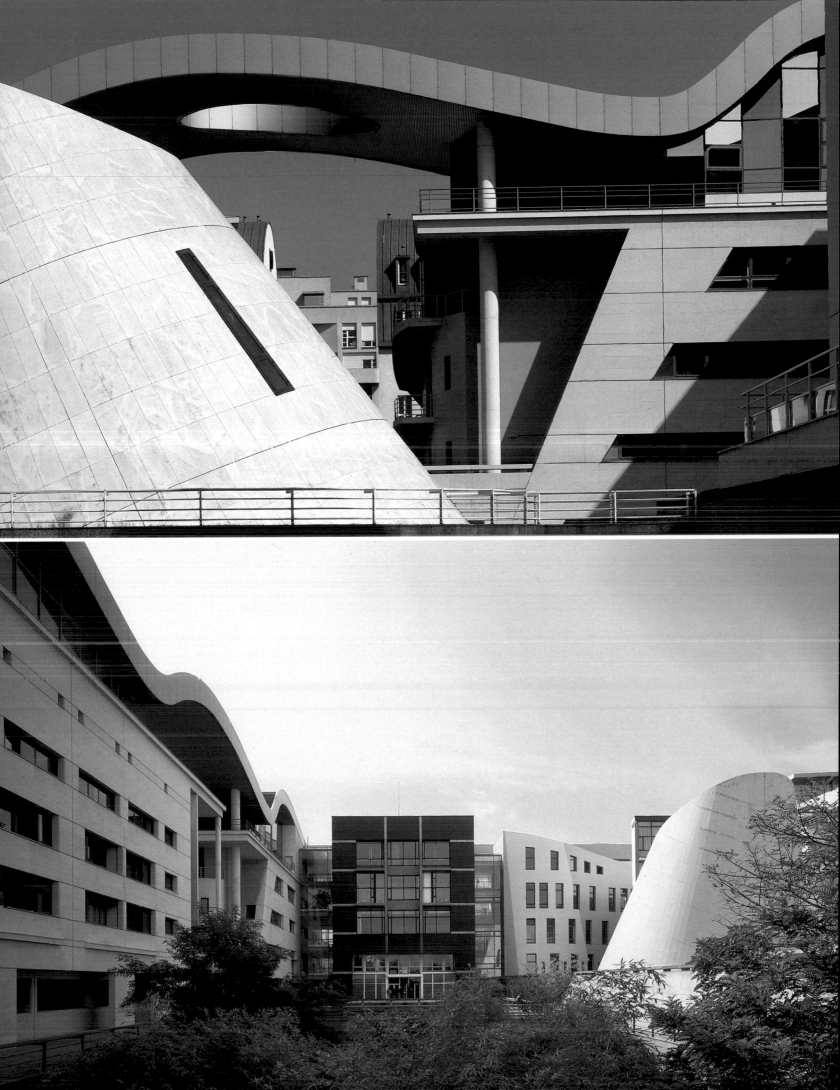

CHRISTIAN DE PORTZAMPARC

Since the 1970s, Portzamparc has understood that cities are by definition incomplete and require diversity, and that dogmatic regimentation kills them. He was far from enraptured by the chaos of the modern metropolis, and sought to develop a strategy for revitalizing the city distinct from the regressive revivalism of a Leon Krier or the typological approach of an Aldo Rossi. The result was his notion of the three ages of the city. More poetic and personal than rigorously scientific, it holds that urban evolution proceeds by successive ages analogous to geological eras.

Extending from Hippodamos to Berlage, the First Age corresponds to the classical city, which evolved over four thousand years, accumulating various conventions for urban forms within a single basic framework governed by the primacy of voids, with the configuration of buildings and blocks determined by empty spaces shaped into a network of streets and public spaces. The Second Age—the modern age—corresponds to the achievement of the *ville radieuse* (radiant city) of Le Corbusier and CIAM, in which buildings float more or less happily in the middle of elastic organizing structures and generalized voids. Here, "the idea of the city is based on objects, with the solid as the defining principle." The Third Age corresponds to the hybrid city, distinct from both the "classical" and "modern" cities. It breaks with the city dominated by freestanding buildings, a model prevalent since the 1920s, without resorting to "Haussmanisation," i.e., "corridor-streets" with continuous street façades completely aligned, the terrible effects of which are all too apparent in Berlin's *Mietkaserne* (apartment buildings). As a consequence, the open or free block assumes central importance in the third-generation city.

Portzamparc began to use the concept of the open block in his design for Enghien (1981) and employed it on a larger scale for Nantes-Atlanpole (1988), Place Coislin, Metz (1990), and Toulouse (1991), and it is fundamental to his proposal for the future Masséna district, at the foot of the new Bibliothèque Nationale in Paris. The open block developed in response to the morphological studies carried out by nineteenth-century hygienists and by Tony Garnier in his Cité Industrielle, and was further explored during construction of low-cost housing on the outskirts of Paris during the 1930s. Discontinuous and thus open, the block banishes the artificial "corridor-street" and the subdivision of blocks into small lots so decried by modernists. Instead, it introduces ruptures, interplay between masses, and pockets of light, and is characterized by blocks arranged randomly within a regular grid.

The designs for the Place Coislin in Metz and for Sector IV of Marne-la-Vallée (1990) also reveal Portzamparc's attraction to Manhattan and its skyline, which taught him lessons about the organization of blocks and the use of setbacks, a volumetric approach that assumes even greater importance where façades lack any relief ornamentation. In Metz, Portzamparc set out to repair the medieval urban fabric, composing in terms of urban landscape. Monolithic blocks, pyramidal blocks, and sequential blocks, organized in layers, provide the basis for an aesthetic premised not on the idea of unity and alignment but on syncopated rhythms and counterpoint.

MARC BÉDARIDA
Translated from the French by John Goodman.

ABOVE AND FACING PAGE
Various views of the model for Portzamparc's housing proposal for Place Coislin, Metz

FACING PAGE, BELOW
Drawing of housing proposal for Place Coislin

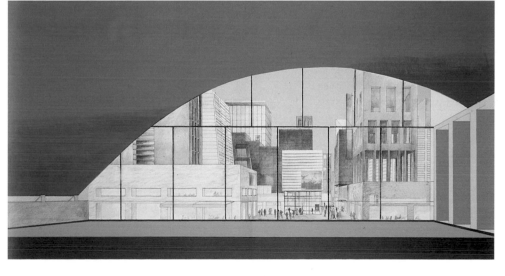

NEMAUSUS 1 APARTMENT BLOCKS, NÎMES
1985-87

Jean Nouvel and Jean-Marc Ibos

JEAN NOUVEL

(b. 1945, Fumel, Lot-et-Garonne)

Nouvel designed his first public housing projects in the early 1980s: a 48-unit complex in Saint-Ouen (in collaboration with Pierre Soria, 1982–87), featuring loftlike spaces, aluminum siding, and exterior stairways and pedestrian walkways; and the 114-unit Nemausus 1 housing project in Nîmes (in collaboration with Jean-Marc Ibos, 1985–87), which developed these same ideas somewhat differently. Nemausus 1 consists of two parallel five-story apartment blocks, with three of the stories articulated on the exterior by continuous balconies that overlook the surrounding suburban houses and an avenue of plane trees in between the two blocks. The structural system consists of an armature of thin concrete floors and walls erected over a half-sunken parking garage; collective spaces are minimal, and the materials (aluminum siding for exterior walls, galvanized steel for stairways, sunscreens, and balcony railings) are inexpensive and unconventional. At the top, a horizontal "visor" floats a half-floor above the roofline proper. Graphic markings (red and white stripes) on the ground and on the walls, metal fire stairs, rounded "prows" and oblique "poops," and the building's clear detachment from the ground all suggest a seaport, a train station, or an airport. The apartments (one-floor, duplex, and triplex) feature seventeen different layouts, and are 30 percent larger than in most housing constructed on an equal budget. Nouvel's design successfully challenges old ideas of public housing, proposing a new model comparable in imaginative power to Le Corbusier's *unités d'habitation* and Jean Renaudie's *étoiles*.

A basic premise of Nouvel's design is that an architect designing such projects should be more concerned with size than with form—that "a beautiful apartment is a large apartment." This notion that, rents being equal, an apartment's dimensions are the primary criterion of quality is a social priority over which architects have little control. Because of it, the Nemausus apartments, which also have certain desirable practical features (double exposures, balconies), present an image that attract individuals and families whose financial resources are greater than those usually interested in public housing. This is a function of decisions related to lifestyle: maximum reduction of foyers and interior partitions; elimination of hallways; multilevel apartments; bathrooms with plenty of natural light; raw concrete interior walls; metal stairways; floor-to-ceiling garage doors fronting the balconies. Structural solutions were simplified and costs reduced; but certain exceptions were made, such as the use of expensive industrial doors. The interiors were designed, ideally, for a minimum of objects and furniture. As Nouvel has commented, "A poster, a table, two chairs, I don't need anything more. I love space." Responding to this lifestyle image, some families have covered the walls and added partitions, reminding the architect that the particulars of private life, such as the treatments of interior walls, is exclusively their concern.

<div align="right">

ALAIN GUIHEUX

Translated from the French by John Goodman.

</div>

Nouvel studied architecture at the École Nationale Supérieure des Beaux-Arts in Paris, graduating in 1971; he opened an office with Gilbert Lézènès and François Seigneur in 1970. His earliest works were influenced by the work of Claude Parent and Paul Virilio, and by Team 10's concepts of cluster housing and integrated spaces. During the late 1970s, his idiosyncratic approach came into focus around the idea of a "critical architecture" skeptical of his contemporaries' intellectual categories. As a result, some of his built works—such as a streamlined aluminum clinic building in Bezons (1976) and several later works, including the Nemausus 1 housing project in Nîmes—resemble vehicles for transportation more than residences.

Nouvel's architecture rejects both the historicism of the European city and the Corbusian tradition. The context of his work is post-industrial modernity, with its questioning attitude and quotidian objects. He understands that advertising, fashion, the movies, art, and architecture all shape the existence of contemporary man. Beginning with the Institut du Monde Arabe (1981–87), Nouvel set out to surpass the technologically oriented models developed by Archigram and other British architects, and he created several designs that show the influence of movies and science fiction. Most of his early 1980s work consists of a series of unbuilt projects, including a Parc de La Villette competition entry (1982) and designs for the Tête-Défense complex (1982) and a media center in Nîmes (1984). The projects he designed after that, some of which were built, explore various ideas: streamlining (Nemausus housing; Tokyo Opera House proposal, 1986; Vinci Congress Center, Tours, 1989–93), surface (Saint-James Restaurant Hotel, Bordeaux, 1987–88; Railroad Triangle, Euralille, 1991–94), and transparency (Fondation Cartier, 1991–94). His Tokyo Opera House proposal (with Philippe Starck) and Endless Tower project (1988) look like abstract objects spawned by science fiction. Since 1988, Nouvel has been working in partnership with Swiss engineer Emmanuel Cattani.

Selected Bibliography

Goulet, Patrice. *Jean Nouvel*, Paris: Institut Français d'Architecture, 1987.

Goulet, Patrice. *Jean Nouvel*. Paris: Édition du Regard, 1994.

Boissière, Olivier. *Jean Nouvel*. Paris: Éditions Pierre Terrail, 1996.

Iwona Blazwick, Michel Jacques, and Jane Withers, eds. *Jean Nouvel, Emmanuel Cattani and Associates*. Exh. cat. London: Institute of Contemporary Art, and Artemis, 1992.

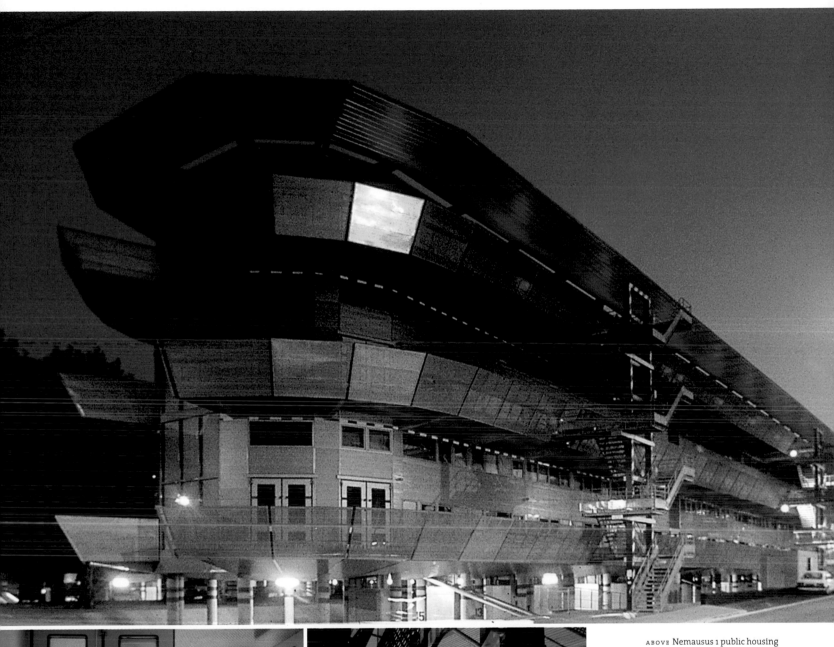

ABOVE Nemausus 1 public housing project: View of one building

FAR LEFT Interior of an apartment, looking out through French windows that are actually floor-to-ceiling garage doors

NEAR LEFT Exterior stairway

THE FABRICATION OF ARCHITECTURE

JEAN PROUVÉ	*APARTMENT BUILDING FAÇADE, SQUARE MOZART, PARIS;*
	ALUMINUM CENTENNIAL PAVILION, PARIS
JEAN PROUVÉ & JOSEPH BELMONT	*FRENCH MINISTRY OF NATIONAL EDUCATION HEADQUARTERS,*
	COMPETITION ENTRY
RENZO PIANO & RICHARD ROGERS	*CENTRE GEORGES POMPIDOU, PARIS*
RENZO PIANO	*IBM TRAVELING EXHIBITION PAVILION;*
	JEAN-MARIE TJIBAOU CULTURAL CENTER, NEW CALEDONIA
JEAN NOUVEL	*INSTITUT DU MONDE ARABE, PARIS;*
	FONDATION CARTIER, PARIS

Technique and fabrication based on industrial mass-production methods have become the hallmarks of certain formal tendencies in architectural modernism. Architects such as Pierre Chareau, Marcel Lods, Vladimir Bodiansky, and especially Jean Prouve have been pioneers in combining the technical with the aesthetic in the production of buildings. The development of the adjustable curtain wall, which is constantly evolving due to technological changes, is just one example of how architectural form has been influenced by industrial fabrication.

Prouvé's work is emblematic of the Modernist belief in bettering the conditions of human existence by providing housing for the largest possible number of people. The notion of architecture as the embodiment of progress has been inspired by the world of machines. Technologies borrowed from aeronautics or automobile engineering have often been appropriated by architects in order to improve and advance the processes of fabrication and assembly, more than as a way of copying their mechanical forms. In fact, Prouvé owned his own factory, enabling him to control production and put innovative ideas into effect.

More than construction, fabrication has become the primary occupation of architectural practice during the second half of this century. Prouvé's Aluminum Centennial Pavilion (1954–56) is a fabricated building; it is closer to the creation of an object such as an airplane than a construction. Prouvé rejected the distinction between furniture and building, regarding architecture as a particular category of fabricated objects. The Centre Georges Pompidou (Prouvé was chairman of the competition jury) is a descendant of the engineering feats of the nineteenth and twentieth centuries. Its lineage of transparent structures can be traced from the buildings of the early world's fairs, through Chareau's Maison de Verre and Oscar Nitzchke's House of Advertising, to the geodesic domes of Buckminster Fuller and the radical megastructures of Archigram. This genealogy is shared by another milestone of the second half of the late twentieth century, the IBM traveling exhibition pavilion created by Renzo Piano. This building is a direct heir of a school of engineering that embodies an intimate knowledge of the fabrication of objects rather than mere calculations.

Jean Nouvel's Institut du Monde Arabe in Paris marks a transformation of the ideas of fabrication and experimentation with surface, already detectable in the rhetorical exaggeration of Piano and Rogers's Centre Georges Pompidou. In buildings such as these, which incorporate elements of advanced technology, construction is less important than streamlining. Other attempts at creating technologically inspired façades, such as the Bibliothèque François Mitterrand by Dominique Perrault, or the work of Jean-Marc Ibos, Myrto Vitart, and Dominique Lyon, confirm this tendency toward industrial metaphors. In this evolutionary sequence, the building remains an object of architectural imagination for the transfer of technological progress and modernity.

APARTMENT BUILDING FAÇADE, SQUARE MOZART
1953

JEAN PROUVÉ
(b. 1901, Paris–d. 1984, Nancy)

Son of painter Victor Prouvé, co-founder of the school of Nancy, Prouvé served an apprenticeship from 1916 to 1919 with master ironworker Émile Robert. In 1923, he opened a workshop in Nancy, equipped it with electric soldering machinery, and made his first furniture prototypes using thin sheet steel. He also made decorative iron pieces for such architects as Rob Mallet-Stevens and Tony Garnier (and would later work with Le Corbusier and Pierre Jeanneret on innovative construction methods). In 1929, he was one of the founding members of the Union des Artistes Modernes.

Fundamentally, when it came to the role of prefabrication in construction, Prouvé was opposed to the very idea of "open industrialization"—that is, the use of the same standardized components for different projects. He held that a building's outer envelope should be a logical development of its specific structure. However, some of the components that he designed for quite specific uses, having proved adaptable to other circumstances, became standard. Still more paradoxically, the contingencies of Prouvé's career made him one of the fathers of the "curtain wall," and his reputation in this field became international when, as consulting engineer and building director of CIMT (Compagnie Industrielle de Matèriel de Transport) in 1957, he perfected a design for remarkable façade panels that could be mass-produced.

Prouvé opened a new workshop in Nancy in 1931, where he developed patents for portable finishing systems and manufactured building components. In 1933, he elaborated principles of prefabrication for a Citroën bus station in La Villette, and then refined them in two collaborative projects with architects Eugène Beaudouin and Marcel Lods: the Roland Garros Flying Club in Buc (1935) and, with engineer Vladimir Bodiansky working with them, the flexible mixed-use Maison du Peuple in Clichy (1936–39). In 1939, he perfected rapid-assembly construction systems, including a "crossbeam" system used in 1945 to erect 450 huts for homeless victims of World War II bombardments in Lorraine. In 1947, he moved his workshops to Maxéville, near Nancy, where he built his own factory and founded a design and production company specializing in metal buildings, building components, and furniture.

Prouvé's first such contribution to a multistory building of reinforced concrete came in 1949, when he designed the curtain wall of the headquarters of the French Building Federation (architects: Gravereaux and Remi Lopez). It was a complete success. But Prouvé, who had at the same time been working on ideas for sunshade panels for tropical houses, was unhappy with the great rigidity of conventional examples and realized that "living" variants could be achieved by introducing simple mechanical elements. So much, at least, can be inferred from his approach to the next such project he was put in charge of, the façade of an apartment building on the Square Mozart (architect: Lionel Mirabaud), where he took the notion of mechanical options to an extreme but, by so doing, gave it its full meaning.

In this adjustable-panel design, Prouvé resolved all the problems presented by such façade units. While they permit a maximum of natural light to penetrate the building's interior spaces, their lower panels can be slid upward and tilted outward to function as sunshade panels. While providing excellent heat reduction, they also allow for the controlled circulation of outside air, and the glazed portions, which can be opened, can also be blacked out when necessary. Incorporating all these possibilities, Prouvé's design is immensely satisfying in architectural terms as well, resulting in an animated façade composition that has yet to find its equal in architectural history.

In the early 1950s, he developed a new structural principle, the load-bearing core, in collaboration with several young architects (Joseph Belmont, Maurice Silvy, Henri Nardin, Pierre Oudot, Tarik Carim). They »

RAYMOND GUIDOT
Translated from the French by John Goodman.

Selected Bibliography

Huber, Benedikt and Jean Claude Steinegger, eds. *Jean Prouvé: Une Architecture par l'industrie / Jean Prouvé: Industrial Architecture*. Zurich and London: Artemis, 1971.

Prouvé, Jean. "Jean Prouvé: La Permanence d'un choix" (interview). *L'Architecture d'Aujourd'hui*, no. 189 (February 1977), pp. 48–49.

Guidot, Raymond, Alain Guilheux, et al. *Jean Prouvé, "Constructeur"* (exh. cat.). Paris: Centre Georges Pompidou, 1990.

Coley, Catherine. *Jean Prouvé*. Paris: Éditions du Centre Georges Pompidou, 1993.

FACING PAGE Façade of adjustable aluminum panels on an apartment building in the Square Mozart

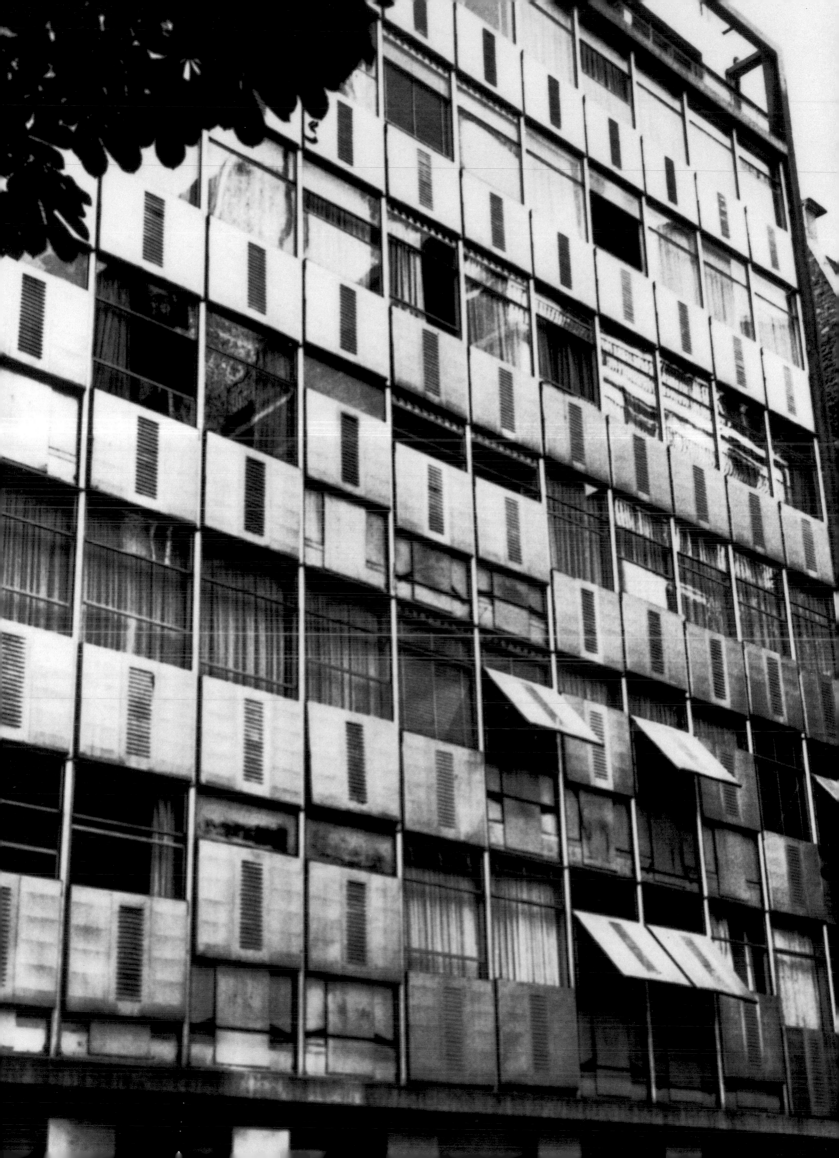

ALUMINUM CENTENNIAL PAVILION
1954-56

JEAN PROUVÉ AND MICHEL HUGONET

In 1954, less than a year after his departure from Maxéville, Prouvé—whose differences with the Studal company had not alienated him from the use of aluminum, a material he held in high regard—began to design the Aluminum Centennial Pavilion in close collaboration with Michel Hugonet, an engineer with Aluminium Français. This was the first significant building realized by Prouvé entirely outside of his own workshops. Some also consider it to be his masterpiece. An enormous structure composed entirely of prefabricated elements to facilitate rapid construction, on the quai Alexandre III in Paris, it was designed precisely to demonstrate the diverse possibilities presented by the use of such an aluminum infrastructure. Three technical processes were exploited: sheet rolling, casting, and extrusion.

In this project, Prouvé sought above all to apply the principle of the self-supporting roof to a large-scale building. Numerous preliminary drawings reveal the broad range of solutions that were explored. All of them called for the construction of identical bays linked to one another by roofing elements either lenticular or double-curved in form, evoking the shape of an airplane wing. The use of crutch-supports was long envisioned, but in the end the designers opted for a sequence of girder units, each consisting of three centered and folded sheet-metal elements assembled by means of cast components. They would be supported by uprights of extruded aluminum connected at their ends, by soldering, to articulated elements of molded aluminum. In addition to their load-bearing function, these uprights would also serve as frames for the plate glass of the façade.

The structure was dismantled after the celebration of the Aluminum Centennial. However, part of it was rebuilt as an annex to the Palais des Expositions in Lille, erected in 1952 for the Foire de Lille, a trade fair whose architect, Paul Herbé, was a friend of Prouvé and had entrusted the design of its façade to him.

RAYMOND GUIDOT
Translated from the French by John Goodman.

JEAN PROUVÉ

designed a twenty-story building for the Cité Universitaire in Nancy and a tower for the future European University, also in Nancy, making extensive use of reinforced concrete. Utilizing the same principle, he and Silvy designed the Maison Alba (1950–52) and a homeless shelter for the Abbé Pierre, the Maison des Jours Meilleurs (House of Better Days, 1956). During these years, Prouvé also perfected other building systems (shell-structure houses, sheds), but in 1953 business conditions forced him to leave the factory in Maxéville and move to Paris.

In 1956, after designing and building the Aluminum Centenary Pavilion (1954–56, with Michel Hugonet), he founded the company Constructions Jean Prouvé. Using the principle of crutch supports, he built the Pump Room of the Source Cachat in Évian (1956, with architect Maurice Novarina and engineer Serge Ketoff) and a temporary school in Villejuif (1957). In 1957, Prouvé merged his company with CIMT (Compagnie Industrielle de Matèriel de Transport); as head of its building department, he developed the principle of the curtain wall and, with Léon Petroff, a reticular roofing system adaptable to various surfaces. He also taught at the Conservatoire National des Arts et Métiers in Paris (1957–71). In 1971, as chairman of the jury for the Centre Georges Pompidou competition, Prouvé played a crucial role in the selection of the winning design.

FACING PAGE Aluminum Centennial Pavilion: View of interior, showing the glass-and-aluminum curtain wall and the roof's girder units

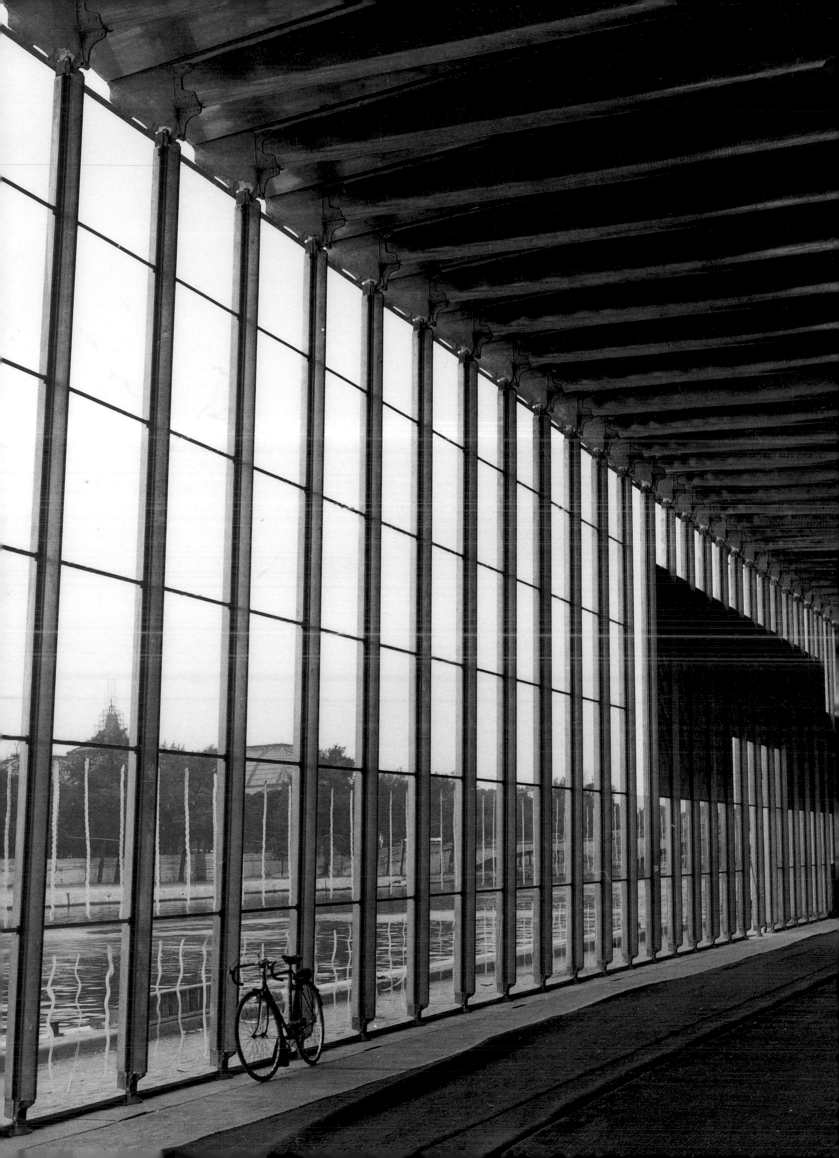

ABOVE Aluminum Centennial
Pavilion: The building's structural
framework being assembled

RIGHT Workers installing
aluminum panels

FACING PAGE A single girder unit

HEADQUARTERS OF THE FRENCH MINISTRY OF NATIONAL EDUCATION, COMPETITION ENTRY
1970

JEAN PROUVÉ AND JOSEPH BELMONT (WITH JEAN SWETCHINE)

In 1970, having reached retirement age, Prouvé left CIMT as well as his teaching post at the Conservatoire National des Arts et Métiers and opened a small design office in Paris, on the rue des Blancs Manteaux. That same year, he collaborated with architect Joseph Belmont and engineer Jean Swetchine on a competition entry for the new headquarters of the French Ministry of National Education. The three of them, drawing on Prouvé's experience at Maxéville, where Belmont had worked with him as an assistant in the early 1950s, designed a tower with a hollow core of ample dimensions, the office spaces being grafted to its periphery. The tubelike core was subdivided, like a stalk of bamboo, into superimposed multistory spaces, with access between levels provided by escalators. These areas, intended primarily for circulation, reception, meetings, and socializing, were enclosed within a double sheath of concrete that accommodated various technical systems—a building principle that resembles that of the "tube within a tube" developed by engineer Fazlur Rahman Khan and used in the fifty-two story One Shell Plaza Building in Houston (1965–71) and the 100-story John Hancock Center in Chicago (1965–70) for Skidmore, Owings, and Merrill.

Prouvé here proposed a daring experiment, radically altering the arrangement of space that had long been accepted as the norm in tall buildings, and indeed, by implication, overturning even more fundamental aspects of traditional approaches to spatial organization. While based on very different principles, Rem Koolhaas's design proposal (unbuilt) for the new Bibliothèque Nationale in Paris sought to challenge fundamental architectural premises along similar lines.

The Ministry of National Education headquarters design by Prouvé, Belmont, and Swetchine won first prize but was never built.

RAYMOND GUIDOT
Translated from the French by John Goodman.

FACING PAGE Competition entry for the Ministry of National Education headquarters: Interior view of model

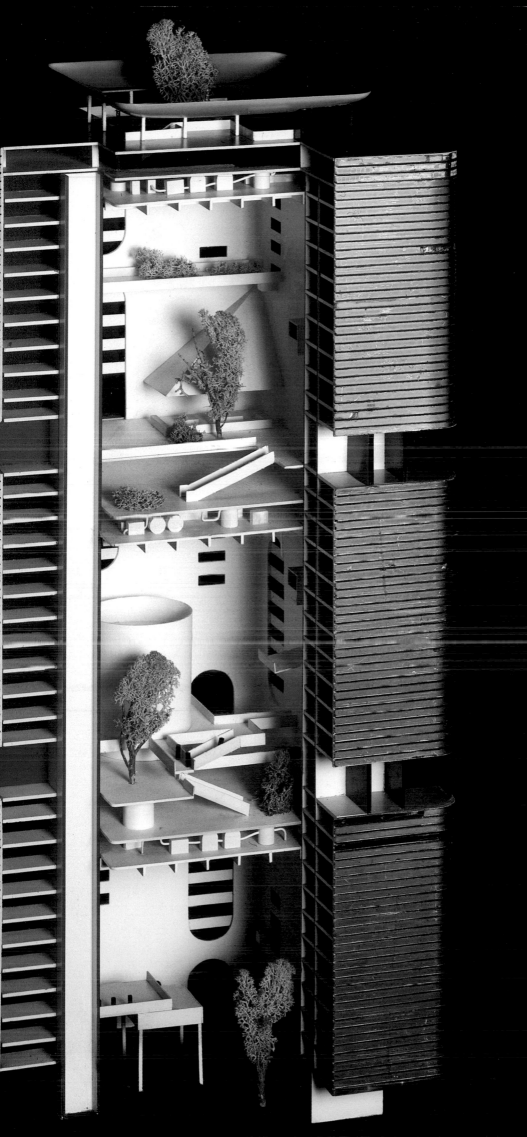

CENTRE NATIONAL D'ART ET DE CULTURE GEORGES POMPIDOU, PARIS
1971-77

RENZO PIANO AND RICHARD ROGERS, WITH OVE ARUP AND PARTNERS

RENZO PIANO
(b. 1937, Genoa, Italy)

The design for this cultural center was the result of an international competition announced in 1970 by President Georges Pompidou. The jury, which included Émile Aillaud, Philip Johnson, Oscar Niemeyer, and Jean Prouvé (its chairman) was nearly unanimous in favor of Piano and Rogers, whose proposal was deemed the best among the 681 entries. Having previously realized only modest projects, largely in the field of industrial building, this young Italo-British partnership suddenly found itself building a 70,000-square-meter project for an institution that would have international influence. It would house a museum of modern art, an industrial design center, theaters for movies and performances, and more.

The winning design broadcast its ambition to achieve a new kind of architecture adaptable to changing circumstances. To some extent, it refers to the ideas of the Futurists, who had advocated an architecture of perpetual transformation capable of responding to life's fluctuating stimuli. But Piano and Rogers were also influenced by the English Archigram group, notably in their "communicating" main façade, treated as a wall of information constantly renewed and animated by the movement of visitors through transparent tubes. The extreme contrast between this surface, transparent and unpredictable, and the opaque rear wall, covered with pipes and conduits painted in bright colors, was determined in part, contrary to appearances, by attentiveness to the site and to the project's scale. Unlike most of the competitors, Piano and Rogers conceived their design more in urbanist than architectural terms, proposing a structure that would occupy only half the allotted site and setting aside the rest for a large plaza (inclined like the piazza in Siena), for spontaneous activities.

In keeping with the period's rebellious tendencies, the architects deliberately set out to subvert the monumental associations inherent in the design program. Accordingly, they devised a kind of giant all-purpose machine of optimal flexibility in the form of a rectangular volume 166 meters long, 60 meters deep, and 42 meters high. Exemplifying a design tendency soon christened "high-tech," the design sought to reconcile architectural concepts with new structural possibilities resulting from breakthroughs in the field of industrial engineering. To create the unobstructed spaces needed to realize the desired flexibility, 45-meter lattice truss spans were used throughout, supported by enormous steel columns. This structural system was conceived by the Ove Arup team led by Peter Rice. The concept is indebted to the Fun Palace design by Cedric Price, notably in its expressive use of the exposed pipes and conduits of its mechanical systems, and to Buckminster Fuller, whose influence is apparent in the wide-span structural system and the use of industrial components that can be assembled on-site. More generally, Piano and Rogers took from them the idea of an aesthetic based on recent technological advances.

MARC BÉDARIDA
Translated from the French by John Goodman.

Piano received his initial training from his father, who was a builder, and in the office of architect Franco Albini in Milan (1958–64). After graduating from the Milan Politecnico in 1964, he worked briefly with Louis Kahn in Philadelphia and then with Z. S. Makowsky in London (1966–70). Piano developed an approach to building based on experimentation allied to artisanal practice. His interest in fabrication processes and his belief in the importance of familiarity with one's materials link him to Jean Prouvé. Piano's determination to free himself from architectural myth and academicism and his admiration for the work of Pier Luigi Nervi led him to devise the novel structural solutions seen in his first projects—a prestressed-steel and reinforced-polyester structure in Genoa (1966), the Italian Industry Pavilion at the Osaka World's Fair (1970), the IBM traveling exhibition pavilion (1981–84)—and eventually to form a partnership with Peter Rice as Piano and Rice, engineers and architects. Before that, from 1971 to 1976, he was in a partnership with Richard Rogers—with whom he designed the winning competition entry for the Centre Georges Pompidou in Paris (1971–77)—and then established the Renzo Piano Studio in Genoa (1977–80).

The design by Piano and Rogers for the Centre Pompidou, influenced by the ideas of Buckminster Fuller and Archigram, achieved optimal spatial flexibility through the use of structural armatures built with prefabricated elements. A combination of repeated geometrical structural units, spatial flexibility, and the use of technological detailing for expressive ends, this approach was developed further in the B&B Italia offices in Novedrate, Italy (1971–73), the Menil Collection museum in Houston (1981–86), and the Beyeler Museum in Basel (1992–97). In contrast, the Bercy commercial center in Paris (1987–90), the airport in Kansai, Japan (1988–94), and the Science Museum in Amsterdam (1994–97) are premised on »

FACING PAGE Centre Georges Pompidou: Aerial view showing the building's exposed structural elements and exterior escalator tube on the main façade, and the large plaza in front

Selected Bibliography

L'Architecture d'Aujourd'hui, no. 189 (February 1977), pp. 40–81.

Piano, Renzo and Richard Rogers. *Du Plateau Centre Georges Pompidou.* Paris: Éditions Centre Georges Pompidou, 1987.

Silver, Nathan. *The Making of Beaubourg.* Cambridge, Mass.: MIT Press, 1994.

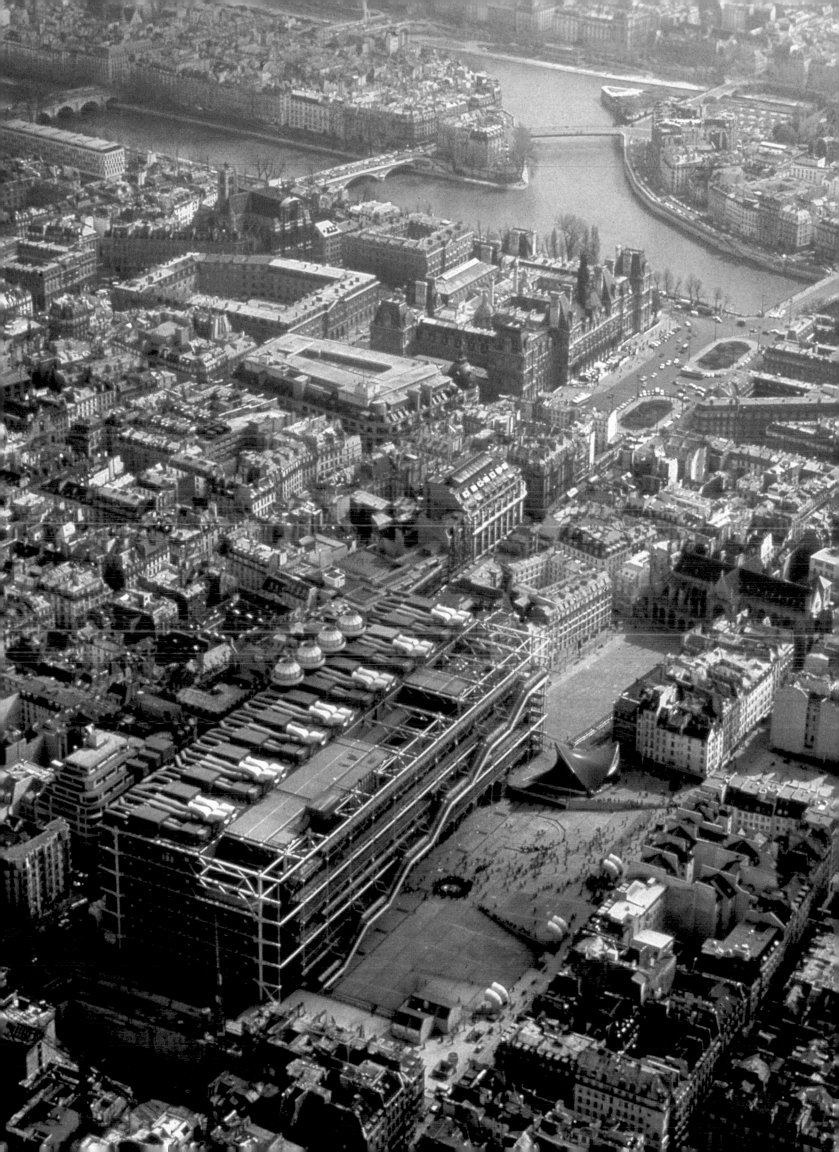

IBM TRAVELING EXHIBITION PAVILION
1981-84

RENZO PIANO BUILDING WORKSHOP

RENZO PIANO

the logic of the container. Their vast interior volumes are rendered coherent by the ubiquitous use of technologically advanced elements, and by the interaction of the structure with the tectonics of a continuous outer skin. As a result of their huge scale, these designs are perhaps best understood not in terms of spatial organization—which in these projects remains largely undefined—but as climate-controlled environments, a prime consideration in the design of the cultural center in Nouméa, New Caledonia (1992–98). Piano has been awarded the International Union of Architects Prize (1978), an American Institute of Architects Honorary Fellowship (1991), and the Pritzker Prize (1998).

With the goal of promoting its computer technology throughout Europe, IBM commissioned Piano to design an exhibition pavilion that could be easily taken apart and transported. Taking his cue from greenhouses (the pavilion would often be erected in parks), he devised a large, transparent, flowing space in the form of a horizontal half-cylinder and elevated above the ground on a platform base. All the electric circuits and plumbing are nestled within this platform. Like the full-story service floors in Louis Kahn's Richards Medical Laboratories in Philadelphia, this "service platform" frees the interior space of all encumbrances, except for a central suspended ventilation pipe that serves as an axis of symmetry. In contrast to Piano and Rogers's earlier Centre Georges Pompidou (1971–77), here the mechanical systems are nearly invisible, including a rigorously controlled ventilation system required for the sophisticated computer products that the structure is intended to showcase.

For this project, Piano imagined a nomadic architecture that can easily be assembled and dismantled in ten days in all sorts of contexts. Once again, he turned to account his experiments with inexpensive, efficient systems capable of ensuring maximum structural cohesion with a minimum of materials. The arched components used here derive from his first structural experiments, notably those carried out in conjunction with his wood-treatment factory in Genoa (1965). Functioning as both walls and ceilings, each of these compound units (there are 160, two per arch) consists of six transparent pyramid modules secured to two large transverse ribs and stabilized by shorter transverse rib segments linking the projecting tips of the pyramids on the outside. The ribs are made of laminated wood; and the pyramidal units—a form chosen for its stability—are of polycarbonate, a light, transparent material. In modular structures of this kind, in which skin and structure are virtually indistinguishable, the points of assembly—edges and joints—take on crucial importance. The polycarbonate units are secured to the wooden ribs by pieces of molded aluminum, a material chosen for its malleability as well as for the legibility it gives the organizing structural principles.

When discussing this building, a recapitulation of much of his earlier research, Piano has spoken of its "natural, almost organic demeanor." In effect, the pavilion's basic form is reminiscent of an animal carapace, and certain of its details, notably the assembly pieces made of aluminum, appear to have been inspired by vegetal structures. In contrast with Art Nouveau, these references to the plant world are not formal but proceed from an understanding of the governing forces of nature. In this respect, Piano's work is related to the investigations of structural morphology carried out by Robert Le Ricolais and Frei Otto, but on a more empirical level, for analogies with the organic world never serve as a fundamental premise or play a determinant role in it.

MARC BÉDARIDA
Translated from the French by John Goodman.

Selected Bibliography

Dini, Massimo. *Renzo Piano: Projets et architectures / Projects and Architecture, 1964–1983.* Paris: Electa Moniteur, 1983; New York: Rizzoli, 1984.

Miotto, Luciana. *Renzo Piano.* Paris: Éditions Centre Georges Pompidou, 1987.

Buchanan, Peter. *Renzo Piano Building Workshop.* London: Phaidon Press, 1993; rev. ed. 1995.

FACING PAGE IBM traveling exhibition pavilion: Exterior view (ABOVE) and interior view (BELOW)

JEAN-MARIE TJIBAOU CULTURAL CENTER, NOUMÉA, NEW CALEDONIA
1992-98

RENZO PIANO BUILDING WORKSHOP

Following protests against French rule, this project was intended to signal a new recognition of the indigenous population at the end of the colonialist era. Undertaken at the behest of President François Mitterrand, the Tjibaou Cultural Center effectively legitimizes Kanak civilization by presenting the riches of its traditions. Aware of the high political and symbolic stakes of the commission, Piano approached the project like an anthropologist, making a careful study of local customs and practices.

The design incorporates elements specific to Kanak culture. The building consists of a continuous covered concourse with, behind it, ten conical timber "cases" constructed like enormous huts that stand facing the lagoon in a formation that resembles a coral reef. The "cases" are arranged along a path bordered with trees as in traditional native villages. Here, the transposition of local traditions into a contemporary concept constitutes an attempt to redefine relations between the project and its intended users, an approach that Piano had already used in his UNESCO commissions in Senegal (1978). According to Piano, the design is premised on the idea of serving the inhabitants and was conceived as a form of mediation between its users and the context in which they develop. This approach to the human environment in its archaic dimension is also apparent in Piano's fascination with the book *Architecture Without Architects* by Bernard Rodofsky, especially its exploration of the fragile boundary between nature and human constructions. In Nouméa, the form results not from some preconceived idea but from organic conditions and thus blurs the distinction between what is natural and what is man-made, which was one of Piano's explicit goals.

Piano has said that Genoa, where he was born, is a city that obliges one to become a sailor. But navigation requires a boat, and the architect built and designed several, an experience that heightened his awareness of the complex relations between form, structural stress, and movement. In Nouméa, as in his design for the science museum in Amsterdam (1997), one senses the effects of this experiment, for the buildings strongly resemble ships' prows as much as traditional Kanak houses. These analogies come from reflecting on the origins of the act of building in such a way that the architecture results almost naturally from the materials used, from principles and methods of assembly, and from the expression of the forces that govern it. Recalling basket-weaving, and thus the materialist theories of Gottfried Semper, the huts' wooden shafts pointing heavenward create images of objects that will forever remain unfinished. Flexible and durable, like an archer's bow, these structures are capable of withstanding strong winds and cyclones, and they also serve as a means of natural ventilation. By integrating advanced technology with native customs, Piano here demonstrates that progress is neither an end in itself nor something to be imposed on others but rather a tool to be used for the benefit of humanity.

MARC BÉDARIDA
Translated from the French by John Goodman.

FACING PAGE Jean-Marie Tjibaou Cultural Center: One of ten timber "cases" shaped like huts (detail)

FOLLOWING TWO PAGES View showing several of the "cases" along a tree-bordered path facing the lagoon

Selected Bibliography

Lavalou, Armelle. "Centre J.-M. Tjibaou," *L'Architecture d'Aujourd'hui*, no. 308 (December 1996), pp. 44–57.

Piano, Renzo and Kenneth Frampton. *Logbook*. London: Thames and Hudson, 1997.

INSTITUT DU MONDE ARABE, PARIS
1981–87

JEAN NOUVEL, GILBERT LÉZÈNÈS, PIERRE SORIA, AND ARCHITECTURE STUDIO

ABOVE Institut du Monde Arabe (Institute of the Arab World): Interior of library wing (detail)

FACING PAGE Corner of southern and western façades of library wing

Nouvel's design for a cultural center, museum, library, and conference center devoted to Arab culture (the winning entry in a competition held in 1981), on which he collaborated with Gilbert Lézènès, Pierre Soria, and Architecture Studio, sets up a dialectic among surface, transparency, technology, and industrial materials, which are all recurrent preoccupations in Nouvel's work. The building is made primarily of glass and aluminum, and its forms honor the surrounding urban fabric: the northern façade, fronting the Seine embankment, follows the curve of the adjacent boulevard Saint-Germain, while the southern façade, with innovative light-sensitive "shutter" windows, overlooks a square separating the complex from the Jussieu University buildings by Edouard Albert. In addition to satisfying the institute's own requirements, the design deftly softens the difficult transition between these university buildings and the city around them. A narrow gap rising the entire height of the Institut building creates a passageway that doubles as the entry to the building and slices it into two parts, one of which houses the museum and the other the library. The library is housed in a spiral-ramped concrete tower visible through the glass-and-aluminum walls of the southern wing, creating an interplay between depth and the contrast of surfaces. Where the two wings meet, the building encloses a square courtyard, the glass walls of which are covered with marble tiles secured only by metal grips at the corners, allowing light to come through between the tiles.

Behind each of the southern façade's 240 2.5-by-2.5-meter double-pane glass panels is a light-sensitive mechanical jalousie, composed of a series of rotatable metal diaphragms forming circular apertures that are opened and closed by electromechanical means. Conceived along the lines of automatic camera shutters, they transform the building into a machine controlling the play of light and shadow, orchestrating uncertainty and transparency in graceful patterns. Nouvel conceived of this constantly shifting surface as a technologically advanced equivalent of the *moucharabies* (latticework screens) of the Arab world.

The slender horizontal mullions in the curving northern façade create a streamlined effect, while the mullions in the southern façade crisscross in a rigorous "plaid" configuration. The entire structure has an elegance generated by the discretion with which its remarkable technological features are introduced, notably in its walls. In addition to the electromechanical shutters, this was the first building to make use of computer-generated color photo images silkscreened on glass. Moreover, all the framing elements, as well as the stair rails, elevators, and ventilation screens, are designed like industrial objects akin to the machined elements of trains and planes. However, in contrast to the high-tech approach first championed by Archigram and epitomized by the Centre Georges Pompidou, with its highly exposed structural elements and service components, here the technology is hidden behind aluminum facing.

ALAIN GUIHEUX

Translated from the French by John Goodman.

FACING PAGE, ABOVE Institut du
Monde Arabe: View through glass
façade panels of library wing,
with opposite façade visible

BELOW Interior view of library
wing, showing electromechanical
sunscreens in windows of
southern façade

FACING PAGE, BELOW View of Institut
from bridge over the river Seine,
showing northern façade of
museum wing

FONDATION CARTIER, PARIS
1991-94

JEAN NOUVEL, EMMANUEL CATTANI, AND DIDIER BRAULT

Erected on the tree-covered site formerly occupied by the American Center, on boulevard Raspail, the Fondation Cartier (Cartier Foundation for Contemporary Art and Company Headquarters) is a glass building in a one-acre garden, behind a high, freestanding glass screen aligned with the frontage of the boulevard and corresponding to the enclosing wall typical of earlier periods. The building is set back behind a natural screen of trees, including a cedar planted in 1823 by French poet Chateaubriand; a gap in the middle of the glass screen provides entry to the site. Just in front of and behind the building are two longer, higher freestanding glass screens, transparent walls that create evanescent frames around the front and back façades and protect the exposed fire stairs on either side in the back. These multiple glass planes create the effect of a floating reflection of the structure itself. They also interact with the nearby greenery, generating an illusion of interpenetration between outside and inside that recalls descriptions of the Crystal Palace (1851), which stressed its airy character, its aura of transparency and liberation, its obliteration of conventional boundaries. The trees establish a "milieu" that, as in Rem Koolhaas's design proposal for the new Bibliothèque Nationale, replaces the traditional notion of space. This visual continuity is reinforced on the ground floor by two open-plan exhibition spaces 8 meters high, which are separated from the garden by floor-to-ceiling sliding glass doors that can be left open in the summer months, allowing inside and outside to merge. With this design, Nouvel sought to erase limits, to undermine the solid/void opposition, to experiment with dematerialization. The result challenges the visitor's habits of perception.

ABOVE Fondation Cartier: View from entrance to building, showing second glass screen in juxtaposition with building's façade (detail)

FACING PAGE View of building showing entire second glass screen, with trees in front and the building directly behind it

The tradition of transparency in modern architecture is here revisited by Nouvel. The mullions of the façades and the sunshades protecting the northern and southern exposures tend toward an objective, neutral design, and the structure itself is thin and delicate, lacking the pronounced visibility typical of most high-tech architecture. The design consistently wages war against thickness, in the façades, which feature long horizontal plates of glass, as well as in the gray epoxy furnishings designed by Nouvel. Moreover, the formal complexity pervasive in modern architecture is eschewed in favor of a strict rectangle.

The exhibition space continues into the basement, where glass-block skylights in the plaster ceiling allow natural light to penetrate. The seven upper floors contain Cartier offices, where the interior walls and partitions also give glass pride of place. Here, the sleek metal skin covering the ceilings of the Institut du Monde Arabe is replaced by a continuous gray metal armature. The top floor features a terrace protected by the freestanding glass screens that rise another full level above it, further extending the building's transparent glass "frame."

ALAIN GUIHEUX
Translated from the French by John Goodman.

FRAGMENT VERSUS CONTAINER

More than just two different terms in architectural discourse, *fragment* and *container* represent radically conflicting concepts of the role of form or appearance in contemporary architectural practice. For the fragment, the first historical reference is Le Corbusier's chapel at Ronchamp (1954), which marks a shift from an architecture conceived in terms of space to one based on an arrangement of fragmented forms akin to a Modern still-life painting. Two decades later, the idea of the fragment underwent a transformation in the work of Christian de Portzamparc and his contemporaries Frank Gehry and Arata Isozaki, who reconceived architecture as a sculptural work. However, this kind of architecture, which also includes the work of Frédéric Borel and the more expressionist, gestural work of Massimiliano Fuksas, is not limited to a purely sculptural approach, but is concerned with conveying a richness of environment that is rightly regarded as utopian, all the more so since it is an idea that is applied quite frequently to public housing. This architecture is intended to compete on an equal basis with other urban signs, and even to assert itself as a completely urban form, in the case of the open blocks of Portzamparc.

The notion of architecture as a container was initially articulated by Paul Virilio, who developed the concept in the course of several trips along France's western and northern coasts between 1958 and 1965, during which he focused on the deserted World War II bunkers that the Germans had built there to form a defensive wall against the Allies. The empty bunker, as Virilio describes it in his influential 1967 essay "Bunker Archeology" and other early writings, is a monolith, a monument, a tomb or perhaps even the origin of architecture itself. In Jean Nouvel's competition entry for the Tokyo National Theater and Opera House (1986), the bunker form is transformed into an instrument case, a black box that contains three theaters suspended within it. Myrto Vitart continued this tendency in his design of a container to house the Onyx Cultural Center in Saint-Herblain (1987–89), giving it the form of a parallelepiped. In this era, in which the consumption of signs is pervasive, these two projects look like something straight out of science fiction—specifically, the monolith in the movie *2001: A Space Odyssey*.

For the container, independent and isolated from the urban context (though not from surrounding traffic patterns), only the interior life counts. If a building can only carry meaning by reverting to the ultimate sign of a tomb, transformed into a container, this is a clear statement of an antiformal architecture. One symptom of the abandonment of traditional formal concerns is the widespread use of the parallelepiped in a particular branch of contemporary architectural practice.

Within this logic, the next step has been for architects to submerge architectural form while freeing up surface elements, as in Dominique Perrault's velodrome and swimming pool in Berlin (1992–98). In this and other buildings, the play of forms recedes in favor of what is immediately perceptible: transparencies, reflections, and diffractions. Interior structures take on the appearance of exterior surfaces, especially through the use of materials such as photo-silkscreened or colored glass, or metal mesh, sometimes making viewers uncertain as to what they are seeing. Steeped in a tradition from Philibert Delorme to Auguste Perret, French architecture takes on a Viennese coating.

PAUL VIRILIO

(b. 1932, Paris)

Between 1958 and 1965, Paul Virilio traveled the French coasts of the Atlantic and the English Channel with his camera, exploring the fortifications of the "Atlantic wall," a line of defense built there by the Germans during World War II. In 1975, he published *Bunker Archeology*, a collection of his photographs and essays on the subject, for an exhibition of the same name that he organized at the Musée des Arts Décoratifs in Paris. In the book's preface, Virilio described a revelation he had on a beach in Brittany during the summer of 1958, when, after using an abandoned bunker as a cabana, he examined "this solid inclined mass of concrete, this worthless object, which up to then had managed to martial my interest only as a vestige of the Second World War, only as an illustration for a story, a story of total war. [I looked] around this fortification as if I had seen it for the first time . . . and decided to inspect the Breton coasts . . . My objective was solely archeological. I would hunt these gray forms until they would transmit to me a part of their mystery . . . : why would these extraordinary constructions, compared to the seaside villas, not be perceived or even recognized? Why this analogy between the funeral archetype and military architecture?"[1] Using his collection of texts, photographs, military maps, architectural plans, and war directives from Adolf Hitler (which he reproduced in the book), Virilio attempted to answer these questions while laying the foundation for the theory of the container, a formal paradigm for a generation of postwar architects in France.

In *Bunker Archeology*, Virilio identified the various kinds of fortifications built by the Todt organization (named for Fritz Todt, the first Nazi chief in charge of European fortifications), each adapted to its location and its strategic function. The "archeological" significance of the dark, hermetic bunkers—made of poured concrete, with only crude entrances and slitlike openings for air circulation—led Virilio to reconsider the problem of architectural archetypes such as the crypt, the ark, and the nave. In his first essay on the subject of "Bunker Archeology" (first published in 1967, in the journal *Architecture Principe*), he suggested that the bunker's closed, semi-subterranean structure evoked "a complete series of cultural memories . . . : the Egyptian mastabas, the Etruscan tombs . . . as if this piece of artillery fortification could be identified as a funeral ceremony, as if the Todt Organization could manage only the organization of a religious space."[2] This initial connection between religious archetypes and the bunker provides one of the conceptual elements that informs the design of the church of Sainte-Bernadette in Nevers (1963–66), on which Virilio collaborated with Parent—one of the few architectural projects involving his active participation that was built. The alien architectural forms of the bunkers—which Virilio found not only on deserted beaches but in city squares and apartment courtyards—provided a means of understanding the appearance of Brutalism in modern architecture. In many ways, Sainte-Bernadette was Virilio's savvy response to the surprisingly similar forms ≫

Originally trained as an urbanist, Virilio co-founded the firm Architecture-Principe (and a journal with the same name) with architect Claude Parent in 1963. They based their short-lived practice together on Virilio's "Bunker Archeology" research and on the theoretical writings that both of them produced for their journal, but focused particularly on the idea of the "oblique function" (the use of sloping surfaces). Virilio, influenced by the philosophy of Merleau-Ponty and by Gestalt theory, questioned the notion of verticality in modern architecture and developed a new set of ideas about figure/ ground relations. The oblique function proposed "a topological conception of urban spaces made possible through oriented surfaces that allow the ground to be covered, allowing for a sort of folded or pleated force field."[1] The application of this idea resulted in two built works: the church of Sainte-Bernadette in Nevers (1963–66) and the Thomson-Houston aerospace research center in Villacoublay (1969). Virilio's participa- tion in the student and worker revolts of May '68 led to a deep ideological schism with Parent, resulting in the dissolution of Architecture-Principe and, shortly after, a radical shift in Virilio's intellectual orientation: "I dropped the issue of space completely to focus on topics such as time [and] speed . . . time and politics."[2] His prolific theoretical writings took him further away from applied architecture and urbanism, instead focusing on a range of contemporary phenomena including telecommunications and the ef-fects of new technology on the mastery of terrain. Among his seminal texts, which have had a significant impact on contemporary architecture, are Bunker Archeology (1975), The Aesthetics of Disappearance (1980), The Lost Dimension (1991), and A Landscape of Events (1996). Since 1969, he has has been a professor at the École Spéciale d'Architecture, and has served as its general director from 1975.

1. John Rajchman, *Constructions* (Cambridge, Mass.: MIT Press, Writing Architecture Series, 1998), p. 84.
2. Paul Virilio, *Cybermonde, la politique du pire: Entretien avec Philippe Petit* (Paris: Textuel, 1996).

FACING PAGE World War II bunkers on the Atlantic wall, photographed by Paul Virilio between 1958 and 1965

present in the architecture-sculpture of Le Corbusier's chapel at Ronchamp (1954).

Virilio's "bunker archeology" continues to provide a formal model for contemporary architects. From Jean Nouvel's design for the Tokyo National Theater and Opera House (1986) to Myrto Vitart's Onyx Cultural Center (1987–89), the notion of the container, as represented by the bunker, has been pushed farther in its monolithic or funerary associations and has attained greater theoretical sophistication.

After the publication of *Bunker Archeology* in 1975, Virilio expanded his investigations to address a larger set of questions around the construction and evolution of what he called "military space," an issue that he had only touched on in 1975. Out of the need to control physical territory during wartime, he noted, new communication, information, and transportation technologies were developed that had an impact on the mastery of space. The failure of the bunker as a tool for observation and defense led to radical shifts in dealing with time and space; and the high speed made possible by various missile and jet propulsion technologies completely collapsed "the distinction between vehicle and projectile." Without the need to mark physical space in order to master a given territory, Virilio realized, the role played by military speed—in rapid transport and ultra-rapid communication—became paramount.[3] The domination of physical space by physical presence has been supplanted by the manipulation of electronic space and the control of time. In more recent writings, he has applied these concepts to urbanism, declaring that, with the new instantaneous communications media, "*speed distance* obliterates the notion of physical dimension" and that "urban architecture has to work with the opening of a new 'technological space-time'"—that "the intersecting and connecting grid of highway and service systems now occurs in the sequences of an imperceptible organization of time in which the man/machine interface replaces the façades of buildings" and that, therefore, "distinctions of *here* and *there* no longer mean anything."[4]

ALISON M. GINGERAS AND STEPHEN ROBERT FRANKEL

1. Paul Virilio, *Bunker Archeology*, trans. George Collins (Paris: Éditions du Demi Cercle, 1991), pp. 10–11.
2. Ibid., p. 11.
3. Ibid., pp. 18, 201–02.
4. Paul Virilio, "The Overexposed City,"(1991), trans. Daniel Moshenberg, in Neil Leach, ed., *Rethinking Architecture: A Reader in Cultural Theory* (London and New York: Routledge, 1997), pp. 385, 383.

BELOW (LEFT TO RIGHT) Claude Parent and Paul Virilio, church of Sainte-Bernadette, Nevers (1963–66): Exterior view; interior; and another exterior view

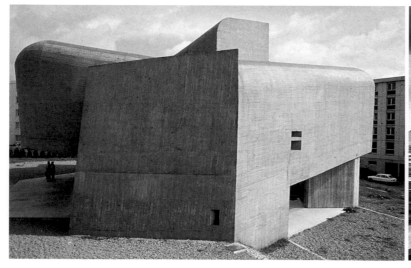
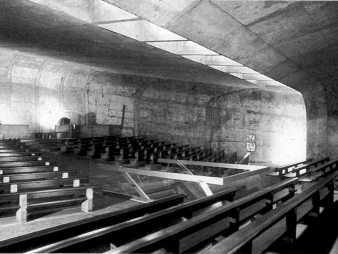

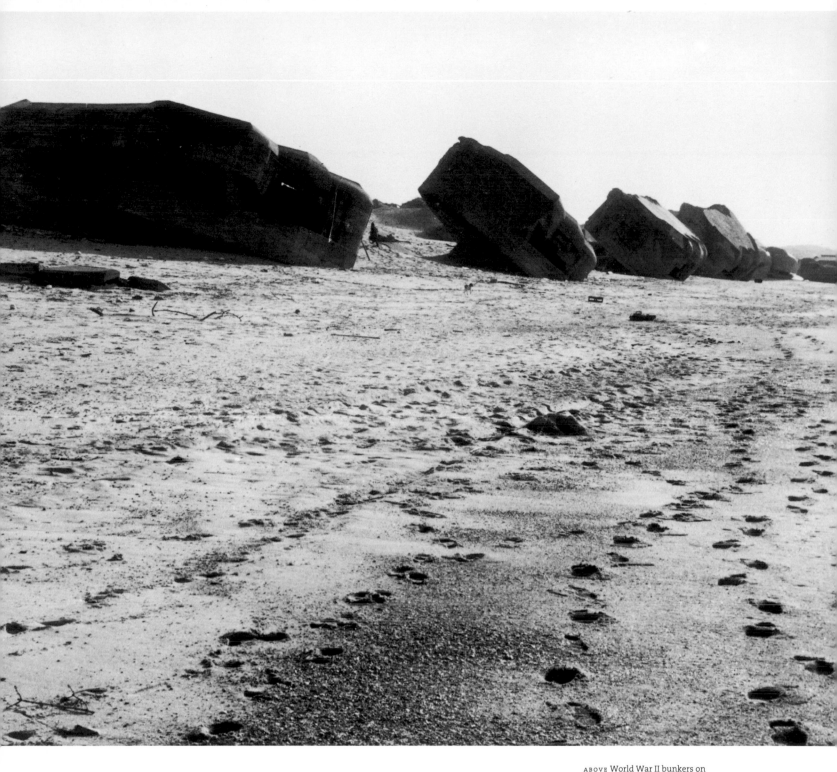

ABOVE World War II bunkers on
the Atlantic wall, photographed by
Paul Virilio between 1958 and 1965

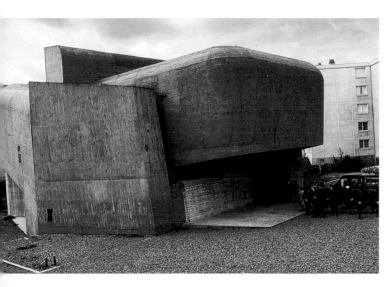

TOKYO NATIONAL THEATER AND OPERA HOUSE, COMPETITION ENTRY
1986

JEAN NOUVEL AND PHILIPPE STARCK

The Tokyo National Theater and Opera House design called for the erection of a conspicuous object that would convey a message in the world's most chaotic megalopolis. Nouvel's proposal (unbuilt) is no longer architecture but instead a sign in the guise of a monumental sculpture. The object, a "black monolith," resembles a musical instrument case with three theaters suspended within it—a seamless envelope that surrounds, and takes the form of, its contents. The maquette also suggests a woman's plastic cosmetics case, a disposable luxury item. As Nouvel describes his design, "Near the entry, the building overawes with its height, its inflections, its reflections. The first temptation is to touch it, to caress it. It is smooth, as black and smooth as a piano." Such streamlined forms serve in Nouvel's work to link architecture to the realm of industrial objects, such as race cars and airplanes. The metaphor of the instrument case explains the gaps between the halls and the outer walls, analogous to the separation between a car's wheels and its mudguards. Seen from the outside, the building might be a bunker or a mausoleum, a design suggesting that a structure's function could be deliberately obscured—a premise later taken up by Renzo Piano in his Bercy commercial center in Paris (1987–90) and by Rem Koolhaas in his Lille convention center (1990–94).

Philippe Starck has compared the design of the Tokyo project to an Egyptian mastaba, but suggesting a kind of remythologization quite removed from that of antiquity, for it epitomizes what happens when architecture consumes popular culture. This persistent theme in Nouvel's work resurfaces in his unbuilt design for the Endless Tower (1988), also a monolith, a cylinder that emerges from below the ground and appears to taper into the air. The drawings of the Tokyo project, with their emphatic contrast between the gold forms and the black background, underscore this integration of the images of mass communication with a sophisticated architecture.

The building was conceived in theatrical terms: There is a broad, low entryway of polished granite 10 meters deep, blank and brightly lit, which culminates in the lobby of a 50-meter-high hall; inside this hall hang three "containers" housing the performance spaces, sheathed in gold. Two large symmetrical stairways flanked by escalators lead to an intermediate level and to two vertical openings almost 30 meters high with views of the sky and the city. A diagonal escalator provides access to the theaters, offering even more spectacular views of the surrounding urban landscape.

Nouvel's unbuilt design has served as the model for several built works: the Onyx Cultural Center, a black monolith designed for Nouvel by Myrto Vitart (1987–89); a rock-music concert hall in Vitrolles designed by Rudy Ricciotti (1994); and Nouvel's Vinci Conference Center in Tours (1989–93), which also features halls suspended within a black monolith, an outer shell made of polyester.

ALAIN GUIHEUX
Translated from the French by John Goodman.

Selected Bibliography

"Concours pour l'Opéra de Tokyo," *Architecture Intérieure Créée*, no. 213 (August–September 1986).

"Opéra de Tokyo, Concours," *L'Architecture d'Aujourd'hui*, no. 247 (October 1986).

Nouveau Théatre National de Tokyo: Jean Nouvel Associés, Philippe Starck. Paris: Les Éditions du Demi-Cercle, 1987.

FACING PAGE Nouvel's design for the lobby of the Tokyo National Theater and Opera House (drawing)

BELOW Model of the exterior

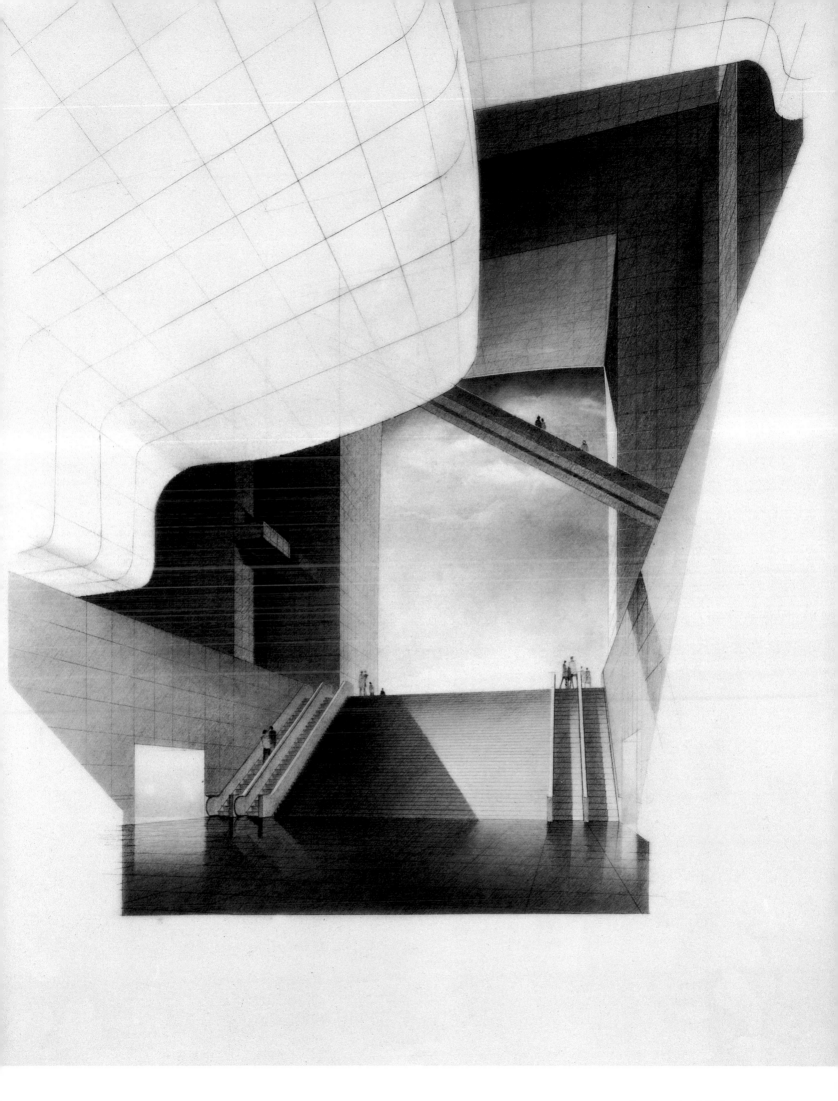

VELODROME AND OLYMPIC POOL, BERLIN
1992-98

Commissioned in conjunction with Berlin's bid to become the site for the summer Olympics in the year 2000, this sports complex is situated on the margins of the city's historical center, in the former eastern zone. The site looks like an orchard planted with 450 apple trees and featuring two "lakes," one round and the other rectangular, which appear phosphorescent at night. In fact, these "lakes" are the roofs of the velodrome and the Olympic-size pool.

Instead of architectural grandstanding and conventional monumentality, Perrault chose to emphasize empty space and absence. But this absence lacks the strange, melancholy atmosphere and spirituality of De Chirico's paintings. As with the image created by the four stark towers of Perrault's new Bibliothèque François Mitterrand (1989–95) and its courtyard planted with pine trees, here all is simple, clear, serene. This simplicity is a result of sinking the building below ground level—a strategy borrowed from Emilio Ambasz and from Jean Nouvel's proposed design for a media center in Nîmes (1984).

It might seem that Perrault made some design choices to appeal to the Germans' fervent ecological mindset in order to win the Berlin commission. For example, the vegetation hides the concrete, leading to the virtual disappearance of the building. In fact, though, Perrault's decision to design a parklike environment represents a rejection of history—specifically, of the monumental architectural tradition—in favor of geography, sites, and the human beings that inhabit them.

Thanks to this approach, Perrault managed to break free of convention. He developed autonomous forms within a simple compositional scheme. Sculpted terrain, sunken paths carved out of the earth around the buildings, and framelike bases are the essential elements of these telluric structures, which project up out of the landscape just enough to suggest their presence. Strongly influenced by Minimal art, especially the work of Donald Judd and Robert Morris, Perrault's buildings seem to belong nowhere in particular, so disconnected are they from the urban context. Isolated, self-contained objects, they reveal everything about themselves while remaining mute.

Rather than evoking the future, the Berlin complex is of its era. Although it incorporates modern structural technology, the structure has no importance. Perrault rejects the tradition of structural rationalism developed by Auguste Perret, who championed the notion of "sovereign shelter" and the dramatic articulation of structure. Perrault's approach to the outer envelope and its texture has certain affinities with Gottfried Semper's analogy of architecture to weaving. Indeed, the pool and cycling track are notable for the homogeneous metal mesh used for their roofs and walls. This sensitive handling of the buildings' skin, here and in the new Bibliothèque François Mitterrand, is the result of a radically different approach to design, in which the expression of feeling is restored to architectural legitimacy.

MARC BÉDARIDA
Translated from the French by John Goodman.

DOMINIQUE PERRAULT
(b. 1953, Clermond-Ferrand)

After graduating from the architecture school at Paris-La Villette, Perrault worked as an architect and adviser to local communities, and took advantage of government initiatives favorable to the emergence of a new French architecture. In 1983, he won two significant awards (for the Programme Architecture Nouvelle XII and the Albums de la Jeune Architecture). This official recognition gave him access to many invitational competitions, most notably the new Bibliothèque Nationale in Paris, now called the Bibliothèque François Mitterrand (a 360,000- square-meter project.

Perrault devises not so much buildings as places. Like an installation artist, he uses the landscape to subvert the architecture, which he often buries to make it disappear. He uses this strategy above all in large projects, such as the Bibliothèque François Mitterrand (1989–95) and the sports complex in Berlin (1992–98). Many of his designs have a classical logic that is transfigured by the use of new materials and novel planning solutions and by the prominence accorded new technology, often used for aesthetic reasons, as in the Berlier industrial loft building in Paris (1986–90). He is the recipient of the Équerre d'Argent (1990), the Grand Prix National de l'Architecture (1993), and the Mies van der Rohe Pavilion Award (1997).

Selected Bibliography

Lucan, Jacques et al. *Dominique Perrault*. Zurich: Éditions Artemis, 1994.

Käpplinger, Claus. "An Arena in the Pit," *Architektur-Aktuel*, no. 208 (October 1997), pp. 48–59.

Perreault, Dominique. "Eine neue 'Natur des Stadt'" (interview), *Anthos*, no. 1 (1998), pp. 26–31.

Dominique Perrault. Barcelona and Zurich: Éditions Actar-Birkhäuser, 1998.

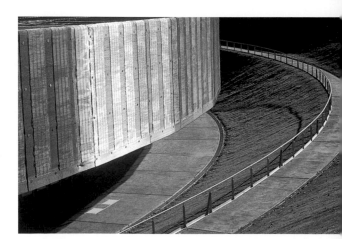

ABOVE View of the Velodrome ceiling (detail)

FACING PAGE View of the Velodrome exterior,
showing the sunken path around it

MYRTO VITART

JEAN-MARC IBOS
(b. 1957, Saint-Cloud)
MYRTO VITART
(b. 1955, Boulougne-Billancourt)

In 1985, Ibos and Vitart joined with Jean Nouvel and Emmanuel Blamont to form the architecture firm Jean Nouvel and Associates, where they remained until 1989. While there, Ibos collaborated with Nouvel on the Nemausus 1 apartment complex in Nîmes (1985–87), and Vitart designed the Onyx Cultural Center in Saint-Herblain (1987–89). Ibos and Vitart then founded their own firm, entering several architecture competitions as well as designing the Musée des Beaux-Arts addition in Lille (1990–97) and the headquarters of the military firemen of Nanterre (now approaching completion).

At Saint-Herblain, amid several shopping centers, there is a dark mass of a building at the edge of a huge triangular parking lot. The end of the lot slopes down to an artificial lake, its apex submerged in the water; around the lake is a park. This small building is the result of a deliberate strategy to establish its difference and to make it a center—indeed, *the* center—of a city without one. First, in an environment saturated with colored signs, images, and large-scale advertisements, it eschews all identifying marks and all architectural detailing, presenting itself as an enigma subject to endless processes of decoding and exegesis. This centripetal object seduces and attracts, but in a way diametrically opposed to buildings that, in effect, desperately pursue their public; tellingly, its entrance is situated on the façade facing away from the city. Second, in contrast with the creeping structures typical of suburban commercial development, which consume vast tracts of space (valueless space, agricultural space that has scarcely been urbanized), this intervention condenses and compacts it, thereby infusing it with intensity and value, and contributing to this suburb of Nantes, newly emerged from the fields, a bit of the singularity, luxury, and richness characteristic of the space of dense urban centers.

The parking lot (designed in collaboration with Bernard and Clothilde Barto) is treated neither as a functional surface nor as a service zone. With its wide painted bands and ground-hugging lights, it has something of the magical atmosphere of docks and airports, and provides the directional template for an improbable, constantly evolving mechanical ballet. The artificial lake swallowing up a corner of the parking lot is a reminder of the violence inherent in nature; it serves to return the stipulations of the program to their status as power plays, as exercises of force. The black box seems to function like a transformer that restores to things the power taken from them by the utilitarian gaze. Apocalyptically concentrated, the Onyx comes across as a stable mass of extreme density surrounded, orbitlike, by colorful moving cars and trucks whose choreography is ultimately unfathomable.

The Onyx proclaims itself as an object but remains utterly mute as to its construction—like Minimalist works that, while seemingly self-evident to the eye, withhold information concerning their mode of fabrication, their structure. In reality, it is a cubical hall surrounded by an envelope of subsidiary spaces (entrance, foyers, stage, administrative offices) and encompassed by a double skin, an inner one of dark concrete, pierced by a few functional openings, and an outer one of metal grating that traps the light, unifies the whole, and gives the impression that the building is without scale, without articulation, without "voice." It presents itself as an object pure and simple, shorn of complications; a dark, absorbent mass of pure density; a black-on-black cube: end-game architecture.

Their work is premised on a redefinition of the role of the architect, who, in their view, should not make formal invention a priority but should strive above all to make the design of a space comprehensible, desirable. The sort of advertising strategy devised to turn a product's advantages and shortcomings into a marketable identity by means of a "concept" seems to be transformed by them into a client-oriented design process. Using this approach, conflicts between a site's history, a program's contradictions, and the desires— avowed and otherwise—of clients and future users can be resolved through thinking and discussion, with just a few words often leading to an appropriate solution. Whether designing a sleek black box to signify luxury on an almost obscenely spacious site, or the largest possible interior spaces for public housing projects (instead of the usual small, partitioned spaces), or devising freestanding reflective walls of glass to reanimate a nineteenth-century museum, their goal is to create structures capable of seduction, a quality possessed by even the most trivial commercial product.

Situated at the outer limits of Minimalism and Conceptual art and beyond all formal expressionism, these very different designs make it possible for us to understand architectural design as an act of thought.

RICHARD SCOFFIER

Translated from the French by John Goodman.

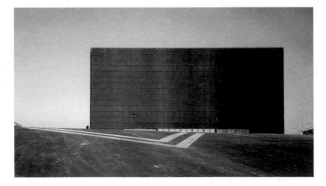

LEFT Onyx Cultural Center: View of building and parking lot

FACING PAGE Façade seen in daylight

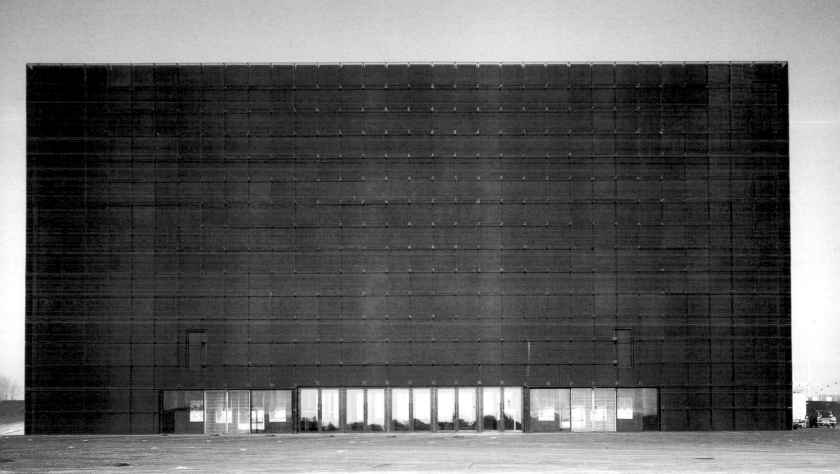

MUSÉE DES BEAUX-ARTS ADDITION, LILLE
1990-97

JEAN-MARC IBOS AND MYRTO VITART

How to complete a museum erected at the end of the nineteenth century but never finished? How to preserve, more than the museum itself, the spell woven by its incomplete state, and in a way that would make the institution more open to the city and allow visitors to think about it on two different imaginative planes?

The Musée des Beaux-Arts commission consisted of two parts: renovation of the extant buildings and construction of a temporary exhibition hall and administrative offices. In the old building, the main staircase, which occupied an inordinate amount of space in the central block, was removed and replaced by a large hall along the transverse axis, and a clumsy early addition was demolished. Ibos and Vitart made disappearance and dissolution central to their scheme, aiming at an effect of openness and incompletion. First they placed the temporary exhibition space underground and covered it with a flat glass roof, which from the outside looks like a pool of water. Then they placed the administrative offices and other service facilities within a thin glass box erected at the far end of the site, the better to accentuate the emptiness, the absence of structure, in front of it.

The architecture was made to withdraw to accommodate a cerebral, abstract landscape from which material structures are seen to emerge. Standing at one end of the glass "reflecting pool," opposite the old museum building, is an enormous double screen of glass. One can see the "pool" through its completely transparent lowest part, but, above this, the space between the two parallel glass curtain walls contains a pedestrian passageway raised on slender steel columns; and extending above the back wall of this passageway is a flat metal silhouette of the old museum building. The back wall and the silhouette are both painted Pompeian red with large gold rectangles and squares (the museum's emblematic colors). Visible through the glass screen's north wall, the entire surface of which is punctuated with small reflective rectangles, this painted pattern merges with a dizzying array of images reflected by the glass and images seen through the glass (where not blocked by the silhouette), all combining to create a spectacle that constantly changes with variations in the light.

When a door opens, a levitating man appears, while the frame reveals a rectangle of clear blue sky superimposed on the reflected sky. With a freedom altogether exceptional in architecture, this design broaches a question that has long haunted the other arts: that of the loss of depth. From Webern to Boulez, from Velázquez to the Cubists, from Mallarmé to the Lettristes, from Rodin to Judd, artists have articulated a frontal space—one without either foreground or background—and then proceeded to fill it with completely unhierarchical events (sounds, figures, letters, volumes). As a function of this loss, Greek light no longer serves as the organizing architectural principle, as it had done from Boullée to Le Corbusier; nor, despite appearances, does the light of Impressionism. Here, it is the imponderable light-energy playing over our television sets and computer screens that has been brought to architectural life.

RICHARD SCOFFIER
Translated from the French by John Goodman.

Selected Bibliography

Michel, Florence. "Ancien et moderne en résonance," *Archicrée*, no. 272 (August–September 1996), pp. 44–49.

"Equerre d'argent," *Le Moniteur Architecture – AMC* (1997 annual), pp. 38–47.

FACING PAGE Musée des Beaux-Arts addition: Two views of the glass screen, with the old building and the "reflecting pool" roof of the new underground galleries visible through it

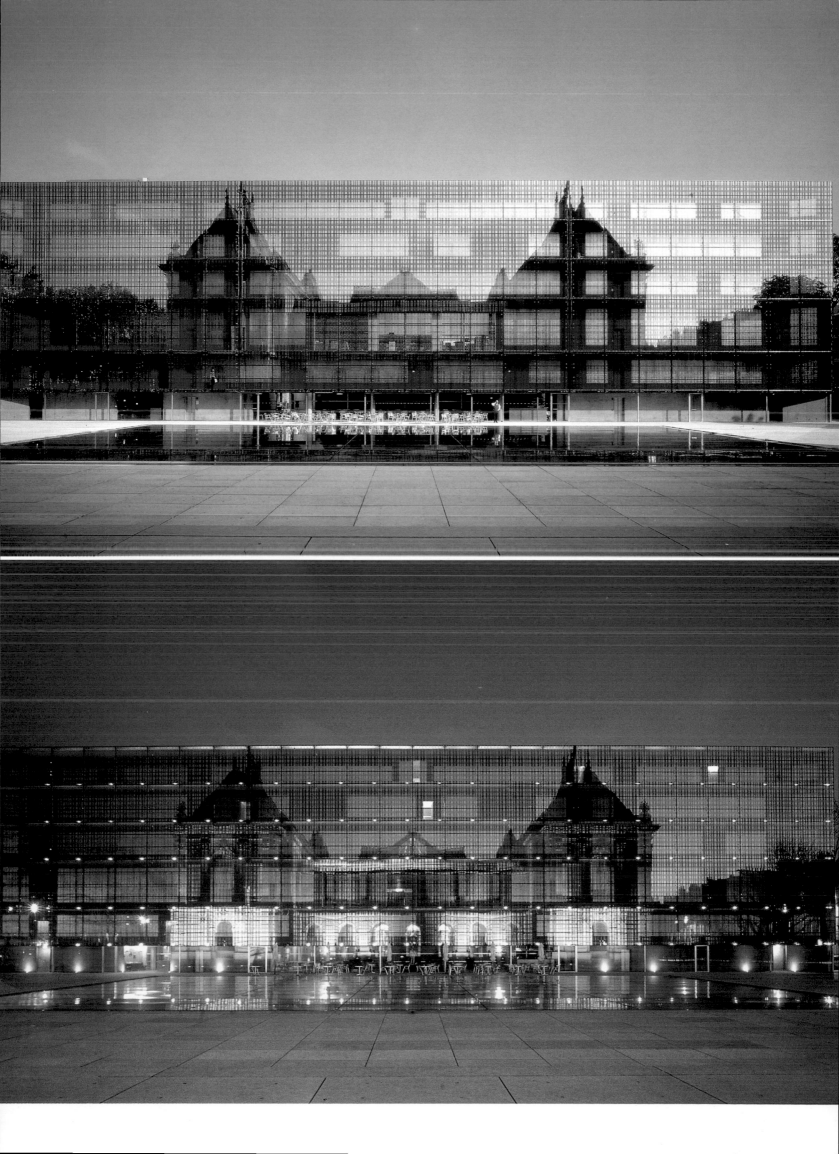

FRÉDÉRIC BOREL

(b. 1959, Roanne, Loire)

Borel graduated from the École Spéciale d'Architecture in 1982. After a brief stint in the office of Christian de Portzamparc, he designed three buildings—on rue Ramponeau and boulevard de Belleville (both 1985–89) and on rue Oberkampf (1990–93). The winner of several design competitions, he is currently completing an apartment complex on rue Pelleport and several public buildings in the French provinces, notably the headquarters of tax authorities in Brive-la-Gaillarde, an addition to the university in Agen, and a courthouse in Narbonne.

In several emblematic buildings characterized by a new formal expressiveness, Borel has elaborated a singular approach to the problem of building in dense urban areas. Whereas most architects, respectful of continuity, situate their buildings along a block's perimeter, he focuses on its center, designing spaces saturated with complex, fragmented volumes that define communal areas complementary to those of the surrounding streets.

Defining the city as a place of heterogeneous character, and refusing to honor conventional typological categories imposed by nineteenth-century planners and architects (street, square, courtyard), he composes plastic "events" carefully adapted to their sites: on boulevard de Belleville, a dizzying canyonlike space, from which emerges an improbable metal tempietto, responds contrapuntally to the main commercial and circulation axis; on rue Oberkampf, the space created by an open mezzanine above the entrance provides a glimpse of two contrasting towers at the rear of the complex and marks a pause in the narrow, sloping street. These scenographic compositions, which exploit internal courtyard spaces that in most buildings are usually inaccessible and invisible, add breathing spaces, punctuation marks, to streets that are often narrow, dense, and homogeneous.

In the narrow rue Oberkampf, which climbs the Ménilmontant hills, is a strange architectural configuration: at no. 113, an opening in the street façade gives passersby a view of a pair of small towers confronting one another, the first dark and firmly anchored in the ground, the second light and seemingly suspended in the air. Here, Borel takes on the complex regulations governing construction at the rear of urban lots to devise a pulsating spatial envelope that covers all the party walls. An ingenious composition based on partial ellipses, trapezoids, hyperbolas, and triangles penetrates the blind end walls, invading the dark, canyonlike site and creating a sequence of totally controlled, architecturally defined voids.

This dramatic complex, which houses only a small post office, a shop, and government housing for young civil servants, represents an attempt to thwart the homogenization of urban forms fostered by the city's building code and the displacement of industrial and artisanal activities. Positing a dreamlike landscape of fractured shapes, colors, and conflicting scales, it strives to recover something of the surreal spatial richness of the early twentieth-century city, with its fortuitous encounters between factory smokestacks, light-industrial sheds, and apartment buildings.

Despite explicit references to the expressionism of Mendelsohn and Poelzig, the streamlined forms of Raymond Loewy, and the Futurism of Saint'Elia, this iconoclastic design was intended not so much to call attention to its own singularity or brilliance of invention as to develop an architectural vocabulary capable of renewing the dialogue between the architect and society. Its fragmented volumes stage veritable formal narratives with a cast of characters drawn from an essentially non-elitist visual culture, for the models here are as various as the spaceships in the movie *Star Wars*, the giant stone heads of Easter Island, dresses designed by Thierry Mugler, and the amusement rides at Coney Island's Luna Park. This primacy of the visual is reinforced by the fact that it is free of all subordination to function, to structure. In the silver tower at the center of the complex, there is no central stairway providing circulation on all floors to the buildings next to it, contrary to what one would expect from its prominent placement and commanding articulation. It contains only apartments, like the buildings that border the rear courtyard, from which, however, it resolutely distinguishes itself. And its structure—a series of superimposed overhanging floors supported by columns—is not legible: it registers as a levitating monolithic form.

There is a profusion of forms and materials. The strip windows are narrow, creating a frenetic staccato effect; the walls divide and fold as if they were breaking up in suspended layers, producing vertiginous openings. The architecture gives an impression of a sumptuous gift with no strings attached. Emphatically severing its ties to use, to function, it projects an image of excessiveness that finds its justification, its foundation, its meaning, only in flaunting its own excess.

RICHARD SCOFFIER
Translated from the French by John Goodman.

Selected Bibliography

Béret, Chantal. "Frédéric Borel," in *Ouvertures*. Bordeaux: Arc en Rêve Éditions, 1990, pp. 12–13.

Scoffier, Richard. *Frédéric Borel: 113, rue Oberkampf*. Paris: Éditions du Demi-Cercle, 1994.

Borel, Frédéric. *Densité, réseaux, événements* (mini-PA no. 15). Paris: Éditions du Pavillon de l'Arsenal.

FACING PAGE Rue Oberkampf housing complex: View of courtyard with three small towers at rear of complex

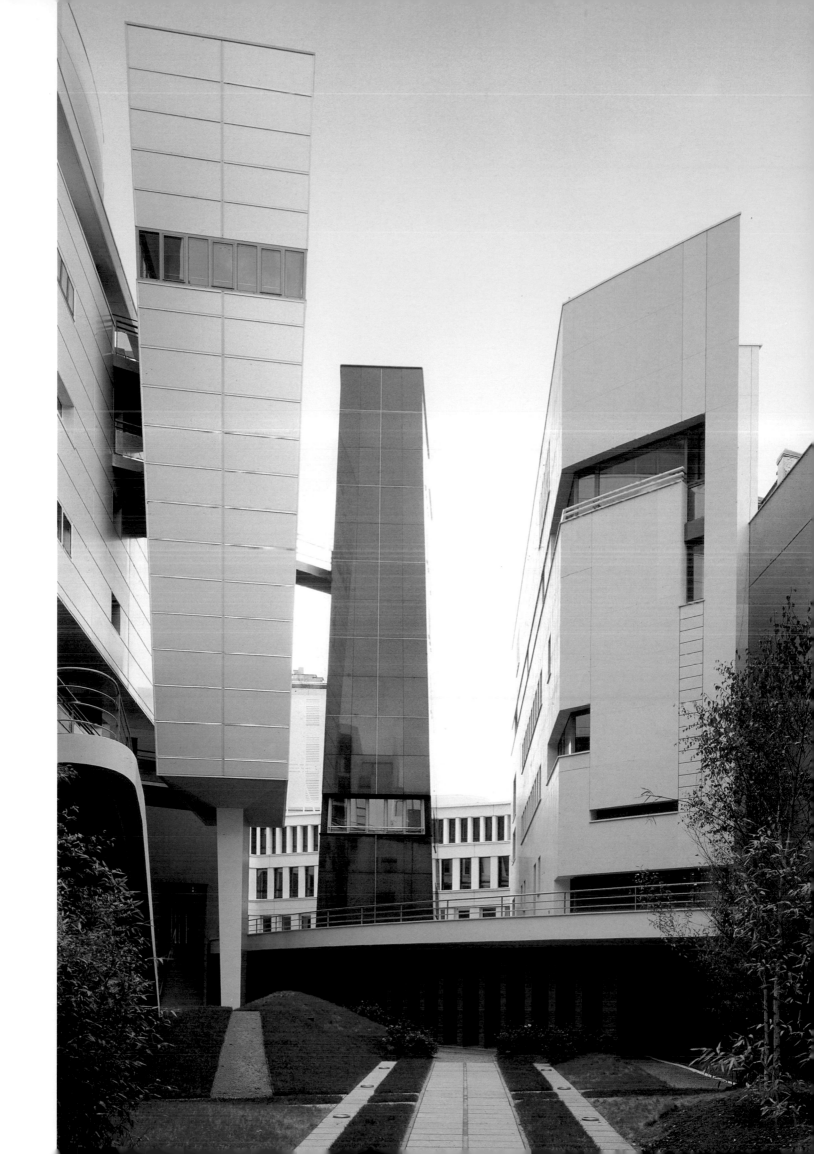

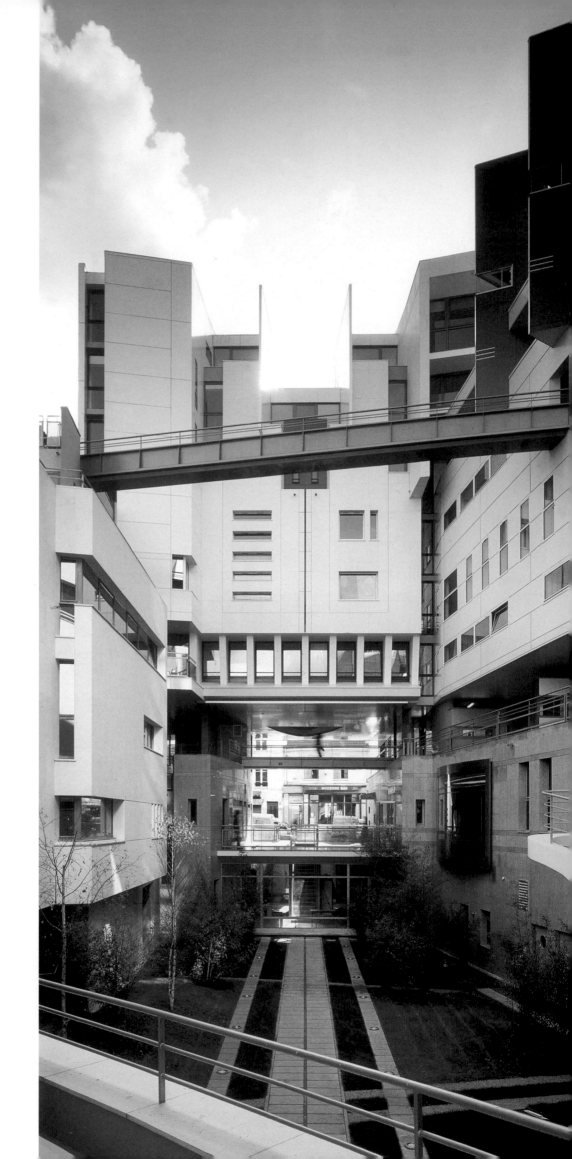

RIGHT Rue Oberkampf housing complex:
View of front courtyard looking toward street,
showing footbridges between buildings

LEFT Rue Oberkampf housing complex: View of towers at rear of complex, seen from behind

BELOW View of building on one side of front courtyard, (shown at right of photo on facing page) giving access to sunken garden with exterior stairway

LEFT Street view showing front façade of rue Oberkampf housing complex

ÎLOT CANDIE/SAINT-BERNARD URBAN RENEWAL PROJECT, PARIS
1987-96

MASSIMILIANO FUKSAS
(b. 1944, Rome)

A graduate of the architecture school in Rome (1960), Fuksas, working in collaboration with Anna-Maria Sacconi, has designed many buildings in Italy. A resident of France since 1989, his notable works there include a media library in Rezé (1987–91), the Îlot Candie/Saint-Bernard urban renewal project in Paris (1987–96), the Entrance Pavilion at the Niaux Caves (1988–93), and the Arts Center of the Michel de Montaigne University in Bordeaux (1993–94).

The buildings that Fuksas designs seem to lose all inertia to become supports for images, for vivid visions. Like deliberately raw or naïve architecture, which strives desperately to find itself though form, and Baroque architecture, which employs a rhetoric of persuasion, Fuksas seemingly intends to express narratives that are almost figurative. A black stone box looks like the monolith from Stanley Kubrick's movie 2001: A Space Odyssey, fallen from the sky and buried like a meteorite in Rezé, a suburb of Nantes; sheets of Cor-Ten steel that might have escaped from the studio of Richard Serra form an improbable zoomorphic figure at Niaux; sheets of zinc surge from the ground to cover a city block at Îlot Candie. Unlike many leftist architects of his generation who opted for an orthodox Modernist idiom, though paying more attention to function, to social context, Fuksas manages to infuse his designs with the lapidary poetry and concise freshness of revolutionary slogans from '68, slogans like "Sous les pavès la plage" or "Assez d'actes, des mots" ("Under the paving stones, the beach"; "Enough action, we want words.")

A wave of zinc on which several volumes float rises abruptly from a narrow street, unfurling and disappearing in the center of the city. On the rue Charles Delescluze, this strange urban configuration reiterates the traditional tripartite scheme of Parisian apartment buildings (basement, main block, crown), to which it adds a slightly incongruous convex swell, the sinuous surface of which is visible from the passage Saint-Bernard. This spasmodic movement serves to contain, as if it were hiding something illegal, public housing and a recreation center. With its colliding volumes and combating lines, the project advances a formal argument about the origins of the city. The design is perceived not in terms of accumulated historical strata, nor as an ordinary social project resulting from a unitary ahistorical vision. Cynically, it assimilates the city in a permanent conflict of antagonistic forces and urban forms, as a fossilization of this balancing act, and presents itself as an allegory of these struggles.

More than forces, it seems as if transitory moments in the construction process are represented here, almost as in a movie sequence: a lower hall, open like an excavation awaiting foundations; a caretaker's residence improbably perched like a provisional shed on top of the complex; galvanized steel fences around the tennis courts like so much dormant scaffolding. The complex seems perpetually haunted by the moment of its own erection. The instant of its transformation is also evoked by a metal box containing apartments, precariously supported by stanchions, that looks like something tacked on. And even the process of deterioration seems to have been integrated into the design; witness the convex walls destined to be adorned by the tracks of dirty, polluted rainwater, the nylon scrims lining the protective fences, which run and tear like ordinary stockings, and the many sheltered nooks all but irresistible to the homeless. It is as though Haussmann's city of light harbored below it another city in a perpetual state of decay, consumed by an endless cycle of death and resurrection, of constant mutation.

The architecture, through all of these feverishly expressive gestures, asserts itself as being part of contemporary culture. And the traditional curved forms found in many Parisian roofs are brutally transformed to evoke long sheets of paper disgorged by a fax machine, an image that symbolizes the appropriation of this popular neighborhood, formerly an artisans' quarter, by professional offices and agencies.

Finally, beyond this vision of the city as a naturizing power, beyond this clutter of images thrown pell-mell on top of one another, beyond this quest for transcendental meaning, the architectural forms occasionally reconfigure themselves, across these scattershot elements, to recover something of their autonomy. Thus the encounter between the wave of zinc and a monolithic block creates a precarious equilibrium, an almost Baroque, even Borrominian expressive movement, that clears a "Roman" space in one of the most Parisian of Parisian quarters.

RICHARD SCOFFIER
Translated from the French by John Goodman.

Selected Bibliography

Tonka, Hubert and Jeanne-Marie Sens. *Là et ailleurs Massimiliano Fuksas*. Paris: Pandora Éditions, 1991.

"Massimiliano Fuksas: Îlot Candie/Saint-Bernard," *L'Architecture d'Aujourd'hui*, no. 294 (September 1994), pp. 60–63.

Rambert, Francis. *Massimiliano Fuksas*. Paris: Éditions du Regard, 1998.

FACING PAGE Îlot Candie/Saint-Bernard urban renewal project: Interior of the enclosed gym, which is partly below ground

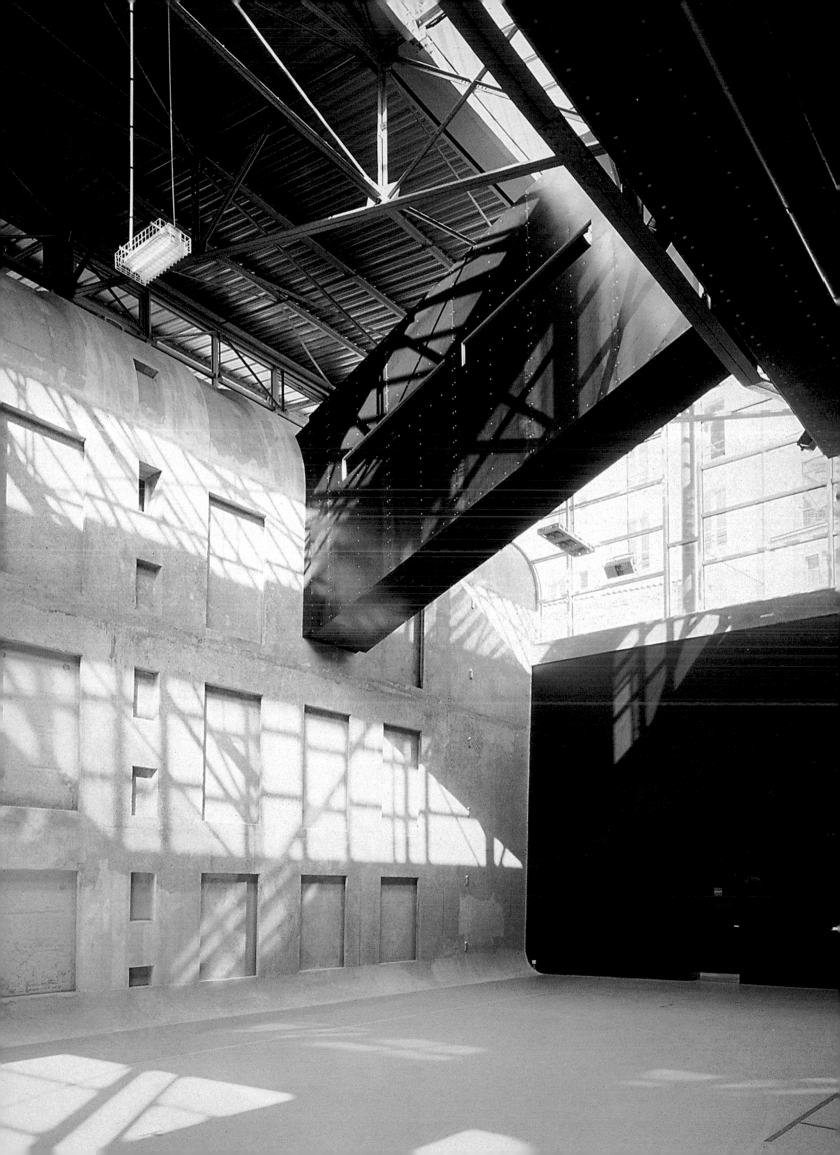

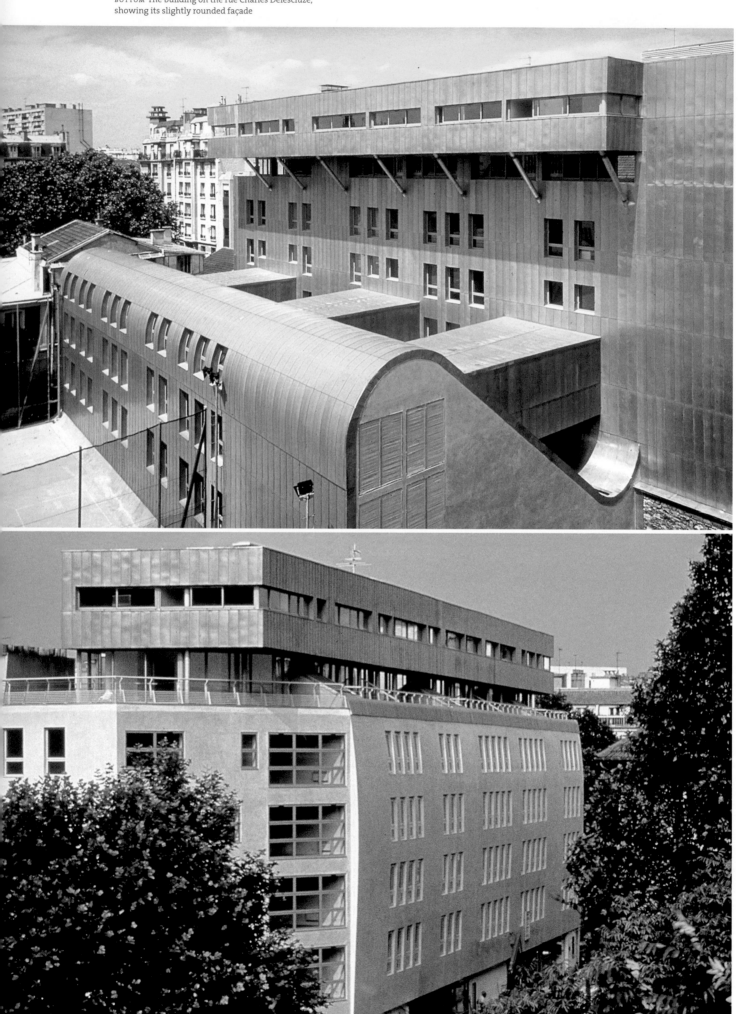

BELOW Îlot Candie/Saint-Bernard urban renewal project: View of zinc-covered "box" (containing apartments) and "wave" form (which encloses the partly sunken gym) next to an outdoor basketball court

BOTTOM The building on the rue Charles Delescluze, showing its slightly rounded façade

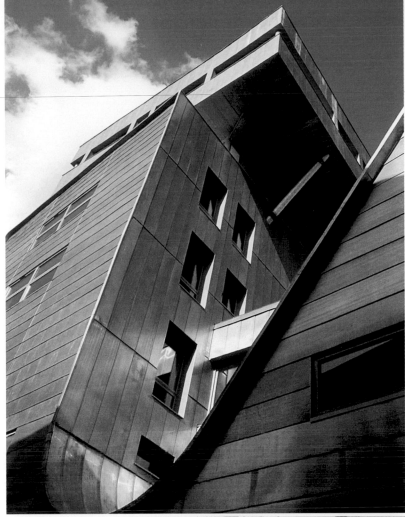

ABOVE View of the enclosed, partly sunken gym

ABOVE LEFT Detail of Îlot Candie/Saint-Bernard complex showing bottom of "wave" form and "box" of apartments supported by stanchions

BELOW LEFT Detail of façade of the building on the rue Charles Delescluze

DEVICES: ARCHITECTURE AS MECHANISM

In its contemporary usage, the term "device" (*dispositif* in French) refers to subtle mechanisms that produce and/or reveal a mise-en-scène related to a given context or site; these involve the transformation of intellectual categories regarding the fundamentals of architecture. An early example of an architectural device is the Maison du Peuple (1936-39, designed by Marcel Lods and Eugène Beaudouin, with Jean Prouvé and Vladimir Bodiansky), a pioneering work of technologically oriented architecture and innovative engineering. Like the workings of a machine, its movable floor, interior walls, and openable roof are made of prefabricated parts for easy dismantling and reassembly, so that it could be quickly transformed from a covered market into a 2,000-seat meeting hall or a 700-seat cinema, or to partition off peripheral areas for separate use. Contemporary examples of the device have moved beyond this purely mechanical sense of the term, drawing from a variety of discourses outside of architecture to create projects that offer new kinds of architectural experience. In the work of Bernard Tschumi and Rem Koolhaas, these are based on ideas and methods of modern cinema, opening up narrative or analytical possibilities through the use of such techniques as montage or the dissolve, or by exploiting disjunctions between objects and events, events and space.

Koolhaas has exercised this approach in several recent projects in France, including a unique commission for a private house in Bordeaux for a paraplegic man and his family (1997–98). Koolhaas challenges the traditional notion of a house defined by conventional ideas of a dwelling with a fixed function and form. By creating a sense of narrative flow borrowed from the cinema, Koolhaas produces fluid arrangements of space that provoke a physical encounter of conflicting forces, played out through friction or movement.

Using similar strategies, Tschumi bases his work on a process drawn from film theory and contemporary French philosophy, developing an approach that serves to expose and dismantle oppositions and assumptions that have traditionally ordered architecture. By pushing the limits of architecture to excess, highlighting its margins, and confronting it with other disciplines, he attempts to transform our reading of the environment. In his Le Fresnoy National Studio for the Contemporary Arts (1991–98), Tschumi creates a new context for the site's preexisting architecture, refocusing these structures by giving them a new framework, both conceptual and physical. Here, the focus is on in-between space, a deliberately indeterminate area where chance events might occur, a place of "fantasies and experiments" akin to cinematic space.

Among the younger generation of architects presented in this section, the very notion of "device" is stretched to its limits. In the domestic architecture by the teams of Edouard François/Duncan Lewis and Anne Lacaton/Jean-Philippe Vassal and the public architecture of Patrick Berger and Finn Geipel/Nicholas Michelin, architectural space is shaped by the function that it engenders or enables rather than by traditional formal parameters. What these architects have in common is an interest in generating flexible systems, ambiguous forms, and architectural devices that promote evolution and change—thus establishing a socially conscious practice harking back to Candilis and Woods.

PARC DE LA VILLETTE, PARIS
1982-97

BERNARD TSCHUMI

(b. 1941, Paris)

In 1983, Tschumi won the competition for the Parc de la Villette, a project that aspired to develop an "urban park for the twenty-first century" on the northeast outskirts of Paris. The park's layout is based on an overlapping of three different systems: a system of built objects placed according to an invisible grid of points, which distributes the program requirements in a regular fashion; a system of lines delineating pedestrian walkways; and a system of ground-surface areas (round, square, and triangular) for playgrounds, open-air markets, and sites for mass entertainment.

The grid of points, spaced 120 meters from one another, determined the placement of 26 *folies*, giving the ambiguously defined site visual coherence. Each *folie*—the French word for "folly," a pavilion or tower in eighteenth-century gardens—consists of an open cube measuring 11 meters (36 feet) per side, subdivided by bars 3.6 meters (12 feet) apart, forming a cagelike framework covered in red-enameled steel, and varied or extended by the addition of other elements (cylindrical or triangular volumes, stairs, ramps). This cubic matrix creates an undefined enclosure, conveying a cross between the "histograms" of the 1960s/70s Italian group Superstudio (in particular a drawing they did for their "Thirteen Ideal Cities") and the constructivist environment of Tschumi's own *Manhattan Transcripts*. Such indeterminacy extends to the *folies'* use or function, which can vary over time, but at present includes a café, a restaurant, and a movie theater (made by larger additions to the original cubes). The *folies*— which range from the basic form of the original "normal" folie to "deviant" ones that transgress the "norm"—emphasize new social relations through a program of flexibility and the potential for discovery, and confirm that a mere combination of elements (Tschumi worked in Candilis's studio in 1968) is not a composition.

There are two kinds of lines. Two orthogonal axes, one running north–south and the other east–west, connect the Porte de Pantin to the Porte de la Villette, and Paris to the suburbs, the latter marking the passage along the canal from the Villette basin to the outskirts. To cover these axes, Tschumi collaborated with engineer Peter Rice to create protected passages and raised walkways. In contrast to these, a circuitous "cinematic" promenade of winding paths moves through various theme gardens and botanical and educational areas.

Here, in his first built work, Tschumi deconstructs architecture by disregarding its traditional categories and favoring movement, object, and event. One should note the extended relationship that Tschumi maintained with Jacques Derrida during this project, which resulted in the publication of *La Case Vide* (The Empty Slot, 1986)

ALAIN GUIHEUX
Translated from the French by Molly Stevens.

After studying architecture at the Federal Institute of Technology in Zurich, graduating in 1969, Tschumi taught at London's Architectural Association School (1970–76). In 1988 he became dean of the Graduate School of Architecture at Columbia University in New York. He has written numerous essays and books, including The Manhattan Transcripts: Theoretical Projects (1981). Tschumi builds in France and the United States, and has won several international competitions, notably for the Parc de la Villette in 1983.

All of Tschumi's theoretical work might be understood as an attempt to tear architecture away from its role as the foundation, the setting, the chiourme (servitude) of social life, as write Georges Bataille has defined it. This approach crosses over into philosophy (particularly the critique of false transcendence of meaning advocated by Derrida) and into film analysis. By drawing a parallel between architecture and cinema—for which there is no hierarchy between frame, action, light, dialogue, and music—it is possible to go beyond the traditional relationship established between form and use: the most trivial gestures are considered artistic realities, and spaces and structure tend to appear as pure events. Tschumi has applied this theoretical concept in several projects: the Parc de la Villette (1982–97), his design proposal (unbuilt) for the new Bibliothèque Nationale (1989), the Le Fresnoy National Studio for the Contemporary Arts (1991–98), and the future School of Architecture in Marne-la-Vallée (begun in 1994).

RICHARD SCOFFIER

Selected Bibliography

Fillion, Odile. "Bernard Tschumi: Portrait," *Architecture Intérieure Crée* (October–November 1983).

Lucan, Jacques. "Déconstuire l'Architecture," *Architecture Mouvement Continuité* (1986).

Tschumi, Bernard and Jacques Derrida. *La Case Vide: Folio VII.* London: Architecture Association Press, 1986.

Tschumi, Bernard. "Le Parc de la Villette," *Architecture Mouvement Continuité*, no. 6 (1994).

Axonometric drawing of Tschumi's design for Parc de la Villette, showing its different components, including the grid arrangement of *folies*, the north–south and east–west axes, and the "cinematic" winding paths

Parc de la Villette: *Folie* L5, which, with additions to the
original cube, is now an information center and cabaret

LE FRESNOY NATIONAL STUDIO FOR THE CONTEMPORARY ARTS, TOURCOING, FRANCE

1991–98

BERNARD TSCHUMI

Le Fresnoy, built at the beginning of this century, was originally a center for leisure activities, comprising bars, restaurants, a horseriding stable, a skating rink, a movie theater, and a dance hall (which could house other events such as boxing matches, or could serve as a music hall). All these recreational activities were thrown together at random in a five-section industrial warehouse. Today, the former activity center for the masses, located in an area of northern France that is seeking a new identity, has been transformed into a cultural institution reminiscent of the Villa Medici in Rome, which houses the National Academy of France and its artist-students. With studios for a variety of artists and classes for seventy-five postgraduate students, Le Fresnoy promotes interaction between the arts (music, film, photography, video, etc.) and state-of-the-art technology (there is a film and video shooting studio, a recording and mixing studio, a photography lab and studio, a computer imaging studio, etc.); it also organizes performances and exhibitions for the general public.

Tschumi's proposal was simple: to rediscover the disjunctions between the vaults of the old building's spaces and the varied activities that they could house, and push them to excess. He preserved most of the existing structures and randomly gave them new purposes, covering them with a huge steel roof above the old tile roofs, creating a superstructure containing electrical wiring and other technical installations, like a gigantic grill over a stage. Thus, in the gap between the spaces and activities, another disjunction is introduced: one between the spaces and the technological overlay. This disjunctive logic subverts the traditional theoretical foundations of architecture. Here, the components of Vitruvius's trilogy (solidity, comfort, and delight), instead of merging and bringing the building into focus, tend to stay separate, keeping the entire entity from achieving a sense of unity.

The architect, like a movie director, "builds" these various systems without a common thread (a gesture, a volume, a beam), without subordinate relationships (without cause and effect, without function dictating form). Between them are empty, in-between spaces, areas of friction and contamination, which can at any moment be occupied, thus leaving room for unexpected events (triggered, for example, by the network of footbridges that provide precipitous passage between the superstructure and the old buildings). These mutant, indeterminate spaces insinuate themselves here like the disturbing infinity that irrational numbers cause to emerge in every gap of the finite series of rational numbers, turning it into one of the richest nightmares in philosophy. The architectural plan proposed does not aim to found, as Hegel had hoped, but rather, to test, to activate. It distributes energy flux (desire to create, spatial sequences, technology, etc.) more than forms. This flux comes together, intersects, diverges, loses itself like a spasmodic machine forever on the verge of imploding. It's as if the machine were running solely on friction, interruptions, short-circuits, which will allow it to emerge while risks and unknown artistic practices multiply.

RICHARD SCOFFIER
Translated from the French by Molly Stevens.

Selected Bibliography

Scoffier, Richard. "L'Effraction de l'action," *Les Cahiers de la recherche architecturale*, no. 34 (October–December 1993), pp. 192–98.

Guiheux, Alain . *Tschumi: Une architecture en projet Le Fresnoy*. Paris: Éditions du Centre Pompidou, 1993.

Robert, Jean-Paul. "Le Fresnoy, un lieu, une école, Bernard Tschumi et Alain Fleischer," *L'Architecture d'Aujourd'hui*, no. 314 (December 1997), pp. 35–55.

Le Fresnoy National Studio for the Contemporary Arts: View of the gap between the new steel roof that Tschumi added above the tile roofs of the old buildings, showing the superstructure containing all the technical installations and one of the many footbridges

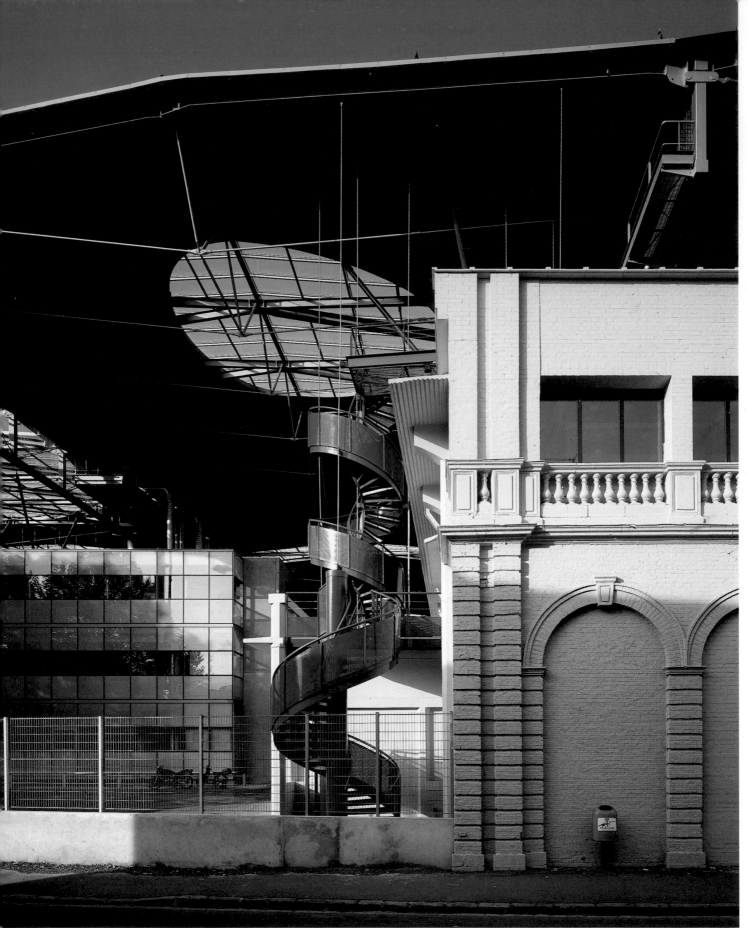

ABOVE Le Fresnoy National Studio for the Contemporary Arts: Juxtaposition of a section of the old building with new additions

FACING PAGE, BELOW Exterior view showing the new structural framework that encompasses the entire complex, with a stairway leading into it

RIGHT Le Fresnoy National Studio for
the Contemporary Arts: Axonometric
drawing of new roof covering the
entire complex

FAR RIGHT Network of stairways and
footbridges below the new roof and
next to vaulted roof of a section of the
old building

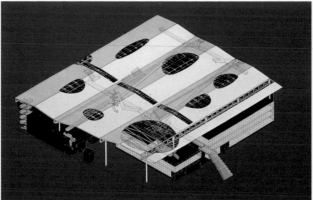

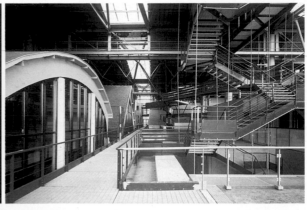

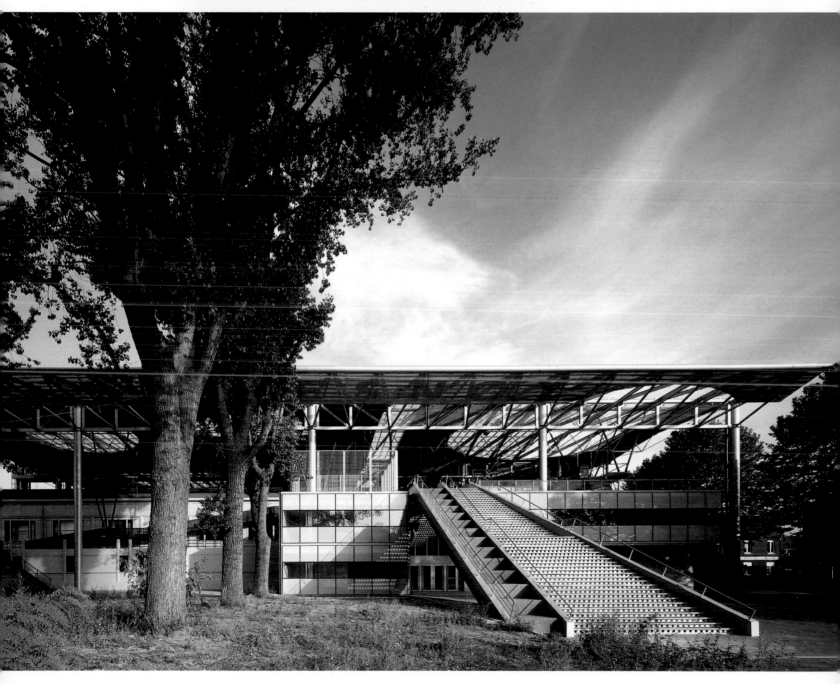

BIBLIOTHÈQUE NATIONALE DE FRANCE, COMPETITION ENTRY
1989

The project of building a new National Library in Paris was launched in a period when the need for it was not as apparent, due to various new means of distributing and compiling information. The program's primary function was the storage of information in all forms (books, microfiche, CDs, videos, computer databases). Koolhaas's unbuilt proposal features a large, almost cube-shaped parallelepiped (80 meters per side). Its imposing scale is called for by the site's two dominant elements: it is on the banks of the river Seine across from the Ministry of Finance and the Bercy sports center, and is just west of the city's beltway.

Inside this huge warehouse, voids with organic yet geometric shapes are designed to accommodate public reading areas amidst the solid block of information. Inside, from bottom to top—using Koolhaas's own descriptions—are the Pebbles (the Sound and Moving Image Library), occupying four levels underground, below the building's forecourt; hovering nine meters above the entry hall, the glass floor of the Great Hall of Ascension, which encompasses the twenty levels aboveground and contains several floors of stored books and the enclosed voids: the Intersection, a cross formed by a long oval tube (a Reading Room) and a sloping rectangular tube (the Auditorium); the Spiral (the Reference Library); the Shell (the Catalogue Room); and the Loop (the Research Library), the middle of which twists in a "loop-the-loop." The design has nine elevators in glass cages traveling through glass shafts, and a series of escalators, providing access to the enclosed voids and all the floors. Electronic billboards on the elevator shafts would display information about the different libraries. In the basement are the technical facilities and the Conservation Department, as well as the structural supports for the building's exterior walls: on one side, a network of crossed beams, and, on the other, a subterranean administrative block. The façades would be photo-silkscreened glass, which would vary their transparency, while lighting would make the different depths of the building visible. The Intersection, the Spiral, and the Loop all end in different-shaped windows in the façades .

Koolhaas's parallelepiped exemplifies a major architectural idea that has emerged at the end of this century, reworking the Crystal Palaces transparency and indistinct form, Frederick Kiesler's concept of continuous space, and the floating rooms of Paul Nelson's Suspended House (1935). It represents a new architectural realm, one that is at once translucent, fluid, and amoebic. In his design proposal, Koolhaas described the hollowed volumes as "absences of building, voids carved out of the information solid. Floating in memory, they are multiple embryos, each one bearing its own technological placenta." Here the architecture is generated by devising a substitute for the notion of space and by carving out cavities rather than developing a "construction." Koolhaas continued this exploration in his Jussieu University libraries competition entry, in which the ground would be the generator of architectural space, a continuous spiral that encapsulates the entire project.

ALAIN GUIHEUX
Translated from the French by Molly Stevens.

REM KOOLHAAS
(b. 1944, Rotterdam, the Netherlands)

After working as a journalist and a screenwriter, Koolhaas studied at the Architectural Association School in London (1968–72) His final project there, "Exodus, or the Voluntary Prisoners of Architecture" (1972), was an anti-utopian story applying the theme of the Berlin wall to London, inspired by the radical Italian architecture groups Superstudio and Archizoom. He continued his studies in the United States, first with Oswald Mathias Ungers at Cornell University, and then at the Institute for Architecture and Urban Studies, which was directed by Peter Eisenman. In 1975 he founded the Office for Metropolitan Architecture (OMA) with Elia and Zoe Zenghelis and Madelon Vriesendorp; that same year, they designed a competition entry for the Roosevelt Island housing complex in New York. In 1978 Koolhaas published his provocative interpretation of Manhattan, "Delirious New York: A Retroactive Manifesto for Manhattan"; it set the direction of his architectural practice and his thinking, which at the time was based on a celebration of Manhattan as a "culture of congestion," using psychoanalytic theory. However, he went on to establish an architecture charged with references to Modernist architecture—notably Mies van der Rohe—and to architecture of the 1950s. In addition to his active international practice, he is currently a professor of architecture at Harvard University.

Several significant projects that were published but not built include the competition entry for the extension of the Parliament Building in The Hague (1978), a study for the renovation of the Koepel Prison in Arnhem, the Netherlands (1979–81), and the competition entry for The Hague City Hall (1986). His first built project was the Netherlands Dance Theater in The Hague (1984–87), after which he built a series of private homes—in Rotterdam (1988), Saint-Cloud (1991), and Bordeaux (1997), using prefabricated industrial materials such as aluminum siding and plate-glass walls—as well as housing in Amsterdam (1989) and in Fukuoka, Japan (1991), and the Kunsthal in Rotterdam (1987–92). The competition for the Center for Art and Media Technology in Karlsruhe, »

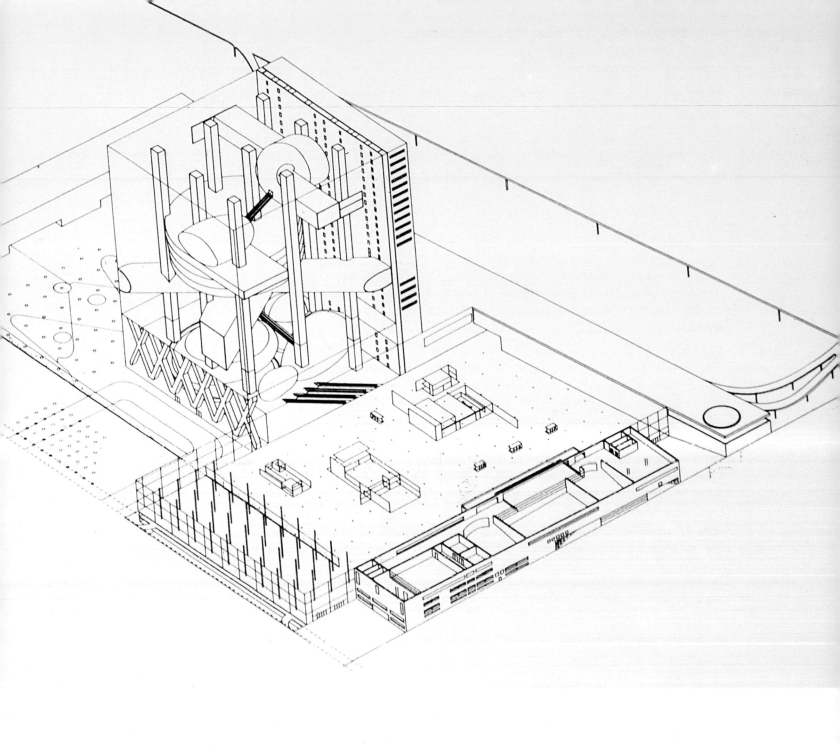

ABOVE Koolhaas's competition entry for the Bibliothèque Nationale de France (axonometric drawing)

RIGHT Exterior view (model)

SCIENCE AND HUMANITIES LIBRARIES, JUSSIEU UNIVERSITY, PARIS, COMPETITION ENTRY
1993

REM KOOLHAAS

Germany (1989) which he won and spent three years developing, but the project was not built—and the competition for the Ferry Terminal in Zeebrugge, Belgium (1989), were among the projects that influenced the way a new generation of architects would think and see.

Numerous competition entries by OMA for projects in France left their mark on contemporary architecture: the Parc de la Villette (1982), the new Bibliothèque Nationale de France (1989), the Jussieu University libraries (1993), the new town of Melun-Sénart (1987), the development of La Défense (1991), and Euralille (1990–94). Each one questioned the traditional concerns of architectural composition by emphasizing the underlying concepts and strategies, rejecting conventional boundaries and fixed forms, and creating fluid sequences of space.

Koolhaas won the 1992 competition for building the two libraries at Jussieu University in Paris at a time when Jean Nouvel was entrusted with the master plan of the campus. Echoing the issues raised by the Candilis/Josic/Woods team that built the Free University in Berlin (1963–73), the campus designed by Édouard Albert (1964–68, and finished after his death; completed 1971) is a uniform grid filling the entire site, with quadrangles and interior courtyards alternating over five levels. A particularly windy parvis (open space) interrupts the sequence of levels, which continue below the ground. The grid has not been finished in its east corner, but Koolhaas, unlike Jean Nouvel, did not offer to complete Albert's grid.

Koolhaas based this project on the model of late-nineteenth-century reinforced-concrete industrial buildings, with their stacked floors—from which the plan libre (open plan) developed—and columns supported by a rigid structural framework. But here, the floors relate to each other; they are sloped as in elevated parking garages in which the ramp and the parking level are combined. The library would have offered a unique pathway—what Koolhaas calls a "warped interior boulevard"—that would have passed through all of its sections, with an average of seven meters between each floor. A view of the pathway in cross-section shows the zigzag descent of this interior boulevard, a far cry from the Guggenheim's spiral. Even if Koolhaas seemed to directly refer to the boulevards of Paris and to those strolling them, the reference could just as easily be to the pedestrian circulation in department stores, where the shelves displaying merchandise, like bookshelves, are not much taller than people.

The design proposal for the two libraries at Jussieu explains that, here, "science is embedded in the ground; humanities rise upward." While again using the idea of the cube and the approach to interior space that he had developed in the competition for the new Bibliothèque Nationale, Koolhaas devised a continuous ramp that would lead the visitor from the ground to the top floor without stairs—an image that might be conveyed by folding or tearing a sheet of paper. As in the Bibliothèque Nationale, this project's program was subjected to a quantitative analysis, which demonstrated that 35 percent of the sloping surface is comparable to the surface normally allotted for circulation in a traditional space. When the project was canceled, this principle of sloping planes—which Koolhaas had already employed in the Kunsthal in Rotterdam—had proved to be viable, even for the library carts. The hollowed volumes that constituted the "inhabited spaces" of his Bibliothèque Nationale design also stand at the heart of this project's superimposed layers, which once again embody its milieu.

Echoing the work of Édouard Albert (and of Shadrach Woods), Koolhaas reconsiders questions of engendering architectural space and the syntax of projection. Here, the plan rids itself of everything, both floor and posts; in other words, it destroys the structure, and from it emerges a continuous space that is demarcated or made visible by the sloping planes that seem as if they were contained in a virtual box.

ALAIN GUIHEUX
Translated from the French by Molly Stevens.

Selected Bibliography

Koolhaas, Rem. Delirious New York: A Retroactive Manifesto for Manhattan. New York: Oxford University Press, 1978; Monicelli Press, 1994.

Lacun, Jacques. OMA/Rem Koolhaas. Milan: Electa, 1990; Princeton, N.J.: Princeton Architectural Press, 1991.

"Rem Koolhaas/OMA 1987/92" (special issue), El Croquis, no. 53 (February 1992).

Koolhaas, Rem and Bruce Mau. S, M, L, XL: Office for Metropolitan Architecture. New York: Monicelli Press, 1995.

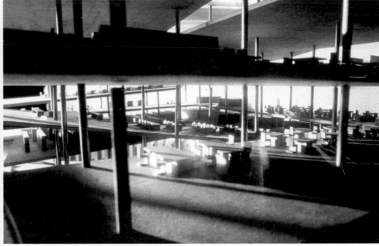

Three views of Koolhaas's competition entry for the Science
and Humanities library of the Université de Jussieu (model),
showing continuous interior ramp

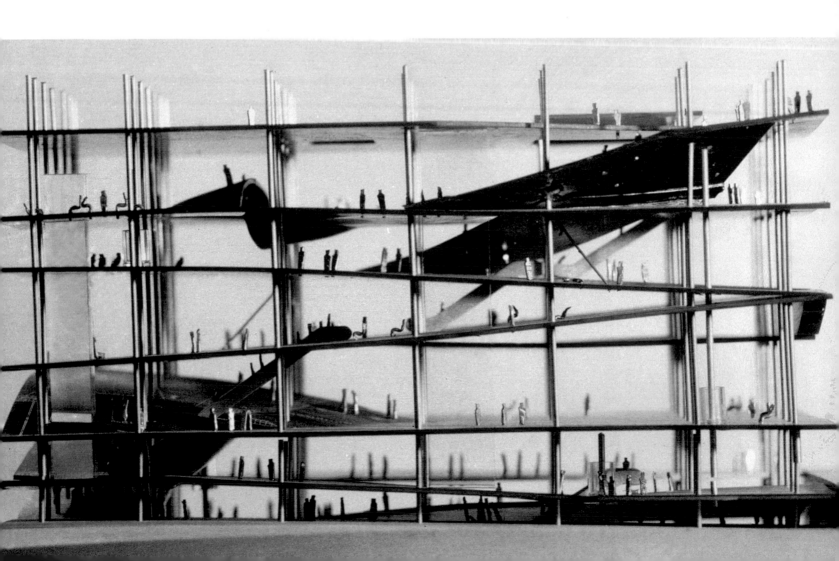

A house divided into three parts, following the Modernist model: an elaborated base, in the form of a Miesien platform, partially set into the hillside; a space occupied by a terrace and a glass-enclosed living area; and, at the top, a cantilevered opaque box open on one end, supported by a steel frame and an off-center column. Here, "construction" is taken to its limits. Koolhaas chose a postheroic building language, turning technique into a game whose strange uselessness is the goal. In this house of various emblematic references, the mystery of the game clues increases with the appearance of the concrete column sheathed in reflective stainless steel that makes it look like a piston. Round openings in the wall surrounding the top floor and on the second floor's western façade emerge from the interiors, with their Incan or comic-strip décor. A photograph shot from below echoes the viewpoint of the famous picture of Frank Lloyd Wright's Fallingwater, accenting the overhang; and the I-beam on the roof is an architectural configuration similar to the Wright house.

Koolhaas describes the Bordeaux project like a fairy tale: "Once there lived a couple in a very beautiful, old house in Bordeaux. They wanted a new house and, why not, a very simple one. [The husband] had a brush with death, but survived. At present, he requires a wheelchair. A new house could liberate the husband from the prison that the old house in the medieval town had become." The new house will become the catalyst for his return to life. It is designed with this goal in mind, implemented by a 3-by-3.5-meter platform supported by a hydraulic piston that enables the disabled husband to move up and down through the three levels of the house. When the platform elevator is on one floor, there is a gaping hole on the other two floors, thus creating a psychological danger and dramatizing the uncertainty of survival. The large, glass-walled living area, the only level with panoramic views of the whole town, becomes almost invisible in relation to the box above it, which does not crush it but adds the idea of the bunker or eagle's nest to that of the terrace overlooking the metropolis. The house is therefore a device that is at once mechanical, cinematic, and psychological, providing architecture with what Claude Lévi-Strauss would call a symbolic function that gives it effectiveness. The fairy tale ends happily with the renaissance and rejuvenation of architecture. Architecture, as a mechanism of re-birth, is able to build or rebuild an identity for owners who, for one reason or another, no longer have one.

The value of architecture lies in its capacity to make us see the world and transform it, and perhaps to engender behavior and actions. Thus, its purpose is contained in its presence and form. The organizing function of the plan is not without problems, for it diminishes the status of form and appearance, whether we want it to or not.

ALAIN GUIHEUX
Translated from the French by Molly Stevens.

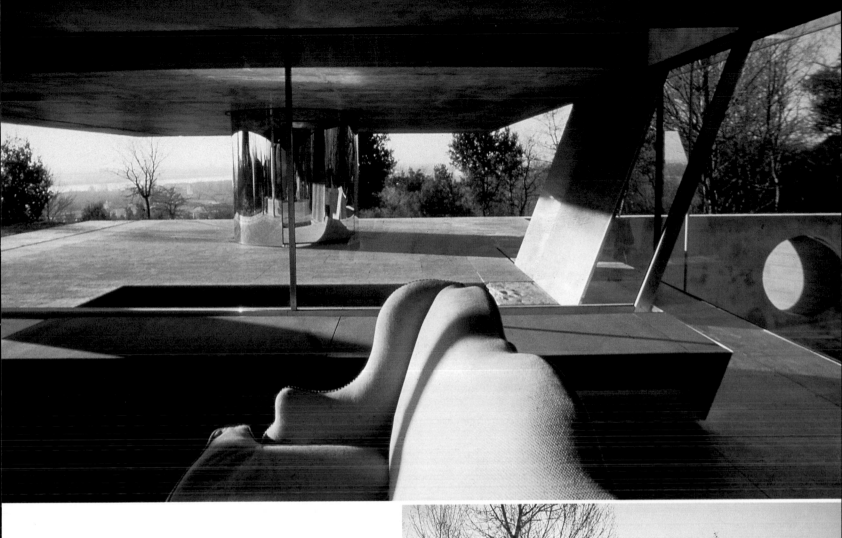

ABOVE House in Bordeaux: Interior view

RIGHT Exterior view, photographed from below, emphasizing the dramatic overhang

BELOW Cutaway view of model, showing arrangement of interior spaces

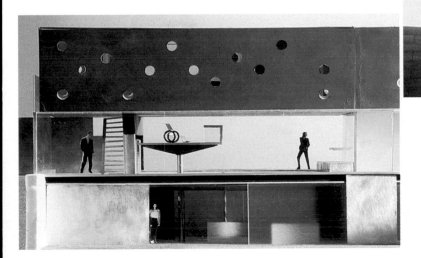

PIERRE DU BESSET *(b. 1949, Paris)*
DOMINIQUE LYON *(b. 1954, Paris)*

Besset and Lyon spent several years working with Jean Nouvel before founding their own firm in 1983. Among their built works are the newspaper Le Monde's *building in Paris (1988–90) and the Media Library in Orléans (1990–94); other important projects (unbuilt) include their competition entries for the French Pavilion in Seville (1990), for the Jussieu University libraries in Paris (1992), and for the Le Fresnoy art school in Turcoing (1992).*

The Orléans Media Library stands beside a residential tower, a train station, and a church, on the boulevard that surrounds the city. The building's plan deliberately departs from the site's footprint and distinguishes itself from its neighbors with a singular façade in the form of a retroflex polyptych. This relative indifference to its context is presented as a challenge, as if its somewhat odd appearance was intended as both a refusal to submit quietly to its environs and as a means of seduction.

This object seems to reveal nothing of itself. On the façade, transparency is subverted by slightly wavy horizontal strips of perforated sheet metal that cover the glass over most of the building, forming a unifying screen which, while eliminating any sense of verticality, does not induce a defining sense of horizontality either. There is nothing to give an idea of the building's scale, no conventional door or window or any other element designed with reference to the human body. Inside, the rooms are of different shapes and sizes and are arranged around the cylinder that houses the stairways, with its fluorescent orange walls.

The Media Library was not conceived as a space dedicated to the ritual of reading as it has been systematized since the invention of the printing press—epitomized by the libraries designed by Louis Kahn, Gunnar Asplund, and Alvar Aalto—but to house and provide access to a broad variety of cultural objects: books, newspapers, CD's, comic books. Each room was designed, in anticipation of the computer revolution, as more of an ambiance than a utilitarian space geared toward getting and reading printed matter. Thus, the reading room is enclosed by a wall of glass (supported by a steel latticework frame) that bulges out from the façade in a half-cylinder, generating forms that have no direct relationship with the act of taking a book, as does Boullée's unbuilt design for a hall of books in the royal library in Paris, where every element is geared toward the gestures of taking a book, turning its pages, discussing it. Here, the reading room could be mistaken for a classroom or a cafeteria, for the building's varied milieux embody a logic arising not from any specific usage but from the relationship of fluorescent orange against reverberant metal reflections, or glass against absorbent padding.

There is autonomy with respect to form, usage, the visible. There is also autonomy with respect to the structure, which is never indicated—as on the ground floor where certain rooms are suspended, conveying an impression of fluid space filled with floating forms. It thus reflects the heterogeneity espoused by constructivist thinking, which readily blends supported and suspended elements. This architecture of streamlined surfaces covering the structure expresses itself through subtle disinformation as a "specific object," an urban fact that is irreducible to any discourse or program.

RICHARD SCOFFIER
Translated from the French by Molly Stevens.

Two premises seem to lie at the root of their work together: that architectural culture is no longer divided while there is a culture of design and of contemporary popular imagery; and that the city is not an unbroken sequence of unified forms but contains clashing images and ideas, the result of ongoing tensions and conflicts. This position seems to involve ideas about strength (instead of ideas about power) as espoused in the philosophies of Spinoza and Nietzsche, and the concepts of 1960s leftist theorists (from Debord to Negri). Thus, architecture is not perceived as resulting from a social contract or an unchanging order, but as a perpetual confrontation of forces. Architects can no longer consider maintaining an illusion of peaceful continuity when building in a city—they must regard urban space as a zone of permanent conflict where they must launch Trojan horses that infiltrate within the constant barrage of competing forces. They cannot just continue to create forms, play with light, or update an age-old vocabulary but must reconceive their discipline in a way similar to the Pop artists, as if producing and marketing merchandise. The buildings of Besset and Lyon, exemplified by the curvilinear façade of the Le Monde *building or the embellished body of the Orléans media library responding to other opposing forms, present themselves as non-articulated blocks, as simply streamlined mechanisms, refusing to express a top or bottom, the supported or the supporter, so as to be seen in all their banality as pure objects.*

Selected Bibliography

Delluc, Manuel. "Du Besset et Lyon Médiathèque à Orléans" and "Entretien avec les architectes," *l'Architecture d'Aujourd'hui*, no. 294 (September 1994), pp. 28–35.

Lyon, Dominique. *Point de vue usage du monde*. Paris: Institut Français d'Architecture-Carte Segrete, 1994.

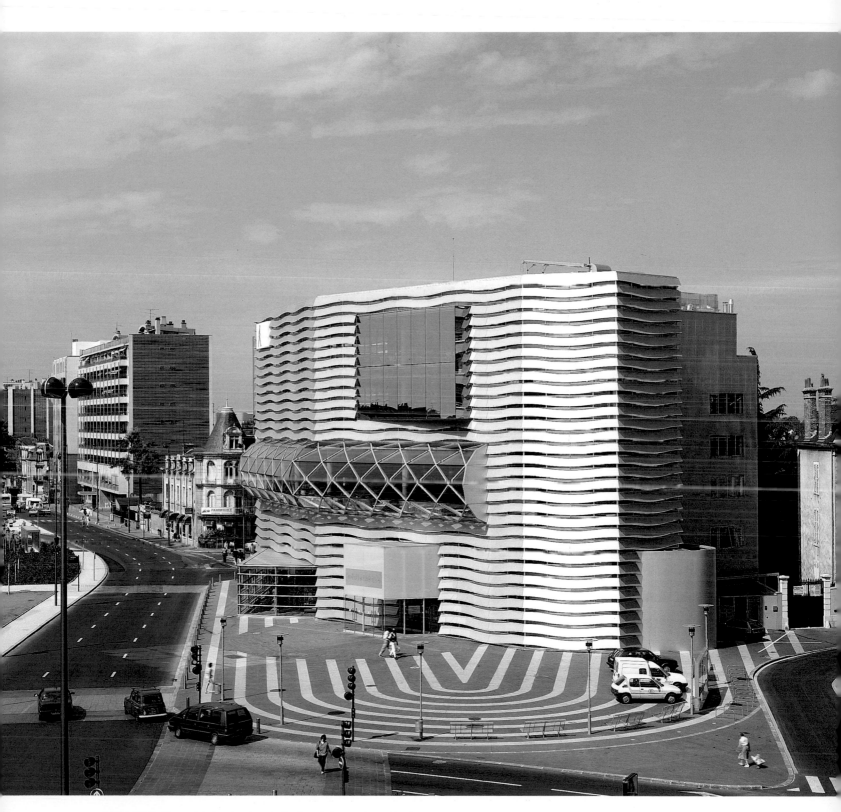

Orléans Media Library: Exterior view from the boulevard, showing the building's front façade with its wavy horizontal sunscreens of perforated sheet metal and the protruding glass-and-steel wall of the reading room

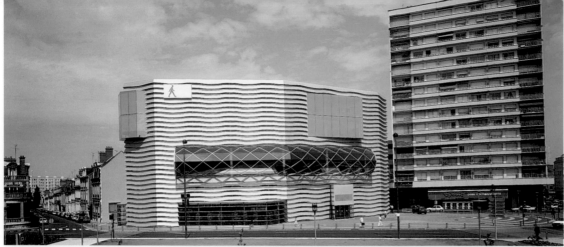

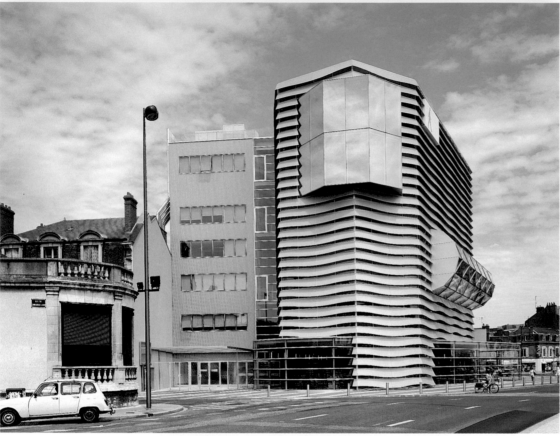

TOP Orléans Media Library: Frontal view showing building next to a neighboring residential tower

ABOVE Side view of building

RIGHT Interior view

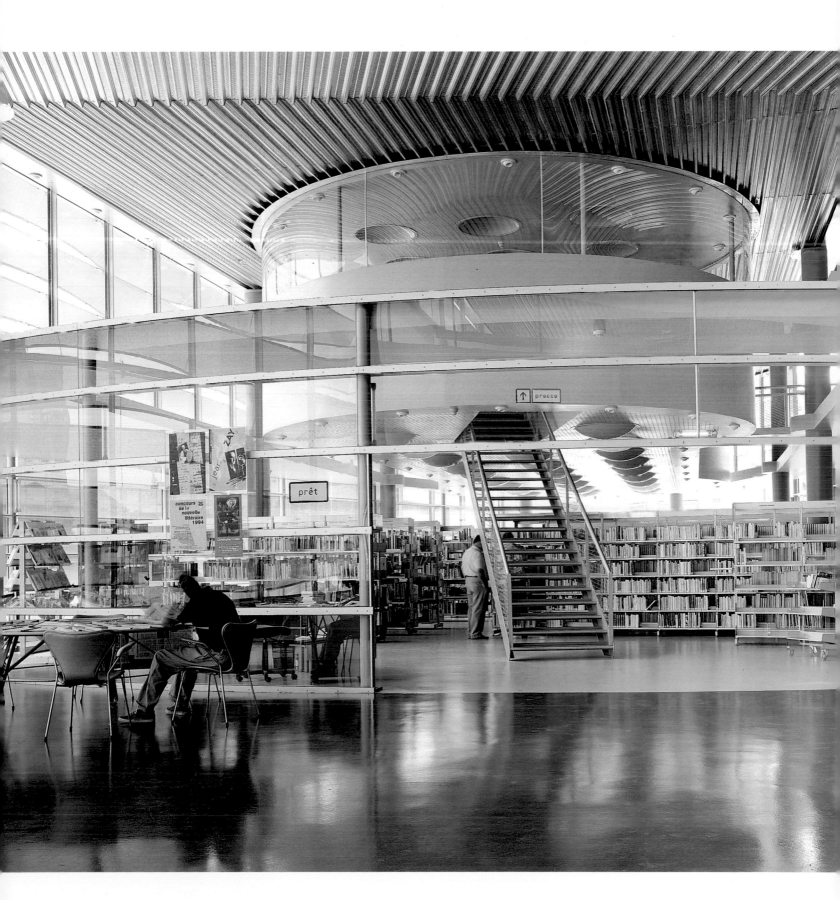

FINN GEIPEL NICOLAS MICHELIN LABFAC

FINN GEIPEL (b. 1958, Stuttgart)
NICOLAS MICHELIN (b. 1955, Paris)

Geipel and Michelin founded their own architecture firm, Labfac, in 1988, after designing a retractable roof for the Roman arena in Nîmes (1986–89). After winning several competitions, they designed and built the National School of Decorative Arts in Limoges (1990–94) and the National Theater in Quimper (1991–98). They are currently working on the Metafort in Aubervilliers.

They base their work on their ideas concerning the making of architecture, defining architectural intervention not as a pure creation of plastic forms but as a process of taking technologies from other fields and products created for other uses and applying them to architecture—a strategy of détournement (a diversion of elements as an act of deliberate misappropriation).

The buildings they design often appear as neutral envelopes that are not perceived as strictly interior or exterior. Within this parameter, the plan they devise can accommodate a flexible arrangement of specific parts that can be multiplied, transformed, or eliminated without affecting the whole— discrete elements such as the mezzanines of the school in Limoges and the temporary studios and the labs of the Aubervilliers Metafort.

This approach revives the questions raised years earlier by the like of Buckminster Fuller, Archigram, and Frei Otto— questions about an open architecture capable of integrating undetermined or random elements without losing its identity. The works of Geipel and Michelin are designed to be active rather than fixed devices, planned not according to a preconceived fiction of usage, but as milieux in which certain behaviors can be fostered— like artificial biotopes that host the development of organisms—while permitting evolution and change.

The Aubervilliers Metafort belongs to that new generation of facilities designed to respond to the expansion of multimedia culture. This project, utopian in many ways, should revive the area around one of the old forts on the outskirts of Paris, which, with its dense vegetation and overgrown lots, today represents a break in the urban fabric. Representing more than a place for new modes of communication (which no longer need to be tied to a physical site), the Metafort was conceived as a locus of cross-fertilization between multimedia culture and more conventional means of artistic expression.

The project's plan consists of six satellite spaces designed in simple forms (cube, cylinder, etc.) around a much larger, lower rectangular meeting hall, most of which is not defined by a fixed purpose. The six peripheral buildings contain specific programs (media library, indoor parking, small-business development, artist residences, university extension, outside activity area). Connected by bridges leading to the central hall, they not only act as subordinate service spaces but also as links between the city and the institution. The central hall is an ambiguous space, as if it were designed for all possibilities, contained within two protective surfaces. The first is a concrete slab raised off the floor, beneath which are the reception, assistance, and delivery areas, and the service core. This slab is pierced with three kinds of openings, varying in size, through which electrical, informational, and water ducts can pass, as can natural ventilation, and it slopes south to accommodate the spaces of what, for now, are two theaters. The second surface is the building's outer one, a slightly asymmetrical envelope with a strange shape that borders on shapeless, vaguely reminiscent of a car body or a mound of earth. This sheath, forming the hall's exterior walls and roof, is made of hundreds of opaque metal panels mixed with translucent glass panels, the latter scattered irregularly in accordance with certain reference points (above the slab's ventilation openings, above the entry stairway) and somewhat more concentrated on one side, reinforcing the asymmetry of the protective shell. But one of the biggest innovations lies in the building's structural framework, a flexible system of multidirectional beams supported by movable posts. Thus, because the hall is not permanently subdivided into a fixed allocation of spaces by fixed rows of posts, it can be easily transformed to meet changing needs.

Enclosed between these two layers are two kinds of spaces: a series of relatively permanent spaces (such as the theaters) around the sides, and temporary installations (studios and labs) in the middle. Water and energy come from the floor, heat and light from the envelope. The temporary spaces—which, it is hoped, will constantly evolve and change—will not be developed according to a plan but just a few rules: for example, the 27-by-27-meter maximum beam span, or the need to keep nine of twelve ventilation openings unblocked. Like the image of the *chora*—described by Plato as the world's original protective shell, beneath which it continually evolved— the architecture here is conceived as a gigantic amniotic space in which the true building, the "village," can appear and grow.

RICHARD SCOFFIER
Translated from the French by Molly Stevens.

Selected Bibliography
Michel, Florence. "Le Métafort d'Aubervilliers," *Archicréé*, no. 272 (August–September 1996), pp. 44–49.

FACING PAGE Metafort Media Research Center: Architectural model, viewed from above, showing arrangement of six satellite spaces around the central hall

LEFT Metafort Media Research Center: Computer-generated light diagram

RIGHT Computer-generated image of central hall and the six satellite spaces, as seen from above

LEFT Computer-generated image of central hall's interior

RIGHT Computer-generated image of structural elements, shown in plan

LEFT Computer-generated image of prototype of central hall's outer skin (detail)

RIGHT Computer-generated image of central hall's outer skin (detail), showing distribution of opaque and translucent panels

RIGHT View of model, showing two of the satellite spaces in front of the large central hall

LEFT Interior of model, seen from above, showing reception area, technical service cells, and "igloos" beneath the central hall

LEFT Metafort Media Research
Center: Interior of model (detail)

RIGHT View of model, showing
overall disposition of spaces

LEFT View of model, showing central hall flanked by satellite spaces

RIGHT Computer-generated image
of support structure (detail)

LEFT Interior of model, seen from
above

RIGHT Computer-generated image
of reception and service areas
beneath the central hall

LEFT Computer-generated image
showing structure of central hall's
concrete platform

RIGHT Computer-generated image
of the central hall's outer skin
(detail)

UEFA HEADQUARTERS, NYON, SWITZERLAND

1994—PROJECTED COMPLETION DATE 1999

The UEFA (Union of European Football Associations) stands on the edge of Lake Leman, amidst other business headquarters. But rather than projecting assertively from the flat part of the site, the building is sunken into the natural slope of the land, giving the appearance of being little more than an open public terrace over the water, facing Mont Blanc. Thus, the site seems to be liberated from all constructed event. At the very ends of the long terrace platform are two boxlike wings (one for the executive committee room, the other for special ceremonies that extend to the outside), which rise slightly above the flat surface, framing the mountain view and acting as the building's only "façade." As a result, there is an initial reversal between form and background, between object and context. The building recedes as an object and serves instead as a referential horizon, behind which the mountain range, with its jagged peaks, becomes more prominent. This is not just a strategy of self-effacement but a way of dramatizing architecture's original sacrifice of itself as pure sculpture, which ensured its singular place among the other arts: primarily, according to Hegel, by not creating forms placed beneath the eye, but rather by defining underlying plans that guide or facilitate all vision.

The building consists of three platforms above a basement level on the ground, with the terrace on the top platform and the lobby on the one below it. Elevators, escalators, and stairs are contained in a narrow glass-covered "canyon" that cuts through the middle of the platforms and runs the length of the building. The supporting structure for this symmetrical, rational spatial partition is based on the archetype of the table, with the supports in the middle: two rows of rectangular concrete piers (with the "canyon" in between), which are set back deeply from the building's front and back edges and disappear into the bands of technical service systems above, while the steel beams vanish beneath the terrace. Looking at the front or back from outside, no structural supports are visible; the interior spaces seem to be defined only by the glass envelope enclosing them and by their floors. Furthermore, each level is supported in a different way: the top platform rests on the concrete piers; the middle platform hangs from the top platform's structural framework; the lowest platform rests on the basement level; and the basement level rests on the ground. Thus, behind this apparent simplicity lies a genuine ambiguity.

This object maintains its inviolable specificity and mass in the very action in which it melds completely into the context. Only the unutterable is to be spoken, only the indescribable will be formalized. Thus, the form fades before the background, only to return again and again. And, gravity seems to be refuted constantly by the expression of weightlessness and therefore can better assert itself in the fragile transparency that gravity makes possible.

RICHARD SCOFFIER

Translated from the French by Molly Stevens.

PATRICK BERGER
(b. 1947, Paris)

Berger graduated from the University of Paris in 1972, and then traveled to Nepal with a team of anthropologists from the National Organization for Scientific Research. After returning to Paris and establishing his own practice in 1974, he renovated the Le Palace theater with painter Gérard Garouste and constructed several small residential buildings. Berger has won international competitions for the design of the France-Japan symbol (1989), the National Theater in Blois (1991), and the revitalization of the historical center of the city of Samarkand (1991). With landscapist Gilles Clément, he designed the Parc Citroën-Cevennes (1985–92). He has also designed the School of Architecture in Rennes (1986–90) and is currently building the headquarters for the Union of European Football Associations (UEFA) on Lake Leman in Switzerland. He has been a professor since 1992 at the École Polytechnique in Lausanne.

His approach is charged by a quest for meaning—in his case, by pursuing two evocative paths: first, a return to basics, through the revival of traditional urban forms or the use of simple shapes, such as the monumental table he designed for the France-Japan symbol; and second, the use of materials according to their characteristic properties—for example, granite (chosen for its weight) for the colossal base of the Rennes school of architecture. By playing with such archetypes and basic ideas, Berger is able to bring out from banal or traditional forms the unconventional clarity of their original models. Thus, the most commonplace elements seem to emerge from the space as if for the first time and form a horizon of expectation, a point of reference that can give meaning to the most trivial gestures of everyday life.

Selected Bibliography

Lacan, Jacques and Richard Scoffier. "Portrait: Patrick Berger," *Le Moniteur architecture*, no. 64 (September 1995), pp. 52–60.

Lacan, Jacques. *Patrick Berger: Oeuvres Projects*. Accademia di archittetura, 1997.

FACING PAGE, ABOVE UEFA Headquarters: View of building from the lake (photomontage)

FACING PAGE, BELOW View of building with lake and mountain behind it (photomontage)

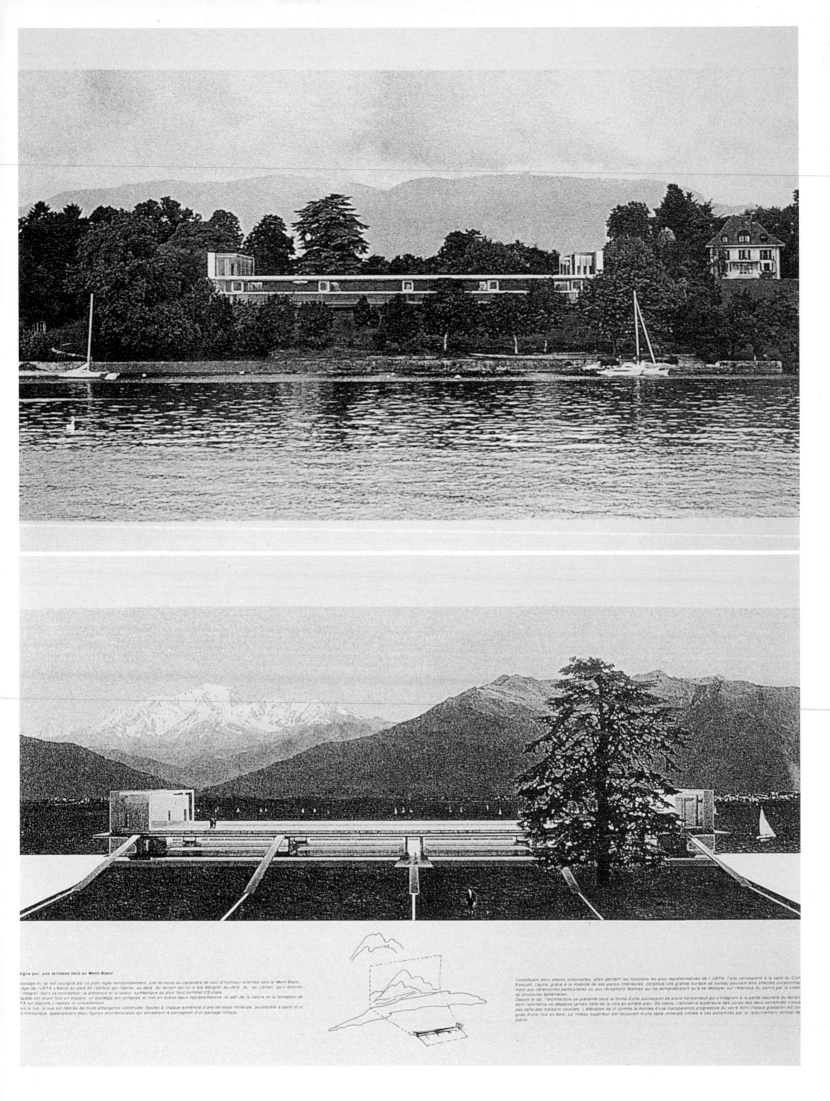

signe pur, une terrasse face au Mont-Blanc.

paysage du lac est souligné par un plan réglé horizontalement, une terrasse au caractère de cour d'honneur orientée vers le Mont-Blanc. vage de l'UEFA s'étend au delà de l'édifice qui l'abrite; au-delà du terrain qui lui a été désigné, au-delà du lac Léman qu'il domine. intégrer dans sa conception la présence et la valeur symbolique du plus haut sommet d'Europe. façade est avant tout un espace, un paysage qui compose et met en scène deux représentations: le défi de la nature et la fondation de FA sur laquelle il repose ici virtuellement. ... la rue, la vue est libérée de toute émergence construite. Seules à chaque extrémité d'une terrasse minérale, accessible à partir d'un n thématique, apparaissent deux figures architecturales qui encadrent la perception d'un paysage unique.

Constituant deux pièces solennelles, elles abritent les fonctions les plus représentatives de l'UEFA: l'une correspond à la salle du Com Exécutif, l'autre, grâce à la mobilité de ses parois intérieures, constitue une grande surface de bureau pouvant être affectée occasionnel ment aux cérémonies particulières ou aux réceptions festives qui ne demanderaient qu'à se déployer sur l'étendue du parvis par la créa de structures éphémères. Depuis le lac, l'architecture se présente sous la forme d'une succession de plans horizontaux qui s'intègrent à la pente naturelle du terrain dont l'altimétrie ne dépasse jamais celle de la voie en arrière plan. De même, l'altimétrie supérieure des voiles des deux extrémités n'excè pas celle des maisons voisines. L'élévation se lit comme la montée d'une transparence progressive du verre dont chaque gradation est so gnée d'une rive en bois. Le niveau supérieur est recouvert d'une table minérale limitée à ses extrémités par le retournement vertical de pierre.

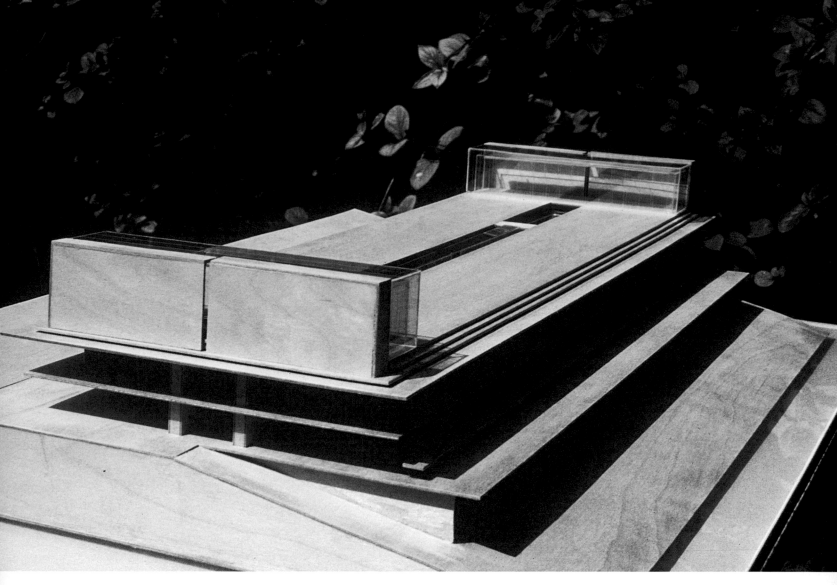

ABOVE UEFA Headquarters: Study model for second phase of the competition, showing the building's four levels. The top level is the terrace; and running through the middle of the terrace, between the two flanking wings, is the glass roof of the "canyon" containing stairs, elevators, and escalators

BELOW View of the terrace with lake and mountain behind it (study drawing)

Four study drawings (TOP TO BOTTOM): View of interior, showing concrete supporting piers; terrace with elaboration of one wing; frontal view showing the three platforms; sketch showing relationship of building to lake and mountains

LATAPIE HOUSE, BORDEAUX
1992-93

On a residential street on the outskirts of Bordeaux is an unlikely object: a house, built for less than 400,000 francs (about $70,000—less than what is usually spent by companies that specialize in prefabricated detached homes). Everything seems to have been calculated to the nearest penny so that the maximum amount of livable space can be offered for the minimum price. The architects, Lacaton and Vassal, rework the most unexpected technologies and industrial elements: agricultural sheds covered with panels of corrugated fibro-cement, greenhouses made of polycarbonate, industrial concrete floors, and so on.

This object seems to be structured around the notion of multiple encasement. Inside the outer envelope—the street side of which is opaque, and the garden side transparent—there is a more complex box, divided into two levels. This box encloses the traditional living spaces, in the middle of which is a service core containing stairways and rooms with running water (bathrooms, kitchen). However, the different spaces are not established as autonomous forms, but as "in between" spaces: between the box's service core and its wooden covering are the garage, kitchen, living area, and bedrooms; between the outer envelope and the back of the box is the enclosed terrace. This enclosed terrace, which retains heat in winter and can be ventilated and even protected from summer's insufferable sun, acts as an important supplementary space in this plan regulated by the principles of economy. It expresses the paradox of maximum space—which is not the opposite or symmetrical counterpart of the minimal space—sometimes using a maximum of means, as has been fancied for unlikely "proletarians" or "homemakers" by advocates of architectural modernity, from Ginsburg to Le Corbusier. The maximum space is unfixed, indefinable; it refuses to adopt limited gesture and usage. If a work does in fact determine a particular use—leisure activities, vacation, idleness—it does so only by defining the possibility or promise.

Thus the Latapie House, neither really inside nor outside, proves that it is impossible to reduce the resident to a utilizer, to reduce man and woman to a mere resident. It embodies Derrida's notion of "supplementarity"—which prevents an entity from being closed off, objectified—causing it to become something other than just a simple dwelling. The rational plan of the design, in which the utility and cost of each component seems to have been carefully considered, is exaggerated to the point where loss is transformed into luxury. As if this house, assembled in a distant suburb, expressed the hyperrealist retranscription of those noble utopias in which absolutely everything was to be possible, or were reminiscent of liberated environments by Buckminster Fuller, Cédric Price, and others.

RICHARD SCOFFIER
Translated from the French by Molly Stevens.

ANNE LACATON
(b. 1955, Saint-Pardoux-la-Rivière, France)
JEAN-PHILIPPE VASSAL
(b. 1954, Casablanca, Morocco)

After graduating from the Bordeaux School of Architecture in 1980, Lacaton and Vassal worked for three years at the architecture firm of Jacques Hondelatte. In 1987, they opened their own firm in Bordeaux, and have designed and built several private homes in the Gironde, and the Arts and Sciences building at the Université Pierre Mendés France in Grenoble (1993–95).

Their work seems to be characterized by a desire to return to the basics. The first project by these very atypical architects was the construction of a wood and straw hut in Nigeria (1983). The question of shelter, of the cabin, continues to inform all of their later work—as if, far from bourgeois notions of comfort and well-being, thoughts on the first refuge, scribbled in the margins of the history of architecture, from Vitruvius's primitive hut to Le Corbusier's vacation cottage in Cap Martin, could allow us to define the ultimate meaning of all things built; as if from the most utilitarian would necessarily come the most poetic. Another aspect of this approach is their propensity for borrowing the construction techniques and inexpensive materials used to build warehouses and other industrial buildings, a strategy that recalls the use of humble materials by the Arte Povera artists thirty years ago. Lacaton and Vassal also employ vegetation and flowers, living and changing nature, using them as substitutes for traditional architectural moldings, as in the bougainvillea and bamboo façades at the University of Grenoble.

Selected Bibliography

Tonka, Hubert and Jeanne-Marie Sens. *Une maison particulière*. Paris: Sens et Tonka Éditeurs, 1994.

Lacaton, Anne and Jean-Philippe Vassal. *Il fera beau demain*. Paris: Institut Français d'Architecture-Carte Segrete, 1995.

FACING PAGE Latapie House: Interior of enclosed terrace at rear of house, showing the fluid relationship between the two spaces

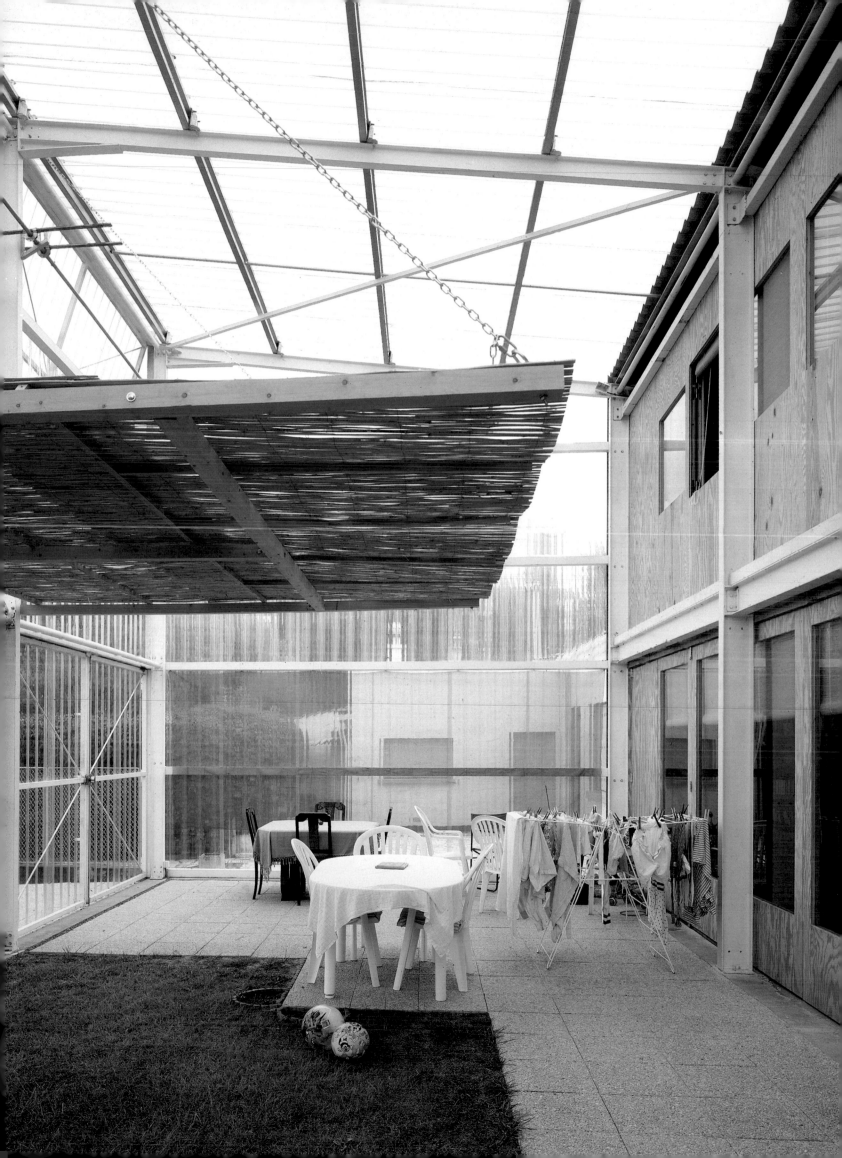

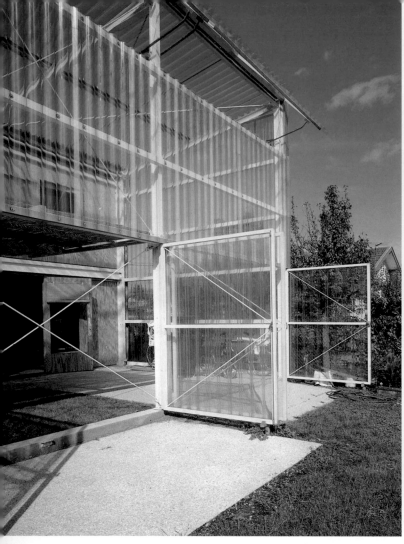 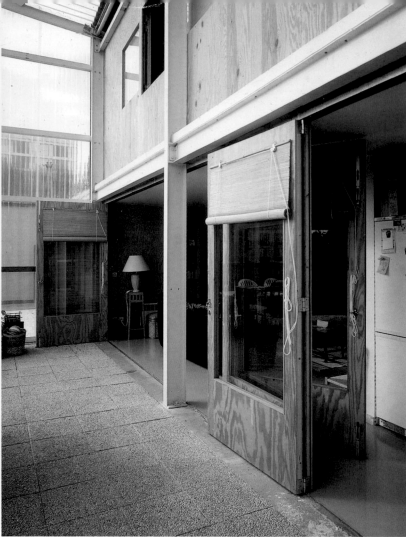

ABOVE LEFT Latapie House: View of enclosed terrace with polycarbonate panels open

ABOVE RIGHT The rear of the "wooden box" enclosing the living areas, and the transition to the enclosed terrace

BELOW LEFT Front of the house, with protective corrugated panels open

BELOW RIGHT Front of the house, with protective corrugated panels closed

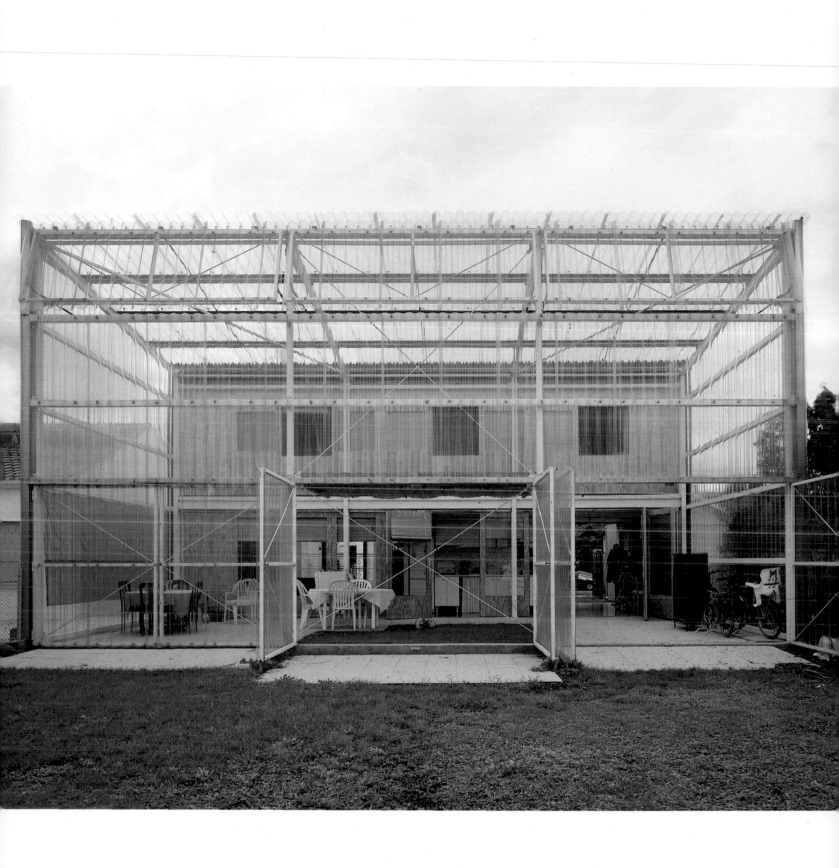

ABOVE Rear of the Latapie House, showing terrace enclosed by transparent polycarbonate

RURAL HOSTELS, JUPILLES
1996-97

These hostels between town and forest are a comment both on the anarchic way buildings are scattered through the countryside and on the standardization of single homes. Here, François and Lewis explore the possibilities of a landscape typology, taking the model of the hedge—which has easily established itself in the countryside —as a basic spatial element capable of transforming the terrain. By making use of this plant model, they temper the violence inherent in any occupation of a site, in the act of building; the boxlike structures they have added here, with their plant-life extensions, create a context that can easily be grafted onto the context of the host site. Trees and their trunks form a protective layer around the boxes mounted on poles. The construction is very simple, and the cost is reduced to its minimum by utilizing poor materials that make it easy to build: concrete structural framework, pine beams, and pine floor. However, although these boxes are extremely severe in form, they bear no resemblance to anything purist or minimalist. The rigor of standardized woodwork is largely offset by a certain element of uncertainty: the irregular rhythm of the boards covering the industrial frame on the ground floor, window frames of various sizes on the second floor. Here again, the issue of economy results in a critical strategy, with materials and methods employed outside of their traditional uses and introduced in new combinations. Rough-hewn logs, cinder-block walls, polished-cement floors: this approach to materials stems more from the research of Beuys, Anselmo, Fabro, and other artists thirty years ago than from Brutalism. The designers, without hypocrisy, borrow from the radical experiments of sculptors, including themselves—one of the strengths of their approach.

Having no desire to impose an aesthetic on the public, they recycle the craving for nature that has become popular, but with a measure of irony. Today, the hostels in Jupilles place within our reach Archigram's utopian propositions, which predicted a true-false nature in which devices and technology placed in tree trunks and rocks would determine the shape of architecture. But this playfully distorted nature is not "natural" nature—it is nature in motion, a naturalizing nature, like the one embodied in the works of sculptors Giuseppe Penone and Richard Long. Thus, these constructions incorporate seasonal rhythms by using a deciduous tree or rotting materials, eroding away like wood. The fundamental idea of the relationship between architecture and time, which has been totally obliterated by modern architecture, is preserved when living materials are used.

Awareness of context, the notion of anchorage, a relationship to time, to otherness—all of which determine the specificity of architecture—are taken into account here. François and Lewis have successfully realigned their approach around simple problems and have dealt with Vitruvius's notions of solidity, comfort, and delight from a new angle—that is, by constructing these comfortable, moderately priced buildings that merge with the landscape, and whose radical poetry is accessible to all.

RICHARD SCOFFIER
Translated from the French by Molly Stevens.

ÉDOUARD FRANÇOIS
(b. 1957, Boulogne-Billancourt, France)
DUNCAN LEWIS
(b. 1960, Wallsend, Newcastle, England)

The work of François and Lewis features humble materials such as cinder blocks, polished concrete, rough-hewn logs, and sheets of PVC, and seems to attest to a desire to create an economical, basic architecture—something between an improvised construction and a shantytown, between "architecture without architects" and a child's treehouse. A bridge covered in foliage, treelike beams amidst the boughs of living trees, a transparent plastic awning supported by bamboo to shelter a few water lilies, plant-covered boxes strewn at random along the edge of a forest—these elements, which they used in their designs for the A86 viaduct in Saint-Quentin-en-Yvelines (1993–94), an addition to a school in Thiais (1994–95), the Chaumont greenhouse (1996), and the rural hostels in Jupilles (1996–97), respectively, all originate in this quest for a basic architectural language that almost everyone would be able to apply or at least understand.

But beyond poor materials and simple forms, these young designers, who refuse to regard architecture as something urban, confront the question of landscape head-on. Disregarding all militant ideology and neoregionalist thought, they attempt to give the natural environment appropriate architectural expression. Their foliage constructions are a true reflection of this new feeling for nature, which runs through the books of Bernard Rudofsky (on vernacular architecture and animal dwellings), the fantasies of the American architecture studio SITE (which stands for "Sculpture in the Environment"), and the radical experiments of Earth Art and Arte Povera.

Selected Bibliography
Rambert, Francis. "Des journées entières dan les haies," *d'Architectures*, no. 65 (May–June 1996), pp. 28–29.

FACING PAGE Façades of rural hostels at Jupilles, covered with living trees

ABOVE Rural hostels at Jupilles: View of site, showing hostels blending into the national environment

RIGHT (AND FACING PAGE, RIGHT) Interior of one hostel, with tree wallpaper, polished concrete floor, and a cowskin rug

FACING PAGE, LEFT Window of a hostel with tree wallpaper visible inside and real trees outside

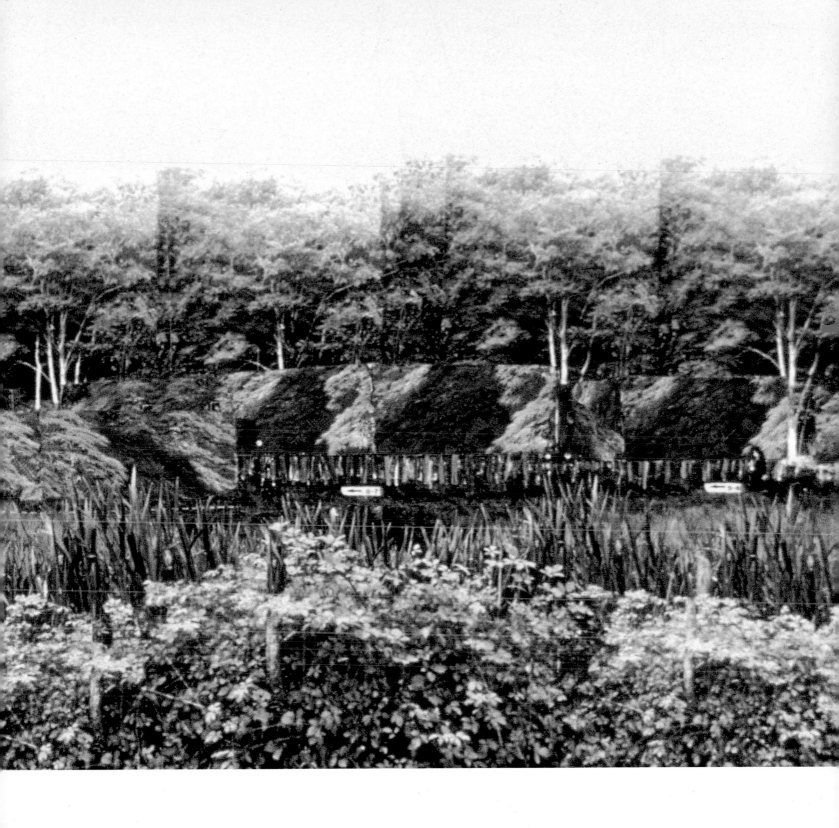

REDEVELOPMENT OF UNIMETAL SITE, CAEN
1995-98

DOMINIQUE PERRAULT

In Normandy, a 700-hectare (172-acre) area outside Caen—a third of which is the industrial wasteland of an old steel plant that closed in 1993—has been studied for pre-landscaping in anticipation of proposed redevelopment construction in the distant future. Like Roman land surveyors, Perrault has superimposed over the site a grid of 100-by-100-meter squares, giving it a geometric reference as well as a scale, but ignoring the local conditions. The general design plan recalls Ivan Leonidov's competition entry for the master plan for the city of Magnitogorsk (1930), with its three-row grid of squares. But Perrault's basic plan here stems equally from Carl Andre's modular compositions, especially his floor pieces such as *Tin Square*. In a similar way to these Minimalist works, the architect uses this idea of setting aside a plot of territory that is simply marked by a few lines of a basic geometric plan. For the moment, there will be no spatial effect (i.e., no three-dimensional change), since some of the squares will be covered with grass, and others in gravel. Meanwhile, for financial reasons, the rest of the squares will be left as they are. Facing the city, along the banks above the river, a planted path forms a picturesque border that encloses the entire tract.

In the middle of the tract, there is an enormous rectangular prairie that does not conform to the grid, clearly a reference to the work of Frederick Law Olmstead and Calvert Vaux in Central Park. (This strategy was already used, not long before, by Christian de Portzamparc in his competition entry for Sector IV of the new town of Marne-la-Vallée [1989] and by Perrault himself in his unbuilt design proposal for the Stade de France in Paris [1993].) As if there were an impenetrable barrier between the grid area and the rectangular prairie, there is no gradual transition between the two; nor is there any sense that the prairie is intended as the center of a composition. For now, the prairie is merely a simple accent within the grid's homogeneous realm, yet the possibility remains open for it to be developed as an area for holding events.

Perrault often repeats the expression, "The further it goes, the more architecture is of no importance to me," which echoes the one asserted by Le Corbusier in 1930, once the "architectural revolution" had occurred: "It is the era of large-scale programs that is beginning; it is urbanism that is becoming the dominant preoccupation." Large-scale projects allow Perrault to abandon questions of form and aesthetics in favor of ideas about territorial use and the urban fabric. The sprawling expanses that he considers, in terms of landscape and nature (already artificial), are dealt with through geography—that is, in terms of networks, topography, and migration. In such ways, the cultural and historical approach to land use is short-circuited by Perrault's direct way of perceiving and understanding any territory being considered for development, without regard to memories of the site.

MARC BÉDARIDA
Translated from the French by Molly Stevens.

Selected Bibliography

Perrault, Dominique. "A Propos des Villes," *Techniques and Architecture*, No. 429 (January 1997), pp 32–35.

"Restitution des Paysages," *Le Moniteur*, No. 4862 (January 31, 1997).

Dominique Perrault. Barcelona and Zurich: Editions Actar-Birkhäuser, 1998.

FACING PAGE Two views of the Unimetal site near Caen, showing Perrault's simple grid treatment of the land and the planted border (photomontages)

FOLLOWING TWO PAGES Detail showing intersection of two paths in the grid

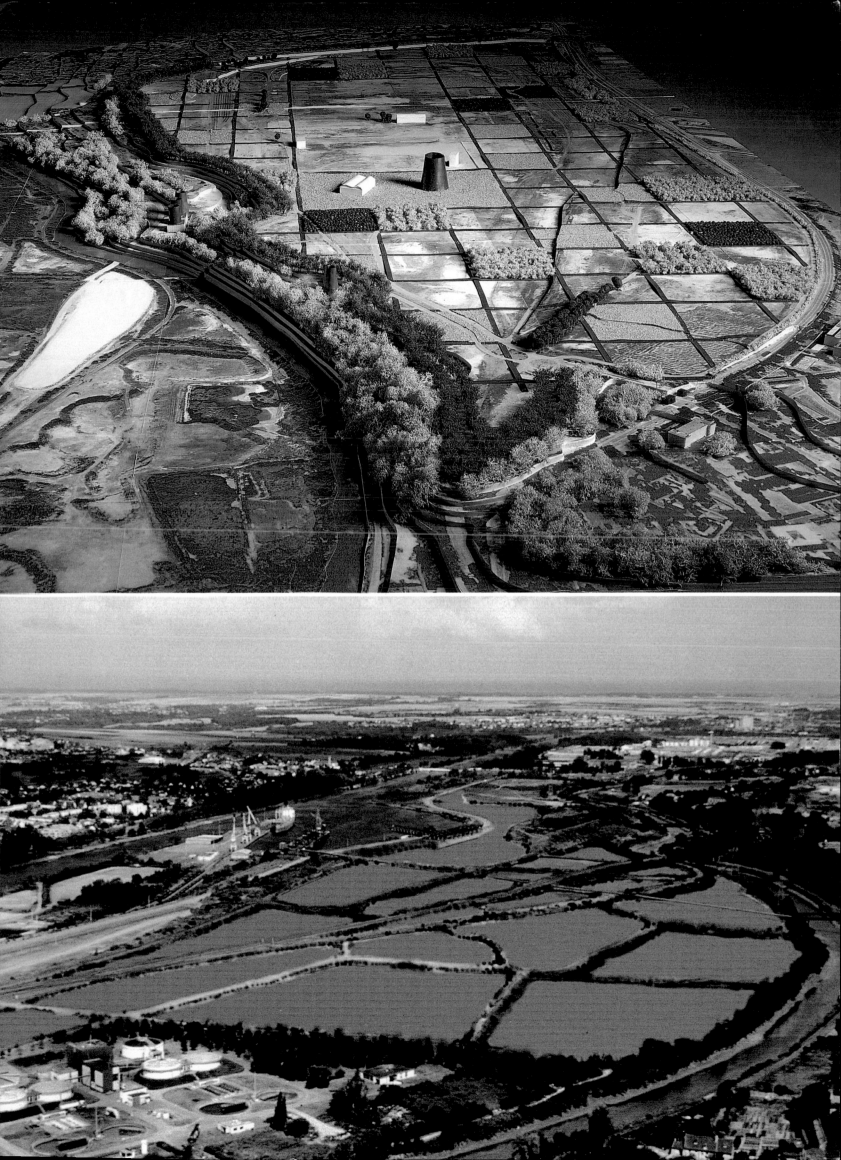

DESIGN

TOWARD A SEMANTIC AND CRITICAL APPROACH TO THE TERM DESIGN

SOPHIE TASMA ANARGYROS

Arriving at a concrete definition of the term *design* can prove problematic, especially in France. Design does not fall within the category of fine arts; it refers to neither architecture nor the plastic arts. Moreover, the word can be applied to an almost infinite range of objects—from a fork to a train, from a chair to a computer. . . . Although the technological demands of the design of such complex machines as the train or the computer do beg the question: Where does the role of engineer leave off and that of designer begin?

Whereas the term in French seems to defy a paradigmatic reading, the British and the Americans have developed a more precise terminology for design, one that specifies various types of design, including graphic design, fashion design, and furniture design. Design in Italy is subject to another approach altogether. Italy's most famous architects are as likely to design an armchair as they are a bank; they might oversee a periodical or teach at a prestigious university. In Italy scale is not an issue; the disparity between large- and small-scale projects does not enter into the equation. An idea, a conceptual process, is at the core of every new design problem.

The ambiguity of the French term, however, is not without interest. On the one hand, it clearly reflects a morality (a moralizing, as opposed to an ethical stance) with respect to the object: The designer's object is intended for business,

therefore it does not pertain to the world of art. (The design movement of the 1980s has played upon this distinction, or rather, on its erosion.) On the other hand, the ambiguity of the term leaves the designer's field of investigation wide open to interpretation. Take the production of Philippe Starck, for example, which ranges from a pair of eyeglasses for Mikli to entire buildings, from communications equipment for Thomson to interior design, book layout, and packaging for sports shoes. Undoubtedly one of the most gifted French designers, he rarely works in France, as he presents the French with an image that is confusing to them, one that defies the strictures imposed on the term.

Is this resistance to the narrow conception of the term design in France culturally based, or does it have its roots in semantics? Is the object an entity in itself, or does it immediately become subsumed within a relationship, a network of meaning? The term *environment* allows all design practices to be brought under one umbrella. Objects, domestic space, public space, civic space, national territory—all take their measure from the concept of the body, as well as from its primal, archetypal presence. Whether a communal space with or without a common center, whether textiles for clothing, material for seating, the language of a tool, the proportion of a room—every object, every structure, enters into a dialogue with the body as well as the space it inhab-

its. And space, of course, can never escape its political, social, and cultural implications.

Design thus finds itself at the intersection of many disciplinary paths, and essentially cuts through every one of them. It touches on both the public and the private; in business it plays a pivotal role in terms of both the product itself and the image it projects; it has the most intimate relationship with use, and yet makes reference to the imaginary; it utilizes, explores, and deploys technology, but at the same time it belongs to the realm of illusion. Despite protests to the contrary, design is repudiated in relation to "pure" art. And yet the greatest artists have resorted to the parameter that basically defines the term design: the knowledge of the real. For this episteme holds a power over the work, whose mediator or prism it becomes. And if, since Marcel Duchamp, artists have placed the object at the heart of the work, it is because the object itself contains a crucial aspect of presence, a modest, anonymous trace of humanity, a souvenir of some past action.

The term "design" is also used to designate a particular style, whether the soft, psychedelic chair of the 1960s, the orange plastic of the 1970s, the streamlined black and white of the 1980s. For beneath the surface of the layers of meaning specific to any one culture or way of thought, design "designates." In a complex system of representation that incorporates forms, functions, usages, and symbols, design designates the state of a society, its technology, its achievements, its costumes, rituals, and signs; design nominates a culture discreetly in its formulation of objects.

Acceleration—Vertigo

The year 1979 saw the founding of the Milanese group Alchymia. Led by Alessandro Gueriero, with architects Ettore Sottsass Jr., Andrea Branzi, Alessandro Mendini, Michele de Lucchi, and Paola Navone, Alchymia emerged from the radical design movement of the 1970s, which was based on the principle of a utopian city and inspired by American earthworks, Conceptual art installations, and avant garde happenings. Towards the end of the '70s, Alchymia dispersed, giving rise in the '80s to the design group, Memphis. Memphis, centered on Ettore Sottsass Jr. Group, International, and included among its members European, American (Peter Shire), and Japanese (Shiro Kuramata) designers, proclaimed the internationality of its influences, communication, and thought— among industrialized countries, that is.

This movement created a true rupture in design, ushering in a new era that reversed the previous values of form following function. It was a revolution created by the information highway that introduced the possibility of objects

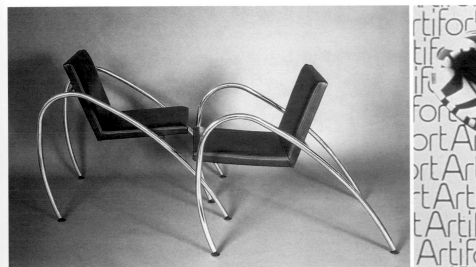

BELOW LEFT Nemo, *Moreno Marini* armchair, 1982. Collection Fonds National d'Art Contemporain, Paris

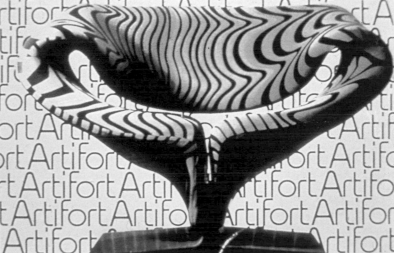

BELOW RIGHT Pierre Paulin, *F 582* chair (known as the "ribbon chair") for Artifort, 1967. Collection Musée national d'art moderne, Centre Georges Pompidou, Paris

whose function was disembodied and disconnected from their appearance. The 1980s brought an irreversible break with tradition from that of the ancient to the modern. Looking back, the approaches of the 1960s and '70s seemed to have harkened from a past that has now completely elapsed. This is confirmed by current trends in fashion and interior design, and exemplified by the recuperation of certain antique design objects and mixing them with contemporary ones—a sign of both romantic reappropriation, a nostalgia for the past in an attempt to compensate for major upheavals of the present, and of "the acceleration of the acceleration." This nostalgia characterizes the political, ideological, and economic vertigoes of today, as well as those engendered by the third industrial revolution that encompasses the information highway: instantaneous information, the virtual, the invisible, the concept of immateriality, and the advent of what Guy Debord called, "the society of the spectacle," or what architect Jean Nouvel calls, "the aesthetic of the miracle."

During the '80s, intellectuals and critics announced the end of "design" and the vogue for the object, a philosphy that seemed to go hand in hand with the illusory economic euphoria preceding an already looming crisis. With the advent of the '90s came a new understanding of the word *design*—an attempt to define a new ethics in the practice of the discipline—a direct response to the acceleration of the world.

The Impossible Legacy of the Modern Movement

If one looks back at the history of design in Europe, keeping in mind that the term arose with the advent of the industrial age, it becomes clear that all design movements from the beginning of the century prepared the way for the investigations of the 1960s and '70s. As Sylvain Dubuisson put it:

All the inventions of the nineteenth century—the lightbulb, photography, the cinema, the automobile, the locomotive, and later, the airplane—have lasted without major new developments until the appearance of the computer chip.

The twentieth century has been living on the acquisitions of the previous century, until the '70s, when the aesthetic apparatus of the "black box" appeared. The other element that characterizes the beginning of the '80s is the end of a single style, or at least, the appearance of a mosaic of styles as well as the absence of models, which goes hand in hand with "the disappearance of great ideological narratives."

Of this mosaic, Modernism has persisted, until very recently, to radicalize form and to remove every system of symbols that do not pertain to the structure of the object, itself a mirror of function. Argentine painter Tomàs Maldonado, who played a role in determining the intellectual direction of the school of Ulm, founded in 1955, shows how pervasive the influence of the Bauhaus remained until the 1960s with his definition of the activity of designing: "Creative activity consists of determining the formal properties of mass-produced objects. By formal properties, we mean not simply the external characteristics but, more important, the structural and functional relationships that make a coherent entity of an object."

These influences stem from the beginning of the century, when the newly dethroned Art Nouveau movement struggled to exist in a shifting market subjected to the fluctuations of the birth of modern advertising and invaded by the introduction of the standardized objectthat was sold through catalogues. Art Nouveau aimed to develop a style inspired by nature and placed an emphasis on the collaboration of the artist and artisan. However, around 1900, the rejection of academic styles produced a major transformation in European design; this metamorphosis emerged from the Arts and Crafts movement, whose primary promoter was Englishman William Morris. Hence arose the school of Nancy in France, whose proponents were E. Gallé, Louis Majorelle, and Victor Prouvé; Belgium's V. Horta and H. Van de Velde; Spain's Antonio Gaudí; the Vienna Secession in Austria, led by J. Hoffmann, with Gustav Klimt, Kolo Moser, Olbrich, Otto Wagner; and the Glasgow school in Scotland, founded by C. R. Macintosh.

These currents coincided with the "exotic" inspirations

Weimar, Le Corbusier and Ozenfant proclaimed the principles of the Esprit Nouveau, later joined by Pierre Jeanneret and Charlotte Perriand. Technological achievements in industry and civil engineering unfolded continuously. All this rich, diverse, and abundant creative ferment would have consequences for art, architecture, and design not only in the 1950s with the spurt of technological advances that occurred in the postwar period, but also in the 1960s and '70s, and significantly, in the '80s. It is possible to think, as Sylvain Dubuisson conjectures, that Modernism was no more than a vast laboratory of experiments, which incorporated the achievements of every postwar period up to the first break of the oil crisis of 1972. It then produced, under a more varied form, whether nostalgic or analytical, multiple or accelerated trends that arose during the same time the cold war ended, the Berlin Wall fell, and the conflicts of the 1990s were beginning. The irony of the Modern movement is that the underlying theory of mass production developed without actual mass production occurring on either an international or social scale, in spite of the fact that this was ostensibly its goal and its end. Instead, Modernism produced isolated visionary projects that were put into a practice after a time lapse had signaled its decline.

The 1960s and 1970s: Creation, Utopia, Crisis

The "ideal city" of Le Corbusier proved a catalyst for both the best and the worst in architecture—although mostly the worst—which appeared in the form of a conventional functionalism and exemplified by the gated communities of the 1960s and '70s. Improbable as it seems, these communities paralleled the movement of contemporary architecture as a whole.

In design, a number of creators made their mark doubtless more by virtue of their approach than by a style that often became quickly outdated(or in any case, dated). This was not the fate, however, of the one-of-a-kind pieces rediscovered at the beginning of the '80s, which were produced

of Japonisme and African art, a legacy of the discoveries made at the world's fairs at the end of the nineteenth century. Sue and Mare, Ruhlmann, R. Adler, Jean Michel Frank, and Eileen Gray envisioned a "total art". Art Deco, a stylization of nonorganic and Art Nouveau forms and representing a radical break with the nineteenth century. Even though the formal language of cabinetmaking and marquetry techniques perpetuated the "classics," Pierre Chareau, Gray, R. Mallet Stevens, among others, explored new materials and reexamined the fragmented bourgeois spaces inherited from the style of Haussmann.

In 1907, Muthesius instigated the creation of the Deutsche Werkbund in Germany, with the goal of reuniting art and industry. Walter Gropius, Joseph Hoffmann, and Henri Van de Velde participated in the birth of the functionalist Modern movement. Other avant-garde Modern movements appeared: De Stijl in Holland, led by Theo Van Doesburg, with Mondrian, and G. Rietvelt; the Futurist movement in Italy; and Constructivism in Russia. In 1919, when Walter Gropius was chosen to found the Bauhaus in

either on a large scale or in limited series by Ecart and signed by the greatest names of the first half of the century: Van de Velde, Rietvelt, Gaudí, Gray, Mallet Stevens, Mariano Fortuny, among others. Every European capital experienced the '60s as a time of euphoria and creativity, especially in the fields of literature, cinema, and fashion. This era came to an abrupt close in 1972, soon after the potent rupture of May 1968.

Throughout this period, the design world not only explored the use of plastic materials but also a myriad of different living styles, as well as the concept of making things light, movable, and inflatable. Roger Legrand envisioned "Pan U"—elements that could be combined and assembled in an infinite number of ways. This is a concept that recalls, on a different scale, the floating utopian cities of the contemporaneous radical Italian movement. Roger Tallon, the uncontested leader of a certain kind of technical design, introduced his plywood folding chair, which has become a classic, and is still produced today by Sentou; later, between 1972 and 1976, he realized the interior design of the Corail train. Marc Berthier conceived the most popular item of the '60s with "La Ruche," a system of compartments made of wooden modules. Olivier Mourgue's series of seating furniture, *Dijin,* represented the image of a futuristic modernism in Stanley Kubrick's film *2001: A Space Odyssey.*

Plastic was in its glory. A material that could take on any shape and color, it invited an anthropomorphic approach that modified existing systems of symbols through an altered relationship to the body and space. Only Italian architect Gaetano Pesce, who is currently living in New York, has continued to pursue his creative and subversive investigations of plastic to the extent to which his colleagues were experimenting during the '70s developing a veritable theory of production and application for new materials.

Italy's Archizoom introduced inflatable systems and the use of cardboard and paper as a response to the incipient trend toward "lightness." In 1964, Prisunic, the French equivalent to Woolworth's, published its first catalogue of furniture, which included pieces produced by Terence Conran, Mourgue, Berthier, Marc Held, and Gae Aulenti. Maffia, the first studio to combine style, design, and advertising, which was founded by Denise Fayolle and Maïmé Arnodin, and soon joined by Andrée Putman, foreshadowed the politics "of communication" that would arise in the '80s. Always prudent, Italy reissued Le Corbusier at Cassina and produced Macintosh and Rietvelt. At the end of the '60s, exploration shifted toward a new mode of habitation with furniture that either approached the floor or was integrated into it. France received the grand prize of the Milan Triennale. François Arnal created Atelier A, which brought together a great number of artists in order to create objects that ran counter to the declining and dogmatic movement that extolled "form-function." Knoll realized the greatest success of all, daring to tap the creative talent of French designer Marc Held for his series of *Culbuto* rocking chairs in Fiberglas and polyester.

Le Corbusier's "machine for living" was a catalyst for the modules or containers that were the solution of choice for designers in the early '70s. These closed universes—soft boxes, bubbles of the future without any rough edges with linear waves for contours—expressed a kind of ultimate hedonism, yet at the same time they suggested a withdrawal of the individual of a sort that precedes a slowly approaching crisis. Despite their ingenuity, Mourgue's "Bloc mobiles" (Movable blocks) were exhibited in *Design français* at the Centre de Création Industrielle, and reverted to uniformity and rationalism. The Italians Bellini and Sottsass created mobile environments that were exhibited in New York.

In 1972, the *Italy: The New Domestic Landscape* exhibition at the Museum of Modern Art in New York, introduced the work of avant-garde designers who would lay the groundwork for the 1980s and vigorously upsetting all the rules. These included Sottsass and Pesce, the groups Archizoom, Super Studio, Magistretti and Mendini. In France, design received an official stamp via a series of public commissions: Isabelle Hébey designed the interior of the Concorde; Pierre Paulin designed the interiors of the pri-

vate apartments of the Elysée Palace for Georges Pompidou; and Maïmé Arnodin and Denise Fayolle, always at the forefront, revamped *Les 3 Suisses* mail-order catalogue—renovating its image, means of production, and methods of communication. In 1973, the American model of large-scale distribution, with its accompanying commercial rewards, was initiated in Europe. Habitat, which developed a new strategy of communication, was established in France, and Ikea introduced its Scandinavian ideology that would prove successful throughout the "wood" period. In the United States, the Site group reworked the image of large surfaces with playful, ironic projects, which also signaled a renewal in the field of architecture. Iconoclastic and visionary, Italy's Archizoom paved the way for Memphis.

This was a pivotal period marked by the events of May 1968 and the oil crisis at the end of 1972, during which the artists who focused on the object and who clung to a declining functionalism stood side by side. Design using Plexiglas, brushed steel, and orange plastic seemed pervasive but quickly dated. The second half of the '70s brought silence and reflection invoked by "the return to wood"—an ecological material less expensive than plastic derived from petroleum. The Shaker style was rediscovered and extolled, as was its monkish philosophy; Scandinavian design became fashionable. At the same time, the fascination with lightness and low-key looks grew more pronounced, as did the allure of that which would become Minimalism. In New York, lofts, as well as a new "high-tech" style, became the vogue. This was the beginning of diversity, of a multiplicity of approaches; it signaled the end of a single style, even if this idea of one style had been merely theoretical. The terms *mosaic society*, *plurality*, and *multiculturalism* began to be heard. In 1979, personal computers arrived on the market, and symbolically, the group Alchymia was formed in Italy. Along with Ecart International, whose revivals would enjoy enormous success, Alchymia revolutionized design at the Milan show, and announced the swinging of the pendulum that would mark the beginning of the 1980s.

The 1980s: Invention and Illusion

In 1981, again in Milan, the exhibition *Memphis, A New International Style* launched a movement that would exert considerable influence throughout the '80s on the notion of "style," on how the creation of an object was envisioned, and, above all, on the intellectual understanding of the object and our relationship to it. The *Memphis* exhibition included its leader (or guru) Ettore Sottsass Jr. This opening signaled a break with the functionalist Modern movement, or at least with what had become of it. The furniture and objects offere drew from a range of cultural sources: Futurism, Constructivism, African art, Indian art, comic books, postmodernism, cinema, fashion, literature, Pop, and graphic art. The exhibition celebrated "multiculturalism": the affirmation of the right to reinterpret everything, to see with new eyes, which is at the heart of a curious paradox that combines iconoclasm through the irreverent appropriation of references. Memphis does not claim to revolutionize "function" that haunts the production of designers, but it is concerned, rather, with making apparent an entirely new language of signs and colors. Its intention is to reestablish by means of objects the supremacy of a lost imagination. Function carries little weight; what counts is the object's capacity for representation, its freight of emotion, its propensity for symbol.

In spite of Memphis' enjoyed success, issues of object meaning began to take on an entirely different cast. A question arose: Could the dreamlike, discursive, or simply "arts and crafts" character of an object made in a limited series—

be incorporated into its larger function, whether hedonistic, cultural, or ritualistic, what Martine Bedin later called that of "the friendly object"? For the fact remains that throughout Europe a large-scale revisitation of the language of domestic objects was occurring. All manner of tendencies were being thrown together: dream and memory in the work of Garouste and Bonetti; the destructive tendencies inherent in the cement compilations of Ron Arad; the unfettered humor of the creations of Javier Mariscal; the minimalism of the typographic furniture of Martin Szekely; the cult of hidden meaning, of secrets, of the poetic, in the work of Sylvain Dubuisson; the redefinition of function by Philippe Starck; scientific high tech in the work of Chaix and Morel; the return to "black and white" in Andrée Putman's references to motifs of the Vienna Secession, as well as her elitist refabrications of early Modernist furniture—to give only a few examples.

Although the '80s were marked by the liberating effect of Memphis, in 1981, Alchymia entered into a pessimistic discourse on the return of the "banal." Design, in the throes of the euphoria of an illusory economic recovery, had become fashionable again. Products were offered only as one-of-a-kinds or in a limited series sold by specialized galleries at prices elevated far beyond those suggested by the democratic slogans of the "old Modernists," which had arisen from a political ideal and had become an aesthetic dictate: "Beautiful, useful, inexpensive, for everyone." Did the production of those years descry the end of a reign, like a great, final celebration? Did they foreshadow the difficult decade ahead? Was there perhaps a sense that everything—in relationship to the object, to space, to time, to rhythm, to meaning—would call for a new perspective in view of the profound changes wrought by the information highway, by science, the new world political order and the disappearance of traditional values? These are the circumstances both imposed and expanded the design activities of the 1990s.

The 1990s: Mutation, Interrogation

The 1980s laid the groundwork for a different kind of design. New approaches and strategies emerged. In a world saturated with information, advertising, and products, the quality of the object's design, and also its image, shrewdly studied by its maker, came into play like an economic trump card. In the '90s, consumption works in tandem with entertainment. The designers who came out of the '80s, like those of the new generation, came to understand that only industry and mass production would present them with a springboard for success. The furniture industry, which, at least in Italy, remained a flagship industry, kept its distance from the '80s model of the one-of-a-kind sofa or chair, and became involved in every phase of an object's production. Weary of "entertainment," even if the goal remained sales, designers sought to define "legitimate" products. Returning to the ideas of service, usage, and utility, they no longer offered tables that weighed close to two thousand pounds or totemic seating on which it was impossible to sit. But the formula had changed. It was no longer form-function but function-form-meaning. The object became openly, voluntarily semantic, yet it also aspired to a "moral" ground. Relying on unimpeachable production techniques and materials as well as savvy packaging, distribution, and communications, designers became conceptualizers, sometimes even

RIGHT Pascal Mourgue, *Lune d'argent* (Silver moon) chair, fabricated by Fermob, 1985. Collection Musée national d'art moderne, Centre Georges Pompidou, Paris

FACING PAGE Martin Szekely, Perrier glass, 1996. Collection Musée national d'art moderne, Centre Georges Pompidou, Paris

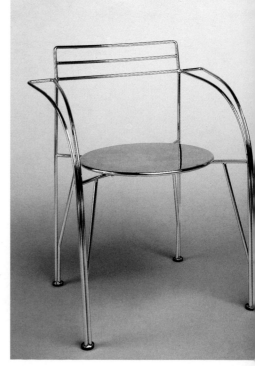

changing the direction of the means of production. In the domestic domain, designers integrated the new information tools with the metamorphosis that had occurred in the object's relationship to space. In this respect, Michèle de Lucchi explains, "As a designer, I am basically confronted with the question of the information superhighway. This is also at the center of a paradox, the time lag between the tool itself and its use; it is at the center of a dialectic between the concepts of minimum and maximum. . . . But everyone, especially what manufacturers call the 'market,' remains fascinated by matter and even more by relations." Confronted with objects whose function cannot be read simply in their appearance, the need arises to construct a relation.

From a different angle, architect Jean Nouvel also works on the dematerialization of architecture, the "informationizing" of services, which he believes has opened up a new place for objects to become works of art—purely expressive, ritualistic, tribal, and cultural. A designer like Marc Sadler works with extremes—his work on the human body incorporates research on sports and the environment, and inhabits a realm halfway between object and prosthetic device. "The factors of understanding a project are multiple, physical, and psychic. We no longer look for an often arbitrary common denominator, but try to conceive objects that evolve, cyclically—we are more interested in concepts and systems than in objects," he maintains. Others work with a new definition of "less." Less matter, less image, less investments, less cost, less ephemeral. The euphoria of the 1960s is distant, as is the abandon of the '80s. Every individual, including those living most isolated of villages, can receive images of war, famine, violence, economic rapacity, corruption and the absurd. The new "master narrative" embodied by television is almost always bad news but parsimonious when it comes to critical self-reflection. Television is completely subject to the logic of immediacy. What television produces, says Dubuisson, is "the illusion of universal knowledge and a psychic inclemency."

When entering into the process of conceptualizing an object, designers can no longer ignore the troubled, diffuse, almost incomprehensible state of the world. Having a good time is no longer in vogue, except, perhaps, in the form of derision or critical discourse, of pessimism or laughter, the "ultimate elegance of despair." On the whole, there is nothing we are more serious about than money. The current phenomenon with regards to money is to render it honest, intelligent, correct, humanitarian, ecological, altruistic, pacifist, nearly biological: this brings in a lot of money. And since everyone is a prisoner of this logic, designers are attempting to frame this new morality. Here, it is summarized by Philippe Starck: "I am not against profit, and I am for business, which is an extraordinary means of communication and belongs to our civilization. On the other hand, the object must be just: it must project a legitimacy, service, longevity; it must be neither aggressive in its meaning, nor harmful for humans and the environment, thus it must be ecological, also, in its means of production—without exploiting people or polluting the environment—it must be inexpensive, and, finally, poetic, filled with that aspect of mystery that links us to art and to dream."

Design has never been "anodyne." All aspects of everyday life are tied to it. The object is narrative. It posits a narrative of science, technology, knowledge, and power, as well as of the minute detail, the sign, the mundane, even anonymity. Between the supremacy of money and the political and ideological chaos that mark the present, the majority of designers have appropriately pondered the notion of the "human." What is its place, its future, and what do its objects look like?

Translated from the French by Lory Frankel.

(b. 1946, Bordeaux)

Sylvain Dubuisson pursued his studies at the Saint Luke School of Architecture in Tournai, Belgium. After several years in the engineering offices of Ove Arup in London, he turned to design.

For Dubuisson, whose works often consist of often single pieces or small series punctuated with literary references and legends, the creation of an object is a marvelous field for experimentation. In 1982, he created a desk, Quasi una fantasia, designed for a woman. Produced by Fourniture, the piece was a mixture of traditional cabinetwork and postmodern styles.

Fascinated with lighting, Dubuisson creates lamps with extremely sophisticated mechanisms; each lamp recounts a kind of story. His love of detail is evident in the design for Beaucoup de bruit pour rien (Much ado about nothing), produced by Ecart International in 1984, which boasts in its assemblage four razor blades, two gold chains, a rubber band, a postcard, and two paper clips. Other lamps followed: Cuer d'amour épris (Cuer in love) and Tetractys (both 1985), and Licorne (Unicorn, 1986). That same year he was voted, in collaboration with the light fixture manufacturer Companie Lita, winner of a lamp design competition. For the Pendule T2/A3 (T2/A3 Clock), Dubuisson refers to Kepler's laws and Einstein's theory of relativity; the piece is simultaneously a symbol of space and time.

The artistic dimension of his approach does not preclude rigor in manufacturing. It is in the use of new materials that Sylvain Dubuisson's talent truly expresses itself; borrowing advanced techniques from aeronautics and the automobile industry, for example, Dubuisson was among the first to make use of carbon fiber. His 1987 composite table, manufactured by Moc, demanded a complex manufacturing process, and the vase Lettera amorosa (Love letter, 1988), produced with the support of CIRVA (Centre International de Recherche sur le Verre et les Arts Plastiques / International Center for Research in Glass and the Plastic Arts), used titanium tubes manufactured from Formula 1 racing car mufflers which had been cut and engraved by laser. Dubuisson knows how to adapt his research to industrial and manufacturing constraints; because his designs can be incorporated into the economics of production, he has been commissioned by numerous companies. Between 1993 and 1996 he designed a collection of table objects for Létang-Rémy, a tea set for Rosenthal in Germany, urban furniture for J. C. Decaux and liturgical objects for Christofle.

In 1990, with carte blanche from Via, he designed a furniture series produced by Fenêtre sur Cour: the Aero armchair, the Portefeuille (Portfolio) table, and the chair L'Aube et le temps qu'elle dure (Dawn and the time it lasts). In 1990 Dubuisson was voted creator of the year at the Salon du meuble, and received the Grand Prix National de la Création Industrielle. In 1993 he was the winner of a competition organized by the Ministry of Culture and Public Assistance for the design of a furnished hospital room.

The first retrospective of his work appeared in 1990 at the Musée des Arts Décoratifs (Decorative Arts Museum), where he exhibited thirty objects and drawings; numerous public commissions were to follow. The Minister of Culture, Jack Lang, hired him to design his office, and Dubuisson created twelve pieces including a semicircular desk in mahogany veneer with leather top. The Musée de la tapisserie d'Aubusson commissioned a tapestry; for the Manufacture Nationale de Sèvres, Dubuisson created the lamp L. Internationally recognized, Dubuisson has exhibited in numerous museums and galleries including the Axis Gallery in Tokyo, the National Museum of Modern Art in Seoul, the Israel Museum in Jerusalem, and the Decorative Arts Museum in Montreal.

Sylvain Dubuisson completed the scenography for several exhibitions, including: The Plastic Years at the Cité des Sciences at La Villette in Paris (1986); À Table at the Centre de Création Industrielle, Centre Georges Pompidou, Paris (1987); Our 1980's at the Fondation Cartier in Jouy-en-Josas (1989); L'art du plastique, École Nationale Supérieure des Beaux-Arts, Paris (1996).

He has also designed the layout of a number of public spaces, including the reception area for the North Tower of Notre Dame Cathedral, Paris (1987), the reception area of the Historic Fabric Museum in Lyon (1988), the Pantheon (1993), and the Fontainebleau Estate (1996). Dubuisson was responsible for the layout of the Fine Arts Museum in Amiens, the bookstore in the Carousel du Louvre, Paris (1993), the Decorative Arts Museum, Paris (1996), and the Bibliothèque Nationale de France, Paris.

Selected Bibliography

Sylvain Dubuisson, objets et dessins (exh. cat.). Paris: Musée des arts décoratifs, 1989.

Sylvain Dubuisson (exh. cat.). Paris: AFAA, 1992.

FACING PAGE, CLOCKWISE Agricultural buildings, Saint-Selve dans Les Graves, S.C.A. Châteaux Branda and Cadillac, 1996

L'Elliptique (Elliptical) hot plate with candles, Edition Algorithme, 1987

Beaucoup de bruit pour rien (Much ado about nothing) lamp, 1983

Lettera amorosa (Love letter) titanium and glass vase manufactured by CIRVA, Marseilles, 1988

Agricultural buildings, Saint-Selve dans Les Graves, S.C.A. Châteaux Branda and Cadillac, 1996

Desk furniture, manufactured by Èdition Fourniture, 1989

L'Aube et le temps qu'elle dure (Dawn and the time it lasts) stackable aluminum chair, 1987

FACING PAGE, MIDDLE Information desk in the North Tower of the Notre Dame Cathedral, Paris, 1987

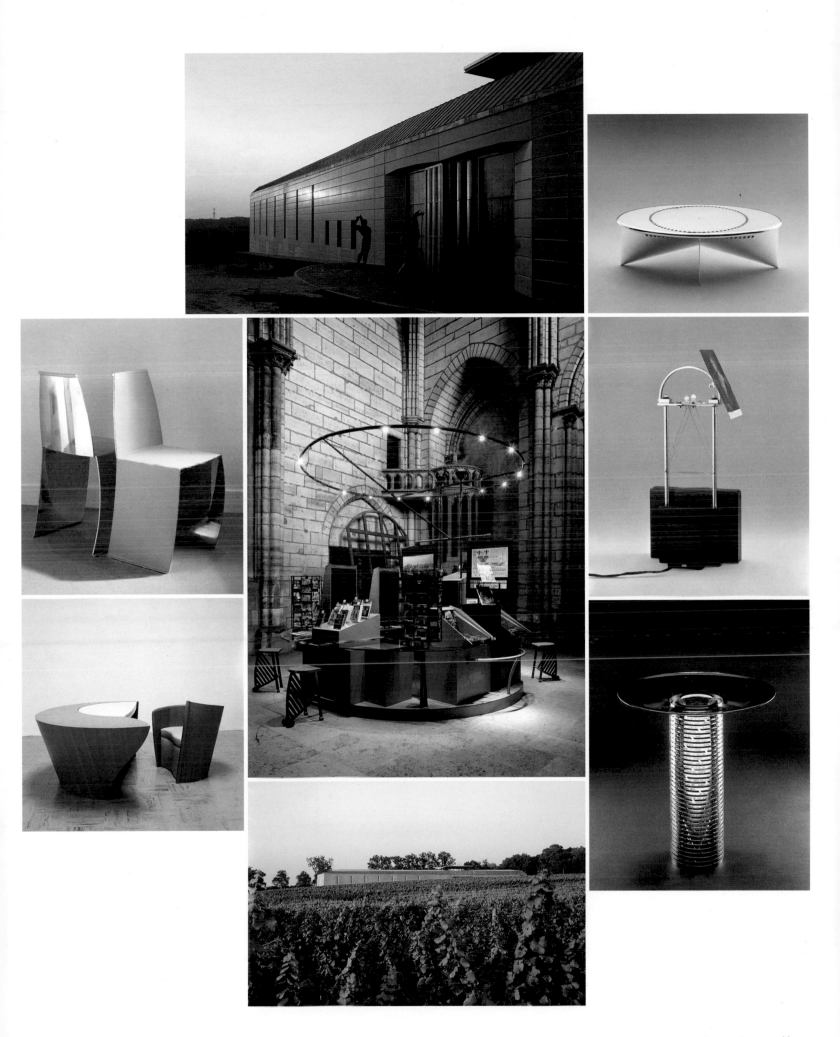

Me, the eternal spinner of blue stillnesses
I miss the Europe of ancient parapets

Arthur Rimbaud

We continue to wait for the end of the twentieth century, as if cutting time into supports and dates makes it possible to identify the period in which we live—as if the impalpable and the changing can be confined, as if tomorrow will be different than today or yesterday, so different in fact that we should delimit today in order to evaluate the change, the movement, the mutation.

Tomorrow will not be like before, neither better nor worse. Conquering modernity is coming to an end. Modernity gained ground throughout the century; its battles were clear and frank; it knew how to identify its enemies and mark its territory with projects that the times recognized as manifestos. Its territories had a place, its ideas had consistency, persuasion and perspicacity. Clarity was its call: to carry better, farther.

We allow ourselves to be won over by the seduction of images and the imaginary. They carry us away, manhandle or ravish us. Today we live in the flux and the moment. The past does not have the shimmering colors of the hyperreal or of high definition; the past does not have the lightness of the moment or its virtuality. The past speaks of clutter, of excess load, of effects. The past is banished—it is a place to be visited, like a nature preserve. The past is tacit and benevolent, it has no more epigones. We have become detached from it. There is no more base; nothing is built to last; everything is spontaneous, everything is appearance-disappearance. We exist in the moment, in instantaneous images passing by. The moment has marvelous youth, the freshness of passage and the new.

We no longer miss "the Europe of ancient parapets." We are even amazed to still be European, barely recognizing ourselves in the land of Europe. Europe is our country, yet our country is elsewhere. A multitude of identities exist there, side by side, the dream of their mixing to be born tomorrow. We do not dream of the status quo.

We want to no longer be recognized in past echoes, in the murmur of pathetic, abrupt, or enigmatic phrases. The scholar is banished, closed in on himself. Outside, hearing and solicitation are infinite and fugitive. The word is banished. Liberty is total. All objects keep quiet. Their silence is the base on which is erected a musical, colored, ethereal life. Their silence is sweet for all of us. They do not leave behind any echo. The time for talking is past. It was brief, the time it takes to reach the crest of a wave that submerges. It rolled its last roll, enormous to be sure.

Everything wears away; the traces are no longer admissible.

SYLVAIN DUBUISSON

Translated from the French by Ellen Sowchek.

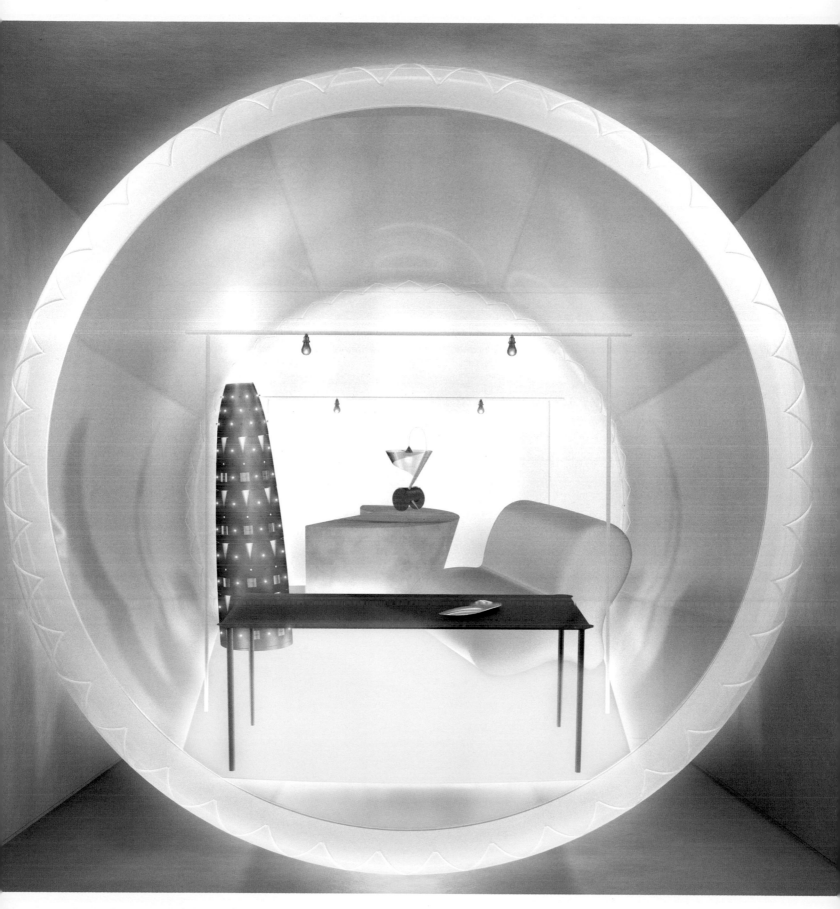

ABOVE Virtual image of an inflatable enclosure for the presentation of a selection of objects designed for *Premises*.

EG *(b. 1949, Paris)*
MB *(b. 1952, Lugano)*

Elizabeth Garouste studied interior design at the Camondo School, Paris. Mattia Bonetti studied textile design at the CSIA (School of Applied Design Arts) in Lugano.

Forming their partnership in 1980, Garouste & Bonetti presented their first collection of "barbarian" furniture—a derivative of the Louis XV rococco style— the following year at the Galerie Jansen in Paris. Experimenting with a mixture of archaism and traditional materials (cast iron, ceramics, wood, glass, cloth), Garouste & Bonetti later presented Rochers *(Rocks, 1983), a table created out of a triangular enameled steel, traffic-control sign support- ed by three uncut stones, and which reveals the confluence of the industrial and the artisanal.*

Subsequent works consist of objects and furniture with their trademark historical references: the Grand Canal *chair (1980); the* Patchwork *collection (1989), created for Carte Blanche of VIA and produced by the BGH Company that Garouste and Bonetti founded with Claude Hass; and the* Kawakubo *chest of drawers (1994), pro- duced by David Gill.*

Working in glass made it possible for Garouste & Bonetti to move from the primi- tivism of the Lune *(Moon) lamp, produced in 1984 by theGalerie En attendant les bar- bares (Waiting for the barbarians), to the coral rococo of the* Trapani *collection of table objects (designed for the Daum Company in 1987).*

When Nina Ricci Perfume and Cosmetics Company approached Garouste & Bonetti to create a range of beauty, perfume, and personal care product-packaging, the design firm introduced elements of baroque into industrial production. The formal pos- sibilities of molded plastic with its rich palette of colors allowed Garouste & Bonetti to demonstrate, in magisterial fashion, the capabilities of lower-cost synthetic materials for "traditional" materials. Nina

Ricci launched the cosmetic line in 1992. The bottling and packaging designs of Deci Delà perfume were created in 1994, while the designs for les Belles de Ricci cologne were realized in 1996.

In 1987, under the rubric of interior design, Garouste & Bonetti designed the salons of the Christian Lacroix couture house. Emblematic of their work, the arcades of white walls, red drapes, carpet bordered in black flames, and cast iron chairs impart a Spanish flavor to the great couturier's milieu.

Garouste & Bonetti have received com- missions from several public institutions: the Goldoni vase for the CIRVA (Centre International de Recherche sur le Verre et les Arts Plastiques / International Center for Research in Glass and the Plastic Arts) in Marseilles in 1988, a Cabinet for the Manufacture de Sèvres in 1990, and the fur- niture set for the Mobilier National in 1996.

Their work has been exhibited at the Cooper-Hewitt Museum in New York, the Seibu Museum in Tokyo, the Kunstmuseum in Düsseldorf, the Fondation Cartier in Jouy- en-Josas, and the Decorative Arts Museum in Paris, among other places.

Individual museum exhibitions were devoted to them in 1985 (Decorative Arts Museum in Bordeaux), 1987 (Villeurbanne Museum), 1993 (Mandet Museum in Riom), and 1997 (Centre Georges Pompidou). They exhibit regularly at the Néotu Gallery in Paris and New York, and the David Gill Gallery in London.

Selected Bibliography

Mattia Bonetti, Elizabeth Garouste (exh. cat.). Bordeaux: Musée des arts décoratifs, 1985.

Elizabeth Garouste et Mattia Bonetti. Texts by François Baudot, Stephen Calloway, and Gérard-Georges Lemaire. Marseilles: Èditions Michel Aveline, 1990.

Garouste & Bonetti. Texts by Walker Albus, Alex Buck, Stephen Colloway, Raymond Guidot, Suzanne Slesin, Sophie Tasma-Anargyros, and Matthias Wogt. Frankfurt am Main: Verlag Form Publishers, 1996.

FACING PAGE, CLOCKWISE
Interior design for P.S. Woo's boat in Hong Kong, 1996

Deci Delà perfume product line for Nina Ricci, 1992

Design for the Christian Lacroix haute couture showrooms, 1987

Design for the Christian Lacroix haute couture showrooms, 1987

Rocher (rock) table, fabricated by Galerie Néotu, Paris, 1983

Garouste and Bonetti's first exhibition at Jansen showroom, Paris, 1981

EXTROVERTED KITCHEN

Put your foot down. Suggest a kitchen. A kitchen that makes its presence felt with an organic form: sensual, tender, human, 5 meters long and 3 meters high.

Proceed with a departure from style, a freedom of spirit that is simultaneously ironic, dreamlike, poetic, and crazy. Defy all the clichés of avant-garde "installations." Combine the automatic quality of manufacturing with the rigor, the purification and the morale of "modern times."

A kitchen as a living space that no longer hides itself, and has become the heart of the home, the meeting place for family and friends. Almost everything is done there. Food is welcomed, prepared, eaten, shared, discussed.

We wanted to magnify this "furniture" by opting for a double reading of pleasure, a certain aesthetic form and function, and the union of form and senses. We have used seduction in adapting the project to our vocabulary and our repertoire of contradictory forms—often round and generous but sometimes refined and geometric. Pleasure and desire make light of derision, fantasy, humor, luxury, and affectation.

As for function, it no longer shamefully hides itself. It exists brilliantly as an integral part of the décor taking its place in the center of our home. The electrical appliances and "kitchen utensils" that we use are integrated into the furniture and recovered with gold leaf.

At the dawn of the year 2000, we challenge the established order of stereotypical forms in our daily lives and propose a new rule in which function is based on freedom of creation.

GAROUSTE & BONETTI
Translated from the French by Ellen Sowchek.

ABOVE Virtual image of the **Extroverted Kitchen**, environment designed for *Premises*

(b. 1949, Paris)

Since adolescence, Philippe Starck has been interested in design; he was probably influenced by the work of his father, a aeronautic engineer. Starck studied interior design at the Camondo School in Paris, and in 1968 founded one of the first companies to manufacture inflatable objects. He established himself as an interior designer at the end of the 1970s, designing the décor for two nightclubs: La Main Bleue (1976) and Les Bains-Douches (1978). In 1979, he founded Starck Products.

The Easy Light *lamp won Starck the Oscar du Luminaire in 1980. His design work would henceforth be divided between industrialized objects, interior design and— by the end of the 1980s—the construction of buildings. His activities are diverse and intense. In 1982, he designed a portion of the private apartments in the Elysée Palace, creating for the occasion the club chair Richard III. One of his most well-known interiors was for the* Café Costes, *in 1984; and the armchair,* Café Costes, *that he designed became famous. That same year Starck became artistic director of X.O., a furniture production company founded by Gérard Mialet; he also began a fruitful collaboration with Les 3 Suisses, a mail order company for which he created furniture and even a house (whose plans are included in the sales catalogue).*

In 1985, Starck designed the Café Manin *in Tokyo, and in 1990, the celebrated nightclub El Teatriz in Madrid. His attraction to architecture materialized at the end of the 1980s with Nani Nani (1989), a building covered with oxidized copper, and the Asahi Building (1990), a black cube topped with a golden flame (both buildings are in Tokyo). In the United States, Starck made his mark with the renovation of two New York hotels, the Royalton (1988) and the Paramount (1990). In the Netherlands he participated in the construction of the Groningen Museum (1991).*

The number of Starck-designed objects in the last two decades is impressive; his work has been produced and distributed by both European and Japanese firms (Driade, Baleri, Kartell, Drimmer, Owo, Flos). Among his notable pieces of furniture are the folding Tippy Jackson *table (1982) and the furniture in the* Lang *series (1987), produced by Vitra. Starck's household objects include the* Etrangets *glass (1988), produced by Daum; the* Hot Berta *kettle (1989) and the* Juicy Salif *citrus juicer (1990), produced by Alessi; and the* Fluocaril *toothbrush (1990). From 1993 to 1996, Starck was responsible for the artistic direction of Groupe Thomson Consumer Electronics. His numerous creations for Thomson include the televisions* Jim Nature *(1994) and* Culbuto *(1996). Starck designed the G.S. motorbike (1994) for Aprilia, and—in the area of urban furniture—a lamp for the Jean-Claude Decaux Company.*

Philippe Starck's work has brought him worldwide recognition. He has been the recipient of numerous prizes, including the Grand Prix National de la Création Industrielle (1988). He has participated in many museum and gallery exhibitions throughout the world; a retrospective of his work is planned for 2001 at the Centre Georges Pompidou, Paris.

Selected Bibliography

Colin, Christine. *Starck, mobilier 1970–1978*. Liège: Èditions Mardaga, 1988.

Bertoni, Franco and Philippe Starck. *Philippe Starck, l'architecture*. Liège: Èditions Mardaga, 1994.

Starck. Cologne: Editions Taschen, 1996.

Mello, Patrizia. *Philippe Starck, Progetti in movimento*. Florence: Editions Festina Lente, 1997.

FACING PAGE, CLOCKWISE
*Starck eye*glasses for Mikli, 1996

Jim Nature television design for Saba, 1994

Lama motorscooter prototype for Aprilia, 1992

Asahi building: detail of the golden flame on the roof, Tokyo, 1990

Ray Menta lamp (prototype), 1984

Rock 'n' Rock radio prototype for Telefunken, 1996

Wim Wenders stools, 1990 manufactured by Vitra

FACING PAGE, ABOVE MIDDLE
Bubu 1st stools, 1991

FACING PAGE, BELOW MIDDLE
Nani Nani building, detail of the rear façade, Tokyo, 1989

FOLLOWING PAGE
Slogan for the end of a millennium ("Love is a species that is in the process of disappearing")

L'AMOUR EST
EN VOIE DE

UNE ESPECE
DISPARITION*

(b. 1956, Paris)

Martin Szekely received a diploma from the Estienne School in line engraving and later completed training courses in carpentry at the Boulle School. The point of departure for his research has always been design, which corresponds to his training as an engraver.

In 1982 he received a commission from VIA (Valorisation de l'Industrie de l'Ameublement) to design the Pi chair that would be later produced by Galerie Néotu. The first element in a collection directly inspired by typography, the Pi chaise lounge, which became a familiar silhouette in the 1980s, consists of some ten pieces in black-lacquered steel and aluminum.

In 1987, Szekely exhibited his second collection, Containers, which were five storage units created with the support of FRAC Limousin. "It marks the taking into account of the body of the furniture in its relationship with architecture, the ground and the wall, as supports."[1] The collection also included the Toro chair and the Stoleru sofa.

In 1989 Szekely once again took up the typology of household furniture in his collection Pour faire salon (To make a living room). The Marie-France Armchair, with its softened shape, breaks with the graphic treatment of the Pi collection. Two vases were added to Pour faire salon: the North Vase, a monumental piece blown, molded and shaped by master glassblowers at the Manufacture de Cristal du Val Saint-Lambert in Belgium, and the Françoise Vase, also in blown glass, created at CIRVA (Centre International de Recherches sur le Verre et les Arts Plastiques / International Center for Research in Glass and the Plastic Arts) in Marseilles. The North Vase offers, in its design, a balance between the dynamic and the static. The Françoise Vase is not the result of a preliminary design but of a decision made during the process of glass blowing.

The 1991 collection Initiales consists of basic furniture suggesting "the imaginary origins of furniture"; its TB Table is a simple assemblage of squared-off boards.

The Maroquinerie Delvaux in Belgium commissioned Szekely in 1992 to design a line of small handbags for men; Szekely took for his inspiration the harnesses of draft horses in resolving the relationship between the pouch and the handle of the bag.

Martin Szekely reinterpreted popular traditions in 1994 with the Satragno collection. The Satragno bookcase consists of modules that are placed one on top of another; the form of the furniture comes from the piling up of the elements that compose it. The Centre de Table Compotier (Center of the Table Fruit Dish), produced in porcelain at CRAFT (Centre de Recherche sur les Arts du Feu et de la Terre / Center for Research in the Arts of Fire and Earth, Limoges), is constructed on the same principle: elements link with each other in order to form the final piece.

While creating furniture collections for the Néotu Gallery, Szekely received numerous public and private commissions for the design of museums, shops and apartments, and also a podium for the XVI Winter Olympic Games in Albertville. For the J.-C. Decaux Company, Martin Szekely designed a line of Urban Furniture in cast-iron steel; its pieces make direct reference to Art Nouveau. In 1994, Szekely created, with Transel (principal supplier of the EDF, Electricité de France), a high-power, electric transformer poles designed to be installed in a rural environment. This wood construction, 31 meters high, "recalls windmills, technological objects, that eventually became part of our heritage."

In 1996, for the Perrier Company, Szekely designed a glass which has become, "since then, the companion of the green bottle." For Hermès he created a line of jewelry in silver and gold, entitled the Queen of Sheba collection. He worked in conjunction with Ceramic Network, organized by CRAFT, on a project for tile for the TBF Company (Tullierie Briqueterie Française) and was later selected as designer for the Legrand Company, a builder of electric materials.

Martin Szekely responds to his clients in a sensitive manner, keeping in mind both production techniques and end use of the objects that are requested. The first part of his professional journey was oriented towards personal research and limited production; subsequently Szekely developed answers to the questions posed by industrial production. Nevertheless, he notes, "whatever the mode of production, my projects are always the culmination of a craftsman's thinking."

1. Interview with Brigitte Fitoussi, *Martin Szekely, meublier-designer, 1983–1995* (Paris: Édition AFAA, 1995).

Selected Bibliography

Martin Szekely, meublier-designer, 1983–1995 (exh. cat.). Texts by Brigitte Fitoussi, Pierre Staudenmeyer, Christian Schlatter. Paris: Éditions AFAA, 1995.

Schlatter, Christian. *Martin Szekely designer* (exh. cat.). Belgium: Éditions Grand-Homu, 1998.

FACING PAGE, CLOCKWISE
Pi chaise lounge, 1982

Cornette chair, 1981

Queen of Sheba necklace, Édition Hermès, 1996

Stoleru couch from the collection *Containers*, Édition Néotu, 1987

SF shelving unit, from the collection *Initiales*, Edition Néotu, 1991

Nord (north) crystal vase, from the collection *Pour Faire Salon*, fabrication by Val Saint-Lambert, 1989

Double-faced park bench, Édition J.-C. Decaux, 1993

FACING PAGE, MIDDLE
Corolle high-power electric transformer poles, 1994

AFTER DESIGN?

1. *No more design*? Having designed a great deal, I have arrived at a proposal no longer directly linked with design per se: a design without design, separating the object from its conception and development. The 1985, *Pi* collection was the manifestation of an expressive design. Today my work seems to be an about-face from this impulse, escaping the expressionism of design and its inevitable result. In my relationship with industrial design and its destiny, a new idea took hold of my practice; in a similar vein, I have reconsidered designers who limit their intentions to variations on a style. I have noted that private stylistics always impose themselves. I seek a simplified result that cannot be called minimalist and still has a connection with style.

2. *Definition.* The limits of the object are the object itself; its semantic definition is in its name. Any attempt to change the definition will lead to a change in the nature of the object. If the object is a chair, the designer must design a chair with a chair's attributes. This is the heart of industrial design. The object's identity must be immediate so long as it is intended for the general public and is not a private commission or the "design" seen in galleries.

3. *For an economy.* One constant in my work is the absence of the mechanical. I freely imagine that it is possible to resolve the problems presented by moving parts of a piece of furniture or a machine through the simple contact of material between them without resorting to mechanical workings. For example, to make a glass door slide, the usual device includes a rail, a shoe screwed onto the glass, and wheels turning around a ball bearing. This is a large number of parts employed to produce a single action; an appropriate material supporting the glass would allow it to slide just as easily. I ask myself if all authentic invention is linked to economy of means implemented, whether material or physical. I remember searching in the library for books on ergonomics and finding them under the heading "economy."

4. *The armoires.* They are composed of layered (aluminum-plastic-aluminum) sheets, cut, grooved, and drilled according to plan; the three operations are performed in sequence by a machine. The base, top, bottom, sides, doors, handles, hinges, and carriers of the armoire are created by a milling machine operating on the surface of the sheet. The transformation of the sheet into its *armoire configuration* is completed by folding it. Thus, the structure and components of the armoire materialize at the end of the manufacturing, all in one piece.

MARTIN SZEKELY
Translated from the French by Ellen Sowchek.

THIS PAGE Unfolding dresser, prototype made from composite sheets of aluminum and plastic, generated by a computer program; virtual project for *Premises*

Premises: French Cinema, 1958 to 1998 is a major film series organized by the Guggenheim Museum which explores this seminal period in the history of French cinema, from the dynamic onset of the *Nouvelle Vague* to the resurgence of French cinema claimed by many critics today. The series is an integral part of Centre Georges Pompidou's collaboration with the Guggenheim Museum, and is guest-curated by Dudley Andrew (Director of the Institute for Cinema and Culture, University of Iowa) and David Rodowick (Professor of English and Visual/Cultural Studies, University of Rochester, New York), leading American scholars on French cinema, and organized by John G. Hanhardt, Senior Curator of Film and Media Arts, and Maria-Christina Villaseñor, Assistant Curator of Film and Media Arts, Solomon R. Guggenheim Museum. Taking as its point of departure the thematics of the *Premises* exhibition, the film series explores the construction, representation, and issues engaged in the creation of a French cinematic space, with films presented within the context of the three main organizing principles:

Cinematic Space
Space of Self/Space of Other
Socio-Political Space

ALL FILMS ARE SCREENED IN 35MM
AND ARE COLOR, SOUND, AND IN FRENCH
WITH ENGLISH SUBTITLES, UNLESS
OTHERWISE NOTED.

TOP TO BOTTOM
Cléo de 5 à 7 (1962),
Agnès Varda, photo courtesy
of Museum of Modern Art /
Film Stills Archive.

Le Samouraï (1967),
Jean-Pierre Melville, photo
courtesy of Museum of Modern Art
/ Film Stills Archive.

Pickpocket (1959),
Robert Bresson, photo courtesy
of Cahiers du Cinéma.

La maman et la putain (1974),
Jean Eustache, photo courtesy
of Museum of Modern Art /
Film Stills Archive.

CINEMATIC SPACE

FABULATION
L'Ami de mon amie
Boyfriends and Girlfriends (1987)
Eric Rohmer; 16mm film; 102 min.

Le Boucher (1970)
Claude Chabrol; 16mm film; 95 min.

Le Camion (1977)
Marguerite Duras; 80 min.

Lola (1960)
Jacques Demy
black-and-white; 91 min.

La Maman et la putain
The Mother and the Whore (1974)
Jean Eustache
black-and-white; 210 min.

CINEMA WITHIN CINEMA
La Chambre verte
The Green Room (1978)
François Truffaut; 94 min.

Irma Vep (1997)
Olivier Assayas; 96 min.

JLG / JLG (1994)
Jean-Luc Godard; 60 min.

Le Mépris / Contempt (1963)
Jean-Luc Godard; 100 min.

Passion (1982)
Jean-Luc Godard; 88 min.

INTERMEDIATION
La Belle noiseuse (1990)
Jacques Rivette; 16mm film
240 min.

L'Hypothèse du tableau volé
Hypothesis of the Stolen Painting
(1978)
Raúl Ruiz; black-and-white; 70 min.

Level 5 (1996)
Chris Marker; 106 min.

La Marquise d'O
The Marquise of O... (1976)
Eric Rohmer; 102 min.
In German with English subtitles.

Othon (1969)
Danièle Huillet and
Jean-Marie Straub; 16mm film;
88 min.

Thérèse (1986)
Alain Cavalier; 90 min.

SPACE OF SELF/SPACE OF OTHER

VOICES OF INTERIORITY
La Naissance de l'amour
The Birth of Love (1993)
Philippe Garrel; 94 min.

Le Pays des sourds
In the Land of the Deaf (1992)
Nicolas Philibert; 99 min.

Pickpocket (1959)
Robert Bresson; black-and-white
80 min.

Le Samouraï
The Samurai (1967)
Jean-Pierre Melville
16mm film; 103 min.

Sans toit ni loi
Vagabond (1985)
Agnès Varda
105 min.

ZONES OF EXCHANGE
Cléo de 5 à 7
Cleo from 5 to 7 (1962)
Agnès Varda; 16mm film,
black-and-white; 90 min.

India Song (1974)
Marguerite Duras, 115 min.

Je, tu, il, elle (1974)
Chantal Akerman
black-and-white; 90 min.

Moi, Pierre Rivière (1976)
René Allio; 16mm film; 125 min.

Muriel, ou le temps d'un retour
Muriel (1963)
Alain Resnais; 117 min.

TRACES, DOCUMENTS, ETHNOGRAPHIES
Chronique d'un été
A Tale of Summer (1961)
Edgar Morin and Jean Rouch
black-and-white; 85 min.

La Comédie du travail (1987)
Luc Moullet; 85 min.

Coute que coute (1995)
Claire Simon
16mm film; 95 min.

Faits divers (1983)
Raymond Depardon
16mm film; 98 min.

Ici et ailleurs (1976)
Jean-Luc Godard, Jean-Pierre Gorin,
and Anne-Marie Miéville
16mm film; 60 min.

La Jetée (1963)
Chris Marker
black-and-white; 29 min.

Moi, un noir (1958)
Jean Rouch
16mm film
black-and-white; 70 min.

Sans soleil (1982)
Chris Marker
16mm film; 100 min.

SOCIO-POLITICAL SPACE

CARTOGRAPHIES
L'État des lieux (1992)
Jean-François Richet,
black-and-white; 80 min.

Hexagone (1994)
Malik Chibane; 90 min.

Paris vu par... / Six in Paris (1962)
Claude Chabrol, Jean Douchet,
Jean-Luc Godard,
Jean-Daniel Pollet, Eric Rohmer,
and Jean Rouch; 93 min.

Play-Time (1967)
Jacques Tati, 16mm film; 152 min.

Thé au harem d'Archimède
Tea in the Harem (1985)
Mehdi Charef, 16mm film; 110 min.

PUBLIC/PRIVATE SPHERES
Un Chant d'amour (1950)
Jean Gênet, silent,
black-and-white; 26 min.

Corps à coeur
Drugstore Romance (1978)
Paul Vecchiali; 126 min.

La Fiancée du pirate
A Very Curious Girl (1969)
Nelly Kaplan; 107 min.

Les Nuits fauves / Savage Nights
(1992), Cyril Collard; 126 min.

Numéro deux (1975)
Jean-Luc Godard
and Anne-Marie Miéville
video; 80 min.

UTOPIA/DYSTOPIA
À nos amours (1983)
Maurice Pialat; 95 min.

L.627 (1992)
Bertrand Tavernier, 35mm film
145 min.

Les Valseuses / Going Places (1974)
Bertrand Blier; 117 min.

Reprise (1996), Hervé Le Roux
192 min.

Integrated in the exhibition galleries, there will be four single-channel video viewing rooms that will house four distinct programs that have been constructed to correspond with the thematic sequences of the exhibition. This interdisciplinary selection will include documentaries, music videos, contemporary dance videos, and television commercials, as well as artists' videotapes. Christine van Assche and Marie Anne Lanavère from the Centre Pompidou organized this program.

ABOVE, LEFT TO RIGHT
Marie Legros:
Les liens: Le thé, le journal, l'argent
(The bonds, tea, newpaper, money)
video still, 1997

Claire Denis:
*Pour Ushari Ahmed
Mahmoud, Soudan*
(For Ushari Ahmed
Hahmoud, Soudain)
video still, 1991

Jean-Michel Carré:
L'enfant prisonnier
(The child prisoner)
video still, 1976

Jean-Claude Gallotta
Claude Mouriéras;
Un chant presque éteint
(An almost extinguished song)
video still, 1986

THIS PROGRAM WILL ALSO FEATURE WORK
BY ALAIN BUBLEX, CLAUDE CLOSKY,
AND PHILIPPE PARRENO.

INBETWEEN: PUBLIC/PRIVATE

Costa-Gravas: *Pour Kim Song-Man, Corée du Sud* (For Kim Song-Man, South Korean), McSolaar, Saï Saï music, Robert Badinter, text; 35mm film transferred to video, 1991, 3:00, color.

Alain Cavalier: *Portraits: la dame lavabos* (Portraits: the bathroom guardian), documentary video, 1988, 13:00, color.

Marie Legros: *Les liens: Le thé, le journal, l'argent* (The bonds, tea, newpaper, money), video, 1997, 5:00, color.

Dominique Cabrera: *Réjane dans la tour* (Réjane in the tower), documentary video, 1993, 15:00, color.

Arman Gatti: *La dernière emigration* (The last emigration) from *Le lion, sa cage et ses ailes* (The lion, its cage, and its wings), video, 1976, 12:00, b&w

Laure Bonicel: *Untitled # 00*, dance video, 1997, 6:00, color

Christian Boltanski: *L'appartement de la rue Vaugirard*, (Apartment on the rue Vaugirard), 16mm film transferred to video, 1973, 4:00, b&w.

Claire Simon: *Le ménage à l'envers (avant...)* (Backwards Household, before) from *Scenes de ménage* (Scenes from a household), 35mm film transferred video, 5:00, 1991, color.

Jean Rouch: *Gare du nord* (North station), 35mm film transferred to video, 1965, 16:00, b&w.

Pierrick Sorin: *Réveils* (Wake-up call), super 8 film transferred to video, 1988, 5:00, color.

Joël Bartoloméo: *La fourmi* (The ant), video in the series *Petites scènes de la vie ordinaire* (Small scenes from ordinary life), 1994, 2: 45, color.

ELSEWHERE

Raymond Depardon: *New York, N.Y.*, 35mm film transferred to video, 1986, 10:00, b&w.

Claire Denis: *Pour Ushari Ahmed Mahmoud, Soudan*, (For Ushari Ahmed Hahmoud, Soudain) music video for Alain Souchon/Laurent Voulzy; 1991, 4:00, b&w.

Gilles Deleuze/Pierre-André Boutang/Claire Parnet: *Abécédaire, V comme voyages* (ABCs: V as in voyage), 16mm film transferred to video, 1988, 7:45, color.

Thierry Kuntzel: *Buenavista*, video, 1980, 27:00, color.

Dominique Bagouet/Charles Picq/Christian Boltanski: *Dix anges* (Ten angels) video, 1988, 32:00, color.

Michel Gondry: *Mermaids*, (advertisement for Levi's), 35mm film transferred to video 1996. 1:00, color.

Agnès Varda: *7P., cuis., s. de b...*, 35mm film transferred to video, 1984, 27:00, color.

Odile Duboc/Harold Vasselin: *Trois regards intérieurs* (Three interior looks), video, 1993, 21:00, color.

Chris Marker: *Junkopia*, 35mm film transferred to video, 1981, 5:21, color.

ENCLOSURES

Chris Marker: *L'ambassade* (The embassy), super 8 film, 1975, 20:00, color.

Raymond Depardon: *Pour Alirio de Jesus Pedraza Becerra, Colombie* (For Alirio de Jesus Pedraza Becerra, Columbia), 35mm film commissioned by Amnesty International, 1991, 3:00, color.

Jean-Michel Carré: *L'enfant prisonnier* (The child prisoner) 16mm film transferred to video, 1976, 26:00, color.

Olivier Dollinger: *Apocalypse Now*, video, 1996, 6:00, color

Charmatz/Luc Riolon: *Aattenent!onon*, video, 1997, 19:30, color.

Vincent Ravalec: *Par delà l'ère glaciaire* (Beyond the Ice Age) 35mm film transferred to video, 1994, 2:57, b&w.

Marion Vernoux: *Dedans* (Inside), 35mm film and video, 1996, 7:00, color

EXCHANGE

Hervé Robbe/Jorge Leon Alvarez/ Richard Deacon: *Factory*, video, 16:00, 1993, color.

Muriel Toulemonde: *Transmissions, levée des corps* (Transmissions, raising of the bodies) video, 2:20, 1997, color.

Giles Deleuze/Pierre-André Boutang/Claire Parnet: *Abécédaire, N comme Neurologie*, (ABC's, N as in neurology) 16mm film transferred to video, 1988, 20:08, color.

Jean-Luc Godard and Anne-Marie Miéville: *France/tour/détour/deux/enfants* (France/tour/detour/two/children), eighth movement (*Désordre/ Calcul*) (Disorder/Calculus), video, 1977-78, 26:00, color

Robert Filliou: *Telepathic Music no.7, the Principle fo Equivalence carried to a Serie of 5*, video, 1977, 15:00, color.

Matthieu Laurette: *Apparitions* (Selection 1993-92) video compilation of TV shows, 1995, 13:50, color.

Jean-Claude Gallotta/Claude Mouriéras: *Un chant presque éteint* (An almost extinguished song), video, 1986, 28:00, color.

Majida Khattari: *Défilé/Performance* (Runway show/ performance) video, 1996-97, 15:00, color.

Samuel Beckett: *Quad*, video, 1981, 16:00, color.

Philippe Decouflé: *Codex*, video, 1987, 26:00, color.

Emile Aillaud, *Le Chemin, c'est le détour* (The route, it's the detour)
Directed by Cesare Massarenti
1979, video, 20:00, color.
© Centre Georges Pompidou

Frédéric Borel:
113 rue Oberkampf, Paris
Stock footage by Jacques Bocquet
1993, video, 60:00, color.
© Frédéric Borel

Georges Candilis/Alexis Josic:
Toulouse Mirail
Directed by Mario Marret
1960, video and 16mm film,
31:00, color
Production Armor Films
Source: Ministère de l'Equipement,
du Logement et des Transports

*The Erratic City in the Hands
of Yona Friedman*
Directed by Esther Agricola
1997,video,15:00, color,
© Esther Agricola and
Helene Fentener van Vlissingen,
Amsterdam/Amersfoot,
The Nederlands

Yona Friedman:
Wunschmaschine – Welterfolg
Directed by Ernst A. Grandits
1996, video, 5:00, color.
©Austrian Broadcasting
Corporation (ORF) Enterprise, Wien.

Massimiliano Fuksas: *Housing
Complex, Ilot Candie-Saint Bernard*
Directed by Odile Fillion
1996, video, 32:00, color
© Odile Fillion

Henri Gaudin: *L'Espace d'un Regard*
(The span of one perspective)
Directed by Jacques Deschamps
with the participation of
Anne de Staël
1985, video, 50:28, color.
© INA/La Sept

Henri Gaudin: *Charléty:
un stade dans la ville*
Directed by Olivier Horn
1996, video, 27:08, color
© La Sept-Arte/ Centre Georges
Pompidou/Les Films d'Ici

Jean-Marc Ibos /Myrto Vitart:
Un Musée dans tous ses états
(A museum in all of its states)
Written and directed by
Alain Fleischer
1998, video, 52:00, color
Delegate production:
Byzance Film, Lille

Rem Koolhaas: *Villa Dall' Ava*
Directed by Richard Copans
An original idea by Alain Guiheux
1992, video, 13:00 and 26:00, color.
© Centre Georges Pompidou/
Les Films d'Ici

Rem Koolhaas:
Une Maison à Bordeaux
(A Residence in Bordeaux)
Written and directed by
Richard Copans
1998, video, 23:00, color
© Les Films d'Ici/
Arc en rêve centre d'architecture

LABFAC (Finn Geipel and Nicolas
Michelin): *Métafort Media Research
Center, Aubervilliers*
Directed by Pierre-Emmanuel Meunier, assistant Adrien Faucheux
1998, computer animation,
2:00, color
© LABFAC

Le Corbusier
Directed by Jacques Barsac
Production Jacques Barsac /
Christian Archambeaud
1987, video and 16mm film,
180:00, color
©CIST/INA/Gaumont/Fondation
Le Corbusier/A2/La Sept.
Source Ministère des
Affaires Etrangères

Le Corbusier: *Le Poème Electronique*
Directed by Le Corbusier
Production and Source Philips
International, Eindhoven
1958, 35mm film and video,
9:00, b&w and color
Production and source material:
Philips International, Eindoven

Marcel Lods:
Constructive System GEAI
1962, 16mm film and video,
10:00, color
© Académie d'Architecture, Paris.

Jean Nouvel: *Architectures en
France 1991* (Architecture in France)
Directed by Richard Ugolini
Written by Odile Fillion/
Le Moniteur
1991, video, 30:00, color.
© Caisse des dépôts et consignations, mission mécénat,
direction de l'information et de la
communication internes

Jean Nouvel: *Demateriality -
Interface - Metaphor*
Designed and directed by
Odile Fillion
1995, video, 30:00, color
Co-produced by Centre Georges
Pompidou/Kunstverein Hamburg
© Kunstverein Hamburg

Jean Nouvel: *Les Diaphragmes de
l'Institut du Monde Arabe*
(The diaphragms of the IMA)
Directed by Pascal Bony
1987, video, 15:00, color
© Gresh Productions, France

Jean Nouvel:
The Institute of the Arab World
Edited by Odile Soudant and
Bernard Semeteys
1987, video, 8:00, color
© Architectures Jean Nouvel

Jean Nouvel: *Lucern Cultural
and Congress Center*
Directed by Beat Kuert
1998, video, 10:00, color
© Trägerstiftung KKSL, Lucern

Jean Nouvel: *Nemausus 1:
Une HLM des années 80* (One public
housing project from the 80s)
Directed by Richard Copans
and Stan Neumann
1985, video, 26:00, color
© La Sept-Arte/ Les Films d'Ici

Jean Nouvel: *Nemausus 1, Nîmes
(1985-1987)*
Filmed and directed by Odile
Soudant and Bernard Semeteys
1988, video, 8:00, color.
© Architectures Jean Nouvel

Jean Nouvel: *Opéra de Tokyo
(Tokyo opera house)*
Directed by Lyonel Guyon
Production Album Production
1987, video, 5:30, color
© IFA

Jean Nouvel: *Portrait volé d' un
voyeur (Stolen portrait of a voyeur)*
Directed by Marie-Jo Lafontaine
Production Ex Nihilo
1988, video, 23:00, color
© Ex Nihilo/CNACGP/CDN/La Sept

Dominique Perrault: *Chantier pour
une Bibliothèque* (Construction site
for a library)
Directed by Jean-François Roudot
Production Vidéothèque de Paris
1995, video, 4:38, color
© BNF/ Vidéothèque de Paris

Dominique Perrault: *Dossiers
audiovisuels de la BNF* (Audiovisual files from the French
National Library) *Les jardins de
la BNF* 1997, video, 14:31, color

*A propos de la BNF- Dominique
Perrault* 1995, video, 38:00, color

Dominque Perrault:
Europasportpark, Berlin
Directed by VISTA Visualisierungsstudio für Stadtplanung,
GmbH, Berlin
1998, video, 10:00, color
© VISTA Visualisierungsstudio
für Stadtplanung, GmbH

Renzo Piano:
The Information Age exhibition
Directed by Marcello Antozzi
1985, video, 8:00, color
© IBM

Renzo Piano:
The Centre Georges Pompidou
Directed by Richard Copans
1997, video, 26:00, color.
© Centre Georges Pompidou/
La Sept-Arte/Les Films d'Ici

Renzo Piano: *Structures Parallèles
(Parallel structures)*
Directed by Gilles Dagneau
1998, video, 8:00, color.
© RFO - New Caledonia/
Agence pour le développement
de la Culture, Kanak

Christian de Portzamparc:
*Notes de Parcours,
Cité de la Musique*
Directed by Philippe Gaucherand
1994, video, 30:00, color.
Production Vidéothèque de Paris
© Cité de la Musique/CAP

Jean Prouvé:
La Maison des jours meilleurs
Directed by Michel Zemer
1955, 16mm film, 5:00, b & w
© Les Films du Rond-Point

Jean Renaudie:
*Architectes et espace urbain:
"marcher sur le dos des maisons"*
Directed by Philippe Laïk
1978, video, 41:00, color
Extract of Jean Renaudie
interviewed by Jean-François
Grunfeld, Curator of the Exhibition
"The City and the child"
© Centre Georges Pompidou

Peter Smithson: *Haupstadt Berlin*
Directed by M. McHale
1958, 12:00, b&w
Peter Smithson Archives

Bernard Tschumi: *Les Grands
Artistes et le Veilleur de nuit Le
Fresnoy National Studio for Contemporary Arts, Tourcoing, 1991-97*
Written and directed by
Alain Fleischer
1998, 35mm film and video,
90:00, color
© Cercle Bleu - France 3 Nord Pas
de Calais Picardie - LE FRESNOY-
C.r.r.a.v Renn Productions

Page 2 and 3: © Holger Trülzsch; pages 4 and 5: © Gabriele Basilico; pages 6 and 7: © Agence Rapho; page 8 and 9: © Suzanne Lafont; page 19:©Webster's; page 21: © Editions Galilée; page 24 and 25: Collection Cahiers du Cinéma; page 28: Photo: Raymond Hains; page 33: Photo: Harry Shunk, © Yves Klein Archives, USA; page 37:Photo: Y. Friedman; page 40: © Agence Rapho; pages 48 and 49: © Flammarion; pages 52 and 53: © Flammarion; pages 58 and 59: © Flammarion; pages 60 and 61: © MIT Press; pages 64 and 65: MIT Press; page 67: Collection Cahiers du Cinéma; page70 and 71: © Photo: Jean Mascolo, Collection Cahiers du Cinema; page 74: Collection Cahiers du Cinéma; pages 78 and 79: Collection Cahiers du Cinéma; page 80: Collection Cahiers du Cinéma; page 87: Photo: Harry Shunk, © Yves Klein Archives, USA; page 90 (top):© Yves Klein Archives, USA; page 90 (bottom): Collection of the Musée d'Art, Geneva; page 91: © Yves Klein Archives, USA; page 92: © Armand P Arman Archives; page 94: Collection of the Musée National d'Art Moderne—Centre Georges Pompidou, Paris/Documentation generale des oeuvres; page 95: Courtesy MFA Houston; page 96: Collection Cahiers du Cinéma; page 97: Collection of the Musée National d'Art Moderne-Centre Georges Pompidou, Paris; page 98:Photo: Alain Bizos, © Armand P. Arman Archives; page 99: Photo: Alain Bizos; © Armand P. Arman Archives; page 101: Collection Cahiers du Cinéma; page 102: Collection Cahiers du Cinéma; page 105: Collection Cahiers du Cinéma; page 106: Collection Cahiers du Cinéma; page 110: Collection Cahiers du Cinéma; page 114 and 115: Collection Cahiers du Cinéma; page 118: François Hers; page 119: François Hers; page 120 and 121 (top): Agence Magnum; page 120 (bottom): Christian Milovanoff; page 121 (bottom): Christian Milovanoff; page 122: Gabriele Basilico; page 123 (top): Pierre de Fenoÿl; page 123 (bottom): Pierre de Fenoÿl; page 124 (top right corner): Agence Rapho; page 124 and 25:Agence Rapho; page 126 (top): Agence Rapho; page 126 (bottom): Agence Rapho; page 127 (top): Jean Louis Garnell; page 127 (bottom): Sophie Ristelhueber; page 128 (top): Jean Louis Garnell; page 128 (bottom):Jean Louis Garnell; page 129: Sophie Ristelhueber; pages 133, 134, and 135 (all photos): © Yves Klein

Archives, USA; page 136 (top):© Photo: V. Döhne; (bottom) © Photo Charles Wilp;page 137: © Photo: V. Döhne, Krefelder Kunstmuseum; pages 13; page 139, 140, and 141 (all photos): © Arman P. Armand Archives; page 143: Courtesy of Holly Solomon Gallery, New York; © Christo; page 144: Photo: Eeva-Inkeri, © Christo; page 145 (top to bottom): Photo: Eeva-Inkeri, © Christo; Photo: André Grossmann, © Christo; Photo: Eeva-Inkeri, © Christo; Photo: Eeva-Inkeri, © Christo 1965; page 147: © Raymond Hains archives; page 148 (top): © Raymond Hains archives; (bottom left): Photo: François Fernandez, © Raymond Hains archives; (bottom right): © Raymond Hains archives; page 149 (all photos): Photo: Raymond Hains, © Raymond Hains archives; page 151: © Barbara Räderscheidt & Daniel Spoerri; page 152 (top): © Daniel Spoerri; (bottom): © Barbara Räderscheidt & Daniel Spoerri; page 153 (all photos): © Barbara Räderscheidt & Daniel Spoerri, page 154, 155, 156, and 157 (all photos): © Armand P. Arman Archives; page 159: © Photo: K. Ignatiadis, Centre Georges Pompidou; page 160 (top): © Photo: K. Ignatiadis, Centre Georges Pompidou; pages 160 and 161 (all bottom photos): © Photo: Nino Barbieri, Düsseldorf; page 161 (top): © Photo: Studio Müller & Schmitz, Remscheid; page 163, 164, and 165 (all photos): Photo: Bruce Fleming, Courtesy of the Lila and Gilbert Silverman Fluxus Collection; page 167: © Private Collection, D.R.; page 169 (clockwise): © D.R.; © Centre Georges Pompidou, Photo : K. Ignatiadis; © D.R.; © D.R.; Page 173, 174, and 175 (all photos):© Chris Marker D.R.; page 177 (all photos): © Photo: Georges Meguerditchian-Centre Georges Pompidou; Page 179: © Photo: Augustin Dumage, 1970-Fondation Jean Dubuffet, Paris; page 179: © Fondation Jean Dubuffet; Page 181:© Photo: Augustin Dumage, 1970-Fondation Jean Dubuffet, Paris; page 183: (top) © Photo: Sabine Weiss-Fondation Jean Dubuffet; (bottom): © Photo: Jacques Faujour Fondation Jean Dubuffet, Paris; page 182: © Photo: Jacques Faujour Fondation Jean Dubuffet, Paris; page 185: © Centre Georges Pompidou; page 186 (top): © Archives Etienne-Martin; (bottom, all photos): © Archives Etienne-Martin; page 187: Photo: Daniel Pype; page 189 (all photos): © Photo: Jacques Hoepffner; page 191: Photo: Bertrand Leroy;

page 192 (all photos): © Photo: Giulio Pietromarchi; page 193: © Photo: Giulio Pietromarchi; page 195: Photo: Peter Bellamy; page 196 (all photos): Photo: Peter Bellamy; page 197: Photo: Peter Bellamy; page 198: Photo: Anders Allsten; page 199 (all photos): Photo: Peter Bellamy; page 201: © Annette Messager, Photo: Adam Rzepka; page 202: © Annette Messager, Photo: André Morin; page 203 (top): © Annette Messager, Photo: André Morin; (middle): © Annette Messager, Photo: Caroline Rose; (bottom): © Annette Messager, Photo: Adam Rzepka; page 204: Gagosian Gallery New York; page 207: © Film stills: Didier Coudray, Centre Georges Pompidou; page 208 (all photos): © Film stills: Didier Coudray, Centre Georges Pompidou; page 209 (all photos): © Film stills: Didier Coudray, Centre Georges Pompidou; page 211: © Sarkis, April 1998; page 212 (all photos): © Sarkis; page 213: © Sarkis; page 215: © Photo Adam Rzepka; page 216: © Photo Adam Rzepka; page 217 (all photos): © Photo Adam Rzepka. page 221: © Archives Denyse Durand-Ruel; page 222: © Archives Denyse Durand Ruel; page 223: © photo Shigeo Anzai, Tokyo; Archives Denyse Durand Ruel; page 225: © Photo: Jacques Faujour-Archives Jochen Gerz; page 226: © D.R. Archives Jochen Gerz; page 227 (top): © photo Jean-Claude Planchet Archives Jochen Gerz; (bottom): © D.R.-Archives Jochen Gerz; page 229: © photo Philippe Migaet-Centre Georges Pompidou, Paris; page 230: © photo Philippe Migaet-Centre Georges Pompidou, Paris; page 233: © Photo André Morin-Caisse des Dépôts et Consignations; page 234: © Photo André Morin-Caisse des Dépôts et Consignations; page 235 (all photos): © Caisse des Dépôts et Consignations; page 237: © Didier Coudray, Centre Georges Pompidou; page 238 (all photos): © Didier Coudray, Centre Georges Pompidou; page 239 (all photos): © Didier Coudray, Centre Georges Pompidou; page 240: © D.R.; page 241: Courtesy Galerie Xavier Ufkens, Bruxelles; page 242 (left, all photos): © D.R.; pages 242-243: © Courtesy Galerie Bob van Orsouw Zürich; page 245; © Photo: Florian Kleinefenn, Paris; pages 246 and 247 (all photos): © Alain Séchas, Paris; page 247 (all photos): © Alain Séchas, Paris; page 249 (top): © Photo: Claude Lévêque.page 255, 256, 257, 258, and 259 (all photos): © Philadelphia

Museum of Art; page 261, 262, and 263 (all photos): © film stills: Patrick Palaquer-Centre Georges Pompidou; page 265: © Françoise Masson-Archives Anne Marchand; page 266 and bottom 267): © Photo: Yves Gallois, 1997-Musée d'art contemporain, Marseille; page 267 (top, all photos): © Françoise Masson-Archives Anne Marchand; page 269: © film stills Patrick Palaquer- Centre Georges Pompidou; page 270 (all photos): © film stills Patrick Palaquer- Centre Georges Pompidou; page 271 (all photos): © film stills Patrick Palaquer- Centre Georges Pompidou: page 273: © Archives Paul-Armand Gette; page 274 (all photos): : © 1986 The Metropolitan Museum of Art; page 275 (clockwise): © Paul-Armand Gette; © Centre Georges Pompidou, Paris; © Centre Georges Pompidou, Paris;© Paul-Armand Gette; page 277: Courtesy of Galerie Chantal Crousel, Paris; page 279: Courtesy of Luhring Augustine Gallery; page 281: Photo: Miki Kratsman, © Marie-Ange Guilleminot Archives; page 282 (top to bottom): Photo: Dike Blair, © Marie-Ange Guilleminot Archives; Photo: Edouard Smith, © Marie-Ange Guilleminot Archives; Photo: Oded Altman, © Marie-Ange Guilleminot Archives, Photo: Marie-Ange Guilleminot, Photo: Oded Altman, © Marie-Ange Guilleminot Archives, Photo: Marie-Ange Guilleminot, Photo: Oded Altman, © Marie-Ange Guilleminot Archives; page 283: © Photo: Florian Kleinefenn, Paris; page 285, 286, and 287 (all photos):© Dominique Gonzalez-Foerster; page 289: Photo: Laurent Pinon; page 290 (all photos): © Pierre Huyghe; page 291 (all photos): © photos Laurent Godin; page 295: © D.D., page 296 (all photos): © D.B.; page 297 (all photos): © D.B.; page 298 (all photos): © D.B.; page 299: © D.B.; page 301: © Archives Claude Rutault; page 302 (all photos): © Archives Claude Rutault; page 303 (all photos): © Archives Claude Rutault; page 304: © Archives Bertrand Lavier; page 305: © Archives Bertrand Lavier; page 306 (clockwise): © Archives Bertrand Lavier; © Archives Bertrand Lavier; pages 306 and 307: © Jacques Faujour; pages 307 (clockwise): © Archives Bertrand Lavier; page 309: © Courtesy Galerie Claire Burrus; page 310 (top 2 photos): © Courtesy Galerie Claire Burrus, Paris; (bottom 4 photos): © Archives Benoît d'Aubert, Paris; page 311 (all photos): © Courtesy Galerie Claire Burrus, Paris; page 313: © Photo: F. Kleinefenn; page 314 (clock-

LE CAMPING INTÉGRAL PAR L'AUTOMOBILE

LA MAISON ROULANTE de M. Raymond Roussel

Fig. 1. — La « roulotte automobile » photographiée dans la propriété de M. Raymond Roussel, à Neuilly.

Nous n'avons pas ici la prétention d'apprendre aux lecteurs de la *Revue* du *T. C. F.* ce qu'est le Camping ni de leur énumérer les joies profondes qu'il procure à ses adeptes.

En effet, dans presque tous les numéros, un campeur nous crie son allégresse de s'en aller le long des routes, libre, fort, de s'arrêter à sa fantaisie près d'un ruisseau, dans une prairie, dans un champ, dans une forêt, de coucher enfin sous le ciel immense à l'abri d'un toit léger, loin des autres hommes qui dorment dans les maisons.

Nous voulons simplement signaler un mode extrêmement ingénieux et confortable de pratiquer le camping intégral.

M. Baudry de Saunier dans son livre la « joie du camping » sépare les adeptes du camping en deux tribus, qui se jalousent un peu certes, mais qui s'aiment bien tout de même parce qu'en somme elles ont le même drapeau : la tribu des *Spartiates* et celle des *Sybarites*.

Les Spartiates ce sont ceux qui s'en vont, soit à pied, soit à bicyclette, en emportant leur maison sur leur dos (une maison de toile qui ne pèse pas 10 kilogs avec tout son mobilier). Ce sont les valeureux, les vaillants du camping.

Les Sybarites au contraire ce sont ceux qui font porter leur maison par un véhicule automobile. Et cette maison, ils la veulent bien entendu aussi confortable que possible. Ils entendent retrouver en plein bois ou en plein champs, les douceurs et les avantages du home familier.

C'est donc pour les Sybarites surtout que nous allons décrire la très luxueuse et très pratique maison roulante conçue par M. Raymond Roussel. L'auteur d'*Impressions d'Afrique*, dont tant d'esprits distingués vantent le génie, a fait établir sur ses plans, une automobile de 9 mètres de long sur 2 mètres 30 de large.

Cette voiture est une véritable petite maison. Elle comporte en effet, par suite de dispositions ingénieuses : un salon, (fig. 2), une chambre à coucher (fig. 3), un studio (fig. 4), une salle de bains (fig. 6), et même un

Fig. 2. — Le salon-chambre à coucher sous son aspect de salon, orné de glaces, éclairé par de larges baies et muni de fauteuils confortables.

Fig. 3. — Le salon-chambre à coucher disposé pour la nuit. On bascule le lit qui, pendant le jour, est dissimulé dans l'encastrement de la cloison.